Lasting Impressions

Lithography as Art

To two women

JUNE WAYNE
who gave a decade of her life
to changing the ecology for lithography in the United States
and
JANINE BAILLY-HERZBERG
one of the most generous print scholars in Paris

Lasting Impressions

Lithography as Art

EDITED BY PAT GILMOUR

upp University of Pennsylvania Press
Philadelphia

Editor: Pat Gilmour
Production Editor: Bruce Semler
assisted by: Mark Henshaw
Picture Editor: Cathy Leahy
Managing Editor: Elisabeth Ingles

Measurements are given in centimeters, height before width,
and refer to image size, unless otherwise indicated

Thanks are due to the Australian National Gallery's Photographic Services Department,
to Gordon Reid and Bruce Moore, the photographers, and Dorothy Rollins, Photographic Records Clerk

First published in North America 1988 by the University of Pennsylvania Press
Copyright © 1988 Australian National Gallery
ALL RIGHTS RESERVED
Library of Congress Catalog Number: 88-1304

ISBN: 0-8122-8126-8

This book was designed and produced by
John Calmann and King Ltd, London
Designer Trevor Vincent
Typeset by Keyspools Ltd, Golborne, Lancs
Printed in Singapore by Toppan Ltd

Contents

FOREWORD 6
Pat Gilmour

INTRODUCTION: THE FELIX MAN COLLECTION OF LITHOGRAPHS 9
The founding of the international print collection
Cathy Leahy, Curatorial Assistant, Australian National Gallery

1 THE NATURE OF LITHOGRAPHY 25
The physical properties and visual possibilities of the process
Clinton Adams, Director Emeritus, Tamarind Institute, University of New Mexico

2 CHARLES JOSEPH HULLMANDEL: LITHOGRAPHIC PRINTER EXTRAORDINARY 42
The first study devoted to Britain's most important lithographic printer
Michael Twyman, Professor of Typography & Graphic Communication, Reading University

3 MANET'S ILLUSTRATIONS FOR 'THE RAVEN':
ALTERNATIVES TO TRADITIONAL LITHOGRAPHY 91
The mystery surrounding Manet's illustrations for 'The Raven'
Jay McKean Fisher, Curator of Prints, Drawings and Photographs, Baltimore Museum of Art

4 FROM REDON TO RIVIÈRE: ALBUMS OF THE 1890s 110
Aesthetic and thematic concerns in fourteen French lithographic albums
Phillip Dennis Cate, Director, Jane Voorhees Zimmerli Art Museum at Rutgers University of New Jersey

5 CHER MONSIEUR CLOT . . .
AUGUSTE CLOT AND HIS ROLE AS A COLOUR LITHOGRAPHER 129
With a selection of letters sent to France's most famous colour printer between 1896 and 1936
Pat Gilmour and the Department of International Prints, Australian National Gallery

6 STARTING AGAIN FROM SCRATCH:
LITHOGRAPHY IN GERMANY BETWEEN THE 1890s AND THE 1920s 183
Three decades of lithographic achievement in the country where lithography was invented
Antony Griffiths, Deputy Keeper, Department of Prints and Drawings, British Museum

COLOUR PLATES 209

7 BIGGER, BRIGHTER, BOLDER:
AMERICAN LITHOGRAPHY SINCE THE SECOND WORLD WAR 257
A survey of lithographic expansion across the United States
Ruth E. Fine, Curator, National Gallery of Art, Washington DC

8 LITHOGRAPHY IN AUSTRALIA: MELBOURNE 1948–1958 283
A decade of post-war socio-political expression
Roger Butler, Curator of Australian Prints, Australian National Gallery

9 LITHOGRAPHY IN NEW ZEALAND: A COMING OF AGE 296
Recent developments 'on the periphery'
Anne Kirker, Senior Curator, National Art Gallery, Wellington

10 LITHOGRAPHIC COLLABORATION: THE HAND, THE HEAD, THE HEART 308
Changes in the working relationship between artists and printers during two centuries of lithography
Pat Gilmour, Senior Curator, Australian National Gallery

NOTES 360

APPENDIX: SCHEDULE OF LETTERS AND PROVISIONAL LIST OF WORKS PRINTED BY AUGUSTE CLOT 382

BIBLIOGRAPHY 392
*Edited by Christine Dixon and Jane Kinsman
and compiled by the staff of the Australian National Gallery*

INDEX 413

Foreword

Even Aloys Senefelder himself seems to have been somewhat confused as to precisely when he 'discovered' lithography. Although the celebrated laundry list dashed off onto his inking slab in Bavaria during 1796 paved the way to his eventual triumph, the process it immediately inspired was in fact a form of relief printing. It was 1798 or even 1799 before Senefelder fathomed the real importance of his far-reaching planographic 'chemical printing' method. His own confusion as to the true nature of the technique he had invented and the claims published in various editions of his treatise that 1796, 1798 and even 1799 were the years in which lithography became a reality, permitted the French to demonstrate their superiority in the process and in an excess of nationalism to steal a march on the German inventors by celebrating the centenary three, if not four years early.

Interested bystanders could be forgiven for supposing that by mounting an exhibition covering the history of lithography in 1988 and producing this book, the Australian National Gallery is celebrating the bicentenary of lithography up to a decade early! In fact, the bicentenary celebrated is that of Australia, for it is an intriguing coincidence that the birth of lithography and the idea of founding a penal settlement at Botany Bay were roughly synchronous. So as one of the strengths of the Australian National Collection lies in its representation of the art of the lithograph, it seemed appropriate that the Gallery should demonstrate at this particular time the richness of its holdings.

The founding of the Department of International Prints and Illustrated Books, which had not been planned when the Gallery was first conceived, was a consequence of a decision in 1972 to purchase the group of lithographs belonging to one of the early historians of the process, Mr Felix Man. The rarity of some of the material was such that it was obvious the Gallery could not have assembled such a collection had it been working from scratch. Once the availability of Man's collection was known, the present Director, James Mollison, then Director-designate, together with Fred Williams, a distinguished landscape artist who became a member of the Gallery's first Council, inspected the prints and made a case to Government for a special purchase grant. Australians can be thankful that Gallery affairs were in the hands of two such expert print enthusiasts and that James Mollison was not merely sympathetic to graphic art, but extremely knowledgeable about it. Formed to care for this wealth of material, the Department of International Prints and Illustrated Books was able to add new acquisitions to this solid foundation. Once the very substantial group of lithographs assembled by Felix Man had been secured, the Director purchased the Gemini archive from the printer Ken Tyler, thus acquiring some of the most outstanding lithographs made in recent times. He also took out subscriptions for other contemporary prints from leading publishers.

This book sets out to circulate information about the Gallery's collection, to establish a forum in which Australasian lithography can take its place and to publish contemporary research of note by scholars of wide reputation. Clinton Adams, artist, historian of American lithography and a former director of Tamarind, which has done so much to change the face of lithography in the United States, writes a personal account of the process towards the end of its second century. Michael Twyman, whose name is indissolubly linked with the history of lithography before 1850, has produced the first study ever to be devoted to Charles Hullmandel, Britain's most important lithographic printer. Jay McKean Fisher of Baltimore has taken a step further his investigation of Manet's use of non-traditional print techniques and points to a need

for future researchers to delve not only into 'original' prints, but also into commercial aspects of print production. Dennis Cate, of Rutgers University Art Gallery, thoroughly steeped in the 1890s which he covered in his book on 'the color revolution', surveys both famous and lesser-known lithographic portfolios produced at that time. Antony Griffiths of the British Museum, who with his colleague Frances Carey mounted a major exhibition of German prints there in 1984, has written the first essay in English about the many different applications of lithography in Germany before the second world war. Ruth Fine, former curator of the Lessing J. Rosenwald Collection and now with the National Gallery of Art in Washington, has cast a non-partisan net across post-war America, revealing a more varied production than has hitherto been documented by east coast historians.

The Australasian contributors, Anne Kirker and Roger Butler, write of continuing activity on the geographical periphery. Despite its tiny population and its need to import lithographic materials from such a distance, New Zealand can boast its Tamarind-trained lithographers and an urbane lithographic output. The account of political intensity expressed lithographically in post-war Melbourne, in addition to showing how the seeds were planted for today's widespread lithographic activity, will surprise those whose imagined Australians were all sun-tanned hedonists lying on a beach.

My own essay on collaboration between artists and printers arises from interviews with some of the world's great lithographic printers and is the result of a long-standing fascination with the way the ideas in the head of one person find resolution partially through the hands of another. The related contribution on Auguste Clot, one of France's most famous colour lithographers, is a team effort which would not have been possible without generous help from the members of my department. Our research was based on a cache of several hundred letters, ably translated by Mark Henshaw, which still belong to the printer's grandson, Dr Guy Georges, but which I found languishing in a cupboard at the Bibliothèque Nationale in Paris. Although the material could have been tapped at any time since it was written, no scholar in the northern hemisphere since Claude Roger-Marx has produced so much as a magazine article on this celebrated and controversial colour lithographer.

In an enterprise such as this book, 'l'entente cordiale' is of major consequence. I should like therefore to thank not only my immediate colleagues and contributors for their innumerable helpful suggestions, but Anne Frolet-Bancroft and her team at the Parisian research agency CPEDERF, who so efficiently tied up some loose ends for us at the eleventh hour. The Gallery has also been fortunate in eliciting information and assistance not only from other contributors, but from scholars around the world, among them Janine Bailly-Herzberg, Arsène Bonafous-Murat, Sarah C. Epstein, Colta Ives, Bente Torjusen, Jeff Rosen, Nicholas Smale, Nesta Spink, and Gerd Woll, all of whom have been more than generous with their help.

In conclusion, perhaps the far-sighted politicians, whose commitment to the Gallery has made possible the acquisitions we now celebrate, should be applauded. As much of the world's wealth these days is deployed on weapons of destruction, it is heartening that a country with a population as small as Australia should have been able to devote sufficient funds to secure these remarkable works of graphic art. As time goes on, not only Australians will realize how well the money was spent, for long after today's anti-missile missiles have become obsolete, these lithographs will still be leaving lasting impressions.

Pat Gilmour

IX.

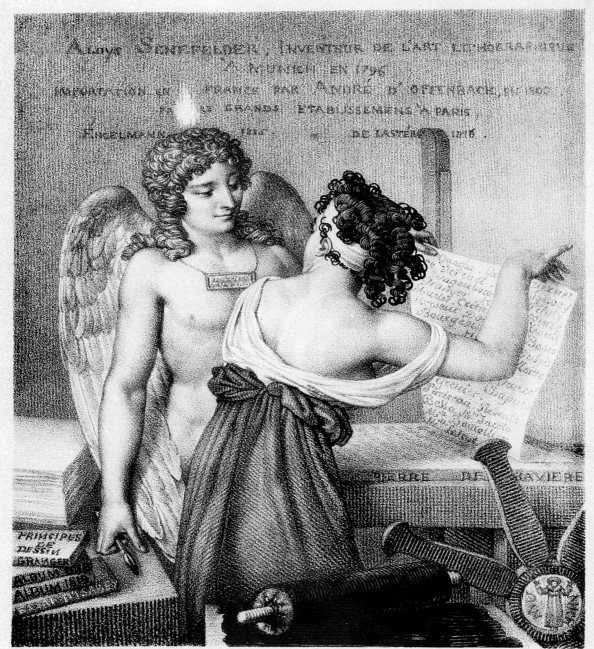

N.H. Iacob Dess.^r de S.A.R. le Prince d'Eichstaedt

Introduction:
The Felix Man Collection of lithographs

Cathy Leahy

...one of the richest private collections of lithography in existence.

elix Man, a German photojournalist who emigrated to England in 1934 after Hitler came to power, began his collection of artists' lithographs in England during the second world war. His unique collection, assembled over three decades, documents the development of lithography at the hands of artists from the early 1800s through to the 1960s. Comprising over 1,000 prints and several hundred books, it was acquired by the Australian National Gallery in 1972 and was especially significant to the history of the Gallery because it was the first international art of real consequence to enter the collection and one of ten major acquisitions that were to shape the Gallery's future direction. Not only did it set a standard of excellence for international acquisitions, but it laid the foundation for the Department of International Prints and Illustrated Books.

Felix Man was born in Germany in 1893, and became interested in art at an early age. He excelled at etching at school and after graduating from Freiburg University in 1912 he continued to study fine art and art history in Munich and Berlin. Although Man first became interested in collecting art when he was a student,[2] it was not until the 1940s that he actually began to assemble his collection. By this time he had become well known as a photojournalist, helping towards the end of the 1920s to establish the modern photo-essay; his own photographs were said to have 'carried to a new pitch the telling of a story in a sequence of pictures which almost rendered text unnecessary'.[3] His photographs were never posed or set up. He preferred to photograph his subjects unawares and to capture an event without interfering in it.

From 1929, Man's photographs were published regularly in the *Münchner Illustrierte Presse* (until 1932) and the *Berliner Illustrirte* (until 1935). In 1934, after emigrating to England, he worked for the *Weekly Illustrated*, the *Daily Mirror* and, from 1938 to 1945, as chief photographer for *Picture Post*.

It was in England that Man began contributing to the scholarship on lithography through the authorship of books and articles. His first book, *150 years of artists' lithographs*,[4] published in 1953, is a historical survey. In 1962, he published the article 'Lithography in England 1801–1810',[5] which was accompanied by a useful *catalogue raisonné* of all the lithographs executed in England between those dates. Man's next book, *Artists' lithographs: A world history from Senefelder to the present day*[6] published in 1970, became a standard reference on the history of artists' lithography. He followed it in 1971 with *The complete graphic work of Graham Sutherland, 1922–1969*.[7] Man also published lithographs in conjunction with Galerie Ketterer of Munich; between 1963 and 1972 he brought out eight portfolios entitled *Europäische Graphik*.

Man first began to assemble his collection towards the end of the second world war. His financial situation was considerably improved by this time, and he began attending print auctions, at first following the inclinations of his taste, buying without any particular plan in mind. He soon realized, however, 'that collecting prints must have a

2 *Above* Plate VII
from Supplement of
illustrations with the French
edition of Senefelder's
treatise, Paris 1819
lithograph
20.9 × 14.4
Felix Man Collection
Australian National Gallery,
Canberra

1 *Opposite* Plate IX
from Supplement of
illustrations with the French
edition of Senefelder's
treatise, Paris 1819
lithograph
19.2 × 16.4
Felix Man Collection
Australian National Gallery,
Canberra

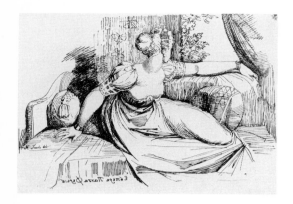

3 *Above* HENRY FUSELI
A Woman sitting by a
window 1802
lithograph
23.0 × 31.8
Felix Man Collection
Australian National Gallery,
Canberra

4 *Right* OWEN JONES
Persian ornament no. 3
plate XLVI in
The Grammar of ornament
by Owen Jones, London 1856
colour lithograph
45.8 × 30.8
Felix Man Collection
Australian National Gallery,
Canberra

5 *Below* CONRAD GESSNER
Horses at a cottage door 1804
lithograph
23.4 × 32.4
Felix Man Collection
Australian National Gallery,
Canberra

6 *Below right* JAMES BARRY
Eastern patriarch 1803
lithograph
23.4 × 32.4
Felix Man Collection
Australian National Gallery,
Canberra

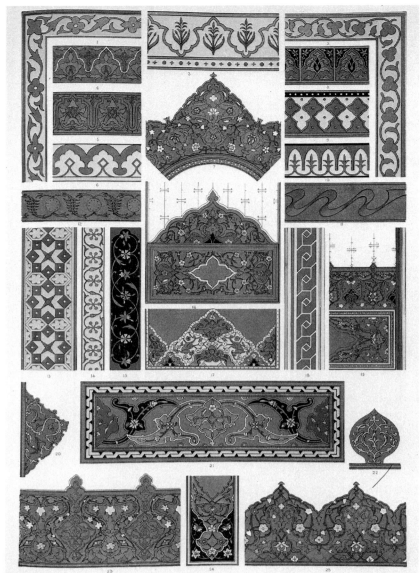

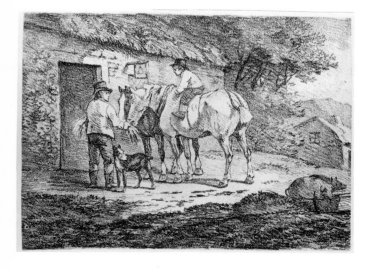

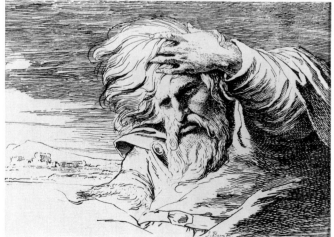

certain direction'.[8] Initially interested in lithographic incunabula, Man soon became convinced that, since lithography was a relatively young medium and as yet little appreciated, it would be possible to assemble a comprehensive collection of artists' lithographs from the earliest to the most recent.

Man began researching the history of lithography by studying the books and early treatises about the process in the libraries of the Victoria and Albert Museum and the British Museum in London. Copies of several of these treatises became part of his collection and are now in Australia (1, 2). He acquainted himself with lithographs by examining as many prints as he could. He observed that so little was known about lithographs at this time that the British Museum had listed a number of early pen lithographs as soft-ground etchings.[9]

The first works that Man acquired for his collection were examples of the English incunabula – works by Benjamin West, Henry Fuseli and Richard Cooper. Many were discovered at dealers' shops and purchased fairly cheaply, as 'dealers had no idea about the value or rarity of some of the lithographs in those days'.[10] He claimed that not all his acquisitions came cheaply, however: 'For works by artists such as Goya, Fantin-Latour, Chassériau and Picasso I had to pay a high price myself, as these had to be acquired at auction.'[11]

Details concerning the order and manner in which Man assembled his collection are unfortunately not available, but he felt it was seen at its best when it was exhibited at the Victoria and Albert Museum from November 1971 to January 1972.[12] It was in March, only two months later, that negotiations concerning the sale of the collection began. Everything exhibited in London is now in Australia and the dealer handling the sale of the collection expanded it by including a number of Victorian chromolithographs, among them the prints published by the Arundel Society, and many such magnificent books as Owen Jones's *Grammar of ornament* (4).

The Man Collection is of great scope and depth. He took on a difficult task in attempting to compile a survey of over 150 years' work in lithography and although the collection which came to Australia has some gaps, it does justice to Man's original intention, recording most of the major developments in the history of the process and representing many of the more important artists associated with it. The greatest strength of the collection lies principally in the period before 1850 where developments and artists are charted most fully.

Although lithography was invented in Germany, it was in England that it was first utilized as a viable form of artistic expression and between 1801 and 1810 a sizeable body of artists' lithographs was produced. Leading artists participated in this new venture and some fine examples of their work are preserved. West is represented by his now famous *Angel of the resurrection*, 1801, Fuseli by *A Woman sitting by a window*, 1802 (3), and James Barry by *Eastern patriarch*, 1803 (6). These three works are pen lithographs and in their linearity and use of cross-hatching reveal their dependence upon etching and drawing. Other artists, however, used crayon for their lithographs and some of these reveal a greater understanding of the possibilities of the medium. Conrad Gessner is particularly noteworthy in this regard and is represented by *Horses at a cottage door*, 1804 (5), which Man felt was probably Gessner's most important print.[13]

The first publication of artists' lithographs, André's *Specimens of polyautography*, 1803, is represented in the Man Collection by six of the twelve lithographs issued. Early English lithographs are a particular strength, for many of the examples are rare or unique impressions. Man's copy of *Angel of the resurrection* is an early proof and Charles Heath's *Head of Christ*, 1802, a unique specimen (7).

In Germany, artists' lithography did not have as auspicious a beginning as in England. Senefelder travelled a great deal and until 1803 the lack of technical knowledge sometimes hampered successful production. Wilhelm Reuter's pen lithograph *The Rape of Proserpina*, 1803 (11), demonstrates some of the technical difficulties experienced at the time. Reuter was particularly influential in the

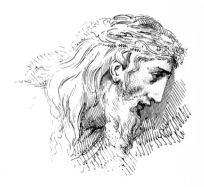

7 CHARLES HEATH
Head of Christ 1802
lithograph
11.6 × 12.6
Felix Man Collection
Australian National Gallery,
Canberra

8 KARL FRIEDRICH
SCHINKEL
Gothic church behind a
grove of oaks 1810
lithograph
48.6 × 34.0
Felix Man Collection
Australian National Gallery,
Canberra

development of German lithography, for he not only produced some 130 lithographs himself, but began the publication of lithographs in the *Polyautographische Zeichnungen vorzüglicher Berliner Künstler* which ran from 1804 through to 1808. Johann Klein's *Students from Erlangen out riding* of 1811 (9) is another interesting example from this early period. Man's collection also includes one of the earliest masterpieces of German lithography, Karl Friedrich Schinkel's *Gothic church behind a grove of oaks* of 1810 (8). Towards the end of this first decade in Germany, however, lithography increasingly became the domain of the commercial lithographer, who used the process for reproductive work.

9 JOHANN ADAM KLEIN
Students from Erlangen
out riding 1811
lithograph
17.0 × 20.6
Felix Man Collection
Australian National Gallery,
Canberra

Lithography in France did not really get under way until 1816, when Engelmann and the Comte de Lasteyrie opened their print workshops in Paris, and many of the foremost French artists then tried the new technique and extended its possibilities beyond anything that had yet been achieved. Man assembled many excellent examples from this period by such artists as Eugène Isabey (10), Carle and Horace Vernet (13), Nicholas-Toussaint Charlet (12) and Antoine-Jean Gros (14, 15). In their work a new freedom of expression and a greater feeling for the 'painterly' qualities of the medium is evident. This is nowhere more dramatically employed than in the lithographs by Géricault, whose complete mastery of the medium is displayed in *Mameluke defending a wounded trumpeter*, 1818 (16), with its fluidity, freedom of line and dramatic use of tonal contrasts.

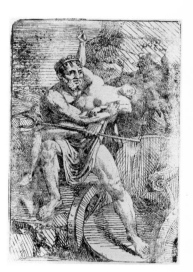

11 *Above* WILHELM REUTER
The Rape of Proserpina 1803
lithograph
28.6 × 19.0
Felix Man Collection
Australian National Gallery,
Canberra

ENVIRONS DE DIEPPE

10 EUGÈNE ISABEY
Near Dieppe 1832–3
from *Six marines*
lithograph
21.4 × 28.8
Felix Man Collection
Australian National Gallery,
Canberra

13 *Opposite top left*
HORACE VERNET
Lancer on duty as a
sentinel 1816
lithograph
24.0 × 20.0
Felix Man Collection
Australian National Gallery,
Canberra

14 *Opposite top right*
ANTOINE-JEAN GROS
Desert Arab 1817
lithograph
18.8 × 26.2
Felix Man Collection
Australian National Gallery,
Canberra

15 *Opposite bottom left*
ANTOINE-JEAN GROS
Mameluke chief 1817
lithograph
31.6 × 24.2
Felix Man Collection
Australian National Gallery,
Canberra

16 *Opposite bottom right*
THÉODORE GÉRICAULT
Mameluke defending a
wounded trumpeter 1818
lithograph
34.4 × 28.0
Felix Man Collection
Australian National Gallery,
Canberra

Another major breakthrough for lithography came in 1825 when Goya, in voluntary exile in Bordeaux, executed his series of four *Bulls of Bordeaux*. The Australian National Gallery is fortunate to own a rare trial proof made before the edition of *Division of the arena* (17), a work that Man particularly treasured.

An exception to the increasingly commercial use of the process from the 1840s is seen in the work of those artists who turned to lithography as a vehicle for social and political satire. Daumier and Gavarni were the two outstanding artists of this tradition and they are represented by famous works – such as Daumier's *Bring down the curtain*, 1834 (18), and Gavarni's *After the ball*, 1847 (19).

Although Rodolphe Bresdin and Adolph von Menzel (20) also made important

12 NICOLAS-TOUSSAINT
CHARLET
French soldier 1818
lithograph
45.8 × 33.8
Felix Man Collection
Australian National Gallery,
Canberra

Arabe du desert

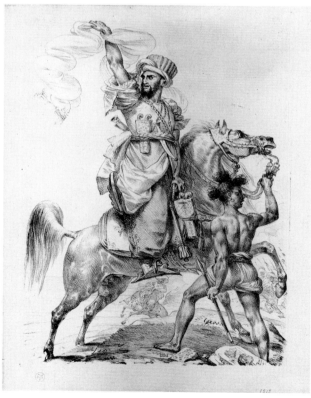

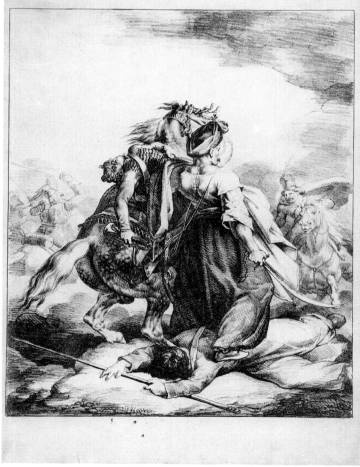

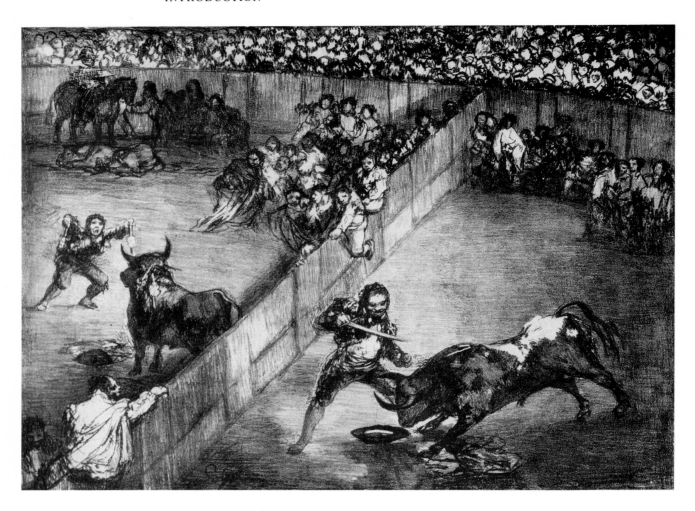

17 *Above* FRANCISCO
GOYA Y LUCIENTES
The Division of the arena
from *The Bulls of
Bordeaux* 1825
lithograph
30.4 × 41.4
trial proof (edition 100)
Felix Man Collection
Australian National Gallery,
Canberra

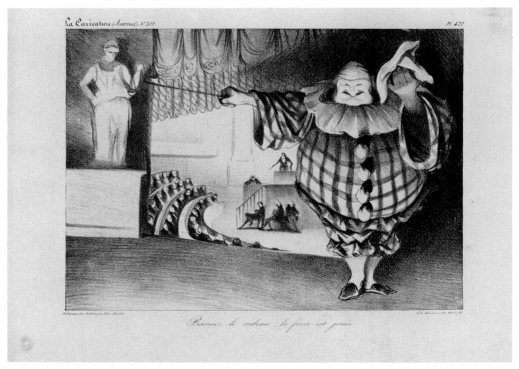

18 HONORÉ DAUMIER
Bring down the curtain
published in *La Caricature*
[*Caricature*]
11 September 1834
issued on white paper
lithograph
20.0 × 27.8
Felix Man Collection
Australian National Gallery,
Canberra

19 PAUL GAVARNI
(Guillaume-Sulpice Chevalier)
After the ball 1847
published in *Les Artistes
anciens et modernes*
[*Ancient and modern artists*]
lithograph
17.4 × 20.8
Felix Man Collection
Australian National Gallery,
Canberra

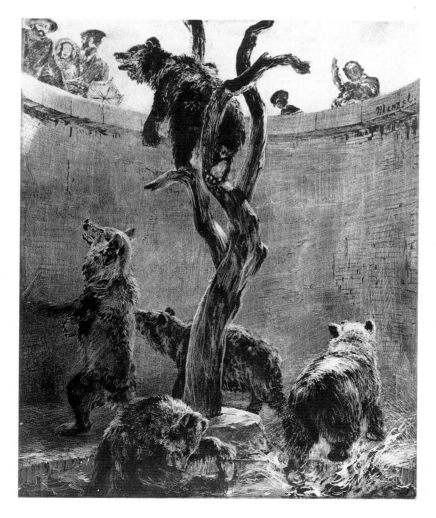

20 ADOLPH VON MENZEL
Bear pit in the zoological
gardens from *Versuche auf
Stein mit Pinsel und
Schabeisen* [*Experiments on
stone with brush and
scraper*] 1851
lithograph
24.8 × 19.8
Felix Man Collection
Australian National Gallery,
Canberra

lithographs about mid-century, lithography was not taken up again by artists as an original means of expression until the 1860s and 1870s. In France, the first major artists to execute original lithographs at this time were Edouard Manet and Henri Fantin-Latour. The Man Collection includes Manet's famous *Barricade*, 1871, while Fantin-Latour is represented by his beautiful *Bouquet of roses*, 1879 (21), and *Sarah the bather*, 1892. Odilon Redon is represented by three pieces, the most poignant of which is the *Head of Christ*, of 1887. This French revival was echoed in the work of James McNeill Whistler, whose *Early Morning* of 1879 (22) was another of Man's acquisitions.

The lithographic revival reached its peak in France during the 1890s. This was the era of artists' albums and portfolios as well as of luxury edition books illustrated lithographically. Colour lithography was especially favoured and was influenced by the colour posters of Jules Chéret and other designers. Nearly all the important artists of the decade produced lithographs and Man collected at least one example by each of them. For example, Henri de Toulouse-Lautrec, Maurice Denis, Pierre Bonnard,

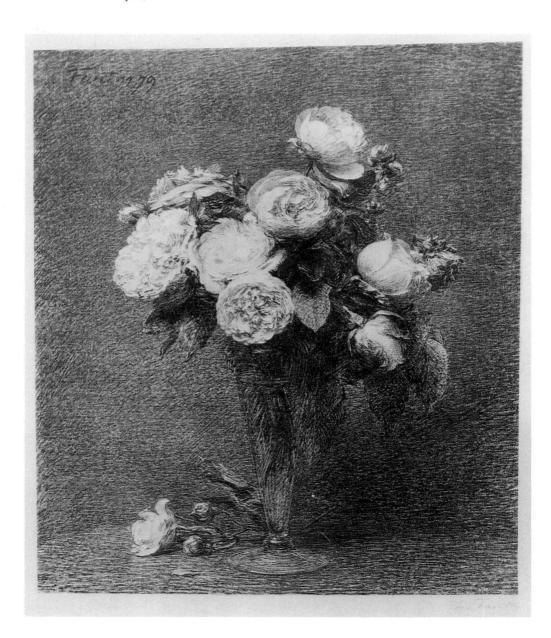

21 Henri Fantin-Latour
The Bouquet of roses 1879
lithograph
41.6 × 35.4
edition 50
Felix Man Collection
Australian National Gallery,
Canberra

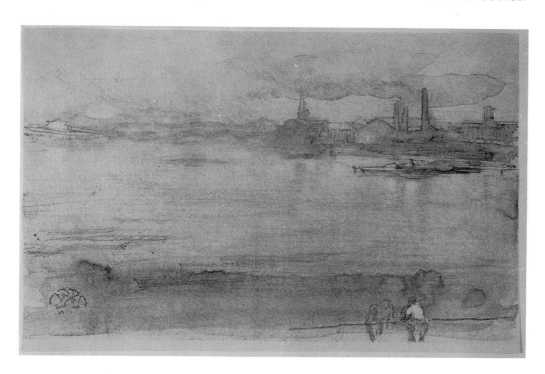

22 JAMES McNEILL
WHISTLER
Early morning 1878
lithotint
16.4 × 25.8
Felix Man Collection
Australian National Gallery,
Canberra

23 *Left* HENRI DE
TOULOUSE-LAUTREC
La Goulue and
Valentin 1894
lithograph
35.0 × 25.6
first edition (50 impressions)
Felix Man Collection
Australian National Gallery,
Canberra

24 *Above* MAURICE DENIS
Tenderness 1893
published in *L'Estampe
originale* [*The Original
print*] album 1, pl. 3
colour lithograph
30.0 × 25.0
edition 100
Felix Man Collection
Australian National Gallery,
Canberra

Édouard Vuillard, Pierre-Auguste Renoir, Camille Pissarro, Paul Gauguin, Alfred Sisley, Paul Signac, Henri Edmond Cross, Théophile Steinlen, Alexandre Lunois and Maximilien Luce are all represented. Toulouse-Lautrec's *La Goulue and Valentin*, 1894 (23), Bonnard's *The Boulevards* of 1899, Denis's *Tenderness* of 1893 (24), Vuillard's *Young woman leaning on her elbow* (25), and Pissarro's *Women bathers wrestling* of 1894 (26) are among the finest examples from this period.

The next major development charted by Man is of a small band of German artists at the beginning of the 20th century. The artists of Die Brücke were committed to printmaking and although better known for their relief prints they were also highly experimental in their lithographs. They treated the medium in novel ways, searching for unconventional effects. This tendency is exemplified by Kirchner's *Head of Sternheim* and *Scene with prostitutes*, both of 1916, Heckel's *Handstand* of the same year and Nolde's *Windmill beside the water* of 1926.

Man's coverage of 20th-century lithography was the least comprehensive aspect of his collection. However, since it opened in 1981, the Australian National Gallery has gradually filled these gaps. American lithography, in particular, both from the early part of the century and from the revival of the 1960s, was barely recorded. European developments, however, were better represented by Man – for example Pablo Picasso's contribution to the medium is recorded with six works, one of which is *Face* of 1928 (28), Marc Chagall is represented by five works, including *The Trough* of 1923–25 (27), and Henri Matisse by *Model resting* of 1926 (29). Man also acquired the first lithographs made by Fernand Léger, Georges Braque and Joan Miró (30, 31, 32). Several of these prints were acquired direct from the artists as a result of his contact with them when working on his book *Eight European artists*. Lithography in the 1960s is represented mainly by Italian, German and British artists, including Giacomo Manzù, Marino Marini, Hans Purrmann, Christian Kruck, Reg Butler and Graham Sutherland. Sutherland executed the poster for the exhibition of the Man collection at the Victoria and Albert Museum in 1971 (33), while one of the works from Man's own

1.11
6.14
col. pl. 21

25 ÉDOUARD VUILLARD
Young woman leaning on her elbow 1894
lithograph
18.2 × 13.6
Felix Man Collection
Australian National Gallery, Canberra

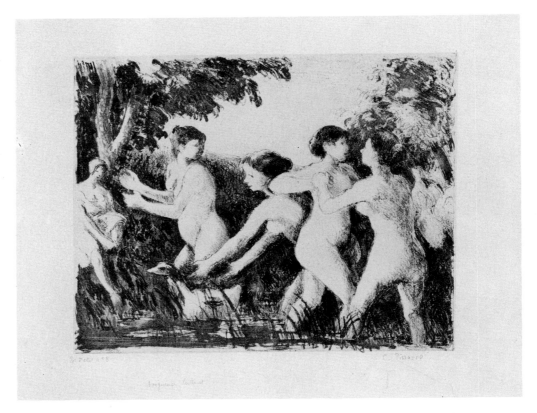

26 CAMILLE PISSARRO
Women bathers wrestling 1894
lithograph
18.6 × 23.6
third and final state
Felix Man Collection
Australian National Gallery, Canberra

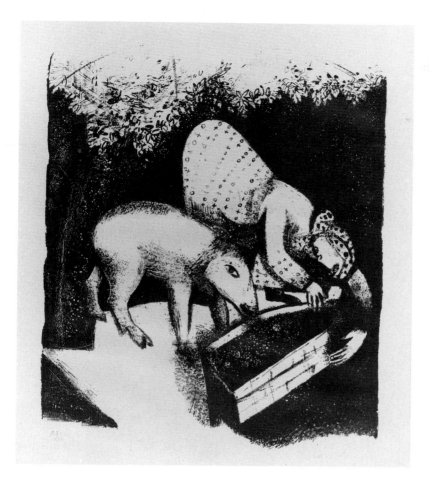

27 MARC CHAGALL
The Trough 1924–25
lithograph
30.6 × 24.0
edition 83/100
Felix Man Collection
Australian National Gallery,
Canberra

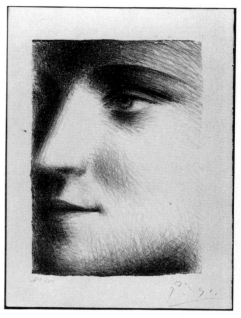

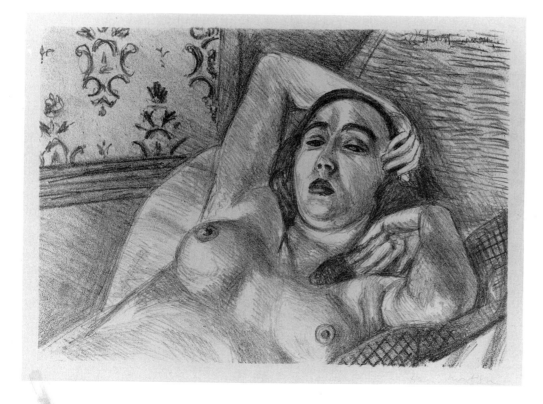

28 *Above* PABLO PICASSO
Face 1928
lithograph
20.4 × 14.0
edition 113/200
Felix Man Collection
Australian National Gallery,
Canberra

29 HENRI MATISSE
Model resting 1922
lithograph
22.2 × 30.4
trial proof (1st edition–100;
2nd–575)
Felix Man Collection
Australian National Gallery,
Canberra

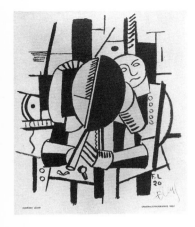

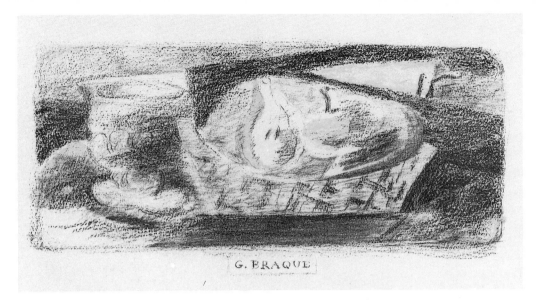

30 *Above* FERNAND LÉGER
Woman with mirror 1920
lithograph
24.4 × 20.0
edition unknown
Felix Man Collection
Australian National Gallery,
Canberra

31 *Above right*
GEORGES BRAQUE
Still life: glass and
fruit 1921
colour lithograph
18.2 × 39.2
edition 3/120
Felix Man Collection
Australian National Gallery,
Canberra

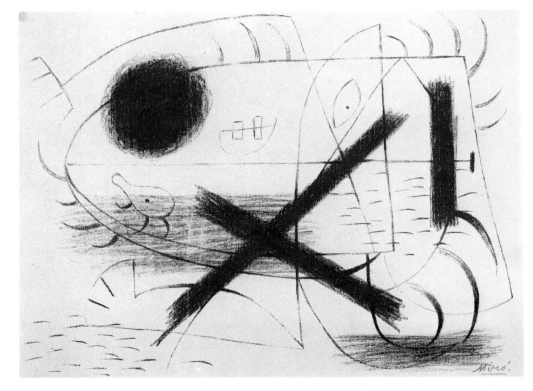

32 JOAN MIRÓ
Composition with crossed
beams *c.* 1930
lithograph
24.5 × 32.5
edition 8/75
Felix Man Collection
Australian National Gallery,
Canberra

co-publications was David Hockney's portrait of him – *The Print collector* of 1969
(34).

The Australian National Gallery is most fortunate to have been able to build its
international print collection on this outstanding private collection of lithographs. The
rarity of much of the early material would have made it impossible for such a
comprehensive collection to be assembled from scratch. The collection was purchased
with the assistance of a special Government grant of A$330,000, and the sum given for
the entire collection in 1972 would today purchase only a handful of the more
important items. This purchase, therefore, has not only furnished the Gallery with
important masterpieces as the basis for its future acquisition but has provided an
invaluable study resource for the Australian people.

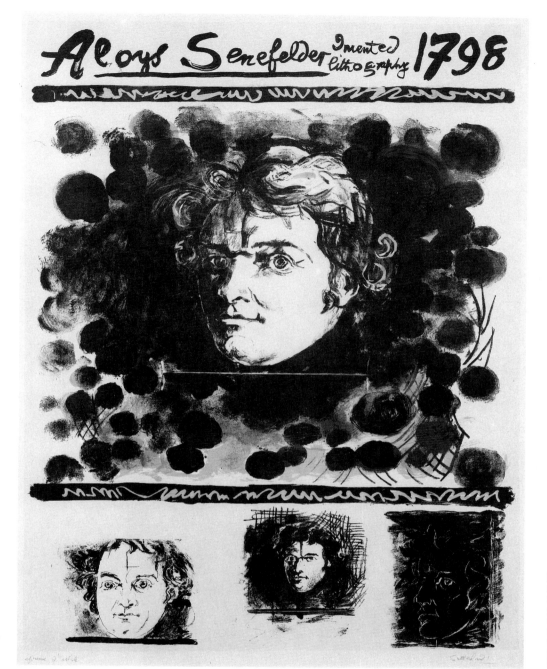

34 DAVID HOCKNEY
The Print collector 1969
from *Europäische
Graphik* VII
lithograph
65.8 × 50.6
edition 100
Felix Man Collection
Australian National Gallery,
Canberra

33 *Left* GRAHAM
SUTHERLAND
Portrait of Aloys
Senefelder 1971
published in *Europäische
Graphik* VIII
colour lithograph
65.7 × 49.2
edition 100
Felix Man Collection
Australian National Gallery,
Canberra

He is not here: for he is risen. &c.

1 The Nature of Lithography

Clinton Adams

Lithography is a chameleon. You can make a lithograph as complicated as a French 19th-century academic painting. But its fundamental nature is limestone, a unique quality which Daumier perhaps understood best. Great lithography has to do with the stoneness of stone.

ROBERT MOTHERWELL[1]

LITHOGRAPHY possesses an intrinsic flexibility greater than any other medium employed by artists to make prints, responding with astonishing ease to the varying technical and stylistic demands made upon it. The chameleon-like nature of the process upon which Motherwell comments was recognized by its inventor, Alois Senefelder, who also developed and described 'all the different branches and manners of that art'.[2]

Soon after Senefelder discovered 'chemical printing', probably in 1798 but possibly in 1799,[3] he received an exclusive privilege for the use of the process in Bavaria. Shortly thereafter he embarked for London and in 1801 obtained an English patent. Later that year Benjamin West, then president of the Royal Academy, drew *The Angel of the resurrection*, the earliest dated lithograph by an artist (1.1). This lithograph, one of six included in the first issue of *Specimens of polyautography*, 1803, was drawn with pen and tusche in a manner that resembles a drawing made with ink on paper. West is also known to have experimented with chalk or crayon drawings on stone, although lithographs so drawn were not published until 1806.

The chalk manner was soon perfected and developed. It became the dominant manner of lithography in ensuing years and by the 1820s had been employed by most of the leading artists of the early 19th century, among them Richard Parkes Bonington, Eugène Delacroix, Théodore Géricault, Francisco de Goya, Eugène Isabey, and James Ward.[4] The original lithographs of such artists were, however, but a small part of the lithographic work produced in the 1820s, particularly in France. By 1828 'there were in the department of the Seine alone, twenty-four lithographic printing houses containing 180 presses and employing 420 workmen.'[5] The work done at these presses included all forms of printed material: maps, sheet music, topographic landscapes, illustrations for books and pamphlets, and reproductive lithographs. A study of the work exhibited in the Paris Salons between 1817 and 1824 reveals a rapid progression from the tentative and coarse beginnings of chalk lithography, as seen in H. B. Chalon's *Wild horses* (1.4), drawn in 1804 and published in 1806, to the astonishing technical virtuosity of such works as *Danaé* (1.2, 1.3), drawn on stone by Aubry-Lecomte in 1824 after a painting by Girodet-Trioson. In this brief time, as McAllister Johnson has noted, lithography shifted

> ... from *incunabula* – done by and for a limited audience of amateurs – to an intense period of commercialization with all the inconsequences and inconsistencies implied in such endeavor. The rapid decline in lithographic quality may be said due to draughtsmen/practitioners who abused the ease of a procedure the artistic perfection of which is otherwise entirely dependent upon advancements of a purely technical and chemical nature.[6]

1.1 *Opposite top left*
BENJAMIN WEST
The Angel of the resurrection 1801
lithograph
31.4 × 22.8
trial proof
Felix Man Collection
Australian National Gallery, Canberra

1.2 *Opposite top right* and
1.3 *Opposite below* (detail)
HYACINTHE AUBRY-LECOMTE
after ANNE-LOUIS GIRODET-TRIOSON
Danaé 1824
lithograph
48.4 × 35.7
University of New Mexico Art Museum, Albuquerque

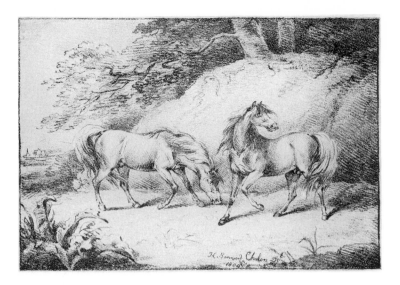

The commercial importance of lithography, which during this period all but totally replaced the laborious processes of metal and wood engraving for reproductive purposes, led to the publication of numerous books and articles in which its technical processes were described with varying degrees of accuracy and completeness. Of greatest interest today are Senefelder's own treatise, first published in English under the title *A complete course of lithography*, 1819, and Charles Hullmandel's *The Art of drawing on stone*, 1824. Through the fortunate circumstances that Senefelder and Hullmandel were good writers, their books remain enjoyable as well as indispensable reading.

A discontented student of the law, a failed actor and minor dramatist, Senefelder was led to his subsequent investigations by a desire to find a means of printing which would be less costly than engraving on copper.[7] Experimenting with stone engraving,

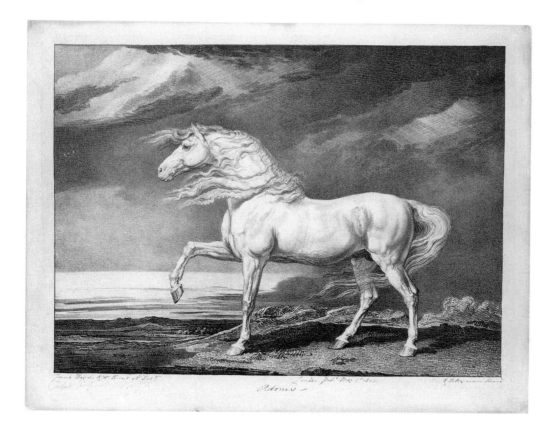

1.6 JAMES WARD
Adonis
from *Celebrated horses* 1824
lithograph
34.0 × 45.0
trial proof
Felix Man Collection
Australian National Gallery,
Canberra

he stumbled upon 'chemical printing', later called lithography. With high expectations, he sought actively but somewhat ineptly to make capital of the process, which he perceived to be a 'cheap and easy' form of printing for commercial purposes. In the first part of his book he relates his travails and disappointments as, like Candide, he sought to achieve the reward that Fortune was so persistently to deny him; in the second part he provides a straightforward description of techniques and materials. Although the words he employs to describe the several 'manners of lithography' differ at times from those later used, Senefelder defines the dimensions of the art remarkably comprehensively, including the pen and chalk manners, stone engraving, the *manière noire*, and printing in colour. He also discusses the use of transfer paper: 'This manner is peculiar to the chemical printing, and I am strongly inclined to believe, that it is the principal and most important part of my discovery.'[8] Differing interpretations of this statement play an important role in later controversies about the appropriateness and merit of transfer lithography, a subject to which I shall return.

The ease with which lithography adapted to a diversity of manners was seen by many not as a strength but a weakness. The empty virtuosity of the French lithographic draughtsmen (such as Aubry-Lecomte) caused many to fear that the world would be 'innundated [sic] with rubbish' and 'the greasy daubs of lithography'.[9] In England, Hullmandel relates, the process was 'cried down (most unaccountably by several painters of eminence) as a *degrading art*, and the means of bringing the works of artists into contempt.'[10] Hullmandel argued vehemently against this view and stressed the very high quality of many artists' lithographs. His detailed and precise explanations of the methods artists should employ in order to achieve such quality are to this day unsurpassed. His accomplishments as a printer were of the highest order and among the prints that came from his press are some of the finest works of the period, among them Théodore Géricault's *Horses exercising* (1.5) and James Ward's *Adonis* (1.6). As Michael Twyman said, 'It would be difficult to over-emphasize Hullmandel's contribution to the development of lithography in England.'[11]

2.36

That development continued to accelerate. In 1839 Hullmandel printed the first series of artists' lithographs in colour, drawn on stones by Thomas Shotter Boys; included in this series was *Notre Dame, Paris, from the Quai St Bernard*[12] (col. pl. 1). In 1840 Hullmandel secured a patent for a process he later called 'lithotint': a manner of working with diluted tusche washes that approximated the character of water-colour painting.[13] The lithotint manner, carried to its greatest heights by James D. Harding in the 1840s, was little used after 1850, the year of Hullmandel's death. Colour lithography, by contrast, assumed increasing importance, largely because of its potential for commercial development. While in the mid-century technological advances came in rapid succession,[14] artists' lithography continued a steady decline from its 'golden age' of the 1820s and 1830s.[15] In England, lithography was soon seldom employed for original work and the medium 'was held in very low esteem by most English artists.'[16] In the United States, few lithographs were made by artists of importance;[17] American lithography consisted almost exclusively of the popular prints published in great numbers by firms of commercial lithographers, the best known of which was Currier and Ives.[18] Even in France the medium fell into disuse. Between the great lithographs of the early 19th century and the equally great, but very different, lithographs of the late 19th century there is a hiatus filled principally by the work of Honoré Daumier (1.7) and Gavarni, who clearly set the medium upon a new and productive path. Precisely because in the art of caricature there were no expectations of representational accuracy, Daumier and Gavarni were free in their political and social cartoons to put aside the slick finish of reproductive lithography and draw their images boldly with a blunt and vigorous line.

19

The emergence of modernist art in the final third of the 19th century gave further impetus to artists' lithography. The 'low esteem' in which the medium was held was of little concern to modernist artists. It was the very unpopularity of the styles within which they worked that made it possible for the Symbolist, Impressionist and Post-Impressionist artists to adopt a medium which was also unpopular. More of a problem for them was what may best be called the 'lithographic environment'.

Spurred on by commercial requirements, the work of the printer had become increasingly mechanized. In the 1850s lithography was combined with photography (announced to the world in 1839) to create photolithography; soon thereafter, stone lithography served as a basis for the development of offset lithography. As commercial lithography – whether printed from photographic or hand-drawn plates – assumed ever-increasing importance, the time-consuming demands of creative artists caused printers to perceive work done for them more as an irritant than as a source of profit. The irritation was mutual: 'My God,' Redon wrote, 'how I have suffered with printers, how I have experienced within myself bursts of rage at the statements of confused incomprehension issuing from the printer of my trial proofs.'[19] Redon's frustrations were inevitable in the circumstances. Soon, however, increasing activity on the part of artist-lithographers made it possible for a few printers to work primarily or exclusively with artists and a satisfactory collaborative relationship was once again established. Gradually, a clear division developed between commercial printing establishments and lithographic ateliers designed to meet the needs of artists.[20]

When Motherwell said of lithography that 'its fundamental nature is limestone', and went on to add that 'great lithography has to do with the stoneness of stone', he stated an aesthetic tenet held by many modernist artists: art should be true to its materials.[21] It is this concept and its interpretation that have led to sharply differing views about transfer lithography, the manner, as we have seen, that Senefelder considered the 'principal and most important part' of his discovery.

3.6

When one compares an Aubry-Lecomte and a Daumier lithograph with a typical transfer lithograph, *Souvenir of Italy* by Camille Corot (1.8), the 'stoneness of stone' is seen most clearly in the Daumier. By contrast with Aubry-Lecomte, who used his great skill to conceal the lithographic means through which his image was developed, Daumier relished the directness with which his crayon moved against the stone:

nothing was concealed; the character of crayon and stone were totally revealed in the print that resulted. Corot, unlike either Aubrey-Lecomte or Daumier, chose to make his print by drawing on paper, not stone. He placed a sheet of autographic transfer paper on top of a sheet of laid charcoal paper, then made a chalk drawing in such a manner that the texture of the laid paper came through frottage to dominate that of the stone from which the impression was printed after transfer.[22]

Corot was but one of many artists who were attracted to transfer lithography in the late 19th century. Some preferred it because the prints that resulted had less the look of lithographs than of charcoal drawings on paper. Some, particularly those who wished to draw landscapes directly from nature, valued the convenience it provided. Some, like Redon, simply did not like to draw on stone:

> The stone is harsh, unpleasant, like a person who has whims and fits. It is impressionable, and submits to the most moving and variable influences of the weather. . . . The future of lithography (if it has one) lies in the resources, still to be discovered, of paper, which transmits so perfectly to the stone the finest and most moving inflections of the spirit.[23]

The cause of transfer lithography was further advanced by James A. McNeill Whistler and Joseph Pennell, most of whose lithographs were drawn on paper. It was with respect to their work that a heated debate as to the merits and propriety of transfer lithography came to public attention. In 1896, following an exhibition of Pennell's transfer lithographs in London, the painter Walter Sickert wrote:

> The artist who does transfer lithographs is . . . using a debased instrument. It has its conveniences, it is true, but it is nonsense to talk of revival of lithography on these terms. It is full decadence. . . . Drawings of merit may be executed in this, as in any other medium; but the art of lithography is degraded.[24]

The issue thus joined went beyond the merits of transfer lithographs: it questioned the nature, and indeed the definition, of lithography. Is the character of stone essential to the process? What about prints made from zinc or aluminium plates? Is an offset lithograph truly a lithograph? Beyond the question of transfers drawn on paper, can we accept as lithographs drawings made on acetate or Mylar,[25] exposed photographically onto light-sensitive plates? And what about prints in colours? Is not the essence of process – as Redon believed – to be found in black and white?

1.7 *Above left*
HONORÉ DAUMIER
This has killed that
from *L'Album du Siège*
[*The Album of the siege*] 1871
lithograph
23.8 × 19.8
Felix Man Collection
Australian National Gallery,
Canberra

1.8 J.-B. CAMILLE COROT
Souvenir of Italy 1871
from *Douze croquis et dessins originaux sur papier autographique par Corot.*
[*Twelve sketches and original drawings on lithographic transfer paper by Corot*] 1872
transfer lithograph
13.0 × 18.2
edition 50
Felix Man Collection
Australian National Gallery,
Canberra

10.19

Ultimately, these questions and others of their kind are answered by history and by the works that artists make. The debate between Joseph Pennell and the American artist-lithographer Bolton Brown[26] did not serve to demonstrate, as Pennell claimed, that 'you can do anything on paper that you can do on stone'[27] and 'no expert is able to tell the difference',[28] nor did it justify Brown's unyielding position that a transfer print 'is not lithography ... calling it a lithograph is just hocus-pocus'.[29] Brown had a point, particularly as to the value of a semantic distinction between transfer lithographs and 'crayonstones' (his word for 'real' lithographs), but he weakened his case by overstating it. Whatever the limitations of transfer lithography – and they are substantial – many of the fine lithographs made by 19th- and 20th-century artists were essentially dependent on the process and could have been created in no other way.

The dispute as to the legitimacy of transfer lithography was paralleled by a similar dispute about colour lithography.[30] By the mid 19th century the word 'chromolithography', once simply descriptive, had acquired a pejorative connotation. Because colour had been used primarily in reproductive chromolithographs, it was no longer thought suitable for serious creative work. As late as 1897 it was possible for Thiebault-Sisson to argue that:

> The painter-lithographers ... waste too much time searching for effects which are not in the domain of lithography; in particular, they are almost all struck by a manic desire to translate into color their elucubrations, and I find that mania deplorable ... [for] it is impossible to make color lithography produce anything but very contrasting effects, which are marvellous in posters, but which bombard and irritate the eye in a carefully done print, made for a collector's portfolio or an album.[31]

In the following year, Henri Lefort, president of the print and lithography section of the Society of French Artists, argued vigorously against admissibility of colour prints to the Salon: 'By its essential principles, its origins and its traditions, the art of the print is, unquestionably, the art of *Black and White*. This is the traditional classification to which it is attributed.'[32]

But the battle against the use of colour in lithography, like the battle against transfer paper, was destined to be lost. 'The right of the color print to exist', André Mellerio argued, 'comes directly from the principle which we consider an axiom: any method or process which an artist develops to express himself is, for that very reason, legitimate.'[33] In tacit acceptance of this principle the rules of the Salon were amended in 1898 to admit prints in colour.

While welcoming this victory, Mellerio further argued the important distinction that should be made between reproductive and original colour lithographs. Condemning the former as 'retrogressive', Mellerio also warned of the traps for painters who sought to make colour lithographs: first, they might use 'the new technique that they have taken up ... [with] no other aim than to render more or less the vision and the values of their usual work'; and, second, they might be dominated by the printer who, through his skill in lithography, 'possesses a superiority over the artist, an undeniable material means of emphasizing his own importance. The more he complicates the printing procedure, the more he points up the importance of his help.'[34] Mellerio counselled 'a simplicity of tone', avoiding 'lines that are too complicated, tangled composition, or elusive delicacies of atmosphere' which do not fall within the competence of lithography.[35] Mellerio's advice, which derives from his regard for the strong, direct and, above all graphic images of Pierre Bonnard, Henri de Toulouse-Lautrec, Édouard Vuillard and other masters of the 1890s, should be read by all painters who make colour lithographs today.

col. pls. 7, 8, 11, 12

At the end of the century, Senefelder's discovery was celebrated in a series of centennial exhibitions documenting the historic importance and technical range of 19th-century lithography.[36] Apart from early pen lithographs, most of the prints included in these exhibitions were drawn in the chalk manner, but some were printed

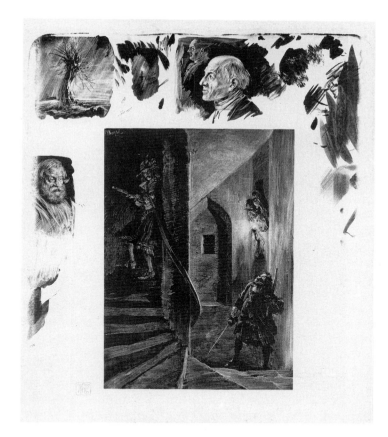

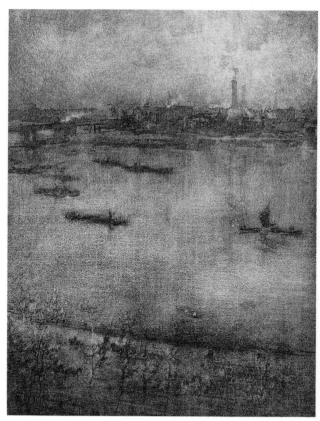

by transfer and a few represented such diverse manners of lithography as stone engraving, the *manière noire*, and the lithotint.

Although lithographic stone engravings resemble etchings or drypoints in appearance, the image is not incised into the stone; the artist uses the needle only to cut through a film of gum, exposing the stone to permit the printing of a lithographic image. It is a beautiful manner but one seldom used.[37] The 'black manner' likewise emulates an intaglio process; as in a mezzotint, the artist first creates a solid black, then works reductively with a scraper to create the image – Adolf von Menzel's *Pursuit on the spiral staircase* (1.9) demonstrates the method. The long-neglected lithotint manner was revived in the late 1870s by James McNeill Whistler, in collaboration with his printers, the firm of Thomas Way in London, who used it in 1896 to create his delicate vision of *The Thames* (1.10).

Before considering the changing nature of lithography in the 20th century, I should like briefly to digress and consider the ways in which our perceptions of it are affected by the practices of writers and curators.

Since its beginnings, lithography in its various manifestations has been the subject of a vast number of books and articles: manuals for artists, discussions of lithographic theory, technical papers on materials and processes, histories and monographs on individual artist-lithographers.[38] Even so, and despite its substantial achievements, lithography continues to occupy no more than a peripheral position within the history of art, often isolated from the other arts of its time by the practices of institutions and the habits of scholars. In museums, lithographs, along with other prints, are housed in separate departments of prints and drawings. In the literature of art, lithographs are too frequently discussed apart from painting and sculpture.

Such discrimination by medium is foreign to the way in which art is created. With but few exceptions, artists are generalists who move freely from medium to medium.

1.9 *Above left*
ADOLPH VON MENZEL
Pursuit on the spiral
staircase from *Versuche auf
Stein mit Pinsel und
Schabeisen* [*Experiments on
stone with brush and
scraper*] 1851
lithograph
28.4 × 26.2
first state
Felix Man Collection
Australian National Gallery,
Canberra

1.10 JAMES MCNEILL
WHISTLER
The Thames 1896
lithotint
26.6 × 19.2
Australian National Gallery,
Canberra

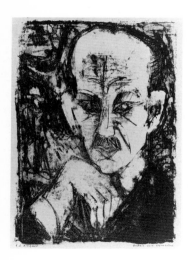

1.11 ERNST LUDWIG
KIRCHNER
Head of Sternheim 1916
lithograph
30.4 × 20.8
edition unknown
Felix Man Collection
Australian National Gallery,
Canberra

Nowhere is this more clearly demonstrated than at the Musée Picasso in Paris, where the prodigious diversity of Picasso's work is seen as he made it: the media intermixed in sequence, the lithographs, etchings and relief prints placed in context with paintings and sculptures. The viewer may perceive Picasso's art as Picasso himself perceived it, as an integrated whole.

In larger and more comprehensive museums such integration is rare. The structure of museums is determined in part by practical considerations having to do with the care and handling of large collections and the need for scholarly expertise. The presentation of exhibitions is determined in part by artistic considerations but also – and too frequently – by the nature of bureaucracy, which, in museums as in other institutions, tends towards the demarcation of territory and the building of barriers that, once erected, are not readily breached. It is not uncommon for an artist's prints to be shown at a location far distant from his or her paintings. Such artificial separation of prints and paintings makes it difficult for the observer to gain a full understanding of the artist's work. Although I recognize its causes and applaud its positive aspects – foremost among them, the rigorous scholarship which can be the fruit of curatorial specialization – I am convinced that our understanding of art would be advanced through a substantial change in museum practices.

A similar distinction between prints and paintings is found in many writings on art. Historians and critics, like curators, are specialists, and are encouraged to remain so not only by the demands of their disciplines but also by academic imperatives. The result is a considerable literature on lithography, but a very small body of writings that endeavours to relate lithography to painting and sculpture, to major artistic movements, to critical considerations, or to aesthetic theory.[39] Few of the principal critics of the 20th century – such as Clive Bell and Herbert Read in England, and Harold Rosenberg and Clement Greenberg in the United States – have paid attention to the work of artist-lithographers or, for that matter, to printmakers of any sort. Yet, as Ernst Ludwig Kirchner once wrote, 'there is no way to study an artist better than by his graphic work.'[40]

Kirchner had the woodcut in mind, but the same may be said of lithography. The way in which artists choose to use lithography not only determines the character of their lithographic work: it frequently reveals the essential spirit of their art. The way in which their lithographs differ from the paintings is most clearly visible when the lithographs and paintings deal with similar subjects and it serves to illuminate the interrelationship between process and image.[41] This relationship is obscured when, as is too frequently the case, artists' prints are kept separated from their paintings, either in exhibitions or in writings about them.

The colour revolution of the 1890s, which so greatly changed the character of lithography in France, had little effect in England or America, where the use of colour continued to be limited principally to popular chromolithographs.[42] In England and America the use of lithography for creative work was hampered by the attitude of the trades unions, which sought to prevent artists from drawing directly on plates (thus obviating the need for union labour) and, in some cases, even from entering the pressroom.[43] In England the Senefelder Club, founded in 1908 with Joseph Pennell as its president, sought to stimulate interest in artists' lithography through a series of exhibitions. But beyond exhibitions 'the scheme of having a private press, a press of its own at which members could print was one of the main reasons for formation of the club.'[44] Similar problems existed in the United States, where not until 1919 was there a printer who devoted his full effort to collaboration with artists.[45]

Although lithography already had a long tradition of collaboration between artists and printers, the obstacles presented by union rules, the disinterest of most commercial printers and the mechanical quality of their work, led many artists to print for themselves. These artists did not, of course, possess either the knowledge or the skill of the professional lithographer. Their impressions were often coarse or poorly inked and

their editions imperfect; even so, their lithographs had a vitality not always found in the work of the commercial printers with whom they might otherwise have worked. Nowhere is the contrast between 'artists' printing' and 'professional printing' more clearly seen than in the lithographs made by the artists of Die Brücke: Erich Heckel, Ernst Ludwig Kirchner, Otto Mueller, Emil Nolde and Karl Schmidt-Rottluff.

col. pls. 21, 23

Kirchner, who began printing lithographs in 1906, believed that 'Only if the artist really does the printing himself does the work deserve to be called an original print.' Writing of his work (in the third person and under a pseudonym), Kirchner said:

> He works on his stones for so long that the first drawing becomes completely graphic – that is to say, that the drawn lines disappear and are re-formed by the etching processes; deep black alternates with a silky grey produced by the grain of the stone. The soft tone of the grey areas, enlivened by the grain of the stone, has the effect of colour and adds warmth to the prints.[46]

Such laboured and reworked tones would doubtless have been anathema to the commercial printers of Dresden. 'Bad printing' it may have been[47] but that it was highly appropriate to Kirchner's expressive purposes is made evident in his powerful *Head of Sternheim* (1.11), an image which depends for its effect precisely upon the smudged and eroded surfaces which Kirchner so knowingly created by flying in the face of lithographic tradition.

Though many fine lithographs were made during the 1920s and 1930s, including the masterpieces of Henri Matisse, few broke new technical ground. Although some artists continued to employ the rough and direct approach to the medium pioneered by Edvard Munch and the artists of Die Brücke and a few explored wash techniques, most were content to work in a conventional chalk or crayon manner.[48] Little work was done in colour, particularly in the United States.[49] It is thus remarkable that during a visit to Los Angeles in 1933 Jean Charlot should have undertaken his *Picture book*, containing 32 multicolour lithographs (col. pl. 2) printed on an offset press, a means of printing then seldom used for autographic work.[50] Charlot worked on four sets of large zinc plates, making eight hand-drawn images on each plate.[51] The artist and his printers, Lynton R. Kistler in Los Angeles and Albert Carman in New York, continued to champion the cause of autographic offset lithography. In the late 1930s Carman printed offset lithographs drawn by Werner Drewes, Albert Gallatin, Ibram Lassaw, George L. K. Morris and other modernist artists.[52] In England, also in the 1930s, such artists as Barnett Freedman, Paul Nash and John Piper were encouraged by Harold Curwen to make use of both direct and offset lithography as a creative medium.[53]

29

5.26, 5.27, 5.30

Given the social, political and economic climate of the 1930s, it is understandable that a principal motivation behind the use of the offset process was to create prints in large (often unlimited) editions which could be sold at low prices to 'the masses'. This inevitably led to tension between the demands of art and commerce. Carl Zigrosser, who was among the early supporters of Carman's print publications in New York, later acknowledged this: 'We had two aims: to furnish works of art and to be popular . . . [but] our duality of purpose involved us in a certain amount of compromise, and as is often the case with half-measures, produced neither art nor popularity.'[54]

The identification of lithography with popular art, on stone as well as offset, worked to its disadvantage in the 1930s and 1940s. The fact that in the United States and Mexico many of the more prominent artists who made lithographs dealt with Social-realist themes led to a modernist belief that the medium was suitable only for popular images, conservative in execution and *retardataire* in style.[55]

A convincing argument can be made that the rehabilitation of lithography began on 2 November 1945. It was then that Picasso went to the Paris workshop of Fernand Mourlot and made the first in a new series of lithographs. These lithographs taken together – he made more than 100 between 1945 and 1947 – served to redefine the medium and re-establish its place in 20th-century art. Above all, in the many subjects that Picasso carried through a sequence of variant states, he convincingly demon-

10.28, 10.29, 10.30, col. pl. 46

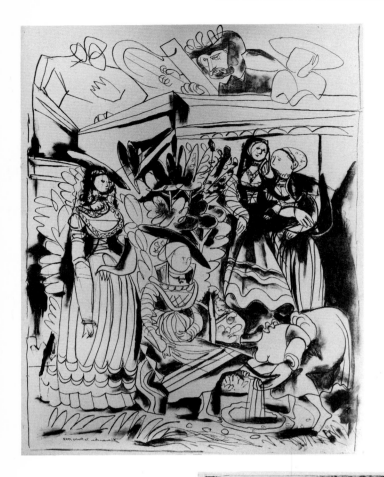

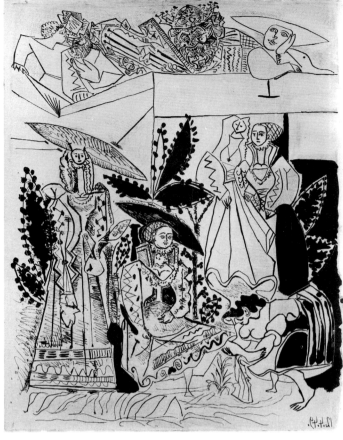

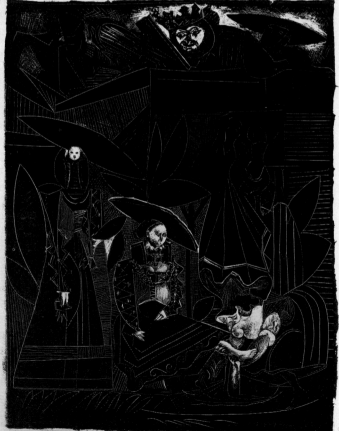

1.12 *Above left*
PABLO PICASSO
David and Bathsheba
(1st state) 1947
lithograph
64.4 × 47.8
printer's proof (edition 50)
Australian National Gallery,
Canberra

1.13 *Above* PABLO PICASSO
David and Bathsheba
(6th state) 1948
lithograph
64.4 × 47.6
printer's proof (edition 50)
Australian National Gallery,
Canberra

1.14 *Left* PABLO PICASSO
David and Bathsheba
(9th state) 1949
lithograph
64.8 × 47.6
printer's proof (edition 50)
Australian National Gallery,
Canberra

strated the ability of lithography to record the process of creation. No longer did he draw passively on the stone;[56] he now assaulted it, scraping and reworking its surface in a manner totally foreign to accepted lithographic practice: a manner so radical that it shocked his printers. In their multiple states such prints as *Les deux femmes nues, Le Taureau* and *David et Bethsabée* [*Two nudes, The Bull* and *David and Bathsheba*] (1.12, 1.13, 1.14)[57] not only reflect Picasso's amazing inventiveness in the use of lithographic materials and processes but also demonstrate lithography's unique ability to preserve in printed form the intermediate and often disparate images brought into being by the artist.

The liberating influence of Picasso's work was so strong that it altered the character and direction of lithography in the 1950s.[58] It led directly and indirectly to the American print renaissance of the 1960s and 1970s, first, by indicating a new range of possibilities, and second, by encouraging printers to accept technical methods they might otherwise have rejected. Without the precedent set by Picasso, it is unlikely that June Wayne, who founded Tamarind Lithography Workshop in Los Angeles in 1960, would have found the French printer Marcel Durassier receptive to her unconventional techniques (1.15). Nor was it necessary to go to Paris to feel the effect of Picasso's work; his prints of the late 1940s were widely exhibited in the United States during the 1950s. Garo Antreasian, who became Tamarind's first master-printer and technical director in 1960, has acknowledged Picasso's profound effect upon his conception of the medium: 'His influence was foremost, above all others at the time. It suggested an entirely new dimension.'[59]

Picasso's stimulus was felt at a time when lithography in the United States was otherwise in decline. Few professional lithographic printers were still active in the late 1950s; intaglio was overwhelmingly the medium of choice among American printmakers.[60] While Antreasian and other artists who printed their own lithographs explored new directions, most of the lithographs produced in collaboration with professional printers during those years were aesthetically and technically unremarkable. Many deserved June Wayne's epithet: they had the look of 'dead mice'.

The establishment of Tamarind Lithography Workshop thus marked a profound change in the character and direction of American lithography.[61] Although Tatyana Grosman's Universal Limited Art Editions (U.L.A.E.) began to print lithographs in 1957,[62] three years before Tamarind, the technical advances that were a central component in 'the renaissance of American lithography' date from 1960. It was directly in consequence of Tamarind's stimulus that fine papers not previously imported into the United States from Europe became available and artists and printers, working together, undertook works of ambitious scale and complexity. Pat Gilmour observes:

> As a touchstone of the quality that emerged from the [Tamarind] Workshop, even in its earliest days, it is interesting to compare Adja Yunkers' *Skies of Venice* with the much more often vaunted *Stones* [printed at U.L.A.E.] of about the same period. The prints by Yunkers are startling in their aesthetic ambition, matched by a technical breadth that American printers were only just learning to encompass.[63]

10.42
10.39

Throughout the 1960s the demands of artists working at Tamarind, U.L.A.E., and other newly founded workshops caused their printers to respond with a series of technical innovations which, taken together, were greatly to extend the range of lithography. Tamarind took the lead in the development of new inks, metal plates and inking rollers; Kenneth Tyler, who went to Tamarind after studying with Antreasian in Indianapolis and later became its technical director, carried forward the research Antreasian had begun. The challenge was sometimes to adapt lithography to the modern world, sometimes to revive or rediscover elements from its past,[64] but always to extend its capacity. Yunkers's *Skies of Venice* required superlative skill in the processing of subtle washes; Josef Albers's lithographs – his two suites made at Tamarind and his *White line squares* (col. pl. 4) printed by Tyler at Gemini G.E.L. –

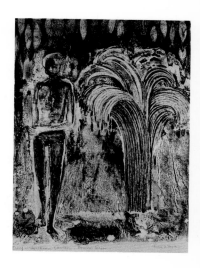

1.15 JUNE WAYNE
Twicknam Garden
from *John Donne: Songs and sonets* 1958
37.8 × 28.3
edition 110
University of New Mexico
Art Museum, Albuquerque
Gift of Allan Sindler

1.16 ROBERT
RAUSCHENBERG
Booster
from *Booster and seven
studies* 1967
colour lithograph, screenprint
183.4 × 90.5
right to print proof (edition 38)
Australian National Gallery,
Canberra

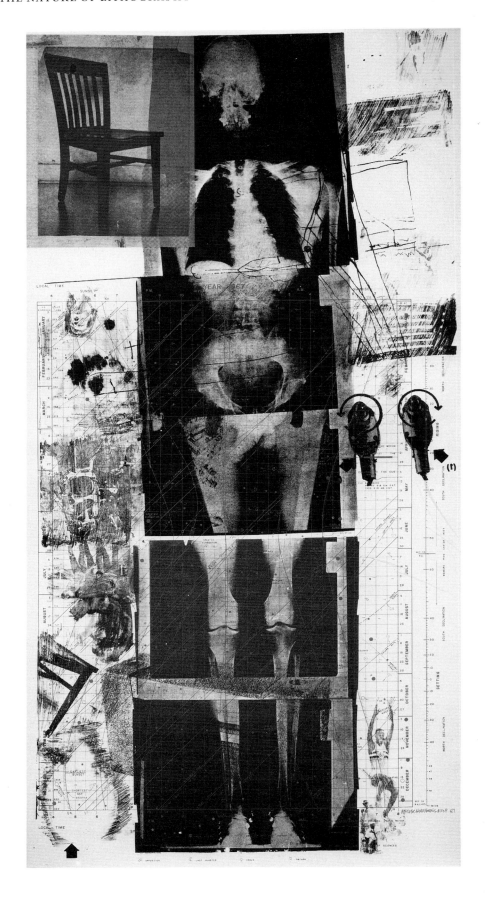

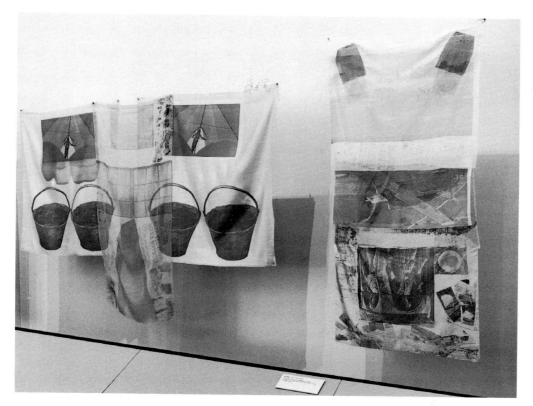

1.17 ROBERT RAUSCHENBERG
Installation shot of
'Plus Fours' and 'Scrape'
from *Hoarfrost editions* 1974
transfer of offset lithograph
and newspaper images on fabric
overall size:
Plus fours – 165.0 × 115;
Scrape – 194.3 × 90.5
Plus fours – artist's proof VIII
(edition 28);
Scrape – artist's proof VIII
(edition 32)
Australian National Gallery,
Canberra

demanded subtle inking and unerring precision in registration; Robert Rauschenberg's *Booster* (1.16) entailed development of a press – and a special paper – that would accept a man-high image;[65] Jasper Johns's lithographs, first his *Color numeral series*, later his *Fragments – according to what* (col. pl. 3), forced extension of the blended-inking method to provide a new visual vocabulary.[66] As one artist after another undertook work which challenged the accepted limits of printmaking, the new American workshops – Tamarind, U.L.A.E. and particularly Gemini G.E.L. – responded by creating new means. In the 1960s Tamarind made editions in which paper was cut and folded, and others that were printed on unconventional surfaces, including layered plastic, metallic foil and polished steel. Gemini undertook projects that involved complex combinations of materials and processes; for Robert Motherwell's *Summer light series* lithography became but one element in works

10.50

1.18 CLAES OLDENBURG
Profile Airflow 1969
moulded polyurethane relief
over lithograph
85.1 × 166.5 × 6.3
(support size)
right to print proof
(edition 75)
Australian National Gallery,
Canberra

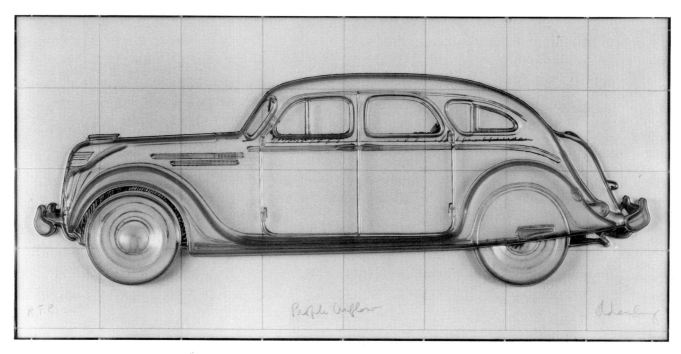

1.19 *Opposite top*
CERI RICHARDS
And death shall have no
dominion 1965
from *Twelve lithographs for
six poems by Dylan Thomas*
lithograph
81.8 × 55.2
edition 37/50
Australian National Gallery,
Canberra

1.20 *Opposite below*
WILLIAM SCOTT
Barra 1962
colour lithograph
53.0 × 60.8
edition 16/75
Australian National Gallery,
Canberra

10.32

incorporating collage as well as printing in silkscreen and pochoir (col. pl. 5); for Claes Oldenburg's *Profile Airflow* (1.18) an image in moulded polyurethane was mounted on a lithographed background; and for Rauschenberg's elegant *Hoarfrost editions*, techniques were developed to permit printing on diaphanous silks and satins (1.17). The cumulative effect of these developments, begun by Picasso in Paris and brought to full fruition in the American workshops, was to redefine the nature of autographic lithography.

While the development of lithography in Britain during the first half of the 20th century in some ways paralleled its evolution in the United States, the level of activity was not comparable. Despite the efforts of the Senefelder Club and later of Harold Curwen, the medium engaged the interest of few artists during the 1930s; further, the stimulus provided to American lithography by the Federal Art Project during the Great Depression had no counterpart in Britain. As a consequence, autographic lithography was all but dormant as a creative medium during the 1940s and 1950s. Not until 1958, when at the urging of Timothy Simon the Curwen Press established a separate studio-workshop to undertake work for artists, were circumstances conducive to its revival.[67] Stanley Jones, who was put in charge of the new studio, had studied lithography and worked as a printer in Paris; upon his return to London he was well equipped to serve British artists as a skilled and sensitive collaborator.

As is clearly seen in the lithographs Jones printed at Curwen Studio for Alan Davie, John Piper, Ceri Richards (1.19)[68] and William Scott (1.20) during the late 1950s and early 1960s, he encouraged an 'unhampered repertoire of techniques.'[69] In this respect, Jones's influence upon the artists with whom he worked in London was comparable to that of Robert Blackburn and Zigmunds Priede at U.L.A.E., and of Garo Antreasian and Bohuslav Horak at Tamarind.

With hindsight, there can be little question but that the time chosen for the establishment of Curwen Studio, U.L.A.E. and Tamarind – all founded between 1957 and 1960 – was fortuitous, coming as it did in a period of transition during which the later phases of Abstract Expressionist painting were challenged by a series of new developments, including the emergence of Pop Art and hard-edge painting. From its London beginnings in 1953[70] Pop Art was by nature sympathetic to the print. Photography and collage, in combination with hand-drawn elements, were the basic vocabulary of its most significant progenitors, Eduardo Paolozzi and Richard Hamilton. Evolving rapidly through the later 1950s and given new impetus by related developments in America, Pop Art shared with Abstract Expressionism none of its concern for the 'uniqueness' of the image. Quite the contrary. For artists who associated themselves with the new attitude, described by Lawrence Alloway as 'an aesthetic proposal made in opposition to established opinion',[71] nothing could be more natural than to seek widespread distribution of images through publication of multiple editions.

The artists who worked with Stanley Jones were mostly of an older generation. Paolozzi and Hamilton found the crisp, 'industrial' look of screenprinting and its bright, heavy inks more congenial to their images than the softer wash and chalk manners that characterized the lithographs of Davie, Piper and Richards. At Kelpra Studio they found an ideal collaborator in Chris Prater, whose command of the process 'singlehandedly moved screenprinting from a commercial medium to a fine art form.'[72] The screenprints that Paolozzi, Hamilton, R. B. Kitaj, Joe Tilson and other artists made at Kelpra Studio are important to the development of lithography not only because of the new sense of excitement they brought to British printmaking but also because of their then radical use of photography, both as an element in the images and as a printmaking process.[73]

The dispute that resulted from that practice centred not so much upon the merits of 'photographic quotation', as seen in Rauschenberg's *Booster*, for example (a practice that has since won acceptance by all but the most conservative), but rather upon the use of photographic processes in the making of plates and prints. That dispute

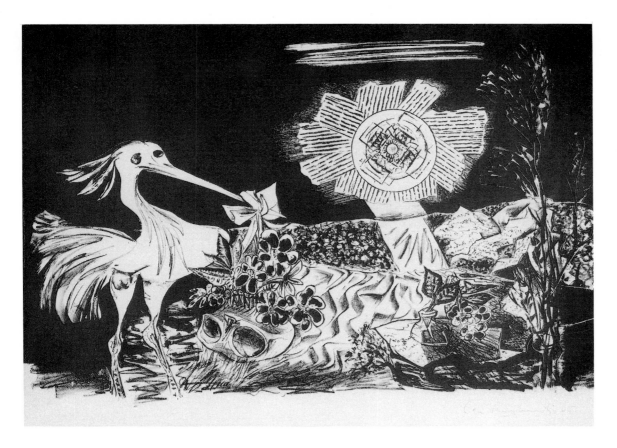

continues, as did the similar long dispute regarding transfer lithography; it affects all print media. Photographic processes are not limited to screenprinting; light-sensitive plates have long been available to the lithographer. The question to be resolved is the appropriate use of such plates: where is the line to be drawn between autographic or original lithographs and lithographic reproductions?

Few would argue that it is acceptable to photograph a pre-existing drawing, make a plate from that photograph, and call the resultant print an original lithograph. Clearly, that is a reproduction. The answer is less evident when light-sensitive plates are used as a means of image-transposition[74] or in lieu of transfer lithography, most often through use of the 'Mylar method', alternatively called 'diazo lithography'.[75] The artist who uses this method, which is a new 'manner of lithography' not imagined by Senefelder, makes a drawing on a frosted, textured sheet of transparent dimensionally stable plastic film; this drawing is then used to create the image on a light-sensitive diazo plate.[76]

Within diazo lithography lies a wide range of possibilities. Henry Moore used it at Curwen in the 1960s; James McGarrell has since used it at Tamarind; and Robert Motherwell, Malcolm Morley (1.21), and David Hockney have used it at Tyler Graphics.[77] In the hands of such artists, the Mylar manner is clearly a legitimate means – a non-traditional but still 'chemical' means – through which to make a lithograph; it is one more aspect of the medium. Like every other lithographic manner it must be used with an understanding of its limitations, often overlooked by its proponents, who claim it to be 'The New Lithography'.[78] Their claim, like that once made for transfer lithography, is greatly overstated. Despite its value in the making of certain kinds of colour separations, Mylar possesses neither the versatility of stone nor its sensuous response to the crayon. It lends itself readily to abuse by artists and print publishers who employ it to make prints that blur the distinction between autographic and reproductive lithography.[79]

In art, no change is forever. It is not in the nature of lithography to continue indefinitely in the direction of ever-increasing size and complexity. In the late 1950s, when the contemporary 'print renaissance' began, lithographs 55.9 by 76.2 cm (22 by

10.47, col. pl. 28

1.21 MALCOLM MORLEY
Goats in shed 1982
lithograph
72.3 × 102.8
right to print proof
(edition 30)
Australian National Gallery,
Canberra

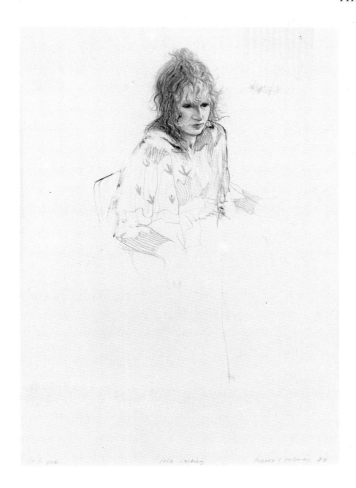

30 in) were considered large and they were seldom printed in more than three or four colours. By the mid 1980s it was possible for a single project at Tyler Graphics to require 'two and a half years of a shop working full time' at a cost of 'hundreds and hundreds of thousands of dollars'.[80] Although the result in this case justified the effort – Frank Stella's *Pergusa three double* is a magnificent and monumental print – the cost of making it was a cause of serious concern to both Stella and Tyler. Nor is Tyler alone in observing that 'prints are getting too expensive' and that 'we have to return to a little smaller scale'.[81] Barry Walker in the 24th National Print Exhibition at the Brooklyn Museum focused attention on the distinction between public and private prints: wall prints which serve as 'substitutes for paintings' and prints in the solander box.[82] While not seeking to deny the continuing importance of very large prints, Walker finds 'a renewal of interest in the small-format print. ... The print meant to be viewed as a private, one-on-one experience between spectator and object is beginning to resurface after more than three decades of relative obscurity.'[83]

So, too, is interest in the traditional techniques of lithography, an interest given eloquent statement in the simple black-and-white lithographs made throughout their careers by such artists as David Hockney (1.22), Ellsworth Kelly and Robert Motherwell. With access to the full range of technical possibilities available to them in the most sophisticated workshops the world has ever seen, these artists and others have chosen to eschew complex cuisine and, as if heeding Mellerio's advice, to use only the most direct of means in lithographs that are intended as *graphic* statements, not as proxies for painting. Such prints return to the basic and essential nature of lithography (1.23): to *The Stoneness of stone*.[84]

1.22 *Above left*
DAVID HOCKNEY
Celia smoking 1973
lithograph
98.8 × 72.6
right to print proof
(edition 70)
Australian National Gallery,
Canberra

1.23 ROBERT MOTHERWELL
The Stoneness of the
stone 1974
lithograph
106.0 × 78.0
right to print proof
(edition 75)
Australian National Gallery,
Canberra

7.17

2 Charles Joseph Hullmandel:
Lithographic printer extraordinary

Michael Twyman

Although good impressions cannot be taken from a bad drawing [on stone], *yet the best of drawings may be spoiled in the printing, so that the excellence of a work . . . depends on the Printer as much as the Artist.*

J. S. PATERSON, in a note about his choice of Hullmandel as his lithographic printer in *Sketches of scenery in Angus and Mearns (c. 1824)*

ANYONE who is in the least familiar with early British lithography, or, for that matter, 19th-century prints, will have come across the name Hullmandel: it appears on the imprints of thousands of surviving lithographic prints, usually as printer, sometimes as draughtsman too. Those familiar with the literature of printmaking will also know Hullmandel through his writings, particularly through his book *The Art of drawing on stone* (London, 1824). He was, without question, the most significant figure in the development of British lithography in the first half of the 19th century.

Although Hullmandel's achievements were recognized by writers on lithography during his lifetime, and have been ever since, he has not yet been the subject of a separate study.[1] The reason for this is not hard to find, since – extraordinary though it may seem – very little is known about his life and affairs. Even though I have recorded all that has come my way about him over a long period of working on the history of lithography, he remains an elusive figure other than through what emerges from his own writings. Nevertheless, his importance in the context of both British and European printmaking is sufficient justification for trying to write something about him. Where facts are sparse or in dispute I have weighed up the available evidence and, on occasions, indulged in what I believe to be legitimate speculation.

In my book *Lithography 1800–1850* (London, 1970) I wrote about Hullmandel's lithographic achievements at some length, and particularly about the improvements he made to the process and his work as a draughtsman and printer of topographical lithographs.[2] Here, I have merely outlined these achievements and concentrated instead on information that has a particular bearing on the running of his lithographic establishment. I have paid particular attention to new material that has come my way since the late 1960s when my book on lithography was completed, and earlier material that was not germane to it.

I have chosen to call the business Hullmandel ran an 'establishment', since this was the term he regularly used for it[3] and which he also used to describe a lithographic undertaking he provided equipment and materials for in Van Diemen's Land (Tasmania) in 1830.[4] It was also the word used to describe Hullmandel's business by many of his contemporaries, including the artist Daniel Fowler[5] and the bibliographer Dibdin.[6] Neither the word press nor the more current terms workshop or studio quite conjures up the kind of entrepreneurial activities Hullmandel seems to have engaged in.

Life and character

Charles Joseph Hullmandel was born in 1789, the year of the French Revolution, and died towards the end of 1850, on the eve of the Great Exhibition.[7] His life spanned a

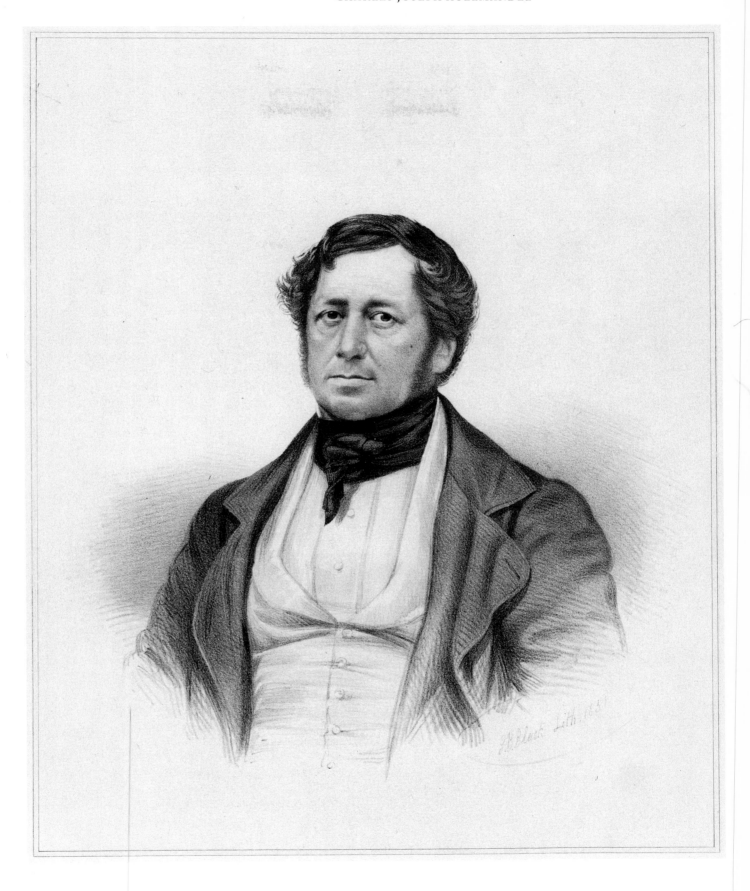

period of unprecedented change in the world of printing, which included the invention of lithography, the mechanization of letterpress printing, and the beginnings of commercial colour printing.

He was the only son of Nicolas-Joseph (Joannes Nicolaus/Joseph-Nicolas) Hüllmandel (1756–1823), an Alsatian composer and performer on the harpsichord, piano, and glass harmonica.[8] Around 1776, while still a young man, Hüllmandel senior moved from Strasbourg to Paris and there established a reputation for himself as a composer and performer, particularly in noble and fashionable circles. In Paris, he married Camille Aurore Ducazan, niece of the Receiver-General of France. She appears to have been a person of some means and, at the time of their marriage, had a sizeable estate at La Roche Guyon, which lies on the Seine about half-way between Paris and Rouen.[9] These circumstances probably explain why the couple left France shortly before the Revolution, by which time Camille Hüllmandel must have been carrying their son. The couple settled in London, presumably in Queen Street, Mayfair, where Charles Joseph is recorded as having been born on 15 June 1789,[10] a month before the fall of the Bastille.

In London, Nicolas-Joseph continued to practise as a musician, though mainly as a performer and teacher. Later, and certainly by 1816, the family was living at 51 Great Marlborough Street, in the premises where Charles Joseph was to set up his lithographic press.[11] Nicolas-Joseph Hüllmandel's death certificate reveals that he died at Great Marlborough Street on 19 December 1823.[12] Nicolas-Joseph and Camille Hüllmandel also had a daughter, Evelina, who wrote several piano arrangements and a teaching method for children, *Musical game, a New Year's gift for children* (1827).[13] She married the flower painter and lithographer Valentine Bartholomew in 1827.

The Hüllmandel family must have been comfortably off, because Charles Joseph was educated at home under a private tutor and then sent to a college in Paris.[14] His multilingual home, coupled with the period he spent in Paris, must have provided him with the linguistic skills he was to make good use of in connection with his lithographic activities. He seems to have been somewhat sensitive about his continental background and anxious to make it clear that he was British. In 1827, for example, in response to an insinuation (probably made by or on behalf of Engelmann, Graf, Coindet & Co.) that he doubted the talent of the English school of painting, he stated that he thought it probable that '. . . being an English Artist myself, I should be at least as proud of my countrymen, as a foreigner, who has resided but a short time in this country'.[15] His father's name was originally spelled Hüllmandel, but both father and son dropped the umlaut, which suggests that they were anxious to lose some of their family's continental trappings.[16]

The obituary notice in the *Expositor*[17] tells us that the young Hullmandel expressed a strong desire to become a painter and that he first studied art in Paris, although it does not state where. The length of his formal education is by no means clear either, although he mentioned 'a residence of many years on the Continent' in his introduction to *The Art of drawing on stone*.[18] He is referred to next in connection with a sketching tour which took him through Italy to Rome and then, on the way back, to Munich.[19] This was in 1817 when he was in his late twenties. The tour marked a turning point in his life because he met Senefelder in Munich and learned about lithography at first hand from its inventor.[20] The circumstances are not clear. It may have been that he heard about lithography while in Munich and then arranged to meet Senefelder in order to find out more about it, but it is just possible that he knew about it before he set out from England – either as a result of his stay in Paris or through Rudolph Ackermann, who produced his first experimental lithograph in January 1817 and published a short account of the process in his *Repository of Arts* later in the same year.[21] If Hullmandel did know something about lithography before setting out on his tour, it is possible that he planned from the outset to take in a trip to the birthplace of the process, since Munich was neither an essential part of the Grand Tour nor an obvious stopping-off point on the way back from Italy. In another respect, too, this

continental trip was important for the young man's future because the period he spent in Italy provided him with the subject matter for some of his first lithographed publications. The sources relating to Hullmandel's life and character are very few and in some cases rather flimsy, but in order to look for the person behind the achievements I have gathered together here all the information I have been able to discover.

First, we should consider the location in Great Marlborough Street, where Hullmandel worked and lived while in town. The earliest reference to him that I have found in directories appears in *Boyle's court guide* for January 1816,[22] though he does not figure in a trade directory until 1824.[23] Both these sources give his number in Great Marlborough Street as 51, which is the number that appears on his imprints for the first ten or so years of his work as a printer. Later, when he expanded his activities, he also occupied number 49, next door but one. He began by working from his father's home at 51 Great Marlborough Street, but the Rate Books for the Parish of St James reveal that he was paying rates on number 51 himself from around 1820.[24] His premises were on the south side of Great Marlborough Street, at the Poland Street end, and numbers 49 and 51 are shown in the detail from Richard Horwood's *A Plan of the cities of London & Westminster* of 1792–99, which remained unchanged in so far as this area of London was concerned through to its fourth edition of 1819 (2.2). Great Marlborough Street is situated in the West End of London: it is a turning off Regent Street, which was only just beginning to take shape when Hullmandel set up his press. Those who recall the 1960s may well locate it by relating it to Carnaby Street, which leads out of it. In the 18th and early 19th centuries it was a wide and handsome street.[25] In the 18th century it attracted the nobility, but by Hullmandel's time it had lost some of its distinction and many tradespeople lived there. In 1830 tailors accounted for a sixth of its tradespeople; the medical and legal professions were also well represented, and there were a few artists and architects.[26] By 1840 as many as eight artists were living in the street.[27] For a while in the period 1838–39 Charles Darwin lived at number 36 (later changed to 41).[28]

2.2 Location of Hullmandel's premises at 49 and 51 Great Marlborough Street (shown solid), adapted from Richard Horwood's *A Plan of the cities of London & Westminster* (1792–99). The major road running more or less east to west is Oxford Street (the part of it shown is just over 500 yards long). This part of Horwood's plan remained unchanged in its fourth edition of 1819, by which time Hullmandel was living and working from 51

CHARLES JOSEPH HULLMANDEL

It does not follow that Hullmandel had any connections with his neighbours. However, we know that he would have met many artists of distinction on a regular basis through his printing activities, including men as different in their achievements as Géricault and Lear. We also know that he held fashionable conversazione which attracted people of note from all walks of society, including Michael Faraday and J. M. W. Turner.[29] So there can be little doubt that he moved in circles that brought him into contact with varied and stimulating people.

In addition to his Great Marlborough Street premises, Hullmandel also had, at different times, two houses in Fulham, to the south-west of London, and then on the fringes of the countryside. According to local sources, Hullmandel lived in Acacia Cottage (later Dungannon House) in Fulham Road from 1839 to 1840, and in Laurel Bank House, about half a mile away in King's Road, from about 1841 to 1847.[30] These houses were demolished in the 19th century, but fortunately drawings of both of them survive. Among these are four pencil drawings, two of each house, by F. W. Fairholt, which were made to illustrate a series of articles by Thomas Crofton Croker recording a walk from London to Fulham. The series began to appear in 1845, but was never completed.[31] Acacia Cottage was a detached house that had been divided into two around the turn of the 18th and 19th centuries. Hullmandel's second house, Laurel Bank House, was also a detached building; it had a mock Tudor frontage and appears in Fairholt's drawings set within leafy surroundings. One of these drawings is labelled 'Cottage of Hullmandel the Lithographer Fulham (Front)'. Another drawing of the house by an unknown artist shows it from the garden side, together with a rudimentary plan recording its position in relation to King's Road and its garden, orchard, and stables (2.3).[32] Both Hullmandel's Fulham houses had sizeable gardens and were, in his time, surrounded by fields, orchards and parkland. It seems unlikely that he would have regarded either of these houses as his principal home since he continued to live in Great Marlborough Street. In all probability they provided him with a weekend retreat in the country.

Two portraits of Hullmandel have survived. One was published in the *Expositor*[33] and portrays a dour and humourless figure. The other, a lithograph in the Department of Prints and Drawings of the British Museum (2.1),[34] suggests a rather more sensitive person, and it seems likely that the *Expositor* portrait suffered somewhat at the hands of its wood-engraver. All the evidence we have suggests that Hullmandel was an extremely sociable person. The lithographic draughtsman, George Barnard, who knew Hullmandel partly because he was related to Faraday by marriage, had this to say about his entertaining:

> At this time we had very pleasant conversazione of artists, actors, and musicians at Hullmandel's, sometimes going up the river in his eight-oar cutter, cooking our own dinner, enjoying the singing of Garcia and his wife and daughter (afterwards Malibran) – indeed, of all the best Italian singers, and the society of most of the Royal Academicians, such as Stanfield, Turner, Westall, Landseer, &c. ... At Hullmandel's excellent suppers, served on a dozen or two small tables in his large rooms, we had charades, Faraday and many of us taking parts with Garcia, Malibran, and the rest.[35]

The picture of Hullmandel we get from his own writings is of a man with a clear sense of purpose in life and a determination to succeed. All that survives about him suggests that he was a hard worker, meticulous in his concern for practical details, shrewd in business affairs, and quick to defend his position when he was under attack. In addition to this, he was clearly a man with both imagination and a sense of judgement. The few descriptions of his character that have come down to us mention in particular his integrity: the obituary notices in the *Art-Journal* and *Gentleman's Magazine* refer to him as 'a man of genius and strict integrity', and in 1843 the *Art-Union*, in support of its decision to publish Hullmandel's defence of his claim to have invented lithotint, wrote:

2.3 Laurel Bank House, Hullmandel's country house in King's Road, Fulham, from about 1841 to 1847. From an archival photograph in Hammersmith & Fulham Public Libraries

The high and honourable character which Mr. Hullmandel has so long sustained in this country may also be worth something in considering a question in which his integrity is at stake. No one has a reputation more entirely unsullied.[36]

Hullmandel's scrupulous concern to get things right comes through in his published writings and the few letters of his that have been traced.

The only first-hand account of Hullmandel as a person that I know about is to be found in the autobiography of Daniel Fowler. Fowler was an English artist who studied under J.D. Harding for three years, beginning in 1831. He emigrated to Canada in 1843, where he achieved some fame as an artist.[37] He wrote his personal reminiscences in his eighty-fourth year, and records things that happened to him 50 years earlier as though that were yesterday.[38] Fowler would have met Hullmandel through Harding and, soon after Fowler's arrival in London, Hullmandel invited him for dinner with some senior members of his establishment. After commenting on Hullmandel as a lithographic printer, Fowler gives his own impression of him and records a memorable meeting at which Hullmandel discussed his work:

He [Hullmandel] was a singular character, a man of very acute intelligence, an accomplished linguist, decidedly caustic; if you made a blot in his presence, he was sure to find it; withal, as it was his business to be, an excellent judge of art. It might be about a year after I had joined Harding that Hullmandel asked me to spend an evening with him, bringing some of my sketches and drawings for his inspection. I did so, and awaited his expression of opinion with no little interest, all the more keen that Harding had treated them with an indifference that disappointed me. Hullmandel looked them over, and then uttered these memorable words. I mean memorable to me, for they have echoed through my memory a thousand times, syllable by syllable – 'You did wrong to go to Harding; you are a clever artist already; you should have gone to Paris.' What sweet music to my ears! 'A clever artist already!' Could it be true?[39]

Fowler's high regard for Hullmandel's judgement of art may well have been coloured by the encouraging things the printer said about his work. But I think we have to go beyond the particular points Hullmandel made to consider his kindness in inviting the young Fowler, a mere assistant in Harding's studio, around for the evening, and before that to a meal with senior members of his staff. Such generosity of outlook and sociability set Hullmandel apart from his colleague Harding, about whom Fowler wrote at length, describing him as always polite, but 'not a genial man ... and without a spark of humour'.[40] I have come across no reference to Hullmandel's marital status, other than in connection with his will, where he was described as a bachelor.[41] And until Evelina Hullmandel's marriage to Vincent Bartholomew in 1827, his future brother-in-law lived in Great Marlborough Street in what was described as 'a refined family circle'.[42]

Hullmandel died in his sixty-second year on 15 November 1850, when preparations were well under way for the Great Exhibition in Hyde Park where his firm had a stand and won a medal.[43] As he was an only son with no children, his line died out and, though I have searched through innumerable listings in directories and elsewhere, I have come across no other Hullmandel in Britain. His death certificate records that he died of a brain haemorrhage (effusion cerebro) at his home, 51 Great Marlborough Street; the informant was Sarah Ling, who was unable to sign her name and was probably a nurse or servant.[44] It seems, therefore, that the man who appears to have enjoyed the company of others died in comparative loneliness. His will revealed that he left the lease on his properties in Great Marlborough Street and his share in the business, together with his patent rights, to his partner Joseph Fowell Walton.[45] An earlier will was annulled because two people named in it had died; one of these may well have been his sister, who died in 1839.[46] Hullmandel was buried in Highgate Cemetery on 21 November in a grave marked with a modest headstone,[47] and not far from where his friend Faraday was to be buried 17 years later. The general location of Hullmandel's grave is known, but a search early in 1987 revealed an impenetrable undergrowth of brambles and ivy in the area where it is supposed to be. Fortunately, a diligent and foresighted historian had taken the trouble a quarter of a century earlier to transcribe the simple inscription on its headstone: 'Sacred to the memory of Charles Joseph Hullmandel who departed this life November 15th aged 61 years'.[48]

Hullmandel's introduction to lithography
Whether Hullmandel knew much about lithography before his visit to Munich in 1817 or not, his first connection with the new process was as an artist.[49] Like many artists of the period, he was fascinated by the opportunities it offered for the multiplication of drawings and must have been anxious to try it out for himself. Only later did he turn to printing his own drawings on stone and, thereafter, those of other artists.

As an artist, it cannot be said that Hullmandel was anything more than a minor watercolour painter and a competent draughtsman. Little of his work outside lithography appears to have survived, though in 1961, shortly after I began to be interested in the early history of lithography, I saw a folio guard book which contained numerous pencil drawings by him.[50] As I remember them, these drawings were similar in style to two linear pencil drawings in the album of experimental prints produced by Hullmandel and Harding, now in the St Bride Library (2.4).[51] If this guard book could be traced, it might provide important clues to Hullmandel's whereabouts at particular times and might also shed light on some of his published lithographs.

By contrast with the uncertainty surrounding much of what Hullmandel did, particularly when he began printing, he even went so far as to identify his first drawing on stone and to indicate the year in which it was done. A copy of this print is preserved in the St Bride Library album and is rather touchingly inscribed in manuscript 'First drawing on stone by me in 1818' (2.5).[52] It probably dates from early in January of that year, since a communication he addressed to the Society of Arts, dated 28 February 1819, refers very specifically to his experiments 'during the space of fourteen months'.

The lithograph is a rather coarse chalk-drawn mountain scene, printed on pale buff paper and touched up with Chinese white. It is not a particularly distinguished piece of work but it shows Hullmandel as a draughtsman, which – it must be stressed – was his original role in lithography.

Hullmandel's first set of lithographs to be published was, it seems, based on drawings made on his Italian tour and was called *Twenty-four views of Italy, drawn from nature, and engraved upon stone, by C. Hullmandel* (London, 1818) (2.6, 2.7).[53] The publication marks a turning point, not only in Hullmandel's career, but also in the history of English lithography; it is the first real topographical work to be produced by lithography in England and also the first major venture in the use of chalk. It did not pass unnoticed and received fulsome praise in the *Literary Gazette* of 15 May 1819.[54]

2.4 CHARLES JOSEPH HULLMANDEL
Elizabeth Castle, St Helier, Jersey, dated Aug. 1818, one of two pencil drawings in his album of experimental prints
sheet size 25.7 × 41.0
St Bride Printing Library

2.5 CHARLES JOSEPH HULLMANDEL
lithograph inscribed beneath 'First drawing on stone by me in 1818' from his album of experimental prints
20.0 × 30.0
St Bride Printing Library

THE TEMPLES OF THE SYBIL AND OF VESTA AT TIVOLI.

London Published by C. Hullmandel Gt. Marlbro' St. July 11th 1818

The publication consists of 24 separate plates, without text, in a landscape format. If variant copies are considered, it can be seen that 13 of its plates exist with the date June 1818 and 12 with the date 10 July 1818;[55] all plates that have imprints name Hullmandel as publisher, but none has a printer's name. The letterpress title-page tells us that the printing was done by Moser & Harris of 52 Ossulston Street, North, Somers Town. This is the firm's first recorded printing. The partnership was dissolved on 1 July, that is, halfway through the production of *Twenty-four views of Italy*, though Moser continued on his own after this date.[56] It is possible, as will be discussed below, that the dissolution of the partnership was connected in some way with Hullmandel's growing involvement with lithography.

Hullmandel claimed that it was the 'repeated failures' he met with when he first began *Twenty-four views of Italy* that persuaded him to have a press and materials of his own. He submitted these prints, together with some others, to the Society of Arts and was awarded the Society's Silver Isis Medal for them in 1819.[57] The communication he submitted with the lithographs was published in the *Transactions* of the Society and is dated 28 February 1819. It has been printed several times since then, but part of it cannot be omitted from an account of Hullmandel's beginnings as a printer:

> The repeated failures I met with when I first began the work entituled '*Twenty-four Views of Italy*' determined me to have a press and materials of my own, and after several failures and renewed attempts during the space of fourteen months, I am at last enabled to offer some drawings which show, I hope, a decided progress in the art. I must beg leave to observe, that the twelve last of the 24 Views of Italy, and the 5 drawings marked 1, 2, 3, 4, and 5, are printed entirely under my direction, and that the preparation of the stones, the chalk, the ink, &c. are entirely done by myself. With regard to the drawings marked 6, 7, 8, 9, the whole process, from the first preparation of the stones, as well as the *printing*, are done also by myself.[58]

This passage records in some detail how Hullmandel edged his way into printing during the course of the production of *Twenty-four views of Italy*. Unfortunately, the last four of the numbered drawings (those marked 6, 7, 8, 9), which can be regarded as

Hullmandel's first attempts at printing, are no longer traceable – or if they are, they cannot be identified. Hullmandel goes on to give more information about some of the numbered examples:

> The tints of the prints marked 6, 7, 8, 9, are produced by a second stone covered over with grease; the lights are scraped out in the places where they are intended to be; and the print being brought on the stone in its exact place, produces the effect of a drawing on coloured paper touched in with white. The drawings marked 7, 8, 9, are printed with a third stone, to give more effect to the fore ground.[59]

I have come across no early English lithographs with two tints added to a black working, but a single-tinted lithograph in the British Museum may well be a copy of the print referred to by Hullmandel as number 6. This lithograph, *A morning scene in the Bay of Naples*, is lettered 'Drawn from Nature & upon Stone by C. Hullmandel/ London: Published & Sold by C. Hullmandel 51 Gt. Marlboro' St February 20. 1819'.[60] The date on it is just right in terms of its submission to the Society of Arts, though the imprint does not specifically state that Hullmandel was its printer.

We have to ask whether Hullmandel undertook the printing of the examples he numbered 6, 7, 8, 9 at Francis Moser's press (after the dissolution of the Moser & Harris partnership), or whether he printed them on his own press at Great Marlborough Street. The question is important mainly because the answer to it might narrow down the period when he set up his own press. In *Lithography 1800–1850* I suggested that we have to assume that Hullmandel was not allowed to do his own printing at Francis Moser's.[61] This still seems a reasonable position to take, and in support of it we can point to the obituary notices in both the *Expositor* and the *Art-Journal*, which claimed that Hullmandel set up his own press at Great Marlborough Street in 1818.[62] On the other hand, it is just possible that Hullmandel was allowed to do some printing at Francis Moser's. After all, if Moser allowed him to do 'the preparation of the stones, the chalk, the ink, &c.' for the last twelve plates of *Twenty-four views of Italy* and for the five drawings marked 1, 2, 3, 4, 5, it would have been a small step to allow him to try his hand at printing too. If this is what happened, it probably puts back the date when Hullmandel set up his own press until after he submitted the collection of prints to the Society of Arts. In his submission, Hullmandel made no acknowledgement of Moser's involvement with *Twenty-four views of Italy*, though it is beyond reasonable doubt that Moser & Harris printed the plates of the first half of the publication. If Hullmandel had set up his press by this time, whether it was involved in the printing of the works he submitted or not, he would surely have mentioned the fact.

Some notes in the Munich Journal *Kunst- und Gewerb-Blatt des polytechnischen Vereins [Art and Trade Paper of the Polytechnical Association]*, which I did not know about when writing *Lithography 1800–1850*, may also have a bearing on when Hullmandel set up his press. The first of these notes, published in July 1819, merely stated that Hullmandel – referred to as an English draughtsman – came to Solnhofen to buy stones.[63] The second, published in February 1820, refers to the award of a silver medal to Hullmandel for the best lithographic drawing in the chalk manner, and adds as a footnote that he visited Munich in the preceding year in order to learn about the various techniques of stone printing and ordered a consignment of stones to the value of 1,000 florins.[64] Taken together, these notes seem to suggest that Hullmandel did not set up his press until some time in 1819, perhaps not much earlier than the middle of 1819. They also throw some doubt on the traditional interpretation – stemming from obituary notices – that Hullmandel learnt what he knew about lithography from a single visit to Munich on his way back from his continental sketching tour. The notice in the *Expositor* even claimed that Hullmandel brought a press back with him to England;[65] but if he did do this, would he have gone to Moser & Harris for his printing? Unless the notices that appeared in the *Kunst- und Gewerb-Blatt* are untrue or inaccurate, Hullmandel seems to have made several visits to Germany.

Common sense suggests that someone with no previous knowledge of lithography is unlikely to have learnt from a single visit all that was needed to practise as a lithographic draughtsman and set up a lithographic press. The most likely interpretation of the few available facts is that Hullmandel was inspired to try drawing on stone as a direct result of his visit to Munich in 1817. On getting back to London, he would surely have looked around for a lithographic printer and have chosen Moser & Harris from the very few available in London at the time.[66] His experience of working with this firm, and later with Francis Moser, persuaded him – as he stated in his submission to the Society of Arts – to set up a press of his own. Nevertheless, the reasons he gave for wanting to do so may not have related solely to the difficulties he encountered while working with Moser & Harris: the lithographs he produced for his first publication, *Twenty-four views of Italy*, were very creditable and may have caused him to realize the potential of the process as far as artists were concerned. Only at this stage – if we may speculate further – did he have a clear sense of purpose and so return to Munich in order to learn more about lithography and buy the necessary equipment and materials to set up a press of his own.

Clarification of the point at which he began printing at Great Marlborough Street is not helped by the fact that one of the earliest of the publications he printed, *Château des Rochers* (the plates of which are dated 1 May 1819), does not name its printer (2.8).[67] Hullmandel made the drawings on stone and is only known to have printed them because of the inclusion of the publication in Rodwell & Martin's list of 'Lithographic works, printed by C. Hullmandel', which appeared with the *Gentleman's Magazine* of December 1820. It follows, therefore, that not every early lithograph printed by Hullmandel bears his imprint, and this makes it possible that he printed the tinted lithograph *A morning scene in the Bay of Naples*, which is dated 20 February 1819.

It can be seen that it is by no means easy to establish precisely when Hullmandel set up his press or what should be regarded as the first lithographs he printed. In *Lithography 1800–1850* I claimed that his press must have been established between 10 July 1818 (the date borne by the latest of the plates in *Twenty-four views of Italy*) and 28 February 1819, when he submitted his communication to the Society of Arts.[68] I now believe that it is possible he was allowed to do his own printing at Francis Moser's. It is even possible that he considered going into partnership with Francis Moser and that there might have been some connection between the dissolution of the partnership of Moser & Harris on 1 July 1818 and Hullmandel's greater involvement with the plates of the second half of *Twenty-four views of Italy*, which are dated 10 July 1818. The dissolution of the partnership would certainly go some way to explain Hullmandel's increased involvement with lithographic printing, and may even have been precipitated by it. All this is, of course, pure speculation. But in any event – though Hullmandel makes no reference to it in any surviving document – we have to see Moser & Harris (or Moser alone) as one of the sources of his initial instruction in lithography. In the light of the above, I would now incline to extend the latest possible date for the setting up of Hullmandel's printing establishment in Great Marlborough Street to 1 May 1819, the date borne by the plates of his *Château des Rochers*.

Whenever it was that Hullmandel set up his press, he was by no means the only lithographic printer in London.[69] Ackermann's press had been going since the beginning of 1817, D. J. Redman was still active, and the in-plant press at the Horse Guards in Whitehall was turning out military circulars by the thousand. Besides these, there were two other presses. One belonged to Charles Marcuard, an artist who had some connection with the press at the Horse Guards and then set up his own in Chelsea; the other to the geologist John Phillips who, as a young man, printed lithographs from his own home. It is also possible that a press called the London Lithographic Institute in the Strand and the important press of Charles Madinger Willich were both already in operation when Hullmandel began printing at Great Marlborough Street. But with the exception of Ackermann, for whom lithography was

LA MOTTE MADAME, LES ROCHERS.

London: Published & Sold by C. Hullmandel 51. Gt. Marlbro' St. May 1. 1819.

2.8 CHARLES JOSEPH
HULLMANDEL
La Motte Madame, Les Rochers
from *Château des Rochers* 1819
tinted lithograph
20.2 × 29.0
Felix Man Collection
Australian National Gallery,
Canberra

just one of many lines of business, there was no lithographic printer in England who made a feature of printing drawings made on stone by artists, especially those drawn with lithographic chalk. Not only was Hullmandel in competition with other lithographic printers when he set up his press, he was also slow in getting his business into the trade directories. Whereas three other lithographic printers are listed in the *Post Office London directory* for 1820,[70] Hullmandel's name does not find its way into this or any other trade directory until 1824.

Apart from Ackermann, who had also visited Senefelder in Munich, the other lithographic printers in London at the time were largely working from second-hand experience of the process, and, in some cases, simply from what they had read. What Hullmandel brought to British lithography, in terms of both drawing and printing, was a first-hand knowledge of what was going on in Germany, which was still the centre of the lithographic world. The rather coarse and mechanical cross-hatching to be found in most of the plates of *Twenty-four views of Italy* is similar to that of such early German lithographers as Joseph Hauber and Max Wagenbauer, whose lithographs, some of which were produced ten years earlier for *Lithographische Kunstproducte [Lithographic artworks]* (Munich 1805–07),[71] he is likely to have seen while in Germany. In addition, Hullmandel's early fascination with the use of tinted lithography must have been inspired by the striking examples of work in this style being produced in Germany at the time of his visit by Strixner, Piloty, and other artists. In particular, Hullmandel's use of two tints with chalk drawing in three of the prints he submitted to the Society of Arts in 1819 relates closely to similar and even more ambitious work done for *Les Oeuvres lithographiques [Lithographic works]* (Munich, 1810–1816) and the *Königlich Bayerischer Gemälde-Saal zu München und Schleissheim [Royal Bavarian picture gallery at Munich and Schleissheim]* (Munich, 1817–36).[72] But probably more important than either of these specific influences on Hullmandel would have been the high standard of craftsmanship and the ambitious scale of lithographic undertakings he would have seen in Germany, where the process had already established itself as a serious rival to the traditional processes of printmaking.

Something more should briefly be said about Hullmandel as a lithographic draughtsman, because he continued to work regularly in this capacity for several years after setting up his press. His *Twenty-four views of Italy* remains his only important one-man collection of original lithographs, but he contributed to many publications and worked as a reproductive lithographer for others.[73] His first work after *Twenty-four views of Italy* was a set of three rather weak chalk drawings and a lithographed plan of the *Château des Rochers*. This publication has been referred to already because of the date borne by its plates and its use of tinted lithography, but it is of little significance for any other reason. In the following year, however, he began work on two much more important publications: *Roman costumes; drawn from nature by Pinelli and C. Hullmandel* (1820–21), and G. B. Belzoni, *Plates illustrative of the researches and operations in Egypt and Nubia* (1820–22). In both of these his role was mainly that of reproductive lithographer, though in *Roman costumes* three of the plates are his own compositions. This work shows Hullmandel introducing a more complex and at the same time less mechanical system of chalk hatching, whereas some of the plates for Belzoni's book, particularly those in the supplement published in 1822, are remarkably free and bold in their hatching. Because of its importance as a text, Belzoni's publication had the effect of recommending the new process and its printer to artists and scholars alike.

The other early work that Hullmandel contributed to as a lithographic draughtsman represents a watershed in drawing on stone in England. This was *Britannia delineata [Britain delineated]* (1822–23), which set out to record Britain county by county in much the same way that Baron Taylor's *Voyages pittoresques et romantiques dans l'ancienne France [Picturesque and romantic travels in old France]* (Paris, 1820–78) had begun to record France. The major difference was that the French publication covered a good deal of France, whereas *Britannia delineata* got no further than 25 plates of the first volume dealing with Kent. Nevertheless, it was important in the context of British lithography because it brought together most of the leading lithographic draughtsmen of the early 1820s: Hullmandel, James Duffield Harding, Samuel Prout, and William Westall.[74] It may also have brought home to Hullmandel that he would be better advised to continue as a reproductive draughtsman and lithographic printer rather than as an original draughtsman. Though he continued to put his own drawings on stone from time to time thereafter, he began to devote himself to other aspects of the process. Had he remained a lithographic draughtsman, he would have been remembered only for the priority of his *Twenty-four views of Italy*. But he made his name by taking on more reproductive work, improving the techniques of drawing on stone and printing from it, concentrating more on the management of his establishment, and by the promotion of lithography in general and his own activities in particular.

The establishment at Great Marlborough Street
We can piece together something about Hullmandel's achievements as a lithographic draughtsman and printer from his own publications and contemporary accounts of lithography. But it is not nearly so easy to find out about his establishment and how it operated. There seems to be no obvious source of information about early lithographic workshop practice in general, and what we can glean about the first half-century or so of this aspect of lithography is essentially a composite of fragments from various sources. For example, we have perhaps a handful of pictures showing lithographers at work in the first half of the 19th century, whether focusing on a single workman or on an entire workshop; these pictures are from Germany and France and span several decades.[75] Moreover, no lithographic craftsman of this period seems to have left a personal account of his craft in the form of a diary, memoirs, or a good body of correspondence. We know very little therefore about the day to day running of a lithographic workshop of the time; and it follows that we know even less about Hullmandel's establishment.

All the same, a few things are known that throw a little light on the way Hullmandel operated. The most concrete evidence of his establishment concerns its location: from beginning to end it was in Great Marlborough Street, in the heart of the West End of London. It was initially set up in what were described in an obituary notice as his lodgings at number 51 though, as already noted, the premises were then owned by his father.[76] This was the address Hullmandel used on his imprints and invoices until around April 1829, when the number changed to 49.[77] Later on, in the late 1840s, it reverted to 51.

Entries for the Rate Books of the Parish of St James, Westminster, reveal that Charles Joseph Hullmandel began to pay rates on 51 Great Marlborough Street in 1820.[78] They also make it clear that the change from 51 to 49 was neither simply a change of premises nor a change in the numbering of the street; they establish that Hullmandel moved into 49 Great Marlborough Street around 1829 while continuing to occupy 51.[79] The assumption must be, therefore, that his establishment expanded in the late 1820s. A set of measured drawings of the Parish of St James produced by Charles Mayhew in the 1830s, which shows detailed plans of the buildings in Great Marlborough Street (2.9),[80] lends support to this view and confirms Fowler's description of Hullmandel's premises as a confusing labyrinth of work rooms.[81] Though none of the buildings has survived,[82] we can form some impression of them from Mayhew's survey, from later plans (2.10), and from wood-engravings of numbers

First Floor

Ground Floor

ft $\underset{\text{10}}{\vdash\!\!\!\dashv\!\!\!\dashv\!\!\!\dashv\!\!\!\dashv} \overset{\text{0}}{\underset{}{}} \overset{\text{10}}{} $ ft

2.10 *Above* Plans of 49 Great Marlborough Street made before the building was demolished in 1953. Reproduced, by permission of the General Editor, from *Survey of London*, vol. xxxi, p. 264

2.9 *Left* Plans of Great Marlborough Street showing the premises on which Hullmandel paid rates (49 and 51, and the premises behind 49 and 50), taken from C. Mayhew's plans of buildings in the Parish of Saint James, Westminster, 1836. Westminster City Archives. The storeys are coded with letters (a,b,c,d,e represent 1,2,3,4,5 respectively; a colon after a letter indicates an attic room). Dimensions are in feet and inches. This detail has been oriented to accord with 2.2. There must be some doubt about which of the outbuildings behind 49 and 50 were occupied by Hullmandel

FEMALE SERVANTS' HOME.—EXTERIOR OF BUILDING.

ENTRANCE HALL.

2.11 Wood-engravings of the exterior and entrance hall of Hullmandel's premises at 49 Great Marlborough Street several years after he moved out of them. From the *Lady's Newspaper*, 4 January 1851, when the premises were occupied by the Servants' Provident and Benevolent Society. Greater London Record Office (Maps and Prints)

49 and 49a Great Marlborough Street published in 1851 (2.11).[83] The original 18th-century buildings with their frontage on Great Marlborough Street consisted of four storeys, including their attic rooms, but behind them was a conglomeration of one, two, and three-storey premises which look as though they were squeezed in to make use of every available space in what would originally have been back gardens. The Rate Books show that Hullmandel (later with Walton)[84] paid rates on both 49 and 51 Great Marlborough Street throughout the 1830s to the mid 1840s, and on the premises behind 49 and 50 in the late 1840s.[85] But Mayhew's survey (made in 1831 and 1832 and updated to 1836) shows that most of these outbuildings must have existed long before they first figure in the Rate Books. Around 1848 Hullmandel & Walton's imprints reverted to 51. What this change means is not absolutely clear, but in 1848 and 1849 rates were being paid on 49 Great Marlborough Street by a George Scrimshaw, even though the premises behind 49 and 50 were still being used by Hullmandel & Walton when Hullmandel died in 1850. These changes must reflect some contraction of Hullmandel's activities in this period, and there is no reason why his establishment should have escaped the depression that hit so many London firms in the 1840s.

On the face of it, it seems remarkable that so productive and influential an establishment should have been housed in premises built initially for domestic use. But a calculation based on Charles Mayhew's measured drawings shows that the total floor space available for Hullmandel's home and his printing establishment would have been in the region of 18,500 square feet by the mid 1830s.[86] The working conditions cannot have been very salubrious, particularly in the outbuildings, which

filled every available space and must have been severely deprived of natural light.[87] Moreover, some of the outbuildings were within ten feet of St James's Workhouse which, in the early 19th century, housed around 750 people.[88]

Most lithographic presses in London survived in business for relatively short periods and changed their premises quite frequently.[89] Hullmandel's establishment was most unusual in its stability as a business and in staying more or less in one place; moreover it grew from an experimental workshop to a fully commercial business in a matter of a few years. According to Dibdin, by the autumn of 1820 Hullmandel had '. . . completed an establishment, where not fewer than 1500 lithographic stones are deposited for the purpose of business; and several skilful workmen (one in particular from Paris) are employed'.[90] Most of the stones were probably acquired as a result of the trip Hullmandel made to Germany in July 1819 because, on the basis of the cost of Solnhofen stone reported by Engelmann 20 years later,[91] his order to the value of 1,000 florins represented about 1,000 square feet of lithographic stone. All this suggests that Hullmandel must have had a sizeable workshop within a few years of setting up as a lithographic printer. The number of surviving items that he printed in the early 1820s provides further evidence of the rapid growth of his establishment.

At the outset, however, Hullmandel must have been unsure of his ground from a technical point of view, and he turned to two leading French printers for guidance: F. Delpech and Godefroy Engelmann. He referred in generous terms to the help he received from Delpech, through whom he claimed to have obtained '. . . a more complete insight into the difficulties of Lithography, than I ever acquired from any other printer'.[92] His association with Engelmann was more specific, and consisted of an arrangement whereby the latter's improvements to the process were communicated to him for a small annual sum.[93] The arrangement ended in the spring of 1826, when Engelmann set up a branch company in London with the style Engelmann, Graf, Coindet & Co. What Hullmandel gained from the arrangement is not at all clear, but the long-term outcome was a degree of friction between Engelmann's branch company and Hullmandel which found expression in several publications.[94] Hullmandel also drew upon the chemical knowledge of Michael Faraday, with whom he was on friendly terms over a long period. Faraday acted as consultant scientist and often came out in public support of the printer. The collaboration was already established in 1826 when the two men demonstrated the capabilities of the process at the Royal Institution.[95] The connection between them was reinforced through Mrs Faraday's youngest brother, the lithographic draughtsman George Barnard, who used to go sketching with the Faradays.[96]

Hullmandel was kept very busy as a lithographic draughtsman in the first few years of his establishment, as is made clear in one of his few surviving letters, written to Matthew Gregson on 13 November 1820. Gregson was a Liverpool antiquarian who wanted Hullmandel to do some drawings on stone for him. In his reply Hullmandel stated that '. . . with regard to my doing them myself I am sorry to say that my time is so engaged for two years to come that it would be totally out of my power to do them.'[97] Instead, he offered to find an artist to do the work under his direction. The growth of Hullmandel's establishment from small beginnings, when he still did a great deal of drawing on stone and also ran the business side, to a large enterprise involving delegation of responsibility, is evident from a passage in Daniel Fowler's autobiography referring to the period when Fowler studied under Harding in the mid 1830s:

> It may be easily understood that when there was so much lithography going on the lithographic printer was very much in request. There was a certain Mr. Hullmandel who was engaged in that occupation on a very large scale, and he and Harding were naturally very intimate. His establishment was a labyrinth of work rooms of one description and another. It was bewildering to be shown through them, and there were on the staff no less than five employees of a superior grade, more or less associates of Hullmandel himself, and I met some of them at his dinner table very soon after my arrival in London.[98]

2.12 EVELINA HULLMANDEL
La Rose et les papillons
[The Rose and the butterflies]
lithographed title of sheet
music with chalk-drawn,
hand-coloured vignette by her
future husband and
Hullmandel's manager,
Valentine Bartholomew,
printed by Hullmandel
approx. 33.0 × 23.0
John Johnson Collection,
Bodleian Library

Short as this passage is, it confirms what can be deduced from the known output of Hullmandel's presses from the mid 1820s onwards: that his establishment must have had some managerial structure involving delegation of responsibilities. Fowler was writing about what he knew of it in the mid 1830s, but even before that, Hullmandel employed managers. One of these was Valentine Bartholomew, a flower draughtsman of some note, who, according to Roget, lived at 51 Great Marlborough Street for five years and managed the establishment for a time before he married Hullmandel's sister in 1827.[99] An unusual record of the connection between these three people survives in the form of a lithographed title to a piece of sheet music (2.12). The music was composed by Hullmandel's sister, Evelina; Bartholomew drew a vignette for it, and Hullmandel's establishment did the printing.[100] Another manager may have been Thomas Walter, to whom, in the will that was later annulled, Hullmandel bequeathed '... one third of the interest & property of the Lithographic Establishment now existing at No. 51 Gt. Marlbro St'.[101] But the only concrete information we have about management concerns Joseph Fowell Walton. Around 1843 Hullmandel went into partnership with Walton, using the style Hullmandel & Walton. No great fuss seems to have been made of the change, which may have been brought about by difficulties the firm encountered during the recession in the 1840s, when it also faced fierce competition from the successful and rising firm of Day & Haghe (later Day & Son). In his revised will, Hullmandel named Walton as the sole heir to his property, which included his two-thirds share of the printing establishment, the leases of 49 and 51 Great Marlborough Street, and his patent rights. This arrangement secured the continuation of the firm without noticeable change for a decade after Hullmandel's death.[102]

Discussion of the management of Hullmandel's establishment raises the question of what we mean when we refer to Hullmandel as a lithographic printer. What did he actually do himself? The question is not easy to answer, but some attempt should be made to do so. Initially, Hullmandel made drawings on stone and was also involved in printing. The level of his activities as a lithographic draughtsman is established beyond reasonable doubt by his letter to Gregson, in which he stated that he was booked up personally for two years ahead. His initial involvement with printing is confirmed by the communication he sent to the Society of Arts in which he stated quite unequivocally that in some examples he did everything himself '... from the first preparation of the stones, as well as the *printing*'. Furthermore, Dibdin, who wrote briefly about Hullmandel's establishment as it was in the autumn of 1820, commented that 'The proprietor himself both draws upon the stone, and superintends the process of printing, with equal skill and success.'[103]

Thereafter, it seems likely that Hullmandel retained some direct involvement with technical aspects of lithography over a long period, at least until the development of lithotint in 1840. How could he otherwise have developed a succession of new methods of working on stone? But he need not have been involved in the routine production activities of his press; his role – to use today's terminology – would surely have been in the area of research and development. He would have needed his early experience of drawing on stone and printing from it in order to understand sufficiently well what needed to be done, since innovation rarely comes from ignorance. But he would not have had the time to involve himself directly with day-to-day aspects of production once his establishment was on a proper footing. One may argue for Hullmandel a position similar to that proposed by Panofsky in relation to Dürer in the context of innovations in woodcutting in the late 15th century.[104] Once Hullmandel had pointed the way and demonstrated the practicability of what he proposed, he must have left others to do the production work. This would have allowed him time to continue with 'research and development'. While Faraday advised him scientifically, his close colleague, the artist Harding, provided drawing skills. A record of some of the experiments Hullmandel undertook, many of them involving Harding as draughtsman, survives in the remarkable album in the St Bride Library of 'Specimens of Early

2.13 CHARLES JOSEPH
HULLMANDEL
Page of his album of
experimental prints,
assembled around 1841
page size 40.5 × 31.5
St Bride Printing Library

Lithography by Hullmandel and by J. D. Harding with his MS notes' (2.13).[105]

Fowler's tantalizingly brief description of the Great Marlborough Street premises as a 'labyrinth of work rooms of one description and another' which he found 'bewildering to be shown through'[106] fits in well with what we now know about the establishment from Mayhew's drawings. Clearly Hullmandel's workshops were very different from those of Lemercier in Paris a couple of decades later, which are shown on a surviving print with serried rows of presses in what looks like a purpose-built hall.[107] We probably have to imagine a progressive conversion of Hullmandel's dignified premises on a fairly *ad hoc* basis to cope with increasing demands. No doubt lithographic presses were fitted in as well as they could be. There may also have been rooms for the drawing and lettering of stones, the preparation of drawings when completed, the storage and damping of paper, the transferring of engravings from copper, the hand-colouring of prints, and, possibly, at a later stage, for colour printing.

Some continuing commitments, such as the printing of plates for academic journals, might have tied up certain areas. In addition, there would have been the overriding problem of the storage of stones. Many early printers stored their stones on racks around their press rooms,[108] but Hullmandel would probably not have been able to store too many stones above the ground floor because of their weight. So the likelihood is that the main stone store and grinding rooms were somewhere on the ground floor. Whatever the particular arrangements may have been – and this discussion is largely speculative – we can imagine the problems that must have arisen as a result of trying to make the most of the available space and moving stones from floor to floor in the older, four-storey parts of the premises.

Whereas we have to speculate about Hullmandel's workshops, we are on much surer ground when it comes to the kinds of presses he would have used, at least in the 1820s. By a stroke of good fortune, an engraved plate of one of his presses, dated 1821, was used to illustrate the entry on lithography in the *Encyclopaedia Britannica* of 1824.[109] It shows a star-wheel press, of a kind originally developed in Germany in 1805, made almost entirely of wood. One of Hullmandel's obituary notices referred to his having carried a press with him to England,[110] and on the basis of what is known about British lithographic presses of the early 1820s it seems likely that the press under discussion was imported from Germany. The drawings in the *Encyclopaedia Britannica* (2.14) show a plan and front, side, and rear elevations, though, oddly enough, without a scale. A model made from these drawings in 1983 gives a more vivid impression of what the press must have looked like (2.15, 2.16),[111] but the making of the model revealed that some details of the engraving, particularly those showing the means of applying pressure to the scraper beam, were not fully resolved. Since the engraved plate has no scale, it is not possible to state precisely how large this particular press was, but already by 1822 Hullmandel had a press which was large enough to print some folding plates in the supplement to G. B. Belzoni's *Plates illustrative of the researches and operations in Egypt and Nubia* (London, 1820–22). Its two largest

2.14 Plan, with side and rear elevations, of Hullmandel's star-wheel lithographic press, taken from Plate xcv of the *Encyclopedia Britannica*, vol. v, 1824. The original plate has no scale

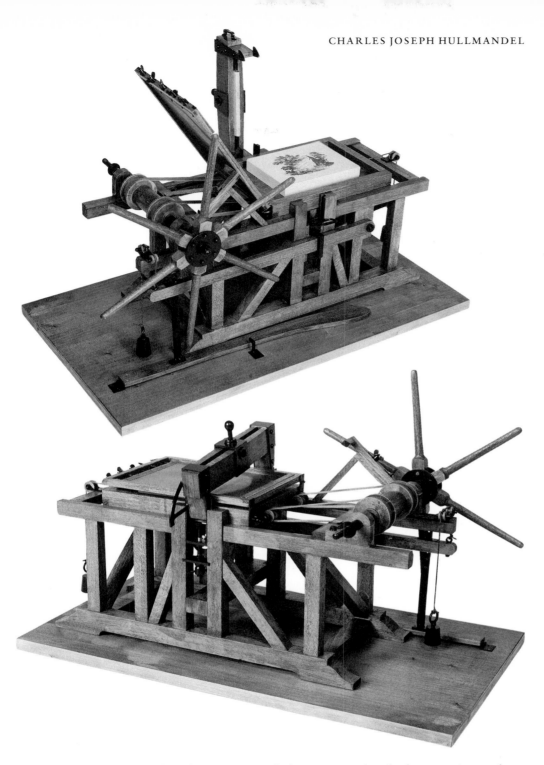

2.15 Wooden model of Hullmandel's star-wheel press, based on the plate in the *Encyclopedia Britannica*, shown with the scraper beam and tympan thrown back. Department of Typography & Graphic Communication, University of Reading, reproduced by courtesy of Arthur Ackermann

2.16 *Below* The same model showing the tympan down and the scraper beam almost closed

plates, which were produced in 1822, needed a press with a bed measuring at least 50.8 × 71.1 cm (20 × 28 in).[112] An even larger early item that Hullmandel printed, a chart with the title 'Chronology of England from the Conquest', probably dating from around 1821, needed a press with a bed size of at least 61.0 × 74.0 cm (24 × 29⅛ in).[113]

How many presses Hullmandel would have had at any one time, and whether they were all similar to the one discussed above, remain matters for further speculation. However, Engelmann's establishments in France provide us with some indication of the scale of large lithographic workshops in this period: by the late 1820s Engelmann had around twenty presses in Paris and ten in Mulhouse.[114] By 1830 it looks as though Hullmandel may have introduced some new kinds of presses, because in May of that

2.17 Hullmandel invoice,
May 1830, listing the
lithographic equipment he
had shipped to the Surveyor
General's Office in Van
Diemen's Land
46.0 × 18.5
Archives Office of Tasmania

2.18 *Above right*
Hullmandel invoice made
out to the lithographic
draughtsman George Scharf,
some time between 1829 and
1848, engraved on copper
and transferred to stone
(heading only of a quarto or
foolscap document).
John Johnson Collection,
Bodleian Library

year he arranged through Edward Barnard, agent for the colony of Van Diemen's Land, for a complete set of lithographic equipment and materials to be shipped there for the use of the Surveyor General's Office (2.17). This shipment included 'An Improved Iron Lithographic Press, colombier size, complete',[115] which suggests that Hullmandel would have had some presses of the same kind in his own establishment by this time. He would certainly have had one or more copper-plate presses for transferring intaglio-printed images to stone, since his invoices include in their displayed heading the words 'Engraving transferred from Copper & Printed from Stone' (2.18).[116]

The list of items to be shipped to Van Diemen's Land gives us some idea of what Hullmandel regarded as the basic equipment for setting up a small-scale lithographic establishment around 1830. But the extent to which he acted as a dealer in lithographic equipment is by no means clear. Many early lithographic printers in Britain stated in their advertisements that materials for lithography, including stones, were available from them,[117] but the evidence for Hullmandel's involvement in the selling of stones is conflicting. Though we know that he sold 32 lithographic stones to the Surveyor General of Van Diemen's Land for £25.8s., ten years earlier he stated categorically in a letter to Matthew Gregson that he did not sell stones:

As to what you mention concerning the stones I never sell any of mine on any account but let them out for the purpose of making a drawing & printing it: the loan of a stone of the size of your drawing is 1s/6d if you wished to have stones of your own I could procure you some which of that size would come to about £1–5 ...[118]

The practice of hiring out stones to artists goes back to the earliest days of lithography and was well established by the 1820s.[119] In *The Art of drawing on stone* Hullmandel devoted a section to the packing of stones for those 'residing in the country, or distant towns' and illustrated a method of crating them so that they could be transported without damage (2.19).[120] It is clear that hiring out was his preferred way of making stones available to artists, and the same terms for doing so were printed on his invoices for a period of at least 12 years.[121] There were probably several reasons for his preference for this method: it may have been more profitable for him to deal in this way

but it was beneficial for his customers too, unless they intended to use the stones over and over again. Nor can it have escaped Hullmandel's notice that hiring out stones was also a way of ensuring that the work of printing came his way. Although his letter to Matthew Gregson makes it plain that he was prepared to 'procure' stones for his customers, this appears to have been an exceptional practice and, in the case of the shipment to Van Diemen's Land, the stones could hardly have been hired out and returned to London for printing. It seems that Hullmandel did not wish to deplete the stock of lithographic stones he kept for his own use, and did not have enough space in his cramped premises to keep stones simply in order to sell them.

But another point relating to the hire of stones deserves mention. Like most good lithographic printers, then and ever since, Hullmandel saw himself as an adviser to his clients. This comes across in the tone of his publications and, more directly, in the couple of letters he wrote to Matthew Gregson in 1820. In one of them, for example, he warns Gregson about the use of unsuitable papers:

> I must beg leave to make some observations with regard to the paper. The choice of paper is most important in Lithography, as some sorts spoil a drawing on stone in a few impressions. These papers are those bleached with lime, plaster of Paris, Acids or containing Alum. Another observation is that to obtain 500 good impressions the paper must be unsized, now I find that there is no such thing as plate foolscap, perhaps some other paper might cut up to or nearly to the size you want.[122]

And after stating that he does not sell his stones but could procure some for Gregson, he writes:

> ... but I must observe that after having obtained 500 Imp[ressions] of a chalk drawing it is so much worn out that it would be of little use to you and it would answer your purpose better to hire it.[123]

Hullmandel's rates for drawing and printing are mentioned in several documents and, though they do not tell us very much, are worth noting. Hullmandel wrote to Gregson on 13 November 1820 that the drawing and writing of a map would come to £2 and the printing of it would cost 4s/6d per hundred, not including the paper.[124] In another letter to Gregson of 4 December [1820] he told him that 'The expence of a drawing with as much detail as you mention in your letter would be six guineas', and 'The printing of a chalk drawing of the size you mention will be 10s/ per hundred.'[125] So it can be seen that his charges for printing chalk drawings were, on occasions, more than twice those for pen and ink work, and the origination of the image was relatively expensive when compared with the printing. A more formal estimate sent on behalf of Hullmandel's establishment to the artist Maria Denman in May 1827 reveals costs of a broadly similar kind:

2.19 Crate for packing lithographic stone, details from Hullmandel's *The Art of drawing on stone*, 1824 plate VII

Mr Hullmandel has herewith forwarded the proofs as also the estimate for printing your drawings as

Printing per 100 (if 500)	£ ″ 7 ″ 0	
Paper 8ᵛ Impˡ	—— 5 ——	
Pressing	————————6	
	£ ″ 12 ″ 6	
Use of each Stone	1 ″ 6	
Preparing each drawing	——— 2 ———	

The Printing if 1000 are wanted will be 6/6 per 100 & the Paper will be the same.[126]

A set of invoices in the Linnean Society Library reveals similar information about Hullmandel's printing costs, and one of them points to the fact that lettering on plates was charged as a separate item.[127]

The few examples of Hullmandel's business dealings that have been traced have to do with private customers and institutions, but the major part of his work would have been with the leading print publishers of his day. Though he published *Twenty-four views of Italy* himself, he soon turned to professional publishing houses, initially to Rodwell & Martin, who announced a range of Hullmandel's lithographic works with the *Gentleman's Magazine* of 1820. Within a few years, however, he was also having his prints published by Rudolph Ackermann and J. Dickinson. The involvement of these three publishing houses with Hullmandel in the early years of his press can be seen on the wrappers (and correction slips to them) of a single publication, *Britannia delineata*, which is still in its original parts in the John Johnson Collection of the Bodleian Library.[128] Hullmandel also worked for John Murray and, in later years, for Longman and other major book publishers, as well as for some of the leading academic institutions, such as the Linnean Society, the Society of Antiquaries, and the Royal Institution.

Hullmandel's relationship with the leading lithographic draughtsmen of the period is less easy to pin down. It has been customary to refer to those who had their drawings printed by him as Hullmandel's draughtsmen, and in one sense it is not unreasonable to refer to T. M. Baynes, Denis Dighton, Maxime Gauci, James Duffield Harding, Francis Nicholson, George Scharf, and William Westall in these terms. But in another sense it may be misleading to do so. There is no evidence that these artists were in Hullmandel's employment, or even that they worked regularly at Great Marlborough Street. In this connection it is worth referring again to Hullmandel's letter to Matthew Gregson in 1820 in which he informed him that he was too busy to undertake a particular piece of lithographic drawing himself and went on to write 'I will procure an artist to do it, under my direction'.[129] Unfortunately, it is not clear whether this meant bringing in someone specially or putting the work out.

Even the draughtsman most closely associated with Hullmandel's establishment, his longstanding friend James Duffield Harding, should probably be seen as an independent figure who worked on a freelance basis. We have reliable evidence that it was not Harding's custom to do his lithographic drawing at Great Marlborough Street, at least not in the 1830s, though it is possible that he did so earlier on. Evidence for Harding's working practice is to be found in the autobiography of Daniel Fowler. Fowler's comments are particularly pertinent since, as a young man, he worked as Harding's pupil for three years in the studio at the back of Harding's house. Fowler would have had ample opportunity to observe his master at work and appears to have been a perceptive and responsible commentator. He had a lot to say about Harding as an artist and teacher, much of it none too complimentary, and wrote the following about his lithographic activities:

During my connection with him he had the following work under his hands – his drawing-book permanently; his 'Elementary Art, or the Lead Pencil advocated and explained', a large folio work with abundant lithographic illustrations all done

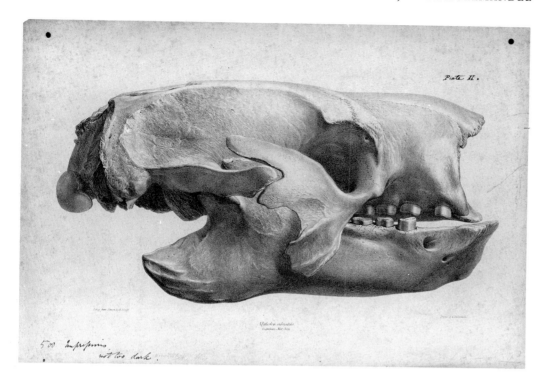

2.20 and 2.21 (detail)
GEORGE SCHARF
Mylodon robustus
lithographed from nature the
same size as the original,
with manuscript note '500
impressions not too dark',
printed by Hullmandel
image with letters 48.2 × 27.5
(detail 11.1 × 6.8)
University Museum, Oxford

2.22 and 2.23 (detail)
Title-page of Prout's
*Illustrations of the
Rhine* 1824
ornamental lettering
by an anonymous artist;
chalk-drawn vignette by
Hullmandel
printed by Hullmandel
page size 39.5 × 30.1
(detail 7.0 × 9.7)

solely by himself; and his 'Sketches at Home and Abroad'. . . . The whole of this mass of lithographic work must have been done by lamplight, for I never saw him at work on any of it in the day time. During all those hours he was fully employed on his drawings for two years of the 'Landscape Annual', some thirty or forty of them.[130]

The implication of this passage is that the stones for all this lithographic work were kept in Harding's studio. Though Fowler does not say so explicitly, the phrase 'for I never saw him at work on any of it in the day time' appears to be a careful way of saying that he would have seen Harding doing the work in his studio had he done it during the day.

Fowler's account puts an entirely different complexion on the Hullmandel-Harding relationship and seems to rule out the possibility that Harding worked on anything like a regular basis at Hullmandel's, at least in the mid 1830s, though it does not exclude the possibility of his having done so in earlier years.

The likelihood is that some draughtsmen did work at the Great Marlborough Street premises. Hullmandel regularly made drawings on stone there himself in the early years, and occasionally later on. When Hullmandel was engaged with other things, someone would have been needed on the spot to put artists' drawings on to stone for publication. Reproductive work of this kind played an important part in the business and it seems inconceivable that such regular and routine work would have been put out to studios. Bartholomew would have taken on some of this work before he turned to managing the establishment; so too might T. M. Baynes, Denis Dighton, Richard Lane, and George Scharf (2.20, 2.21), all of whom worked on a fairly regular basis for Hullmandel as original and reproductive lithographers.[131] Artists such as Prout and Westall, who did their own drawing on stone and turned to lithography less regularly than Harding, might also have worked at Great Marlborough Street. It is reasonable to suppose that they would have found it more convenient to work there than in their own studios, since lithographic stones are not the easiest drawing surfaces to move around. Moreover, they may have found it helpful to have the benefit of expert advice and to see their work proofed on the spot. We have also to remember that Hullmandel employed specialist ornamental letterers to produce title-pages and wrappers for the publications he printed (2.22, 2.23),[132] and other letterers (or perhaps the same ones) to produce the lettering of the imprints and titles of the prints themselves (2.24). Common sense tells us that most of these people, certainly those concerned with the lettering of imprints, would have worked at Great Marlborough Street. In addition, there may well have been lithographic assistants whose sole job it was to lay in straightforward areas of tone, such as skies, and, from the mid 1830s, to help with the production of tint stones.[133]

Harding may, therefore, have been a special case. He was doing work so regularly for Hullmandel that it would have paid him to gear his studio for such work, even to the extent of employing his own assistants. It may be significant that Fowler referred to Harding's *Elementary art* as done 'solely by himself', as if to suggest that he sometimes

2.24 Imprint of *St. Clement* from Prout's *Illustrations of the Rhine* 1824
4.0 × 9.5

used assistants. We should also remember that Harding had no great need to see proofs of his lithographs since he, more than most lithographic draughtsmen, knew precisely how they would look when printed – indeed, this predictability could be said to have been one of Harding's failings as an artist.

So when we refer rather loosely to Hullmandel's draughtsmen, we probably need to consider three categories of people: first, those who worked at Great Marlborough Street, principally as reproductive lithographers and possibly as Hullmandel's employees; secondly, those, most notably Harding, who had lithography as one of their special lines and had their own facilities for drawing on stone; and thirdly, those who worked less regularly as lithographers and, for a variety of reasons, preferred to work at Hullmandel's. Into this last category should be put the few great painter-lithographers whose drawings on stone were printed by Hullmandel, the most significant being Géricault (2.25).[134]

1.5

Hullmandel's improvements to lithography

It is no exaggeration to state that nearly every major improvement made to lithography in Britain in the first half of the 19th century, in terms of extending its range of expression, stemmed from Hullmandel; and many of them were significant in the context of European lithography too.

Hullmandel's improvements related primarily to those aspects of the process that concerned the artist, and in this respect they reflected his own interests and training. His attitudes were coloured by his early days as an artist and it is no coincidence that he called his book on lithography *The Art of drawing on stone*. Three other factors must have played their part in leading him to make the kinds of improvements he did. One of these, particularly early on, was his knowledge of what was going on in lithography in France and Germany. The second was his connection with Michael Faraday, who seems to have provided him with a kind of consultancy service on matters relating to the chemistry of the process. The third was his longstanding friendship and association

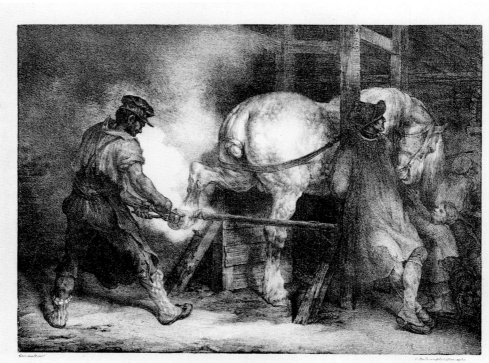

2.25 THÉODORE GÉRICAULT
The Flemish farrier
from his *Various subjects drawn
from life and on stone* 1821
printed by Hullmandel and
published by Rodwell & Martin
22.8 × 31.4
Felix Man Collection
Australian National Gallery,
Canberra

with Harding, which meant that he had a patient and highly skilled executant on hand to implement and help develop some of his ideas.

Some of Hullmandel's later improvements involved new or considerably changed methods of working on stone and can be dated with reasonable precision. But his first major contributions were more general. They had to do with demonstrating to artists that tonal images could be built up on stone with lithographic chalk by a careful system of hatching in such a way that they printed well.[135] The basis for this approach was provided by such early German lithographers as Joseph Hauber and Max Wagenbauer, who developed successful methods of chalk drawing long before Hullmandel and other lithographers set up their presses in England. Hullmandel began to explore methods of chalk drawing for himself in *Twenty-four views of Italy*; then he turned to instructing others in these methods and refining them himself. It may seem misleading to group such developments with Hullmandel's more technical improvements, since they had as much to do with his work as a publicist for lithography, but the changes to lithography he brought about in the early 1820s – and hence in attitudes to it – were as significant as any in the history of the process in Britain.

The approach to drawing on stone which Hullmandel developed in the early 1820s was dependent on the effective preparation of the stone and on the way it was printed. Such improvements are difficult to pinpoint. Nevertheless, it is clear from surviving accounts that Hullmandel provided artists with a service that gave them confidence that their images would print as they intended them to do, and that quality would be maintained over a print run. In his advice to those intending to draw on stone Hullmandel stressed that the artist should always ask 'Is what I have just done, drawn so as to print well?',[136] and it is obvious that he saw lithography as a process that required a sensitive relationship between draughtsman and printer. Lithographic printing called for more than the mechanical replication of an immutable image; it involved subtle modifications and presented opportunities for a degree of interpretation.

Hullmandel's skills as a printer and manager of printers were recognized by some of his clients, who commented on them when discussing the prevailing unreliability of lithographic printing. In August 1821 George Cumberland (Senior) referred to his own experience of such problems in a single-page note to *Scenes chiefly Italian by G. Cumberland*.[137] He wrote that the work was undertaken as an experiment '... to try how far the Lithographic mode of publishing Scenery would answer, as a substitute for Engraving'. He then went on to outline some of the difficulties associated with lithography and pointed to the superiority of Hullmandel's printing:

> ... we soon discovered that this art has been more boasted of than it deserved, and that there are continual accidents to which it is liable, that reduce the *certainty* of good impressions to about 150 [out of 300] only, especially where, as in this work, Pencil Drawings are desired to be closely imitated; for the finer the lines, the less certainty there is of clear impressions; and although it may so happen that hundreds may be taken from one Stone, you may in another find the ground torn up before you come to 50. Out of our small number of Prints, several blocks have failed at the first impression; sometimes because the chalk was too much burned, or too hard; sometimes because it was too soft, or the hand too hot when worked with. Again, if the Stone was too soft, or too coarse grained in preparing it; or if the acid used to clean the stone was too sharp or too weak; or even if too little warmed in the fixing process, or too much. And these accidents were found alike possible under the hands of all the most skilful printers of the day excepting in the workshop of Mr. Hullmandel: so that you can never make any work uniform, or be sure after three days labour, that your best drawing will not be spoiled in a minute; and this renders it a dangerous speculation for artists who get their bread by their labours.

This passage provides vivid testimony to the importance of a good printer and to the exceptional role played by Hullmandel, who printed the whole of the last number of

the publication. And Cumberland went on to claim that Hullmandel '... seems likely to bring this art to perfection, by his experience and unwearied assiduity.'

The superiority of Hullmandel's printing in the early days of lithography in Britain was referred to again in a similar context in a note to J. S. Paterson, *Sketches of scenery in Angus and Mearns* (c. 1824).

> As the *Printing* of Lithographic Drawings requires much skill and experience, and as it has only been a few years practised in this kingdom, there are comparatively few who may be properly said to be masters of the art. Although good impressions cannot be taken from a bad drawing, yet the best of drawings may be spoiled in the printing, so that the excellence of a work of this kind depends on the Printer as much as the Artist. Some of the drawings for this work, on which most labour was bestowed, have been the worst printed, and even whole impressions have been rejected, after being printed. And as some of the views which have been published, have had the sky and other delicate touches lost in the printing, – and being anxious that this work should be worthy of the distinguished patronage it has received, the Artist, after having tried two different Printers in Edinburgh, has gone to London, and made trial of two there also, who were reputed to be the most eminent. Without meaning any disparagement to any of them (all of whom he believes, will arrive at eminence in the profession), and without making any invidious comparison, he is, from the trial he has now had, inclined to abide by Hullmandel, in which opinion he finds he is supported by those of his Subscribers whom he has consulted.[138]

Hullmandel had begun to single himself out from the handful of other lithographic printers in Britain with the publication of *Roman costumes* (1820–21) and Belzoni's *Plates illustrative of the researches and operations in Egypt and Nubia* (1820–22). There can be little doubt that his ability to print chalk lithographs well, and particularly to maintain quality over a long print run, improved considerably in the early 1820s. In his letter to Matthew Gregson of 4 December [1820] already quoted he pointed to the effect different kinds of paper had on a print run and admitted that a chalk drawing would wear out after 500 impressions.[139] By about 1822, however, he had developed a special preparation for the stone – he called it his special facing – which improved its performance.[140] He did not announce this improvement until some years later, when he issued a pamphlet called *On some important improvements in lithographic printing* (London, 1827), but remarks in several publications which appeared in 1822 confirm that he first began using his special facing in that year.[141] The most informative of these remarks appeared in the *Gentleman's Magazine* in 1822, in connection with Harding's chalk lithograph *Netley Abbey* (2.26) which, according to the text, was printed by Hullmandel in an edition of some thousands:

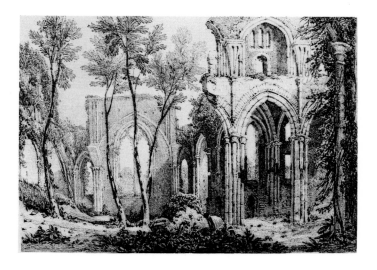

1827

Plate 7

J.D.Harding del.

Nº 1.
Landscape by Harding of which 500 were printed

Plate 8

J. D. Harding del.

Nº 2.
Nº 1 with alterations & additions of which 500 were also printed

Plate 9

J.D.H.

Nº 3.
Nº 2 again altered & of which 500 were also printed

The impression here submitted is one of some thousands, all equally good, taken from a single chalk drawing, by a new process invented by Mr. C. Hullmandel, of Great Marlborough-street. Mr. H. has tried the process on upwards of 30 drawings with equal success; thus establishing the important desideratum in Lithography, of multiplying copies to an almost indefinite extent, and at the same time ensuring the impressions being uniformly good.[142]

Hullmandel does not describe his special facing in any of his writings, and it was clearly his intention to keep it secret; but since claims had been made that the idea came from abroad, he called on Faraday and Harding to provide testimonials for him, which he printed in his 1827 pamphlet.[143] This in turn prompted a reply from John Coindet, of the firm of Engelmann, Graf, Coindet & Co., which is discussed below.

The other improvement Hullmandel announced in this pamphlet, but did not describe, was the facility with which he could make changes to a drawing on stone once printing had begun. He demonstrated his ability to do this with a remarkable set of examples drawn by himself, Harding, and Lane, each of which was printed in two states, and an even more startling set of three prints of a landscape by Harding in which the whole of the left foreground and middle distance was changed successively from a bridge with trees, to a rocky valley with houses and, finally, to a view of a lake (2.27).[144] The second alteration was made after 1,020 impressions had been taken from the stone, and Hullmandel rightly regarded this as something of a tour de force.

By 1827 Hullmandel had resolved most of the problems associated with making chalk drawings on stone and printing from them. Thereafter, he turned his attention to extending the range of effects that could be obtained in lithography. It is ironic that the process that had been heralded initially as an extension to drawing on paper and a means of multiplying an artist's sketches should have become, in the hands of Hullmandel and his associates, a fully-fledged process with its own graphic syntax. Already by the mid 1820s lithographic chalk drawing had come to require skills which were just as demanding in their own way as those required by the other graphic processes, and it had almost ceased to be a speedy sketching medium. Hullmandel must have recognized that his improvements had their drawbacks too, and it is greatly to his credit that he set about looking for easier, quicker, and more intuitive ways by which artists could produce tonal effects.

His searches for such methods are best studied in the St Bride Library album already referred to. They occupied him throughout the 1830s and included a host of ways of achieving tonal effects; in particular they led to the development of the stump style, an improved form of tinted lithography, and lithotint.

The first of these methods related to traditional drawing techniques; it was an extension of Engelmann's *lavis lithographique*, which Hullmandel used for a time and called the 'dabbing style'.[145] Hullmandel does not describe the stump style, but a short passage about it in an article on lithography in the *Transactions of the Society of Arts* attributes it to him.[146] The technique was used for covering large areas of a lithograph with an even tint and involved the use of a piece of leather glued to a strip of wood. This tool was then charged with lithographic chalk and applied to the stone, leaving small dark touches to be put in with the common artist's stump.

As in other lithographic methods, light areas could be reserved with gum arabic. It was not a technique that could easily be used on its own, and it was normally employed along with chalk drawing or on tint stones. Hullmandel must have developed the stump style some time in or before 1835, because the St Bride Library album contains several sketches produced by such means, one of which is described as 'Trial of the Stump style made in 1835'.[147] Harding must have been associated with these trials in some way since one of the sketches is described as a 'Trial of Stump style by Harding with Stopping' (2.28),[148] while under a pair of sketches there is the note 'One of these was sent to Mr Harding when in Devonshire in the Summer of 1835'.[149] These trials seem to relate to Harding's *Sketches at home and abroad* (London, 1836),[150] which Hullmandel printed in tinted lithography.

Trial of Stump Style by Harding with Stopping

2.28 J. D. HARDING
Experimental print from
Hullmandel's album of
experimental prints,
described as 'Trial of Stump
style by Harding with
Stopping'
printed image approx.
12.0 × 18.5
St Bride Printing Library

Tinted lithography itself was not at all new.[151] It became one of the accepted idioms of lithography almost from its outset and had been used for major publications in Germany even before Hullmandel set up his press. Some of Hullmandel's first lithographs were made in the tinted style in imitation of the prevailing fashion in Germany, and he continued to produce the occasional tinted lithograph throughout most of the 1820s. But Hullmandel's early use of tinted lithography was relatively crude; full lights in the tint stones were either reserved with gum or scraped away, and half-tone effects were simulated by a series of white lines drawn side by side. This was the approach recommended in *The Art of drawing on stone*[152] and which Richard Lane adopted in *Studies of figures by Gainsborough* (London, 1825); it provided the most effective application of tinted lithography in Britain in the 1820s (2.29). Even in Germany, however, where tinted lithography had developed to such an extent that several tint stones were used on a single print, very little was done in terms of producing genuine half-tone effects. Technical difficulties in the production of half-tones were clearly a factor limiting the popularity of the tinted lithograph in the 1820s. Tint stones had not kept up with advances made in the laying of tones in monochrome lithography and, consequently, had begun to look rather crude by the mid 1820s. But tinted lithography got a new lease of life in the 1830s as a result of Hullmandel's experiments.

It would seem from a study of the St Bride Library album that Hullmandel began the experiments which were to lead to the extended range of tones in tint stones as early as 1831, when he made eight small studies which are described as 'Trials of the Brush

2.29 RICHARD LANE
Tinted lithograph
from *Studies of figures by
Gainsborough* 1825
printed by Hullmandel
19.0 × 14.0
Reading University Library

2.30 *Right* Experiments in
producing variation in tone
on a tint stone
from Hullmandel's album
of experimental prints
page size 40.5 × 31.5
St Bride Printing Library

2.31 Detail of 2.30 showing
dry-brush work using a
reserve of gum arabic
7.8 × 11.2

2.32 J. D. HARDING
Remains of Holy Island
Cathedral
from *Sketches at home and
abroad* 1836
tinted lithograph
printed by Hullmandel
29.2 × 40.2
Felix Man Collection
Australian National Gallery,
Canberra

Style made in 1831'.[153] They are all printed in black, but they show considerable use of techniques of reducing the tone of a solid area by rubbing it down or scraping it away, which are similar to methods he applied on tint stones. Two examples in the album are acknowledged to be tonal experiments for tinted lithographs (though one of them is printed in black) because they are accompanied by the note 'Trial for producing variety of tint in a tint stone, which enabled Mr. Harding to produce his "sketches at Home & abroad" & established and introduced what has since been called, the tinted style in 1835' (2.30, 2.31).[154] In both these examples the tones were produced almost entirely in a negative way by reducing an overall tint. The pure lights were obtained by a combination of scraping and gumming out (some of it with vigorous dry-brush strokes), whereas the middle tones seem to have been produced by rubbing away the full tones with steel brushes and coarse cloth. Such techniques were also being used in France at much the same time, but were limited to black workings.[155]

The first publication to include examples of the use of the stump style and Hullmandel's new form of tinted lithography, Harding's *Sketches at home and abroad* (1836), was published by Charles Tilt in an edition of 1,000 copies (2.32). The tones of the tint stones in this publication are not nearly so adventurous as those in Hullmandel's experimental prints. Nevertheless, *Sketches at home and abroad* was greeted with approval and set the seal on tinted lithography; it began a fashion which swept the country and established a new idiom for lithography – or, more correctly, revived an old one – in Britain and France alike.

Sketches at home and abroad and many other publications of the 1830s and 1840s with tinted lithographs do not give the impression that there is much tonal work on their tint stones beyond what appears in skies. But a set of proofs of the tint stones of Thomas Shotter Boys's *Original views of London as it is* (London, 1842), which Hullmandel printed, reveals that this was not always the case.[156] Although in their published form Boys's lithographs may not suggest that they contain very much work in their tint stones,[157] when the tinted workings are seen on their own it is obvious that they do. These tint stones are similar in handling to some of the sketches in the St Bride

Library album and, though they provide an echo of the drawings in the black workings, they display a painterly freedom comparable to that seen in the colour-printed plates of Boys's *Picturesque architecture*. In the published plates of *Original views of London* the tint stones appear very light in tone, presumably because they would otherwise have conflicted with the rather crisp chalk work on the black stones.

The positive methods of building up a tone using dry-brush work or the stump style, and the negative methods of reducing an existing set of marks by rubbing and scraping away, were applied to tint stones much more than they were to black ones, which usually carried the principal part of an image. They did not therefore solve the problem that must have plagued Hullmandel for some years: how to provide artists, and principally water-colour artists, with a means of working on stone similar to that used when applying washes of varying strengths to paper. The process that went some way to satisfying this need – at least in principle – was lithotint, which Hullmandel patented on 5 November 1840. Lithotint has to be seen as the culmination of the programme of experimentation documented in the St Bride Library album, beginning with the brush sketches of 1831 referred to above.

In *The Art of drawing on stone* Hullmandel had argued that it was not possible to retain in printing the variation of tone that resulted from the dilution of lithographic ink in varying degrees.[158] The brush sketches of 1831 merely confirmed that this had not changed in the meantime. But by 1840 Hullmandel had found a method of working which enabled him to produce what he described in his patent as 'A new effect of light and shadow, imitating a brush or stump drawing, or both combined, produced on paper, being an impression from a plate or stone ...' (2.33).[159] Later he called this process lithotint, presumably to indicate that it was the tonal branch of lithography

which paralleled aquatint and mezzotint in intaglio printing.

Considerable confusion surrounds the process itself, which Hullmandel seems to have been at pains to keep obscure. His patent specification is not at all easy to understand and, partly I suspect because of this, an action was brought against him by Charles Hancock seeking an injunction for an infringement of his patent of 25 January 1838. The hearing in the Court of Chancery was completed on 21 August 1842 with judgement going in Hullmandel's favour.[160] All that needs to be said in this context about the actual process of lithotint is that Hullmandel developed a method of preparing drawings made on stone with washes of lithographic ink diluted to different strengths which made it possible to retain variation in the washes during the printing.[161] In a small publicity brochure issued by Hullmandel & Walton in connection with the Great Exhibition of 1851, lithotint is described as '... simply making Drawings on Stone with a liquid ink and brush ... which gives it [the drawing] all the freedom, feeling, and beauty of the original Drawing made on paper in Sepia or any other colour'.[162] But whatever the secret of Hullmandel's method, he provided artists with a means of working on stone in a way that came naturally to them, and so restored some of the freedom offered to an earlier generation when lithography was invented. In short, lithotint provided artists with the best means then available for making prints that looked like wash drawings.

Hullmandel's friend and collaborator, Harding, played a special role in the development of lithotint[163] and became by far its most skilful and prolific exponent. The *Dictionary of national biography* and *Allgemeines Lexikon der bildenden Künstler [General dictionary of pictorial artists]* edited by Thieme and Becker even credit Harding with its invention. Notwithstanding the protection of his English patent, Hullmandel may have feared that he might lose credit for the process.

One of the experimental plates in the St Bride Library album bears a note in Hullmandel's hand which attempts to make the contributions of the two men clear: 'Modification of Lithotint – invented by me put in practice by Harding in 1841. as above'.[164] Harding became the undoubted master of the process and was responsible for the first publication with all its plates produced by it, *The Park and the forest*

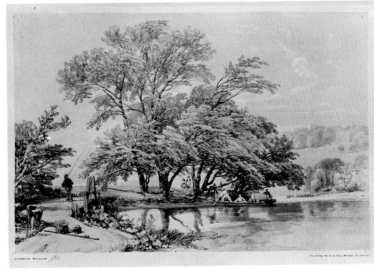

2.34 (detail) and 2.35
J. D. HARDING
Common willow
from *The Park and the forest* 1841
tinted lithograph
printed by Hullmandel using
his patent lithotint process
29.8 × 42.3
(detail 10.8 × 7.9)

(London, 1841) (2.34, 2.35).[165] This folio volume remains the best example of Hullmandel's lithotint process and the finest application of it in artistic terms. It consists of 26 plates, all in tinted lithography. The lithotint process was used for both the black and the tint workings, but no print was produced entirely by means of washes of ink. In some of the black workings it is hard to detect any wash work, but the technique was used much more liberally on the tint stones, which assume far more importance than hitherto in tinted lithography. The more audacious of these prints show the closest approximation to sepia wash drawing yet achieved in printmaking. Harding and others continued to use lithotint for topographical publications[166] and also for some scientific purposes. All such work appears to have been printed by Hullmandel.[167]

Hullmandel lost no time in protecting his process in France and in promoting it there.[168] He took out a French patent for 'Perfectionnemens apportés à la lithographie' on 6 February 1841 and in the spring of the same year he went over to France with specimens of the process. The reception there was none too enthusiastic, but a consequence of his visit was that the leading French printer of the day, R.-J. Lemercier, was prompted to experiment along similar lines. Unfortunately for Hullmandel, lithotint did not achieve the success he had hoped for; it clearly had some technical limitations and must have required a lot of care and attention both at the preparation stage and in the printing. But even more important than this, it required a great deal of skill on the part of the artist to assess the strengths of the washes on the stone. Hullmandel must have retained a special fondness for lithotint because, in his very short will, he mentions specifically that the patent rights to it should go, along with all his other assets, to his partner Walton.[169]

Hullmandel's last technical improvement to be discussed here – though not his latest in terms of date – was colour printing. His priority in Britain in this branch of lithography was referred to briefly in several early discussions of his achievements. For example, the obituary notice in the *Art-Journal* noted that 'His next application of lithography was to printing in colours by means of various stones, which he succeeded in perfecting seventeen years since, by producing a plate fac-simile of paintings in the interior of an Egyptian tomb, published by Messrs. Longmans of Paternoster Row.'[170] Seventeen years ago would have been 1834. These imprecise clues to Hullmandel's early involvement with colour printing have previously either not been spotted or trusted, but a few years ago, with no knowledge of these accounts, Bamber Gascoigne pointed to the priority of Hullmandel's colour lithography in Britain.[171] He demonstrated that the four double-page plates of paintings in Egyptian tombs which Hullmandel printed for G. A. Hoskins's *Travels in Ethiopia* (London, 1835) must be regarded as earlier than the few plates dated 1836 which Owen Jones printed for his *Plans, elevations, sections and details of the Alhambra* (London, 1842) and the plates printed by Day & Haghe for J. Wilkinson's *Manners and customs of the ancient Egyptians* (London, 1837). Coincidentally, therefore, he identified the publication referred to obliquely in the *Art-Journal* and elsewhere. Hullmandel's plates for Hoskins's book all carry the publication date 6 April 1835 and entries in the publisher's ledgers under June 1835 confirm that the latest possible date for their production would have been in that month.[172] The plates are not at all ambitious when compared with colour printing of the period in other processes, or even colour printing by lithography produced earlier on the continent, but they are important in the context of British lithography. Most copies of Hoskins's book appear to have hand colouring on all their plates, but one copy in the Grenville Collection of the British Library has its plates printed in colour throughout. The number of workings on each plate varies between six and eight; they are all printed in flat areas of full tone with hardly any overprinting. Bamber Gascoigne has suggested that Hullmandel turned to colour printing for *Travels in Ethiopia* because it was preferable to hand colouring, but it was some time before he printed plates in colour for another important publication.

When he did so, however, he had a hand in the production of one of the landmarks

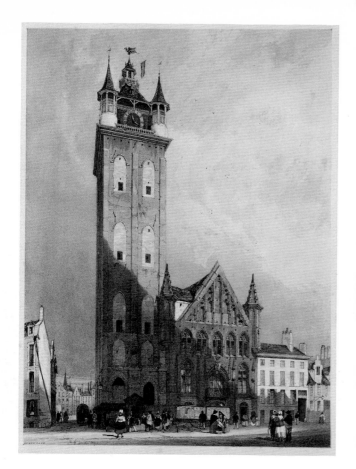

ol. pl. 1 of 19th-century colour printing: Thomas Shotter Boys's *Picturesque architecture in Paris, Ghent, Antwerp, Rouen &c.* (London, 1839) (2.36, 2.37).[173] In the meantime, Hullmandel's long-standing competitor, Godefroy Engelmann, had patented *chromo-lithographie* in France in 1837,[174] and shortly afterwards produced his *Album chromo-lithographique ou recueil d'essais du nouveau procédé d'impression lithographique en couleurs [Chromolithographic album or collection of experiments in the new process of lithographic printing in colour]* (Paris and Leipzig, *c.*1838). The significance of Engelmann's improvement was that he abandoned the use of numerous flat areas of colour which did not interact with one another, and instead broke up the component colours of an image so that they produced a wider range of colours by optical mixing. Hullmandel must surely have known of Engelmann's patent. Apart from anything else, his use of the word 'chroma-lithography' in Boys's book is so similar to Engelmann's 'chromo-lithographie' as to suggest some influence. But it could be argued that Hullmandel's use of flat areas of colour in *Travels in Ethiopia*, along with his tonal experiments in tinted lithography in the mid 1830s, would have led him sooner or later to a similar approach to Engelmann's.

Picturesque architecture was an audacious undertaking which leaves Engelmann's collection looking somewhat pedestrian, as may have been the intention. Although it did not treat the problem of colour separation in quite such a systematic way as Engelmann's *Album chromo-lithographique*, it showed how a limited number of colours printed in different tones could be harnessed to achieve a variety of effects without loss of freshness. The descriptive notice in the volume explained that the publisher stipulated that there should be no hand colouring and that '. . . every touch is the work of the Artist, and every impression the product of the press.' Whether credit for *Picturesque architecture* should go primarily to the artist or the printer is open to debate, but it is clear that the undertaking could not have got off the ground, let alone succeed to the extent that it did, without the full backing of a skilled and well-managed

2.36 *Above left*
THOMAS SHOTTER BOYS
The Belfry at Ghent
from his *Picturesque architecture in Paris, Ghent, Antwerp, Rouen &c.* 1839
printed in colours by Hullmandel
25.0 × 38.4
Felix Man Collection
Australian National Gallery, Canberra

2.37 Detail showing variation of tone in several of the workings
11.8 × 9.6

col. pl. 38

workshop. It would also have been inconceivable but for the experiments in producing tonal variations on tint stones which Hullmandel undertook during the 1830s.

Although Hullmandel did little to promote colour lithography thereafter[175] and, as far as I know, never wrote about it, he stands at the beginning of its development in Britain and made a marked contribution to it in a European context through *Picturesque architecture*. What is perhaps odd is the absence of colour experiments in the St Bride Library album and the apparent rejection of colour lithography by Harding, who had been involved with all Hullmandel's other developments in making drawings on stone.

Publicist and protagonist

The revival of British lithography, which began hesitantly a few years after peace was established on the continent following the Napoleonic wars, was led by the German-born printseller and publisher Rudolph Ackermann. The first productions of Ackermann's lithographic press appeared in January 1817, and within a year he used the process in his journal the *Repository of Arts* and included an account of it there.[176] All this was more than a year before Hullmandel set up his press. Ackermann was responsible for the first lithographic productions to attract much public attention in Britain, and he then gave the process a tremendous boost with the publication of an English translation of Senefelder's treatise, *A complete course of lithography* (London, 1819). But though Ackermann deserves credit for the initial promotion of lithography in Britain, Hullmandel soon assumed his mantle and became the leading publicist for the process for a couple of decades.

Hullmandel's promotion of lithography was combined – with varying degrees of subtlety – with that of his own establishment, and cannot by any stretch of the imagination be described as disinterested. Even his collaboration with Faraday in explaining lithography at the Royal Institution must have been a useful public relations exercise. In his later years he was centrally concerned with the interests of his own firm, but even his early writings and actions reveal his awareness that the promotion of lithography and of his own press went hand in hand. We have evidence of his very early concern to promote himself in the communication he addressed to the Society of Arts in February 1819 to accompany his *Twenty-four views of Italy* and some other lithographs.[177] Although he began by drawing attention to the advantages of lithography generally, the substance of the statement revolved around his own contribution to it and he refrained from referring by name to Moser & Harris (or Francis Moser), who printed some, if not all, of the lithographs he submitted. Hullmandel was an eloquent writer and must have been genuinely enthusiastic about lithography. But he was also an astute businessman who took every opportunity to advertise the improvements he had made to the process and to defend his position vigorously when he felt his interests were at risk.

Hullmandel's best known and most influential publication is his book *The Art of drawing on stone*, which was first published in 1824 and ran to two further editions in 1833 and 1835.[178] But in terms of establishing lithography in Britain, his translation from the French of a treatise by Raucourt de Charleville was probably just as important. Colonel Antoine Raucourt was chief engineer at the Ecole des Ponts et Chaussées in Paris and ran its in-plant lithographic press.[179] His book was originally published in Toulon in 1819, with the title *Mémoire sur les expériences lithographiques faites à l'Ecole Royale des Ponts et Chausées de France; ou manuel théorique et pratique du dessinateur et de l'imprimeur lithographes*. In his translation, Hullmandel had the sense to reverse the two parts of the title, so that it read: *A Manual of lithography, or memoir on the lithographical experiments made in Paris, at the Royal School of the Roads and Bridges* (2.38). It was published by Rodwell & Martin in 1820, with its translator's preface dated 10 December 1819. Hullmandel thought highly of Raucourt's treatise – as did several other lithographers – and said that he was prompted to translate it because he had met many of the difficulties referred to by the

2.38 Title-page of Antoine Raucourt, *A Manual of lithography*, 1820, translated into English by Hullmandel from the French edition of 1819
page size 20.8 × 12.2
Felix Man Collection
Australian National Gallery, Canberra

author and found himself in need of a guide of the kind Raucourt had written. Compared with Senefelder's treatise, which was published in the previous year, Raucourt's book had the great merits of clarity and brevity. Hullmandel seems to have had Senefelder's treatise in mind when writing in his preface to the translation:

> The books which have hitherto been published on lithography are very imperfect, and are much more adapted to persons who already understand the art than to those who wish to learn it: they explain, it is true, the different styles to which lithography may be applied, and the preparation of the chalks, inks, and stones, but give no clue to the labyrinth in which a beginner is soon bewildered, when he once attempts the practical part of printing from stone.[180]

In choosing to translate Raucourt's book, Hullmandel showed sound practical judgement. He wrote in his preface that he was confident that he was '... forwarding the progress of this new and highly useful art, and saving to those who wish to study and practise it much trouble and loss of time.'[181] His confidence seems to have been fully justified because the book ran to two further English editions in 1821 and 1832.

This is not the place to discuss the content of Raucourt's book, except to state that it covers the whole subject of lithographic drawing and printing. In later years Hullmandel came to regard it as complementing *The Art of drawing on stone*, in which he had written exclusively about lithographic drawing. In this respect it is worth noting that when he sent the shipment of lithographic materials to Van Diemen's Land in 1830, both books were included;[182] and when he brought out a smaller-format edition of *The Art of drawing on stone* in 1835, he commented that 'It now corresponds in size with the "Manual of Lithography;" a work which is to the printer, what this treatise is to the draughtsman.'[183] For all this, the part of Raucourt's treatise that deals with drawing on stone bears some resemblance to what Hullmandel wrote a few years later in *The Art of drawing on stone* and must have had some influence on it.

When Hullmandel came to write his own book (2.39, 2.40, 2.41), which was

2.39 *Below left* Lithographed boards of Hullmandel's *The Art of drawing on stone*, 1824, printed black on what was originally pink paper overall size 28.5 × 19.4 Reading University Library

2.40 Lithographed title-page of Hullmandel's *The Art of drawing on stone* 1824 page size 27.0 × 17.0 Reading University Library

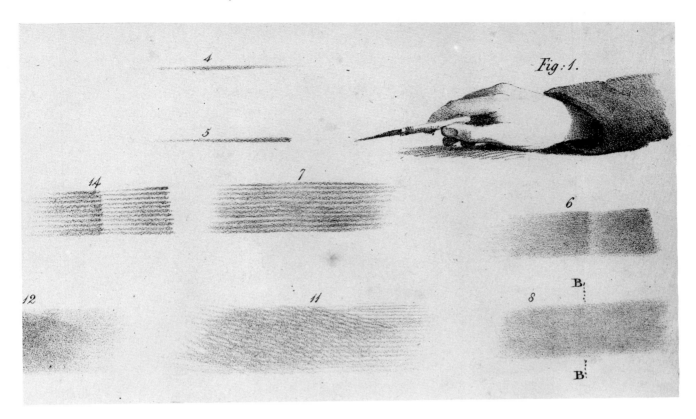

2.41 Detail of plate II of Hullmandel's *The Art of drawing on stone*, 1824, showing the basic elements of his method of building up tones in chalk lithography (7.5 × 12.5). Figures 4, 7 and 8 show the recommended methods, figures 5, 14 and 6 those that were not.
Felix Man Collection
Australian National Gallery, Canberra

published in 1824, there can be little doubt that his objectives were fairly clear. His press was well established by this time and he and other artists working with or for him had already developed effective ways of drawing on stone. He must have had two complementary aims in mind. First, of course, he wanted to describe methods of drawing on stone in such a way that artists would be encouraged to turn to lithography in the knowledge that their drawings would turn out well. He made this point twice in different parts of his introduction and wrote that most failures arose from the draughtsman '... not attending sufficiently to those minute precautions which are necessary to ensure success',[184] and that '... there are certain rules and precautions to follow, without which there can be no good impressions.'[185] But secondly, and probably just as important, he was establishing himself as the premier lithographic printer of artists' drawings in Britain and was therefore addressing potential customers. Hullmandel concluded his book with a section on the packing of stones (2.19) so as to avoid damage in transit (a topic that would have been of interest to likely customers), but he described none of the procedures in lithography that would have been the concern of the printer. For example, he made no reference to the grinding of stones, the preparation of the drawing on stone prior to printing, or the printing process itself; he did not even describe the press. It could be argued that these points were adequately covered in Raucourt's treatise, but so too was drawing on stone. Though Hullmandel touched on the drawing of maps, book wrappers, technical drawing, and the transfer of writing and copper plates, he was mostly concerned with telling pictorial artists how to draw on stone, particularly with lithographic chalk.

Hullmandel's book embodied his own experience over six years as an artist and printer, together with what he had learned from the artists who worked with him, especially Harding. It reveals a strong influence of Engelmann's *Manuel du dessinateur lithographe [Lithographic draughtsman's manual]* (Paris, 1822), particularly in its design and choice of illustrations, and Hullmandel's debt to Engelmann was specifically acknowledged in connection with the latter's *lavis lithographique*, which he described and called the dabbing style. Although *The Art of drawing on stone*

covers a range of methods, Hullmandel followed Raucourt and Engelmann in concentrating on planographic aspects of the process rather than those methods of imitating other processes that had seduced Senefelder and some other early writers on lithography. The book's main interest for us today lies in its careful description of a systematic way of laying in tones with lithographic crayon, which influenced a whole generation of lithographic draughtsmen. Its text and pictures provide a model of what today would be called technical writing, though Hullmandel found it necessary to apologize 'for the apparently childish minuteness' with which he described things, and for leaving 'nothing unexplained'.[186]

In his lengthy introduction Hullmandel was able to adopt a different tone and to air his views on broader matters relating to lithography. Here he emerges as a forceful champion of lithography, defending it vigorously from the attacks of its critics, including 'several painters of eminence'.[187] In his defence of lithography he returned to the very familiar claim that 'A lithographic impression is not even a fac-simile . . . but the original drawing itself.'[188] He pointed out that since the process was entirely chemical it was open to innumerable improvements, and referred to some that had already been made:

> Let the early productions, given four years back, be compared with what is now done, and I am certain that every impartial judge will say, that the Art has made gigantic strides in that short space . . .[189]

But despite this progress – which modesty forbade him to claim any credit for – he contrasted the state of lithography in Britain with that in France, where he held that it met with a degree of encouragement quite unknown in his own country. In particular, he pointed to the lack of encouragement from the British Government, which went so far as to impose a duty on the import of lithographic stone for three years and then, when they did lift it, also reduced considerably the duty on foreign prints '. . . thus throwing into the hands of the French an immense trade'.[190] In France the attitude to lithography was different, he claimed: there, instead of being despised and abused by talented artists '. . . men of real merit have taken it in hand, have perceived at once the immense advantages which it offers to persons of ability', and have '. . . produced such specimens, as must astonish all those who see them'.[191] Hullmandel was, as Daniel Fowler pointed out, a man of acute aesthetic judgement; he must have been fully aware that, despite all his efforts, the best artists in Britain had not turned to lithography – including the greatest of all, Turner, with whom he was later to be on social terms.[192]

Hullmandel's flair for seeing how things fitted together in his overall scheme for promoting his own establishment is evident from his involvement with drawing books. From 1822 he worked as a lithographic draughtsman and printer for a series of drawing books which was published first by Ackermann and then by Dickinson, originally with the title *Ackermann's lithographic drawing book*. But by 1827, though Dickinson remained the publisher, it had become *Hullmandel's lithographic drawing book* (2.42).[193] Although we may be inclined to interpret this change as a clear acknowledgement of Hullmandel's growing reputation, he must have seen it as a further way of steering potential artists in the direction of his own establishment. His treatise and the series of publications with the title *Hullmandel's lithographic drawing book* should therefore be seen as complementing one another in the business of encouraging artists to associate his name with the printing of artists' lithographs.

By the mid 1820s Hullmandel had achieved considerable success in promoting the work of his own establishment and, partly as a consequence of this, he began to find himself under attack. Thereafter, his approach to publicity appears to have become more single-minded and – to use a modern marketing cliché – aggressive. After having overshadowed the lithographic presses of Ackermann, J. Boosey & Co., N. Chater, and Rowney & Forster – his major competitors in the field of pictorial lithography in London in the early 1820s – he came up against more serious competition from the branch company set up in London by his major rival in Europe, Godefroy Engelmann.

2.42 Plate 48 of *Hullmandel's lithographic drawing book*, 1827, drawn and printed by Hullmandel page size 18.0 × 26.0

The firm Engelmann, Graf, Coindet & Co. was established in 1826 and seems to have engaged in attempts to undermine Hullmandel's hitherto unchallenged position as the leading lithographic printer in Britain.

In 1827, Hullmandel first published his misgivings about the kind of campaign he felt was being waged against him in his pamphlet *On some important improvements in lithographic printing*. He was in no doubt that the source of the opposition was Engelmann's branch company in London, because his pamphlet begins as follows:

> A Foreign Lithographic Establishment, lately settled in this country, having held forth to the public that they possessed an advantage peculiar to themselves, viz. the power and possibility of RETOUCHING, I have been induced, for the last six months, to turn my whole attention towards obtaining also that advantage.[194]

Though Hullmandel could not quite bring himself to mention Engelmann's company by name, he was honest enough to concede its priority over the question of retouching. But he took a much firmer line over allegations that had been made about his method of preparing drawings for printing:

> A plan has been adopted, with a view to injure me, of spreading false reports concerning my establishment; and, as an attempt has been repeatedly made to impress persons with an idea that it was not true that I had a mode of preparing drawings peculiar to myself, I am obliged, much against my will, to speak in my own favour; and, in addition to the proofs which I give in this pamphlet, of the possibility of retouching, to add testimony of such respectability, with regard also to my mode of preparing, as will silence those who are doing all they can to harm me.[195]

Hullmandel tried to counter the 'false reports' by including testimonials from Faraday and Harding supporting his claims to a special method of preparing drawings, and two more general and unsolicited letters of recommendation from Baron Taylor, the sponsor of *Voyages pittoresques et romantiques dans l'ancienne France*.[196] And he demonstrated beyond doubt that he had not been left behind in the battle to accomplish retouching by including the demonstration plates referred to above.[197]

A further challenge came from T. Crofton Croker, writing anonymously in the

Foreign Review in 1829, who pointed out that Hullmandel had spent several months working under Engelmann in Paris and, up to 1826, had contributed annual sums for the communication of Engelmann's improvements.[198] Hullmandel felt that Croker was using this information to undermine his position as the leading lithographic printer in Britain and replied in the same year with an eleven-page pamphlet countering Croker's allegations.[199] In it he acknowledged the arrangement he had come to with Engelmann in 1821, but revealed the identity of the author of the article in the *Foreign Review* and his close connection with Engelmann's branch company.[200] His main concern seems to have been to deny Croker's claim that Engelmann had been the first to come up with a special facing for stones.[201] In support of his position he reprinted the testimonials he had received from Faraday and Harding in 1827.

In turn this led to the publication in the *Literary Gazette* of a rather ill-considered letter, dated 16 September 1829, from John Coindet, the manager of Engelmann, Graf, Coindet & Co. In particular, Coindet maintained that Hullmandel had learned about a special facing for stones from Engelmann as part of the arrangement between the two men.[202] Hullmandel demolished Coindet's arguments in a reply which was published the following month. He was prepared to concede that Croker was not a partner in the firm of Engelmann, Graf, Coindet & Co. and apologized for his error, but he maintained his general position by asserting that 'Mr. Coindet well knows that at no distant period Mr. Croker was not very far from being received as one'.[203]

It may have been the competition presented by Engelmann, Graf, Coindet & Co. which led Hullmandel to try to broaden his markets by taking on different kinds of work, and in April 1829 he issued a set of specimens to accompany a circular letter addressed specifically to publishers, architects, and surveyors.[204] In their subject matter the specimens are all illustrations that might appear in a scholarly publication. They were all drawn with very fine lines in pen and ink, and one of a Greek vase was printed in black and terracotta. The circular letter stressed their clearness and sharpness, the moderate prices charged, and the number of good impressions that could be obtained – in effect, everything the editor of an academic journal would have asked for. It comes as no surprise that copies of this set of specimens were sent to the Royal Institution and the Society of Antiquaries, where they still survive.[205] It was not new for Hullmandel to seek work from scholarly institutions, but he may well have been spurred on to find more of it by Engelmann's efforts to attract the attention of the same market.[206] A few plates of a technical kind were included in *The Art of drawing on stone*, but the set of specimens Hullmandel issued in 1829 suggests some change of emphasis in the kind of work he was prepared to do.

A decade or so later Hullmandel was involved in two further disputes concerning his contributions to lithography, both of which had a thorough airing in the pages of art journals. The first concerned the relative roles of Hullmandel and Thomas Shotter Boys in the production of the remarkable colour plates of *Picturesque architecture in Paris, Ghent, Antwerp, Rouen &c.* The dispute took place in the *Probe* in the early months of 1840, following extensive notices of the publication.[207] The tone of the correspondence was altogether more gentlemanly than that of the dispute Hullmandel had with Engelmann, and the two protagonists appear to have remained on good terms. The discussion should have hinged on the relative importance of the role of the artist in making the colour separations and the printer in mixing the inks and controlling production, but Hullmandel was sidetracked into a rather pointless defence of his position as the inventor of the stump style.[208]

Hullmandel found himself under threat again with Charles Hancock's application for an injunction to restrain him from using his process of lithotint. In the course of the court hearings in 1842, affidavits were presented on behalf of both sides: those for Hullmandel included Boys, Brockedon, Faraday, Haghe, Harding, one of the Gauci family, Scharf, Stanfield, and Walton. In support of his case Hullmandel prepared a Harding drawing by means of the lithotint process and took a print from the stone in court. The *Art-Union* records the occasion in the following terms:

2.44 *Opposite* Buy a broom!
lithographed title, *c.* 1823,
with chalk-drawn vignette
by Maxime Gauci and
lettering by the artist with
monogram RB.
printed by Hullmandel
c. 1823
overall size 33.0 × 23.0

Much curiosity was excited in court by Mr. Hullmandel producing a lithotint drawing made by Mr. Harding, and subjecting it to the process described in his specification, in presence of Sir Launcelot Shadwell, to whom an impression, taken at the moment, was presented; on which his Honour wittily remarked, that this was a new kind of 'drawing in equity.'[209]

Whether the court was swayed by this demonstration or not, judgement went in Hullmandel's favour. But that was not the end of the story. In response to its report of the case, the *Art-Union* received letters from people either claiming the invention for themselves or that brush drawings had been produced on stone many years previously. Hullmandel reacted with a convincingly argued response which, following the example of his earlier pamphlets, included some testimonials.[210] The *Art-Union* was able to print only a few of these, but they are of some interest because they provide an insight into Hullmandel's range of connections. Among those who supported him were King Louis Philippe of France, the King of Bavaria, the King of Prussia, and distinguished lithographers and publishers from abroad. Hullmandel had no need to call on any British lithographers, since many had supported him in court. By contrast, Hancock, who was given the right of reply by the journal, simply provided the affidavits of some of those who had supported him in court: the wood-engraver Landells, the lithographic draughtsman Thomas Fairland, and two lithographic printers, Jeremiah Graf and William Day.[211] Jeremiah Graf was a member of the family that had earlier formed part of the firm Engelmann, Graf, Coindet & Co., and was running his own lithographic business; William Day managed the lithographic firm of Day & Haghe, which presented the principal commercial competition to Hullmandel in the 1840s. The affidavits of these two printers did little to support Hancock's case and reveal that they had not understood Hullmandel's process, which may suggest that they had ulterior motives in agreeing to testify against him.

Hullmandel's pamphlets, together with the letters he wrote to the *Literary Gazette*, the *Probe* and the *Art-Union*, show that he was not prepared to have taken from him what he regarded as his rightful dues. On each occasion when he felt himself unfairly treated he responded vigorously and revealed considerable skills in marshalling his arguments. But though he pulled no punches, as far as can be told from this distance in time, he appears to have been punctilious in his respect for the truth.

His range of work

Most of Hullmandel's work that has come down to us, particularly that for which he is best known, can be described as picture printing. Some of the pictures he printed were published in parts and may have been bound up in volume form, with or without accompanying text. But when found singly, as they often are today, they are taken to

2.43 Folding map
from E. Boys, *Narrative of a
captivity and adventures
in France and Flanders* 1827
drawn by Valentine
Bartholomew and printed by
Hullmandel
page size 19.0 × 11.5

be individual prints. Pictorial work was undoubtedly the mainstay of his establishment[212] and there is no reason to question the spirit of what he wrote in 1829 when supporting his claim that Harding should be considered the major lithographic artist of the day:

> I wish it to be understood that I am only speaking of Lithography as far as it concerns the production of real works of art, for I care little whether Lithography has been used for maps and writings for ten years past, or for twenty.[213]

Nevertheless, Hullmandel's establishment did take on jobbing work of a kind that might be classed with maps and writings;[214] it also took on the printing of routine illustrations for book and journal publishers. Very little jobbing work that Hullmandel printed seems to have survived, though this does not tell us much about the amount he printed because such work is not usually preserved for long. However, the number of surviving illustrations he printed for ordinary trade books and academic journals suggests that this kind of work was common enough in his establishment (2.43).[215] For example, in the early days of his establishment he printed the large synchronistic chart already mentioned, 'Chronology of England from the Conquest',[216] which is a carefully lettered piece of work set out in tabular form. Hullmandel also printed some covers to popular sheet music in the 1820s, including the item composed by his sister (2.12) and others lettered by an artist with the monogram RB (2.44).[217] Bearing in mind his connections with the world of music, it is hardly surprising that he undertook such work from time to time; but, as far as I know, he did not print any music itself.[218] Music covers were, of course, no more than an extension of the kind of work his establishment undertook regularly for the wrappers and title-pages of the collections of pictorial lithographs that he printed, some of which are works of art in their own right. The publicity item Hullmandel printed for Géricault in 1820 in connection with the exhibition of *The Raft of the Medusa* in London, falls into a similar category.[219]

From time to time, however, Hullmandel must have taken on work that was more obviously commercial in spirit. In *The Art of drawing on stone* he devoted a short section to the production of wrappers for books[220] and described how light marks could be produced against a dark ground by drawing on stone with gum arabic. This was the technique he used for the decorated boards of his own treatise (now faded but originally either blue or salmon pink); he used it again for the wrappers of Bohte's *Catalogue of books* (London, 1824), which followed a similar idiom and were printed on green paper (2.47).[221] He must also have made use of the technique of transferring images from copper plates, which he referred to in his treatise as advantageous when long print runs were needed.[222] He used this technique for his own invoices (2.17, 2.18)[223] and for the very routine illustration which serves as the frontispiece for the first volume of *Memoirs of Marmontel* (2 vols., London, 1826) and bears the unusual imprint 'Transferred from Copper & Printed from Stone by C. Hullmandel'. Hullmandel was also responsible for printing maps and plans of the kind he was so scathing about, though they seem to have been mainly for publications for which he printed other kinds of illustrations as well. What is more, he is known to have printed such ephemeral items as tickets and cards.[224] The most delightful example of Hullmandel's jobbing printing I have traced is a ticket for a performance of 'Extempore poetry', to the accompaniment of music by Mr Philipe Pistrucci (2.45).[225] The ticket, which cost as much as 10s/6d, was drawn in chalk lithography by Pistrucci himself. But since the performance included songs which were to be sung by, among others, Hullmandel's friend Garcia,[226] we probably have to assume that this ticket was regarded as a rather special job.

Hullmandel's establishment also printed one of the most notable examples of a book printed throughout by lithography in the age of the hand press: Edward Ryde, *Ryde's hydraulic tables* (London, 1851) (2.46).[227] The book was printed by Hullmandel & Walton in the year following Hullmandel's death (the preface is dated 1 May 1851), but it may well have been planned and even under way before he died. It is an

2.45 *Opposite top* Ticket for *Mr Philipe Pistrucci's performance of extempore poetry*, in the Argyll Rooms, 23 June 1824. Lithographed by Filippo Pistrucci and printed by Hullmandel. John Johnson Collection, Bodleian Library

2.46 *Opposite below* Double-page spread from Edward Ryde, *Ryde's hydraulic tables* 1851 Whole book drawn in Ryde's office by J. M'Nevin on zinc plates and printed by Hullmandel & Walton lithographically page size 24.0 × 15.0

extraordinary book both in design and production, and its imprints state that it was 'Drawn upon zinc' in the offices of the author, and 'Printed from the zinc plates at The Lithographic Establishment of Hullmandel & Walton'. This is one of the few recorded examples of the use of zinc plates by Hullmandel's establishment.

These few items suggest that the activities of Hullmandel's press were somewhat wider than either historians of lithography or even Hullmandel himself would have us believe. And they allow us to see another side of his activities that should not be ignored.

Though Hullmandel's whole life may have revolved around lithography, and particularly pictorial lithography, he had other interests too. His sociability and involvement with musicians, actors, and artists of distinction have already been noted; but we should remember that the same inventive mind that found expression in the many technical improvements he made to lithography, also found outlets in other directions. One of his obituary notices made this point in the context of the forthcoming Great Exhibition:

> But at the Exhibition there will be other fruits of the inventive genius of Hullmandel besides those furnished in lithography. The marble earthenwares, which will be shown by the Messrs. Copeland, and the calicoes printed from copper rollers, with what is technically termed granite grounds, are the fruits of discoveries patented by Hullmandel.[228]

And on a rather more domestic level, he invented a new razor strop, which was announced in the pages of the *Builder* in the year of his death.[229]

This may seem a trivial way in which to bring to a close an account of the major figure in British lithography in the first half of the 19th century and, possibly, the most important British printer of artists' lithographs of all time. But it has the value of drawing attention to the fact that Hullmandel's more obvious qualities – his keen intelligence, artistic sensibilities and skills and personal ambition – were underpinned by a restless curiosity and a down-to-earth concern for practicalities.

2.47 Lithographed wrappers of J. H. Bohte, *Supplement to a catalogue of books in English literature* 1824 printed by Hullmandel in black on green paper page size 21.5 × 13.5 John Johnson Collection, Bodleian Library

3 Manet's illustrations for 'The Raven':

Alternatives to traditional lithography

Jay McKean Fisher

For most artists, original and reproductive prints existed side by side, and for artists like Degas and Manet polemical separations were irrelevant to their artistic goals.

THE growth in artistic printmaking in France in the mid 19th century is now well-known, but relatively little attention has been paid to the technical revolutions in the printing industry during the same period. Far too many art historians have relegated these developments to the category of industry and craft, though it is hard to imagine students of 19th-century prints who have not encountered untraditional print processes. Research has suffered too often from a preconceived view of artistic originality according to which new technologies and work intended for mass distribution have been segregated from more individualized artistic production. Most discussions of 'originality' grew from the study of etching, where this narrow view of original printmaking made refugees of even such important objects as Manet's etchings, which were most often interpretations of his own paintings. For most artists, original and reproductive prints existed side by side, and for artists like Degas and Manet polemical separations were irrelevant to their artistic goals.

The 19th century saw the development not only of lithography and photography but also of a wide range of new printing technologies evolving from them, which together brought about the most significant changes in the printing industry since the 15th-century invention of movable type. Interrelated artistic and commercial uses of these new technologies were present from the first, though most art historical writing appears to restrict artists' 'original print' output to works produced by purely manual print processes. Some prominent exceptions clearly indicate the direction for fruitful research and, not surprisingly, studies of lithography have been in the forefront.[1] Important references to broader technical questions have been made in general historical surveys of the 19th century[2] but these bring us only to the threshold of the systematic research that must now be undertaken.

In my catalogue of Manet prints[3] I suggested that all of the prints traditionally identified as 'autographies' might be gillotages rather than transfer lithographs, the more usual interpretation of the term 'autographies'. Gillotage is a relief print process from a metal plate,[4] while transfer lithographs are printed planographically from stone or plate. The transfer process was described in an 1818 treatise by the inventor of lithography, Aloys Senefelder, whose work was translated into French the following year.[5] That this suggestion concerning autography stimulated five critical responses – two by Pat Gilmour, two by Antony Griffiths, and one by Barbara Shapiro[6] – provides an instructive illustration of the limitations of past research and a clear statement of priorities for future investigation concerning the prints of Manet and his contemporaries. The debate centred on Manet's six illustrations for Stéphane Mallarmé's translation of Edgar Allan Poe's *Raven* (3.1–5, 3.16). Along with the five other 'autographies' catalogued by Marcel Guérin[7] these illustrations heralded either a new

3.1 *Below* ÉDOUARD
MANET
Ex libris (Raven in flight)
for *Le Corbeau* [*The Raven*]
by Edgar Allan Poe,
translated by Stéphane
Mallarmé
Paris 1875
transfer lithograph?
image: 6.0 × 24.2; sheet:
12.3 × 28.6
edition 240?
Felix Man Collection
Australian National Gallery,
Canberra

3.2 *Right* ÉDOUARD MANET
Poster for *Le Corbeau*
[*The Raven*] by Edgar Allan
Poe, translated by Stéphane
Mallarmé
Paris 1875
transfer lithograph?
letterpress text
sheet: 53.2 × 36.2
edition 240?
Felix Man Collection
Australian National Gallery,
Canberra

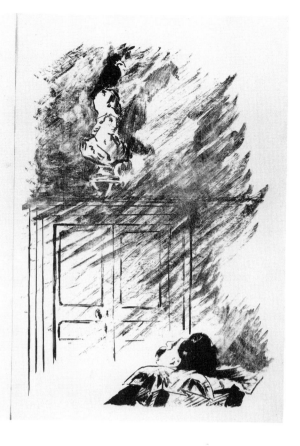

3.4 ÉDOUARD MANET
'Perched upon a bust of Pallas
...' (Raven on bust)
double-page spread from
Le Corbeau [*The Raven*]
by Edgar Allan Poe,
translated by Stéphane
Mallarmé
Paris 1875
transfer lithograph?
letterpress text
image: 48.0 × 32.0;
spread: 54.4 × 72.6
edition 240?
Felix Man Collection
Australian National Gallery,
Canberra

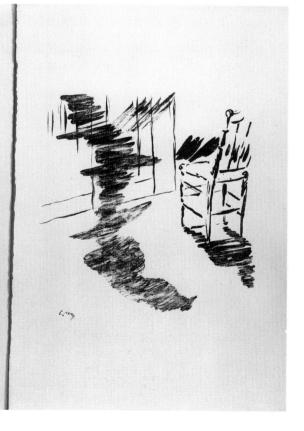

3.3 *Opposite bottom*
ÉDOUARD MANET
'Once upon a midnight
dreary ...' (Under the lamp)
from *Le Corbeau* [*The
Raven*] by Edgar Allan Poe,
translated by Stéphane
Mallarmé
Paris 1875
transfer lithograph?
27.4 × 37.8
edition 240?
Felix Man Collection
Australian National Gallery,
Canberra

3.5 ÉDOUARD MANET
'That shadow that lies
floating on the floor ...'
(The chair)
double-page spread from
Le Corbeau [*The Raven*]
by Edgar Allan Poe,
translated by Stéphane
Mallarmé
Paris 1875
transfer lithograph?
letterpress text
image: 29.8 × 27.8;
spread: 54.4 × 72.6
edition 240?
Felix Man Collection
Australian National Gallery,
Canberra

dimension in the artistic potential of the transfer lithograph or, conversely, the experimental use of a new printing technology in the service of art. The prints approach the freshness and spontaneous verve of Manet's brush and ink drawings and, as such, are unlike the transfer lithographs published prior to this time. As expositions of a new technology, whether photographic or manual, relief or planographic, these prints reveal clear indications of experimentation and the process of perfecting a new application of recent print technology.

Print terminology

The *Raven* prints are described in the advertisement for the publication simply as 'dessins', just as another of Manet's 'autographies', *In the upper gallery*, carries the description 'dessin inédit'. The term 'dessin' was commonly used to denote gillotage prints made from original drawings and may indicate a purposeful distinction at this time between multiple drawings and original printmaking, a distinction now blurred. Douglas Druick and Peter Zegers have pointed out that there was a strong desire on the part of many artists to distribute drawings as multiples, whether as lithographs, etchings, or by other mechanical processes.[8] In refuting the significance of the term 'dessin' for a gillotage, Griffiths noted that Corot's transfer lithographs printed by Lemercier in 1872 were described as 'douze croquis et dessins originaux', although they were clearly original transfer lithographs.[9] However, unlike Manet's publisher Lesclide, Lemercier was careful to describe the process accurately, for the description went on to state '... sur papier autographique par Corot.' Pat Gilmour noted another Corot print, *Souvenir de Sologne* (Delteil 34, Melot XX) which Robaut described as a cliché-verre and Delteil identified as an 'autographie'; it appeared in an 'album contemporain' of 'dessins' and the notice discussed a new printing process without specifying which, leaving it uncertain whether the print represented a photographic or manual transfer to stone or plate (3.6).[10]

Unfortunately, no documentary evidence concerning the technique of Manet's 'autographies' has so far been discovered. In 1898 Joseph and Elizabeth Pennell described the *Raven* prints as lithographs, but mentioned a second set printed as relief process blocks; I have located no such second set and one wonders if Pennell was alluding to some more complicated technology for *The Raven*[11] or to a set of the illustrations which Moreau-Nélaton describes as being published by Vanier in 1889.[12] The first catalogue raisonné of Manet's prints, that of Moreau-Nélaton in 1906, separates the autographies from the direct lithographs, stating only:

3.6 J.-B. Camille Corot
Souvenir of Sologne *c.* 1873
transfer lithograph?
24.3 × 13.7
Samuel P. Avery Collection,
The New York Public Library
Astor, Lenox and Tilden
Foundations

1.8

It was always the case, in his last years, that Manet no longer touched the stone. There are two sketches made by him with a brush loaded with autographic ink and transferred to the stone afterwards.[13]

Moreau-Nélaton carefully distinguishes between Manet's autographies (including *The Raven*) and those instances where Manet's drawings were reproduced photomechanically.[14] In 20th-century surveys of lithography, including that by Felix Man, the *Raven* illustrations are used as textbook examples of the innovative use of transfer lithography. Moreau-Nélaton's description of the *Raven* illustrations as autographies went unchallenged until Druick and Zegers suggested that they might be gillotages, a position I carried further in my Manet catalogue.[15]

The French word 'autographie', which has been taken so certainly by 20th-century writers to mean transfer lithograph, actually had a far more variable usage in the 19th century and went beyond lithographic techniques. It is true that Senefelder considered the ability to transfer and print autographic writing as the greatest contribution of his invention (3.7),[16] but it was not until transfer papers were improved a half-century later that the artistic potential of the technique began to be explored. The transfer lithographs Corot made in 1872 were among the first of artistic significance to be published. Although in his preface to this publication Robaut praises the transfer process as a vehicle for the transcription of Corot's drawings as multiples, he does not mention any intrinsic artistic potential for the process.

1.8

There are also instances of the term 'autographie' clearly meant to refer to images produced by a mechanical or relief process technology like gillotage; for instance, Louis Rousseau's publication *L'Autographe au Salon* included gillotage prints made after artists' drawings of their own paintings in the Salon and Manet was among the contributors.[17]

A. TRANSFER

Ackermanns Lithography

3.7 SAMUEL PROUT
Ruins of a windmill 1818
published in *A complete course of lithography*
by Aloys Senefelder
London 1819
transfer lithograph
16.4 × 22.4
Felix Man Collection
Australian National Gallery, Canberra

3.8 J.-B. CAMILLE COROT
The Philosopher's retreat 1871
from *Douze croquis et
dessins originaux sur papier
autographique par
Corot*[*Twelve sketches
and original
drawings on lithographic
transfer paper by Corot*]
1872
transfer lithograph
21.4 × 14.4
1st state (edition 50)
Australian National Gallery,
Canberra

It is therefore clear that terms such as 'autographie' or 'dessin' cannot be cited as conclusive evidence as to the processes used. Acknowledging the vagueness of the terminology previously employed to describe Manet's autographies has caused me to question the technical process he used, led by three factors: first, the unique visual quality of the prints; second, the choice of printer, a man better known for gillotage and photographic transfer than for standard lithography; and third, their function as works associated with printed texts and intended for wide distribution.

Manet's autographies are unlike any other contemporary prints and it is difficult to determine whether this is the result of new demands which his unique drawing style placed on a traditional medium, such as transfer lithography, or of the exploitation of new technologies in the service of his aesthetic concerns. Unlike Corot, whose crayon drawing style lent itself to the standard transfer techniques described by Senefelder (3.8), Manet's brush and ink drawings presented peculiar problems for transfer and printing.

Could Manet's autographies be direct lithographs using a liquid tusche ink? Several factors argue against this possibility: first, the fluidly drawn signature is not reversed; second, the print surface lacks the crispness and animated surface which characterize lithographs worked directly on the stone; third, the dark lines end too abruptly and lack the subtle resolution of the hairs of a brush. A fourth peculiarity is the way in which the edges of the autographies often end abruptly, sometimes interrupting the image and creating a black line where ink has accumulated; this is consistent with transfer processes rather than the result of cleaning a stone to create clean margins beyond the image. Clearly the images were transferred from the original drawing surface to the stone through some intermediate process. However, since no firmly identifiable transfer lithographs of brush drawings exist from the period, it is difficult to identify these as such solely on the basis of visual quality.

What is puzzling is that a great deal of what was originally brushed on the drawing surface appears to have been lost in the final print. The brushstrokes are sometimes fluid and black, sometimes broken, grey and dry leaving only traces of a fuller stroke. What kind of transfer paper could have been used and what was the nature of its surface? Was it smooth or textured, absorbent or resistant to ink? If the paper was textured enough to resist the movement of the brush in the drier passages, why is no texture visible elsewhere in the darker areas? How can one explain an area such as that shown in this detail of *The Café* (3.9–3.10), where underlying lines seemed to have been rubbed away during a second stage of drawing?

3.10 *Above* ÉDOUARD MANET
At the café 1874
transfer lithograph?
26.4 × 33.3
The George A. Lucas
Collection of the Maryland
Institute College of Art
on indefinite loan to
The Baltimore Museum of Art

3.9 *Left* ÉDOUARD MANET
At the café 1874
(detail)
transfer lithograph?
13.2 × 16.6
The George A. Lucas
Collection of the Maryland
Institute College of Art
on indefinite loan to
The Baltimore Museum of Art

3.11 LOUIS LEFORT
after J. G. VIBERT
Spider woman 1875
gillotage
48.3 × 26.5
The George A. Lucas
Collection of the Maryland
Institute College of Art
on indefinite loan to
The Baltimore Museum of Art

The printer

All of Manet's autographies appear to have been printed by J. Lefman (not to be confused with the minor etcher Ferdinand Lefman); his name appears as the printer for *The Raven* and on impressions of *The Café* and *In the upper gallery*.[18] Manet's lithographic printer had previously been Lemercier, who was well versed in transfer lithography and was clearly more attuned to artistic production than Lefman. Numerous examples of Lefman's work can be found, including illustrations by Louis Lefort after J. B. Vibert's *Spider woman* (3.11); this is obviously a gillotage, showing the embossing of a relief process printed on a normal press, and signed 'Lefman sc.', a common designation for gillotage printers. Further, the 'S.N.R.' category of uncatalogued materials at the Bibliothèque Nationale[19] contains a portfolio of material by Lefman, including an advertisement for his firm, J. Lefman et C. Lourder, at 57 rue Hauteville in Paris, recorded in 1870 in the Dépôt Légal. It is a carefully printed advertising notice announcing a patented process, 'phototypographie':

> We have the honour of informing you that our printing establishment is in full operation, with our process called photo-typography, and with simple relief.
>
> Our special facilities permit us to offer our clients the two advantages so desired in this industry – speed and economy.
>
> Our photo-typographic process, for which we hold a patent, has been praised by the major publishers of Paris and by the principal industries using gravure.
>
> What could be more valuable than to be able to obtain, with a simple drawing or an old print, a matrix in relief on zinc, which we will deliver completely mounted and ready to be put on the press.
>
> As this process is obtained by photography, reduction and enlargements are more exact; one will become aware of this on glancing through our specimen album, in which we have brought together a variety of types of our work.
>
> We are, in sum, at the service of whomever might wish to attempt as something of a trial, any kind of gravure, whether industrial or artistic.
>
> As for the printing of drawings into simple relief by means of transfer, we obtain, thanks to the technical facilities of our installation, an exceedingly fine gravure, and this at a price greatly reduced.[20]

The most important text to assist the researcher exploring the new technologies during this period is Motteroz's, *Essai sur les gravures chimiques en relief*, written in 1871.[21] Although he does not discuss lithographic processes, Motteroz refers to Lefman in a chapter discussing 'photogravure par le bitume':

> In making gillotages on prepared zinc, one can obtain a relief from all kinds of engravings. M. Lefman, who for a long time has made industrial photogravures, does not operate in any other way for relief printing; only his transfers are different.[22]

Lefman's use of gillotage, as in the *Spider woman*, was standard procedure but Motteroz is tantalizingly unspecific about his other speciality, the use of photographic processes in transfer. Apart from the particular issues raised by his autographies, Manet used gillotage, through both manual and photomechanical transfer, throughout his career for the purpose of reproducing his drawings in various art publications. This was not unlike the practice of his contemporaries who also explored the artistic possibilities of the new medium. Karl Bodmer used a relief process related to that of Gillot, called *procédé Comte* (3.13), which is carefully described by Motteroz as being particularly popular with artists.[23]

The publication

The *Raven* illustrations were announced as an edition of 240, but it is likely that they were printed on demand. Juliet Bareau has recently discovered through research in the Dépôt Légal that the letterpress sections of *The Raven* were printed in far fewer copies

3.13 after KARL BODMER
Untitled c.1880
procédé Comte
29.6 × 21.4
The George A. Lucas
Collection of the Maryland
Institute College of Art
on indefinite loan to
The Baltimore Museum of Art

3.12 after ÉDOUARD MANET
Jeanne
from *Gazette des Beaux-Arts*
June 1882, page 545
gillotage
Johns Hopkins University
Library, Baltimore

than the 240 specified on the cover.[24] Bareau cites a letter from Mallarmé which tells Manet of the possibility of an American edition of 500 to 1,000 copies,[25] but this never came to pass and the entire project was a commercial failure. Two other autographies, *The Café* and *In the upper gallery*, were also intended for large publication runs and appeared in periodicals: *In the upper gallery* in *Revue de la semaine* and *The Café* in an as yet unidentified periodical.[26] The three other autographies catalogued by Guérin are of the greatest rarity and are obviously trial proofs from an abandoned edition or simply experiments pulled in only a few proofs.

The text for *The Raven* was printed on separate sheets by letterpress, but we do not know when this decision was made. *The Café* autographie is more problematic and it may well exist in two versions, as suggested by the Ingelheim Manet catalogue.[27] The

impression described there (with a Lefman gillotage on the verso) could well be a conventional gillotage with indications of relief embossing, different from rare proofs of the print such as the Baltimore copy illustrated here, which were not included in a publication and show no signs of obvious relief embossing. *In the upper gallery* was apparently inserted in the periodical as a separate leaf and its text is not printed by letterpress, but rather from the same matrix as the image. The integration of text and illustration is important because one of the prime advantages of gillotage over lithography was its compatibility with letterpress printing; text and illustration could be printed in a single run. So, while Manet's autographies were apparently never joined with letterpress text in a single printing, the fact that this could be effected in mass publications through gillotage led me to consider that as a possibility.

Gillotage or lithography?

While conclusive evidence was not available, these legitimate doubts made it inappropriate to catalogue these prints again as transfer lithographs. As a result of preliminary investigation, it seemed sensible as well as provocative to suggest that the illustrations for *The Raven* and Manet's other autographies might be gillotage prints made from a direct transfer of the artist's drawings. This stimulated several articles which challenged the suggestion and proposed further possibilities. All nevertheless agreed that our knowledge of the actual processes and their use was seriously inadequate to the task of explaining the peculiarities of Manet's prints.

Gillotage was the best known and perhaps most common new printing process being perfected in the year before and during Manet's production, but further investigation now argues against the attribution of this process for the *Raven* prints on several counts: lack of visual evidence, inappropriateness of the medium for a wash effect, and evidence of lithographic stone marks on the prints.

First, as evidence of gillotage one would like to have found signs of relief embossing on these prints, though Druick and Zegers maintain that this is not absolutely predetermined by the gillotage process and it was possible, and even desirable, to print without indications of embossing.[28] In the same folder as Lefman's advertisement mentioned earlier is a commercial poster, *Tous les lundis en vente ici* [On sale here every Monday][29] (3.14), which shows no indication of the embossing sometimes seen in relief processes like gillotage; while lacking the broad brushstrokes of Manet's *Raven* prints, it is not unlike his other autographies, such as *The Café*, with evidence of the use of a brush.

Second, and far more compelling than the lack of relief embossing, is the fact that the medium was primarily effective as a method for translating linear designs, and such wash techniques as Manet's were unknown at this date. It is difficult to imagine how a line-cut like a gillotage could capture the brushy character of his drawing, far more tonal than the poster just cited. An excellent case in point is the 1882 gillotage reproduction of Manet's brush drawing of *Jeanne*, published in the *Gazette des Beaux-Arts* (3.12), where brushstrokes similar to those in the *Raven* prints are miserably realized.

Finally, careful scrutiny of the prints has shown the existence of stone marks on some impressions. Barbara Shapiro challenged the notion that the printing surface was a zinc plate,[30] reproducing a magnified photograph of a stone mark on the Boston Museum of Fine Arts impression of *Under the lamp*.[31] What was visible was a rounded edge with rasp marks. These marks alone did not seem conclusive since such sloppy stone preparation was decried by all lithographic printers since Senefelder and seemed unlikely to have come from a professional, though it must be mentioned that Lefman, chiefly a commercial printer, may have been less sensitive to the refinements of fine art editions. Gilmour did not find Shapiro's evidence conclusive either, citing the sharp angles at other corners and the existence of a smoothing of the paper on the Australian National Gallery impressions beyond this possible stone mark. The notion of plate or stone being used to smooth the paper for printing remains a possibility. A photograph

3.14 J. LEFMAN
On sale here every Monday 1875
gillotage
Cabinet des Estampes,
Bibliothèque Nationale,
Paris

of the Bibliothèque Nationale impression of the first version of *La Fenêtre* clearly shows these lines defining smoothed areas, all rounded like a stone (3.15). In this rare proof, however, no fewer than three such 'stone marks' are visible and it is difficult to explain this. Is one from the print matrix and the others the result of an effort to smooth the paper? A systematic examination of marks on numerous impressions with careful comparative measurements might yield more information.

A further examination of several impressions has yielded an even more conclusive indication of a stone mark in the Boston impression of *Under the lamp*. Several inches below the upper right corner, illustrated by Shapiro, is the clear indication of an indentation caused by a chip broken off the side of the stone. While the corner could be from a metal plate, the chip must evidence a stone. Furthermore, the image must come from the stone, for the position of the image does not vary in relation to the perimeter of the marks on impressions I measured.

However, the technical processes associated with gillotage ought not to be dismissed on these grounds alone, for it is clear that the various transfer and printing processes were closely related and perhaps interchangeable in the hands of a specialist like Lefman. Perhaps a combination of processes developed for this project finally resulted in a lithographic printing, but might have incorporated untraditional methods or multiple transfers during the intermediate stages.

3.16 *Opposite* ÉDOUARD MANET
'Open here I flung the shutter ...' (At the window)
from *Le Corbeau* [*The Raven*] by Edgar Allan Poe, translated by Stéphane Mallarmé
Paris 1875
transfer lithograph?
38.0 × 31.0
edition 240?
Felix Man Collection
Australian National Gallery, Canberra

3.15 ÉDOUARD MANET
At the window
(first state) 1875
transfer lithograph?
40.0 × 28.0
Cabinet des Estampes, Bibliothèque Nationale, Paris

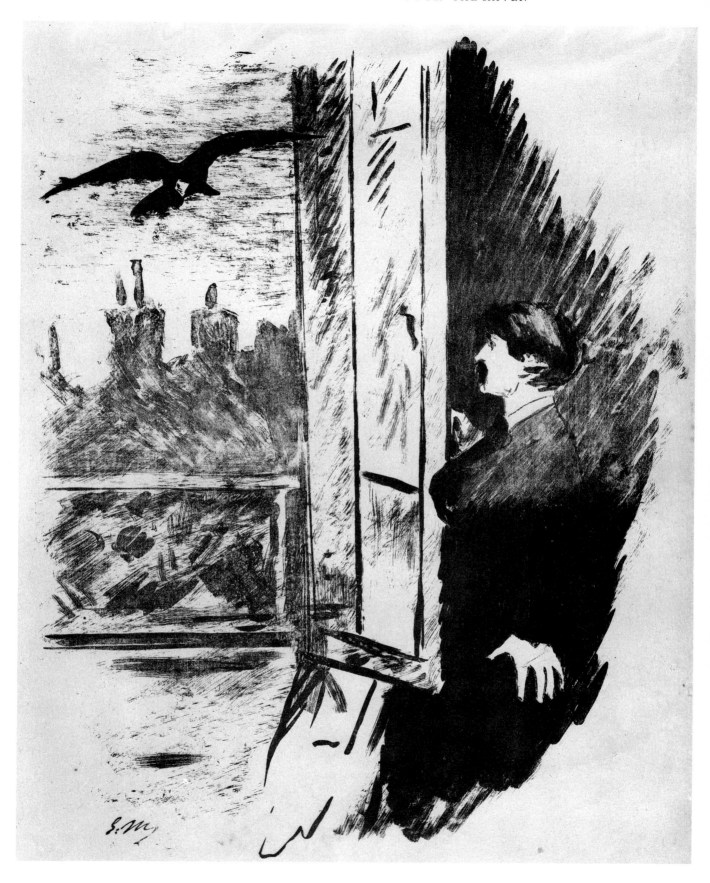

Two other pieces of visual evidence also lead to the conclusion that these images are lithographically printed. Stretch and wrinkle marks observed on impressions of the *Raven* prints at the Australian National Gallery and at the Metropolitan Museum of Art, New York, reveal that the paper was dampened and a directional stroke of a lithographic scraper bar may also be visible. In a letter to Pat Gilmour, artist Jacob Kainen agreed with the dismissal of the gillotage possibility by describing the nature of the gillotage plate which 'demands the sawing away of surface areas beyond vignetted subjects. Otherwise everything would receive ink in rolling up.'[32]

It is typical for a lithograph to print darker as light areas fill in during the printing of a large edition. The opposite can also be true, as a printer could rework the stone with acid, burning the image and losing information. A careful comparative study of various impressions of the autographies reveals light-dark differences that do not in any way suggest the addition of drawing to the stone as if it was a subsequent working state. For example, the raven's head on the cover of the book is consistently darker than the head on the poster. What Guérin has catalogued as two states of *The Raven on the bust* are actually a light and a dark rendering of the stone similar to the *Raven's profile*. Traces of brushstrokes are still visible in the white areas of his first state. A further example is *In the upper gallery*, where light and dark impressions of the image have led some to suggest different states of work. These differences are so consistent that there are two types of *In the upper gallery*. Were the darker impressions printed later? Is it possible that there were separate printing surfaces? Could impressions have been pulled before and after an additional acid wash? Since *In the upper gallery* was included in a periodical, might multiple surfaces have been used to print the edition faster, thus explaining the two different inkings?

One of the *Raven* plates, *At the window*, exists in different states; Guérin catalogued one intermediate state and examination of other copies may reveal additional states. Between Guérin's first state and the final version, significant changes were made, substituting an entirely different scene outside the window on the left. Otherwise, there is no indication of change to other parts of the image. Beyond demonstrating again that it is unlikely that a relief plate is the matrix, this intermediate state poses the question of whether the change was made on the drawing surface or directly on the stone. There is no textural difference between the changed area and the rest of the image, as one would expect to find if some strokes were made on paper and others on the stone surface, but Juliet Bareau has recently observed that the brushstrokes in the reworked window scene run in the opposite direction from Manet's usual drawing, raising the distinct possibility that this change was made directly on the stone by the artist.[33] Neither this fact nor the existence of preliminary states for autographies, however, offers a definite indication of how the original drawings were transferred to the stone.

If these images were printed lithographically then it must be determined how they were put on the stone, through conventional transfer from paper or photographically from a negative by way of a light-sensitive gelatine on the surface of the stone. The case against conventional transfer has already been discussed. Clearly a transfer from paper could not have yielded the intense blacks and subtle brushstrokes.

What should be investigated is the possibility that Lefman was chosen as printer because of his expertise at photographic transfer methods. In addition to conventional gillotages, Lefman perfected and held a patent for a photographic transfer process, the *photo-typographie* mentioned in his advertisement. Experiments with photographic transfer were begun earlier by Gillot and his son and were closely parallel to those by Alphonse Poitevin, who invented the carbon process and eventually a photolithographic process; Poitevin's ideas were taken over by Lemercier, who perfected his own process using a light-sensitized gelatine, as described in his nephew's later treatise of 1896–98.[34] Motteroz singled out Lefman's work in the development of a light-sensitive gelatine process, although both he and Lefman's advertisement speak of it in relation to a relief printing process. Motteroz states the following:

... having produced an image on the surface under a print or photographic negative, they damp the proof on the paper side and put the gelatinous side on to the stone; by passing it through a press, the gelatine not acted upon by light sticks to the stone and furnishes the imprint destined to receive the lithographic ink. By operating in this way on a plate it would be simple to obtain by gillotage all kinds of marks; one would have, in this fashion, a variation on Lefman's process. This artist, who was the first to apply paniconography to photogravure, obtained his transfer proofs with bichromated gelatine paper which he inked with the help of a lithographic roller after exposure to light, and which he then transferred like an ordinary proof onto zinc plate. These extremely simple processes are patented, and it is thanks to them that Mr Lefman has been able to make of photogravure a veritable industry.[35]

An examination of the prints provides some hints about the surface on which Manet might have drawn; apparently it was not absorbent but rather resisted the ink like a gelatine sheet or a piece of glass.[36] Referring back to the detail of *The Café*, it is clear that the ink underneath had dried at the edges but not in the centre, and that the later brushwork pulled the ink away from the centre of the lines. This would be typical of a non-absorbent surface. The different stages of brushwork in *The Raven* are similar. None of the drawings used for Manet's autographies survives, though Manet seems otherwise to have destroyed few of his drawings. This suggests that the drawings were either destroyed in transfer or drawn on an impermanent surface like glass or gelatine. The Lochard albums in the Bibliothèque Nationale contain photographs of several pen and brush drawings related to autographies of the café subject.[37] These drawings are on a paper which appears to be transparent, described as 'papier jaune' in the annotations below two of a 'chanteuse'. Another brush drawing in the Louvre of a café-concert is on a transparent paper, although I have not examined it. Again two possibilities exist: that a conventional transfer was made from drawings on such a paper, or that the transparent paper allowed for the exposure of a photosensitive bitumen on the stone. Occasionally, drawings used for photographic gillotage reproduction like that of Henri Vignaux have come down to us (3.17, 3.18).

Processes for the transfer of designs to relief plates or to lithographic stones were closely related, and Gilmour has aptly observed that they might all have been 'available under one roof ', that of Lefman.

3.17 *Left* after ÉDOUARD MANET
Portrait of M. Vignaux n.d.
gillotage
9.8 × 7.6
The George A. Lucas Collection
of the Maryland Institute
College of Art
on indefinite loan to
The Baltimore Museum of Art

3.18 *Below* ÉDOUARD MANET
Portrait of Henri Vignaux
pen and ink
19.9 × 14.3
The Baltimore Museum of Art,
Cone Collection

PORTRAIT DE M. VIGNAUX, PAR ÉD. MANET.

3.19 EUGÈNE GRASSET
page 181
from *Histoire des quatre fils Aymon* [*Story of the four Aymon brothers*] Paris 1883
multicolour photo-relief process (chromotypographie)
20.1 × 14.2
edition 200
Australian National Gallery, Canberra

prierai ces larrons de vous rendre le vôtre, et s'ils ne le font je leur donnerai des coups avec mon bourdon. Quand les marchands entendirent Maugis parler ainsi, ils le regardèrent. Un d'eux lui dit : Ils sont sept et vous êtes seul, sans armes et ils sont armés ; et d'ailleurs à peine pouvez-vous tenir votre bâton. Un autre dit : Laissez aller ce fol, car il ne sait ce qu'il dit ; voyez comme il remue la tête ! Il dit à Maugis : Frère, passe ton chemin et nous laisse en repos, ou je te donnerai un tel coup que tu le sentiras. Maugis lui répondit : Frère, tu as grand tort de m'injurier ainsi, mais je ne te peux faire bien par force.

Maugis quitta alors les marchands et marcha tant qu'il trouva les brigands. Il leur dit : Seigneurs, je vous prie de me dire pourquoi vous avez pris le bien de ces marchands ? Vous savez qu'il ne vous appartient pas ; ainsi je vous prie de remettre leurs marchandises. Quand les larrons entendirent Maugis parler ainsi, ils furent irrités. Le Capitaine des larrons dit à Maugis : Retire-toi, mon ami, ou bien je te donnerai un

Manet was not alone in his interest in the new printing technologies that were being developed around him. The same type of artistic-technological collaboration can be seen in the 1893 development of Eugène Grasset and Charles Gillot of a multicolour photo-relief process, used to produce Grasset's *Histoire des quatre fils Aymon* (3.19). Cate explains the improvement over previous colour relief processes thus:

> ... the printed color areas took on a speckled, aquatint quality which accommodated an intermixing of color and, since the white of the paper could show through, a lighter overall effect was produced ... Charles Gillot translated, with much input by the artist, the watercolor designs of Grasset into richly grained, subtle and refreshing color illustrations innovatingly integrated with the text.[38]

A further example in Australia presented a challenge which must also have led to innovation in the area of relief colour printing. This gillotage of a Japanese woodcut from the Cernuschi Collection was published in *L'Art japonais* in 1883 (3.20). Gillot's new techniques achieved the variable flat areas of colour which had previously been difficult to achieve with relief processes.

Original printmaking and the dissemination of images

As a printmaker, Manet was most often motivated by a desire to disseminate his subjects to the widest possible public. Rather than entrusting this work to professional printmakers skilled in reproductive engraving, Manet approached the assignment himself, more freely translating the ideas of his paintings into the language of printmaking. His prints are equivalent to his paintings in creative inspiration, although they explore different artistic issues. As a printmaker, it was in lithography that Manet achieved his greatest artistic contribution, for even as a novice his artistic demands

SANSONNETS SUR LE SOLEIL COUCHANT, PAR SHINMAN (1815)

Gravure en couleurs de la collection de M. Henri Cernuschi

3.20 Starlings over the setting sun from *L'Art japonais* [*Japanese art*] vol. 1 by Louis Gonse, Paris 1883 colour gillotage 20.8 × 18.2 1400 copies Australian National Gallery, Canberra

fully explored the potentials of the medium. But the chronology shows Manet's growing departure from direct printmaking. He made few etchings after 1872 and his last direct lithograph was *Polichinelle* of 1874. The autographies are all later than his direct lithographs and even in *Polichinelle*, Manet was assisted by a professional chromolithographer.

Manet's last etching, *Jeanne: Spring* of 1882, is the most revealing of his attitudes towards printmaking. He considered this etching to be a failure, instructing his printmaking adviser Henri Guérard to cancel the plate. He preferred instead a photomechanical reproduction of his painting, one of the first such images to be printed in colour. Notions of originality in printmaking were irrelevant here, for Manet clearly saw the new technology as better able to capture the more diffuse light of his later painting style. As we have seen, the gillotage was also inadequate as a reproduction of his work.

It is with the idea that Manet did not feel fettered by a collector's conception of the 'original print' that we might also learn from a master printer's reaction to the *Raven* prints. Kenneth Tyler has suggested that the stone was poorly prepared, either from a bad transfer or because the printer washed away the subtle details of the strokes with too much acid; wipe marks can be observed across the surface; this would also explain why the dark strokes end so abruptly; fine details were lost. As a professional printer Tyler found these *Raven* prints wholly unsatisfactory, a failed attempt, suitable for discard.[39] As art historians we appreciate how close these prints come to the freshness of the original pen and brush drawing, but careful examination of details indicates that they must represent a very experimental stage in a new technology. In short, we accept the trade-off which Manet has made between perfection of technique and communication of image and broad aesthetic ideas.

Judging from the correspondence between Manet and Mallarmé and the exacting specifications for their second collaboration, *L'Après-midi d'un faune* in 1876 (for which Manet entrusted his drawings to a professional wood-engraver), the two must have had exacting demands for the *Raven* project. Manet would not have insisted on a traditional printmaking technique if a different technology would have come closer to capturing the essence of his vivid brush drawings. Like Degas he was entirely open to any technical innovations that would assist him, although he seemed less inclined than Degas to participate in the more active and direct aspects of printmaking. It seems quite in character for him to have supervised print technicians as they attempted the translation of his drawings into printed multiples.

This examination of technical aspects of Manet's illustrations for Poe's *Raven* questions the adequacy of our understanding of the technologies associated with mid 19th-century lithography and also challenges the concept of originality which for so long has determined the parameters of research.

Especially in the United States, but also in Europe, the impetus for most research on 19th-century printmaking has been provided by the museum exhibition. Beginning in the 1970s, there was renewed interest in the so-called 'forgotten printmakers', not so much from a revisionist point of view as from an acknowledgement of just how widespread creative printmaking was in the 19th century. The making, exhibiting and collecting of prints was the subject of a great deal of critical commentary, much of which focused on the etching revival[40] and its suitability for spontaneous artistic expression since, like lithography, it allowed great freedom of drawing and for the production of drawings as multiples. In exhibition catalogues, however, an inflexible barrier was drawn between original and reproductive printmaking methods to the exclusion of new technologies growing out of the commercial printing industry. Descriptions of the so-called artistic revival of lithography in the 1880s and 1890s often decried the commercialism that had gone before, although Dennis Cate in his studies of the period always considered the importance of alternative technologies side by side with the evolution of colour lithography.[41] Museum curators, in exhibition catalogues, have been chiefly responsible for the character of scholarship concerning this period,

and their role as builders and keepers of collections has most often directed them to object-oriented rather than document-oriented research. Limitations have also been imposed by the nature of the exhibition catalogue, requiring it to supply the factual data for specific objects while also striving to provide a general historical context which aimed to further print scholarship while also serving the less specialized interests of the museum-going public.

The museum catalogue is best suited to stylistic analysis, discussion of chronology, abbreviated iconographical reference, and surveys of groups of artists or of a particular medium – always in the context of exhibited objects. By concentrating on what is visible in the object itself the author of a catalogue sacrifices historical concerns for the intimate understanding of an artist which comes only from direct contact with his production. A forum for study which is less object-oriented has recently been provided by the new journal *Print Quarterly* and more frequent print articles in general scholarly art publications such as *Art Bulletin* and the *Burlington Magazine*. It may well be that exhibition-directed research on 19th-century printmaking has properly run its course and that what is now most necessary is an approach which gives less prominence to aesthetic considerations and more attention to issues of technique, distribution of images, patronage, and the economic aspects of collecting, all of which require careful comparative analysis of objects as well as extensive archival research. The prints which would form the basis of such a study might be wholly inappropriate or unattainable for a public art exhibition, but this must no longer restrict the historical perspective of print research.

If research is ever to clarify the problems presented by Manet's *Raven* prints and accurately reveal the attitudes which artists held about printmaking at that time, scholars must come to grips with the basic technical questions increasingly evident to all interested in print production in the period. The various processes must be codified, compared, and substantiated by archival research, in particular that of the printing industry. Printing journals must be carefully surveyed for relevant articles. Above all, these processes must be recreated to see what visual results were actually possible and what the limitations of the various technologies might have been. In pointing to the relevancy of these issues, the work of Dennis Cate and Druick and Zegers, as well as the dialogue provided by the recent controversy over the *Raven* illustrations, expose the clear priorities we must establish. The *Raven* illustrations by Manet are well understood stylistically in the whole of Manet's art and they have been researched in terms of their role as illustrations of the importance of Poe's works in French cultural history; what is not known is the particular technical circumstance of their production. What can be gained from this determination of technique is an important insight into the creative attitudes of the artist and how the newest technologies were exploited along with traditional printing in the furtherance of artistic goals.

I wish to thank Juliet Wilson Bareau, Arsène Bonafous-Murat, Pat Gilmour, Antony Griffiths, Jacob Kainen and Barbara Shapiro for their frequent observations and suggestions regarding my investigation of Manet's prints. I am grateful to Malcolm Daniel for his assistance in editing this article.

4 From Redon to Rivière:

Albums of the 1890s

Phillip Dennis Cate

In the hierarchy of the arts, lithography has the right to a place of honour. It is not the adaptation of the thought of a creator by an interpreter more or less adroit – it is the same work of the creator.

HENRI BOUCHOT, *La Lithographie*, Paris 1895

THE revitalization of lithography by artists during the last decade or so of the 19th century gave rise to a number of single-artist lithographic albums which together define the aesthetic and thematic concerns of French art at the turn of the century. The phenomenon follows the precedent of the lithographic albums of the 1820s and 1830s by Charlet, Géricault, Delacroix, Decamps, Grandville, Isabey and others and was stimulated anew in the 1880s by the work of Fantin-Latour in particular.

The albums of fourteen artists, beginning in 1888 with Odilon Redon's *La Tentation de Saint Antoine* [*The Temptation of Saint Anthony*] and ending with Henri Rivière's *Les Trente-six vues de la Tour Eiffel* [*Thirty-six views of the Eiffel Tower*] of 1902, present a broad spectrum of technical and aesthetic achievements as well as a glimpse of Parisian society during this intense period of French printmaking.

Single-artist albums have on the whole a more specific aesthetic or thematic focus than group albums. The seven group albums of *Les Peintres-lithographes* [*Painter-lithographers*] published by the journal *L'Artiste* from 1892 to 1897 and the four albums of *Études de femmes* [*Studies of women*] published by *L'Estampe originale* [*The Original print*] in 1896 offer diversity but do not lend themselves to such succinct analysis of major trends as single-artist albums.[1] On the other hand, although the very important group albums published by André Marty under the title of *L'Estampe originale* between 1893 and 1895, and by Ambroise Vollard in 1896 and 1897, lack common themes or artistic intent, they offer a fairly complete survey of the vanguard activities of the time, representing the work of about 100 artists in various techniques.[2]

During the same period there were single-artist albums of intaglio prints by artists such as Mary Cassatt, Charles Maurin and Eugène Béjot and of woodblock prints by Auguste Lepère and Paul Gauguin, but these techniques, whether in single images or in albums, do not provide such a representative cross-section of avant-garde activity as lithography.[3]

The principal literary concerns of the period – Symbolism and Realism – are reflected in the content and the style of single-artist lithographic albums. The symbolist albums of Redon, Charles Dulac and Joaquim Sunyer have specific literary counterparts. The albums of Gauguin and Emile Bernard visually enunciate Synthetism, the particular kind of pictorial, non-literary symbolism of these artists, while the album *Amour* [*Love*] verbally and graphically presents the symbolist philosophy of Maurice Denis. Maximilien Luce, Félix Vallotton, Pierre Bonnard and Rivière created albums employing varying degrees of realistic representation but all having the city of Paris as their sole subject. Toulouse-Lautrec's *Elles* [*Womankind*] is an introverted and empathetic study of the private existence of prostitutes in a brothel and is symptomatic of that segment of avant-garde interest which deals with outcasts of society. By contrast, Hermann-Paul's albums ridicule the life of the bourgeoisie and reflect the strong journalistic current of social satire directed against the mores of the

Third Republic. Vuillard's colour lithographs of domestic tranquillity and pastoral ideals verge on the non-objective, yet maintain a strain of symbolist intent.

The *Café-concert* series comprising eleven lithographs each by H. G. Ibels and Henri de Toulouse-Lautrec is the only exception made here to the single-artist album. The work is a unified summation of the café-concert theme by two of the most prolific and exciting young artists of the end of the century, who carried on the avant-garde infatuation of Manet and Degas with this genre of popular Parisian entertainment.

After creating a small number of etchings in the mid 1860s, often in very limited editions, Redon produced his first eleven lithographs for the album *Dans le rêve [In the dream]* in 1879.[4] This was followed by the lithographic albums *A Edgar Poe*, 1882, *Les Origines*, 1883, *Hommage à Goya*, 1885, *La Nuit [The Night]*, 1866, and *Le Juré [The Juror]*, as well as a number of individual lithographs all of which present his unique proto-surrealist, dream-like imagery which defies precise interpretation and reflects the inexplicable realm of the subconscious. Like the series *A Edgar Poe* and *Le Juré*, Redon's 1888 album *La Tentation* is inspired by the work of a particular author. Gustave Flaubert's 1874 novel is the literary counterpart to Redon's lithographs.

10.18

Printed by Becquet in an edition of 60 in black ink on *chine collé*, this album of ten plates plus cover is the first of three lithographic series by Redon, dated 1888, 1889 and 1896, dedicated to Flaubert's account of the trials and tribulations of the fourth-century hermit saint. The hallucinatory and fantastic images and scenes described by Flaubert find their parallel in Redon's lithographs, as indicated on the cover: 'Tentation de Saint-Antoine – Text de Gustave Flaubert'. Redon's titles for the ten prints have been selected very carefully by the artist word for word from Flaubert's text. The title of no. 9 of the series, for instance, derives from the passage in Flaubert's seventh chapter which describes Saint Anthony's encounter with the Chimera:

And opposite, on the other side of the Nile, the Sphinx suddenly appears. He stretches out his paws, shakes the fillets on his brow and lies down on his belly.

Springing into flight, spitting fire from her nostrils and striking her dragon's tail with her wings, comes the *green-eyed Chimera, wheeling, squealing*.

Her ringleted tresses, thrown back on one side, become entangled with the hair of her back, while on the other, they hang down to the sand and sway with the rocking motion of her whole body.[5]

Redon found in Flaubert's *La Tentation* a vision of the mysteries of life comparable to his own obscure perceptions and inquiries. Redon's lithographs are not so much illustrations to the novel as graphic equivalents and distillations of the evocative and irrational qualities of the author's text. The writer and artist were obviously kindred spirits, a fact which Redon eventually acknowledged in his three Saint Anthony albums, although it is surprising that he waited until 1888 to deal with Flaubert's work.

It may be more than a coincidence that on 28 December 1887 Rivière's shadow theatre production of *La Tentation* began its long run of performances at the famous Chat Noir cabaret in Montmartre.[6] The cabaret was well patronized by the literary and artistic community of Paris and was often a forum and catalyst for artistic interchange.[7] J-K. Huysmans, for instance, a strong supporter of Redon's art for whom the artist had created a lithograph for the frontispiece of *A Rebours [Against the grain]* in 1888, was one of the so-called 'founding members' of the Chat Noir.[8] It is unlikely that Redon was ignorant of the highly popular shadow theatre production or of Rivière's photomechanically illustrated album based on the shadow play and published in 1888.[9] Rivière's version of *La Tentation* is a much more literal translation of Flaubert's novel than Redon's and it also relocates many of the events to contemporary Paris. Flaubert's novel reads as a play with actors' lines complemented by descriptive and introductory passages. Rivière's theatre performance treated the book as a play and quoted the characters' lines directly from Flaubert's text while his descriptive passages served as indications for the realistic stage sets.

Unlike Redon's lithographs which succinctly suggest the essential symbolist

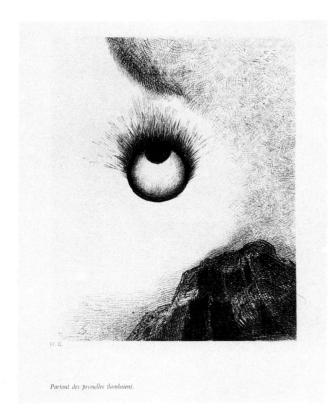

Partout des prunelles flamboient.

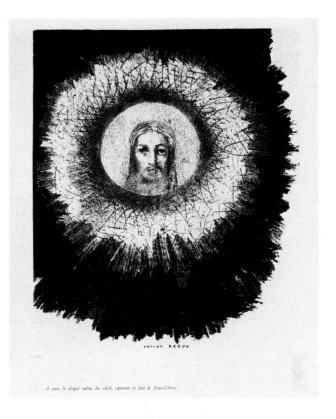

... et dans le disque même du soleil, rayonne la face de Jésus-Christ.

4.1 ODILON REDON
'Everywhere eyeballs
are aflame'
No. 9 from *La Tentation de
Saint-Antoine* [*The temptation
of Saint Anthony*]
(first series) 1888
lithograph
20.4 × 15.8
edition 58
Museum of Modern Art,
New York

4.2 *Above right* ODILON REDON
'And in the very disk
of the sun shines the face of
Jesus Christ'
No. 10 from
La Tentation de Saint-Antoine
[*The Temptation of Saint
Anthony*] (first series) 1888
lithograph
28.2 × 23.0
edition 58
Museum of Modern Art,
New York

qualities of Flaubert's work, Rivière's album of 44 images in narrative sequence leaves little to one's imagination. The two albums strikingly reveal the difference between symbolist and realist approaches to a similar subject. Stylistically they are totally unlike: Redon's abstract use of lithographically printed subtle greys and rich blacks (4.1) contrasts with Rivière's elaborate descriptive colour schemes applied with multiple stencils over a photo-relief printed image. The eerie, mysterious solitude of Redon's prints is the antithesis of Rivière's theatricality. Yet Rivière's proto-cinema theatre performance, on its own terms, is as sophisticated a response to Flaubert as Redon's proto-surrealist lithographs (4.2). It would be ironic, but it is tempting and not illogical to suggest that Rivière's realist shadow theatre prompted Redon's sustained, productive and more symbolist involvement with Flaubert's work.

At the Paris Universal Exposition in the late spring of 1889, the same year as Redon's second series of *La Tentation*, Paul Gauguin and Émile Bernard presented their two albums of zincographs at the Groupe Impressioniste et Synthétiste exhibition which Gauguin organized at the Café Volpini, a small restaurant located on the periphery of the Champ-de-Mars fairground just below the Eiffel Tower and behind the Palais des Beaux-Arts.[10] Just back in Paris from Brittany, Gauguin had established the café as a sort of Salon des Refusés at the exposition site in order to proclaim the new synthetist aesthetic which he, Bernard and others had formulated the previous year. Unlike the symbolist work of Redon, the Volpini album of eleven zincographs depicting scenes of Arles, Martinique and Brittany (4.3) by Gauguin, and *Les Bretonneries*, an album of six handcoloured zincographs by Bernard, had no literary allusions. Synthetism was a different kind of symbolism from that of Redon: one which placed its primary emphasis on form, stressing the abstract, two-dimensional qualities of line and colour as a means of *suggesting* mood and meaning while still retaining a semblance of reality.

Gauguin, Bernard and their colleagues at the Volpini show must have had mixed feelings about the great new tower which hovered over them at the western end of the Champ-de-Mars. Dramatically silhouetted against the Parisian skyline, the Eiffel Tower's bold abstraction could not but have impressed and simultaneously repelled

4.3 PAUL GAUGUIN
Breton women at the gate
No. 4 from
Lithographic studies 1889
zincograph on yellow paper
16.2 × 21.6
edition 30–50
Felix Man Collection
Australian National Gallery,
Canberra

them. The tower represented the industrialized and bourgeois society from which Gauguin was trying to escape and against which his art rebelled. Indeed, Gauguin and Bernard's zincographs were oddly out of place at the Universal Exposition. They could easily have been misinterpreted by visitors as relating to the re-creation of various primitive human habitats – Etruscan, Mexican, American Indian – incongruously installed along the Seine on the western side of the Eiffel Tower. However, rather than a pastiche or a sentimental replication of the past, the albums by Gauguin and Bernard

4.4 PAUL GAUGUIN
Human misery
No. 5 from *Lithographic
studies* 1889
zincograph on yellow paper
28.7 × 22.9
edition 30–50
Baltimore Museum of Art,
Blanche Adler Memorial
Fund, BMA 1944.69

4.5 PAUL GAUGUIN
Sea tragedies
The descent into the maelstrom
No. 8 from
Lithographic studies 1889
zincograph on yellow paper
30.5 × 44.3
edition 30–50
The Jane Voorhees Zimmerli
Art Museum, Rutgers University

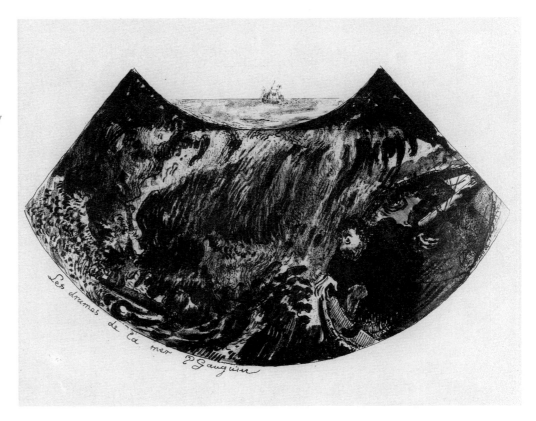

were investigations of peoples still living in relatively unindustrialized environments where their existence was directly tied to the land or the sea. Gauguin found in Arles and Martinique, and in Brittany with Bernard, people who retained a combination of innocence and psychological complexity approaching what the two artists saw as essentially human. Gauguin's *Les Misères humaines [Human miseries]* (4.4) and *Les Drames de la mer [Sea tragedies]* (4.5), for instance, are attempts to suggest, but not to explain, primitive mysteries, hidden truths and primal fears by using a crude formal vocabulary of line and flat simplified shapes, unifying the composition by ignoring traditional Western perspective in favour of the two-dimensional abstraction found in medieval and Japanese art, in which a rhythm of line, form and colour is established across the frontal plane.

As Carolyn Boyle-Turner has explained in her catalogue on the Pont-Aven printmakers, Gauguin and Bernard deliberately printed their two suites of zincographs in early 1889 in order to present to the vast public attracted to the Universal Exposition the aesthetics of Synthetism which the two artists had evolved in their paintings during the previous year. While the Volpini exhibition displayed 100 works by the circle of artists who worked with Gauguin at Pont-Aven, the zincographs were the first cohesive public statement of Gauguin and Bernard's new theory of art (4.6).

The landscape aesthetic of many of the Post-Impressionists, as manifested in the synthetist style, was predicated on the search for a non-classical, ideal depiction of nature. For Charles Dulac, a close friend of the Catholic symbolist poet Huysmans, that ideal was based upon a pantheistic view of nature which found its Catholic rationale in the poems of Saint Francis of Assisi. Like the art of the Pont-Aven artists – Armand Seguin, Roderic O'Connor and Robert Bevan – the work of Charles Dulac was greatly influenced by the dynamic unity created in Van Gogh's landscapes with the swirling and sensuous merging of sky, trees and land. From June 1892 to April 1893 Dulac was involved in the production of eight landscape images printed in subtle earth tones of green, red, brown and black, each enhanced by a different *remarque* in the

4.6 ÉMILE BERNARD
The Harvester
No. 6 from *Bretonneries*
[*The Bretons*] 1889
hand-coloured zincograph
23.7 × 29.5
David A. and Mildred H. Morse
Art Acquisition Fund
The Jane Voorhees Zimmerli
Art Museum, Rutgers University

bottom margin. The prints were a unique combination of lithography and zincography and were published together in 1893 as the album *Suite de paysages [Suite of landscapes]* (4.7). Dulac explained the purpose of the series on the album's frontispiece:

> These few prints are the modest results of my first experiments. They inaugurate a *Suite of landscapes* in which I have tried to express the elusive emotions which various aspects of nature produce in us. My aim was to idealize as much as possible, without, however, falsifying the real forms.[11]

Total abstraction was never Dulac's aim; like Gauguin and Bernard he felt that the evocation of mood and emotion by nature could best be realized in art by the simplification or idealization of what the artist saw. For Dulac this sometimes meant utilizing the two-dimensional style of Synthetism but more often one which placed less emphasis on flatness and decorative line. However, he innovatively manipulated the printing of each plate with tint stones printed in different colours on different papers in order to create a number of aesthetic effects which were for him parallel to the emotions engendered by nature. Although Dulac stood in awe of nature's universal mysteries, he nonetheless carefully documented on the album's frontispiece the printing process for each plate and the means by which he achieved the different effects of each impression. This calculated technical reporting seems contrary to Dulac's symbolist intent, yet the fact that he went out of his way to record the process suggests that he wished humbly to reveal that he was not competing with the incomprehensible powers of God, but rather that his efforts were clearly understandable and he served only as a tool of God. This position becomes more evident in Dulac's only other album *Cantique des créatures [Hymn to creation]* of 1894, a series of nine colour lithographs directly based upon the 13th-century poem of Saint Francis of Assisi.

In his preface to *Cantique des créatures* the Jesuit writer Charles Clair places Dulac's artistic role within the context of Catholic theology.

> Do we have to include in our list of artists, those who, in their servile adherence to the vulgar doctrines of materialism, are unable to see anything beyond sensual reality? It is to these that the divine poet David seems to allude when he writes: 'The man crowned with honour has not understood: he has become the equivalent of an animal without reason.'
>
> But, thank God, there are others who know that what the eye sees is nothing but a symbol and mirror of the Invisible, and that, following Dante's sublime insight, *the order which unites all to all creates a universe in the image of God.*[12]

4.7 CHARLES DULAC
Untitled No. 1
from *Suite de paysages*
[Suite of
landscapes] 1892–93
colour lithograph
50.4 × 33.8
edition 54/100
Australian National Gallery,
Canberra

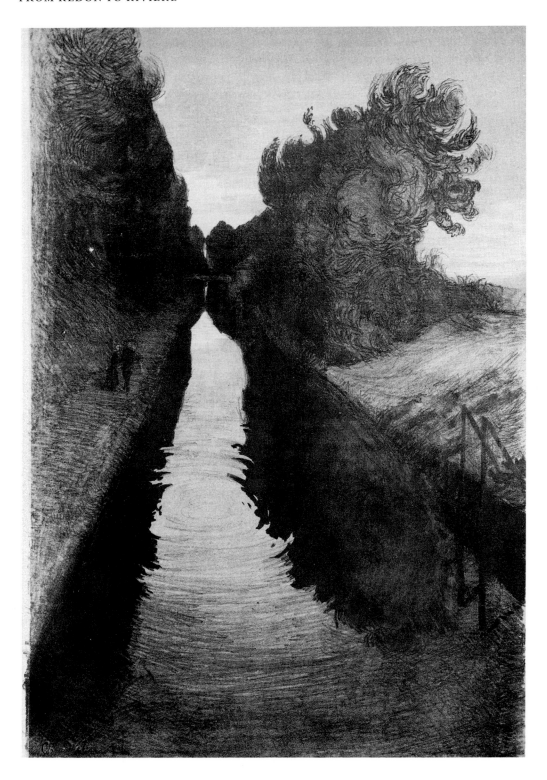

Dulac collaborated on his album with Eugène Belville and Pierre Roche. The former produced the colour lithographic cover and the latter decorated the prefatory sheet with a frieze of angels embossed by gypsography, a process for which Roche became renowned. Dulac, himself, included an embossed cross in the centre of one of his plates for the album but otherwise reserved his experimentation for printing in colour. Belville's cover design depicts a mandala in the centre of which is the hand of Christ

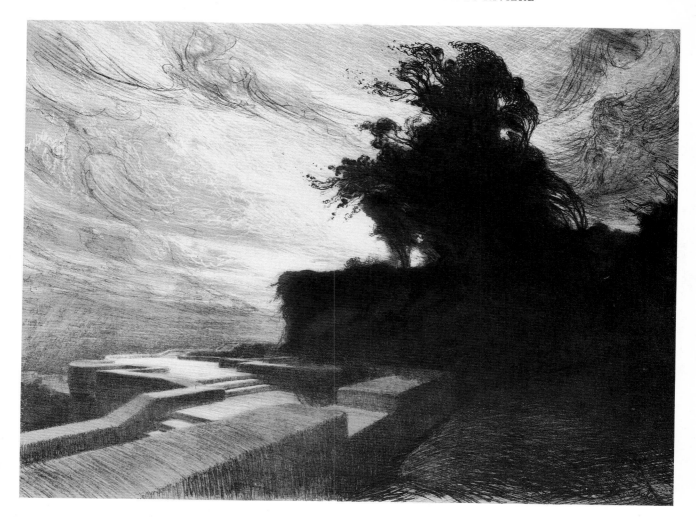

4.8 CHARLES DULAC
Spiritus sancte Deus
[Holy Spirit of God]
No. 4 from
Le Cantique des Créatures
[*Hymn to Creation*] 1894
colour lithograph
37.6 × 49.4
supplementary colour proof
(edition unknown)
Australian National Gallery,
Canberra

offering a traditional three-finger blessing; it is reminiscent of the final image of Redon's 1888 Saint Anthony album, a mandala framing the face of Christ. Dulac must have been aware of Redon's albums, especially the two dedicated to Saint Anthony with their Christian symbolist implications. Dulac emulated Redon's practice of quoting from Flaubert for the titles of his prints (col. pl. 6); in Dulac's case the Latin titles are derived from Saint Francis. While Redon worked in black and white and Dulac in colour, both appreciated the subtleties offered by printing on *chine collé*. Dulac, at times, allowed the border of the *chine* to serve as the apparent frame of his image, which he would cross over with crayon hatchings. In some instances he omitted the actual application of *chine collé* but retained the appearance of the rectangular border normally resulting from it. His use of tint stones created subtle variations and layers of colour, while hazy, gossamer effects were obtained by softly scraping crayon away from the stone or zinc surface. He was a masterful technician who, as his technical description in *Suite de paysages* indicates, combined and exploited the numerous options of lithography to create ambiguous landscapes imbued with religious spirituality (4.8).

Maurice Denis first met Redon in 1889, the year he viewed the Café Volpini exhibit at the Universal Exposition. Both encounters were to have a lasting impact upon his work. Already in 1885 at the age of fourteen he had determined to become a 'Christian painter'.[13] Redon's *La Tentation* validated the quest of Denis for a contemporary art with Christian content, and the Pont-Aven synthetist style appealed to him as the appropriate form with which to infuse Christian meaning into his work. When in 1889

Paul Sérusier organized the group of young artists called the Nabis to promote the synthetist tenets of Gauguin, Denis, because of his Catholic orientation, was nicknamed 'Le Nabi aux belles icônes' [The Nabi with the beautiful icons]. Denis became, with Sérusier, a principal advocate of the Nabis and his style throughout most of the 1890s was based upon Synthetism. It was he who in 1890 wrote: 'Remember that a picture, before being a war horse, a nude or some sort of anecdote, is essentially a flat surface covered with colours assembled in a certain order.'[14]

Although the twelve colour lithographs for *Amour* (col. pl. 9) were published considerably later, Denis began creating studies for them in 1892 and completed them as lithographs in 1899.[15] This seven-year span may account for the unevenness of the series, both in style and quality, yet there is a conceptual consistency which makes the portfolio an important contribution to symbolist activities at the turn of the century. As in the albums of Redon and Dulac, the relationship of text or title to the image is important for *Amour*. The emotive power of such phrases as those for no. 2 and no. 9: *Les Attitudes sont faciles et chastes* [*The Attitudes are easy and chaste*] and *Nos âmes en des gestes lents* [*Our souls, with slow gestures*] link and heighten the mood established by their related images.

Unlike later work by Denis, *Amour* makes no overt religious statement but it does implicitly express his striving to comprehend the ideal states of Christian love and purity. Like other symbolist printmakers of the period, such as Dulac and Aman-Jean for instance, Denis preferred subtle, muted colours and soft pastels in his work, finding primary colours too direct and therefore less appropriate for the variety of moods he endeavoured poetically to suggest.

It is the real rather than the ideal world which is the concern of the albums of Ibels, Lautrec and Hermann-Paul. In 1893 André Marty, editor of *L'Estampe originale*, comissioned Ibels and Lautrec to create 22 monochrome lithographs for the album *Le*

4.9 HENRI-GABRIEL IBELS
Cover for *Le Café concert*
[*The Café-concert*] 1893
lithograph
44.2 × 32.5
edition 550
Australian National Gallery,
Canberra

4.10 *Below right*
HENRI-GABRIEL IBELS
Émelienne d'Alençon rehearsing
at the Folies-Bergère
from *Le Café concert*
[*The Café-concert*] 1893
lithograph
31.0 × 23.0
edition 550
Australian National Gallery,
Canberra

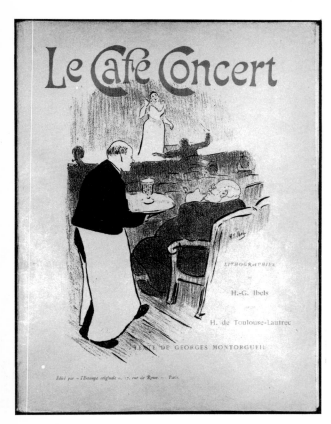

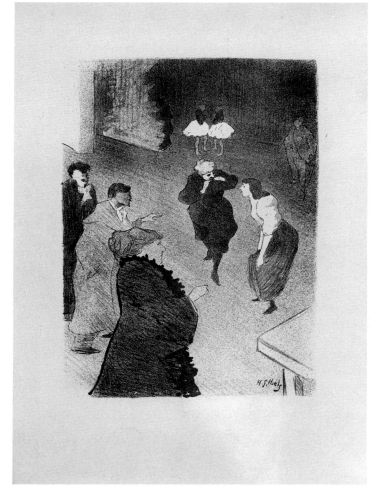

Café-concert (4.9) while Georges Montorgueil wrote the introductory text. Lautrec depicted such popular café-concert entertainers of the time as Yvette Guilbert, Aristide Bruant, Jane Avril, Edmée Lescot, Caudieux and others while Ibels portrayed Marcel Legay, Mévisto, Polin, and Anna Block. The café-concert theme was basic to each artist's overall interest in contemporary Parisian dance-hall and nightclub entertainment, which became more and more predominant in Lautrec's work from the mid 1880s.

In 1892 Ibels had created for Mévisto's performances of that year a large poster and a small album of colour lithographs entitled *L'Amour s'amuse [Love amusing itself]*. Ibels also received wide recognition for his series of eight colour lithographic programmes for the 1892–93 season of the Théâtre Libre.[16] Concurrently, Lautrec was commissioned by Bruant to produce the poster for the latter's performance at the Ambassadeurs; this was followed in 1893 by Lautrec's posters for the café-concert performances of Jane Avril and Caudieux, his colour lithograph of Loïe Fuller and his series of café-concert drawings reproduced in the July issue of *Le Figaro illustré*.[17] In March of that year Marty published the first quarterly instalment of his important *L'Estampe originale* albums. Lautrec created the colour lithographic cover for this first group of ten prints by various artists including Ibels. Accordingly, when the *Café-concert* album was finally published by the end of 1893, both artists were thoroughly immersed in its theme and the medium of lithography.

Ibels was chosen to illustrate the cover. The decision may have arisen from the fact that Lautrec was already represented on the cover of *L'Estampe originale* and was also in the process of producing for Marty the album of 16 black-and-white lithographs of Yvette Guilbert published the next year. The cover design by Ibels realistically depicts a full interior view of a cabaret in which the singer Paula Brébion is on stage and the theatre critic Francisque Sarcey is seated at the back, being served. Except for Ibels's more finished drawing of Emilienne d'Alençon in rehearsal (4.10), the other lithographs for the album are simple portraits, almost caricatures, of male and female entertainers whose performances Ibels and Lautrec had undoubtedly observed (4.11).

Montorgueil's preface analyses the personalities of the star performers portrayed in the album. He sums up the two basic criteria for a good café-concert entertainer in his description of the qualities of Yvette Guilbert:

> What one sings at a café-concert is not as immaterial as many stars suppose. An intelligently chosen repertoire confers certain advantages. The spectacular success of Yvette Guilbert is the result of two things: her own outstanding talent, her mordant voice, her dress sense, her air of mournful gaiety which for us is the latest thing in laughter; but the other thing is her repertoire. She sang differently and she sang different things. She became the muse of people with dry wits, the translator of a very odd sort of humour, a humour which was splenetic and ingenuously immoral.[18]

Throughout the 1890s Lautrec and Ibels were to continue to deal with the individuals and the environment of the café-concert. In addition to his *Yvette Guilbert* album of 1894, Lautrec produced a second series on Guilbert, this time of eight lithographs published in 1898 by W. H. B. Sands in London.[19] Lautrec's *Treize lithographies [Thirteen lithographs]*, an album depicting some of the same actors and actresses represented in the *Café-Concert* album, was published after 1899.[20] In 1896 Ibels illustrated *Les Demi-cabots [The ham actors]*, a book of essays by four authors addressing topics of the café-concert, the circus, and street performers. Seven years later, the 7 December special issue of the satirical journal *L'Assiette au beurre [The cushy job]* was dedicated to the series of illustrations by Ibels entitled 'La Censure: Les Cafés-concerts'. The 1893 album, however, is significant not simply because it is the only instance at the end of the century in which two artists collaborated on a print album, but also because it is the first of a number of artistic anthologies of actual café-concert performers. As such, it represents the important role this popular form of

4.11 HENRI DE TOULOUSE-LAUTREC
Yvette Guilbert
from *Le Café Concert*
[*The Café-concert*] 1893
lithograph
21.0 × 18.0
edition 550
Australian National Gallery, Canberra

entertainment played in the cultural life of Paris and the substantial impact upon avant-garde art of the period.

Lautrec's portraits of contemporary life encompass the highly visible world of the café-concert as well as that of the less public realm of the brothel. His 1896 *Elles* series of 11 colour lithographs plus cover is very unlike other depictions of prostitutes (col. pl. 7). Those by Louis Legrand, for instance, feign a kind of social concern while exploiting the lurid qualities of the subject, and the many humorous journal illustrations on the theme were filled with risqué puns and innuendoes. Lautrec treats the brothel as he often does the circus and the theatre, by going behind the scenes. *Elles* is a non-judgemental view primarily of the after-hours of prostitutes, of their moments of reflection and rest and attending to their personal needs and grooming. Except for the subtle appearance of the erotic picture on the back wall, *Femme au tub [Woman at the tub]* (4.12) suggests the same kind of bourgeois domesticity found in the paintings and prints of Edgar Degas and Mary Cassatt, which are stylistic predecessors of the realistic representations in Lautrec's album.[21]

Hermann-Paul's 1895 album *La Vie de Madame Quelconque [The Life of Madame Someone-or-other]* is on the other hand a criticism, with moral implications, of the predictable patterns of bourgeois life. It is the second of two albums in the series the artist began in 1894 entitled *Les grands spectacles de la nature [Great spectacles of nature]*. The first, *La Vie de Monsieur Quelconque*, is the male counterpart to his series of ten lithographs dealing with the various stages of Madame Quelconque's life. The impersonal pejorative quality of the word 'quelconque' [someone-or-other] immedi-

4.12 HENRI DE TOULOUSE-LAUTREC
Woman at the tub
from *Elles* [*Womankind*]　1896
colour lithograph
40.4 × 52.8
edition 100
Australian National Gallery,
Canberra

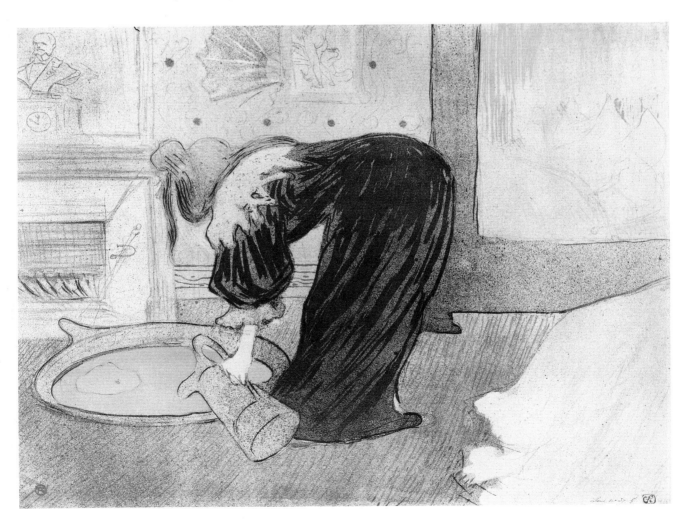

ately reveals the contempt in which Hermann-Paul and most of the avant-garde held the typical bourgeois way of life. 'The great events in nature' are nothing but routine episodes in a boring existence. Hermann-Paul's ten-lithograph narrative presents the life expectations of the typical middle-class woman: a happy childhood, a good education, charitable work, coming out in society, a honeymoon, the joys of motherhood (4.13), the thrills of adultery, the charms of family life (4.14), and becoming a grandmother. Madame Quelconque is faceless, without individuality; the artist's images suggest that the 'great events' in her life such as motherhood do not in the least resemble the middle-class dream. In the end she dies forgotten.

Lautrec's *Elles* and Hermann-Paul's *La Vie de Madame Quelconque* are contrasting studies of contemporary French women. The former presents a subculture existing, at least within itself, without pretence; on the other hand Hermann-Paul's highly critical images imply that the life of Madame Quelconque is based upon hypocrisy and is, therefore, typically bourgeois. Both artists made part of their living as illustrators for satirical journals such as *Le Rire [Laughter]*, where criticism of the bourgeoisie was the main fare. The middle-class establishment had been the butt of artistic social satire since the 1830s; in general, artists saw themselves as being outside the mainstream of society. Lautrec could feel empathy for the prostitutes he depicted in *Elles*, because, as an artist as well as a disabled individual, he more closely corresponded to the outcast position of the prostitute in society than to the comfortable middle class. This anti-bourgeois sentiment often placed artists on the side of the disadvantaged and resulted in a large number of works devoted to the plight of the lower classes.

In 1894 the poverty-stricken poet Jehan Rictus published *Les Soliloques du pauvre [Soliloquies of the poor]*, a collection of poems unified by the theme of urban poverty, specifically as experienced by Rictus himself. In the realist tradition of Jean Richepin's *La Chanson des gueux [The Song of the beggars]* of 1876 and Emile Zola's *L'Assommoir [The Grogshop]* of 1877, Rictus relates in slang the odyssey and

4.13 *Left above*
RENÉ GEORGES HERMANN PAUL, called HERMANN-PAUL
'Then the joys of maternity'
No. 6 from
La Vie de Madame Quelconque [The Life of Madame Someone-or-other] 1895
lithograph
34.0 × 24.0
Herbert Littman Purchase Fund
Jane Voorhees Zimmerli
Art Museum, Rutgers University

4.14 RENÉ GEORGES HERMANN PAUL, called HERMANN-PAUL
'After which she returns to the charms of family life'
No. 8 from
La Vie de Madame Quelconque [The life of Madame Someone-or-other] 1895
lithograph
32.0 × 24.5
Herbert Littman Purchase Fund
Jane Voorhees Zimmerli
Art Museum, Rutgers University

4.15 JOAQUIM SUNYER MIRÓ
Untitled
from *Les Soliloques du pauvre*
[Soliloquies of the poor] 1897
lithograph
13.0 × 8.3
edition 200
David A. and Mildred H. Morse
Art Acquisition Fund
Jane Voorhees Zimmerli
Art Museum, Rutgers University

4.16 *Far right* JOAQUIM
SUNYER MIRÓ
Untitled
from *Les Soliloques du pauvre*
[Soliloquies of the poor] 1897
lithograph
13.4 × 8.2
edition 200
David A. and Mildred H. Morse
Art Acquisition Fund
Jane Voorhees Zimmerli
Art Museum, Rutgers University

impressions of the impoverished man who walks the streets of Paris seeking food, shelter and companionship. The poet caused a sensation when he first recited his poems in 1896 at the Montmartre Quat'z'Arts cabaret, which had by this time usurped the popularity of the Chat Noir. He began his performance with the word 'merd'', the first word of his poem *L'Hiver [Winter]*:

> Shit! 'Ere's winter with its harsh battle,
> 'Ere's the moment you can't strip bare;
> 'Ere's when those who love heat's glare
> To the south of France skedaddle.[22]

Les Soliloques du pauvre is a harsh personal denunciation of an unjust society (4.15); it corresponded to and reinforced the criticism of the Third Republic by French anarchists and socialists, many of the most ardent of whom were artists such as Camille Pissarro, Maximilien Luce, Vallotton and Théophile Alexandre Steinlen.

Steinlen was one of the first to respond sympathetically to Rictus's poems. His art dealt primarily with the poor and the downtrodden of Paris. He found in Rictus an obvious literary counterpart to his own experiences and artistic concerns. In 1895 Steinlen began a series of over 100 black-and-white illustrations for *Les Soliloques du pauvre* which were first published in the 1897 edition. Steinlen's drawings depict the chief protagonist as a tall, emaciated, sorrowful man, with a long beard, shabby coat and top hat. That same year, when the young artist Joaquim Sunyer Miró published his album of eight colour lithographs dedicated to Rictus's poems he directly appropriated from Steinlen's illustrations not only the appearance of the poor man but also the older artist's style of drawing in which the rough crayon grain subtly merges the black spectre of poverty, Rictus himself, into the dark, shadowy Paris cityscape (4.16). Sunyer, however, was also fully aware of the more abstract compositional devices of the Nabis, such as that found in the work of Denis, where space is conflated and figures are pressed against the frontal plane.

Born in Spain in 1875, Sunyer moved from Barcelona to Paris in 1894. He soon became an important link between the avant-garde humanist tendencies in French art, à la Steinlen, and the early work of the group of Spanish artists associated with the El Quatre Gats cabaret in Barcelona, particularly Pablo Picasso.[23] Sunyer's album, an important precursor to Picasso's art, pays tribute to both Rictus and Steinlen, as well as the anarchist-socialist movement in France.

Prior to Steinlen's illustrations for Rictus, the artist had become well known for his

collaboration with Aristide Bruant, the Montmartre cabaret owner, singer and songwriter. In 1885, he began illustrating Bruant's songsheet-journal *Le Mirliton [The Kazoo]* and in 1888 he created the drawings for the first edition of *Dans la rue [In the street]*, a compilation of Bruant's earthy songs and monologues which deal with the people of the street, the poor, tramps, rogues and prostitutes.[24] Featuring the working-class districts of Montmartre, Belleville and Ménilmontant, Steinlen's images reveal a view of Paris quite different from typical depictions of the medieval and monumental aspects of the city. Proletarian Paris subsequently became the focus of a number of artists with anarchist-socialist sympathies.

In 1890 Luce published *Le petit betting [small-time betting]*, the first of an intended series of albums under the general title *Coins de Paris [Corners of Paris]*. Printed by Lemercier on *chine collé*, the eight lithographs were not a financial success and Luce was unable to continue the series. The album's commercial failure was mainly the result of its lack of appeal to potential bourgeois consumers. Its subject is small-time betting at the race track in Saint-Ouen. Located outside the northern limits of Paris, Saint-Ouen was a flat, unattractive industrialized suburb along a northern bend of the Seine. Its race track was constructed in the early 1880s. Unlike Longchamp in the Bois de Boulogne with its elegant aristocratic clientele, Saint-Ouen catered for the numerous small-time gamblers who travelled the few miles from the crowded working-class districts of Montmartre and surroundings (4.17). In the preface to the album Gustave Bogey describes the character of the place:

> Bordering the southern part of the Saint-Ouen race track, along ill-defined tracts of land covered in scabrous patches of turf, with the melancholy silhouettes of factories with immense chimneys outlined against the horizon, endlessly belching out clouds of thick black smoke, extends a dusty road where vehicles of all sorts are parked. . . . It's here, along this road, following the convention which anglicizes everything far and wide that is associated with racing, that what is called *Small-time betting* takes place.

All *Small-time betting* in fact; a sort of window, a den of thieves gambling.[25]

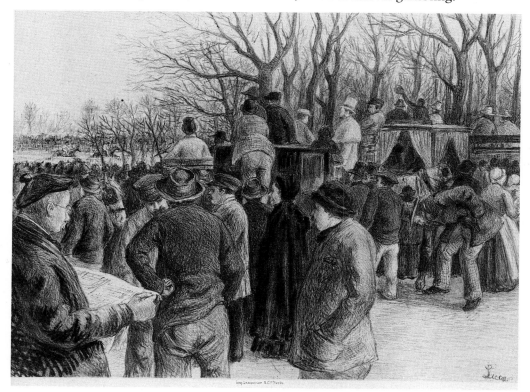

4.17 MAXIMILIEN LUCE
Race track at Saint-Ouen
from *Coins de Paris,
le petit betting
[Corners of Paris,
small-time betting]* 1890
lithograph
21.5 × 29.5
edition 150
David A. and Mildred H. Morse
Art Acquisition Fund
Jane Voorhees Zimmerli
Art Museum, Rutgers University

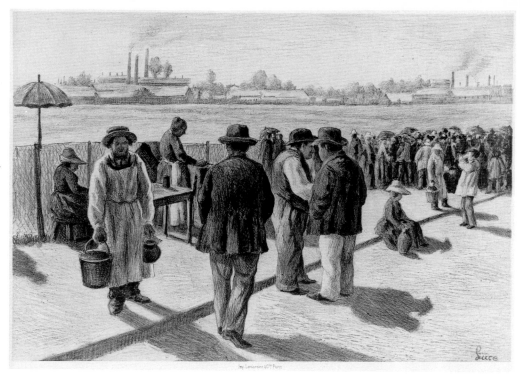

4.18 MAXIMILIEN LUCE
Along the Seine at Saint-Ouen
from *Coins de Paris,*
le petit betting
[*Corners of Paris,*
small-time betting] 1890
lithograph
21.5 × 30.0
edition 150
David A. and Mildred H. Morse
Art Acquisition Fund
Jane Voorhees Zimmerli
Art Museum, Rutgers University

Luce's restrained and realistic depictions are devoid of any kind of sentimentality which would appeal to bourgeois taste. Unlike Steinlen's portrayal of the poor and working class of Paris, Luce recorded the Saint-Ouen population as if he were a camera. He objectively depicted groups of gamblers in the stark, dusty, barren landscape, watching races, reading the odds in *Le Jockey* and playing penny ante games. He completely avoided the suggestion of intrigue and heated animal passions associated with the lower classes since the romantic novels of Eugène Sue in the first half of the century. Luce was an active anarchist-socialist to the extent that at the peak

4.19 FÉLIX VALLOTTON
Cover for *Paris Intense* 1894
zincograph
22.0 × 31.3
edition about 100
The Baltimore Museum of Art,
unknown donor, BMA 1956.162.1

of anarchist agitation in 1894 he was imprisoned for his sympathies.[26] However, the socio-political statement in *Le Petit betting* is made solely by the choice and direct treatment of this essentially drab and unpretentious subject as the theme of the album (4.18).

Stylistically, Luce's lithographs for *Le Petit betting* are relatively conservative. They are related to the pre-Impressionist paintings of Claude Monet in which sunlight swathes the landscape, leaving dark shadows against a bleached ground, and the dramatic perspective views of Paris by Gustave Caillebotte. *Le Petit betting* shows none of the two-dimensional concerns of the newly founded Nabis group. On the other hand, Luce's fellow anarchist sympathizer, Vallotton, combined a synthetist aesthetic with proletarian Parisian street scenes in his 1893–94 album *Paris-Intense*.[27]

The seven black-and-white lithographs, including the cover of Vallotton's album (4.19), are a mixture of caricature and whimsical satire on fleeting moments and daily events in the streets of Paris. Earlier in 1893 Vallotton had produced an album of twelve etchings of pastoral views of Paris in which the human factor plays very little part.

Paris-Intense humorously examines the predicament of individuals as, patient but bored, they wait crammed in line at a box office, press through crowds in celebratory procession, join street entertainers in song or scurry across the street on a windy, rainy day (4.20). Vallotton's humour is subtle; in *Au violon [Off to the clink]* a street paver in the depths of a manhole peers over cobblestones to witness two drunken brawlers being escorted to jail by police. He can also be sympathetic; in *L'Accident* men struggle to pull a horse off a woman who has fallen beneath it as she crosses the street and her small child races over to help.

Vallotton shows what he learned from the compositions of Japanese woodcut prints of the same century, boldly contrasting broad flat black-and-white shapes and creating extreme diagonals and high horizons in order to diminish perspective and accentuate the picture plane. He continued to produce this kind of instantaneous glimpse of daily Parisian street life in his numerous colour photomechanical illustrations for the humorous journal *Le Rire* in the mid-1890s and in his mass-produced colour

4.20 FÉLIX VALLOTTON
The Downpour
from *Paris Intense* 1894
zincograph
22.7 × 31.3
edition about 100
Gift of Edward T. McClellan
in Memory of William Sloane
Jane Voorhees Zimmerli
Art Museum, Rutgers University

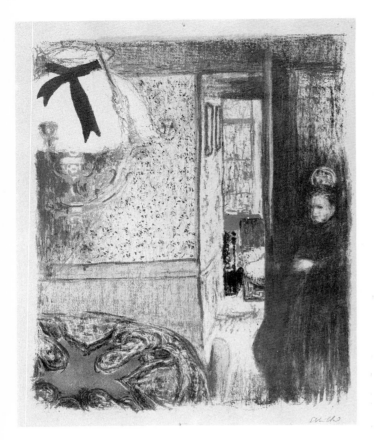

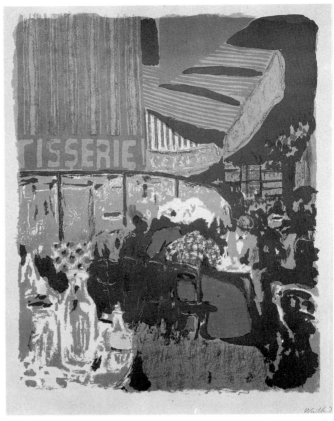

4.21 ÉDOUARD VUILLARD
Interior with hanging lamp
from *Paysages et intérieurs*
[*Landscapes and interiors*] 1899
colour lithograph
35.0 × 28.0
edition 100
Museum of Modern Art,
New York

4.22 *Far right* ÉDOUARD
VUILLARD The pastry shop
from *Paysages et intérieurs*
[*Landscapes and interiors*] 1899
colour lithograph
35.5 × 27.0
edition 100
Museum of Modern Art,
New York

lithographs published in 1902 as a special issue of the satirical journal *L'Assiette au beurre*.

In 1899 Ambroise Vollard, the dealer and avant-garde art publisher, finally published two previously announced albums of colour lithographs: *Paysages et intérieurs* [*Landscapes and interiors*] by Vuillard and *Quelques aspects de la vie de Paris* [*Some views of Paris life*] by Bonnard.[28] *Amour* by Denis was the third album Vollard published, while a fourth proposed album of twelve colour lithographs by Ker-Xavier Roussel was never completed. Nine of Vuillard's twelve prints are interior views (4.21) while three are outdoor Parisian scenes – *L'Avenue* (col. pl. 8), *Sur le Pont de l'Europe* and *La Patisserie* (4.22) [*The Avenue, On the Bridge of Europe,* and *The pastry shop*].[29] Bonnard's series of twelve lithographs is dedicated entirely to the Paris in which he lived.[30] These two albums, plus Rivière's *Les Trente-six vues* of 1902, mark the culmination of a century-long fascination of artists with the city of Paris. The three albums are hallmarks of colour lithography not only as conceptualizations of particular themes but also as evidence of avant-garde aesthetic concerns of the period.

The multiple colour patterns juxtaposed and overlapped in the interior views of Vuillard's album are paralleled by the complexity and abstraction of his Parisian street scenes. The application of formal synthetist theory allied to colour lithography perhaps achieved its greatest artistic sophistication in this album. Bonnard's *Quelques aspects* takes less advantage of the possibilities of colour lithography and often relies on a subtle combination of two or three secondary colours to create the effect of Japanese woodblock sketchbooks. Vuillard and Bonnard depict specific sites. Vuillard's view of the *Pont de l'Europe* is based upon fact, just as his description of the pastry shop and cafés in *La Patisserie* is based upon his own experience. No matter how abstract, reality is never lost in the works of the Nabis. This is confirmed in Bonnard's cover for his album, which includes a scene in Montmartre not far from

where he worked and lived (4.23). The view beyond the female portrait is of the rue Tholozé, with the windmill of the Moulin de la Galette dance-hall in the distance. He thus begins his series with the hustle and bustle of the artistic and working-class community of Paris and continues with a sequence of views of the lively, populated areas of Montmartre, such as Place Pigalle, from various vantage points, by night or day (col. pl. 11), in good and bad weather. Central Paris is included in what appears to be a view of the Pont-au-Change, crowded with an omnibus, carriages and pedestrians crossing the Seine. He offers a more tranquil vision of the Champs-Elysées as riders on horseback casually proceed towards the Arc de Triomphe.

Previous studies have dealt in depth with the stylistic and compositional influences of Japanese woodblock prints on the albums of Vuillard, Bonnard and Rivière. These have dealt specifically with the conceptual importance to Bonnard of Ando Hiroshige's series *One hundred views of famous places in Edo*, 1856, and of Katsushika Hokusai's *Thirty-six views of Mt Fuji*, 1823–29, to Rivière.[31] The longstanding admiration of the French artists for the art of Japan reflected the interest of artists, writers and collectors both of their own generation and the one preceding. The appeal of Ukiyo-e woodblock

4.24 HENRI RIVIÈRE
The Painter in the tower
No. 36 from *Les Trente-six vues de la Tour Eiffel* [*Thirty-six views of the Eiffel Tower*] 1888–1902
colour lithograph
21.1 × 17.0
edition 500
Australian National Gallery, Canberra

4.23 PIERRE BONNARD
Cover for *Quelques aspects de la vie de Paris* [*Some views of Paris life*] 1899
colour lithograph
41.0 × 33.0
edition 100
Gift of Selma Irving, 1978
Smith College Museum of Art, Northampton, Massachusetts

prints to French artists varied but, in general, it lay in the qualities of immediacy and spontaneity, fresh colours, unusual spatial systems and the variety of everyday subject matter, from the street to the boudoir. During the last quarter of the 19th century Japanese prints helped to satisfy the quest of avant-garde French artists for a non-academic art. Ukiyo-e prints provided a precedent for their latent concern for abstraction and inspired a number of them to take aesthetic chances in their work.

Rivière's album *Les Trente-six vues* comprises 36 five-colour lithographs printed in muted tones of grey, olive, blue, pink, and ochre with black.[32] Begun in 1891 with two woodcut images, the complete series was finally published in 1902 as lithographs, although it retains many of the visual qualities of the woodcut. The album was more than ten years in the making; the final images, in fact, are based upon watercolour studies and photographs begun by the artist in 1888.

Rivière created his first lithograph in 1889, a snowy view of Montmartre for the cover of a Théâtre Libre programme. Eugène Verneau was his printer, as he was for all the programmes of André Antoine's avant-garde realist theatre after 1888. He was to be the only printer of Rivière's numerous lithographs throughout the artist's career. Their prolific collaboration ended in 1916 with Verneau's death, after which Rivière stopped working in lithography. As his photomechanical illustrations for *La Tentation*, Rivière had begun in 1888 to create albums based on his shadow theatre productions. In the 1890s he reverted to lithography to illustrate albums for such plays as *La Marche à l'étoile [Stairway to a star]*, *Clair de lune [Moonlight]*, and *Le Juif errant [The Wandering Jew]*. Prior to 1902 Rivière and Verneau also collaborated on the production of several series of multi-coloured, large-format lithographs dealing with themes in nature. For instance, *Les Aspects de la nature* of 1897–99 and *Les Paysages Parisiens [Parisian landscapes]* of 1900 comprise sixteen and eight images respectively, printed in editions of 500 and 1,000. Although Rivière had created two extensive series of colour woodcuts between 1890 and 1894, lithography was the medium most natural for him at the turn of the century and most appropriate for the publication of a large edition album.

The prints for *Les Trente-six vues*, unlike all the other albums discussed, are stitched together, bound in a hard cover and presented in a slipcase. The cover, its endpapers, and the slipcase are decorated with motifs of Japanese derivation designed by Rivière's close friend and colleague, George Auriol. Auriol also designed the album's ornamentation and the typography for the preface by Arsène Alexandre and for Rivière's list of illustrations. The album is visually unified by the ornamental designs, the low-key colour scheme, the Japanese stylization of the depictions and the equal sizes of the images. It is conceptually unified by the theme of the Eiffel Tower and the emulation of Hokusai's series about Mt Fuji.

Essentially a realist, Rivière integrated into his work the descriptive pictorial aspects of Japanese aesthetics more than the formal decorative and abstract qualities which appealed to the synthetists. Rivière gave exact titles to each of his views of and from the Eiffel Tower (4.24), as in Japanese albums. While his prints accurately record the city and suburbs of Paris (col. pl. 10), the images are not topographical in detail; rather, they are subtle, dramatic and poetic representations of Paris with the tower an ever-present gentle colossus.

The last great print album of the period, Rivière's *Les Trente-six vues* epitomizes the exploration of a particular theme and an aesthetic under one cover by turn-of-the-century French artists. Lithography served as the preferred vehicle for these works and its appeal to so many diverse artists for such a variety of purposes demonstrates its flexibility.

5 Cher Monsieur Clot...
Auguste Clot and his role as a colour lithographer

Pat Gilmour

He was much more than a collaborator. Without him, some of the most beautiful books published in the last 30 years would perhaps never have seen the light of day; without him, the renewal of lithography, which took shape towards the end of the last century and which, after a rather long interruption is reviving again today, would have been impossible. ... While so many printers received official recognition, this modest but top-ranking craftsman found reward only in his work. His name remains gloriously linked to the history of the original print which he enriched every day.

CLAUDE ROGER-MARX in *Le Populaire*

5.1 Auguste Clot in retirement at Vielleneuve-St-Georges
c. 1928–30
photograph, courtesy of
Dr Guy Georges

APART from the lithographs he helped to produce and which remain his most enduring memorial, the information we have about the printer Auguste Clot has been largely supplied by just two of his contemporaries.

The writer Claude Roger-Marx, a man unusually sensitive to the contribution a printer can make to a work of graphic art, published so many sympathetic and appreciative accounts[1] that he alone will ensure that Auguste Clot's name remains 'gloriously linked to the history of the original print' (5.1). He told Auguste's son André, who carried on the business, that he referred to his father 'sans cesse'[2] and several touching letters to Auguste's widow reveal that Roger-Marx sought her out to reminisce about a past 'equally dear to us both' and to show her the tributes he had paid to 'the important role your husband has played in the renaissance of modern printmaking.'[3] On the other hand, André Mellerio, whose influential book on colour lithography was published a few years after Clot opened his own workshop, was insidiously critical. While appearing to praise the printer's skill, Mellerio took Clot to task on the one hand for making facsimile reproductions and on the other for helping 'original' printmakers too much by substituting his own judgement 'when their personality was not very strong or assertive'.[4] From that day to this Mellerio's thinking has coloured the attitudes of those defending a narrow conception of the 'original print', seeing its unalloyed purity as a moral imperative. Yet as a matter of fact, only a year or two after expressing his somewhat negative view, Mellerio completely changed his mind and wrote much more positively about Clot's achievements – a revision of opinion that few have noticed.[5] The surviving correspondence to Clot and his son from artists and dealers – an apparently random selection of close to 800 items[6] now analysed here for the first time – sheds new light on the lithographic activity which generated these divergent opinions.

Clot was working at a time when the developing concept of originality in printmaking – the idea that artists should do all their own work – required the printer to keep a low profile. Ironically, the more complex colour printing became, thus increasing the likelihood that an artist would need the help of a professional lithographer, the less acceptable it was for such assistance to be disclosed. Prints of the mid 19th century were usually clearly captioned with the name of the artist, the lithographic draughtsman if someone other than the artist, and the printer. By the end of the century only posters (which Clot rarely produced) and those images appearing in magazines like the *Gazette des Beaux Arts* were similarly lettered; in the second decade

5.2 ÉDOUARD MANET
The Barricade c. 1871
lithograph
47.0 × 34.2
Felix Man Collection
Australian National Gallery,
Canberra

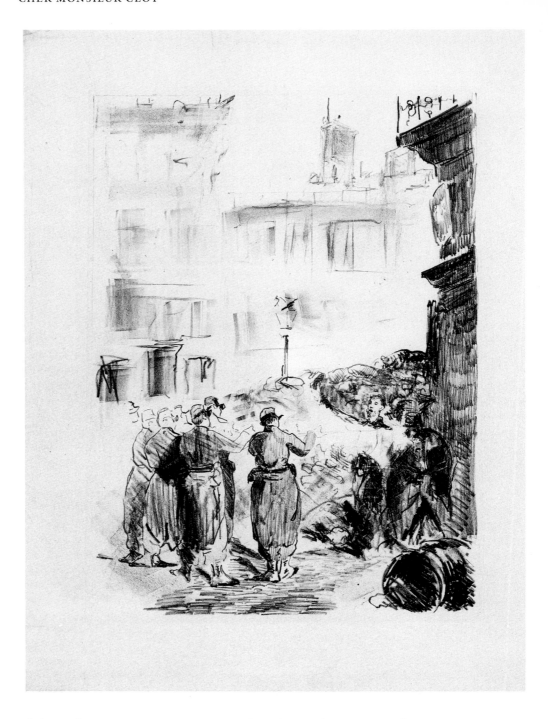

of the 20th century even magazines often dropped printer attributions. Quite apart from equating unaided autography with originality, modernism in the graphic arts demanded an image be placed on a sheet chosen not simply as a neutral substrate, but for its calculated contribution to the overall aesthetic. So apart from an occasional and by no means guaranteed credit at the back of some of the books on which he worked, we might now be scarcely aware of Clot's existence had his contribution not been so dazzling that his contemporaries were unable to overlook him.

Just when Clot set up his own business is still a matter for debate, but around 1869 when he was between eleven and twelve years of age he joined the staff of the most important lithographic printer in Paris, the huge firm of Lemercier. In his treatise on

lithography, published in parts in 1896–98,[7] Alfred Lemercier claimed that merely to have served an apprenticeship with the firm his uncle had founded was sufficient recommendation to ensure employment elsewhere.[8] Apprentices, who were expected to have completed an elementary education and to have made their first Holy Communion, were encouraged to study drawing at night school while they were systematically introduced to the four main branches of lithography by day. The vast Lemercier establishment was equipped with 70 presses for crayon work, 20 for tinted lithography, 30 for chromolithography and 12 for 'gravure sur pierre' (lithography in the engraved manner). According to Roger-Marx, when Clot joined the firm it had 300 workmen and as early as 1839 a trade journal revealed that the élite among them could earn up to 7,000 francs per annum.[9] After three years, apprentices were directed to the area for which they had shown most aptitude. The fact that by June 1874, a couple of months before his sixteenth birthday, Clot had drawn the colour stones for Manet's lithograph *Polichinelle*[10] indicates that he had already marked himself out as an outstanding colour lithographer. In 1884 he was also entrusted with the chemical preparation and proofing of four monochrome lithographs by Manet – *Barricade* (5.2), two portraits of Berthe Morisot, and *Les Courses* – drawn earlier but not processed or printed until after the artist's death.[11]

It is fair to say that when it comes to a work of lithographic art as opposed to a commercial print, the rubric 'printed by Lemercier' may very well mean printed by Clot or one of the firm's other 'essayeurs'.[12] At least three of Lemercier's trial proofers eventually established significant independent reputations: Clot, Henry Belfond[13] and E. Duchâtel. Belfond, whose name is associated with some outstanding lithographs made between 1890 and 1892, preceded Clot in setting up his own business, but by 1893 he was in financial hot water. Duchâtel, whose *Traité de lithographie artistique* *[Treatise on artistic lithography]* was published in 1893 when he was still a Lemercier employee, surfaced again as the printer of Frapier's monochrome albums which, following a period of inactivity exacerbated by the first world war, helped to resuscitate lithography in the 1920s.[14]

Some sources say Clot set up his business in 1888, others, including the *Inventaire*, suggest his enterprise dates from 1896 and that Odilon Redon was his first customer. These dates must both be incorrect. Mellerio, Redon's cataloguer, rightly names Clot as an independent printer for *Le Buddha* in 1895, a print that was the artist's contribution to *L'Estampe originale [The original print]*, which was one of the most celebrated print portfolios of the late 19th century.[15] Edward Ancourt was the main lithographer for this publication, although it is quite possible that Clot helped with other images for it. The earlier date has probably crept into the literature because in 1888, soon after his thirtieth birthday, Clot asked for and was given a reference by his employers. Signed by Alfred Lemercier and witnessed by the Commissioner for Police, the reference states that Clot

> ... occupied for many years the job of trial proofer. He knew his craft perfectly and the lithographic studies both in black and in colour that he made will undoubtedly enable him to render valuable service to any house employing him. He conducted himself well and during the eighteen years he was employed in my workshops I never once had to reproach him for anything.[16] (5.3)

A number of factors, apart from his maturity, may have encouraged Clot to consider starting his own business at this point. Prints and posters were becoming daily more popular and the various publishing ventures then being launched attested to lithography's growing vitality. At the same time, the firm he had known since boyhood was changing in character following the death of its founder. Nevertheless, before he did set up his own business, Clot carried out at least one more major job for Lemercier – the colour plates for the catalogue of Spitzer's collection[17] which was dispersed in 1893 in 'the greatest sale of the century'.[18]

10.16

5.3 Auguste Clot's reference
from Lemercier
27 August 1888
Courtesy of Dr
Guy Georges

5.3 Auguste Clot's reference from Lemercier 27 August 1888 Courtesy of Dr Guy Georges

Frédéric Spitzer, born in 1816, was a private collector who had gathered together a magnificent group of decorative art objects spanning the period from antiquity to the Renaissance. Until his death, which occurred during the preparation of volume two of the catalogue, Spitzer initiated and supervised a luxury publication which eventually appeared in six volumes between 1890 and 1892.[19] The astonishing group of objects he had assembled – with which few public institutions could then have competed – eventually totalled 3,369 sale lots. Part of the collection was shown at the Universal Exhibition of 1889 and preparations for the catalogue must already have been in hand. The most covetable items were illustrated by Dujardin's colour heliogravures and Krieger Bela's etchings, as well as numerous line blocks and half-tones. The catalogue's tour de force, however, was Clot's contribution: 116 hand-drawn colour lithographs credited to Lemercier and distributed through five of the six volumes. No expense was spared and Clot was able to print as many colours as he felt necessary, using a gloss varnish to accentuate the reflective surfaces of jewels, porcelain, enamel and glass, as well as gold, bronze and silver inks to recreate the metalwork. Clot also cunningly deployed various devices to suggest the texture of woven tapestries and other richly embroidered fabrics. The lithographic historian Henri Bouchot described the achievement as 'the summit of the chromolithographic art'.[20]

It is difficult to trace Clot's activity between early 1892, which is about the time he must have finished drawing the last of these plates, and the point at which he set up his own business and became lithographer to Ambroise Vollard, a man destined to be counted among France's most illustrious publishers.

In the account he wrote of his life as a picture dealer[21] Vollard is hazy about precisely when he opened his gallery and began publishing, but a story he tells about seeing a general on horseback set up as a model in John Lewis Brown's garden reveals that he was already immersed in the Paris art world before November 1890, when Brown prematurely died. His first rue Laffitte gallery probably opened in 1893; certainly his arrival on the scene was favourably noticed by the Impressionist artist Camille Pissarro in letters of January and March 1894 to his son Lucien. At first, Pissarro credited Vollard with enthusiasm and knowledge but by 1896, two years later, he was

beginning to change his mind and Vollard sank lower in his estimation during June and July. He noted the picture dealer's first exhibition of graphic art, his tendency to embark on too many projects at once and his dogged pursuit, not of the monochrome prints Pissarro wanted to make, but of images in colour for which he offered only bargain basement prices. 'It seems that colour is the fashion', Pissarro wrote wryly, determining not to be easily seduced. Finally, in September 1896, he reported:

> Vollard is going to have a press for lithographs in his place, rue Laffitte. This Creole is amazing; he wheels from one thing to another with startling ease. Poor Vollard! I told him that he was venturing into a field that one has to understand thoroughly, that prints don't sell, the dealers don't know much about them and depend solely on tricks, like posters, colour prints etc. . . . This young fellow is really too flighty.[22]

There is a possibility that Pissarro did not have his facts straight, because the exhibition Les Peintres Graveurs, advertised by Bonnard's handbill from 15 June to 20 July 1896 with a rare credit to Clot at the bottom, already featured a number of lithographs. In addition, a single copy of a Vollard prospectus survives, advertising an irregular publication called *L'Estampe moderne*; although it does not seem to have appeared, it was promised for 2 October 1895.[23] Of the 22 prints exhibited in June 1896, 13 (possibly even 14) were printed lithographically, 10 of them in colour. Moreover, although none of the correspondence can be securely related to this early Vollard project, letters from ten of the artists who made a lithograph for the show have survived in the printer's archive.[24] In the few cases where subsequent catalogues have identified the printer of one of the works Vollard exhibited – such as Fantin-Latour's exquisite large plate of Venus telling Cupid where to point his dart, or Bonnard's scurrying laundry maid (5.4) – Clot is cited. Even where one print is given to another printer, like Redon's *Vieux chevalier* to Blanchard, the presence of a dedicated proof in Clot's 1919 sale plus the existence of a number of copies in his estate throws some doubt not only on whether Blanchard printed this particular image, but on a number of other lithographs traditionally credited to him.[25]

5.4 PIERRE BONNARD
The laundry-maid
published in
Album des peintres-graveurs
[*Album of artist-engravers*]
1896
colour lithograph
30.0 × 19.0
edition 100
Private collection

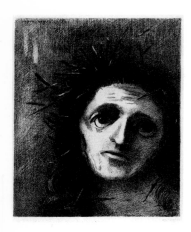

Vollard himself confessed that his print portfolios did not sell too well, a fact confirmed by the number of his prints still part of Clot's estate nearly 60 years later. The checklist then made by the Parisian dealer Paul Prouté records chiefly Vollard's publications plus a sprinkling of colour prints published by Gustave Pellet and a handful made for unattached artists or other publishers. There were also over 70 unique works. A few items even date back to the late 1880s when Clot was still with Lemercier and probably thinking of setting up on his own. These very early prints invite speculation as to whether some lithographs, or perhaps the stones to reprint them, were transferred to Clot when the firm of Lemercier was dismantled. Alternatively, perhaps two of his oldest customers – Fantin and Redon – used him in a semi-independent capacity before he completely severed his Lemercier connections, for several copies of Redon's *Christ* of 1887 (5.5) and over 400 copies of the 28 plates for Fantin's 'Berlioz and Wagner'[26] made at around the same time were found in the printer's workshop after his death.

While Pissarro may have reflected Vollard's momentary intention to install a printer to work exclusively for him, either the dearth of immediate sales convinced him the game was not worth the candle or he realized he would find no other printer to equal Auguste Clot. Either way, there is no doubt that from the time of his first published portfolio the dealer remained Clot's most important client, although Pellet must have run him a close second. Yet the only surviving correspondence that bears witness to the contact these two men must have had with Clot comprises 20 letters from Vollard and two from Pellet; this cannot possibly represent all the letters he received from them. The dated letters from Vollard that survive span the years from 1897 to 1928;[27] although invariably dashed off in a hurry, they display a cultivated hand, whereas the two from Pellet, written late in his career at about the time of the Degas sales, are rambling and scrappy. Vollard's letters reinforce the suggestion that he stored editions on Clot's premises rather than at his own place, because in several of them he requests prints by Renoir or Rodin to be sent to him a few copies at a time. A remark from Pellet, however, suggests that Clot had irritated him by requesting permission to keep a personal copy of the prints he had editioned for him. Pellet's habit of stamping or initialling his prints as he issued them displays a much more precious attitude to print production than Vollard's and he makes it clear that every print Clot pulls is to be surrendered. 'You really put me on the spot,' he wrote, 'because you know quite well that I don't want to give even a single print away. I think you are satisfied with the work you do for me, because I never paid as much for editioning.'[28]

Clot's two most important customers were characters. Pellet, a man of means forced to make a living after a financial crisis in 1886, turned to print publishing.[29] Walking around Paris with two great dogs and described by de Goncourt in 1895 as resembling a medieval torturer, Pellet inclined to intaglio prints, especially the erotic. With Clot's help, however, he also published some of the great colour lithographs of the late 19th century, notably *Elles [Womankind]* (5.6) by Toulouse-Lautrec, some remarkable plates by Lunois and radiant Neo-Impressionist landscapes by Signac and Luce. Vollard's most celebrated prints were those produced by the Nabis, to whom he said he was introduced by Maurice Denis in 1893. The American writer Gertrude Stein, who said the discovery of Cézanne was the great romance of Vollard's life, left an amusing glimpse of the dealer in his natural habitat:

> ... in one corner was a small pile of big and little canvases thrown pell mell on top of one another, in the centre of the room stood a huge dark man glooming. This was Vollard cheerful. When he was really cheerless he put his huge frame against the glass door that led to the street, his arms above his head, his hands on each upper corner of the portal and gloomed darkly into the street.[30]

The writer André Suarès described Vollard as 'powerfully built, like a New Zealand Maori chief' with eyesight that had deteriorated so badly that he 'had a habit of trying to leave a room by the window.' He had a soft voice with a lisp, but could emit a

4.12, col. pl. 7

deafening bellow if angry (5.7). The main impression Vollard made on Suarès, who was writing after the dealer's death in a car accident in July 1939, was of his perfectionism. He devoted endless care to the books he published, revising them again and again:

> He loved them; he questioned me endlessly about the sense of a certain page, or the appropriateness of an illustration and how it fitted in with the text. I would see him on my doorstep twice a day about a word, a space, a capital letter, a comma, or the end of a line.[31]

This, then, was Clot's chief client, who within the first decade of their long working association commissioned the printing of some of the loveliest prints and books of the modern period. But although Vollard once expressed the hope that Clot, having finished some work for Rodin, would now work exclusively for him, Clot seems to have been too astute ever to put all his eggs in one basket.

In addition to links with Fantin-Latour and Redon that stretched back to Lemercier,

there were also continuous threads between Clot and Alexandre Lunois and Clot and Lewis Brown. The very interesting contribution to colour lithography made by these two artists has been eclipsed by lithographs considered more avant-garde – a term which David Hockney wittily suggested should be given back to the French army. Although both artists used the services of more than one printer – in particular Belfond in 1890 when Clot was in the thrall of the Spitzer catalogue – anyone working in colour at Lemercier is likely to have met Clot. The largest number of letters from one individual to Clot came from Lunois; mostly undated, they nevertheless provide evidence of the long and close association between the two men. While no letters to Clot from Brown are to be found in the printer's archive, the artist made colour lithographs at Lemercier at least a decade before the practice became widespread. The evidence linking him to Clot is a letter from the curator Léonce Bénédite[32] asking the printer for information, lithographic stones, sketches and so on, probably for the posthumous exhibition of the artist's work arranged at the Musée du Luxembourg in 1903. The connection is also supported by the printer's sale of four dedicated proofs of Brown's colour lithographs of equestrian subjects, made between 1884 and 1889. Brown even supplies a tenuous link with Manet's sister-in-law, Berthe Morisot, for they worked on a project to illustrate *Le Tiroir de laque [The lacquer drawer]* by the poet Stéphane Mallarmé. The idea was never brought to a successful conclusion, probably because of Brown's sudden death. Berthe Morisot, however, did proof two colour prints[33] and is said to have been stimulated in this not only by Brown's example, but by Manet's colour lithograph *Polichinelle*. Indeed, when one finds painters experimenting with colour lithography at Lemercier by this early date, then Clot is seldom very far away.

Although he was still a Lemercier employee, the *Inventaire* names Clot personally as the lithographer of a Lunois curiosity dated 1885 – a menu for the simultaneous celebration of a silver wedding and a baptism in the Lunois family. Lunois had begun life as a professional reproductive lithographer; the presence in Clot's sale of a copy of his 1888 lithograph after Daumier suggests that Clot probably printed it for him. Clot too was a reproductive lithographer in the 19th-century tradition, and showed at the Société des Artistes Français from 1886. His most notable early work was a splendid portrait of Louis Pasteur, made in 1886 at about the time the Pasteur Institute was set up in Paris. When the Société decided to open the doors to colour as well as black-and-white graphic art, Clot showed some colour lithographs, of a very different nature, that he had made after artists such as Rodin and Renoir.[34]

In the eyes of Mellerio – whose strategy as a writer was to have his cake and eat it – the skill Lunois derived from his training as a professional lithographer was both his strength and his weakness, impeding him as it served him.[35] An effective evangelist for the original print, Mellerio nevertheless had somewhat restricted ideals for colour lithography. For him, an original lithograph, no matter what its subject, had to have lightness of touch, its paper respected as an important component; high marks were awarded if the artist contrived to leave some of the paper blank. Colours had necessarily to be limited, particularly if superimposed, and form required simplification, tonal modelling rarely winning the critic's approval. His assessment of Grasset's lithograph for Vollard's second album is particularly instructive; the socially conscious artist chose to depict a drug addict injecting morphine into her thigh and Mellerio complained that it 'lacked lightness'. A letter to Clot from the artist, however, makes it clear he went out of his way to make the print darker and warmer: an intense coloration for an intense subject.[36] So while Mellerio maintained that his was not a rigid prescription, he deceived himself; all other artists, despite very different ambitions, were measured against Lautrec and the Nabis. To be fair, his conception of an original lithograph, created for its own sake and not to copy another artwork, had been formed in contradistinction to the worst excesses of chromolithography at mid century. In fact, 'chromolithography' was simply a neologism meaning colour lithography, but when Mellerio was writing the word had become an automatic

pejorative for all commercial colour lithography. As such, the term senselessly damned not only the flood of reproduced oil paintings in which too many inks clogged cheap papers and created slick and shiny surfaces, but also sophisticated masterpieces such as *The Grammar of ornament*, by the British artist Owen Jones.

Lunois, who as Mellerio admitted 'knows the stone really well', was nevertheless chided for coming perilously close to chromolithography, yet the artist was not only an innovator in the revival of the most difficult painterly form of lithography, known as lavis, but in his prolific output, facilitated by Clot, he pioneered strategies for an enormous variety of approaches to colour lithography. The titles which emerge from his letters suggest that Lunois began working with Clot at about the time of Belfond's bankruptcy. Certainly there is a dramatic increase in the artist's colour work and the enormously wide range of methods he uses from this time onwards, although precision concerning his activity is rendered more difficult by the chaos of his print catalogue.[37]

While some of the themes Lunois favoured have been subsequently rendered commonplace by run-of-the-mill tourist brochures, they must have been more novel and alluring in the days when, fired by an insatiable wanderlust, he reported back from travels all over Europe and North Africa. The superb prints he made for Vollard, however, which inspired a 'tender letter' from the dealer,[38] include *Le Colin-maillard [Blind man's buff]* and *Lawn tennis* (col. pl. 13), both of which still strike one as highly original compositions, the brilliant colour applied by dense but varied crayoning covering most of the paper surface. One of Mellerio's criticisms was that Lunois often conceived his lithographs in black crayon and wash, then merely coloured this completed monochrome drawing; to a certain extent this is true of the suite of eight prints for Pellet called *La Corrida*, dramatically picturing the phases of a bullfight. It was by no means a blanket solution, however, and by the end of his career, which since he was tubercular came soon rather than late,[39] Lunois was rendering the southern sunshine with washes of intense colour not applied *à plat* (flatly) like the colours of the Nabis, but in nuanced washes uncorseted by outline and unmuddied by shading.

Tusche lavis – a lithographic method of painting in wash on stone or transfer paper – is one of the most difficult techniques; before Lunois, Raffet was one of the few French lithographers to attempt it. One writer of the 1890s called its difficulties almost insurmountable, and in an early 20th-century article, Raymond Escholier noted:

> In 1888 this process, which brought a painterly quality to the print, was, because of the difficulty of processing it, entirely abandoned. Lunois restored its distinction and made it truly his own.[40]

Many passages in the prints of the 1890s look at first sight like wash but are in fact obtained by gumming out areas of the stone not required for the image and applying rubbing crayon with a soft cloth. Indeed the so-called lavis method developed by the pioneering printer Engelmann was of this nature and not truly a wash method at all.[41] Although undoubtedly some printers cultivated its mystique and kept their technical advances secret so as to remain superior and in control of the work, to this day it is extremely difficult to predict the precise value that a given wash will print, particularly if it is a nuanced stroke and not a flat and even tone. Duchâtel spelt out the problems very clearly in his 1893 treatise, advising that a beginner should leave lavis alone and warning that even a relatively successful wash drawing might produce only a limited number of copies. His homily concluded:

> In general, this process is full of surprises and the unexpected; it is necessary then for this kind of work more than any other that the artist helps with the proofing of the stone, so that following his advice the printer can make all the changes judged necessary as each successive proof is pulled, be it to diminish with a brushful of acidulated gum the parts which are printing too strongly, or to increase the value of those that are not printing heavily enough. . . . This cuisine can only be carried out under the requisite conditions by a printer who has an absolute mastery of his craft and who is at the same time very experienced in this sort of work.[42]

Even Clot did not always get it right; a letter to him from Roger Grillon complains that a wash area in one of his prints resembles burnt chiffon.[43] The problem, then as now, is that the grease in the diluted drawing medium, which alone determines the nature of the image, bears no relation to the black colourant which merely allows the artist to see what has been put on stone. Moreover, if the drawing is not right first time and needs retouching, enormous experience is required because of the fickle way that earlier applications of tusche may be affected by subsequent layers. The long runs of lavis lithographs that Clot was able to pull for magazines – such as *La Guitarrera* (5.8) by Lunois for the *Revue de l'Art* – are impressive demonstrations of the extent to which the printer had mastered its vagaries.

Such problems make it clear why a printer's hand was often necessary, more particularly when an artist was too busy to spend an interminable time hanging about for proofs in the print workshop, and it helps to put Mellerio's criticism of Clot into some kind of perspective.

If the dates assigned to several Pellet prints known to have come from Clot's workshop are correct, it would establish that Pellet's publications preceded Vollard's activity by about two years, but this seems unlikely. For example, Louis Anquetin, said to have become interested in the races at Longchamp around 1894, made two dashing pen lithographs infilled with remarkably spontaneous colour. An Anquetin line drawing of horses galloping up to the finishing post, entitled *L'Arrivée*, was reproduced in the centrefold of *Le Courrier français* on 13 May 1894. However, Pellet's archive sale suggests, more credibly, that *L'Arrivée* and another of Anquetin's

5.8 ALEXANDRE LUNOIS
The Guitar-player
published in *Revue de l'art ancien et moderne*
[*Review of ancient and modern art*]
vol. 9, no. 50, May 1901
lithograph
23.8 × 17.4
Australian National Gallery, Canberra

lithographs of a single jockey were in fact published 'around 1898', so the linear reproduction in the illustrated paper captioned 'dessin' may merely be an early drawing of the theme that Anquetin later adapted for lithography.[44] What can be said with certainty is that by the time he worked with Clot the artist had abandoned Cloisonnism and the self-conscious making of 'modern' art and had entered his Rubenesque phase in which, as Augustus John put it in *Chiaroscuro*, 'he had for the fifth time discovered the only way to paint'.

The Pellet sale catalogue is less reticent concerning the date that the six sparkling prints by Paul Signac were published; two are placed in 1894 and the remainder in 1895 – a judgement with which the writers of his print catalogue raisonné concur.[45] Signac was a follower of Seurat and after his mentor's death in 1891 he became the leading theorist of Neo-Impressionism, Pointillism or 'Chromoluminarism', as the method was variously called. Vollard wrote that he had regarded it as women's needlework until it dawned on him what the artists were trying to do. Signac was unusual in putting his divisionist theories into practice in his prints. He had had more experience in colour printing than most of the artists who came to work with Clot, having made a

col. pl. 39

theatre programme in 1888 with Eugène Verneau, using the mechanical tints of a professional lithographer for his celebration of the colour theorist Charles Henry. Despite this accomplishment, the series Signac made with Clot for Pellet is on an altogether different plane. Each of the scenes he depicted – the majority of them featuring boats on reflective water under an expanse of sky – is interpreted in prismatic touches of pure colour, rendering both the local hue and the various effects from its irradiation, harmonized through a subtle understanding of the laws of contrast and colour degradation. Unlike his friend Cross, who was accused by Mellerio of hitting

col. pl. 41

the viewer in the eye with large dots – exemplified by those depicting nursemaids in the Champs Elysées – Signac chose a scale of markmaking in proportion to the support on which he was working. From a vaporous and misty view of a Dutch canal, to reseda green riverbanks on which his laundresses kneel to do their washing, or the golden sunshine bathing the blue-grey walls in St Tropez, Signac rarely puts a foot wrong.

A letter of condolence is the only letter from Signac to Clot that is dated,[46] but several which discuss prints clearly concern the commission from Count Kessler for the magazine *Pan*, in which Signac acted for Cross (and maybe Petitjean or Luce) as well as himself. His letters throw serious doubt on the previously accepted time frame, for it seems that one plate for Vollard and another for Pellet were made *after* the lithograph which appeared in the Neo-Impressionist issue of the 'rich and prestigious German journal' in 1898.[47] Although one of Signac's letters complains bitterly about a delay which forced him to send on an article he had written for *Pan* without the lithographs destined for the same issue, Clot obviously eventually turned up trumps and completed in time the long and complex magazine runs for the four Neo-Impressionists. Signac's lithograph poetically renders an evening scene at Flessingue in five delicately adjusted colours; the primaries, plus grey-blue and green. By deftly overlapping these few shades the artist produced with Clot's help an exquisite tessellation enriched by secondary mixtures of marigold, lilac, turquoise, and lime (col. pl. 17).

Signac worked through colour trials and annotated proofs inscribed 'bon-à-tirer après les corrections indiquées'.[48] This practice of instructing the printer about the modifications needed by means of a proof covered with written instructions is characteristic of Clot's working method. In his essay on Toulouse-Lautrec, which significantly cites the very colour prints by the artist on which Clot is thought to have worked, Antony Griffiths notes the extent to which Lautrec 'must have been dependent on the help and advice of the professional printer' and mentions an early proof of Vollard's *Partie de campagne [Country outing]* in which the outlined dog-cart has been circled and labelled with the colour 'jaune'.[49] Although such annotations indicate an artist's supervision and involvement, they may also imply that other hands have carried out part of the work; an artist need hardly write an instruction to fill an undrawn area with yellow or change the intensity of a mark, if he intends to do it himself. One of Signac's irritations about Clot's lateness, apart from the fact that the

artist was crisply businesslike and did not want to let Count Kessler down, was that he was anxious to leave Paris. The incidence of heavily annotated proofs for prints in which the exact disposition and transparency of the colour touches is so critical, suggests that Clot played a major role in their ultimate realization.

Leaving aside considerations of his 'extremist' style, Mellerio approved of Neo-Impressionists such as Signac, particularly the way that their images conspired with the unprinted paper, 'circulating air and giving lightness'. Luce, however, who like Cross tended to make prints following his own paintings, was convicted of 'unpleasing heaviness'. Like many of his contemporaries Luce was politically active and was imprisoned for nearly six weeks in 1894 for anarchist-communist sympathies. He was trained as a graphic artist and made many prints in black and white, particularly for the illustrated papers, but the seven lithographs he made with Clot for Pellet in 1897 were his first prints in colour.

Although Signac and Cross shared Luce's politics, they believed an artist should be aesthetically radical, not an aesthetic conservative dealing with radical subjects. Luce, however, had opted not for visionary idylls of a society in which the cause had been won, but for subject matter mirroring the realities of urban expansion and the lives of people at work in their environment. He had moved away from the Neo-Impressionist 'petit-point' to broader applications of contrasted colours and his unusually sonorous small plate for *Pan*, of a factory at Charleroi glowing incandescently as it belches smoke, demonstrates the committed artist's perennial problem of rendering the terrible beautifully. Mellerio merely commented that his print 'overwhelmed the paper.'

Steinlen was another politically committed artist who worked with Clot from 1895, chiefly for the publisher Kleinmann. Writing with perfect naturalness as if thinking

5.9 THÉOPHILE-ALEXANDRE STEINLEN
Caulaincourt Street
published in Delteil's
L'Estampe moderne
[*The modern print*] 1896
lithograph
25.2 × 36.0
edition 240
Australian National Gallery, Canberra

aloud, Steinlen was one of the printer's most sympathetic correspondents. 'Why it's perfect – my dear Clot – I won't need to make the slightest change', enthuses one brief but typical note. Apart from occasional instances when the impecunious artist is guilt-ridden through owing Clot money, the same warmth and absence of discord permeates the entire correspondence. Steinlen's colour posters would have been too large for Clot's Jésus and Colombier presses,[50] but in any case the artist's range – from newspapers and song sheets to collector prints and posters – would have made him familiar with the whole spectrum of printers. Many of the black-and-white prints, at which he excelled, were printed in Clot's workshop and, despite their plebeian subject matter, required considerable finesse in their printing. The artist was especially fond of the transfer paper Clot made for him and several times asked for some of the paper for drawing without Clot's transfer preparation on it. His letters make it clear that Clot offered the kind of service he did not find with other printers: 'I'm a little afraid of the way that Dupré – a slapdash worker – will pull these rather delicate things', he wrote around 1897, and several other letters support the fact that this was one of the reasons

letter 11 why he chose Clot to print the 16 *Chansons des femmes*.[51] It was also by way of recompense for taking away from Clot's shop and giving to another printer a 'femme sauvage', one of five popular types he had worked on in the rue du Cherche-Midi.

A 'master of the street', Steinlen worked in the tradition of Daumier. His subjects were the crowded trams, street girls with their pimps, workers on a dark and gusty night walking up the rue Caulaincourt in which Steinlen himself lived (5.9), or trooping out of the factory. As further evidence of his political sympathies, he made an impressive portrait of Gorki for Carl Lebeau of Heidelberg whose eight patient letters of 1905, full of compliments about Clot's skill, detail the project. The print was fraught with diabolic difficulties yet Clot seems to have given great satisfaction in return for the 346 francs which, for once, was paid him promptly.[52] A close-up of Gorki's head and shoulders is dissected by a band bearing his name; in the luxury editions other small sketches of Gorki and a bird in flight adorn the lower margin. Clot had to print 200 ordinary lettered copies without the remarque, then two special editions with the marginal drawings. For one of these, eleven additional pieces of paper were sent to Clot bearing Gorki's signature. Allowing no room for error, Lebeau warned Clot that the ink of the signature not only had to be kept dry, but must not be covered by the image, no mean feat, since Gorki's name was written in a slightly different place on each sheet. The publisher was not disappointed, because Steinlen's catalogue raisonné records that the special proofs signed by Gorki did indeed number eleven. One only wonders whether Clot, as he laboured over the various marketing opportunities, was mildly amused at two socialist radicals generating a print with 200 ordinary copies for the hoi polloi, 50 for those able to afford just one signature and eleven for the élite who could afford two.

Other commissions from Germany in the years leading up to the first world war speak for Clot's burgeoning reputation. In the second decade of the 20th century, Bruno Cassirer negotiated a group of self-portraits and various crowd and beach scenes for Max Liebermann. Clot also worked for Max Slevogt and between 1910 and 1913 he kept the artist's illustrations for Goethe's *Benevenuto Cellini* moving backwards and forwards between Paris and Berlin on stone and transfer paper; a telegram shows that at one stage Cassirer was expecting Clot to go to Germany. The 305 lithographs were produced as a book and as a luxury edition in a portfolio. Slevogt's catalogue states that Clot was asked to pull the luxury edition because

20, 1.9 > ... the trial proofs made in Berlin revealed that their techniques of tusche lithography, a method which had become almost unknown in Germany since the time of Menzel's *Experiments with brush and scraper*, could not achieve satisfactory results. A comparison of the French and German trial proofs confirms this judgement.[53]

The first dated letter in the Clot archive is that of 2 April 1896 from Jacques-Émile

Blanche. Together with Steinlen's prints, the Redon for the last facsicule of *L'Estampe originale* and the date of Vollard's first exhibition, it suggests that the most likely date for the establishment of Clot's own workshop in the rue du Cherche-Midi is somewhere in the middle of 1895.[54] Blanche, a fashionable portrait painter and anglophile, became, like Lunois, a master of lavis. He took as his model 18th-century English portraits, particularly as interpreted by mezzotint. The *Inventaire* of the Bibliothèque Nationale, which records prints acquired during the artist's lifetime, says he made 30 plates with Clot, beginning in 1895, and he certainly contributed to most of the portfolios then being published (5.11). A particularly interesting short letter from Vollard about a print by Blanche confirms that the dealer commissioned prints first and decided how to use them afterwards. The extensive contact Blanche had with Clot seems to have stopped short around 1900 when lithography fell into disuse, but, writing by chance in March 1936 to seek some of his prints for an exhibition, Blanche discovered that Auguste Clot had died the previous month. In his letter of sympathy, he told André Clot that the memories he had of his father were 'full of gratitude and pleasure'.[55]

letter 2

The guarantee of work offered by quantity editioning for the ubiquitous portfolios of the 1890s must have comforted Clot when he set up on his own account. Certainly in 1895 he produced two lithographs for his old Lemercier customer Fantin-Latour: *Les Brodeuses* for the August/September issue of *L'Epreuve*, and in December a second version of Venus and Cupid (this time with a smoking torch) for Delteil's *L'Estampe moderne*.[56] Clot is usually named as the printer for all the lithographs in the latter portfolio, an attribution supported by letters from Blanche which mention Deltheil (sic) and suggest the print's title,[57] as well as correspondence from lesser-known contributors, such as E. Ogé. The printing of *L'Epreuve*, however, is usually credited to Lemaire of Atelier Dumont, although Fantin's re-run of *Les Brodeuses*, an image

5.10 *Below left* PAUL RANSON
Jealousy
from *Le Centaure*, vol. II
Paris 1896
colour lithograph
23.0 × 18.2
Australian National Gallery,
Canberra

5.11 JACQUES-ÉMILE BLANCHE
Young girl
from *Le Centaure*, vol. I
Paris 1896
colour lithograph
22.4 × 17.0
Australian National Gallery,
Canberra

which Lemercier had found too shocking to edition in 1862,[58] is obviously one documented exception. Prints with other titles suggesting *L'Epreuve* images which crop up in Clot's possession include some by La Gandara, Legrand, Maillol and Bonnard. For example, two prints made by Bonnard, listed in his catalogue raisonné as *La Partie de cartes sous la lampe* (two people playing cards by lamplight) and *La Grandmère* (an old lady peering at a tiny child) may well coincide with numbers 16 and 17 of Clot's sale catalogue, there entitled *Les Cartes [Cards]* and *Le Nouveau-né [The Newborn]*. Be that as it may, it is at about this point that the Nabi generation, to a man, defects from Ancourt's shop where many earlier monochrome prints and colour posters were made, and starts making infinitely more subtle colour lithographs with Clot.[59]

It is on the prints he made for four of the Nabis that Clot's most solid reputation has been founded; Pierre Bonnard, Edouard Vuillard, Maurice Denis and Ker-Xavier Roussel all worked extensively with him. Despite their individual differences, these painters shared a style which lent itself brilliantly to printmaking. It was partly inspired by the flat colour, pattern-making and unusual compositional devices of the Japanese woodblock prints then flooding France, which, together with other oriental curios, provided an object lesson of the aesthetic sense permeating everyday life.

The Nabis, whose group name meant prophets or seers, treated art almost as a religious ritual, meeting in Ranson's studio known as 'The Temple' and theorizing about the way expressive shapes and colours could go beyond mere representation (5.10). They venerated many of the older Symbolists such as Redon, Puvis de Chavannes, and Carrière, and were also stimulated by Gauguin's theories, relayed from Pont-Aven by Sérusier. This influence, coupled with the Ukiyo-e prints, reinforced the tendency towards abstraction inherent in simplified outlines and intensified colour and it was Maurice Denis who formulated the famous definition that before representing something a two-dimensional work of art is 'essentially a flat surface covered with colours assembled in a certain order.'

A considerable number of notes to Clot has survived from 'the very Japanese Nabi', Bonnard. Few are dated, although addresses and other clues prove a coverage from the 1890s, through 1912–13, to a date after 1919 when the artist moved to the rue Molitor; a request for proofs from the latter address may relate to *Place Clichy* of 1922, a sumptuous lithograph commissioned by Bernheim Jeune which was the last colour print Clot made for the artist. An earlier note asks for proofs to be sent to 6 rue Ballu, which was the address of the Théâtre des Pantins, so Clot may also have printed the six song covers for the Nabis puppet theatre in 1898. Of Bonnard's two prints for Vollard's album, the little laundrymaid is one of his undoubted masterpieces, while
4.23 his suite *Quelques aspects de la vie de Paris [Some views of Paris life]* captures impromptu everyday moments in an almost throwaway manner. Two rainy night scenes – *Place, le soir* (col. pl. 11) and *Rue, le soir, sous la pluie* – capitalize with brilliance on a limited palette: golden yellow casting reflections, a neutral middle tone, and a darker colour, illuminated here and there with brighter touches, to define the silhouettes of people skipping through the lamplit puddles. Whistler's method of drawing on transfer paper placed over the linen cover of a book to give a random rather than a mechanical texture has been exploited much more vigorously. Although an 1899 drawing in watercolour, pastel and Indian ink prefigures *Place, le soir*, and some other prints recapitulate paintings, Bonnard worked through very few corrected

5.12 PIERRE BONNARD
Clot and Bonnard
making prints
drawing from
Bonnard's sketchbook
c. 1910
Whereabouts unknown

5.13 ÉDOUARD VUILLARD
Across the fields
from *Paysages et intérieurs*
[*Landscapes and interiors*]
1899
colour lithograph
28.0 × 35.5
edition 100
Private collection

proofs, going straight to what he wanted without too many false starts. Although he is repeatedly credited with printing his own lithographs 'under Clot's supervision', the sketch he made of them both in a drawing book of around 1910 makes it quite clear who is at the press (5.12). Recalling their activity in a letter to Claude Roger-Marx over 20 years later, Bonnard wrote his appreciation of Clot's flexibility, and the way it had aided his work.[60]

One letter from Bonnard throws an interesting sidelight on the far-reaching influence Clot may have had on printmaking in Poland. The artist wrote to make an appointment for a Polish friend, then staying with the Godebskis in Neuilly, who wanted to consult Clot about lithography.[61] The friend was Leon Wyczółkowski, later to become an ardent landscape lithographer and already Professor at the Kraków Academy of Fine Arts. The art school, founded in 1818, had never been equipped for graphic arts and students who wanted to make prints had to work in private studios. The Director of the Academy, Julian Fałat, was known to be unsympathetic to the problem, but in 1906 Wyczółkowski encouraged the students to present a petition, followed by a demonstration. As a result, graphic art studies were introduced, an outcome in which Clot's enthusiasm for lithography may well have played its part.[62]

Vuillard's contact with Clot was not so extensive, although his deeply reflected portfolio *Paysages et intérieurs* achieved as high a standard as Bonnard (5.13). Vuillard is the master of understatement, framing outdoor scenes with an apparent casualness that conceals a subtle skill (col. pl. 12), and creating a modest and undemonstrative poetry from the bourgeois interiors in which he and his mother lived. Although he does not work through annotated proofs like some other painters who used Clot's services, neither does he, like Bonnard, hit his mark at first go. Many surviving preparatory designs and revised proofs reveal how, through Clot's help with continual trials, he carefully pondered every move.[63] Despite the brilliance of his contribution in the 1890s, the only other lithographs that Vuillard made were some much later portraits and the attractive monochrome plates for *Cuisine*, which André Clot helped him produce in 1935; the few surviving letters all relate to this last project.

4.21, 4.22, col. pl. 8

5.14 PIERRE BONNARD
Plate from *Daphnis et Chloé*
by Longus, Paris 1902
lithograph
14.8 × 13.8
edition 250
Australian National Gallery,
Canberra

5.15 *Right* PIERRE BONNARD
Plate with text
from *Daphnis et Chloé*
by Longus, Paris 1902
lithograph, letterpress text
15.4 × 14.0
edition 250
Australian National Gallery,
Canberra

demeurât au troupeau, comme devant, à paître
avec les autres, il coupe un scion de franc osier,
dont il fit un collet en manière de lacs courant, et
s'en venoit pour l'attraper au creux du rocher.
Mais quand il y fut, il trouva autre chose : il voit

5.17 *Opposite top*
PIERRE BONNARD
Pages 14 and 15
from *Parallèlement*
by Paul Verlaine, Paris 1900
colour lithography,
letterpress text
double-page spread: 30.0 × 48.8
edition 200
Australian National Gallery,
Canberra

5.18 *Opposite below*
PIERRE BONNARD
Preface and facing page from
Daphnis et Chloé
by Longus, Paris 1902
lithograph, letterpress text
double-page spread:
32.4 × 49.0
edition 250
Australian National Gallery,
Canberra

5.16 Bonnard's revision of
the early pages of *Daphnis et
Chloé* in a letter to Clot
courtesy of Dr. Guy Georges

Bonnard was much the more prolific illustrator and the two books he made with Clot at the dawn of the 20th century must count among the masterpieces of modern bookmaking. *Parallèlement*, published in September 1900, featured Verlaine's poetry set in an exquisite font of Garamond italic, its arabesques deliciously complemented by Bonnard's tender pink lithographs curving themselves around the verses and straying voluptuously into the margins (5.17). The sedate Imprimerie Nationale, which printed the text, judged Verlaine's sapphic themes too risqué and withdrew its imprint; equally scandalized bibliophiles accustomed to relief prints refused to contemplate the shocking abandon of these lithographic nudes. It is a measure of Vollard's courage that, undeterred by these setbacks, he promptly commissioned another book. This time Bonnard took the classical tale of *Daphnis and Chloe* by Longus, setting the still wittily artful illustrations into a stricter and more formal framework, appropriately accompanied by the much less frivolous Grandjean type (5.14, 5.15). A short note survives in which Bonnard rearranges the early pages of the book (5.16). The extent to which Clot's expertise in printing helped to interpret Bonnard's intention is captured by Jacques Guignard, who wrote of its

… unprecedented lightness of touch, [the lithographs] have been printed with such subtlety and skill that you seem to see the original crayon …[64] (5.18)

«Aimons, aimons!» disaient vos voix mêlées,
Claire, Adeline, adorables victimes
Du noble vœu de vos âmes sublimes.

Aimez, aimez! ô chères Esseulées,
Puisqu'en ces jours de malheur, vous encore,
Le glorieux Stigmate vous décore.

PRINTEMPS.

Tendre, la jeune femme rousse,
Que tant d'innocence émoustille,
Dit à la blonde jeune fille
Ces mots, tout bas, d'une voix douce:

«Sève qui monte & fleur qui pousse,
Ton enfance est une charmille:
Laisse errer mes doigts dans la mousse
Où le bouton de rose brille.

15

PRÉFACE
DU TRADUCTEUR

La version faite par Amyot des Pastorales de
Longus, bien que remplie d'agrément, comme tout le
monde sait, est incomplète et inexacte; non qu'il ait
eu dessein de s'écarter en rien du texte de l'auteur,
mais c'est que d'abord il n'eut point l'ouvrage grec
entier, dont il n'y avoit en ce temps-là que des copies
fort mutilées. Car tous les anciens manuscrits de
Longus ont des lacunes et des fautes considérables,
et ce n'est que depuis peu qu'en en comparant plu-
sieurs, on est parvenu à suppléer l'un par l'autre et

B.

Like that of Bonnard, who made two more lithographically illustrated books in 1930 and 1946, the association between Denis and the Clot Atelier stretched halfway into the 20th century. Already a seasoned lithographer, Denis was also commissioned to make a suite of a dozen prints for Vollard, which he completed in 1899. An entry in the artist's diary for 1 January 1897 mentions beginning the work although the idea for *Amour [Love]* had been planted years before. Someone said of the artist that he could make a sacrament out of afternoon tea, and the substance and even the titles for his prints come from the diary he wrote in 1891 when, like a knight in a medieval romance, he courted his wife-to-be with a kind of holy awe. 'She is more beautiful than all pictures, all representations, all subjective imaginings', he wrote[65] and *Elle était plus belle que les rêves [She was more beautiful than dreams]* became one of the loveliest manifestations of his mood of gentle introspection. As the 20th century progressed, however, his religious commitment became overt, almost to the point of propaganda and, as such, produced rather less satisfactory art.

To a far greater extent than Bonnard and Vuillard, Denis was inclined to write to Clot about the changes he wanted; he often described colours by post, leaving their mixing to the printer. In one case, he invited Clot to choose 'an intense mauve to suit your whim'.[66] This distant supervision, which would continue even when he was away

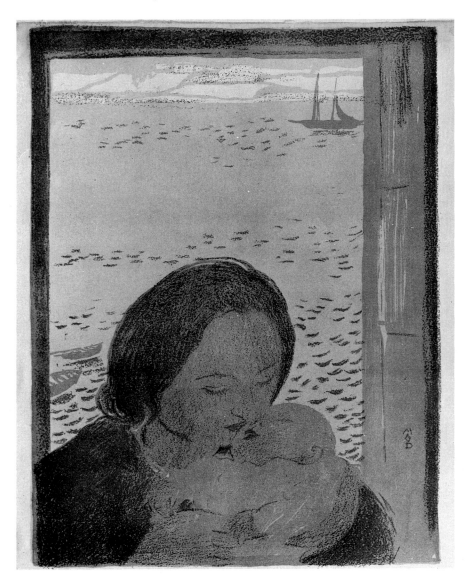

5.19 MAURICE DENIS
Maternity by the sea 1900
colour lithograph
34.7 × 25.0
Private collection

5.20 *Opposite*
KER-XAVIER ROUSSEL
Woman in striped dress
from *L'Album de paysage*
[*Landscape album*] c. 1898
colour lithograph
21.4 × 32.4
edition 100
Australian National Gallery,
Canberra

on holiday, did not prevent him achieving masterpieces like *Le Reflet dans la fontaine* [*The Reflection in the fountain*] for Vollard's second album (col. pl. 16); the Australian National Gallery copy is inscribed 'à Clot, souvenir d'une opération laborieuse.' This print may well be the 'green plate for Vollard' referred to at the opening of a letter in which Denis asks Clot to make modifications to other prints, looking after them 'as if I were there'. Concerning another unidentified image he tells Clot that if he can 'bring out better the line of the head, the line of the arm, the breast, it will be perfect',[67] while yet another note confidently relies on the printer to render a diluted wash on transfer paper 'as it is', with all its tonal nuances (5.19).[68]

letter 4

While Denis, Bonnard and Vuillard all completed their albums before the 19th century was out, Roussel, the fourth member of the Nabis commissioned by Vollard, was unfortunate in that the slackening of interest in prints overtook him and his album was never properly issued. The informal asymmetry and the delightful way he places figures in a landscape show his affinity with the group, although his mythological subject matter gives him very different emphases. One of his masterpieces is *Femme en robe à rayures* [*The Woman in the striped dress*] (5.20), where the figure, which one might find in a Vuillard, becomes one with the landscape. Otherwise nymphs and fauns cavort in the bush-covered foothills and coppices of his homeland at L'Etang-la-Ville, converting it into a lost Eden. Two uninformative notes from the artist and a letter of 1928 from Vollard asking Clot if Roussel's stones are ready to be worked, are the only documents recording Clot's extensive collaboration with him. Despite the fact that so few of his prints were published, however, Clot evidently worked on a large number of black-and-white lithographs between the wars, among them *Leda and the swan* for an uncompleted portfolio of nudes which Vollard planned, and as many as 50 proofs of illustrations for some poems by Maurice de Guérin, only a handful of which were editioned.[69]

Although we shall never read Clot's replies to the letters he received, a good deal of information can be gleaned about his personal life by reading between the lines. He clearly enjoyed the theatre: Henry Bataille, an artist and a playwright for whom Clot printed lithographic portraits of celebrities,[70] often sent Clot and his wife tickets for the theatre. So did one of the dramatist's leading ladies, Berthe Bady, who told Clot she expected him to wear clappers to swell her applause. Letters also show the printer mixed socially with Rodin and Vollard and was invited to banquets, such as that for Octave Mirbeau, organized by *La Plume*. Until 1906 he regularly exhibited, and was invited by his professional association to teach at an evening school for lithography.[71] Several letters ask for advice or a helping hand. In 1908 the well-known printer, Frazier-Soye, asked Clot to recommend a suitable husband for his twenty-year-old daughter, since he wanted a 'young man of the future' to 'infuse new life into his establishment'.[72] In 1910, the artist Charles Milcendeau, writing that he respected Clot 'both as an artist and as a man', sent his not very bright brother to him for suggestions as to how he might make his way in the world.[73]

The letter from Signac in 1898, already quoted, refers to some unspecified tragedy, but may mark the same event as undated notes from Bonnard and Charles Éphrussi, influential director of the *Gazette des Beaux Arts*, expressing sorrow at the death of Clot's child. Pierre-Georges Jeanniot, on the other hand, congratulates the printer on *letter 10* the birth of a little girl, although this shared joy does not prevent him in the next sentence from tearing Clot apart for editioning a print without correcting an error in the drawing – in his view Clot's fault rather than his own; the fact that in the same letter he grumbles that the only alternative to such disasters is 'to spend entire mornings at your place', is revealing.

The letters also add up to a picture of lithographic practice at the turn of the century. According to his grandson, Dr Guy Georges, although Clot thought lithography was finished and the future belonged to photography, he never used mechanized presses and pulled everything he printed by hand. Indeed, when the British printer, Stanley Jones, met Clot's son in the 1950s, the Frenchman was still grinding all his own inks – a

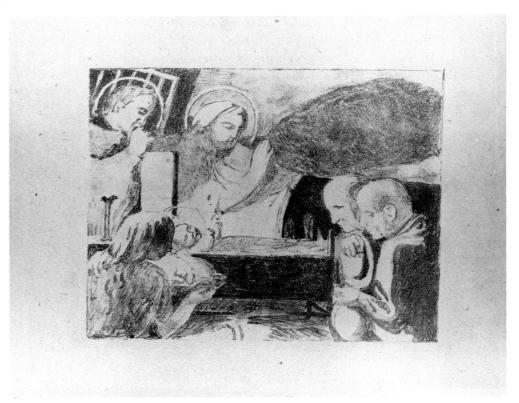

5.21 MAURICE DENIS
Nativity (blue separation)
published in
Gazette des Beaux-Arts 1907
colour lithograph
13.9 × 17.7
Australian National Gallery,
Canberra

workshop tradition.[74] The use of an entirely manual press would have made particularly daunting the task of editioning original prints to be bound into such journals as *Pan*, *L'Art Décoratif*, *Revue de l'Art* and *Studio*. Editions of 2,000 to 3,000 prints were not unusual and Clot pulled a Steinlen in 5,000 copies for *Studio* in 1903 and 4,000 copies of another for *L'Art Décoratif* in 1910. In 1907 he produced in 1,500 copies the lithograph *Nativité* by Maurice Denis for the *Gazette des Beaux Arts* (5.21); since it had four colours, this job involved 6,000 passages through Clot's press. One can only judge what pain it occasioned to both sides by reading successive letters which betray the escalating stages of panic in the Gazette's Administrator who, trying to put together the May issue, was, on 8 June, still telling Clot 'but you promised . . .'[75]

The complaints about quality are relatively few. Apart from one or two instances concerning colour, such as a Jeanniot 'lacking energy' and a snow scene that the proto-Fauve Guillaumin thought had been 'washed in the gutter' (col. pl. 14), most artists regarded Clot as a colour expert and took his advice. Clot also received a constant stream of queries requesting technical information on such problems as whether gouache would work over a wash, how to employ a scraper on a varnished plate, or to restore an image ruined by the 'sandpaper method'. By far the most common cause for complaint concerned the speed of his delivery. The size of his operation probably meant that even a printer of Clot's fame was unable to turn work away. Whereas a huge undertaking like Lemercier had sufficient workers to absorb the most importunate demands, Clot does not ever seem to have employed very many people. Despite this, one of Bataille's complaints – in which he certainly cemented his reputation for consummate melodrama – was that Clot had left a workman to process and produce prints unsupervised, whereas Bataille had wanted them pulled by Clot's own hand. The results were judged disastrous by the artist, although despite his threats the portfolio did eventually come out and was described flatteringly as having been drawn by 'an elegant, supple caressing crayon.'[76] In a way, even Bataille's cry of rage was a backhanded compliment: 'I could have gone to the worst printer in Paris and got better treatment', he fulminates, the implication of course being that he had gone to the best. Vollard also chided Clot for always being out on business. Nearly every correspondent sends greetings to Madame Clot, who, it seems, must have helped at the rue du Cherche-Midi. One wonders if the round hand on Clot's receipts and documents, with its steady rhythm and attractive flourishes, was her contribution to her husband's undertaking.

The letters reveal that one of the greatest demands on the day-to-day running of the establishment was keeping up with the despatch and collection of stones. They had to be grained in various ways, to be proofed, to be corrected, to be prepared with 'faux décalques' facilitating the registration of colour[77] and finally to be editioned; Clot was eternally ferrying them backwards and forwards to artists in their own homes or studios, so that, aside from its efficacy in helping to register colour, one can quite see why transfer paper became so popular. Bataille's command to send a stone 'tomorrow evening by the boy' or the request of Hermann-Paul for the pick-up of a stone that 'the kid will find on the ledge under the window' are typical of countless references to a 'garçon', 'gosse', or 'gamin' whose services are required. There are no clues as to how the stones were packed or carried, apart from a 1903 note from Veber which states that he has just forgotten to give Clot's boy something and wants him back again with his 'petite voiture'.[78] As Veber had begun a letter of 1901 with the exclamation: 'Heavens! what a long way the rue du Cherche-Midi is from the Boulevard Péreire!' one assumes that this was a problem only when *he* was making the journey. The artist's rather macabre work, featuring scenes of primitive dentistry and the like, by Breughel out of caricature, was printed by Clot between 1897 and 1904;[79] he must have had considerable confidence in what Clot did, because in two successive letters he first asked Clot to proof and print the keystone, and then to mix and print two colours without him – all to get to an exhibition on time a work that he has hardly clapped eyes on since he first put it on stone. One letter, from Victor Hugo's grandson, Georges, who made a colourful suite of boat subjects with Clot in 1896–97, asks the printer to

letter 8

letter 1

letters 14a & b

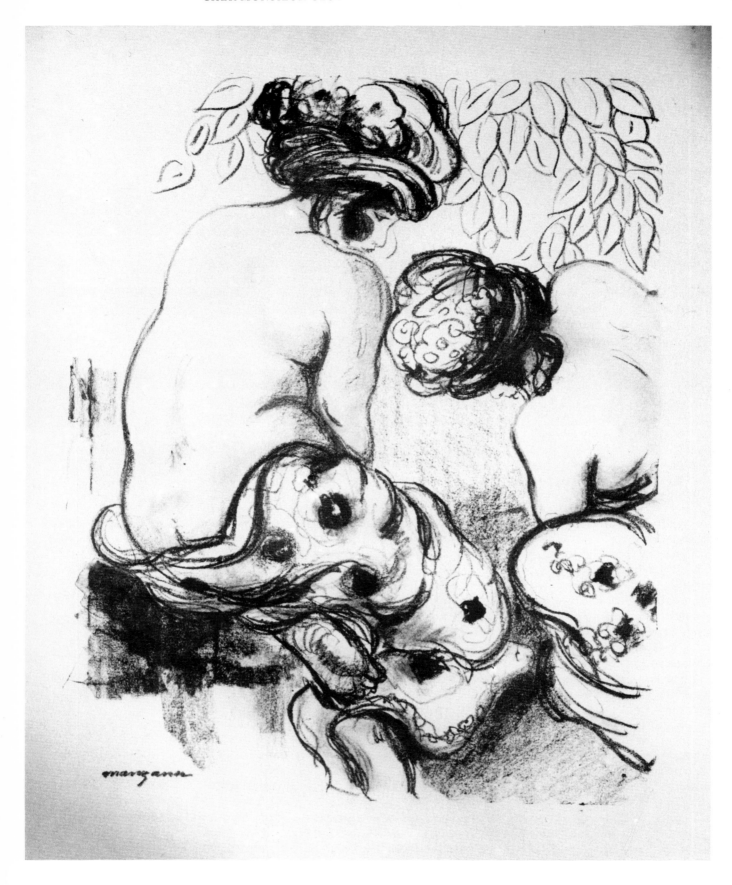

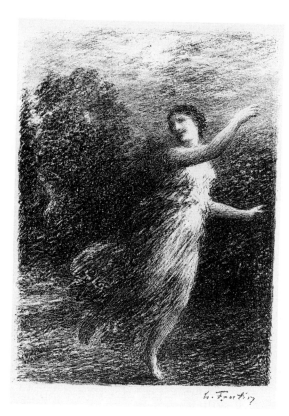

5.23 HENRI FANTIN-LATOUR
Plate XXIV
from *Les Bucoliques,*
Poems of André Chénier
Paris 1903
lithograph
20.2 × 14.9
edition 31/177
Australian National Gallery,
Canberra

5.22 *Opposite* GEORGES
MANZANA-PISSARRO
Sultanas washing *c.* 1910
colour lithograph
43.0 × 35.0
Private collection

strip down and clean a press, restoring it to pristine condition. There is also a hilarious exchange in which Jeanniot doggedly tries to sell back to Clot, first for 150 francs and then for 100, a press he bought from the printer for 250 francs.

Clot printed on a great variety of papers; in fact, his awareness of the importance of paper almost turned him into a distributor. He printed on Chine, Japan, Perrigot and Masure, and quite frequently on an impossible, ineffable, pearly, fly-away sheet called Japon pelure, otherwise known as 'onion skin'. He also provided all the standard brands of transfer paper, as well as 'Clot paper' which he prepared himself.[80] A Whistler proof he printed for Vollard's second album is described as being on 'papier ancien' which the artist, who had a fetish about old paper, may well have supplied.[81]

The trappings of the original print or 'belle épreuve' were certainly well in place before Clot set up shop, although a double standard seems to have applied. Some prints are run off, on demand, from stones which are kept by the printer for the purpose, while for others the whole marketing paraphernalia comes into play, with limitation, cancellation proofs, and stern injunctions that no 'épreuves de passe' be allowed to circulate.[82] For some reason, such considerations particularly affected the later work of Fantin-Latour, most of which Clot printed; maybe it was because the popularity of the artist's sensuous nymphs and shepherds had, towards the close of his life, made him a much sought-after property. Sharp correspondence survives from the President and Secretary of the Société des Amis des Arts de Pau who, for the 100 francs they paid Clot for printing Fantin's *Maléfice*, expected to get the stone as well. 'You are only the printer', they informed Clot, ordering him to surrender it. The incident points to the peculiarly ambiguous situation in which a printer could find himself – owning the drawing ground, yet having no rights at all over the drawing. Matters came to a particularly nasty head with Charles Meunier concerning the printing of Fantin's exquisite illustrations for *Les Bucoliques, Poésies d'André Chénier* (5.23). The artist appears to have given Clot the bon-à-tirer proofs which Meunier officiously retrieved. The bad odour generated by his high-handedness seems to have had an unpleasant

letter 7

sequel, for despite the superb care that Clot devoted to the illustrations, which he printed in triplicate on three different papers, neither title page nor justification bears any reference to his collaboration. The poet, the writer of the exegesis, two artists, the publisher, the binder and the text printer are all named – but not Clot.

letter 5

As Pellet's remark has already established, Clot's services were not cheap. A letter from Maxime Dethomas records, with mild demur, that Clot charged him 165 francs for a small poster. By way of comparison, Henry Stern, who went into business for himself in the late 1890s when his former employer Ancourt was absorbed by Bourgerie et Cie, asked Toulouse-Lautrec for 41 francs for an edition of 100 impressions: 3 francs for the stone, 5 francs for the preparation and 33 francs for printing.[83] This may explain why Lautrec made extensive use of Stern's services, although the two men were also drinking partners, which gave them an additional bond. A letter from Arne Kavli (who had just married the discarded Tulla Larsen on the rebound from a disastrous affair with Edvard Munch[84]) reveals that Clot was charging 1 franc per proof in 1903. Two years later, the Steinlen commissioned by Lebeau for the portrait of Gorki, already discussed, worked out at 346 francs for 250 proofs for which the dealer supplied the paper, so avoiding Gorki's signature certainly had its price. Fantin's print for the organizers of the Berlioz Festival cost them 100 francs for 125 impressions. The price for really extensive editioning seems to have been considerably less. Bataille's first portfolio was charged at 12 francs per 100 monochrome prints and 15 portraits were pulled in editions of 850 copies.[85] When Fasquelle was considering a later portfolio, he offered 13 centimes per print for a job which would have necessitated 2,700 impressions. 'Don't quibble,' the artist counselled Clot, which perhaps explains why the portfolio was never published.

letter 12

Octave Uzanne was another celebrated Parisian for whom Clot also worked; Uzanne struck a hard bargain, negotiating with some care as to exactly how many polychrome cover reproductions (including false starts!) he was likely to get for 450 francs.

The lowest price asked for a print during the most intensive period of Clot's working life seems to have been about 30 francs for a Héran advertised in *Le Centaure* in 1896. Lunois enjoyed a healthy collector's market and his wife even sold Clot's rare proofs to her 'amateurs' at from 50 to 75 francs apiece. By 1910, Manzana Pissarro was writing to tell Clot 'the State' had paid 100 francs for one of his sumptuously decorative oriental lithographs elaborated by metallic colours; he later sold four proofs for 400 francs and told Clot not only that he would now be able to pay him, but that they could really look forward to some future work (5.22)! By the 1920s, Clot was asking Georges Rouault 7 francs each for his proofs – 'a bit steep' commented Rouault (who nevertheless paid 175 francs for 25 proofs promptly), 'because I haven't sold any yet'.[86]

Edvard Munch arrived in Paris in February 1896. His famous lithograph, *The Scream*, printed in Germany, had already appeared in the *Revue Blanche* in 1895. The artist's removal to Paris was perhaps occasioned partly by the breakup of the group he had frequented in Germany and partly by the presence in the French capital of his friend, Julius Meier-Graefe. Meier-Graefe had already published a group of Munch's etchings and was now working at Bing's. He been one of the founding publishers of *Pan* but his German colleagues forced his withdrawal in 1895 after he published Toulouse-Lautrec's eight-colour lithograph *Marcelle Lender en buste saluant*, which they viewed as the height of French decadence.

A surviving agreement drawn up in Clot's workshop was signed by Munch on 29 May 1897 just before he returned to Norway to prepare a major exhibition in Oslo (5.24). It shows that the artist had drawn, and wished to retain, 23 stones. The agreement committed Munch either to buying the stones for 598 francs, or, after three months, paying Clot 25 francs a month in rental. Two letters accompanying the rental fee after Munch's return to Norway survive in Clot's archive and two of Clot's receipts can still be seen in the Munch Museum in Oslo.[87] The workshop's romantic letterhead (5.25), presumably drawn by Clot, shows Cupid, upholding a curved form which does

double duty as bow and capital C, kneeling on a branch of blossom and smiling at two swallows fluttering below. Another short note from Munch also survives, telling Clot not to destroy 'the portrait with the green frame', which now pleases him.[88]

There is a very real possibility that Munch met Toulouse-Lautrec in Clot's shop, for the crippled artist's most famous portfolio, *Elles*, was exhibited at the offices of *La Plume* in April 1896, and although it was Pellet and not Vollard who published it, it was shown again with Vollard's first graphic album in June.[89] Indeed, a set of *Elles* was found in Munch's estate. Munch himself showed 50 prints at Bing's in May. The lithograph *Le Soir*, or *Anxiety*, was also part of Vollard's album; the image shows a crowd of ashen-faced figures advancing on the spectator out of a lurid sunset and was ingeniously inked by Clot with red and black on the one stone.

Another person known to have been in Clot's workshop with Munch was the German artist Paul Herrmann who, to avoid confusion with the French artist Hermann-Paul, called himself Henri Héran whilst in Paris.[90] Héran had made a bid for Clot's services but was told that Munch was 'booked in' already.[91] Héran's eyewitness account, relayed to Munch's biographer via Erich Büttner, tells how Munch ordered the colour variants of *The sick child*, his first and most famous full-colour print:

The lithographic stones with the great head were lying next to one another, neatly lined up, ready to print, Munch arrives, positions himself before the row, closes his eyes firmly and begins to direct blindly with his finger in the air: 'Go ahead and print ... gray, green, blue, brown.' Opens his eyes, says to me: 'Come, drink a Schnaps ...' And so the printer printed until Munch came back and gave another blind order: 'Yellow, rose, red ...' And so on another couple of times ...[92]

5.24 *Above left* Edvard Munch's agreement with Auguste Clot to rent or purchase 23 lithographic stones 29 May 1897 courtesy of Dr. Guy Georges

4.12, col. pl. 7

5.25 *Above* Rodin receipt on Auguste Clot's letterhead September 1898 photograph courtesy of Musée Rodin, Paris

Héran was obviously on good terms with Munch and his cataloguer relates how the impecunious Norwegian vacated his lodgings where he owed money by letting his personal effects down to his friend on a rope.[93] The revelation that Munch was pursued not only by an inner demon but by his creditors provides evidence of yet another stress that undoubtedly contributed to his alcoholism and subsequent breakdown. Héran and Munch were more than drinking partners, however; their output, not only with Clot's assistance, but as a result of other Parisian endeavours, confirms their considerable appetite for graphic experimentation. For example, they both produced intaglio prints using readymade aquatint plates with clipped corners.[94] Héran had been in the United States until 1895, but by August–September 1896, when the second and last volume of the magazine *Le Centaure* appeared, the prints that could be seen at the *Centaure* offices included several of his mixed media prints. One of these combined lithography with etching, several others combined lithographs with from two to four woodblocks. Clot was lithographer to *Le Centaure*, for which he printed Héran's *Nymphe effrayée [Frightened nymph]* (col. pl. 15); he is also credited in the artist's catalogue with a similar print called *Sirène* or *Undine*.[95] Héran's images are not particularly distinguished, rather banally employing transparent layers of ink and the striations of the woodblock to suggest the subaqueous environment of his water sprites. What is interesting is the way that the iconography of the submerged couple in the published print either imitates or prefigures Munch's more aesthetically compelling *Lovers in the waves* (5.26). The way this Munch is printed is another powerful testimony to Clot's remarkable expertise, for the broad swathes of the engulfing water, crudely drawn by the standards of the 1890s, are richly furnished with ink while the delicately crayoned features of the drowning couple retain their fragile vulnerability. Many of Munch's most famous lithographs – such memorable images as *Attraction*, *Separation* and *Jealousy* – were drawn in Clot's shop. The printer also introduced the artist to relief prints and almost certainly provided a model for the investigative attitude and technical ingenuity that characterizes Munch's later production, particularly where mixing media is concerned.

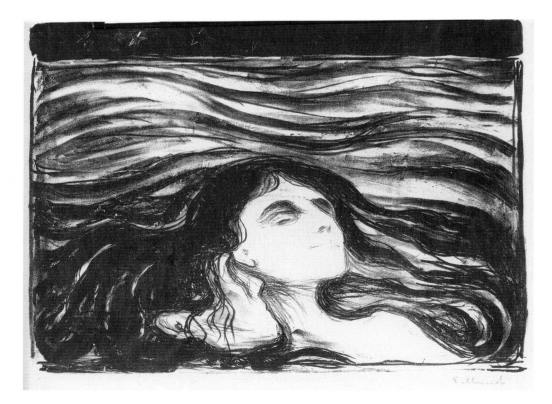

5.26 EDVARD MUNCH
Lovers in the waves 1896
lithograph
31.1 × 42.0
Australian National Gallery,
Canberra

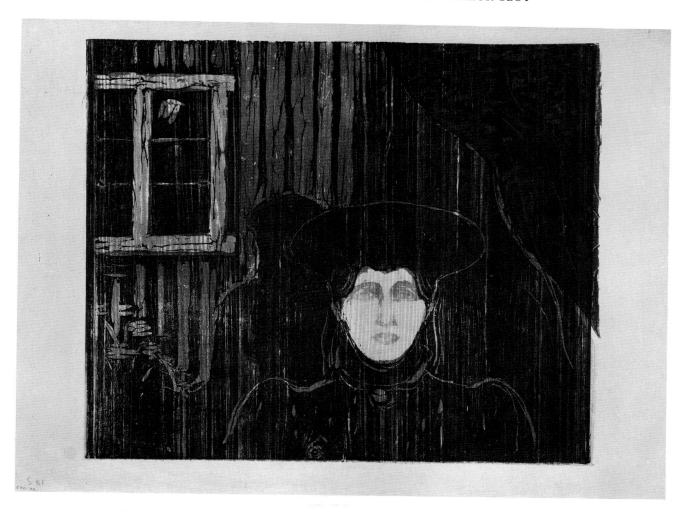

5.27 EDVARD MUNCH
Moonlight 1896
colour woodcut
40.7 × 52.7
Munch Museum, Oslo

Rendering an image cut in wood by lithographic process is a strategy Munch undertook soon after his return to Norway. Although the resort of printers rather than artists, it has been commonplace since lithography began to take a print from the surface of cut wood or intaglio metal onto a lithographic stone by means of transfer paper (5.28). The possibility is mentioned in most treatises, including the one published by Clot's former boss, Alfred Lemercier.[96] Although the transferral changes the nature of the image to a certain extent, if expertly done, the lithograph can retain such characteristics of the original matrix as the wood grain, while at the same time the process greatly facilitates the pulling of an edition. It is more than possible that the Héran print for *Le Centaure* was pulled by this means, but there was also a woodblock print called *Le Bain [The Bath]* in Vollard's first album, by the little-known artist James Pitcairn Knowles. This print manifests exactly the same suave veils of colour as some copies of Munch's woodblock print *Moonlight* (5.27) and both have obviously been pulled by a professional printer. There is also evidence in a letter to Clot from Jeanniot that woodblock prints transferred to lithography were by no means unknown among other artists frequenting Clot's workshop.[97] Equally Vuillard, who had previously combined techniques at Ancourt's shop, quite possibly deployed a small relief printing device partially to create the wallpaper patterns in some prints of his Vollard suite.[98] Some influence from Vuillard to Munch can certainly be argued, for one notices that the pattern of a tablecloth in one of Vuillard's interiors finds its way into Munch's later painting of his sister.

letter 9

After Munch's return to Norway with many plans for printmaking[99] he found life so

5.28 Transfer of wood to stone
plate VI from Supplement of
illustrations to the
French edition of
Senefelder's treatise.
Paris 1819
lithograph
9.7 × 13.2
Felix Man Collection
Australian National Gallery,
Canberra

VI.

Taille de bois transportée sur pierre

5.29 Draft of a letter from
Edvard Munch to Auguste Clot
courtesy Munch Museum, Oslo

158

hard and the 'Norwegian peasants' so unwilling to buy what he had to offer that on 26 June 1897, desperately short of money, he drafted a letter to Meier-Graefe in Paris, asking for a loan to be secured against 50 copies of *The sick child*. He wanted the money to recover printmaking equipment sent from Paris but held at the railway station because he could not afford the transport charges. At about this time, he also drafted a letter to Clot (5.29) asking him, as a beginning, to pull 50 copies each of *Attraction I* (5.30) and *The Lovers in the waves*.[100] This letter seems not to have been dispatched, but one of the surviving letters which did reach Clot, accompanying the monthly rent for stones, asks how much it will cost to pull 100 or 200 impressions from the stones he has left in Paris.

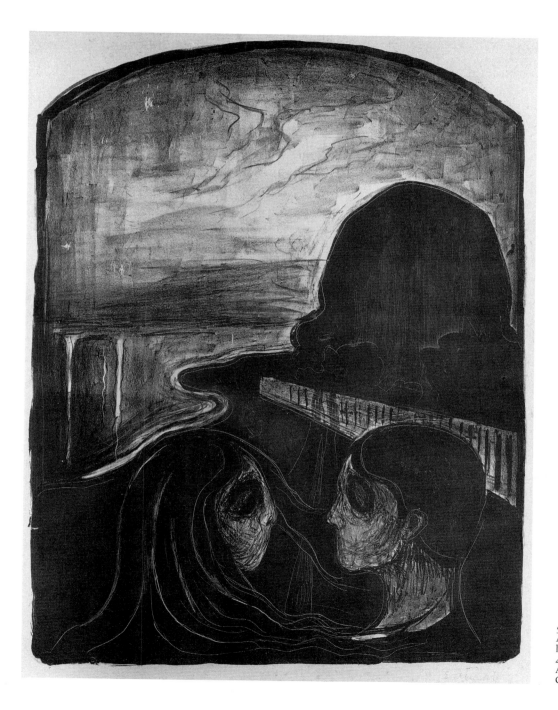

5.30 EDVARD MUNCH
Attraction I 1896
lithograph
47.4 × 36.0
Australian National Gallery,
Canberra

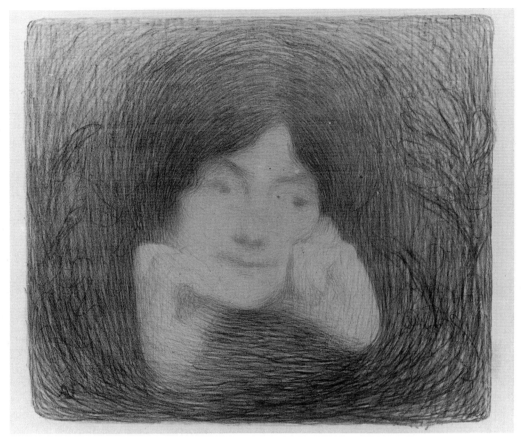

In September Munch had a major show in Oslo. For the exhibition poster, adapted from *Man's head in woman's hair* which is thought to have been the first woodcut Munch made at Clot's shop, the artist made a frottage from the woodblock which was then transferred to litho stone. He seems also to have used the device in other prints, for in early December in response to a request for a woodcut from Meier-Graefe, who may already have had the portfolio *Germinal* in mind, Munch wrote:

> If you want colour woodcuts they must be printed here because I am having the colours printed with litho stones.[101]

During the course of the next two years Meier-Graefe repeatedly tried to get the print he wanted from Munch, without success. Eventually, the publication of *Germinal* being imminent, he wrote a bitter letter complaining of the way he had been inconvenienced, suggesting Munch should either provide the print or return his money. Munch eventually submitted a crayon drawing which, as Meier-Graefe wrote much later in 1913, was 'very beautiful . . . but too late and unable to appear'.[102]

When Vollard showed his second album in December 1897, it convinced Mellerio, who reviewed the show in *L'Estampe et l'affiche*,[103] that colour lithography had arrived. As well as hanging Toulouse-Lautrec's *Partie de campagne* and the Nabis artists who were the mainstay of his publishing programme, Vollard fielded an even more varied assortment of lithographs, most of which were printed by Clot. The artists included the boldly decorative Auriol, the vivid Guillaumin evidently agreeing with Gauguin that a pound of red is redder than an ounce, and the mysterious Aman-Jean, who cast all the women he depicted in the role of his tubercular mother, wistfully gazing at her children from behind glass (5.31). The sorrows of Breton peasants were addressed by Charles Cottet and Lucien Simon, while Shannon and Whistler

contributed images of domestic bliss drawn on transfer paper. Vollard relates that when he visited Whistler to seek a print for his album, he was invited to what he thought would be an aesthetic lunch, which turned out to be half a chop and some cold spinach. However, although his culinary expectations were disappointed, the dealer seems not to have been disappointed in art and he probably came away with a choice of two images of Mrs Birnie-Philip and her daughter.[104]

Only five of the 31 prints in Vollard's second album were not in colour and only two were not lithographs. The great majority had been printed by Clot, who, to Mellerio's chagrin, had drawn some of them as well. In his review, Mellerio expressed for the first time his ambivalent view of Clot's contribution. He was forced, he said (showing that penchant for giving with one hand while he took away with the other), to simultaneously 'highlight and call to account a player hidden backstage – the printer Clot'. He continued:

> With him when he takes the trouble, colour lithography displays workmanship of an extraordinarily expert quality. . . . [however] . . . Readymade displays of brilliance, with which a facile printer can easily but treacherously seduce one, must be rejected out of hand. The artist has to acquire his craft himself, actually put his hand to stone manipulating the technique fearlessly. In a word . . . he must stamp his prints with a style that identifies them as having been indisputably made by him . . .[105]

Since he was defending a purist conception of originality, Mellerio might have done better to focus his attention on the title rather than the content of the album, for Vollard had now revised the *Album des peintres-graveurs* as the *Album d'estampes originales de la Galerie Vollard*. Invoking the 'original print' did indeed raise questions as to the legitimacy of Clot's intervention. It seems Clot probably drew the Rodin, the Sisley, and the Redon in the second album and in the following year – for Vollard's third album, which was never officially published – he helped by drawing the colour stones for prints by Renoir and Cézanne. It is a measure of the extent to which judgements about such matters are made in the mind rather than with the eye that when Mellerio took the subject up again in *La Lithographie originale en couleurs* (5.32) of 1898 he hailed Manet's *Polichinelle*, from an artist 'revolutionary in prints as elsewhere,' as having 'lively and gay colours which were neither harsh nor heavy, auguring a new style';[106] apparently he did not realize that here, as in other images,

5.32 PIERRE BONNARD
Cover for *La Lithographie originale en couleurs*
[*Original colour lithography*]
by André Mellerio
Paris 1898
colour lithograph
22.4 × 19.0
edition 1000
Felix Man Collection
Australian National Gallery,
Canberra

Clot's facile and treacherous hand had been at work. Even less was he aware that the exquisite *Béatrice* by Redon (col. pl. 19), an artist he revered and whose prints he was later to catalogue, was a reproduction by Clot of a pastel belonging to Vollard.[107] In his review of the 1897 album, Mellerio described this lithograph as 'so personal and intense'; in his 1898 book he noticed its 'delicate, almost hesitant charm'. Neither of these descriptions exactly squares with a colour lithograph drawn for the artist by a chromiste displaying facile brilliance.

The artists Mellerio did castigate included Sisley and Cézanne, whose semi-reproductive colour lithographs the critic dismissed as slick technical achievements, falling between truly original lithographs and vulgar chromos. He also fulminated against facsimiles at some length, frankly employing the term to describe the lithograph after Rodin, drawn by Clot. Mellerio judged the tendency 'deplorable' and condemned it in no uncertain terms. Although 'lazy' artists came in for a portion of the blame, Mellerio decided it was the printer who was really at fault. The artists allowed themselves to be 'caught in the net' of his technique and the printer then found this 'an undeniable material means of emphasizing his own importance'; 'impatient to use the tricks he has learned or discovered', Mellerio felt that for his own aggrandizement he either paralysed the artist with fear or 'dazzled him with readymade displays of brilliance'.

5.33 PAUL CÉZANNE
Large bathers 1896–97
colour lithograph
42.0 × 51.8
2 variant editions
each about 100
Australian National Gallery,
Canberra

The injustice of this as a general criticism of Clot's method can be illustrated by his work with Fantin-Latour. Clot printed almost all the artist's later lithographs, clearly encouraging him to chance his arm and draw directly on the stone, rather than drawing on transfer paper as he had habitually done.[108] Similarly, although Sisley was mortally ill and, not unreasonably, sent Clot a pastel to interpret, his letters show he certainly supervised the work and he even appears to have sent an outline of some kind as well, so he may have had more to do with the print than has been commonly supposed.[109] As to Cézanne, there is no correspondence with Clot and it is probable that Vollard talked his idol into making prints for which he had little enthusiasm. Nevertheless, Douglas Druick's brilliant and exhaustive article on the now legendary images of bathers (5.33) demonstrates that the artist drew the black keystones in both cases and that Clot's help was enlisted chiefly to realize the colour as indicated by Cézanne on several maquettes. The most subtle part of Druick's analysis concerns Clot's continuing experimentation as he tried to keep the print alive in the process of editioning, making minute changes as he went. This is a feat for which Druick believes Clot cannot be faulted, since the lithograph intentionally records 'the search for, rather than the duplication of the successful image'.[110]

There is no doubt that Mellerio's strictures had considerable impact. Maurice Eliot, an 'also-ran' in Vollard's second album who was almost completely overlooked by the critic, worked on another print the following year at a time when he was suffering from an unspecified illness. Languishing on his sickbed, he agonized in several letters to Clot that he could not get to the workshop himself and, practically in Mellerio's own words, he expressed his desire to avoid the look of a 'chromo' and to give the print a few blemishes so that it had 'the look of having been made by me'. Clot cannot have been unaffected either; over 50 years later, André Clot was still displaying his father's Rodin watercolour interpretations in the workshop, and told the British lithographer Stanley Jones how his father was criticized for usurping the artist's role.[111]

letter 6

Perhaps nothing exposes the ridiculousness of Mellerio's thesis more surely than imagining how Clot could have snared the immortal Rodin in his net, had Rodin not been fascinated by the prospect. In 1899, Clot's reproduction of a Rodin drawing appeared in the first edition of Octave Mirbeau's *Jardin des supplices*. Not long afterwards Vollard commissioned Rodin to draw 20 figures specifically for a luxury version of the same book; receipts for the collection and return of drawings at the Musée Rodin suggest that Clot embarked on the project almost immediately.[112] Clot's task was particularly difficult: the drawings Rodin was then making were lightning pencil sketches later loosely washed with transparent colour, spontaneously set down while the sculptor gazed at the uninhibited models draping themselves about his studio. Trial proofs reveal that contrary to superficial appearances Clot did not use tusche wash to interpret the watercolour, but applied rubbing crayon and stumping of Whistlerian sensitivity (col. pl. 18). While the colour is certainly hand drawn, the outline may well have been photographic, for although each illustration follows the size of the original, it also appears as a linear miniature on the tissue overlay carrying the caption and protecting the plate.

In 1900, *La Plume* devoted a special number to Rodin. Mellerio, whose letters asking to see the printer survive,[113] was commissioned to write about Clot's reproduction of the sculptor's drawings. Less than two years after expressing a negative opinion of Clot and damning all facsimiles out of hand, Mellerio effected a complete *volte face*,[114] for Clot's hand was suddenly seen as preferable to photomechanical solutions. Monsieur Clot, the critic now told the world approvingly, rejects photographic compromise or three-colour process. What he brings to the task is 'an intelligent mind which observes, reflects and then decides ... without the comforting aid of any ready-made formulas.' The printer, who was without rivals, he went on, decided each case on its merits so that his strategy resulted 'not in a lifeless facsimile but in the transposition of a living vibrant equivalence.' And Mellerio praised the artist (for, he had decided, Clot 'truly is one') not for his facile brilliance, but for his profound knowledge of the chromiste's

skill and 'subtle and accurate feeling for art'. Together, Mellerio opined, these permitted him to bring into being 'a reproductive print using polychromatic lithography while retaining its interpretative character.'[115]

In an earlier magazine issue devoted to Rodin, Fagus had commented that Clot's reproductions were so perfect that the sculptor could not distinguish them from the originals.[116] Rodin himself was quoted by Vollard as saying: 'When Clot is gone lithography will be a lost art.'[117] Quite apart from reports of such high opinions, the documentation shows that the two men had great respect for each other and that they often met when Rodin supervised Clot's work. Clot visited the sculptor socially and invited him to dinner at his own home in La Varenne St Hilaire. There is even a small card from Gabriel Astruc asking Clot to put in a good word with the master for his sculptress niece: 'I have written myself,' he tells Clot, 'but I know that you are the one with the real influence.'[118] In 1904 Clot and Éphrussi of the *Gazette des Beaux Arts* initiated a plan to produce an album of Rodin's drawings at their own expense; for his part, the sculptor supplied lists of people he thought could afford to subscribe. For some reason, the project seems to have aborted, possibly due to Éphrussi's death.[119] Clot, however, continued to reproduce drawings for Rodin's book *The Cathedrals of France*. He often visited the sculptor at Meudon (5.34). Another extraordinary job arising from his association with Rodin was for the black magician and confidence trickster, the 'Great Beast' Aleister Crowley. Crowley, an Englishman with literary aspirations, must have seen *Jardin des supplices* soon after it came out and around 1904 he decided to ask Rodin for similar watercolours for his own use. A surviving telegram reveals that Crowley and Clot visited Rodin together. In 1912, Clot also

5.34 Rodin (left), Auguste Clot (right) in the garden at Meudon with the Czech sculptor Frantisek Bilek (centre) photograph courtesy of Dr Guy Georges

lithographed 1,000 copies of a portrait of Crowley, for which the model was an Augustus John drawing. Although Clot was undoubtedly used to exotic characters – the eccentric Henry de Groux, complete with frock coat and gold earrings, was among his customers – he can never have encountered anyone quite as bizarre as the 'Great Beast'. From 1903 to 1912, the years they corresponded, Crowley variously styled himself the Laird of Boleskine, Count Svareff, or Prince Chioa Kahn, and dressed to suit the part in everything from Highland regalia to black silk knickerbockers. After his unlikely marriage to Rose Kelly, daughter of a Camberwell vicar, Crowley roamed the world, writing to Clot from Rangoon, St Moritz, or his estate in Scotland, between climbing the Himalayas, crossing China on a donkey, and indulging in mystical orgies in Egypt. It is small wonder that, after a sinister incident widely reported in the press, Clot made his own enquiries about this dodgy customer.[120] In his own good time, the 'Great Beast' paid Clot 10,000 francs for ten Rodin reproductions in editions of 500, so the experience, however nerve-racking, proved a good deal more remunerative for Clot than similar work for Rodin. Crowley used seven of Clot's plates for *Rodin in rime* and three others to embellish slim volumes of his own poetry. Characterized as 'Swinburne with water', his verse celebrated his wife Rose, who was first exalted, then found wanting and finally driven to drink and discarded. Between 1905 and 1907 Clot's exquisite lithographs followed Rose's waning star from *Rosa mundi* and *Rosa coeli* to *Rosa inferni*. At last, with *Rosa decidua* recording his divorce in 1910, Crowley, who was running out of money, also ran out of Rodin watercolours and made do with a photograph.

After the virtual collapse of the satiated original print market at the turn of the century, Clot found himself increasingly engaged on reproductions rather than original prints. Even the latter may have a somewhat equivocal character from a purist's point of view. He experimented, for example, on various ways to make lithography easier for artists who did not really want to spend much time at his studio, but to treat the process as drawing rather than to master it as a métier. In 1910 his 'new discovery' was hailed in a somewhat ambiguous account written for *L'Art Décoratif* by de Crauzat, Steinlen's cataloguer. Describing the state of lithography as torpid and currently faced with 'the spectre of death', de Crauzat wrote that after incessant research, Clot could now transfer and print from

> . . . any drawing done in crayons of whatever sort, be they black or coloured, just so long as they are greasy (like German crayons with their oily base or children's Raphael crayons), or even drawings using graphite or lead pencils, as long as they are not too hard . . . [such drawings] . . . will be able to be transferred to stone and reproduced lithographically, even if they were not specifically designed for this purpose in the first place . . . whereas formerly such drawings were lost in the process of transferring them to stone, now nothing of them is lost: it is as though they are merely reflected in the stone like a face in a mirror or like an image on a photographic plate.[121]

De Crauzat explained that not only could Clot use and then return the original drawing to the artist, but could reduce or enlarge it as well, with a process called Fougeadoire. The interested reader could well have been forgiven for feeling that the whole procedure had a somewhat magical air. The Fougeadoire process certainly existed, but it was not Clot's discovery, and one of the treatises describing it notes that it was rapidly overtaken by photolithography.[122] Equally, by super-sensitizing the stone with alum, it had long been possible to take some kind of transfer from an ordinary crayon drawing so that at least some trace of the original survived. It is not clear, therefore, to what extent Clot had improved on existing possibilities. The article gives no inkling whether Clot's new practice was in any way linked to the counterproofing of pastel portraits for Mary Cassatt around 1904, and possibly to the same process also undertaken for Renoir. Nor does it mention the various photographic experiments, chiefly in collotype, that Clot had embarked on by this time.

5.35 PIERRE-AUGUSTE
RENOIR
Odalisque *c.* 1904
lithograph
8.2 × 12.4
edition 75
Felix Man Collection
Australian National Gallery,
Canberra

There is a possibility that around 1913 Clot used his new techniques on the drawing Munch had sent too late for *Germinal*.[123] Clot had printed a number of lithographs for this portfolio, published by Meier-Graefe at the turn of the century and named to show solidarity with Zola during the Dreyfus affair. Clot not only printed, but also drew a brilliant interpretation of a pastel of a half-length dancer by Degas and he editioned the lithographs of the Nabis, of Renoir, of a large and handsome Brangwyn, and the contribution of Van Rysselberghe. Due to this artist's disaster with his transfer paper, the printer must have needed almost to start again from scratch.

letter 13

Clot's entire technical repertoire from the most original to the most reproductive – plotted on a sliding scale from black to white through several shades of grey – is probably to be found in the work he did for Renoir. Certainly the colour prints, which seem to have sold well, are a constant topic of Vollard's correspondence between 1900 and the first world war (5.37).[124] Claude Roger-Marx, the first cataloguer of Renoir's lithographs, admits in the introduction to his book that Clot played an enormous part even in the execution of the monochrome prints (5.35). For the portfolio of 'autographies'[125] (5.36) – said to have been made in 1904 but published in the year of

5.37 *Opposite* PIERRE-
AUGUSTE RENOIR
The pinned hat, 1st
plate 1897
colour lithograph
59.0 × 49.2
edition 200
Australian National Gallery,
Canberra

5.36 PIERRE-AUGUSTE RENOIR
Study of seated female nude
c. 1904
from *Douze lithographies
originales de
Pierre-Auguste Renoir*
[*Twelve original lithographs
by Pierre-Auguste Renoir*] 1919
lithograph
19.3 × 16.4
edition 1000
Australian National Gallery,
Canberra

5.38 PIERRE-AUGUSTE RENOIR
Frontispiece
from *Douze lithographies
originales de
Pierre-Auguste Renoir*
[*Twelve original lithographs
by Pierre-Auguste Renoir*] 1919
collotype
30.7 × 19.0
edition 1000
Australian National Gallery,
Canberra

the artist's death – Clot reproduced by collotype an attractive table of contents which was to become a leitmotif in Vollard publications (5.38). No letters survive from the artist to Clot, nor did he exactly wear out the path to the rue du Cherche-Midi. He was only too happy to 'throw a drawing on transfer paper' and leave his guide to orchestrate the result.[126] As for Renoir's colour prints, Clot made some of his most delicious interpretations for the old and by then tragically arthritic artist: a tender, luminously rendered standing nude and the even more enchanting close-up of Renoir's baby with a biscuit, which with its subtle veil of modifying white, betrays one of Clot's hallmarks. As Roger Passeron observed: 'Clot alone would never have been able to create such a lithograph. But for Clot, on the other hand, Renoir would never have undertaken it.'[127] Indeed, Clot's comprehension of the models from which he worked was said to be 'so full of respect, his fidelity so lucid', that in Roger-Marx's view even the prints after Renoir for which Clot was alone responsible warranted consideration as originals.

The range of Clot's tasks as the 20th century progressed was considerably wider than it had been in the 1890s. More frequently without a credit, he still made long runs of prints in journals for the new wave of 'impressionists of the shadows', such as Le Sidaner, Lebasque and Lévy-Dhurmer. He continued to make lithographs for old customers like Lunois and Fantin, and he took on newcomers like Henri Matisse.

Matisse's great Fauve woodcuts were pulled in Clot's shop, as were two extensive runs, in 1906 and 1913, of deceptively simple linear lithographs. These represented a new manner of drawing for Matisse, their fluid arabesques related to his painting, *Joie de vivre*. More than one commentator has perceived the influence of Rodin, whose drawings the younger artist would almost certainly have seen in Clot's workshop. Several of the prints Matisse made at this time have surfaced with dedications to Clot,[128] and one letter has survived. It accompanied the return of some damp proofs which Matisse asked the printer to dry, telling him to be sure to follow the mise-en-page he had indicated to M. Carré. It would be interesting to trace the exact relationship between Matisse's lithographs, Clot's 'new process', and 17 of the artist's original drawings which remained in Clot's workshop and were handled along with his estate.[129] Equally fascinating is the remarkable correspondence between the 'Fauvist vibrato' brush drawings and the woodcuts identically matching them.[130]

Although the exact date can only be conjectured, somewhere around the turn of the century or shortly afterwards, Clot must have worked with Edgar Degas, perhaps the most demanding artist he ever encountered. While there is no correspondence from Degas himself, Vollard's letters often mention him, particularly in relation to the reproduction of his pastels. It is not clear which reproduction is the subject of the anecdote, but Vollard tells how Degas was at first angry when he caught sight of 'an admirable colour lithograph by Auguste Clot of one of his own works'. The artist had apparently never been consulted about it – 'What? They have dared . . .' he began, and then reconsidering: 'All the same, he's a clever fellow the wretch who did that!'[131]

letter 3

Pellet too was interested in Degas and was involved in the sales of his estate. Several impressions of the late lithographs by Degas depicting women washing themselves have surfaced from sources that indicate Pellet bought in, or had small editions made. As with his reprints of Toulouse-Lautrec's stones, there are very few clues as to date.[132] It could appear that Pellet simply acquired the artist's stones and had editions pulled without the involvement of Degas. However, radical revisions mark the closing stages of the sequences, and copies, not just of the last stage of several different images, but of earlier states as well, have re-surfaced at sales where they were identified as having been in Clot's possession. This, plus the presence of multiple copies of three different Degas images in Clot's estate, would seem to offer additional confirmation that these two extraordinary individuals worked together.[133]

The last sequence of lithographs by Degas is usually placed in 1891 or 1892 on the basis of a letter the artist wrote to a friend, in which he speaks of intending such a series.[134] However, Mary Cassatt, whose prints of similar subjects may have acted as a

spur, wrote in a letter of 1893 that Degas had been 'talking for some time of doing a series of lithographs' but that she was afraid that there the matter would end.[135] Until recently, the tortuously interwoven sets of images have been difficult to unravel, but after some remarkable curatorial detective work, the way Degas continually restated and transformed his obsessive theme has been made much clearer. Apart from one rare and undeveloped sketch, there are essentially three pictorial ideas – a standing nude drying herself and looking to the viewer's left; three complex sequences of a bather looking right, entitled *After the bath* and generated initially from one photo-transfer but developed on three stones over nine states; and a larger separate version of a similar scene.[136]

While the precise date may still be in question, annotated proofs confirm that Degas began his work on the series with a friend called Manzi skilled in phototechniques, and that the *After the bath* sequences started out as an experiment in transferring an image on transparent film by light.[137] Although the exact train of events may now be impossible to prove, Degas seems to have travelled a certain distance with each idea, and then set it aside. At a significantly later date when, one hazards, Clot entered the picture, radical reworking often involving transfer to another stone took place. In two cases in which there is a marked disjuncture – the abandoned first try for *After the bath I* and state 3 of the largest print just before it is reworked and transferred to a new stone – impressions are taken on the exquisite gossamer paper called Japon pelure. This is a paper Degas had never used before but which was frequently used in Clot's workshop.[138] There is also another coincidence: when Fantin-Latour worked in 1903 on his illustrations to the Chénier poems, Clot not only printed the impressions on the same paper, but the artist adopted the somewhat unusual practice, also seen in the case of Degas, of applying later modifications by means of transfer paper over work already put directly on the stone (5.39). As to the processing and printing of these images, not only is the painterly work with acid and the transferral from surface to surface a task requiring the skill of a consummately professional lithographer, but the pulling of impressions from the completed stones, particularly on the fine fly-away paper, also requires a highly sophisticated printer. As Michel Melot noted:

5.39 HENRI FANTIN-LATOUR
Lydé
in *Les Bucoliques,*
Poems of André Chénier
Paris 1903
lithograph
23.4 × 18.4
edition 31/177
Australian National Gallery,
Canberra

The proofs on Japan of this series are the summit of technique, as much for the drawing as for the printing, which rivals the intensity and velvet quality of pastel and where innumerable nuances are retained from the stone (at the price of what manipulation?).[139]

Clot's life was nothing if not full of variety. One day he could be working for the greatest graphic artist of the era, the next, printing slim volumes of no consequence for titled amateurs of doubtful talent. An unusually complete correspondence chronicling their joint endeavour survives from the Comtesse Molitor (pen name 'Quill'), whose unremarkable brainchild *Vieux échos d'une éternelle chanson [Old echoes of an eternal song]* illuminated 1903. Clot did not simply work on its lithographic embellishment. For the handsome sum of 4,000 francs he helped bring the entire work into being and the title page names him Editor. Editing may not have been his forté, for not only does the title change between the cover and the first page of the book, but 'Quill' too, sinks without trace. Nevertheless, the letters present an attractive picture of the Countess correcting galleys at her country château and supervising the exact disposition of the lilies and irises in her Art Nouveau borders as she is gradually transformed into a particularly satisfied customer. Clot also worked on a book about Egypt called *Terre de symboles [Land of symbols]* for a famous Jewish society hostess of the period, Madame Ernesta Stern (pen name 'Maria Star'). This time, the book was editorially masterminded not by Clot, but by André Marty; Clot's task was confined to reproducing the watercolours made by an Italian artist who had accompanied the author on her travels. When the book was finished the author graciously wrote an elegant letter telling Clot that her success was in large part due to him and that his artistic care was 'today the admiration of all rare booklovers'.

Famous for his earlier portfolio *L'Estampe originale*, Marty was now in the employ of the *Gazette des Beaux Arts*. Although his reputation is founded on his publication of original prints, several letters show he was also involved in the reproduction of art as well, an aspect of his activity in which, predictably, history has shown little interest. Marty drew on Clot's skills, for example, for the exquisite book he wrote on print processes in 1906, when Clot drew and/or printed most of the illustrations for the chapter on lithography.[140] Although the letters rarely make clear the exact nature of his dealings, Marty evidently had some kind of business contact with Théodore Duret and the art dealer Bernheim Jeune. Duret, a Parisian luminary and friend of Whistler who wrote a book about the artist in 1904, used Clot to reproduce two of the illustrations in it; a famous portrait of the author himself in colour and *Nocturne*, one of Whistler's most celebrated lithographs. At about the same time Duret, on the headed notepaper of Bernheim Jeune, mentions a whole string of painting reproductions after artists such as Monet, Cézanne, Sisley and Guillaumin, among others. As further evidence of this extensive reproductive activity before the first world war, Clot also drew and pulled a lithograph for Vollard, based on Cézanne's painting, *Déjeuner sur l'herbe*.[141] In the 1920s Clot, possibly photomechanically, illustrated a number of books; one of them was *Gavarni* by de Goncourt, in which several of the illustrated lithographs were the printer's own property.[142] The record therefore shows Clot moving effortlessly between the most photographic and the most autographic means, making every conceivable kind of print from the reproduction to the original. Moreover, the complete range of possibilities was often undertaken on behalf of the same artist.

Just as he had collaborated on originals and interpreted pastels for Degas,[143] so after the artist's death Clot made collotypes for two books published by Vollard and illustrated with Degas's monotypes (5.40). The work Clot did for these volumes might well be classified as reproductions of reproductions, for Maurice Potin first interpreted the monotypes in aquatint and then Clot made pictorial contents tables by means of which Vollard now announced the distribution of illustration in each book.

Georges Rouault is another great artist of the 20th century whom Clot advised on the entire spectrum of graphic techniques. Despite the fact that Rouault eventually

5.40 EDGAR DEGAS
Woman seated in an armchair
c. 1879
monotype reproduced by Clot
on pictorial contents sheets of
La Maison Tellier (Vollard 1934)
original monotype in
Australian National Gallery,
Canberra

letter 15

abandoned the work Clot did for his albums of reproductions, the association between the two men was a particularly warm one, as can be seen by Rouault's affectionate and idiosyncratic letters.[144]

It seems that from the beginning Rouault thought of graphic art in reproductive terms, as a way of circulating his ideas; he dreamed of making albums. He first worked with Clot in 1910, when he made a colour print of horses in harness, known by a number of titles.[145] It seems very likely that this superb four-colour print was drawn by Clot – it is technically far too sophisticated to have been put on stone by someone who had never drawn a colour lithograph before. Rouault was nevertheless heavily involved in its supervision and, writing to his friend Florian in Prague to discuss the albums he still had in mind, Rouault told him that he had been working with 'a very famous artist for reproductions of this sort who produced my "horses" . . . (and they were admirably reproduced) . . . BUT' he went on, 'I know that I should never get it finished with that man alone, it would have taken years.'[146] In 1912, mourning the recent death of his father, Rouault expanded his ideas to include a *Miserere* and planned various ways to turn the solemn themes of this great series of drawings into print. In December he showed the model for such an album to Vollard who said: 'So you are a traveller in lace are you? . . . In the past I would have been delighted to publish this. I don't publish anything any more.'[147] By 1913, Florian had found a Czech printer called Unie who might have undertaken Rouault's work, but war prevented the development of the association. Towards the end of the combat, Vollard bought everything in the artist's studio and it was then that a bargain was struck that Vollard would publish *Miserere* if Rouault would illustrate a book the publisher had written.

The fraught association between the artist and the publisher has been admirably treated in the book about Rouault's original prints by François Chapon and the artist's daughter Isabelle. Briefly, Vollard at considerable expense eventually transferred by photo-process onto copper about 150 of the artist's profoundly moving Indian ink drawings. In view of Vollard's heavy disbursements, the artist was now bound to these plates like a dog with a tin can tied to its tail and he went on reworking them throughout the remainder of the publisher's life.

After a fallow period, Vollard had gathered all kinds of craftsmen around him by the early 1920s, but Chapon hints at elements of discord in the relationship Rouault formed with some of his printers. Hidebound by their own traditions, they could not fathom the artist's exhaustive struggle for perfection, more particularly since Vollard required them 'in all humility, to remain the artist's servitor and to accept his demands for miracles of technique without in any way vying with him.'[148]

Clot, of course, was still one of Vollard's co-workers and the success of his collaboration with Rouault is a most eloquent testimony to his ability to empathize with every kind of artistic temperament. Rouault's daughter says that the artist used Clot as intermediary because he did not get on with the firm of photo-engravers in the rue du Cherche-Midi who were carrying out some of the work on *Miserere* for him. As Chapon explains:

> Rouault greatly liked this craftsman and enjoyed working at his studio. Further-more this studio was next door to Macquart copperplate printing works in the rue du Cherche-Midi where the initial plates for the *Miserere* were probably photo-engraved. The artist apparently used Clot's studio for research and experiments that were not concerned solely with lithography, the firm's speciality.[149]

It seems therefore that, although etching was not his craft,[150] Clot nevertheless assisted Rouault at least in the initial stages of the *Miserere* project. In fact, in January 1922, the artist wrote to Vollard that he should go to Clot's where he would see 'that retouching is no joke'.[151] Some three years later Clot found himself working lithographically for the artist on parts of his album, as well as proofing colour collotypes of two of his *Miserere* subjects.[152] Eventually Rouault returned to an all-intaglio conception and reworked the plates again and again using every conceivable technical strategy and

running through a whole succession of intaglio printers to try to achieve the quality he desired. Far from being a reproductive album, *Miserere* became one of the most original and inventive works of the century, involving the artist in endless handwork to vivify, and reclaim as his own, the photomechanical base. Vollard's death in 1939 was almost immediately followed by the second world war and as a result it was 1948 before *Miserere* was actually published.

In the mid 1920s Rouault also made some original monochrome lithographs for Frapier's albums and a little later began work with Clot on similar lithographs for Vollard. For some reason these were set aside and a letter from Rouault to Vollard in 1931 complains of how difficult it is to work on stones that have been for some time unused. By 1933, however, the artist had completed magnificent portraits of *Hindenburg*, *Verlaine* and *St John the Baptist*, representing divergent types of personality – the warlike, the poetic and the religious. Rouault went to inordinate trouble and one of the subjects involved five studies and nineteen states. He also made a superb architectonic composition of figures in a landscape, *Automne [Autumn]* (5.41). It was a subject he had taken up twice for *Miserere* and abandoned, but reworked with Clot's help it became one of his greatest lithographs. In Chapon's opinion:

> The prodigious skill of the work, the admirable understanding of the possibilities of black and white that Rouault lavishes upon it, suffice to show that his genius had fully mastered the art of lithography and would have brought to it, had time permitted, a similar rich inventiveness, in its own domain, to that he attained with copper engraving.[153]

5.41 GEORGES ROUAULT
Autumn 1927–1933
lithograph
44.0 × 59.5
Australian National Gallery,
Canberra

At the time that these prints were completed, Clot, even if he never completely retired, was at least easing up. His grandson Guy Georges, destined to take over the workshop when his Uncle André died, often played with his grandfather in the studio during this period. He remembers that Rouault and Auguste Clot were often conferring, and he also met Roussel, Denis and Vuillard. After the economic doldrums following the first world war, the market for original prints had picked up again. Both longstanding customers like Maurice Denis and a new generation of artists, such as Luc-Albert Moreau (5.42), Vertès and Ernotte, flocked to the rue du Cherche-Midi. Their high-spirited letters, mostly addressed to André Clot, use affectionate nicknames for the workshop, calling it 'La Ratière' or 'Le Palais lithographique'; their custom ensured the continuation of the tradition.

History, W. R. Lethaby was fond of saying, is what we think happened; the real thing was different. Certainly Auguste Clot has so far eluded art historians. It is as false to see him through Roger-Marx's rose-coloured spectacles as a collaborator in purely original art as to condemn him, like the mud-slinging Mellerio before he saw the light, as the Svengali of the facsimile. Clot's life was much more complex. As a practitioner at a time when printmaking was undergoing a radical transition, he proved himself one of the greatest all-rounders that lithography has ever produced.

5.42 LUC-ALBERT MOREAU
Negro dancer 1927
lithograph
35.2 × 26.1
2nd state 1/10 (artist's proof)
Australian National Gallery,
Canberra

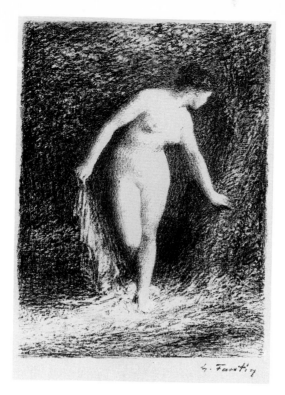

5.43 HENRI FANTIN-LATOUR
Diana in *Les Bucoliques,*
Poems of André Chénier
Paris 1903
lithograph
20.2 × 14.4
edition 31/177
Australian National Gallery,
Canberra

Far from dominating his victims with his facile brilliance against their will, the record shows that Clot adjusted to a whole variety of situations. As Bonnard found, Clot was only too happy when artists rolled up their sleeves and got their own hands dirty alongside him. Judging the appropriateness of each occasion, he could be an unobtrusive and deferential servant, or an ally with an imagination of his own. Unusually for a printer at a time when secrecy was a matter of job protection, he showed remarkable openness. This extended to supplying those artists interested in the technical side of the process with the chemicals to print their own lithographs in their own homes. He (and his son after him) would mix an appropriate 'mélange' and send instructions to artists as to how to use it,[154] a service Whistler never got from Way.[155]

As to his reproductions, the word covers a multitude of sins. Artists like Rodin, large enough not to be threatened by the printer's skill, left Clot to his sublime devices and were rarely disappointed. To others he offered the complete range of possibilities for their participation. With, or without the credit, he would draw and print the whole work for an artist or he would simply draw the colour plates based on an approved keystone. As a matter of course, he would retouch the washes that artists found too tricky. Yet whether he was preparing a diploma for the Central Society of Aquiculture and Fish or a gossamer vision of Diana to make the artworld catch its breath (5.43), he brought to both the same fastidious care.

He could not have seen it as his job to uphold the purity of the original print, or, as a competent photomechanician, to turn his back on the most recent innovations. In good times and bad he aimed to stay afloat. De Groux called him king of a diabolic craft, the elder Roger Marx spoke of his 'consummate science';[156] but both men knew that he distinguished everything he touched and that (even if he was a little late at times) whatever he did, he did beautifully.

Although I have signed this essay and am responsible for its faults, it could not have been written without generous help from the members of the Department of International Prints and Illustrated Books at the Australian National Gallery – Stephen Coppel, Christine Dixon, Ross Gould, Lanier Graham, Mark Henshaw, Jane Kinsman, Cathy Leahy and Margaret Stack.

A selection of letters to Auguste Clot

Translated by

Mark Henshaw

1]

from HENRY BATAILLE

'*I could have gone to the worst printer in Paris and got a better job* . . .'
n.d.

My dear Clot

I am more than surprised about what's going on. First of all, I came at the agreed time, you weren't there. And despite all my warnings, my entreaties, the printing was done in such conditions that I can and will say, my dear Clot, that you are falling down on your obligations – and even on the honour of your firm and your name. You put stones and make-readies[1] into the hands of workers who don't know a thing about them and <u>without your even being there</u>!!That's a bit thick! The result is not only an indescribable mess but the stones are completely and perhaps irreparably damaged. And not only did you let a worker initiate the process while you were absent, but the printing afterwards wasn't even supervised.

The stones have become filthy without this being remedied and the prints bear no relation to the *bon-à-tirer*. It's been done any old way . . . I could have gone to the worst printer in Paris and got a better result.

You do have, however, a great responsibility toward me, and toward Ollendorff,[2] and you owe it to yourself to give a minimum of attention.

It's not because I didn't warn you.

I must tell you that I've decided to skip the printing – and not to underwrite the cost of my album if it continues like this for one more day. I'm going to notify Ollendorff about this. And I'm also stating, since my warning has meant nothing and it's as though I were wasting my breath, that the 150 to 200 unsatisfactory prints pulled of <u>Gide</u>[3] (the green gentleman) will have to be torn up and re-done and it will be the same for all the prints that are like this.

Further (and I'm making this absolutely clear), if any of the stones has deteriorated to the extent that you cannot get it back to the state of a *bon-à-tirer* – since I do not wish to re-do the portraits – I've decided to <u>drop the album</u>. You'd have to come to some arrangement over the costs with the Ollendorffs as you will understand.

I'm telling you this for the last time – but that's it. I repeat I had confidence in your name and your word and it would never have occurred to me that you would leave an album in which both our reputations are involved in various ways in the hands of a workman without even being there yourself and without supervision.

That should sort things out. My compliments
[signed] Henry Bataille

Mon cher Clot

Je suis plus qu'étonné de ce qui se passe. Je suis venu d'abord à l'heure dite, vous n'y étiez pas. Et malgré tous mes avertissements, mes prières, le tirage s'effectue dans des conditions telles que je peux dire, et je le dis, mon cher Clot, que vous manquez à vos engagements – et même à l'honneur de votre maison et de votre nom. Vous mettez entre les mains d'ouvriers qui n'y entendent rien, des pierres à tirer, des mises en train[1] *sans même que vous soyez la!! C'est raide!*

Le résultat est non seulement une cartonnerie sans nom, mais les pierres sont complètement et peut-être irréparablement abimées.

Et non seulement vous confiez la mise-en-train à un ouvrier pendant que vous êtes sorti mais le tirage après cela n'est pas même surveilli. Les pierres s'encrassent, et les épreuves n'ont aucun rapport avec le bon-à-tirer, sans qu'il y soit remédié. Ça va comme ça peut . . . C'est à dire que

je me serais adressé au[sic] dernière imprimerie venue de Paris j'aurais eu mieux.

Vous avez cependant une grave responsabilité vis à vis de moi, d'Ollendorff[2] *et vous devriez à vous même un minimum d'attention.*

Ce n'est pas faute de vous avoir prévenu.

Ce que je peux vous affirmer c'est que je suis décidé à sauter le tirage et à ne pas laisser garantir mon album si ça continue un jour de plus comme ça. Je vais en avertir Ollendorff.

Et ce que j'affirme aussi puisqu'aucun avertissement de ma part ne sert à rien et que c'est comme si je chantais, c'est que les 150 à 200 épreuves ignobles qu'on a tirées des <u>Gides</u>[3] *(le bonhomme vert) seront déchirées et recommencées. Et qu'il en sera ainsi pour toutes les épreuves du même genre.*

De plus encore (et j'en prends l'engagement ferme) si une pierre est détériorée sans que vous puissiez la remettre en état du bon-à-tirer – comme je ne veux pas recommencer les portraits – je suis décidé à <u>lâcher l'album</u>. *Vous vous arrangiez avec les Ollendorff pour les frais comme vous l'entendez.*

C'est dit pour la dernière fois. Mais c'est la borne. Je vous répète que je me suis fié à votre nom et à votre parole et qu'il ne me serait jamais venu à l'idée que vous laisseriez aux mains d'ouvriers sans même vous trouver là, et sans surveillance même, un album où nos deux réputations sont engagées à des titres[?] divers.

Voilà qui est entendu – Mes compliments
[signed] Henry Bataille

1. 'Mise-en-train', used in a general sense, means to begin a process. Used as a noun, it translates as 'make-ready'. This technical printing term is more often applied to relief printing or typography than to hand lithography, although in recent years it has been associated with photolithography.
2. The album *Têtes et pensées* was begun in 1898 and published by Paul Ollendorff in 1901.
3. The album comprised twenty-two portraits of notable Frenchmen; one was André Gide (1869–1951), whose portrait was printed in green.

[CA 18/19]

2]

from AMBROISE VOLLARD *re* JACQUES-ÉMILE BLANCHE

'*I did not wish to have the same artists using the same process as in the first year.*'
Paris, 3 July 1897

Dear M. Clot

You will have to do the editioning of the Blanche plate for the <u>third year</u> of my album as soon as you have the *bon-à-tirer*.

Be sure to tell M. Blanche that I did not have this plate appear in the second year because I did not wish to have the same artists using <u>the same process</u> as in the first year.

Until I see you
Regards
[signed] Vollard

Paris le 3 juillet 1897

Cher M. Clot

Il faudra que vous fassiez le tirage de la planche de Blanche pour la <u>troisième année</u> *de mon album aussitôt que vous aurez le bon-à-tirer. Dites bien à M. Blanche que je n'ai pas fait paraître cette planche dans la deuxième année, c'est pour cette raison que je ne voulais pas avoir les mêmes artistes avec* <u>même procédé</u> *que dans la première année.*

En attendant de vous voir
salutations
[signed] Vollard

[CA416]

3]

from AMBROISE VOLLARD *re* DEGAS

'*Before I left Degas, I saw a pastel . . . The colours are dazzling. It's one like this we want.*'

Cabourg, 28 April 1911

My dear Clot

At the same time that you bring me my Degas on Monday, call at Lézin[1] and pick up his book of paper samples for framing. Here's why.

Before I brought my pastel to you I had the chance to show it to Degas who said that the white frame does not suit him at all and he wants to frame it in the same manner as his pastels. [Crossing out] Before I left for the country he asked if the pastel had been reframed and to show it to him. I believe that what he has in mind is a painted wooden frame. I would much prefer a paper mount and therefore I think it should be chosen with the greatest of care so that if Degas finds it an acceptable colour he will give it his approval. So there is no use reframing the pastel. Just fix it lightly in place and wrap it up with the utmost care.

Another thing. You commented that the photograph was not as good as it could have been. Since Délétang will be here on Monday at the same time as you, we'll have to discuss the photograph of the pastel with him and not let the least thing get by so that he can try and do an even better job. Before I left Degas, I saw a pastel which he was in the process of doing. The colours are dazzling. It's one like this that we want.

Have you finished the first Renoir plate – the one which was missing a colour – the two little girls. I understand you intend to work exclusively for me now and that you haven't taken on any other plates for Rodin. I believe your daughter is getting better, or rather is completely recovered, after the last news you gave me in Paris. If I get back before Monday, I will let you know.

Greetings
[signed] Vollard

Cabourg le 28 avril 1911

Mon cher Clot

En même temps que vous rapporterez mon Degas lundi passez chez Lézin[1] et prenez son carnet d'échantillons de papier pour encadrement. Voilà pourquoi.

Avant que je porte mon pastel chez vous j'ai eu l'occasion de le faire voir à Degas qui m'a dit que ce cadre blanc ne lui allait pas du tout et qu'il fallait l'encadrer dans le genre de ses pastels. Avant mon dèpart pour la campagne il m'a demandé si le pastel était reencadré et de le lui faire voir. Je crois que dans son idée il a en vue un cadre en bois peint, moi j'aimerais beaucoup mieux une bordure en papier. Je suis donc à ce que ce soit choisi avec le plus grand soin afin que si Degas le trouve bien comme couleur il y donne son approbation. Il est donc inutile de reencadrer le pastel, mettez-y simplement quelques points et enveloppez le tout avec le plus grand soin.

Autre chose. Vous m'avez fait remarquer que la photographie n'était pas aussi parfaite qu'elle avait pu l'être. Comme Délétang sera chez moi lundi à la même heure que vous il faudra discuter avec lui la photographie d'après le pastel et ne pas laisser passer la moindre chose afin qu'il cherche à faire encore mieux. J'ai vu chez Degas avant de partir un pastel qu'il est en train de faire. Les couleurs sont éblouissantes. C'est un comme cela qu'il faudrait.

Avez vous terminé la première planche de Renoir, celle à qui il manquait une couleur – les deux fillettes.

Je pense que vous avez l'intention de travailler exclusivement pour moi maintenant, et que vous n'avez pas entrepris d'autres planches de Rodin.

Je pense que votre fille va mieux ou plutôt tout à fait bien d'après les dernières nouvelles que vous m'avez données à Paris. Si je rentre avant Lundi je vous préviendrai.

Salutations
[signed] Vollard

1. Lézin was the framer Degas preferred; Vollard devoted a chapter to 'Degas and his frames' in his book *Degas, an intimate portrait*, London 1928.

[CA414/415]

4]

from MAURICE DENIS

'*Look after this for me as if I were there . . .*'

Perros Guirec 22 July [18]97

Dear Monsieur Clot

I am happy with the green plate for Vollard as it is.[1] You can pull it. If however we could replace the head of the woman dressed in black by the one that I have drawn on transfer paper, which I am sending you, that would be better, so please do this.

Regarding the two proofs, I would also have preferred to have another one, the transfer paper for which I gave Mr Mellerio. The one I prefer is the one on Clot paper, on which I put a black dot. I would have preferred that the black be less greasy, the texture less filled in, in a word, what was excessive about the way the other proof had been worked [I want changed]. I have marked in pencil one place that is very good, so that you can understand what I mean.

There's virtually no way to remedy this defect.

Of course you will do the edition on yellow paper – and less thickly if possible.[2]

My regards to Madame Clot.

Look after this for me as if I were there . . .
Yours
[signed] Maurice Denis

Chez Madame Peuven[?] Briquir
à Perros Guirec
Côtes du Nord

Perros Guirec le 22 Juillet 97

Cher Monsieur Clot

La planche de vert pour Vollard me plaît ainsi.[1] Vous pouvez tirer. Si cependant on peut remplacer la tête de la femme habillée en noir par celle que j'ai dessinée sur le calque, et que je vous envoie, ce serait mieux, et je vous le demande.

Quant aux deux épreuves, j'aurais préféré avoir aussi une autre dont j'avais donné le calque à M. Mellerio. Celle que je préfère est celle sur papier Clot où j'ai mis un point noir. J'aurais voulu le noir moins gras, le grain moins rempli, en un mot, ce que l'autre épreuve a d'excessif dans le travail. J'ai marqué au crayon un endroit qui fait très bien, pour que vous compreniez ce que je veux dire.

Il n'y a guère moyen de remédier à ce défaut. Vous tirerez, c'est entendu, sur papier jaune – et moins gras si possible.[2]

Mes hommages à Madame Clot.

Soignez-moi bien; comme si j'étais là . . .
votre
[signed] Maurice Denis

1. This may refer to *Le Reflet dans la fontaine*. (C100, UJ31)
2. This sentence is ambiguous and the request concerning thickness may relate to the ink or to the paper.

[CA74]

5]

from MAXIME DETHOMAS

'*One could not pay too much for your talent.*'

Sunday, 3 January [1897]

Dear Monsieur Clot

You have just plunged me into the utmost astonishment. My proofs were wrapped up in yellow-grey paper with no title at all [and] could not be [mis]taken for a portrait of Bequier. Moreover, the size of my poster differs quite considerably from a package made for the litho of Blanche whose width was, it seems to me, narrower. So I haven't anything in common with the proof, which you must have misplaced and which I'm sure you'll find again. It was you yourself who showed me Blanche's work so that I would be able to make complimentary remarks about it to Madame Bequier by asking if she had it or if one would soon be able to see it at her place.

Would you please tell J. E. Blanche as soon as possible that I am not a fence for stolen goods and that the idea that he could for one moment have thought that I was displeases me

absolutely. To speak of something else, I would like to tell you that our poster will be reproduced in the publication *Maîtres de l'affiche*.[1] I have been asked for the authorisation for this. I find that the price you are asking (165 fr) has risen considerably.

In addition, I've sought advice about this and I've been told everywhere that you have treated me as if I were a wealthy man, which I assure you is not the case. No matter, one could not pay too much for your talent or your willingness to oblige and you can still count on me for the things ordered, the cost of which I'll gladly pay.

Cordially yours and my regards to Madame Clot please.
[signed] Maxime Dethomas

Dimanche 3 Janvier [1897]

Cher Monsieur Clot

Vous venez de me plonger dans l'étonnement le plus complet. Mes épreuves étaient enveloppées dans un papier gris-jaune qui a aucun titre. Vraiment ne pourrait passer pour un portrait de Bequier. Du reste la grandeur de mon affiche éloigne toute idée d'un paquet fait avec la litho de Blanche de taille plus restreint il me semble. Je n'ai donc rien de commun avec l'épreuve que vous avez dû égarée, que vous retrouverez j'en suis certain. C'est vous même qui m'avez montré l'oeuvre de Blanche et fait que j'ai pu en faire compliment à Madame Bequier en lui demandant si elle l'avait ou si on la verrait bientôt chez elle.

Veuillez je vous prie et le plus vite possible dire à J. E. Blanche que je ne suis pas un receleur, que l'idée qu'il ait pu le penser un moment me déplaît absolument. Pour parler d'autre chose je vous dirais que notre affiche sera reproduite dans la publication des 'Maîtres de l'Affiche',[1] l'autorisation m'en a été demandée, que je trouve le prix que vous m'avez demandé (165 francs) bien élevé.

J'ai du reste consulté là-dessus et l'on m'a dit partout que vous m'aviez traité en homme riche. Je vous assure que cela n'est pas le cas. N'importe on ne saurait trop payer votre talent et votre complaisance et pour les choses commandées dont les frais me seront payés avec joie je vous serais fidèle.

Bien cordialement votre. Mes hommages à Madame Clot je vous prie.

[signed] Maxime Dethomas

1. No poster by Dethomas was published in *Maîtres de l'affiche*.

[CA81/82]

6]

from MAURICE ELIOT

'*I prefer a few more marks, but particularly so that it looks as though it has been done by me.*'

Tuesday evening

Monsieur Clot

I hope on Thursday that together we can alter the stones in such a way that we can obtain the various tones of pure blue or red or yellow which will give 'crispness' to the proof. I can see what it needs and will be able to do it myself.

The result is already much better; what remains is to avoid the 'chromo' look which still persists, and [to achieve] this by giving it a freshness which brings out the adjacent grey tones. I prefer a few more marks, but particularly so that it looks as though it has been done by me. So I count on retouching the stones. I hope Thursday will be convenient. I will come quite early so that I can have a really good look and to have enough time to do the retouching – from 9 until 11 o'clock. Write to me if you won't be free. But that would really put us behind and Mr Blot[1] is despairing of ever seeing the portrait again – how this is dragging on!

Best wishes
[signed] Maurice Eliot

Mardi soir

M. Clot

J'espère que jeudi nous pourrons modifier ensemble les pierres, de façon à obtenir les quelques tons bleus ou rouges purs, ou jaune qui donneront de 'croustillant' à l'épreuve. Je vois ce qu'il faut et pourrai le faire moi-même.

Le résultat est déjà beaucoup meilleur; il reste à éviter l'aspect 'chromo' qui persiste encore, et cela en donnant un[sic] fraicheur qui fait valoir les tons gris à côté. Je préfère encore quelques tâches, mais surtout, que ça ait l'air d'être fait par moi. Je tiens donc à retoucher les pierres. J'espère que jeudi pourra convenir. Je viendrai de très bonne heure pour bien voir et avoir le temps de faire les retouches, de 9 à 11 heures. Ecrivez-moi si vous n'étiez pas libre. Mais ça nous remettrait bien loin et M. Blot[1] désespère de revoir jamais le portrait – que tout cela est long!

Recevez toutes mes salutations
[signed] Maurice Eliot

1. Probably Eugène Blot, a collector.

[CA104]

7]

from CHARLES MEUNIER *re* HENRI FANTIN-LATOUR

'*It is unacceptable that this series of proofs . . . can exist outside of my personal edition without causing me moral or material harm . . .*'

[printed letterhead]
Ch. Meunier
A la Maison du Livre
3 Rue de la Bienfaisance Paris

Paris 21 March 1906

Sir

Following your request for a copy containing your printing of Fantin-Latour's lithographs, I am waiting for you to send me the series of *bons-à-tirer* which Mr Fantin-Latour sent you a short time ago, proofs which he had signed in order to identify them at the time of his verification of the edition.

I have, in all propriety and as is attested by the receipt of M. Fantin-Latour, ordered and paid for the twelve lithographs, the *Bucoliques*;[1] the artist doesn't then have the right to dispose of impressions without them being stamped with my own special mark as the owner of the edition.

It was then agreed between you and me that I would set aside for you one copy of your edition, but on the understanding that you handed over to me all the proofs, good and bad, which would have been pulled by you.

Now it is unacceptable that this series of proofs of which you wrongly claim to be the owner can exist outside of my personal edition, without causing me moral or material harm in the world of subscribers.

It is, moreover, as a consequence of this agreement that I granted you a copy of my edition.

Would you then please send me this series of prints and on receipt of this I will remit to you your copy.

Yours most sincerely
[signed] Ch. Meunier

Ch. Meunier
A la Maison du Livre
3 Rue de la Bienfaisance Paris

Paris 21 March 1906

Monsieur

Comme suite à votre réclamation de l'exemplaire contenant votre tirage lithographique de Fantin-Latour j'ai attendu pour vous l'envoyer que vous m'ayez fait remettre la suite des bons-à-tirer que vous a remis peu M. Fantin-Latour, épreuves qu'il avait signées pour les rendre reconnaissables lors de la vérification du tirage par lui-même.

J'ai, en toute propriété, et ainsi qu'en fait foi le reçu de M. Fantin-Latour, commandé et payé les douze lithographiques des 'Bucoliques',[1] l'artiste n'avait donc pas le droit de disposer d'épreuves sans quelles fussent timbrées d'un signe particulier et personnel à moi, propriétaire de l'édition.

Il fut donc convenu entre vous et moi que je vous réservais un exemplaire de votre tirage; mais à charge par vous de me livrer toutes les épreuves, bonnes et mauvaises qui auraient pu être tirées par vous.

Or, il est inadmissible que cette série d'épreuves dont vous vous prétendez, à tort, propriétaire, puisse exister en dehors de mon tirage personnel, sans peine de me causer un préjudice moral et matériel dans le monde des souscripteurs.

C'est, du reste, à la suite de cet accord que je vous ai reconnu un exemplaire de mon tirage.

Veuillez donc me faire parvenir cette série d'épreuves contre la remise de laquelle je vous remettrai votre exemplaire.

Recevez mes salutations distinguées.

[signed] Ch. Meunier

1. The 'Bucoliques' were the illustrations for the poems of André Chénier (Paris: Maison du livre, 1903). Hédiard 161–172

[CA112/113]

8]

from ARMAND GUILLAUMIN

'Once ... it has been cured of its profound anaemia, this lithograph could well go.'

Crozant 4.7.98

Monsieur Clot

I am returning to you the proof that I received and have corrected. The corrections to be done concern certain emphases in the shadow areas. Moreover, since they've been marked with black lithographic crayon you will see what is involved. Can you do these? I think you can.

The colouring in general seemed weak to me, not true in tone. The pinks of the snow [and] the sky are really quite pale, the yellows of the sky are too green, the blues not true.[1] To me it looks as though the proof has been washed in the gutter. There must be some way this can be fixed. I hope so. Once the corrections have been made and it has been cured of its pale colours, of its profound anaemia, this lithograph could well go.

It would be good if you could inform M. Vollard of all of this because I don't know where I stand with regard to what he wants. Has he seen this proof? Is he satisfied with it? I think you would do well to get his orders with respect to the editioning before undertaking anything because I just haven't been able to understand Vollard's way of going about things for some time now. I would be grateful to you if you could send me a reply as soon as you have settled this matter.

I hope Mme Clot and the children are well, that their time away from Paris, I don't dare say in the country, did them some good. In your reply tell me a little of what you are up to.

I left Paris with a case of bronchitis complicated by pharyngitis, all of which meant that I was ill for a good month, as a consequence of which I haven't done much work. It has only been about ten days or so now that I've been back on my feet.

While awaiting your reply
I send you my warm regards
[signed] Guillaumin

Crozant Creuse
par St Sebastien

Crozant 4.7.98

Monsieur Clot

Je vous retourne l'épreuve que j'ai reçue et corrigée. Les corrections à faire portent sur certaines soulignements dans les parties d'ombre: du reste, comme elles sont faites au crayon litho-noir vous verrez de quoi il retourne. Pouvez-vous les faire? Je pense que oui.

La coloration générale m'a parue pauvre, pas franche de ton. Les roses dans la neige, le ciel sont bien pâles, les jaunes du ciel trop verdâtre, les bleus pas francs.[1] Il me semble que cette épreuve a été lavée par une gouttière. Il doit y avoir un reméde à cela, je l'espère. Une fois les corrections faites et guérie de ses pâles couleurs, de sa profonde anémie, cette lithog. pourrait aller.

Il serait bon que vous fassiez part à M. Vollard de tout ceci car je ne sais pas à quoi m'en tenir au sujet de ses désirs. A-t-il vu cette épreuve? En est-il satisfait? Je crois que vous ferez bien de prendre ses ordres au sujet du tirage avant de rien entreprendre, car je ne puis m'expliquer les allures de M. Vollard depuis quelque temps. Je vous serais obligé dès que vous serez fixé sur ce point de me répondre.

J'espère que Mme Clot et vos enfants vont bien, que le séjour hors Paris, je n'ose dire à la campagne, leur a fait du bien. En me répondant dites-moi un mot de ce qui vous intéresse.

J'ai quitté Paris avec une bronchite compliquée de pharyingite. Tout cela m'a rendu malade un bon mois de sorte que je n'ai pas beaucoup travaillé.

Voici à peine une dizaine de jours que je suis solide. En attendant je vous donne une poignée de main.

[signed] Guillaumin

à Crozant Creuse
par St Sébastien

1. The reference to snow identifies this lithograph as *Paysage aux meules* [*Landscape with haystacks*]. The date of the letter proves it was made in 1898 rather than 1896.

[CA136/137]

9]

from PIERRE-GEORGES JEANNIOT

'Don't forget the ink for the wood transfers ...'

n.d.

Dear Monsieur Clot

Don't forget to send me, with the man who is coming to pick up the stones, the ink for the <u>wood transfers</u> on to stone which you spoke to me about, [and] the unsized paper which you require, since I would like to do my woodblock in colour (the woodblock of the young girl standing out against the flowers). Without being obliged to trim them, could you lend me for a short time some larger stones. I will be doing it in four colours – yellow, blue, red and a grey. Now, you've told me to look after the roller but you haven't made up any of the black varnish to do this. Let me know how to prepare it.

Regards
[signed] Jeanniot

[Envelope]
Monsieur Clot
Lithographic printer
23 R. du Cherche-midi
Paris

[on reverse of envelope in Clot's handwriting]
1of ink
6f chine transfer paper
25 sheets of unsized paper

n.d.

Cher Monsieur Clot

N'oubliez pas de m'envoyer par l'homme qui viendra chercher les pierres, l'encre pour <u>les reports des bois</u> sur pierre dont vous m'avez parlé; le papier sans colle dont vous avez besoin – Puis je [le] voudrais pour faire mon bois en couleurs (le bois de la jeune fille que se détache sur les fleurs). Sans être obligé d'en rogner, que vous me prêtiez momentanément des pierres plus grandes; je ferai cela en 4 tons – jaune, bleu, rouge et un gris. Maintenant vous m'avez dit d'entretenir le rouleau mais vous n'avez pas preparé le vernis noir necessaire à cet entretien. Dites-moi comment je dois le préparer.

Bien à vous
[signed] Jeanniot

[envelope]
Imprimeur lithographe
23 R. du Cherche-Midi
Paris

[on reverse of envelope in Clot's handwriting]
1of Encre
6f Chine à report
1 main papier sans colle

[CA166]

10]

from PIERRE-GEORGES JEANNIOT

'Things on the home front seem to be pretty rosy. But . . .'

n.d.

Dear Monsieur Clot

Let me first congratulate you on the birth of your little daughter and assure you I share your joy.

Things on the home front seem to be pretty rosy. But, because there is a but, a big but! You should have let me know about the man's chin. There's a grey spot which eats into the red of the collar of the overcoat and completely deforms the face. This makes it extremely ugly. I told you to send me a telegram in the event that the chin wasn't brought into line by the red which I had added, and you didn't even see this fault, and yet it's terribly obvious. If you had looked where the black had been left out you would have seen this. So I am extremely unhappy [about this]. To the extent that I cannot offer a proof in this state for sale. I am going to correct the stone and you will have to pull some proofs after correction.

Now you see, this is the danger of editioning in colour for which I am obliged to spend entire mornings at your place, or alternatively, resign myself to not being able to supervise the details.

The point is, details <u>are</u> important, they are of major importance. You can see this from the present case.

What a nuisance, what a nuisance.

What are we going to do? Do you think each print could be corrected individually? This seems impossible to me and yet I <u>cannot</u> leave things as they are.

Regards
[signed] G. Jeanniot

n.d.

Cher Monsieur Clot

Je vous fais d'abord mes compliments pour la naissance de votre petite fille et vous assure de la part que je prends à votre joie.

Les pays sont évidemment d'une jolie harmonie. Mais, car il y a un mais, un gros mais! Vous auriez dû m'avertir pour le menton de l'homme. Il y a une tâche grise qui mange le rouge du collet de capote et lui déforme la figure complètement. Ce qui fait que c'est fort laid. Je vous avais dit de m'envoyer un télégramme au cas où ce menton ne serait pas rattrapé par le rouge que j'y avais ajouté, et vous n'avez pas vu ce défaut, qui cependant est terriblement gros. En regardant le noir où ça n'existe pas vous vous serez aperçu de ça. Je suis donc absolument désolé.

A tel point que je ne puis offrir une épreuve dans cet état. J'irai corriger la pierre et vous me tirerez des épreuves après corrections.

Voilà voyez-vous le danger de ce tirage en couleur pour lequel je suis obligé de passer des matinées chez vous ou bien me résoudre à ne pouvoir surveiller les détails.

C'est que le détails <u>ont</u> leur importance. Ils ont même une importance capitale. Vous le voyez dans le cas présent.

Quel ennui, quel ennui.

Comment faire. Croyez-vous qu'on pourrait corriger chaque épreuve? Ca me paraît impossible et pourtant <u>je ne puis</u> laisser ça ainsi.

Bien à vous
[signed] G. Jeanniot

[CA175/176]

11]

from THÉOPHILE STEINLEN

'I am giving [Marty] one of the five heads which you pulled for me recently.'

2 Jan[uary] [18]97

My dear Clot

For a long time I've owed my friend Marty[1] a stone for his *Etudes de femmes.*[2] Not knowing what to do for him and with the conclusion of his publication imminent I am giving him one of the five heads which you pulled for me recently – *la femme du peuple* – the one I liked the most. As Marty is contracted to Lemercier, he is not able, as I would have liked, to ask you to

do the edition. I don't think it would be too much of an imposition for you to give him my stone. On Tuesday or Wednesday I will come to see you to settle my account and if things are sufficiently advanced on my part – to work something out with you for an album of some importance for which I have a publisher.[3]

Please send the stone to Marty, who you will find has a note from me.

Thanks in advance.

Best wishes to Madame Clot and to you.

Cordially
[signed] Steinlen

2 Janv. 97

Mon cher Clot

Je devais depuis longtemps à mon ami Marty[1] *pour ses 'Etudes de Femmes'*[2] *une pierre. Ne sachant trop que lui faire et la fin de sa publication arrivant je lui donne une des cinq têtes que vous m'avez tirées ces derniers temps – <u>la femme du peuple</u> – celle qui me plaisait le plus. Comme Marty est engagé avec la maison Lemercier il ne peut – ce que j'aurais désiré – vous demander le tirage. Je pense que ça ne sera pas pour vous une grosse contrariété que de lui remettre ma pierre. Mardi ou mercredi je vous irai voir pour vous solder d'abord ce que je vous dois et peut-être si les choses de mon côté sont assez avancées, m'entendre avec vous pour un Album de quelque importance pour lequel j'ai éditeur.*[3]

Remettez-donc la pierre à Marty qui vous ira trouver avec un mot de moi.

Merci d'avance
Nos bonnes salutations à Madame Clot
et à vous
Cordialement
[signed] Steinlen

1. André Marty, having published *L'Estampe originale* [The original print], went on to publish several other portfolios and books.
2. *Type populaire* 1896, from *Études de femmes*, 1897 (Crauzat 180)
3. Although Steinlen's catalogue raisonné indicates that *Chansons des femmes* was printed by Verneau, other letters to Clot mention a suite to be made on 16 stones and the publisher Enoch. This, together with the appearance of the suite in the printer's sale in 1919, indicates that the edition on Japan was pulled by Clot. (Crauzat 183, 594)

[CA378]

12]

from OCTAVE UZANNE

'Does this seem just to you?'

[Letterhead]

to M. AUGUSTE CLOT
Printer of art

17 Quai Voltaire
Paris
12 October 1902

Dear Sir

I have received your note – you've fixed a price of 450 francs for the composition, preparation and editioning of 300 copies of the reproductions of the bindings. You also add that the trials will be at my expense (similarly the paper and printing).

I'd like some more information. If that fixed sum of 450 fr is meant to cover all the reproductions of the red and gold bindings and the polychrome ones with mosaic, then we have an agreement.

If it's a matter of only the simple example I have given you then it seems to me that it would be better to try and reach some sort of average price from five or six other examples, which are not more elaborately gilded but which have more colours based on the leather mosaics.

As far as the <u>trial proofs</u> at my expense are concerned this is something which may lead to a number of surprises. Let's assume that you succeed to my satisfaction and that I accept the

definitive plate or *bon-à-tirer* – will there be trial proofs at my expense?

Another supposition – you present me with a defective reproduction, unsatisfactory, frankly bad – even you agree that it is so and say that you could do better – what would I owe you for this miscarriage?

<u>Does this seem just to you?</u>

Let's define then what counts as a trial proof – what sum they could amount to and whether I would have to bear the cost of unsuccessful trials. You yourself will understand that I want to be absolutely sure on all of these points.

Another thing – let's assume you're successful with the first example which you already have in, say, a fortnight – how long will it take to compose, prepare the plate, and print lithographically and typographically five or six other bindings with more or less decoration?

I'm asking 'for a rough idea'.

I want an answer to all of these points because I want to know my responsibilities in order to conduct my business with as much loyalty to you as to those who have commissioned work from me.

Yours sincerely
[signed] O. Uzanne

[Letterhead]
à M. Auguste Clot
Imprimeur d'art

12 Quai Voltaire
Paris
12 Octobre 1902

Cher Monsieur

Je reçois votre mot. Vous me fixez un prix de fr 450 pour composition, gravure, tirage à 300 exempl. de reproductions de reliures. Vous ajoutez que les tentatives d'essai seraient à ma charge (le papier ou tirage également).

Je désire plus ample information. Si cette somme de 450f est fixée pour toutes reproductions de reliures rouge et or ou polychromes avec mosaïques nous pouvons nous entendre. S'il s'agit du seul type très simple que je vous ai confié, il me semble qu'il vaudrait mieux chercher à établir une moyenne d'après 5 à 6 autres types, pas plus compliqués de dorures, mais plus variés de tons, par suite de mosaïques de peau. Quant aux <u>tentatives d'essai</u> à ma charge, c'est là un mot qui prête à des surprises nombreuses. Admettons que vous réussissiez à mon gré et que j'accepte la planche type définitive ou bon-à-tirer – y aurait-il tentatives d'essai à ma charge.

Autre supposition – vous me présentez une reproduction difectueuse, désagréable, franchement mauvaise – vous le constatez vous même et me déclarez de pouvoir mieux faire – quelles sommes vous devrais-je pour ce ratage?

<u>Cela vous semble-t-il juste?</u>

Délimitons donc ce qui peuvent être ces tentations d'essai – la somme à laquelle elles pourraient se monter et si j'aurais à les supporter en cas d'insuccès.

Vous comprendrez vous même que je désire être fixe sur tous ces points.

Autre chose – admettons une réussite sur le premier type en vos mains et cela d'ici quinzaine. Combien vous faudrait-il de temps pour composer, graver, imprimer litho et typographiquement 5 à 6 autres reliures plus ou moins chargées de décor?

Je demande 'dès à peu près'.

J'espère réponse sur tous ces points, car je désire connaître mes responsabilités pour pouvoir m'engager loyalement aussi bien vis à vis de vous que vis à vis de mes mandataires.

Bien sympathiquement
[signed] Octave Uzanne

[CA398]

13]

from THÉO VAN RYSSELBERGHE

'I am relying moreover on your great experience and your talent'.

Ambleteuse, par Marquise
Pas de Calais
10 October [18]99

Monsieur

I am sending you enclosed the transfers and the maquette for the print for M. Meier-Graefe's album.[1] It will be, I think, essential for you to take charge of the retouching of the different matrices on the stone yourself after they have been transferred, because for certain flat colours it was impossible for me to get a result since the transfer paper swelled up as soon as it came into contact with the lithographic ink. In addition, I cannot get sufficient idea in black of the strength of the coloured inks to be sure that the colours are true.

Would you keep as close to the maquette as possible. I am relying moreover on your great experience and your talent which I have often admired.

Cordially yours
[signed] Van Rysselberghe

Ambleteuse, par Marquise
Pas de Calais
10 Octobre 99

Monsieur

Je vous fais parvenir ci-joints les décalques et la maquette de l'estampe pour M. Meier-Graefe.[1] Il sera, je pense, indispensable que vous vouliez bien vous charger de retoucher sur la pierre, après report, les différentes planches, car pour certaines teintes plates il m'a été impossible d'arriver à un résultat, le papier de report se boursouflant aussitôt le contact de l'encre lithographique: et d'autre part je me rends pas suffisamment compte de la force des encres de couleur pour être sûr de la justice des valeurs, en noirs.

Veuillez je vous prie, vous en tenir le plus possible aux indications de la maquette; je me rapporte d'ailleurs à votre grande expérience et à votre talent que j'ai maintes fois pu admirer.

Agréez je vous prie, Monsieur, mes bien cordiales salutations.
[signed] Van Rysselberghe

1. This letter refers to *Femme sur la jetée [Woman on the jetty]* for *Germinal*, 1899.

[CA403]

14]

a] *from* JEAN VEBER

'I haven't been able to find the time to proof my plate.'

n.d.

My dear Clot

I haven't been able to find the time to proof my plate. Would you at least commence it without me and pull the black impression.

I want to have about 20 proofs, half on Japan with small margins and the ten others on white paper – 2 or 3 on chine and the others on a beautiful Holland or Whatman, whichever you prefer. Would you please efface the marginal drawing after doing three proofs. Print quite black and take care to keep all the faulty or deteriorated proofs for me.

I will come on Monday evening at about 5pm to do the red proof. I am extremely pushed. The latest we can leave it is 2 April and we must have time to make the frame.

I send you my warm regards and, more than ever, count on your kindness.

[signed] Jean Veber

n.d.

Mon cher Clot

Je n'arrive pas à trouver le temps de faire l'essai de ma planche. Voulez-vous au moins le commencer sans moi et tirez la planche noire.

Je voudrais avoir une vingtaine d'épreuves dont le moitié sur japon petites marges mais très beau papier et les 10 autres sur blanc. 2 ou 3 sur chine et les autres sur beau papier de Hollande ou Whatman à votre goût.

Vous aurez l'obligeance d'éffacer la remarque au bout de 3 épreuves. Tirez bien noir at avez soin de me conserver les épreuves mauvaises ou détériorées.

Je viendrai lundi soir vers 5 heures pour faire l'essai du rouge.

Je suis extrêmement pressé! Pensez donc le dernier délai est 2 avril et il faut le temps de faire le cadre.

Je vous serre bien cordialement la main et compte plus que jamais sur votre obligeance.
[signed] Jean Veber

[CA424]

b]

from JEAN VEBER

'It has been impossible for me to come to proof the red with you as I intended.'

n.d.

My dear Clot

It has been impossible for me to come to proof the red with you as I intended.

And time is pressing! Would you do it without me. A good shade of sanguine that you will know how to vary. For the yellow stone, try to find a shade made with ochre and a spot of black and warm it with a little burnt sienna.

And would you please send me the proofs as soon as they are pulled. I am trembling! You'll receive this note tomorrow, Tuesday, and the proof must be at the Palais on Thursday and it will have to be framed first. Will we ever get there? Yes, if you really want to.

Amicably yours
[signed] Jean Veber

n.d.

Mon cher Clot

Il m'a été impossible de venir comme j'en avais l'intention faire l'essai avec vous de la pierre de rouge. Et le temps presse! Voulez-vous le faire sans moi. Un bon ton de sanguine que vous saurez varier. Pour la pierre de jaune cherchez moi un ton fait avec de l'ocre et une pointe de noir et rechauffez avec un peu de terre de sienne brûlée. Et sitôt les épreuves tirées ayez l'obligeance de me les adresser. Je tremble! Vous recevez ce mot demain mardi et il faut que l'épreuve soit au Palais jeudi et il faut auparavant la faire encadrer.

Y arriverons-nous jamais?
Oui, si vous le voulez bien.
Amicalement à vous
[signed] Jean Veber

[CA423]

15]

from AMBROISE VOLLARD

'No matter what time or what day I call by to see you, you're always out on business.'

Paris 4 August 1912

My dear M. Clot

I cannot wait any longer for the small print. If you are unable to give it to me in the next few days, then I'd prefer you to efface what you have done and we'll say no more about it – likewise for the litho after the little painting by Cézanne, *Le Repas sur l'herbe*. I need my picture which I entrusted to you more than a year ago, and at the rate that all this is going, there's no reason to think it will ever be finished. No matter what time or what day I call by to see you you're always out on business or at Villeneuve St. Georges, so that it's hardly surprising that I don't have anything. I will drop by your studio <u>Monday at 2pm</u>. Would you please wait for me and assemble everything that you have already done so that I can take stock of where we are. I'm telling you <u>Monday</u> so that you have time to receive this letter, since I don't know if these days you get to Paris regularly.

Would you pull for me <u>immediately</u> thirty proofs[1] on japan of the portrait of Wagner by Renoir.

Greetings,
[signed] Vollard

PS. Has Madame Clot made a complete move to the country, or does she spend some days in Paris? I would like to see her on the subject of certain prints.

Paris le 4 Août 1912

Mon cher Monsieur Clot

Je ne peux plus attendre plus longtemps pour la petite estampe, si vous ne pouvez pas me la donner dans quelques jours, j'aime mieux qu'on efface ce qui est fait et on n'en parlera plus – de même pour la litho d'après le petit tableau de Cézanne, le repas sur l'herbe; j'ai besoin de mon tableau que je vous ai confié depuis plus d'un an et au train où tout cela va il n'y a pas de motif pour croire que ce soit jamais terminé. Quelque soit le jour ou l'heure où j'aille chez vous vous êtes en courses ou à Villeneuve St. Georges, ce n'est pas étonnant si je n'aie rien.

Je passerai chez vous à l'atelier <u>Lundi à 2 heures à l'après-midi</u>. Veuillez m'attendre et me préparer ce que vous avez déjà fait afin que je puisse me rendre compte où cela en est. Je vous dis <u>Lundi</u> afin que vous ayez le temps de recevoir ma lettre comme je ne sais pas si en ce moment vous venez à Paris regulièrement.

Veuillez me faire tirer <u>de suite</u> trente épreuves[1] sur japon du portrait de Wagner par Renoir.

Salutations
[signed] Vollard

PS *Madame Clot, est-elle fixée complètement à la campagne ou vient-elle quelque fois à Paris. Je voudrais la voir au sujet de certaines estampes.*

1. According to Delteil, the stone for the portrait of Wagner was cancelled in 1900.

[CA 412/413]

6 Starting Again From Scratch:

Lithography in Germany between the 1890s and the 1920s

Antony Griffiths

The battlecry 'Lithography' has been raised with our young warriors as they join in their fresh, happy struggle against the old and the worn out ...

<div align="right">MAX LEHRS, Pan, 1896</div>

Only the artist who has a love and ability for working with his hands should make prints; only when the artist really prints himself does his work deserve to be called original printmaking.

<div align="right">KIRCHNER ON KIRCHNER, 1921</div>

(Lithography is able) to supply an almost unlimited number of impressions at the fastest possible speed in an almost mechanical way ... This clearly shows the democratic character of lithography.

<div align="right">KANDINSKY, 1926</div>

SOME of the difficulties in the way of writing the history of lithography are constant, irrespective of the country or period being examined. Others vary, depending more on the subject of discussion. To write a history of an artistic medium presupposes that there is some central continuity, some consistent application of effort and direction that allows the various threads to be gathered together to form part of one story. These conditions do not always obtain. For example, it would not be possible to write a history of etching in Britain between the 16th and 18th centuries. The technique is too closely tied up with engraving and lacks independence, but from the 19th century onwards the project would be perfectly viable. Thanks to Seymour Haden and others, etching was given a theory and elevated to a primacy and self-sufficiency that were quite new.

An essay which aims briefly to cover more than three decades of extremely varied achievements in a very large country would be easier to write if the groundwork had already been prepared. But previous studies of specific aspects have – with a very few exceptions – not yet been carried out, and what ought to be a summary of existing knowledge will be recognized for what it really is—a summary of present ignorance.

One central aspect of the history of lithography is the immense commercial importance it had assumed as a method of printing since the 1820s. In this respect there is a mismatch between lithography and the other printmaking forms. Its parallel is with letterpress rather than with etching or woodcut,[1] and the centre of its history lies outside the field of the art historian. In the 20th century, exactly the same is true of screenprinting, a commercial process that only in various subsidiary manifestations attracted the attention of artists. By the end of the 19th century Germany possessed a vast lithographic industry which exported everywhere: for instance many if not most of the greeting cards which were sold in Britain during the second half of the century were printed by German chromolithographers.

By the late 19th century, with the triumph of photomechanical processes for normal reproduction of images, the traditional processes of etching and woodcut were left exclusively to artists. This allowed them to acquire a certain mystique derived from

such elevated functions. But lithography, because of the term's semantic ambiguity, could not so readily identify itself as a process enrolled among the fine arts. So perhaps the most important aspect of the history of artists' handling of the medium during our period is the attempt to escape the banal connotations that attached to it. This underlies the startling variety of approaches that artists adopted as well as the surprisingly varied terms used to describe the prints. It is the felt absence of an artistic tradition that leads to the number of attempts to start again from scratch that are so characteristic of German lithography in the period.[2]

20, 1.9

This is curious in that lithography was a German invention and was practised with great artistic success in Germany in its early years. But after the masterpieces—which were commercial failures—produced by Menzel in the early 1850s, the medium was neglected by German artists. The revival of the 1890s was recognized by contemporary German writers as having started in France and this helped the French in their audacious attempt to take over the history of lithography and rewrite it around French achievements. On learning that the Germans were intending to celebrate the centennial of lithography in 1896, they brought forward their own celebrations in an entirely unhistorical way to 1895. The gigantic show in Paris invited the participation and attention of the rest of the world. The exhibitions of the following year scattered in various German centres could not compete.[3]

This may help explain why later writers on prints in Germany pay surprisingly little attention to lithography. After the various essays of the 1890s, to which I shall return, there is to the best of my knowledge almost no criticism specifically devoted to lithography until after the second world war.[4] There are no monographs and hardly any articles. The contrast with the attention paid to the woodcut in books, pamphlets and special editions of magazines is extreme. Woodcut had come to be seen as the Germanic answer to the (French) lithograph. Its tradition reached back to Dürer and the Renaissance and its achievements were recognized everywhere.

Another factor that hindered the development of the lithograph in Germany was the huge size of the country, which had been unified politically only in 1871. This left the legacy of a number of smaller regional centres. The most famous of the art schools of the 19th century were located in Düsseldorf and Munich, but those at Leipzig, Karlsruhe, Frankfurt, Dresden and Hamburg were also important. It was only gradually that Berlin, with very little artistic tradition of its own, raised itself shortly after the turn of the century to the centre of the German art world. This parochialism affected all the printmaking media, but lithography perhaps above others because it relies for its development as much on the availability of the technical skills of printers as on the enthusiasm of artists. Lying behind many of the most flourishing episodes of the art of lithography has been a printer or workshop attuned to the needs of artists. Indeed it is this phenomenon that has led to the tendency for modern scholars to turn their attentions more to the printer than to the artist. As research in the field of German lithography proceeds, the names of certain printers will emerge. The dominant figure was certainly M. W. Lassally in Berlin, who printed for Munch and the Cassirer cousins, although as yet virtually nothing is known about him.[5] But through much of the period artists outside Berlin had to rely on presses installed in art schools or on co-operative local printers if they wanted to make a lithograph.

That there was felt to be a revival in German lithography in the 1890s is attested by two contemporary critics, Max Lehrs writing in *Pan* in 1896, and Hans W. Singer in *The Studio* in 1899.[6] Both men were museum officials and this certainly coloured their approach to the subject. Lehrs began his article in a belle-lettristic manner which he no doubt thought appropriate to an advanced cultural magazine: 'Everywhere in German lands art after a long beauty sleep has been kissed to life by the breath of fresh youth and, forcing its energies forward into new forms, has been on the move for several years. The battlecry "Lithography" has been raised with our young warriors as they join in their fresh, happy struggle against the old and the worn out and advance to new victories.' His account of recent German lithography is the starting point of this essay, and may briefly be summarized.

It is no surprise that it is organized by towns, beginning with Frankfurt, which was recognized as the centre of the lithographic revival. The precursor is Wilhelm Steinhausen, who had made a few experiments in Berlin in the mid 1870s; after moving to Frankfurt, he joined with his friend and neighbour Hans Thoma in making a number of lithographs around 1890 (6.1). In Munich the names picked out are those of Max Dasio and Otto Greiner, the spiritual pupil of Max Klinger, who himself scarcely made any lithographs. Greiner's speciality was large compositions of nudes, drawn with a pen on the stone and handled in very much the same way as an etching. The pathfinder in Dresden was Georg Lührig, who drew wooded landscapes, in which he was followed by Otto Fischer. Fischer however had also made a name for himself with a number of posters. The artistic poster, which had started in Munich, had become a Dresden speciality mainly through the efforts of the establishment of Wilhelm Hoffmann: ' . . . here the artists do not scorn to transfer their designs themselves onto the stone'. Hoffmann was also the printer of the *Viertelsjahrshefte* [Quarterly] of the

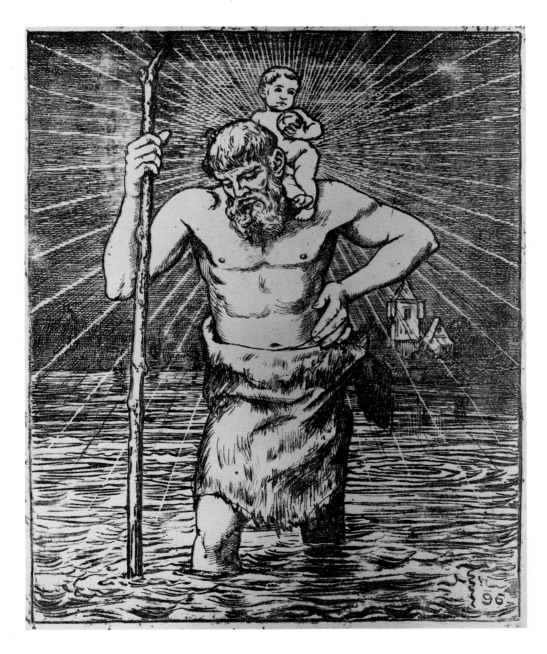

6.1 HANS THOMA
St Christopher 1896
lithograph
44.0 × 35.0
Felix Man Collection
Australian National Gallery,
Canberra

Verein bildender Künstler [Society of Pictorial Artists] in Dresden (that is the Dresden Secession), which contained examples of the work of a number of other Dresden artists. The last two centres that Lehrs singled out are Hamburg with Eitner, Illies and Vollmer, and Karlsruhe, where the Verein für Originalradierung [Society for Original Etching] had recently published a volume of nine lithographs 'which share a certain broad decorative tendency'. They worried Lehrs: ' . . . all in all the prints go further in the generalization of form than has been customary until now, and in part further than seems artistically justified.'

Writing only three years later, Singer was able to expand Lehrs' three-page article into one of three parts and 38 pages. He was quite sure why lithography had fallen from grace during the 19th century: ' . . . the stereotype method of producing a crayon drawing, without any distinctive features to show that it had been made on stone rather than on paper, necessarily caused lithography to degenerate in a way that seems almost incomprehensible to us today.' Local patriotism perhaps led him to begin with Greiner and the Dresden school, but while exalting Greiner he had to admit that his monochrome pen style was no longer typical: ' . . . the interest recently awakened for lithography has within a very short time come to be fixed almost exclusively on lithography in colours. There are very few artists today in Germany who engage in simple black-and-white work; the possibility of attaining new colour effects, which is greater in this than any other of the graphic arts, fascinates them.' This leads Singer into a discussion of the predilection for colour of the members of the Dresden Secession, and their success in the field of the poster. The most important individual in his view was Georg Lührig, who had apparently tried to persuade the members of the Dresden Secession to set up their own lithographic press. Failing in this he acquired a press for himself—perhaps one of the first German artists of whom this can be recorded.

Singer's second essay is devoted to Karlsruhe and to the Künstlerbund (or Secession) which was formed there in 1896 under Count Kalckreuth as a reaction against 'senile academic tradition'. Kalckreuth, as professor at the Academy, laid great stress on lithography, and arranged that it should be taught there. The result was the publication of two portfolios of lithographs in 1896 and 1897. The members of the club intended 'above all to devote their energies towards improving commercial or "applied" lithography . . . the production of single-sheet pictures without any particular application is to become a secondary matter.' And again: ' . . . from the very start all the members seem to have had one common object in view—the elevation of chromolithography to a fine art.' The third essay treats three remaining centres, Hamburg, Düsseldorf and Frankfurt. The Hamburg contribution was inspired by the dynamic figure of Alfred Lichtwark, the director of the Kunsthalle, and its most significant product was a portfolio of eight prints published in 1897. In Düsseldorf there was no 'lithographic movement' as such, but a few individual attempts, and the same was true of Frankfurt where a few artists were grouped around the central figure of Thoma.

From the texts by Lehrs and Singer it is clear that lithographic developments in Germany during the 1890s were greatly influenced by France. Many of the same underlying conditions applied to both countries. Thus the rise of illustrated magazines like *Fliegende Blätter* [*Loose leaves*] and *Jugend* [*Youth*] created a demand for illustrations that, in the case of high-quality productions like *Pan*, could rise to the status of original works of art in their own right. These could be supplied more easily by lithographs than etchings or engravings. Similarly, the development of advertising created a great demand for posters designed by artists. The house of Hoffmann in Dresden was not the only firm specializing in this field. The index to *Das frühe Plakat* [*The early poster*] reveals a large number of competitors.[7] Among them the firm of Hollerbaum & Schmidt in Berlin published a catalogue entitled *Moderne Plakate: Innen- und Strassen Plakate, Transparent-Plakate* [*Modern posters: indoor and outdoor posters, transparent posters*] in 1905, four years after it had held an exhibition

col. pl. 41

of its products at the Kunstsalon Louis Bock & Sohn in Hamburg. In this they had been preceded by museums: Lehrs himself had held an exhibition of artistic posters in the Kupferstichkabinett in Dresden in 1896.

But the lithographic movement in Karlsruhe is particularly interesting because it developed into something rather different to anything seen in France.[8] As Singer put it, ' . . . they have created something worth expanding and bearing a typically German character—they have created a "National" art, as one would term it here.' A certain sort of large colour lithograph, proclaiming itself to be an 'Original Künstler Steinzeichnung' was produced in huge numbers for a very wide public in the years up to the first world war. A catalogue issued by the Leipzig publisher Voigtländer in 1912 lists over 400 such prints in three sizes: 100×70, 55×42 and 41×30 cm.[9] A definition is offered: 'An original stone drawing or original lithograph is a picture which is prepared in the only reproductive method that allows a result which is fully equal to an original oil painting.' The account continues to stress the involvement of the artist in preparing all the plates and supervising the final effects. The role of assistants is tacitly accepted, but the important feature was the equivalence of effect to a painting and the extraordinarily low prices, ranging from $2\frac{1}{2}$ to 6 Marks. The subjects appealed to a wide range of tastes and included scenes from medieval and recent history, peasant life, religious images and landscapes as well as pictures of steamships and railways.

These ideals exerted a surprisingly wide influence. A catalogue issued in 1909 by the left-wing Social-Democratic Party included a selection of such prints, drawn from the stock of six different publishers, which was recommended for purchase by workers.[10] The beginning of the catalogue sets the tone for what follows: 'Only rarely does a ray of light fall across the bare, raw emptiness of the life of the worker.' The quality of such images may have been low, but they are of great importance as having determined the general public's perception of the type of object that an 'artistic' lithograph was, as well as the role of lithography as a medium.

The diffusion of images of this kind was helped by a technical innovation, the invention of a method of preparing cheap aluminium plates for lithographic printing, which was patented by Josef Scholz of Mainz under the name Algraphy in about 1895. This was reported in *The Studio* in 1897, in an article that claimed that the new plates offered 'nothing to hamper the artist in gaining his effect, or to prevent him expressing the widest range of tones and gradations from the most delicate greys to the deepest and most solid blacks.'[11] In fact of course neither aluminium nor zinc allows anything near the range of stone lithography. It was widely used by artists at the time but did not encourage them to extend their range.

Perhaps the most famous lithographer of the 1890s was Hans Thoma, and his route to lithography is revealing of the very peculiar circumstances of the period. According to contemporary accounts,[12] Thoma had made in about 1892 a number of watercolours which he wished to replicate. He did this by using a tachygraphic machine which allowed him to trace the outlines of the watercolour mechanically onto the stone. In order to reverse the image in the printing he employed a sort of offset process using an elastic gelatine 'bat'.[13] Only 10 to 20 impressions were printed, all of which he then coloured by hand. Some years later he progressed to printing in colour, the extra plates being provided by the printer. Finally he turned to making the colour plates himself, using in his most recent prints Scholz's aluminium plates, 'which is much easier and allows the same effects to be achieved.' A contemporary critic saw the result as an approach to a 'Volkskunst' and thought that only a lack of organization prevented their being sold in large numbers at a low price.[14] The prints are a shock to a modern viewer; thick, heavy outlines are printed on top of flat coloured backgrounds which often use silver and other inks which are iridescent when held to the light. Singer welcomed these: ' . . . his fine artistic tact has always hindered him from becoming vulgarly imitative and naturalistic in his colours.'[15]

All alternative approaches to lithography had to struggle against the weight of these conceptions, which were so dominant that they lasted a remarkably long time. At this

point it is important to establish the chronology of events clearly. It might be supposed that there was a two-stage development: that the so-called Impressionists of the Berlin Secession reacted against the generation of Thoma and then the Expressionists reacted against the Impressionists. This is not correct, for both the Impressionists and the Expressionists took up lithography at almost exactly the same time, in 1907–08. They must therefore be recognized as two parallel and alternative assaults on the single main tradition of German lithography.

Individual artists had of course been handling the medium in quite different ways during the late 1890s and early 1900s, the most important being Edvard Munch. His first lithographs were made in Berlin in 1895 and were printed by Lassally, but although Berlin remained the centre of Munch's activities until his collapse in 1908, it is impossible to describe him as a German artist. His nearest German parallel was Käthe Kollwitz. The first of her lithographs were made in 1896–97, and belong to the sequence *Ein Weberaufstand [Weaver's rebellion]*. She recorded that three of the six plates of the series were made as lithographs only because her attempts at etching them had failed and so it is not surprising that these prints are very close to her soft-ground etchings in their manner of drawing. It was not until about 1901 that she turned to chalk-and-wash lithography in a concentrated way (col. pl. 20). For the next four years she made lithographs—often printed in colour—in tandem with her etchings, and in a few extraordinary cases combined the two processes in a single print, using a lithographic toneplate under an etched design.[16] Unfortunately there is little evidence to show what led her to this conclusion; it is not even clear where the lithographs were printed. But it seems reasonable to suppose that the influence of Munch was decisive; in particular the experiments that he had made in combining woodcut with lithography. After 1905 she abandoned lithography except for a few posters. When she took it up again in 1913, her approach was quite different.

The early years of the century saw a quickening of interest in printmaking in general. The most significant phenomenon was the founding in 1898 of the Secession by the leading artists in Berlin; its management was entrusted to the cousins Bruno and Paul Cassirer, who had recently opened an art gallery and publishing business.[17] In the first exhibitions prints and drawings were combined with paintings and sculpture, but from 1901 a summer show of paintings alternated with a winter 'Schwarz-Weiss' exhibition of graphics. These continued regularly until 1911 and the catalogues are an essential source for the history of printmaking in this period. Although the introduction to the 1909 catalogue complains about the small amount of interest shown by the public in the exhibitions, the one for 1911 proclaims that they are a necessity to Berlin, because, although paintings are shown in plenty, there is still no rival exhibition of graphic arts. It might have added that, since Berlin was by now the undisputed centre of the German art world, the shows were of more than local importance.

An examination of the catalogues shows how restricted a place lithography held in the output of the period. Only 45 lithographs are to be found against 88 etchings in the 1901 exhibition, and in 1911 (excluding foreign contributors) there are only 62 against 226 etchings. The number of woodcuts is about half the number of lithographs. In short, the field was dominated by the intaglio processes. The revival of lithography within the work of the Secession was the work of the two cousins, Bruno and Paul Cassirer, working no longer as partners but as rivals. Their partnership had been dissolved in 1901, Bruno taking the press and Paul the art gallery, each promising not to re-enter the other's business for seven years. The first book illustrated by an artist that Bruno published was Max Slevogt's *Ali-Baba* of 1903. This used only line-block reproductions of pen drawings and it was not until 1908 with Slevogt's *Sindbad der Seefahrer [Sinbad the Sailor]* that he succeeded in marrying letterpress with original lithographic illustrations.[18] Curt Glaser, writing in 1922, saw this publication as opening a new chapter in German book illustration.[19] In combining two different methods of printing it went against all the canons of fine book production. But, as Glaser explained, the more 'proper' wood-engraving seemed old-fashioned while

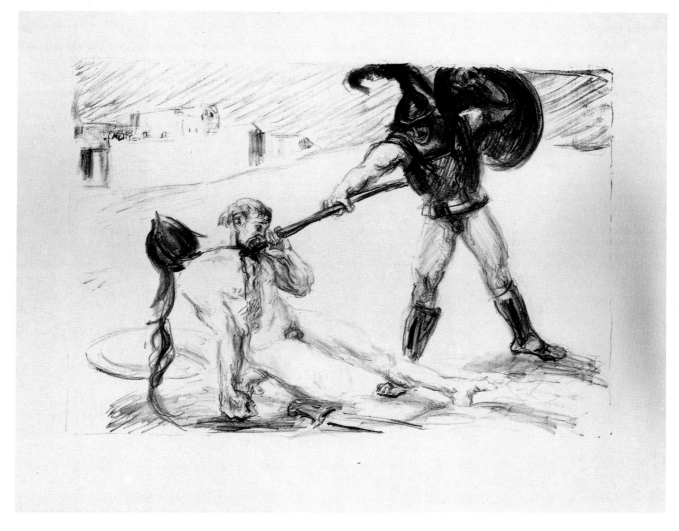

6.2 MAX SLEVOGT
The Death of Hector
plate 12 from *Achill*
[*Achilles*] 1907
lithograph
27.4 × 38.0
Felix Man Collection
Australian National Gallery,
Canberra

etching disrupted the text. The way forward had been shown by Vollard's productions.

Although it took a long time for traditional bibliophiles to get used to the innovation, Bruno Cassirer had opened up an entirely new area for German lithography and forced a new method of drawing on the technique: an illustration combined with a text almost inevitably tended to the vignette, drawn with lithographic chalk as a sketch and confined by no border line. In the same year as *Sinbad der Seefahrer* appeared, Paul Cassirer re-entered the publishing business, the seven years having elapsed. His first illustrated book was also by Slevogt and this and most of his later publications used lithography. To print his books, Paul established the *Pan-Presse*, advertised as a 'Druckerei für Künstler-Graphik'. 'The Press undertakes orders for proofing and editions. There are only hand presses, both for etching and for lithography. Since the Press is directed not by artisans but by artists, every demand for artistic execution can be met. The workers are accustomed to follow the intentions of the artist, with the result that even artists resident elsewhere can rely on the fulfilment of their artistic intentions.'[20]

In a catalogue of his publications put out in 1912, Paul Cassirer claimed that he had now supplied a sympathetic printer (R. Hoberg) and facilities that were previously obtainable only in Paris.[21] It is arguable that he had done even more than this. The Pan-Presse seems to be the first lithographic workshop specifically set up to service the needs of artists; as such it is a forerunner of the developments that have had such a

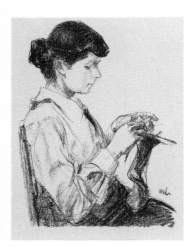

6.3 MAX LIEBERMANN
Woman knitting 1915
lithograph
16.5 × 11.5
British Museum, London

huge influence on the history of the medium since the late 1950s. But it cannot be claimed that the Pan-Presse was vitally important in itself. Rather it reinforced the direction taken by Bruno Cassirer. Together the two cousins commissioned such a quantity of single-sheet prints, portfolios and books illustrated with lithographs that the medium has come to be closely associated wtih the members of the Berlin Secession.

The three most important figures were Max Liebermann (the first president), Lovis Corinth and Max Slevogt. All had in fact made a number of lithographs before 1908. The first two had each drawn a few directly on the stone in the 1890s; they are in the closely worked and highly finished manner that we have already seen with Käthe Kollwitz. But when their publishers urged them to take the medium up again in 1908, the pressures of the illustrational mode which was expected led them to adopt a quite different and more sketchy manner of drawing. For this there was no need to draw directly on the stone and increasingly they tended to confine themselves to using transfer paper. This limitation undoubtedly affected the quality of their prints as compared with their earlier stone lithographs. By resigning all claim on the special effects possible only in stone lithography they rested the entire aesthetic weight of their prints on the strength of the drawing itself. Corinth's draughtsmanship (6.4) usually stands up to this pressure, Liebermann's less frequently (6.3). Slevogt (6.2) is a lesser

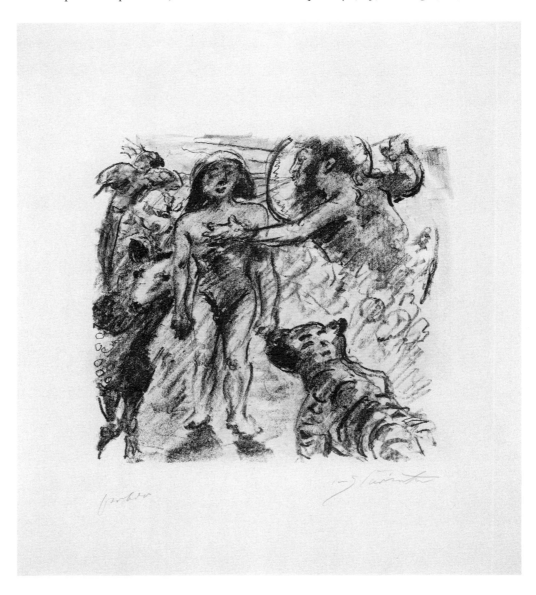

6.4 LOVIS CORINTH
The Creation of Adam
from the portfolio *Im Paradies*
[*In Paradise*] 1920–21
colour lithograph
33.0 × 31.0
Felix Man Collection
Australian National Gallery,
Canberra

figure than either, although he was the artist that Bruno Cassirer seems to have admired the most, going so far as to print in 1924 a special catalogue of all his works that had been published by the Cassirer-Verlag.

The case of another member of the Secession, Max Beckmann, is typical of the period. At the age of twenty-two he won the Villa Romana prize with his painting *Young men by the sea* and on his return from Florence in 1907 he became a member of the Berlin Secession, being elected to the committee in 1910. At this time there was nothing revolutionary in his painting; in 1912 he was involved in a public controversy in which he ranged himself against the new art of the Expressionists. So it is not surprising that his first prints in 1909, apart from a few student essays, were nine illustrations commissioned by Paul Cassirer to a text by Johannes Guthmann, *Eurydikes Wiederkehr [Eurydice's return]*. His next two publications in 1911 and 1912 were also sets of illustrations. But from 1913 he abandoned illustration and lithography with it. His new personal subject-matter demanded at first a new medium, drypoint. After his shattering experiences in the war he returned to lithography, but in a quite new way.

Similar pressure from a publisher seems to lie behind the lithographs of two other artists who rose to prominence before the first world war, Ernst Barlach (6.5) and Oskar Kokoschka (6.6). Barlach's early career was rather similar to that of Beckmann. He found his personal style on a journey to Russia in the autumn of 1906 and in 1907 signed a contract with Paul Cassirer to sell him his entire output in return for a fixed salary. He also joined the Berlin Secession. He finished his first play, *Der tote Tag [The dead day]*, in 1910, and intended to illustrate it with reproductions of his drawings. It was Cassirer who persuaded him to redraw his designs on to stone and then printed the work as an édition-de-luxe in his series of Pan-Presse publications.[22] Kokoschka was also a protégé of Cassirer and signed a similar contract with him in 1910. He already had a certain experience with lithography in the highly finished coloured works that

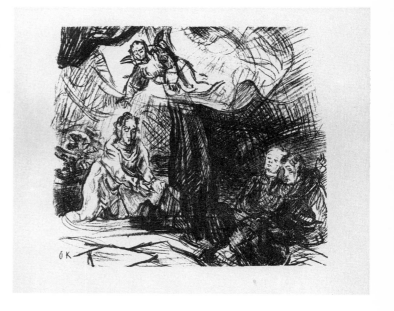

6.6 *Below*
OSKAR KOKOSCHKA
Christ on Mount Olive
from *Der Bildermann*
[*The Picture-man*] 1916
lithograph
27.8 × 31.0
Felix Man Collection
Australian National Gallery,
Canberra

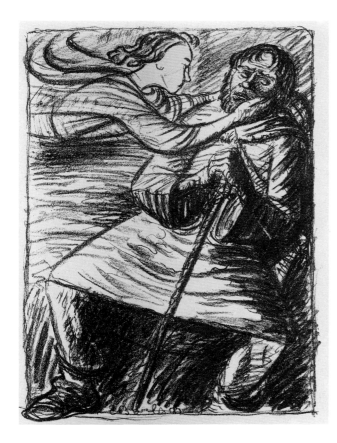

6.5 *Left* ERNST BARLACH
The tired man
from *Der Bildermann*
[*The Picture-man*] 1916
lithograph
29.4 × 21.2
Felix Man Collection
Australian National Gallery,
Canberra

had been made after his designs for the Wiener Werkstätte in 1906–08. But when he took up lithography again after moving to Berlin shortly before the war, it was in the new 'Secession' manner: in other words his plates were made as illustrations to texts— often his own plays—and adopted the feel of chalk drawings.[23] Indeed the best term to describe the works of the entire circle of artists around the Cassirers is one that is frequently found in their publications: 'Steinzeichnungen' or 'stone drawings'. The word 'Lithographie' was rarely used.[24]

The Secessionist approach must be seen as an assault on the main tradition of German lithography. It met with rapid acceptance and by the 1910s had itself begun to represent the main stream in the eyes of many of the more aware critics. The parallel assault which took place in Dresden among the members of Die Brücke was far more radical in its procedures and took far longer to gain acceptance. The group was founded in June 1905 by three men in their early twenties, Ernst Ludwig Kirchner, Erich Heckel and Karl Schmidt-Rottluff, with a programme that called together all youth: 'As youth, which bears the future, we wish to create for ourselves freedom of

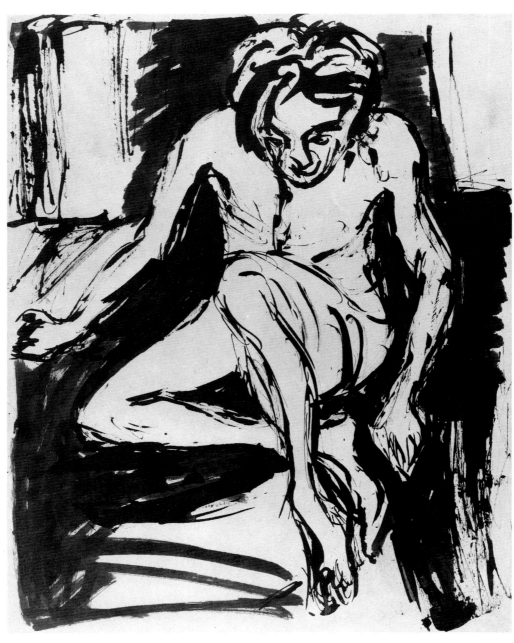

6.7 ERNST LUDWIG
KIRCHNER
Seated nude child c. 1907
brush drawing
44.0 × 34.0
British Museum, London

movement and life against the entrenched older forces. Everyone belongs to us, who sets down immediately and truthfully whatever impels him to creation.' Such a programme imposed no specific style, but did presuppose a break with the past. In painting this emerges as a refusal to blend colours; they applied areas of pure pigment to the canvas, often leaving bare patches between the brushstrokes. In drawing, their innovation was to abandon the finished composition in favour of sketches taken directly from life with the greatest possible rapidity: in their sessions with a model they allocated a maximum of fifteen minutes to a sheet (6.7).

Before 1905 all three had made woodcuts in a Jugendstil manner, with stark contrasts of black and white excluding any half-tones, and woodcut remained their favourite method of printmaking until the end of 1907. But the sheer amount of time needed to cut a block detracted from the spontaneity that they were seeking and already in 1906 they had begun to experiment with etching. This in turn led them to lithography, where the method of drawing could be as quick and unconfined as they liked. It is for this reason that in the decisive years from 1907 to 1909, while they were finding a style to match their intentions, etching and lithography became far more significant printmaking media for them than woodcut, the technique with which they are normally associated (6.8).[25] Even in the later years up to the dissolution of Die Brücke in 1913 and the outbreak of the war in 1914 lithography remained very important.

The first of the members of Die Brücke to take up lithography was Schmidt-Rottluff in 1906. All his early prints up to mid 1908 were drawn directly on the stone and printed at the Dresdner Kunstanstalt. Technically they are of the simplest, using only chalk and scraper, but the draughtsmanship was bold and aggressive enough to alarm even Munch when he was shown some by Gustav Schiefler in 1907. Schiefler recorded in his diary that Munch had said 'This is insane' and added 'Now I'm going to say the same about him as they have always said about me: God protect us, we're heading for bad times.'[26] But these results did not seem enough to Kirchner and Heckel. As Kirchner's later writings make plain, the trouble was that a lithograph looked like a reproduced drawing, whereas it should look like an original work of art created by the printing process.

6.8 ERICH HECKEL
after ERNST LUDWIG
KIRCHNER
Franzi seated
from the catalogue of the
Galerie Arnold exhi-
bition 1910
woodcut
16.6 × 10.8
Australian National Gallery,
Canberra

6.9 ERICH HECKEL
House in the woods 1909
lithograph
28.2 × 38.0
Australian National Gallery,
Canberra

We have only to look back over the history of lithography to see how radical this criticism was. Senefelder's claim was that he had invented a printing method that could give a precise replica of any type of drawing made on the stone. This great achievement was of no interest to Kirchner. If he wanted to make a drawing, he could simply use a sheet of paper; if he was going to draw on stone the results should look as though they were drawn in this way. Hence he and Heckel embarked on a series of experiments that still remain the most extraordinary departure in the history of the medium as an art form (6.9).

6.10 ERNST LUDWIG KIRCHNER
Leipziger Strasse, Berlin 1914
lithograph on yellow paper
59.5 × 50.8
Photo-archive Wolfgang Wittrock

6.11 KARL SCHMIDT-ROTTLUFF
Cows in the stable I 1908
lithograph
34.0 × 39.8
Felix Man Collection
Australian National Gallery,
Canberra

In 1958 Heckel recalled in an interview that he and Kirchner were given a single stone by a lithographic firm. 'On this stone Kirchner and I made in turn the most varied experiments: from these emerged potentialities which were not to be met in normal practice in making lithographs. We were not searching for new techniques, but our methods of working the litho stone gave rise to new possibilities.'[27] Kirchner, writing in the third person about himself in 1921, claimed:

Through patient researches and many mistakes, he has discovered in lithography processes which have allowed this technique, usually handled for both just and unjust reasons in a somewhat step-motherly fashion, to take its rightful place next to the other graphic processes. His method of turpentine etching brings to the stone areas of tone never seen before. His lithos are hand-printed. He goes on working his stones until the first drawing has become fully graphic—that is, until the drawn lines vanish and are reformed through the etching. Deep blacks and a silky grey which is produced by the grain of the stone alternate. The soft tonality of the grey areas divided by the grain of the stone produces an effect of colour and lends warmth to the sheets. Thus Kirchner found for himself in lithography a personal technique that is far richer as a medium than woodcut. (6.10)[28]

The techniques invented by Kirchner and Heckel were communicated to Schmidt-Rottluff (6.11), who from mid 1908 abandoned his earlier way of making lithographs, and then to a handful of other artists who were later associated with the members of Die Brücke, notably Pechstein, Mueller and Tappert (6.12).[29] Otherwise they have scarcely been used by any other artist. The accounts quoted above are elucidated by Schiefler. The stone, or simply areas of it, was washed with water to which drops of turpentine had been added:

Through this both the drawn line and the wetted surfaces undergo a change of substance: the particles of pigment of the crayon or lithographic wash are loosened

and refixed according to the structure of the stone, the line loses its sharp edges, the gaps between the thickly laid areas of line are more or less filled up, while the darker areas are reduced to a lighter tone.[30]

Then, after the water was dry, the design on the stone could also be altered in the etching process, either by over-etching so that the line broke down into a series of grainy globules or by under-etching so that the stone accepted a heavier charge of ink. These processes could so alter the design that it is sometimes unclear whether the original drawing was in crayon or wash (6.13). The design could also be changed more simply by polishing off parts with a pumice stone, reducing the areas with alum, and redrawing them afresh. Heckel claimed that in this way they could move whole lines from one place to another without anyone noticing the correction (6.14). Finally, they always inked the stone up to the edges and printed it so that the inky contour was visible (6.15). If the turpentine and etching processes made it clear that the work was a

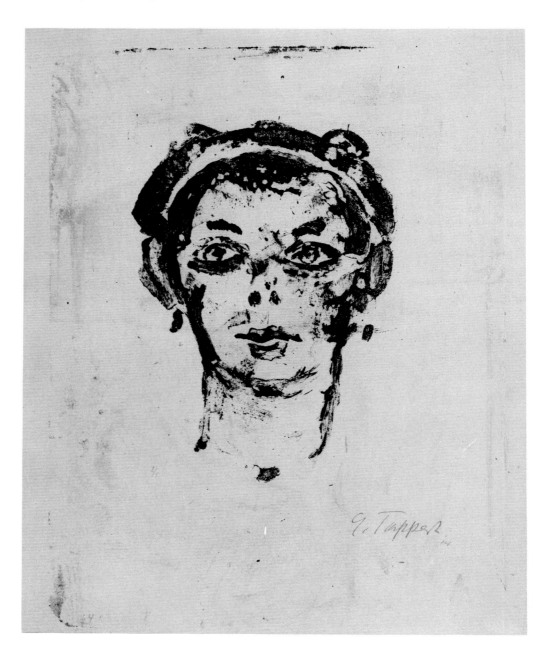

6.12 GEORGE TAPPERT
Head of a woman 1914
lithograph
43.0 × 31.8
British Museum, London

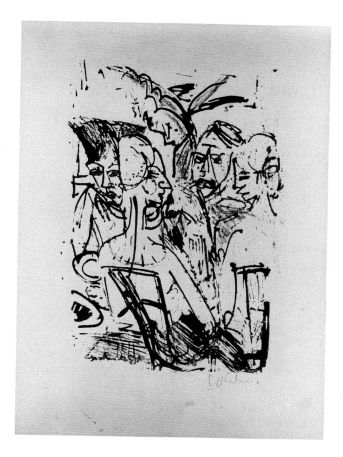

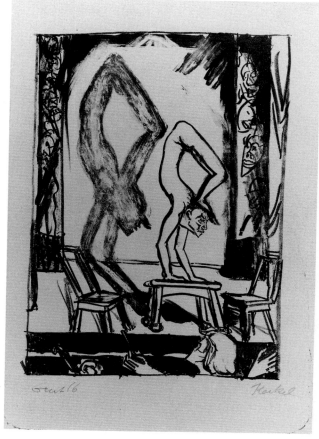

6.13 *Above left*
ERNST LUDWIG KIRCHNER
Dinner scene
from *Der Bildermann*
[*The Picture-man*] 1916
lithograph
33.0 × 22.0
Felix Man Collection
Australian National Gallery,
Canberra

6.14 *Above* ERICH HECKEL
Handstand 1916
lithograph
27.8 × 19.6
edition 125
Felix Man Collection
Australian National Gallery,
Canberra

6.15 MAX PECHSTEIN
In the rain 1909
lithograph
35.0 × 38.8
Felix Man Collection
Australian National Gallery,
Canberra

print rather than a drawing on paper, it was the inking to the edges that made it evident that it was indeed a lithograph. In order to draw attention to the fact that they had printed the works themselves, they usually signed impressions and annotated them 'Handdruck' or 'Eigendruck'.

The members of Die Brücke also took radical steps forward in colour printing. Since lithographic stones have always been expensive, and they had very little money, they never had more than a few stones available which they ground down each time they wanted to make another print. Conventional colour printing using a separate stone for each colour was thus impossible. The first technique that they tried was simply to use water containing coloured pigments when they washed the stone as part of the printing process. Thus at the same time as they printed the black, the white areas of the paper would be watercoloured. But the trouble with this was that the washes were very faint, and rapidly faded. So the next development was to print a certain number of impressions in black, and then rub the stone down so that they could only just see the drawing. On top of this they would draw the first colour area, print it onto the black impressions, and then repeat the whole procedure for each of the other colours (col. pl. 23).[31] Registration seems to have been achieved simply by eye. This technique was used to make the masterpieces of Brücke colour lithography. It was breathtakingly risky, because once the black design had been taken off no more impressions could be printed; every sheet spoiled in the colour printing reduced the size of the edition.[32] The key stone also had to be printed first rather than last as is usual in colour printing.

Kirchner frequently printed his lithographs on coloured—usually yellow—paper. In one extraordinary print, *Das Kamel*, made in 1916, he adapted this by printing two impressions from one stone, once on yellow and once on red paper. The camel from the red impression was then cut out and pasted over the same figure on the yellow impression to create a colour lithograph.[33] Admittedly this was most exceptional, but it reveals how fertile in unconventional expedients Kirchner's mind was. Pechstein invented his own simple method of adding colour: he simply printed an impression in black, and then inked the stone in monotype fashion for overprinting (col. pl. 24). This allowed only one strong and one weak impression of each to be made, but this hardly mattered as it was not until shortly before the war that any of these artists found any significant market for their work.

Emil Nolde was only a member of Die Brücke for eighteen months, between February 1906 and the autumn of 1907; he had departed before Kirchner and Heckel developed their new lithographic techniques and Nolde's lithographs show no awareness of what they had discovered. Nolde's characteristic way of working was in brief and intense bursts, and almost all his lithographs fall into five groups. The first was made in 1907, and were all drawn on transfer paper using a brush and printed in monochrome (6.16). Another group of brush lithographs followed in 1911, but Nolde drew these directly on the stone, apparently prompted by critical remarks from Schiefler. In 1913 and again in 1926 he turned to colour lithography, working on the stone at the printer Westphalen in Flensburg to make two groups of prints, almost all on a very large scale. The complexities of Nolde's procedures in these can be seen in *Mühle am Wasser (Windmill beside the water)* (col. pl. 21). To the key stone were added three colour stones, each of which was taken through various states. These were printed onto the key in varying combinations and with constant changes of colour. According to Mosel's catalogue, Nolde printed 25 impressions in all, but these come in seven different variants, sometimes using all four stones, sometimes only two.[34]

Technically there is nothing unusual in Nolde's procedure. The surprise is in his arbitrary approach to colour and the way in which the series of variations excludes any ideas of a definitive version. In 1915, the success of his series of colour lithographs made in 1913 led him to the conclusion that his early black-and-white lithographs of 1907 would be improved by the addition of colour. To this end he made a number of new colour stones, but then seems to have found that he had not enough impressions remaining to overprint. He therefore had photomechanical reproductions made of

6.16 *Above* EMIL NOLDE
Tingel-Tangel III 1907
lithograph
32.4 × 48.2
edition 100
Felix Man Collection
Australian National Gallery,
Canberra

6.17 OTTO MUELLER
Girl lying on a couch *c.* 1919
lithograph, hand-coloured
22.4 × 32.2
Felix Man Collection
Australian National Gallery,
Canberra

some of the lithographs, which were then overprinted with his new colour stones – a curious mixture of the original and the reproductive in a single print.[35]

The last recruit to Die Brücke was Otto Mueller, who joined in May 1910. Lithography was always his favoured method of printmaking and his early prints show in a pure form the methods preferred by Die Brücke, which he probably learnt from Kirchner, to whom he was particularly close. From about 1910 to the end of the first world war almost all his prints were printed from one stone measuring 43.3 × 32.6 cm, which Mueller used to refer to as his 'alter Stein' [old stone]. His compositions look as if they were drawn directly from nature, which implies that he took his stone with him to the country where his models could pose nude. He printed them himself in tiny numbers and different impressions often show changes of state, either through redrawing of the composition (as described by Heckel) or by applications of turpentine and re-etching to soften the lines. Impressions are frequently printed on yellow paper or hand coloured, but never printed in colours. During the war years Mueller gradually moved away from the purity of the Brücke technique, initially by substituting drawn border lines for inking up to the contour of the stone (6.17). In 1919 he moved to Breslau, where the academy at which he was teaching had a fully equipped studio which henceforth did all his printing for him. This led to another move which Kirchner would have abhorred: he began to use transfer paper with a pronounced grain. These later prints were published in large editions and to this day Mueller's fine early work remains virtually unknown and his qualities are misjudged by his weak later work.[36]

The sheer difficulties of circumstances during the war forced changes and compromises on all sides. The only artists to avoid being called up into the army were those of the older generation. Only a few publishers managed to start up again during the war years, the most notable being Paul Cassirer. His major publication was a broadsheet periodical called *Kriegszeit [Time of War]*, which was later succeeded by *Der Bildermann [The Picture-man]*. This was printed lithographically by Lassally in Berlin, and bears the sub-title *Steinzeichnungen fürs deutsche Volk [Lithographs for the German People]*. A wide range of artists were asked to contribute, among them Kirchner, Mueller and Heckel. The nature of the production—a single broadsheet containing both image and text—made it imperative that the design be supplied on

6.18 *Below* OTTO MUELLER
Three figures bathing
from *Der Bildermann [The Picture-man]* 1916
lithograph
26.2 × 20.4
Felix Man Collection
Australian National Gallery,
Canberra

6.19 *Below right*
ERICH HECKEL
Eating mussels
from *Der Bildermann [The Picture-man]* 1916
lithograph
28.2 × 20.6
Felix Man Collection
Australian National Gallery,
Canberra

transfer paper, which in turn implied that the drawing should be made directly on it. This was evidently anathema to the former members of Die Brücke. So they made lithographs in their usual way on stone, but printed them onto transfer paper for posting on to Berlin (6.18, 6.19). Heckel later changed his approach but this was one of the only occasions that Kirchner ever used transfer paper or allowed someone else to print his lithographs.[37] After the war, buried in his retreat in Switzerland, he went back to his stones, preserving the original purity of his technique until his suicide in 1938 (6.20).

The sub-title of *Der Bildermann* is one of the last references to the ideals of the old 'Künstlersteinzeichnung' [Artists' lithographs] movement, which seems to have petered out after the war. On the other hand the 'Steinzeichnungen' of the Berlin Secession enjoyed a continuing and indeed increasing popularity as its members succeeded their predecessors as the 'safe' artists of the culturally aware bourgeoisie. But the appalling legacy of the war and the feverish political situation after the Revolution of 1919 produced some interesting shifts in practice, two of the most pronounced being with Käthe Kollwitz and Max Beckmann. Kollwitz completely changed her opinion about the function of art; whereas before she had thought of her subject-matter in purely aesthetic terms, she now wished to have an effect on the world by calling attention to its wrongs and injustices.[38] She took up woodcut for the first time in 1919, but her favoured medium became lithography mainly because it allowed her images to be multiplied almost indefinitely. To convey their starkness, transfer paper, often selected for the prominence of its grain, proved much more suitable than the nuances obtainable by drawing directly on the stone (6.21). In the case of Beckmann two reasons seem to have led him to make his two great series *Die Hölle*

6.20 *Above left* ERNST LUDWIG KIRCHNER
Peasant family 1937
lithograph
32.6 × 27.4
Felix Man Collection
Australian National Gallery, Canberra

6.21 *Above* KÄTHE KOLLWITZ
Small self-portrait 1920
lithograph
23.4 × 21.0
Felix Man Collection
Australian National Gallery, Canberra

[Hell] and *Berliner Reise [Berlin Journey]* (6.22) as lithographs rather than as drypoints. Both series present themselves as eye-witness accounts of the collapse of society and for this the directness of a drawing (transferred to the stone) must have seemed preferable to the fine art connotations of the drypoint. More simply, lithography allowed him to use sheets of a much larger size and to play tricks with the space by bringing figures forward out of the drawn borderlines, something which would not have worked with the additional border created by the platemark of a drypoint.

The post-war years saw the triumph of Expressionism as a style among the radical youth. Its most characteristic device, which it had learned from Cubism, was the foreshortening of space by bringing forward the lines of recession into triangles that press against the picture surface. The graphic medium best suited for this splintered

6.22 MAX BECKMANN
The Disappointed II 1922
from the series *Berliner Reise*
[*Berlin Journey*]
lithograph
48.0 × 38.0
edition 54/100
Australian National Gallery,
Canberra

6.23 HEINRICH ZILLE
My Sausage is good
from *Der Bildermann*
[*The Picture-man*] 1916
lithograph
22.6 × 20.0
Felix Man Collection
Australian National Gallery,
Canberra

effect was the woodcut, validated in any case by its long and distinguished history in German art. The years of the boom in print publishing in Germany from 1919 up to the collapse in the great inflation of 1923 are marked by the close attention paid to woodcut. As early as 1918 the leading avant-garde artistic journal *Das Kunstblatt* published a special number on the woodcut and this was followed by several books. Etching, or more particularly drypoint, also had its place in this interest because it seemed to be a medium that allowed a directness and rawness of response, but lithography played relatively little part. Perhaps this need not have been the case if the prints of Die Brücke had been generally known or their discoveries published. Since they were not, lithography only returned to prominence in the reaction against Expressionism among the Constructivists and at the Bauhaus.

Before examining this, a quite separate phenomenon in post-war print publishing should be considered; its origins can be traced to the illustrated journals that were so common from the 1890s up to 1914. Many men who later made their reputations as painters or sculptors began their careers as illustrators for magazines such as *Simplicissimus*; among them were Barlach and Feininger. From such humorous cartoons there was an easy transition to producing illustrated books where the caption to the plate was often the only text. Such books were usually published in enormous editions on poor paper and the artists' drawings were reproduced as line or half-tone blocks. But as these artists gained in reputation, a market developed among collectors for special editions with better-quality reproductions on finer paper. Such better reproductions were normally printed lithographically and the fact that they were usually photolithographs rather than transfer lithographs tempted the publishers to preserve a welcome ambiguity by describing them simply as lithographs. The uncertainty in the public mind as to quite what was meant by a lithograph was only further confused by this strategy.

One of the first artists to be treated in this way was Heinrich Zille, the illustrator of Berlin low life (6.23). No proper account of his prints has ever been published, but it is questionable whether he ever made an original lithograph. But a much greater figure emerged from this same tradition—George Grosz. His style of drawing was always

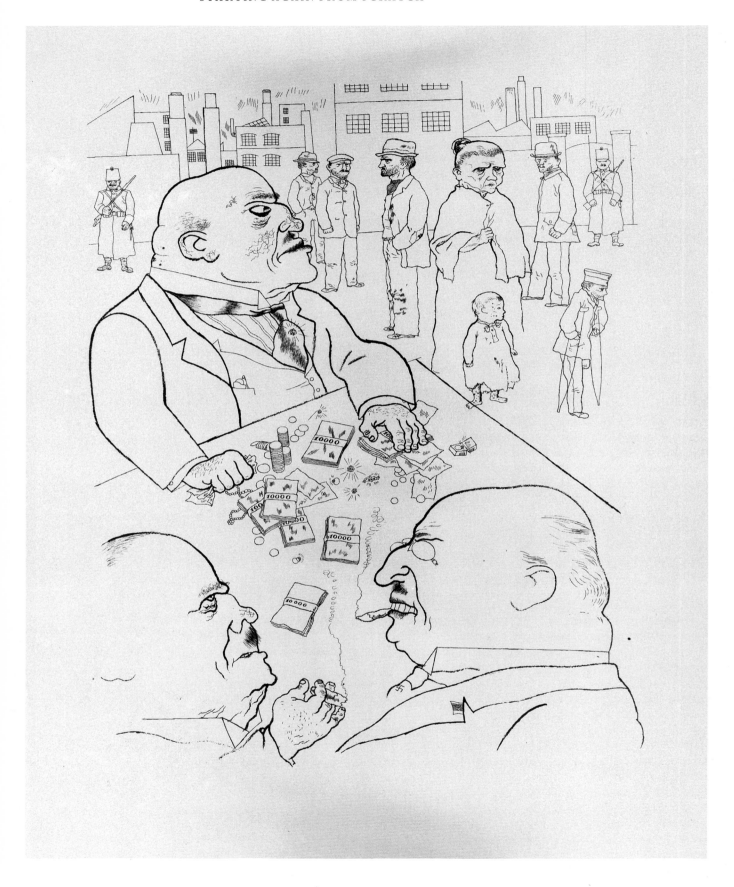

determined by the demands of reproduction and he first came to prominence for the biting line of his drawings in left-wing journals. In 1917 he and the Herzfelde brothers founded the Malik-Verlag and it was a calculated commercial policy of the press to publish his drawings (many of which had already been reproduced in newspapers) in signed and limited editions for collectors under the vague description 'lithos'. According to Grosz's cataloguer, only a few of the prints made before 1918 are even transfer lithographs; after 1918 they are exclusively photolithographs (6.24).[39] But the important point is that it is really of very little concern which they are. For Grosz, both types were simply variant methods of reproducing his drawings. It is the collector or the historian who causes the trouble by trying to match them to irrelevant criteria.

Otto Dix is often associated with Grosz as a prominent figure in the Neue Sachlichkeit (New Objectivity) of the 1920s, but as a printmaker he belongs to a different tradition in that he was never an illustrator or political cartoonist. His training was as a painter, and it was only after the war that he turned to printmaking. His most celebrated work is the cycle of etchings entitled *Der Krieg [The War]* begun in 1922 and published in 1924, but in the previous year he had made for his publisher Karl Nierendorf a group of 26 lithographs, mostly printed in colour. Dix was an extremely accomplished watercolourist, and it has been stated that the motive for making these prints was his publisher's wish 'to stimulate the graphic market which had become problematic in the critical year of 1923' by multiplying them in editions of (normally) 65 to 100.[40] But Dix was too fine an artist merely to produce reproductions of watercolours and by working directly onto the stones with a combination of chalk and lithographic wash, he made some of the most startling images of the period (col. pl. 22).

With the Bauhaus we return to the mainstream of printmaking.[41] Within six months of the foundation of the school in early 1919, a workshop had been set up with equipment for all the three main graphic processes. The technician was Carl Zaubitzer and the master in charge was Lyonel Feininger. Although the school would print on commission for external publishers (Kandinsky's *Kleine Welten [Small worlds]* were printed in this way for the Propylaen Verlag of Berlin), the main productions were four portfolios of original prints, published in 1922–24.[42] Three of these were supplied by German artists and in them the number of the lithographs is approximately equal to the total of the etchings and woodcuts. But in the fourth portfolio of works by Italian and Russian artists, all but one of the prints are lithographs, evidently because the artists were not themselves in Weimar and found it much simpler and cheaper to send a drawing on paper for transfer rather than a block or plate.

In the history of German lithography the Bauhaus portfolios must be seen as somewhat transitional works. They belong to the early years of the Bauhaus, when for many artists (most obviously Feininger himself) Expressionism was still the dominant style, and there is no uniformity in the types of images included. Nor is there any consistency about terminology; in the contents sheets of the portfolios the term used to describe the prints is indifferently 'Lithographie' or 'Steindruck'. The discomfort that many contributors seem to have felt can be seen in the case of Paul Klee, who made a number of lithographs in a similar way between 1919 and 1925. Almost all of them were prepared on transfer paper and depended on earlier drawings; for example, the pen drawing which is the source of the lithograph *Akrobaten* (6.25) was made in 1916. But when he copied it in 1919 he must have felt that something more was needed and so traced it through a sort of 'carbon' paper onto the transfer paper. This produced the blurred line and random background that is visible in the lithograph. But the effect was at least partly spoiled by the acrobat's right foot having failed to transfer.[43] Although this print was published in a large edition in *Münchner Blätter für Dichtung und Graphik [Munich Broadsheets for Poetry and Graphics]*, Klee never corrected the stone.

It was however at the Bauhaus that one of the few attempts was made to formulate a theory of the different graphic processes. This can be found in Kandinsky's book *Punkt und Linie zu Fläche [Point and line to plane]* first published in 1926. Kandinsky thought

6.24 *Opposite*
GEORGE GROSZ
'Under my rule...' 1920–21
from *Die Räuber [Robbers]*
1922
lithograph
50.6 × 39.2
edition 30/100
Australian National Gallery,
Canberra

6.25 PAUL KLEE
Acrobats
from *Münchner Blätter für
Graphik und Dichtung
[Munich broadsheets for
graphics and poetry]*
pt 1, 1919
lithograph
19.2 × 7.4
Felix Man Collection
Australian National Gallery,
Canberra

6.26 *Above*
WILLI BAUMEISTER
Apollo I 1922
lithograph
37.4 × 23.0
Felix Man Collection
Australian National Gallery,
Canberra

6.27 *Above right*
LAZLO MOHOLY-NAGY
Untitled variant
from *Konstruktionen* 1923
lithograph
60.0 × 44.0
British Museum, London

6.28 *Opposite*
KURT SCHWITTERS
Untitled
from the *Merz*
portfolio 1923
lithograph
55.5 × 44.5
Photo-archive Wolfgang
Wittrock

that lithography's 'exceptional speed of preparation together with the almost undamageable toughness of the plate answers completely the "spirit of our time"'. He was particularly impressed with the ease of correction which allowed the artist to experiment without having any previously formed plan. In a footnote he claimed that each of the three processes had a different social character: the etching is aristocratic, the woodcut less so but handicapped by the difficulty of adding colour, while the lithograph is able 'to supply an almost unlimited number of impressions at the fastest speed in an almost mechanical way, and through the constantly increasing employment of colour is drawing closer to the hand-painted picture. At any rate it generates a certain substitute for a painting. This clearly shows the democratic character of lithography' (col. pl. 25).[44]

This account is surprisingly unsympathetic to the graphic qualities of the medium and would have made Kirchner scream with fury. But Kandinsky's own practice in his series *Kleine Welten* of 1922 is no more sensitive than his theory and pays no attention to niceties of texture and impression. Its arrangement is programmatic: there are four prints in each of the three processes of etching, woodcut and lithography and half of them are printed in colour. The one black-and-white woodcut is printed directly from

206

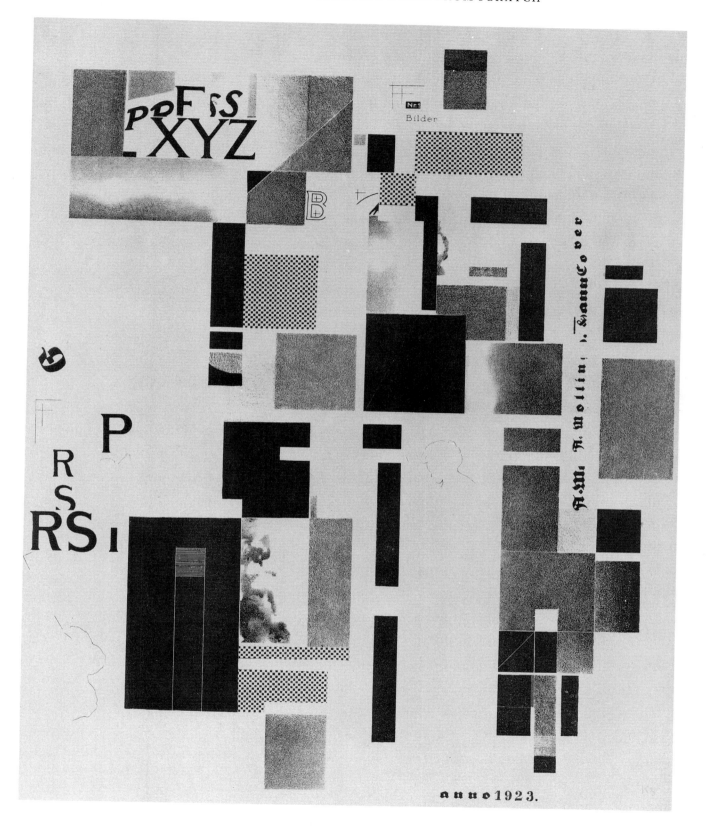

the block, but, astonishingly, the two colour woodcuts are printed lithographically. The basic design was printed in black from a transfer of an impression from a woodcut, while the colour gives every appearance of having been drawn directly on the lithographic stone, or more likely (to judge from Kandinsky's terminology quoted above) zinc or aluminium plate. In other words Kandinsky's interest extended little further than to the characteristic line produced by each process.

Nevertheless Kandinsky's insistence on the mechanical character of lithographic printing, as opposed to the more variable results produced by the other two processes, points to a new aesthetic approach which is of great importance in the art of the 1920s. Its origins can be traced to the Russian Constructivists, whose art aimed at the impersonal and a finish that denied the appearance of the artist's own hand. Etching was excluded because its line was always too tremulous and betrayed craftsmanship; woodcut in the same way was tainted by its firm association with Expressionism. This left lithography, and this was the medium chosen by both El Lissitzky and Laszlo Moholy-Nagy in the portfolios they made for the Kestner-Gesellschaft in Hanover in 1923.

Moholy-Nagy's series of six prints entitled *Konstruktionen* are the more remarkable in their technical innovations. To judge from surviving examples, Moholy prepared very precise drawings which would have formed the basis of the work carried out at the firm of printers Leunis & Chapman. Whether Moholy did the redrawing on the stones himself is not known; it is quite in keeping with his philosophy of art to have left this task to the craftsman. It was certainly on his instructions that a number of prepared tonal screens and other mechanical ruling devices were employed (6.27). The results achieved the strict impersonality to which other Bauhaus artists are documented as having aspired. Willi Baumeister, for example, is recorded as having struggled to remove any trace of handworking from his lithographs of the 1920s even though he was making them entirely by traditional hand processes (6.26), while it is known that Schlemmer never drew on the stones himself but simply supplied precise preparatory drawings to the printer.[45]

In 1923 a third Kestner-Mappe was prepared by Kurt Schwitters, a close friend of El Lissitzky. Schwitters had already published a set of eight lithographs under the title *Die Kathedrale* in 1920. These prints show an astonishing range of textures which derive from his interest in collage. He seems to have glued to wooden blocks a variety of bizarre materials ranging from embossed papers to shoe leather. They were inked and printed onto paper which was cut up and rearranged in the process of being transferred to stone for printing.[46] In the *Merzmappe* of 1923 Schwitters refined and extended these interests to create some of the finest German lithographs of the 1920s[47] (6.28). He made them at the Molling printing plant, where, as an advertisement put it, they were 'Merzed by hand onto the stone' from pieces of scrap paper he found lying around. Since the ink was still wet he could cut them up and press them onto the stone in any arrangement he chose. Thus he could combine half-tone images, single letters and the registration marks from colour printing with areas of solid black or various shades of grey. He often made the photographic images even more ghostly by taking a separation made for four-colour printing. The resulting compositions were printed in a variety of colours and on some impressions he enhanced the collage effect by pasting actual pieces of coloured paper onto the print.

Schwitters's achievement was perhaps too extraordinary to have found any successors even if the recession after the inflation of 1923 had not effectively stifled the market for prints. It was not only the Bauhaus and Kestner publications that finished. Almost all the artists discussed in this essay more or less ceased to make prints after 1923. Only Kirchner, who in his fiercely independent way had never depended on a publisher, continued as if nothing had happened.

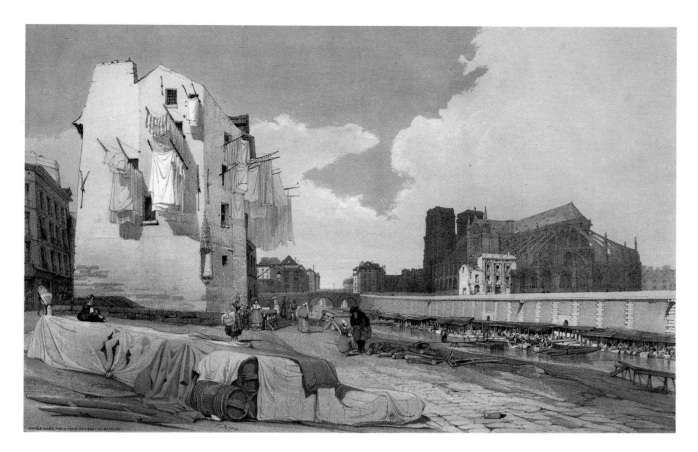

1 THOMAS SHOTTER BOYS
Notre Dame, Paris, from the Quai St Bernard
from *Picturesque architecture in Paris, Ghent, Antwerp,*
Rouen, &c 1839
colour lithograph
25.0 × 38.4
Felix Man Collection
Australian National Gallery, Canberra

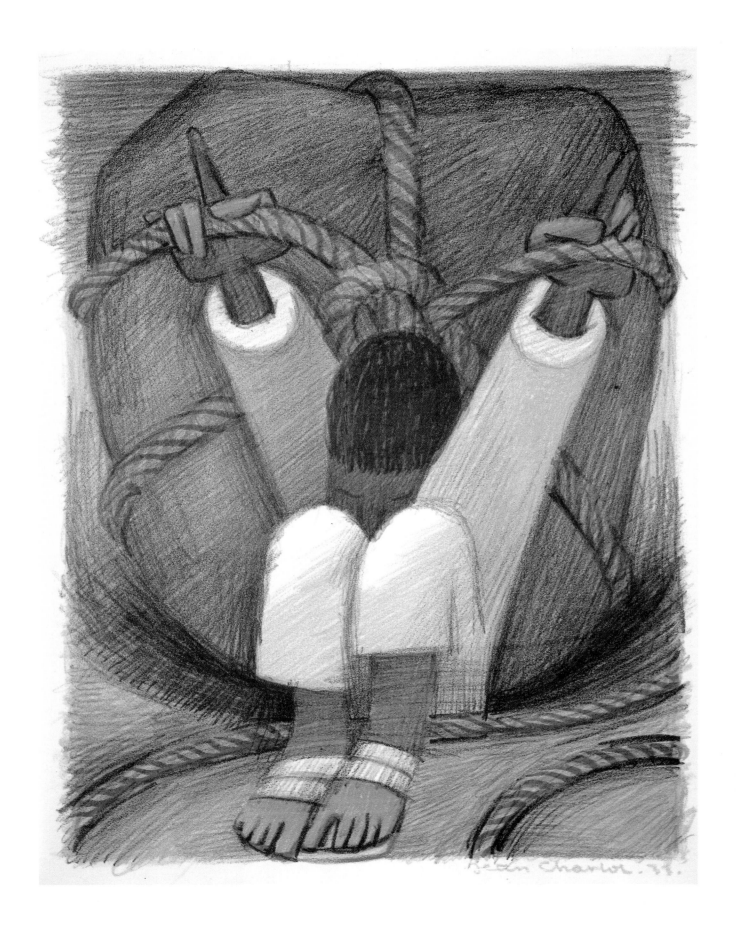

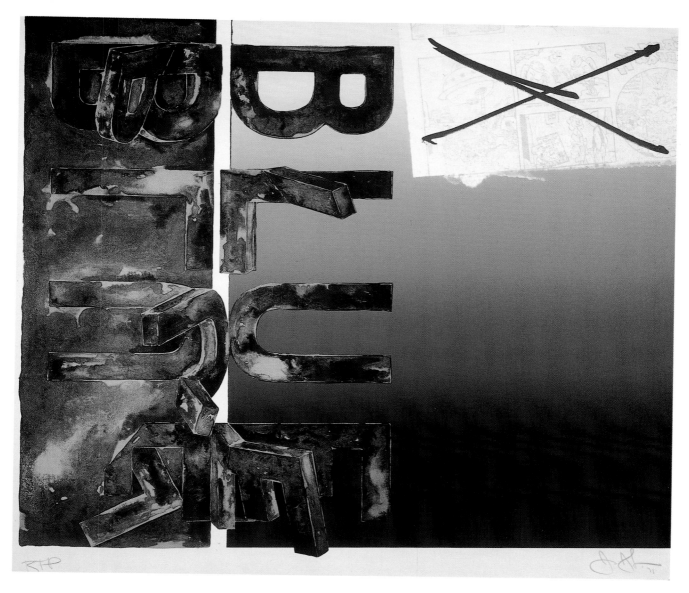

3 JASPER JOHNS
Bent blue (second state)
from *Fragments – according to what* 1971
colour lithograph with monotype
64.6 × 73.4
right to print proof (edition 66)
Australian National Gallery, Canberra
© Gemini G.E.L.

2 *Left* JEAN CHARLOT
Cargador
no. 7 from *Picture book* 1933
colour lithograph
20.6 × 16.0
edition 500
Australian National Gallery, Canberra

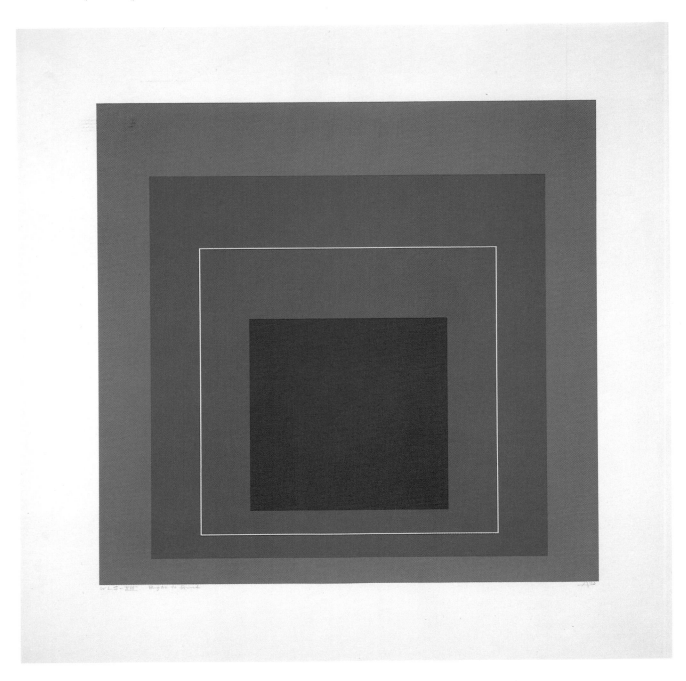

4 Josef Albers
White line square XIII
from *White line squares* 1966
lithograph
40.0 × 40.0
right to print proof (edition 125)
Australian National Gallery, Canberra

5 ROBERT MOTHERWELL
Pauillac #2
from *Summer light
series* 1973
lithograph, screenprint,
pochoir, paper collage
76.2 × 30.3
right to print proof
(edition 55)
Australian National Gallery,
Canberra

6 CHARLES DULAC
Jesu corona sanctorum omnium. Jesu sapientia aeterna
[Jesus crown of all holiness. Jesus, eternal wisdom]
No. 7 from *Le Cantique des créatures* [*Hymn to creation*] 1894
colour lithograph
36.6 × 54.2
No. 59 of unknown edition
Australian National Gallery, Canberra

7 HENRI DE TOULOUSE-LAUTREC
The seated clown (Mademoiselle CHA-U-KA-O)
from *Elles* [*Womankind*] 1896
colour lithograph
40.4 × 52.8
edition 100
Australian National Gallery, Canberra

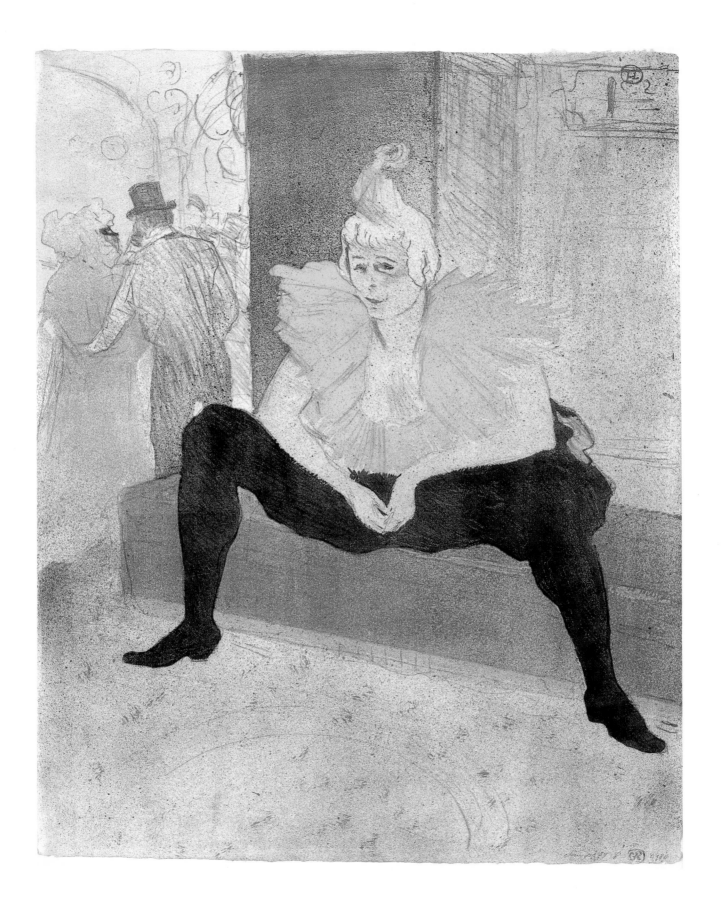

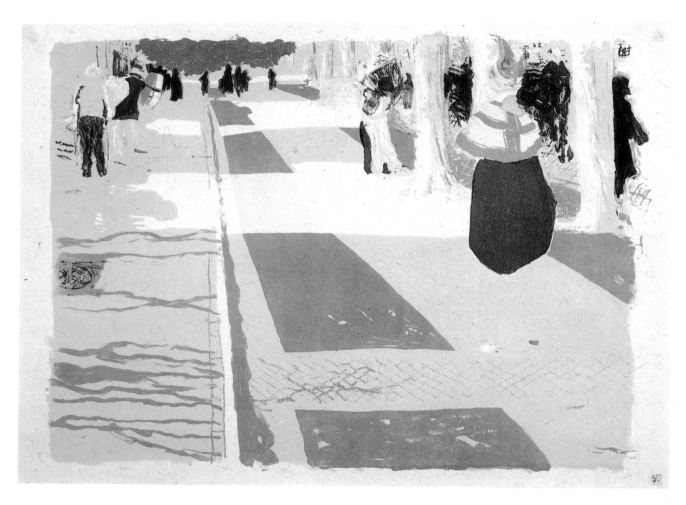

8 ÉDOUARD VUILLARD
The Avenue
from *Paysages et intérieurs*
[*Landscapes and interiors*] 1899
colour lithograph
41.3 × 30.5
edition 100
The Baltimore Museum of Art,
Print Fund, BMA 1952.86

9 MAURICE DENIS
She was more beautiful than dreams
No. 7 from *Amour* [*Love*] 1892–99
colour lithograph
40.8 × 29.4
edition 100
Australian National Gallery, Canberra

10 HENRI RIVIÈRE
The Isle of Swans
No. 24 from *Les Trente-six vues de la Tour Eiffel*
[*Thirty-six views of the Eiffel Tower*] 1888–1902
colour lithograph
17.1 × 21.2
edition 500
Australian National Gallery, Canberra

11 PIERRE BONNARD
The Square at evening
from *Quelques aspects de la vie de Paris*
[*Some views of life in Paris*] 1899
colour lithograph
28.0 × 38.8
edition 100
Australian National Gallery, Canberra

12 ÉDOUARD VUILLARD
Children's games
from L'*Album d'estampes originales de la Galerie Vollard*
[*Album of original prints from the Vollard Gallery*] 1897
colour lithograph
26.0 × 44.8
edition 100
Australian National Gallery, Canberra

13 ALEXANDRE LUNOIS
Lawn tennis
from *L'Album d'estampes originales de la Galerie Vollard*
[*Album of original prints from the Galerie Vollard*] 1898
colour lithograph
38.2 × 50.4
Australian National Gallery, Canberra

14 ARMAND GUILLAUMIN
Landscape with haystacks 1898
colour lithograph
35.0 × 51.6
Felix Man Collection
Australian National Gallery, Canberra

15 HENRI HÉRAN
Frightened nymph
from *Le Centaure*, vol. II 1896
colour woodcut, lithograph
22.9 × 16.5
Australian National Gallery, Canberra

223

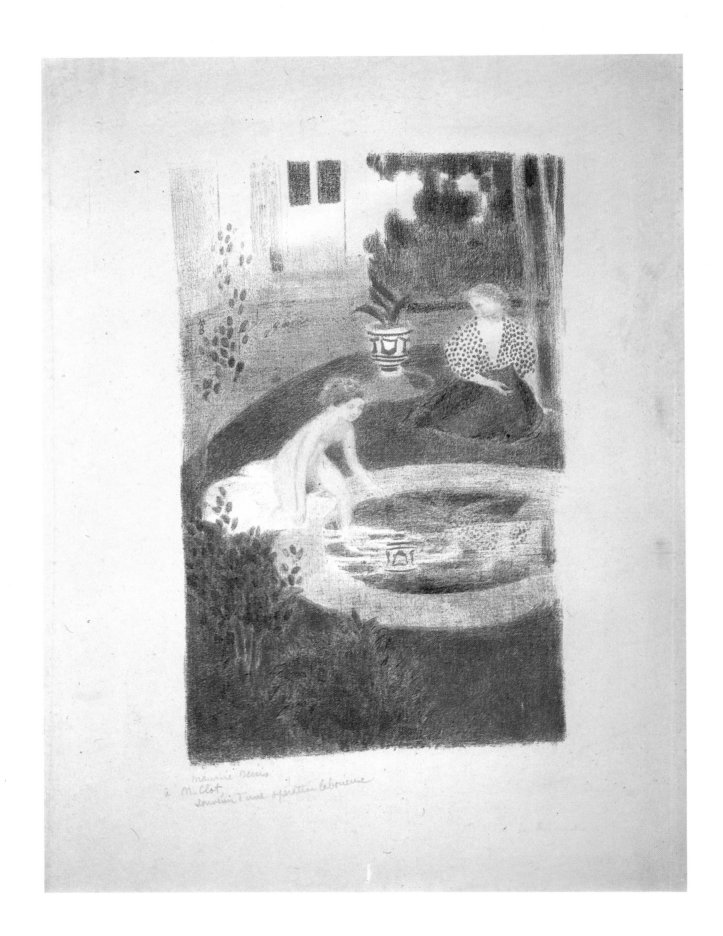

17 Paul Signac
Evening
from *Pan*, vol. 4 1898
colour lithograph
20.2 × 26.2
Australian National Gallery, Canberra

16 *Left* Maurice Denis
Reflection in the fountain
from L'*Album d'estampes originales de la Galerie Vollard*
[*Album of original prints from the Vollard Gallery*] 1897
colour lithograph
41.4 × 25.0
proof dedicated to Clot (edition 100)
Australian National Gallery, Canberra

226

18 *Left* AUGUSTE CLOT after AUGUSTE RODIN
'With slow and charming gestures, Clara smoothed the
red-gold of her hair'
from *Le Jardin des supplices* [*The Garden of torment*]
by Octave Mirbeau, Paris 1902
colour lithograph
30.6 × 21.4
Australian National Gallery, Canberra

19 ODILON REDON
Béatrice
from L'*Album d'estampes de la Galerie Vollard*
[*Album of original prints from the Vollard Gallery*] 1897
colour lithograph
33.4 × 29.4
edition 100
Australian National Gallery, Canberra

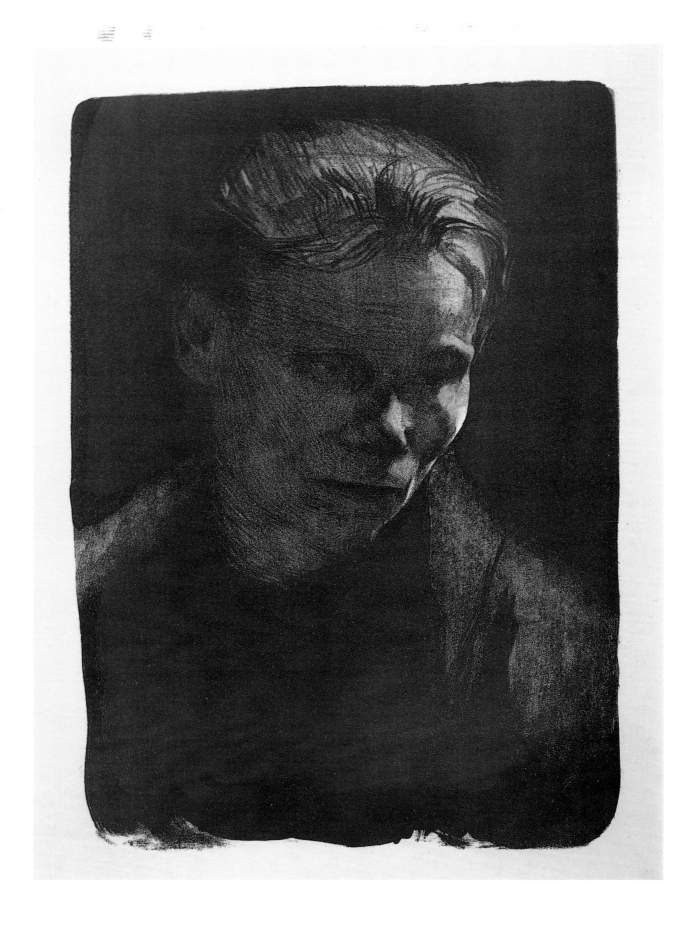

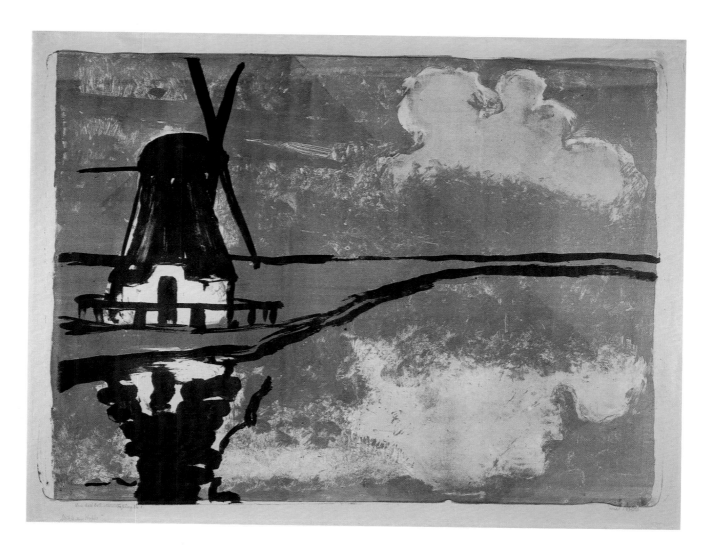

21 EMIL NOLDE
Windmill beside the water 1926
colour lithograph
60.6 × 77.8
edition 25
Felix Man Collection
Australian National Gallery, Canberra

20 *Left* KÄTHE KOLLWITZ
Portrait of a working-class woman with a blue scarf 1903
colour lithograph
35.4 × 24.6
Felix Man Collection
Australian National Gallery, Canberra

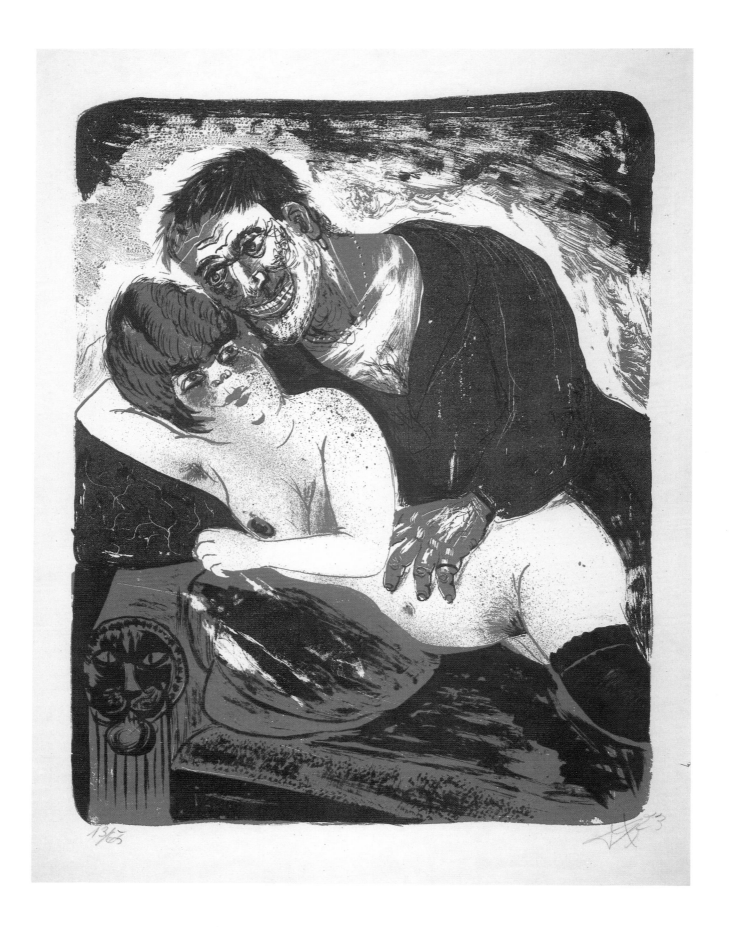

13/65

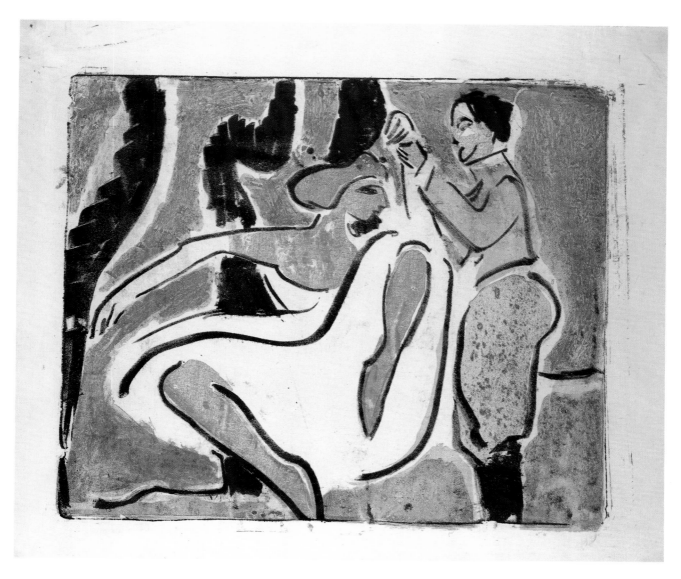

23 ERNST LUDWIG KIRCHNER
Russian dancers 1909
colour lithograph
32.7 × 38.5
Le Roy E. Hoffberger, Baltimore, Md.
Courtesy Linssen Gallery, Cologne

22 *Left* OTTO DIX
Sailor and girl 1923
colour lithograph
48.4 × 37.0
edition 13/65
Felix Man Collection
Australian National Gallery, Canberra

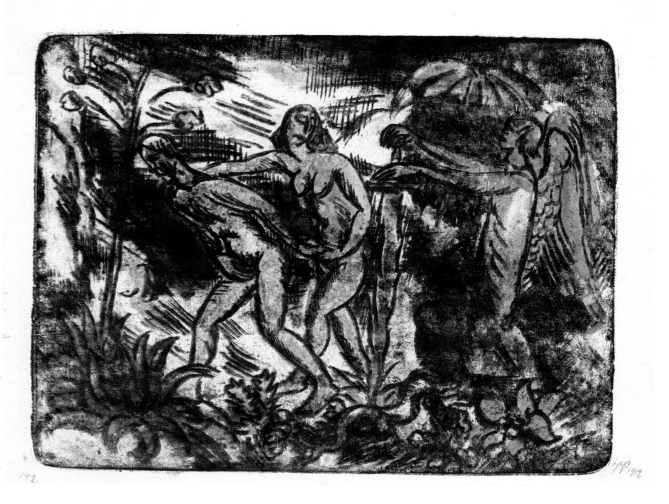

24　Max Pechstein
The Expulsion from Paradise　1912
lithograph with monotype colouring
42.3 × 55.2
Photo-archive Wolfgang Wittrock

25　Vassily Kandinsky
Lithograph for the fourth
Bauhaus portfolio　1922
colour lithograph
28.0 × 24.0
edition 110
Felix Man Collection
Australian National Gallery, Canberra

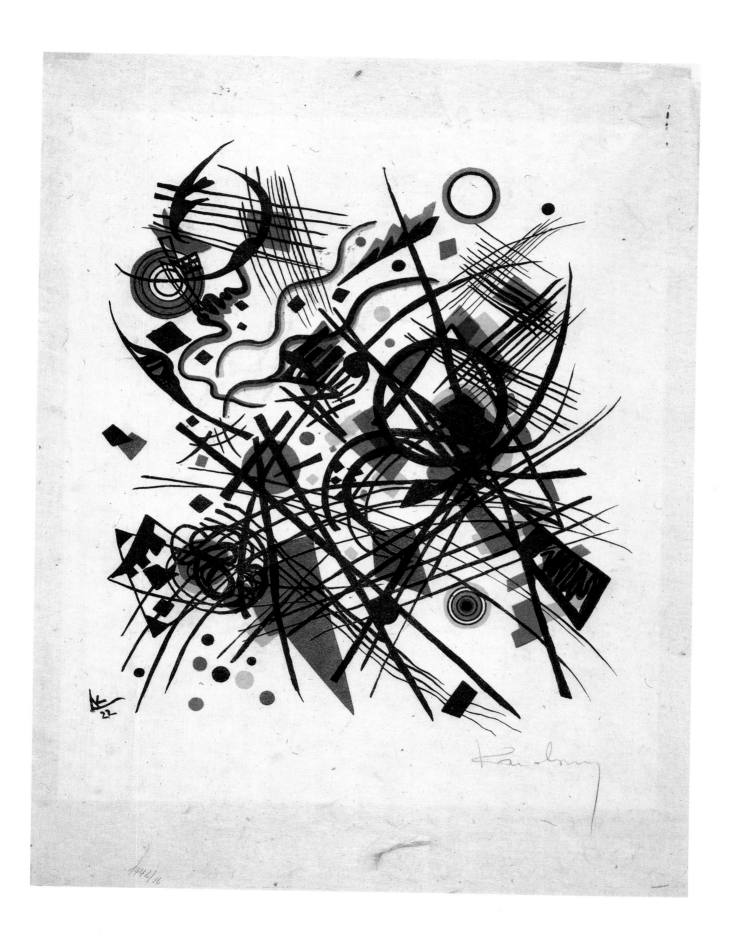

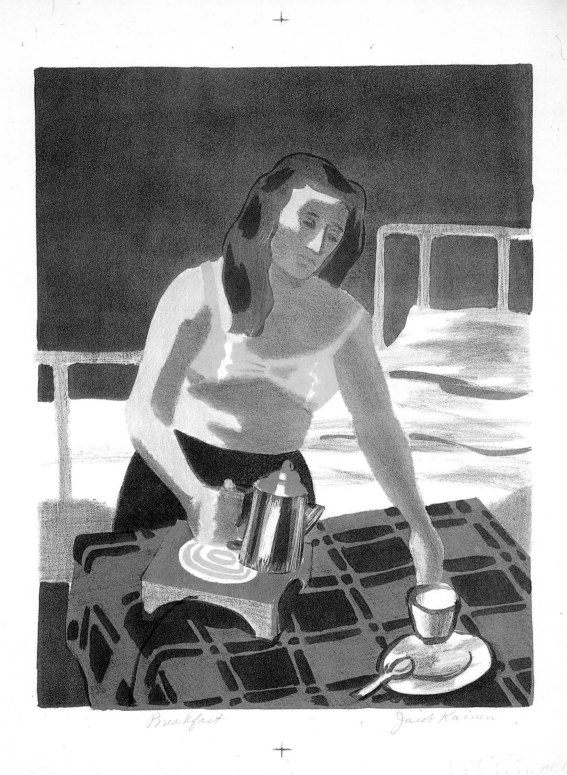

Breakfast Jacob Kainen

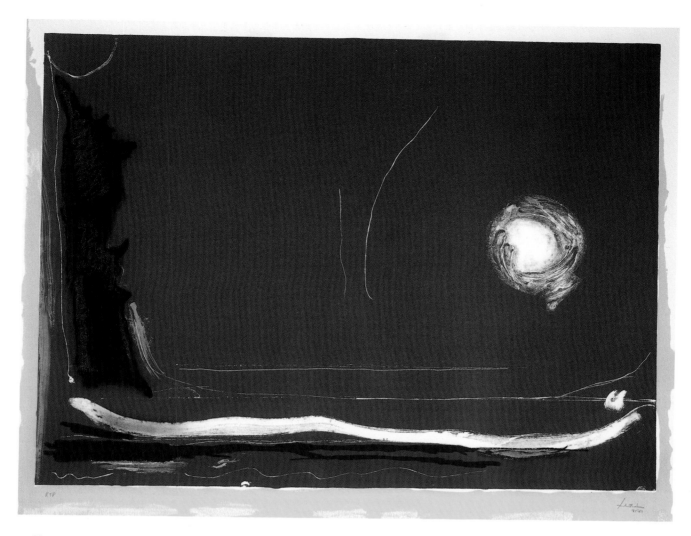

27 HELEN FRANKENTHALER
Yellow Jack 1985–87
lithograph, hand-stencilled pastel and acrylic paint
76.4 × 97.0
right to print proof (edition 54)
Australian National Gallery, Canberra

26 *Left* JACOB KAINEN
Breakfast 1938
colour lithograph
34.9 × 26.0
edition approximately 25
Australian National Gallery, Canberra

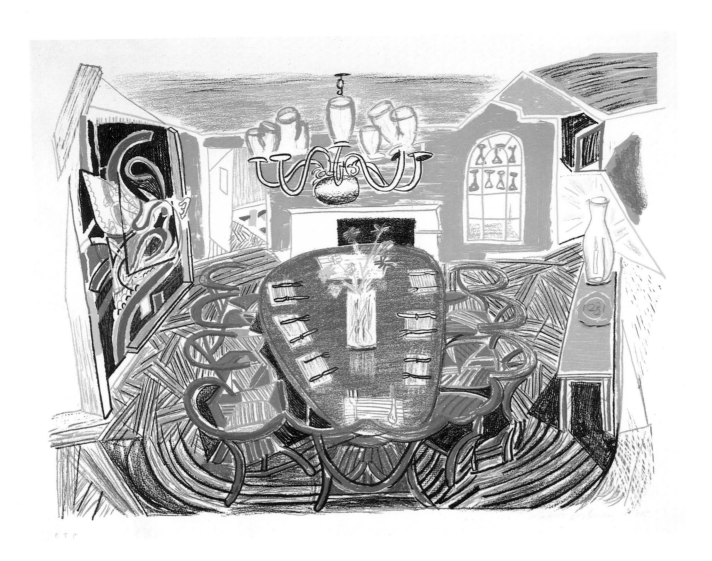

28 DAVID HOCKNEY
Tyler dining room 1985
colour lithograph
81.2 × 101.5
right to print proof (edition 98)
Australian National Gallery, Canberra

29 JOAN MITCHELL
Bedford 1 1981
colour lithograph
108.9 × 82.5
edition 70
Australian National Gallery,
Canberra

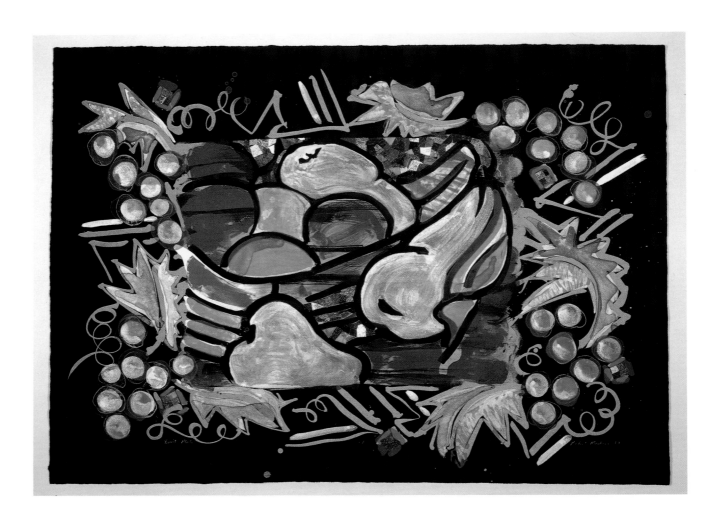

30 ROBERT KUSHNER
Fruit plate 1983
colour lithograph, collage
78.8 × 107.2
edition 28/30
Australian National Gallery, Canberra

31 JOYCE KOZLOFF
Pictures and borders 1 1977
colour lithograph
73.6 × 46.9
Collection of the artist

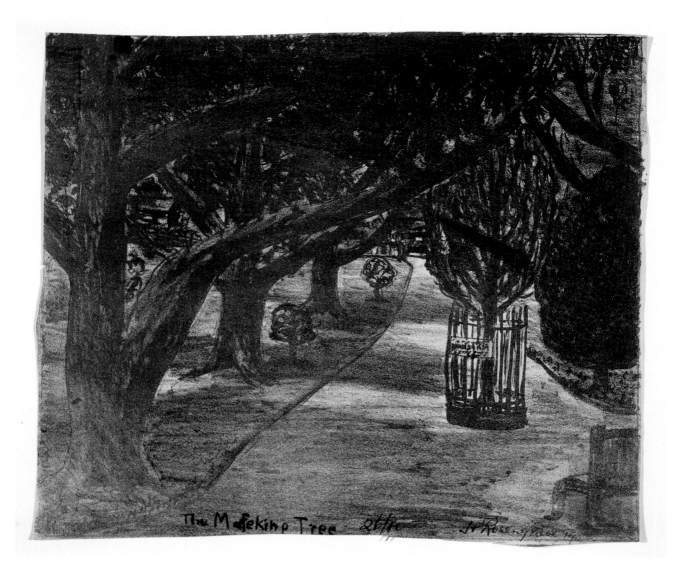

34 HARRY ROSENGRAVE
The Mafeking tree 1954
colour lithograph
23.4 × 26.9
Australian National Gallery, Canberra

32 *Previous page, left*
STEVEN SORMAN
Now at first and when 1984 33 *Previous page, right*
colour woodcut, lithograph, EUGENE FELDMAN
etching, collage Segovia *c.* 1966
169.0 × 134.0 colour lithograph
right to print proof (edition 18) 88.8 × 58.4 (sheet)
Australian National Gallery, Australian National Gallery,
Canberra Canberra

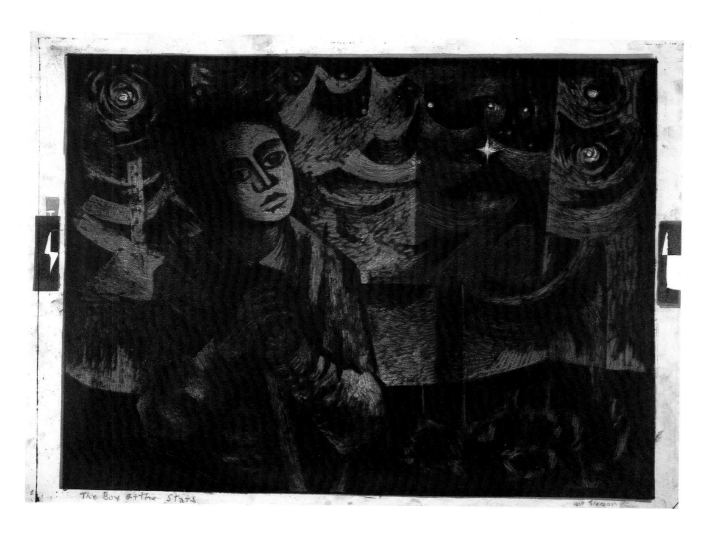

35 BILL GLEESON
The little boy and the stars 1957
colour lithograph
36.0 × 47.6
Australian National Gallery, Canberra

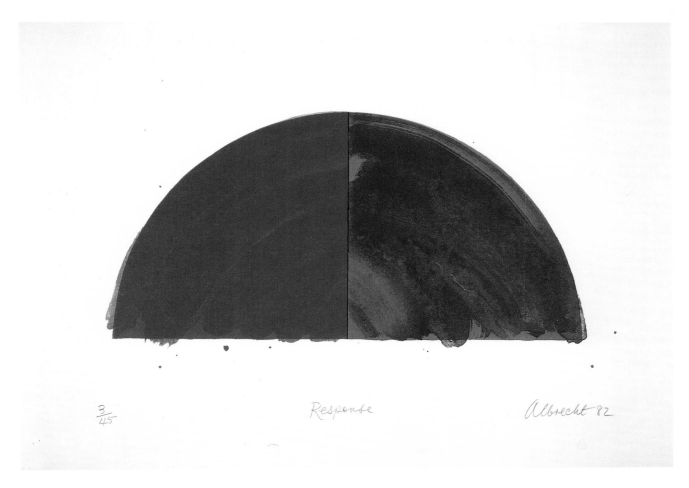

3/45 *Response* *Albrecht 82*

36 GRETCHEN ALBRECHT
Response 1982
colour lithograph
26.0 × 52.0
edition 3/45
printed by Robert Jones, Beehive Press, Adelaide
National Art Gallery, Wellington

37 DELYN WILLIAMS
Tuis in a flame tree 1984
colour lithograph
45.6 × 31.8
edition 11/16
printed by Graeme Cornwall at Atelier Studio, Auckland
National Art Gallery, Wellington

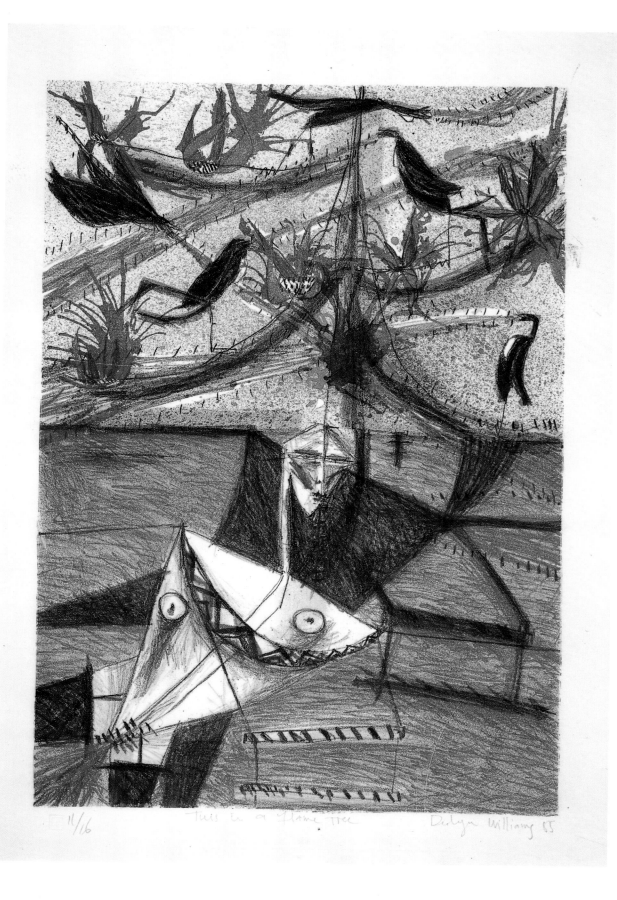

E 11/16 T...s in a Flame Tree Delyn Williams 85

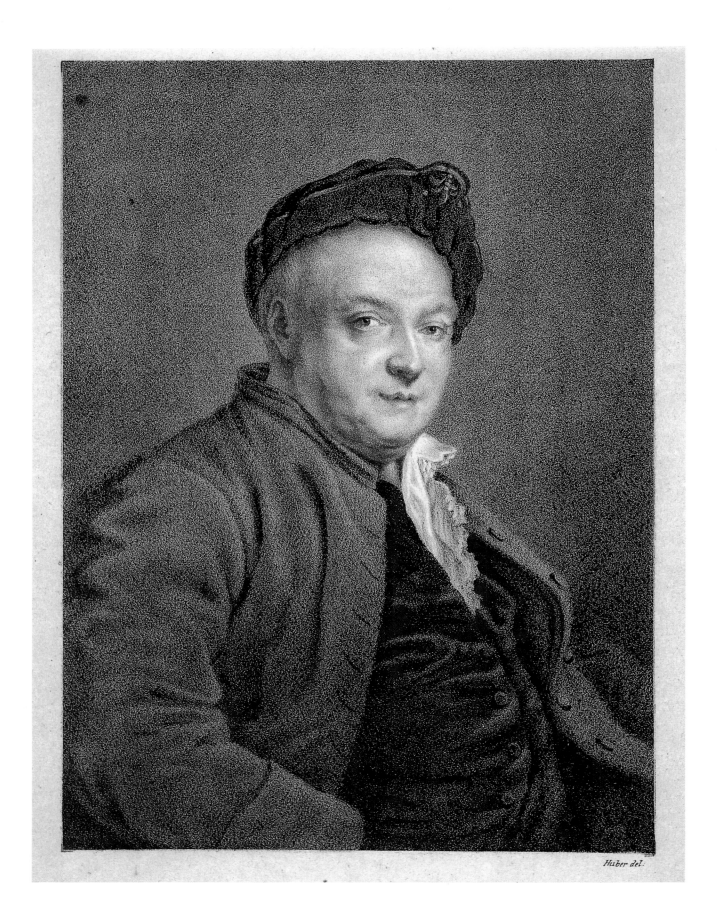

Huber del.

Application du Cercle Chromatique de Mr Ch. Henry.

P. Signac

Lith. EUGÈNE VERNEAU, 108, Rue de la Folie Méricourt, Paris.

39 PAUL SIGNAC
Application of the chromatic circle of Mr Charles Henry
programme for the Théâtre Libre 1888
colour lithograph printed by Eugène Verneau
16.0 × 18.6
Australian National Gallery, Canberra

38 *Left* GOTTFRIED ENGELMANN
after JEAN-BAPTISTE GREUZE
Portrait
from *L'Album chromolithographique*
[*The chromolithographic album*] 1837–8
colour lithograph printed by Engelmann
19.0 × 13.6
Felix Man Collection
Australian National Gallery, Canberra

41 Henri-Edmond Cross
In the Champs Elysées
from *Pan*, vol. IV 1898
colour lithograph
21.5 × 26.2
Felix Man Collection
Australian National Gallery, Canberra

40 *Left* E. J. Steven
Evening (detail)
stipple lithograph used as an advertisement for lithographic ink
frontispiece to *British Lithographer* vol. II 1892–3
colour lithograph
20.0 × 15.0 (detail: 10.0 × 8.5)
Australian National Gallery, Canberra

42 JAMES McNEILL WHISTLER
Lady and child 1890–93?
colour lithograph printed by Belfond
16.0 × 23.0
proof
Australian National Gallery, Canberra

43 JULES CHÉRET
Shaded stone and completed cover for
Catalogue d'affiches illustrées 1891
colour lithograph
each sheet 30.0 × 32.8
Australian National Gallery, Canberra

44 Georges Braque
Leaves, colour light 1953–54
colour lithograph printed by
Mourlot
97.5 × 60.0
printer's proof (edition 75)
Australian National Gallery,
Canberra

45 TREVOR BELL
Tidal objects 1958
colour lithograph printed by
Stanley Jones
49.5 × 36.5
edition 7/30
Australian National Gallery,
Canberra

46 PABLO PICASSO
The Picador II 1961
from *A los toros*
colour lithograph
printed by Mourlot
20.0 × 26.0
book edition plus 50 proofs
Australian National Gallery,
Canberra

I. La peinture
ne se reproduit pas en captivité,
Fernand Mourlot le sait,
il la laisse libre.
Elle lui en sait gré.

47 JOAN MIRÓ
Pages 1 and 2
from *Lithographies originales
de Joan Miró* [*Original
lithographs by Joan Miró*] 1963
colour lithographs
double-page spread: 65.0 × 96.0
edition 125
Australian National Gallery,
Canberra

II. De la Tour pointue, du Quai de l'Horloge,
les filles de tapin ont émigré.
C'est rue de Chabrol que leur sont maintenant
délivrés leurs diplômes d'excellente santé et
de haute respectabilité.

De même, de la rue de Chabrol à la
Butte-aux-Cailles, les ateliers Mourlot, sur
un tapis volant, ont déménagé.

Çà et là, à part les murs, rien n'a changé.
Rue de Chabrol, toujours la déprimante
beauté de l'Amour avili, tarifé, traqué.
À la Butte-aux-Cailles, toujours
la surprenante beauté du travail bien fait,
toujours la magie du Métier.

Jacques Prévert,

7 Bigger, Brighter, Bolder:
American lithography since the second world war

Ruth E. Fine

Every age has the renaissance it deserves.
E. H. GOMBRICH quoted by FRANK KERMODE in *Forms of attention*

ONE reflection of the expansion of printmaking in the United States since the end of the second world war has been the unprecedented flourishing of the art of lithography. The alchemy by which the antipathy of grease and water may be employed to form pictures on stone captured the imagination of virtually all the foremost artists.[1] Helen Frankenthaler, Jasper Johns, Roy Lichtenstein, Robert Motherwell, Robert Rauschenberg, James Rosenquist and Frank Stella are among a lengthy list of artists who have completed significant bodies of work in lithography since 1960. During the late 1940s and 1950s, too, there was serious interest in lithography, an interest which has been eclipsed by the attention given to printmaking in more recent years.

Any account of the ferment during these decades is largely the story of artists working with printers in specially equipped lithographic workshops. These have been set up in universities and art schools and, especially since 1960, also by print publishers as well as artists and craftsmen eager to work as printers.

The activities of several of the larger lithography shops have been documented at length. Universal Limited Art Editions (U.L.A.E.), West Islip, Long Island, founded in 1957 by Tatyana Grosman and now directed by Bill Goldston, was devoted to lithography after working very briefly in screenprinting, but has expanded to include work in other media; Tamarind Lithography Workshop, Los Angeles, founded in 1960 by June Wayne and continued since 1970 as the Tamarind Institute at the University of New Mexico in Albuquerque, has always been devoted solely to lithography; Gemini G.E.L., Los Angeles, founded in 1966 by Kenneth Tyler, Sidney B. Felsen and Stanley Grinstein, concentrated initially on lithography but soon branched out not only into all of the principal graphic media but also into sculpture; Tyler Graphics Ltd, set up by Tyler in the mid 1970s after he left the Gemini partnership, was equipped from the start to undertake almost every sort of printmaking and papermaking activity an artist might wish to explore. A wide range of processes is also available at Graphicstudio, the publishing workshop established by Donald Saff at the University of South Florida, Tampa, in 1968. This is the first important university-based publishing workshop; several others, less active and less ambitious, have been established in recent years.[2]

Given the diversity of these important, long-established shops, it is clear that the growth of lithography in the United States since World War II has not taken place in isolation from efforts in other printmaking media, nor, for that matter, in isolation from painting and sculpture. The nature of events nevertheless allows for artists' explorations in lithography to be examined somewhat independently.

The roots of this development may be traced to the pre-war decade of the Great Depression when a number of printmaking workshops were scattered across the country as part of the government-sponsored Works Progress Administration Federal Art Programs.[3] The first of these was opened in New York City in February 1936 and was eventually equipped for work in all of the major graphic processes. W.P.A.

48 *Opposite* JUNE WAYNE
Desert wind
from *Stellar winds* 1975
colour lithograph printed
by Edward Hamilton
40.5 × 34.4
edition 9/20
Australian National Gallery,
Canberra

257

7.1 JACOB KAINEN
Waitress
lithograph
27.0 × 37.0
edition approximately 25
Collection of the artist

workshops not only provided many artists with a way to make a living; they also encouraged them to be productive within the community atmosphere of a workshop as distinct from the privacy of their own studios. If only by being in the same place at the same time, artists worked together, sharing ideas and learning about printmaking processes that otherwise would most likely have remained outside their spheres of experience.

Screenprinting, called serigraphy at the time and a relatively new process in the fine art context, was extensively explored in these shops and interest in lithography also grew considerably during this period. Technical information was shared to some extent, enabling artists to learn various secrets of lithographic printing although the printers themselves generally guarded special information.[4] Nevertheless, the workshops facilitated changes in artists' dependence upon professional craftsmen.

Jacob Kainen is among the artists who participated in these W.P.A. printmaking programs (col. pl. 26, 7.1) and continues today as a painter/printmaker working in several graphic media. He has vividly described the era:

> The printmaking workshops that were set up in the 1930s were pioneer centers for technical and artistic growth and the artists who worked there ... popularized lithography, the woodcut, serigraphy, and most of all color printing ... [later] they joined the staffs of schools and universities which increasingly added printmaking departments. The artists knew how to set up workshops and they knew all the media ... when Stanley William Hayter came to this country in 1940 to open his experimental graphic arts studio, Atelier 17, he found the artists ready.[5]

Atelier 17 concentrated on intaglio processes, which sets it outside the scope of the present discussion although it was certainly the best known print workshop in the United States in the 1940s.[6] However, it was not the only one that was established during this period; in 1948 for example, also in New York, Robert Blackburn set up the Bob Blackburn Workshop.[7] As a youth Blackburn was introduced to lithography by Riva Helfond at the Harlem Community Arts Center, another W.P.A. project. He later studied the process at the Art Students League under Will Barnet, who is well known for the generosity with which he shares his expertise. In his own art, Blackburn was to become involved with transforming objects and spaces in the visible world into broadly geometric, abstract compositions as seen, for example, in *Heavy forms*, 1961 (7.2), and *Fenêtre [Window]*, its eccentric format determined by the shape of the lithographic stone. Committed to exploring his visual ideas through lithography,

Blackburn also loved to print and understood the advantages of sharing ideas and equipment in a workshop situation. He set up a shop where artists who were so inclined could increase their knowledge of the necessary processes and print their own images, or work hand-in-hand with professional printers such as himself.

Although the Printmaking Workshop, as Blackburn now calls it, presently enables artists to work in a variety of media, at first it specialized in lithography. The experimental approaches prevalent from the very start in Blackburn's shop were similar to those of Atelier 17, and these same attitudes came increasingly to be encouraged in art schools and university printmaking departments. The process was explored, at times almost for its own sake, to see what might happen if one or another technical experiment was employed. A narrative approach was set aside as notions of abstraction took root in many artists' visual vocabularies, drastically changing their approach to drawing as an aspect of printmaking. The spirit of experimentation in Bob Blackburn's workshop generated a radical change in the way artists used lithography and marked a movement away from the styles and techniques that had been prevalent earlier in the century.

The early decades of the 20th century saw the first wave of painter-lithographers in American graphic arts. George Bellows, Childe Hassam and Joseph Pennell, for example, all produced significant bodies of lithographs at a time when the etching revival dominated the American scene.[8] A few highly skilled printers provided the key to their artistic success in lithography; best known among them were Bolton Brown and George C. Miller in New York City, and Lynton Kistler in Los Angeles.[9]

Brown was an artist as well as the foremost printer of the extraordinary body of lithographs that Bellows produced between 1916 and his death less than a decade later. The dramatically composed lithographs that Bellows made were rich in black-and-white contrasts and some were relatively large for their time. Among the best-loved prints of their era, they depict boxers, often surrounded by elegantly dressed

7.2 ROBERT BLACKBURN
Heavy forms 1961
lithograph
39.3 × 49.5
artist's proof II (edition 10)
Collection of the artist

onlookers, leisure activities such as tennis, and portraits. They exerted considerable influence on the next generation of artist-lithographers, for example Robert Riggs and *10.23* Benton Spruance.

Bolton Brown's reputation has been based primarily on his work as a printer. During the summers, in Woodstock, New York, however, he printed his own light- *10.21* drenched lithographs which are not only extremely handsome but also demonstrate the way many artists of this period approached lithography. Into the 1940s the dominant format for lithographs and other prints was relatively small. Artists drew their images on stone with greasy lithographic crayon, developing form by layering their strokes to build tone.[10] Tusche, which permits a more fluid expression, was not tolerated by professional printers because it is more difficult to print.

The qualities exemplified in prints from Bolton Brown's workshop are also evident in works printed by George Miller and Lynton Kistler, but Kistler was more far-sighted. He encouraged Jean Charlot to use colour as early as 1933 and he is well *col. pl* known for his pioneering work in offset lithography.[11]

Like other printmaking processes in the United States during this period, lithography seems to have been attractive to the more conservative artists. Despite considerable interest in abstraction from as early as the 1913 Armory exhibition, figuration dominated pre-war lithographs and figurative artists such as Raphael Soyer, Yasuo Kuniyoshi, and Louis Lozowick who started making lithographs before the war continued to explore similar themes in the post-war period, although their later impact has been negligible. Lozowick's *Relic of old Rome*, 1958 (7.3), was among the lithographs included in the American Prints Today – 1959 exhibition discussed below.

The restrictive attitude of the print community is revealed by the fact that lithographs and wood engravings were included in *Fine Prints of the Year* for the first time in 1936.[12] Woodcuts and colour prints in all media were still unacceptable. The Society of American Etchers expanded in 1947 to become the Society of American Etchers, Gravers, Lithographers, and Woodcutters, and a few years later altered this unwieldy title to the Society of American Graphic Artists. These often hidebound print societies dominated the field and painter-printmakers were already viewed as unfair competition, and are still accused of it today.[13] An exception to this severely limited frame of reference was the American Institute of Graphic Arts, which selected Fifty Prints of the Year from the mid 1920s to the 1950s. Works in all media were featured, including lithography and exploring a variety of aesthetic approaches.

Of course there were exceptions to the conservative point of view. Among them was Stuart Davis, whose lively lithographs restructuring the visual components of the city are landmarks of early modernism in America. Lithography was taken up also by the American Abstract Artists to mark their first group exhibition in 1937 at the Squibb Building Galleries. They produced a portfolio of offset lithographs based on drawings by most of the exhibitors which sold at the exhibition for 50 cents per portfolio, not per print. Prints by Ilya Bolotowsky, Louis Schanker and Vaclav Vytlacil (7.4) were included.[14]

Lithography is technically the most capricious of the printmaking processes. For example, during the edition printing of an etching or a woodcut a number of substandard impressions may be pulled without altering the matrix itself in any way. In lithography, however, the printing process has certain inherent hazards: in pulling a poorly inked impression it is possible to alter the chemical balance of the artist's drawing and thereby destroy its subtleties. Because a drawing that has been worked on for months can be ruined in a matter of minutes, the skills of the person who chemically prepares the stone and then prints it are critical.

Professional printers often shrouded their techniques in secrecy. Robert Blackburn recalls George Miller's refusal to give any information about his printing processes.[15] The availability of technical expertise in W.P.A. workshops, albeit circumscribed, opened up the possibility of the expansion of lithography which took place immediately after the war, principally in art schools and universities and a few isolated

7.3 LOUIS LOZOWICK
Relic of old Rome
(The Colosseum) 1958
lithograph
35.3 × 20.1
edition 15
Rosenwald Collection
National Gallery of Art,
Washington

7.4 VACLAV VYTLACIL
Untitled
from the
American Abstract Artists'
portfolio 1937
lithograph
17.8 × 22.8
edition 500
Australian National Gallery,
Canberra

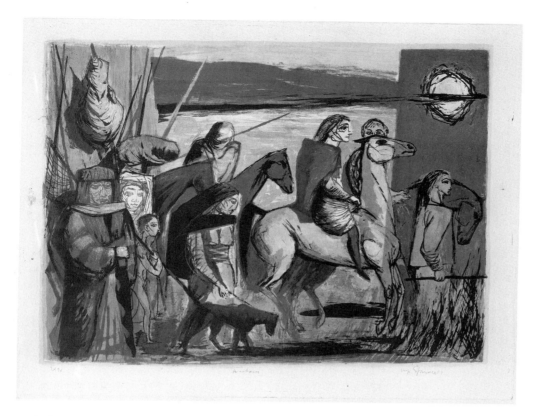

7.5 BENTON SPRUANCE
Anabasis – The
March 1957
colour lithograph
43.0 × 60.0
edition 30
Rosenwald Collection
National Gallery of Art,
Washington

workshops such as Blackburn's. Through the end of the 1950s there was little
opportunity outside the academic community for artists interested in lithography to
acquire the information and skills needed to undertake work in the medium. Thus the
sharing of information became a central tenet of the Tamarind Lithography
Workshop when it opened in 1960.

In general it has remained the tradition for artists to draw their images on stone and
printers to print them in close consultation with the artists, especially through the
proofing phase. There is logic to this collaborative approach, for few artists want to
devote as much time to printing as to drawing. To ensure the stability of the drawing
throughout printing requires the refined sensitivity and keen touch that can be
developed only through continuous printing experience.

There are, of course, artists committed not only to drawing their images on stone
but also to printing them. Blackburn is one; his mentor Will Barnet, who in recent
years has tended to work with professional printers, is another. Benton Spruance, too,
became committed to developing his own prints through both drawing and printing.[16]
Anabasis – The march (7.5) gives some indication of Spruance's approach to figuration
in which he was always juggling a fascination with abstraction and a commitment to
moral and social comment through themes taken from the Bible and other literary
sources. Spruance was especially experimental in his approach; as one of very few
artists to use colour lithography as a primary form of expression during the 1950s, he
met the technical challenges head on. A teacher as well as an artist, he was committed
to conveying through his teaching the excitement of printmaking, especially in
lithography. He was also one of the original members of the Board of Directors at
Tamarind Lithography Workshop and a member of Tamarind's selection panel of
artist-fellows.

The concept of artist and printer working together has operated in art school
facilities that have continued to play an important, if fairly low key, role in supporting
interest in lithography.[17] This is exemplified by Will Barnet, the painter-printmaker
who taught lithography at the Art Students League for several years from 1934.

Encouraging his students to work on stone in an experimental manner with a variety of drawing materials, Barnet himself was responsible for printing editions for his students, a practice that has continued to the present. Among other artist-printers who have printed at the League are Arnold Singer and Deli Sacilotto, present technical director of the Graphicstudio workshop.[18]

In the 1940s, at the teaching workshop of the Colorado Springs Fine Art Center, the aesthetics of lithography were guided by artist Adolf Dehn, who, like Barnet, encouraged an experimental approach. Lawrence Barrett was responsible for all of the printing; like Bolton Brown he made his own lithographs and also printed for artists. According to artist Reginald Neal, who worked at the Art Center in 1940, secrecy about the craft was maintained:

> Unless you were there as a technical assistant, as I was, you learned nothing about printing; all you did was make the drawing . . . Barrett did the printing and pulled twenty prints from each stone He would never let anybody touch his roller or do any printing.[19]

Although in recent years Neal has devoted more of his time to painting, lithographs were an important part of his oeuvre into the 1970s.[20] As well as making and printing his own lithographs Neal continued to print for other artists, including Adolf Dehn and Doris Lee, with whom he worked at the lithography shops organized in the early 1950s at the Woodstock Art Association in New York State and the Contemporaries Gallery in New York City by artist and critic Margaret Lowengrund.[21] In 1956, while teaching at the University of Mississippi, Neal completed an educational film titled *Colour lithography: An art medium*, clear evidence that interest in lithography in the United States in the mid 1950s was far from moribund.

Three of the best-known university printmaking facilities in the United States have concentrated on intaglio processes: Yale University under Gabor Peterdi; Iowa University under Mauricio Lasansky; and Indiana University under Rudy Pozzatti.[22] But despite the powerful influence of these intaglio workshops, lithographic workshops in art schools grew in number after the war and functioned in a variety of ways. In Philadelphia for example, where from the time of Joseph Pennell lithography had played an important role in the artistic life of the city, the process could be studied at several places. These included the Philadelphia School of Industrial Art (now part of the University of the Arts) where Benton Spruance and Jerome Kaplan printed the students' stones until the early 1950s, and the Tyler School of Art, Temple University, where students were printing their own stones by the late 1940s. Increasingly, with exceptions like the Art Students League, the latter practice has become usual in the educational structure. Lithography developed more slowly in west coast art schools and universities. The first programme in Los Angeles, for example, was not even started until after the war when Jules Heller joined the faculty at the University of Southern California.[23]

The impact of teaching facilities on the development of lithography has yet to be fully assessed; since the founding of Tamarind it has become an especially complicated subject. It is obvious that committed teachers interested their students in lithography to the extent that they applied for Tamarind's printer fellowships and many of these fellows became teachers rather than full-time professional printers. For example, at the University of Wisconsin – unlike Yale, Iowa, and Indiana – lithography has long been an important aspect of the broadly based printmaking programme. Alfred Sessler started the programme and Jack Damer is presently teaching the process there. Damer was never a Tamarind printer but his teacher at the Carnegie Institute of Technology (now Carnegie Mellon University) had been. Among Damer's former students is Bud Shark, who after studying further with Garo Antreasian and at Tamarind Institute set up his own publishing shop, Shark's Lithography in Boulder, Colorado.

Damer, like Barnet, Blackburn, Spruance and Kaplan, concentrates on his own lithographs, but occasionally prints for other artists.[24] So, too, does Wayne Kimball,

7.6 WAYNE KIMBALL
H.F.A.C. 1985
lithograph
28.2 × 35.6
artist's proof
Collection of the artist

an artist whose meticulously worked images, such as *H.F.A.C.*, 1984 (7.6), present a collage of objects in mysteriously surreal settings. *H.F.A.C.* was made for a faculty student portfolio celebrating the opening of a new printmaking facility in the Harris Fine Arts Center at Brigham Young University. Kimball has taught lithography at numerous places—briefly at Wisconsin, at California State College at Long Beach, at Arizona State University, and presently at Brigham Young. His own lithographs have on occasion been printed by other printers. For example, he has worked at the Normal Editions Workshop, at Illinois State University, Normal-Bloomington.[25]

These are a few examples among dozens. The point is, of course, that there is a coterie of people working today who love making images on stone and who love to print as well, and they carry on the master-apprentice approach to the process, albeit in modern dress. These artists readily explain their passion for making prints, for handling materials, for independently carrying their own projects from beginning to end. When they want to, they concentrate on the craft aspect of printmaking by printing for artists whose work they admire.[26] This approach flourishes hand-in-hand with the large collaborative workshops that dominate our consciousness of the art of lithography in our time.

With this increasing activity in the educational arena the nature of prints had begun to change, even by the late 1940s. Works increased in size and printmaking shifted from a predominantly monochrome investigation to one that championed the use of colour. Both screenprinting and lithography gained in popularity. So far as lithography was concerned – to refer back to the W.P.A. period – Gustave von Groschwitz, one of the supervisors of the New York shop and later curator of prints at the Cincinnati Art Museum, claimed the New York graphic workshop 'produced more fine color lithographs than had ever been made before in the United States.'[27] Von Groschwitz also suggested that interest in lithography per se may have been generated by two large exhibitions of prints, the first in Boston at the Museum of Fine Arts in 1937, and the other at the Cleveland Museum of Art in 1948. It is noteworthy that both shows included relatively few colour lithographs although an increasing interest in making colour prints seems to have been concurrent with the growing interest in lithography.[28]

For the most part, printmakers working in lithography in America developed themes that had interested artists working in other media, themes that focused on the world around them, the city and the country, without feeling the necessity to make them more elegant than they were. Among subjects of the modern era they emphasized were the construction of skyscrapers, bridges and vehicles of transportation.[29] As the practice of lithography extended, painters and sculptors, too, began to make prints, along with artists who saw printmaking as a primary form of expression.

Throughout the 1950s, Gustave von Groschwitz organized for the Cincinnati Art Museum a series of international exhibitions focusing on colour lithography. One senses that these exhibitions were, at first, a response to the germinating interest in the field that von Groschwitz aptly perceived. As time passed, however, the curator's enthusiasm for colour lithographs, and the exhibitions that he organized, undoubtedly inspired additional artists to do work that might be included in them.[30]

The 'First International Biennial of Contemporary Color Lithography', from 2 March to 23 April 1950, included 235 prints by more than 130 artists from 14 countries. Seventy of the artists were from the United States, Garo Antreasian and Clinton Adams among them. These two men, two decades later, co-authored *The Tamarind book of lithography: Art and techniques*.[31] Included, too, were lithographs by Will Barnet, Robert Blackburn, Riva Helfond, Russell T. Limbach, the technical adviser to the New York W.P.A. shop, and Benton Spruance, who had set up not only the lithography printshop at the Philadelphia School of Industrial Art, but another at Beaver College, then a women's liberal arts college in suburban Philadelphia. At least ten of the United States exhibitors were women, showing that at least some opportunity was afforded women artists in this particular artistic community.

Von Groschwitz's introduction to the catalogue for the First International gives some indication of the thinking that has helped to maintain the distinction between printmakers and painters who make prints, to the disadvantage of the former. After enthusiastically discussing the qualities of lithography that attracted painters to the medium, von Groschwitz concluded 'painting, to be sure, is the major art, but color lithography is first cousin to it.' He also suggested some limitations to lithography, limitations that were rejected by artists then and would certainly be questioned today: for example, 'too many colors (more than four or five) cannot be printed over each other without a resultant muddiness and loss of brilliance, nor can the lithographer model his shapes as fully without imitating painting.'

Von Groschwitz pondered the reasons for the renewal of interest in colour lithography, suggesting artists were rediscovering technique as 'a temporary release from the fears of our times'; or a response to 'the public's new feeling for brighter and more intense colors in everyday life'; or a bridge between the artist and the public 'to whom art is still a remote mystery, because lithographs cost less than paintings'; printmaking as the democratic art form.

The catalogue also includes a brief historical note as well as a technical explanation, but there is no mention in it of the fact that, over time, most lithographs had been printed by professional printers rather than the artists who conceived the images. However, the catalogue for the Second International, which included 408 prints from 18 countries, did state that 'some artists print their own color lithographs, but others depend on the knowledge and ability of a small group of expert printers.'

As early as 1954, in the catalogue for the Third International Biennial which included 457 prints from 24 countries, von Groschwitz noted that 'in a larger sense we seem to be at the beginning of a renaissance of the print, a clue to which is to be found in higher auction room prices.'[32] In this 1954 exhibition, 113 artists from the United States were represented, including most of those that had been shown in the first exhibition four years earlier. Among the new exhibitors were Margaret Lowengrund, director of the lithography workshops in Woodstock and New York City; June Wayne, who would soon start planning Tamarind; and Arthur Flory, who in 1960, working on a Rockefeller Foundation Grant, was to set up the first fine art lithography workshop in Tokyo, Japan. There he introduced the process to numerous Japanese artists including Toshi Yoshida, Hideo Hagiwara and Shiko Munakata, who later came to make lithographs with Tamarind-trained Irwin Hollander in New York City.[33]

The last of von Groschwitz's colour lithography exhibitions took place in 1958. It included prints by Garo Antreasian in Indianapolis, Indiana; Ralston Crawford, Stuart Davis, Adolf Dehn, Andrew Stasik, and John von Wicht in the New York City

area; Max Kahn and Eleanor Coen in Chicago; Emil Weddige in Ann Arbor, Michigan; James Louis Steg in New Orleans; Jack Perlmutter in Washington, DC; and Nathan Oliveira, Mel Ramos and Wayne Thiebaud in California. The geographical range of this list suggests that in the late 1950s interest in lithography in the United States was not only considerable but also widespread.

Two more biennial print exhibitions were held in Cincinnati in 1960 and 1962, but they included works in all media. In the introduction to the catalogue for the 1960 show, the year Tamarind Lithography Workshop opened, von Groschwitz indicated that he felt the colour lithography shows had accomplished their purpose and that it was time to take note of 'the emergence of remarkable talents in other fields of printmaking.' Perhaps the 1959 exhibition organized by the Print Council of America, titled American Prints Today – 1959, demonstrated that a single-medium show was an anachronism given the range of prints being made.[34] In the 1959 show – a second American Prints Today exhibition was held in 1962 – only 13 of the 62 prints on view were lithographs. Two, *Blue, grey, and black*, a spare abstraction by Ralston Crawford, and *Boardwalk*, a selectively rendered view of a place by Jack Perlmutter, had also been included in the 1958 Cincinnati biennial.[35]

By contrast, almost half of the works in the 1960 International Biennial of Prints were lithographs, perhaps reflecting von Groschwitz's curatorial interest as much as the extent to which artists were employing the process. More than half of the 425 prints were described as 'abstract [non-representational]', both terms apparently being used to make the point absolutely clear. In his catalogue introduction von Groschwitz once again voiced concern that certain technical experiments, this time in the intaglio processes, 'would result in printmaking becoming a mere imitation of painting.' He went on to point out that another vital change from tradition was the increasing size of prints in recent years, notably in Mauricio Lasansky's life-sized intaglio portraits and a woodcut by Leonard Baskin that was 210 cm (83 inches) high. He commented: '... fortunately not all of the prints are so large: most sizes are falling between 14 by 19 inches and 30 by 40 inches.' Needless to say, the 'fortunate' conditions did not last long; finding ways to store large prints safely when they are not displayed on walls remains a challenge.

In the catalogue for the last of the Cincinnati biennials, von Groschwitz voiced alarm in the face of printmaking's many new directions. He warned that 'tendencies and practices exist that may destroy printmaking as an independent medium and reduce it to a level of unimportant reproduction'; he was also upset by the technical virtuosity that he felt brought prints close to paintings, looking down on the notion of lithography as 'painting with graphic means'; on embossings that might associate printmaking with relief sculpture; and on the failure to make consistent editions—which may be important to print publishers, collectors and curators, but is often of little interest to artists. Broadly, von Groschwitz was lamenting the breakdown of generally accepted practices, a breakdown that has often been the major thrust and aim of artists. In fact, all of his fears have proved to be founded; the qualities he condemns have marked many of the prints that have been produced since that time. The point is whether these qualities, in fact, are so questionable.

The last international biennial was held in the same year as the Print Council's second exhibition, American Prints Today – 1962. The Cincinnati show included two prints, *Blue blood stone* and *The white line* by Sam Francis, an artist who has since become a fully committed painter-printmaker. Not only has he worked at numerous print publishing workshops including Tamarind, U.L.A.E., Gemini, and one run by Garner Tullis; he has become so involved with the various printmaking processes that he has set up extensive facilities of his own including direct and offset lithography presses with George Page as his personal lithographic printer.[36]

The American Prints Today – 1962 exhibition included several lithographs that had been printed at the two relatively new lithography workshops. Adja Yunkers' *Skies of Venice 1* dates from 1960, the first year of activity at the Tamarind Lithography Workshop in Los Angeles; and Fritz Glarner's *Drawing for tondo: Stone 4*, 1959,

10.42

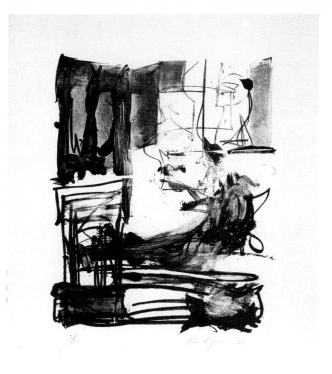

10.39

7.7 FRITZ GLARNER
Page 5 from the portfolio
Recollection 1964–68
colour lithograph
22.4 × 23.4
edition 10/30
Australian National Gallery,
Canberra

7.8 *Above right* GRACE
HARTIGAN
Pallas Athene 1961
lithograph
43.0 × 34.2
edition 3/10
Australian National Gallery,
Canberra

Grace Hartigan's *Pallas Athene*, 1961 (7.8), and Jasper Johns' *Coathanger*, 1960, had all been printed and published by U.L.A.E.

The milieu of this period was very different from that of the present. Today there is a flourishing market for prints and an active public relations structure to announce their publication. Through the 1950s, while printmaking was becoming more widely accepted as a way of exploring serious pictorial ideas, there certainly was no ready market for prints, nor even much of a vehicle for showing them.[37] With the inclusion of lithographs from Tamarind and U.L.A.E. by painters whose work was already highly admired, the American Prints Today and Cincinnati's International Prints exhibitions, both of 1962, acknowledged a watershed in American art, concerning the role of prints in general and lithographs in particular.

In 1957 Tatyana Grosman founded Universal Limited Art Editions by setting up a lithography press in the living room of her Long Island home. She set to publishing *livres de luxe*, working closely with artists and poets, the first pair being Larry Rivers and Frank O'Hara, who completed *Stones* in 1959. Bob Blackburn was the printer. Mrs Grosman was able to stimulate artists of stature to explore the printmaking media at the time when, fortuitously, art galleries with their related activities were gearing up as well. Her keen intelligence, her iron will and her extraordinary taste soon became legendary.

Mrs Grosman's love of fine handmade papers, the close relationships she formed with many of the artists whose work she published, and her willingness to nurse a project along for years are all well known. For example, *Very first stone* by Sam Francis was drawn on stone in 1959 but was not proofed and printed until nine years later, after his *First stone* had been printed in Europe. Lee Bontecou, Jim Dine, Fritz Glarner (7.7) and Barnet Newman, among other artists who worked at the Long Island atelier, reflect Mrs Grosman's primary intention to produce and publish significant art.

A somewhat different ambition was the primary motivation for the Tamarind Lithography Workshop founded in Los Angeles by June Wayne in 1960. Important work was certainly produced there, however, not only by Sam Francis and Adja Yunkers but also by Josef Albers, Anni Albers, Richard Diebenkorn, Philip Guston and David Hockney, among others.

June Wayne had exhibited *The Anniversarie* from her John Donne series in the last of the Cincinnati lithography biennials in 1958. The series was printed in Paris, rather than the United States, because Lynton Kistler, Wayne's California printer, was by this time shifting his attention to printing full time by offset rather than both offset and directly from stone. Wayne's need to go to Europe to have her images printed lay behind her application for funding to establish Tamarind as a centre for the revitalization of lithography in the United States by introducing it to artists and training printers in the craft. More than a quarter of a century has passed since its founding and it is clear that Tamarind has been a major factor in the expansion of interest in printmaking in the United States, and certainly the interest in lithography.

Tamarind's impact on printmaking education has already been noted. The number of private workshops that have roots in Tamarind's programme is also enormous. One of the first Tamarind master printers to go out on his own was Irwin Hollander. In 1964 Hollander set up his workshop in New York on the top floor of the building on 10th Street that had housed the forward-looking Tanager Gallery. Hollander has commented: 'I was absolutely lucky to be at that place at that time; we could do no wrong.'[38] *Portfolio 9*, which Hollander published in 1968, included prints by the artists he believed represented the diversity of lithography in the United States at that time: Willem de Kooning, Sam Francis, Ellsworth Kelly, Roy Lichtenstein, Richard Lindner, Robert Motherwell, Louise Nevelson, Henry Pearson, and Saul Steinberg. Hollanders

> ... was an open shop. I did work for other publishers. I published myself. I did work for artists; so it varied ... We would do prints. Sometimes we would split editions. Sometimes I would pay the artist and he would sign the whole edition and I would sell it in my gallery; sometimes the artist would pay me and take the edition. Each time it was different.[39]

Hollander exemplified the many ways in which a printer-publisher may approach his or her work in the field. He has since followed the path of many Tamarind-trained printers: he closed his workshop in 1972, taught for a while, and is now busy working at his own art.

Kenneth Tyler was technical director at Tamarind before he founded Gemini Ltd in 1965, a workshop which was renamed Gemini G.E.L. when he formed a partnership with Sidney B. Felsen and Stanley Grinstein. Tyler directed the Gemini shop until he left the partnership to set up Tyler Graphics Ltd, now in Mt Kisco, New York. Gemini has continued under the direction of Felsen and Grinstein. These two shops have published some of the most far-reaching and beautiful prints of our time.

In Los Angeles, Jean Milant of Cirrus Editions and Toby Michel of Angeles Press;[40] in Chicago, Jack Lemon of Landfall Press; in Houston, Richard Newlin of Houston Fine Arts Press; in New York, Maurice Sanchez of Derrière L'Étoile and Judith Solodkin of Solo Press, are among the many Tamarind-trained lithographers who have set up printing and/or publishing businesses that are still active. While they may have started as lithographers, many have expanded their operations to include other media, in keeping with the needs of artists.[41]

Despite its great contribution, Tamarind was sometimes regarded as restrictive and conservative. For example, in describing the qualities he sought in a printer at the time he was starting Graphicstudio, Donald Saff explained:

> I knew I wanted a Tamarind-trained printer but had mixed feelings on that issue. Tamarind training assures a high level of technical skill but also a tendency to approach printing problems methodologically, sometimes even inflexibly. I didn't want the shop to be pervaded by the kind of thinking that produced the Print Council of America's definition of an original print. How can you define originality outside the workshop when the people inside are redefining it? I wanted an open situation, conducive to artistic invention, and I needed someone whose technical skills would serve the new, bending, or enlarging technique to serve art, not someone seeking to reduce conception to the limits of method.[42]

Nevertheless, while Tamarind is not the only place where lithographic printers have received their training in recent years, it has touched virtually everyone in the field. In that many Tamarind graduates have taken on teaching posts, as noted above in respect of Wayne Kimball, the Tamarind training has been indirectly influential. For example, among the printers who have worked at Gemini, James L. Webb, Timothy Isham and Daniel B. Freeman are three of several who were trained by Robert Evermon, a Tamarind graduate teaching at Long Beach State College. Freeman in turn trained Chris Sukimoto, who worked at Gemini for some years and is now a partner in Simmilink/Sukimoto Editions, an etching shop in Venice, California. Tracing the network of printers reveals interesting connections across the country.

Artists now take full advantage of this workshop network. Since the late 1950s almost every major artist in the United States has undertaken some form of printmaking and it is probable that quantitatively lithography leads the list.

The European émigrés who had worked in Hayter's Atelier 17 during the 1940s brought with them concepts of surrealism and abstraction that stimulated dramatic changes in the imagery of American artists. The landmark portfolio published by the American Abstract Artists in 1937 reveals the unity of commitment to abstraction in the United States, and it is evident that there was already some interest in lithography among artists less oriented towards narrative. The interest remained, and among the earliest and most beautiful lithographs of an abstract expressionist nature are the group of six that David Smith completed at Woodstock, New York in 1952, working with Michael Ponce de Leon, Margaret Lowengrund's newly hired assistant.[43]

Apparently *Don Quixote*, seen here in the second of two states with white areas scratched into the broad gestural strokes (7.9), was the first of them. Most of the first state impressions are reworked with blue paint onto the printed strokes. According to Ponce de Leon, neither he nor Smith had ever made a lithograph before. Eager to get to the printing and unaware of Ponce de Leon's inexperience, Smith pressed him into service, suggesting they use beer, which was readily at hand, rather than water that had

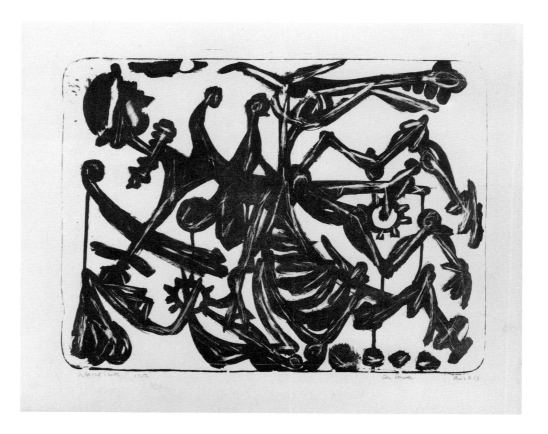

7.9 DAVID SMITH
Don Quixote 1952
lithograph
45.6 × 60.6
2nd state (edition unknown)
Australian National Gallery,
Canberra

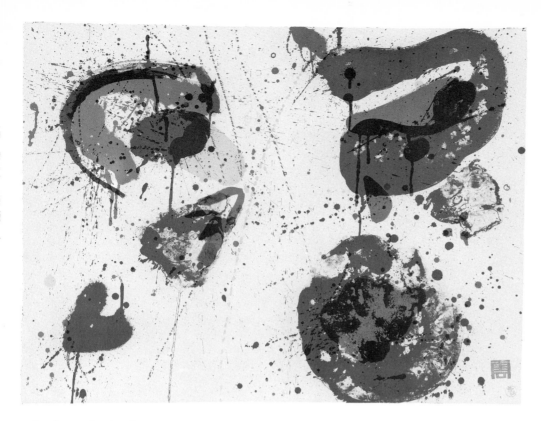

7.10 SAM FRANCIS
Hurrah for the red, white
and blue 1961
colour lithograph
50.4 × 65.4
edition 75/400
Australian National Gallery,
Canberra

to be brought in from a nearby stream.[44] The quality of the impressions varies considerably, undoubtedly because of the two men's lack of printing experience, but also because absolute consistency of impression was less of an issue then than it is now. *Don Quixote* is typical of Smith's lithographs, all of which are freely drawn and painted, filling the surface of the stone in a manner similar to his vigorously executed drawings.

The process of drawing directly on stone or metal, or on transfer paper which can then be impressed onto the printing matrix, was especially appropriate to the abstract expressionist approach. Several artists with that vision have produced numerous prints in lithography as well as other media throughout their careers. Sam Francis, as seen in *Hurrah for the red, white and blue*, printed in Europe, seems to have immediately recognized an affinity for the process (7.10). Irwin Hollander has described how the artist '... had the ability to see color, to see composition, while he worked on five or six surfaces at the same time, without using tracing papers and devices. He could orchestrate that in his mind, and he had the feelings and subtlety of such directness'.[45] Since the 1960s Robert Motherwell and Helen Frankenthaler have vigorously explored not only lithography but also other graphic media, working in a number of shops, in particular U.L.A.E. and Tyler Graphics. Both artists have discovered and invented ways to invest their printed images with a sense of their individualized mastery of abstract form, and the prints have been the subject of major exhibitions and catalogues raisonnés.[46] Among Frankenthaler's most recent prints is *Yellow Jack* (col. pl. 27), a dense, dark field interrupted by brilliant whites and subtle blues and framed on three sides by the yellow of its title. Direct work with pastel and acrylic paint adds to the sumptuousness of the printed surface.

Jack Tworkov and Philip Guston were among other abstract expressionist artists who worked in lithography. All 'were very much interested in the medium ... its washes working ... and their lines working in such a rich way. And it was almost all black and white. To love lithography is really to be interested in black and white ... Their drawings and compositions were worked right from the moment and their motions were something to see.'[47]

Guston completed a fine group of lithographs, printed by Irwin Hollander, in 1966 (7.11):

7.11 PHILIP GUSTON
Untitled from
A Suite of 10 lithographs　1966
lithograph
53.0 × 71.0
edition 19/25
Australian National Gallery,
Canberra

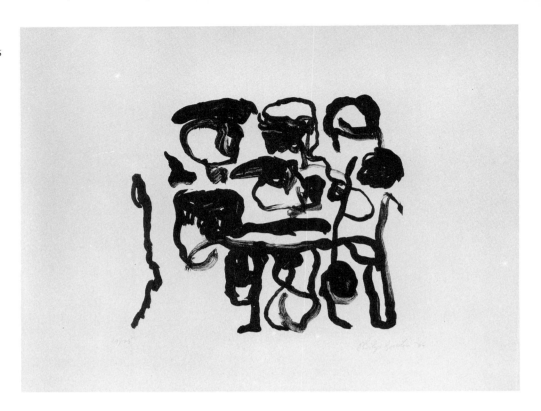

. . . getting that image out from inside him, it was an act of such a spiritual nature. It was also fast – the gesture that came out, and the line could really describe that. The speed of [the] brush was perfect and described by the trailing grease wash; so you could really feel [the] feelings. With Guston that was magnificent because the squiggle and the shape and the richness was immediate. Then he would be spent, it would be like being with a boxer, and he had to leave, just to get out.[48]

Given the artist's obvious affinity with lithography it is unfortunate that he waited until the very end of his life to explore it extensively again. In 1979 he completed twenty-five editions published by Gemini. Vigorously worked, their commitment to figuration reveals the apocalyptic vision that characterizes all of Guston's late work.

Important, too, and also not very well known, is the series of abstract expressionist lithographs completed by Willem de Kooning working with Irwin Hollander and Fred Genis. Although a print by de Kooning was included in Hollander's *Portfolio 9* and the artist worked on a few others at the same time, it was not until 1971 that de Kooning completed a significant body of lithographs, including *Woman at Clearwater Beach* and *Weekend at Mr and Mrs Krishner* (7.12). He explored a wide variety of ways of working on stone, on aluminium and zinc plates, and on transfer papers, which he was able to tear, cut and rearrange before imposing his collaged images onto the printing matrixes. The lithographs as a group have a directness and liveliness, a visual density that corresponds to de Kooning's inventive piercing and layering of space, and a sense of joy in the process, making them an important aspect of the artist's work and a substantial contribution to the prints of this period.

Fortunately, just as Motherwell and Frankenthaler have continued to add to their print oeuvres, other artists whose work is rooted in abstract expressionism also expand upon this tradition. Among them is Joan Mitchell, who completed eleven splendid prints at Tyler Graphics in 1981. *Bedford I* (col. pl. 29) in its lush use of colour is among the most beautiful. Mitchell's vigorous strokes, layered colour over colour, evoke memories of the experience of landscape free of any attempt at mimesis.

The lithographs by all of these artists are a strong indication of the powerful

7.12 *Opposite* WILLEM DE KOONING
Weekend at Mr and Mrs Krishner　1970
lithograph
107.8 × 76.3
printer's proof (edition 75)
Australian National Gallery,
Canberra

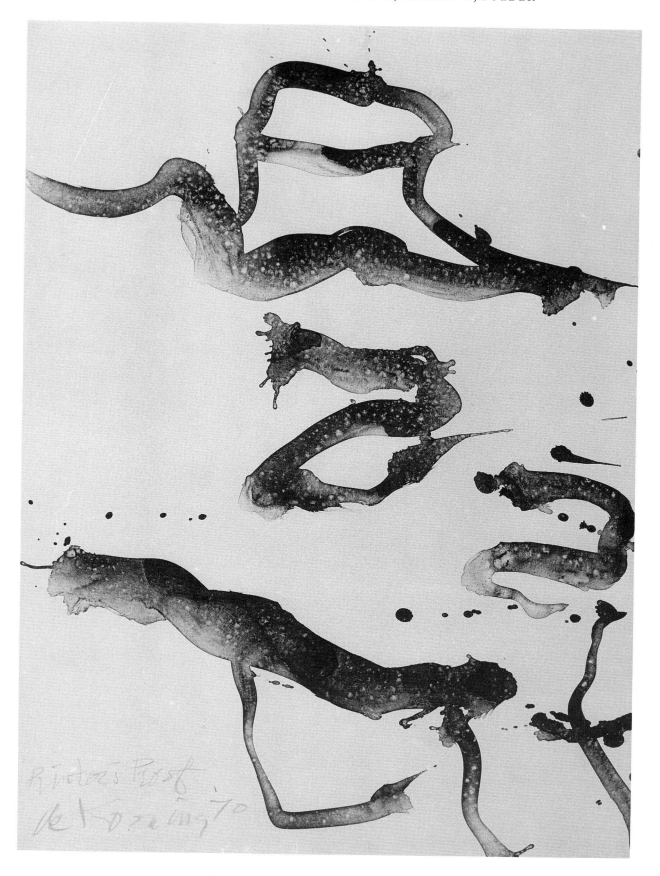

presence of which lithography is capable. But American art was to add to its scope in other directions in the late 1950s and early 1960s, just as the network of print workshops was gearing up.

In the vanguard of these new ideas were Jasper Johns and Robert Rauschenberg, both of whom were among the artists Tatyana Grosman encouraged. Not only have Johns and Rauschenberg continued to work in printmaking, completing extraordinary lithographs among works in other media but, in addition, their involvement with graphic art seems also to have encouraged other artists. According to Frank Stella:

> Bob and Jasper set the tone, in a certain way. They created an excitement around printmaking as a special, exclusive, self-contained activity that rubbed off . . . I think it was the intensity of their graphic touch that turned people on . . . they were involved with the technique and into the possibilities derived from mechanical virtuosity. They pushed it a bit and got other people interested in printing, at least indirectly.[49]

Working at several publishers' shops Johns and Rauschenberg have each pushed an individual conflation of the felt, the seen and the known in a direction that has had a profound influence on the art of our time. In so doing each has called into play whatever medium was being used to expand upon his own individual vision. In lithography, Johns's essentially autographic approach ranges from the extraordinarily delicate, impeccably controlled washes of his *Voice* 2 prints made at U.L.A.E. in 1982, to vigorously worked black crayon strokes, as in *Land's end* (7.13), completed at Gemini in 1979. Drawn entirely on one plate, the rich tonal range presses the medium to its very limits.[50]

7.13 *Opposite* JASPER JOHNS
Land's end 1979
lithograph
132.0 × 92.4
artist's proof VIII/XII
Australian National Gallery, Canberra

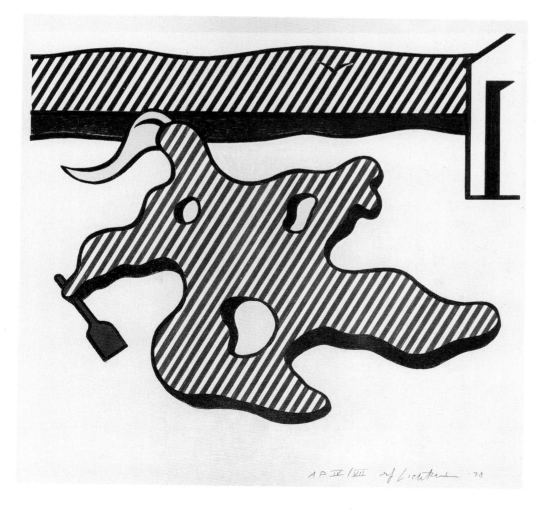

AP IX/VII *rf Lichtenstein* '78

7.14 ROY LICHTENSTEIN
Nude on beach
from *Surrealist series* 1978
colour lithograph
65.2 × 62.2
artist's proof IV/VII (edition 38)
Australian National Gallery, Canberra

1.16

Rauschenberg, too, has sought to question the very nature of his materials. His *Shades*, 1964, a lithographic book-object printed on plexiglas 'pages', was undoubtedly a challenge to the printers at U.L.A.E.; and his *Booster*, 1967, a work that is considered one of the lithographic landmarks of the period, was printed one half at a time, no stone then in the Gemini shop being large enough to carry the life-size X-ray of the artist that forms the central image. The concern of both Rauschenberg and Johns to incorporate aspects of the 'real' world into their art and to explore process and method as an aspect of meaning reflects a central aspect of today's art.

In the work of Roy Lichtenstein, a vanguard figure in the pop art movement that introduced the 1960s, one sees the self-conscious exploration of art as a subject for art. This worked hand-in-hand with Lichtenstein's concern for exploiting mass media concepts and techniques within fine art, a direction explored in some depth in screenprinting, especially by Andy Warhol. Lichtenstein's approach has evolved, however, from one that was initially mechanical to his *Nude on beach*, 1978 (7.14), from his surrealist series. This group of lithographs was the first time that Lichtenstein worked on the stone itself, drawing directly rather than using photographic or other mechanical means. For these prints, his key images were worked with ordinary graphite and liquid tusche was used for filling in fields of colour. In his more recent series, for example the *Landscapes* published by Gemini in 1985, Lichtenstein combined lithography with woodcut and screenprinting. Freely drawn, joyously gestural lithographic brushstrokes are enhanced by contrasting them with striated wood grain and the dense flatness of screenprinting.

The west coast version of pop art was oriented especially toward the depiction of everyday objects, usually in a cool and detached manner. An example is Joe Goode's highly refined *Glass middle left: Spoon middle right*, 1967, from the *English still life*

7.15 JOE GOODE
Glass middle left:
spoon middle right
from *English still life series*
1967
colour lithograph, screen print
53.4 × 53.4
right to print proof
(edition 4)
Australian National Gallery,
Canberra

7.16 VIJA CELMINS
Untitled (desert) 1971
lithograph
53.6 × 70.3
edition 64/65
Australian National Gallery,
Canberra

series (7.15), in which a glass and a spoon hover on an isolated field. Lithography is combined with screenprinting and the images are somewhat surreal. The pop art direction is only one of many in which artists have continued to see figuration and direct representation as parallel explorations to those that have grown out of abstract expressionism's commitment to method as integral to content. Another example is Vija Celmins's *Untitled* (7.16), in which a vast desert is meticulously rendered in lithographic crayon. Published by Cirrus Editions in 1971, it exemplifies Celmins's tracking of a surface in both her drawings and prints. Here, as in many representational lithographs, theory as well as observation has functioned to determine the direction of the figuration.

Drawing based on the observable world has been the central concern of Englishman David Hockney, who has completed many of his most important prints in workshops in the United States. Even in the development of his complex colour lithographs, his draftsmanlike approach is evident. Hockney's close friends, such as fabric designer Celia Birtwell, have been the subjects of many of his lithographs and etchings and his immediate surroundings are other sources for his art. Several brilliantly coloured lithographs formed a visual diary of a trip to Mexico with Ken Tyler of Tyler Graphics. Hockney's concern with systems of perception, as revealed in the depiction of the printer's dining room (col. pl. 28), is as much an outcome of his study of Picasso's art as his delight in colour and pattern.

1.22

The range of approaches to representation in current lithographs is made evident in the contrast between Hockney's passionate rendering of place and Philip Pearlstein's more coldly analytical works of models in the studio. In his tautly delineated compositions, Pearlstein appears eager to mechanize his own mind, eye, and hand in order to control their responses to the pulsations of the visible world. Other figurative artists have responded to nature with various but related levels and styles of coolness, among them Alex Katz, who like Pearlstein has completed a sizeable body of prints, including many lithographs.

Like David Hockney, many other artists have used lithography to chronicle their surroundings and travels and, through the 1970s into the present decade, the landscape and cityscape. Fairfield Porter and Neil Welliver come to mind, but many of the artists

who have approached these subjects in recent years have been women.[51] In lithography, in particular, one might note Yvonne Jacquette's *Northwest view from the Empire State Building*, 1982, *View of Schumnemunk Mt*, 1980, by Sylvia Plimack Mangold, and *Rock face/Zion Canyon*, 1982, by Susan Shatter. Differing widely in their approach to defining form, all three prints present the world from a dramatic and somewhat distant view.

Figuration has become increasingly common during the 1980s, but this visual orientation was less evident in the immediately preceding decades. Well before the term 'minimalist' came into use, spare images were seen in the lithographs of Josef Albers, the early prints of Frank Stella and the work of Ellsworth Kelly. Albers was one *col. pl. 4* of the few artists of the older generation to make extensive use of the nascent lithography workshops, completing prints in collaboration with Ken Tyler at Tamarind, at Gemini, and at Tyler Graphics.

Although Stella has credited Jasper Johns and Robert Rauschenberg with inspiring interest in printmaking on the part of other artists, Stella's own prints have evolved as among the most impressive of our time.[52] Starting on a small scale by recording such paintings as *Marriage of reason and squalor*, 1967 (7.18), the autographic aspect of printmaking seems eventually to have had a great impact on his later prints, introducing gestural forms and brazen mark-making into the work, which aspects have come to dominate Stella's art in recent years. His focus in many recent prints, for example the *Circuits* and *Swan engravings*, has been on relief and intaglio processes, although he has also completed work in lithography including his *Had Gadya* series. Ellsworth Kelly, too, has found in lithography a medium sympathetic both to his boldly abstract, carefully delineated colour-forms and to the spare studies of leaves and plants (7.17), usually drawn over life-size, that have occupied him concurrently throughout his career.

At another extreme to the work of Albers, Kelly, and the early Stella, one finds the decorative patterning of artists like Robert Kushner and Joyce Kozloff. Kozloff's *Pictures and borders 1*, 1977 (col. pl. 31), developed from Islamic ornament, presents a richly worked overall surface drawn in intricate detail that reveals the artist's close study of the rich colours and dense geometry of Islamic art; while Kushner's vivid *Fruit*

7.17 ELLSWORTH KELLY
Leaf II from the series
Twelve leaves 1978
lithograph
33.0 × 58.0
artist's proof 8/9
(edition 20)
Australian National Gallery,
Canberra

7.18 FRANK STELLA
Marriage of reason and
squalor
from *Black series I* 1967
lithograph
25.6 × 38.1
right to print proof
(edition 100)
Australian National Gallery,
Canberra

plate, 1983, invests a traditional motif with a totally personalized and distinctive *joie de vivre* (col. pl. 30).

All the prints mentioned so far have been printed on paper as flat, two-dimensional pieces. Since the 1960s there has been an ongoing interest in developing prints as physical, three-dimensional objects. Claes Oldenburg's *Profile Airflow*, a homage to the classic 1936 Airflow car, was produced at Gemini in 1968-69. The piece consists of a moulded polyurethane car-form over a two-colour lithograph. The research and development into moulded plastics that preceded the production of the edition – which itself took more than a year to complete – led the Gemini staff to believe that they could make anything.

1.18

During the 1970s James Rosenquist, another artist associated with pop art, completed a number of three-dimensional works employing numerous processes: printing, moulding plexiglas, die-cutting, burning, rolling, folding, collaging and so forth. Among them is *Mastaba* (7.19), completed at Graphicstudio in 1971. A printed collage of shoes, and cans with labels ranging from motor oil to turkey dinner, is surmounted by a vacuum-formed plexiglas hourglass with plastic beads that move if the print is turned upside down. An element of participation and a certain unpredictability as to what one might see at a particular moment are added to Rosenquist's collage view of the world.

Not all artists working in three dimensions have become involved with the high-level technology of the three-dimensional work of Oldenburg and Rosenquist. Several recent prints completed at Shark's Lithography, Boulder, Colorado, are dependent essentially upon the basic ingredients of lithographic ink on paper, the paper then being variously manipulated. These include Yvonne Jacquette's night cityscape, *Glimpse of Lower Manhattan (night)*, 1986, gently curved and viewed through a window-like frame; and the complicated interior space, *Subway*, 1986, by Red Grooms in which figures and interior details of a subway car are cut and folded forming an environment reminiscent of a pop-up book.[53]

Among the most beautiful three-dimensional prints of the 1980s are the group of lithographs by Dorothea Rockburne, published by Gemini in 1983. Approached with a very different sensibility than the works just mentioned, the lithographs were printed on both sides of transpagra vellum, and the sheets were then cut and folded to form a configuration based on the golden mean. Rich in colour, they are intellectually demanding and precise in their approach to form.

In the period with which this essay has been concerned, enormous numbers of prints have been produced and it is obvious that stylistic developments in printmaking have paralleled artistic ambitions in other fields, certain aesthetic directions being better

7.19 JAMES ROSENQUIST
Mastaba 1971
colour lithograph, glass beads,
plexiglass
76.2 × 55.9
edition 70
Gift of the University of
South Florida Foundation
National Gallery of Art,
Washington

served by processes other than lithography. Obviously the lithograph has at no time played a minor role. It is true, however, that the exquisite, sleek aquatints associated with Kathan Brown at Crown Point Press, for example, were more prominent than lithographs among the works of certain artists oriented toward a minimalist aesthetic, among them Robert Mangold and Brice Marden.[54]

Jim Dine, an artist with a great commitment to printmaking, has completed numerous lithographs and works that combine lithography with other processes, such as *Bathrobe*, 1975 (7.20), a lithograph with woodcut completed at Graphicstudio. Dine, however, has elected to work in lithography less frequently than in other media, indicating that 'lithography isn't as interesting to me as woodcut, and etching is my favourite thing to do.'[55]

In recent years the woodcut and monoprint have been increasingly prominent, as have prints worked with several processes.[56] While lithography has not dominated the field during the 1980s, important works in the medium have been completed by artists already mentioned; others who have made significant contributions include Susan Rothenberg, Richard Serra, Terry Winters, Elizabeth Murray, and Richard Diebenkorn.

Artists wishing to work in a variety of media have caused workshops to tool up accordingly and this has allowed the shops to offer a menu of processes; like Lichtenstein and Dine, many artists have taken advantage of this luxurious

10.51

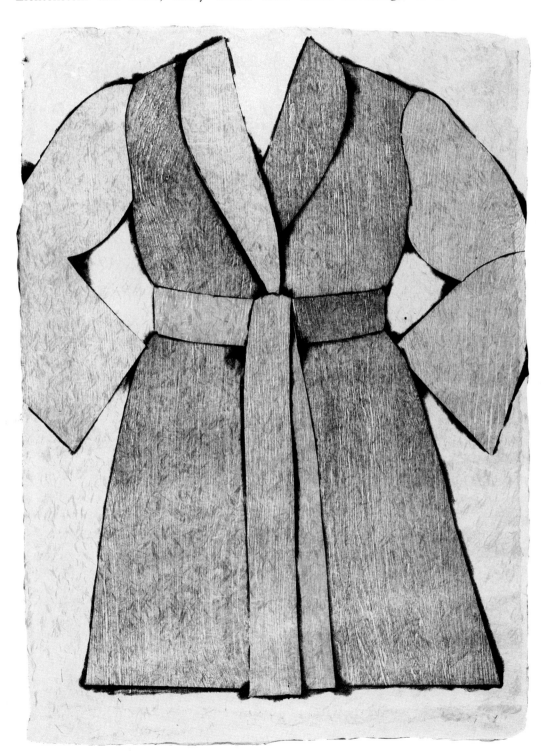

7.20 JIM DINE
The Woodcut bathrobe 1975
colour woodcut, lithograph
85.2 × 62.4
edition 59/60
Australian National Gallery,
Canberra

circumstance. In Steven Sorman's *Now at first and when* (col. pl. 32) completed at Tyler Graphics in 1984, lithography is used in combination with woodcut, etching and collage. Like all of Sorman's paintings and prints, this piece is a juxtaposition of beautifully worked surfaces and fragmented forms from the visible world, which nevertheless appear to be totally imagined. The collage of imagery and process establishes a sense of place and mood that transports us into an elegantly conceived world.

The increasing interest of artists to work in printmaking workshops and the workshops' commitment to expand their facilities to offer artists a vast variety of technical expertise have extended the concept of the fine art print. One consequence has been the interest in paper making and paper pulp imagery.[57] In the purest sense, this has little to do with our present topic, but many artists have combined paper pulp and printing, notably Kenneth Noland. His *Circle I, Series II–36* (7.23), worked in oriental and western paper fibres with lithographic overprinting, is an exquisite example of the subtlety that is possible.

7.21 EUGENE FELDMAN
Girl from Brooklyn *c.* 1966
lithograph
96.6 × 63.5 (sheet)
Australian National Gallery,
Canberra

7.22 MICHAEL HEIZER
Swiss survey no. 1
lithograph, screenprint
85.7 × 133.7
Gift of
Mr & Mrs Roger P.
Sonnabend
National Gallery of Art,
Washington

7.23 KENNETH NOLAND
Circle I (Series II–36)
from *Handmade papers* series
1978
three layers of coloured paper
pulp with three monotype
lithograph printings
51.0 × 41.8
Australian National Gallery,
Canberra

Completely lithographic in conception is the use of offset for both single sheet images and for artists' books. The subject of artists' books is too extensive to pursue here,[58] but offset lithography is immediately germane.

To this day, the rotary offset press, as distinct from the flat bed proofing press, has suffered from its association with commercial printing; this is so despite the fact that several artists have used it as a primary medium and others have produced extraordinarily beautiful images that could not otherwise have been achieved. Among the earliest was Jean Charlot, who worked with Lynton Kistler as early as the 1930s. Eugene Feldman, working from the 1950s to the 1970s, was a pioneer in the use of altered photographic images in fine art offset lithography.[59] Starting with a 35mm transparency and then making multiple separations which he enlarged several times, Feldman used a single photographic image as the source for several printing elements that he then combined in various ways. For prints like *Segovia*, and *Girl from Brooklyn*, both *c.* 1966 (col. pl. 33, 7.21), he used the high speed four-colour machines with which he equipped his Falcon Press, a high quality commercial enterprise. In his fine art prints Feldman more often than not produced series of related unique images rather than the editions of thousands for which the equipment was designed.

col. pl. 2

Among the artists already discussed, those who have worked in offset as well as direct lithography include Jasper Johns, Robert Rauschenberg and Frank Stella. Others not previously mentioned include Hanlyn Davies, Ron Davis, and Michael Heizer. Heizer's *Swiss survey # 1* (7.22) is one of a group of prints that combine photo-offset images of the Säntis Alps with screenprinted markings that chart the sculptor's proposed land displacement/replacement project, yet to be realized.[60] These prints were published by Gemini, the offset image being printed at Continental Graphics, a commercial press.

To work in offset otherwise than with publishers who have the necessary presses, artists must generally buy time in commercial shops. Workshops willing to undertake art projects with their time-consuming exploration are rare, nevertheless interest seems to be increasing. In the early 1980s, Hanlyn Davies and Hiroshi Murata set up the Oxbow Press in Amherst, Massachusetts. They hoped an artist-run press might become a profitmaking concern but the operation was short-lived. Brandywine Offset Institute, founded by Alan Edmunds, is functioning in Philadelphia where Eugene Feldman worked, as is the West Coast Print Center in Berkeley, California, founded by Don Cushman. The offset press at Pyramid Atlantic, a paper making and printmaking workshop under the direction of Helen C. Frederick, who has recently moved to Washington DC from Baltimore, is in the process of producing a portfolio of offset prints. The first was completed by Shoichi Ida, a Japanese artist visiting the Washington area late in 1986. However, Kevin Osborn, who directs the offset aspect of Pyramid, mainly works with artists' books, as do the Visual Studies Workshop press run by Joan Lyons in Rochester and the Nexus Press run by Clifton Meador in Atlanta.[61]

It seems today that any aspect of art in any one place may have far-reaching ties. Shoichi Ida's print, one of many he has completed in the United States, is a splendid demonstration of the fact that artists today are travelling all over the world to produce art. At any moment, important American art may be produced halfway across the world; or, like Ida, an artist whose home is elsewhere may be working in the United States.[62]

With lithography in particular, the amount of work being produced in publishing workshops, in universities, and in artists' studios is extraordinary. To survey it briefly is an impossibility but one may hope to indicate its range. Responding to artists' needs, lithography continues to thrive and undergo constant transformation and expansion, confirming many of Gustave von Groschwitz's fears of the 1950s. Now, however, instead of viewing these possibilities with chagrin we can recognize that they exemplify challenges that new art always presents.

8 Lithography in Australia:

Melbourne 1948–1958

Roger Butler

Art is a social activity, and as such is organically united with the struggles and aspirations of humanity towards the ideals of democratic life. The body of art is created in the crucible of human natural and social experience, and achieves an independent volition of its own which co-evolves with society. Art modifies, alters and enriches the psychological responses of those human units which, in their agglomeration, form the social organism. Thus art directly affects society itself.

ANTI-FASCIST EXHIBITION, Contemporary Art Society of Australia, 1942[1]

THE Australian continent was the last great land mass to be explored and colonized by Europeans in the Age of Enlightenment. The first European settlement, Sydney Town, was established on the eastern coast in 1788 only ten years before Aloys Senefelder, some ten thousand miles away in Bavaria, discovered the principles of lithography.

As an English penal settlement, the small community had little need at first for locally produced pictorial images and few intaglio or relief prints were made in the first four decades of colonization.[2]

In 1821 the newly appointed Governor, Sir Thomas Brisbane, an amateur astronomer, brought to Sydney, which then had a population of around 44,000 people, two lithographic presses for the publishing of star maps of the Southern Hemisphere. These presses remained in the colony after his departure. It was on one of them in 1825 that the itinerant British artist Augustus Earle (1793–1838) printed the first lithographs in Australia,[3] while the second press was purchased by the colonial Government. It was also around this time that free settlers began to outnumber convicts and printed images were sought after for home decoration, gifts for abroad and commercial use. The availability of two presses together with Government interest in lithography quickly established it as the foremost means of producing prints in the colony. It thus became the preferred graphic arts process in Australia for the next half century.

Lithography also became the process mostly used for replicating images in the other Australian colonies. Hobart, Tasmania, founded in 1804, had a lithographic press operating by 1833; Perth, Western Australia, 1829, had one by *c.* 1852; Adelaide, South Australia, 1836, had a lithographic printer working by 1841; and Melbourne, Victoria, 1838, had a lithographic establishment by 1844.[4]

It was not until the Victorian gold-rushes of the 1850s, when the population was increased by 290,000 immigrants in eight years, that other forms of printmaking became widely practised as a result of the demand for illustrated newspapers and commercial images. Nevertheless, until the first centenary of European settlement of Australia all major pictorial prints were lithographs. The pre-eminence of the process was enhanced by the number of skilled practitioners who emigrated to Australia from various European countries in the decade from 1850.

William Strutt (1825–1915) had studied with the French painter and lithographer Horace Vernet (1789–1863);[5] Cyrus Mason (*c.* 1829–1915) and Joseph Aresti (active 1840–60) had written books on lithography that had been published in London in 1852 and 1856 respectively;[6] Edward LaTrobe Bateman (1816–1897) had been the lithographer for three of Owen Jones's publications;[7] Eugene von Guérard

(1811–1901) had studied at the Düsseldorf firm of Heinrich Arnz[8] and George Stafford (c. 1825–c. 1885), was born and trained in India.

The artisans were not all men. A distinguished group of women also made lithographs in Australia during the 19th century. Mary Morton Allport (1806–1895) produced examples in Hobart in the early 1840s;[9] the sisters Harriet (1830–1907) and Helena (1832–1910) Scott drew the illustrations on the stones for many of the major scientific publications in Sydney,[10] and in Melbourne Elizabeth Parsons (1831-1897) published lithographed *Drawing books of Australian landscapes* in 1882–83.[11]

In Australia lithographs were printed with tint stones by 1844, colour printing was practised in 1845,[12] 'chromo' lithographs were first published in 1864,[13] and John Osborne developed a form of photolithography that was in commercial use by September 1859.[14]

Artisans in Australia remained well informed of European and American developments. John Degotardi (1823–1882) kept in touch with overseas developments by corresponding regularly with Alois von Auer of the Imperial Printing Institute in Vienna. Books on the subject, illustrated magazines like *The Chromolithograph* and trade journals such as the *American Art Printer* and *The British Lithographer* were readily available.[15]

By 1889 when a lithographic club was formed in Melbourne the lithographic boom in Australia was almost at an end.[16] Although some young painters of the Australian Impressionist school had their initial art training as lithographic apprentices, the 'artists' prints' they produced conformed to the current fashion for etchings and these artists formed an etching club in 1893.[17]

The interest of artists in the practice of lithography was kept alive by poster art which flourished around the turn of the century. The first exhibition of posters held in Australia in 1897 included examples by Alphonse Mucha (1860–1939) and Jules Chéret (1836–1932) from France, R. Anning Bell (1863–1933) and Dudley Hardy (1865–1922) from England and Joseph Christian Leyendecker (1874–1951) from the United States, as well as those by Australian artists.[18] The influence of the English Beggarstaff Brothers, who befriended the Australian artist Blamire Young (1862–1935), was particularly evident in the posters that Young produced after his return to Melbourne in 1896.[19]

In the first two decades of the 20th century Australian expatriates working in England, France and the United States frequently produced lithographs but rarely continued to work in the process if they returned.[20] Although lithography was used extensively in commerce in Australia and many artists worked as commercial artists, only isolated examples of artists' lithographs (albeit many of great interest) were produced between 1900 and the second world war.[21]

During these years the technique was overshadowed by the popularity of etchings and, from the 1920s onwards, wood and linocuts. The Australian Painter-Etchers Society (1920–38) promoted mainly conservative images of ideal pastoral subjects, and picturesque old buildings; wood and linocuts, which were mostly bold and decorative, projected a modern, leisured image of society.

The outbreak of the second world war marked the end of both these traditions; the Japanese bombings of Australia dispelled the myths of the continent's invulnerability, pastoral tranquillity and carefree living. Perhaps because lithography–unlike etching or relief printing–had not been so publicly tainted by such pre-war associations it seemed a viable process for artists to use in a world that had been irrevocably changed.

Lithography in Melbourne 1948–1958[22]

The depression years saw the rise of a politically engaged art which challenged the notion of art's neutrality. Workers' Art Clubs were established in Melbourne, Sydney and Perth. Writers and intellectuals formed corresponding organizations, such as the Melbourne University Labor Club and the Friends of the Soviet Union. Support for a committed art practice was consolidated with the anti-fascist movement.

Exhibitions of lithographs held in Melbourne, Sydney and Adelaide between 1937 and 1942 stressed the educative and democratic possibilities of the technique. *Contemporary lithographs* printed in London by the Baynard and Curwen Presses in editions of 400 were exhibited and stocked in Sydney in 1937,[23] and the *Everyman prints*, lithographs published by the Artists International Association which recorded wartime England, were available in Sydney in 1940.[24] But it was in Melbourne that the practice of lithography was most prevalent.

Six lithographs by Käthe Kollwitz, whose work had been included in Hitler's exhibition of degenerate art, were featured in the Anti-Fascist Exhibition organized by the Contemporary Art Society for display in Melbourne and Adelaide in 1942. The catalogue which illustrated her *Mütter* of 1919 claimed: 'Art is a social activity, and as such is organically united with the struggles and aspirations of humanity towards the ideals of a democratic life.'[25]

This exhibition, instigated by communist painter and printmaker Noel Counihan (1913–1986), saw artists who belonged to the Communist Party join forces with conservative painters against the common threat of fascism. Counihan was also engaged in the formation of the Artists' Unity Congress, which sought to advise the government on the best ways to utilize the expertise of artists during wartime. Rem McClintock (1901–1969), a fellow communist, artist and commercial printer, represented the Artists' Advisory Panel in these discussions.[26]

In 1948 Counihan and McClintock together with Vic O'Connor (born 1918), Yosl Bergner (born 1920), Nutter Buzacott (1905–1976) and James Wigley (born 1918), all fellow communists who had made prints in the social realist style, attempted to revitalize the conservative Victorian Artists' Society. Their campaign was spearheaded by the publication of a new magazine, *The Australian Artist*, edited by Richard Hauton James.[27] The democratic concerns of this group are evident in the editorial of Autumn 1948: 'Today patrons should not only be the rich but also the ordinary man on ordinary wages, not only the State or the Church, but also the business house, the public corporation and Trade Unions.'[28]

Industrial arts, cartoons, murals and particularly printmaking were seen as ways of achieving these ends. For both producer and consumer printmaking had advantages. *The Australian Artist* observed that because of their low price 'Anyone may acquire prints ... Furthermore any artist will find among the numerous techniques of printmaking one that suits his hand.' The writer went on to explain:

> Some [techniques] are neglected today—notably auto-lithography, which in England has recently been most profitably revived, as a practical and economical method of producing up to a few thousand copies of such useful commodities as book jackets, children's books and wall-pictures for schools. In the hands of Barnett Freedman, Edward Bawden and Paul Nash their appeal has extended far beyond the collector portfolio or the dining-room wall.[29]

10.24

The article was unsigned but may have been written by Rem McClintock, who in the next issue offered his working knowledge of lithography to other artists: 'Lithography—anyone interested? I am all set to reproduce and/or print your original lithograph in one or more colours. Plates and the knowhow supplied. Maximum size 15 × 20 inches.'[30]

McClintock, the joint owner of a commercial screenprinting business, had had a long association with artists and radical politics. His father was a well-known watercolourist and his second cousin, Herbert McClintock (1906–1986), artist and communist, had been forced to leave Melbourne in 1931 because of his provocative linocuts for the magazine *Strife*, which advocated immediate revolution. Rem McClintock served in the first world war and on his return to Australia studied commercial art under a retraining scheme at the Working Men's College (now Royal Melbourne Institute of Technology) in Melbourne. It was here that he learnt lithography.

Around 1947 he purchased a lithographic hand press capable of printing crown-sized paper and set up a workshop in his home at 11 Selbourne Road, Kew, an inner suburb of Melbourne. He continued to work as a commercial printer and printed for others in his spare time.[31] His first 'customer' was Noel Counihan,[32] who was once more exploring the possibilities of printmaking. In 1931, aged nineteen and a foundation member of the Workers' Art Club, Counihan had produced two powerful linocuts, *Tycoon* and *Sexless parson*. Most of the next fifteen years was spent drawing political cartoons and illustrations for newspapers and left-wing magazines, and from 1940, painting. In that time he produced only occasional prints; a linocut cover for the magazine *Proletariat* in 1932 and three woodcuts for *Stories of Australia* 1938 by his friend the Jewish author Pincus Goldhar.

Counihan demonstrated a sustained return to printmaking in 1947 with the publication of *The Miners*, a set of six linocuts that paid tribute to the efforts of Victorian coal miners during the second world war. In 1948 he produced twelve lithographs; six of these were published in the portfolio *Lithographs by Counihan*, a seventh was used on the folio cover, the rest were rejected variants. Although these were the artist's first lithographs, he obviously felt at ease with the process. Except for the cover illustration drawn on a zinc plate Counihan worked directly onto the stones. Using both the point and side of the crayon and occasionally working back into the image with a scraper, he showed in these prints his characteristic energetic line and the smudged shadows found in his charcoal drawings of the previous years.

The theme of Counihan's lithographic folio is not as didactic as that of *The Miners*. There are two depictions of foundry tradesmen (8.1), one of *A Worker resting* (8.2), a portrait of the artist's mother and another of his two-year-old son Mick. The other plate, *An important conversation*, is a humorous comment on current fashion; the print is mainly worked with brush and tusche and is related to his pen-and-ink caricatures for newspapers.

By the time Counihan began working in lithography he had already decided to travel overseas. This could be seen as part of a general exodus after wartime travel

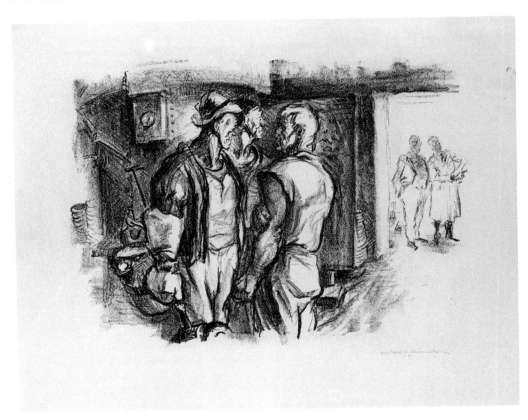

8.1 NOEL COUNIHAN
In a foundry 1948
lithograph
28.2 × 39.1
edition 100
Australian National Gallery,
Canberra

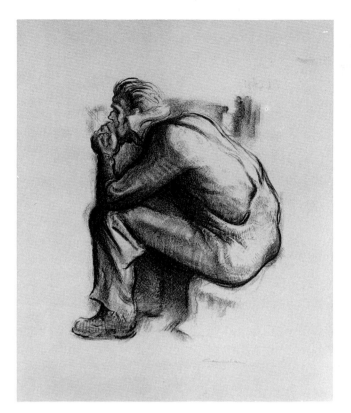

restrictions, but the local political climate in the late 1940s was undoubtedly also a deciding factor. The alliance between communist and conservative painters lasted only until the end of the war. The Labor Government elected in 1941 lasted only a few years longer; when it tried to nationalize banks in 1948 a middle-class backlash resulted in electoral defeat in December 1949.

The new Liberal Prime Minister, R. G. Menzies (remembered in the art world for having helped form the short-lived Australian Academy in 1937), had fought the election on an anti-communist platform. Within months of his election he tried unsuccessfully to outlaw the Australian Communist Party. By the middle of 1949 reactionary artists had already regained control of the Victorian Artists' Society. The magazine *The Australian Artist* was attacked as a hotbed of communist propaganda by such apolitical artists as George Bell, Max Meldrum and Victor Greenhalgh; the editor R. H. James was sacked and after the Winter 1949 issue the magazine ceased publication (8.3).

Communist artists working in Melbourne began to disperse. Bergner and Wigley left for Europe in 1948, Roy Dalgarno and Counihan followed in 1949 and in the same year Nutter Buzacott moved to Queensland. Rem McClintock stayed in Melbourne and was asked to resign from his position of Honorary Secretary of the Discussion Group of the Victorian Artists' Society in August 1949, after being named as a member of the communist-controlled Arts Council of Australia in the enquiry into the activities of the Victorian branch of the Communist Party.[33] (He was also said to have printed communist leaflets on his lithographic press.)

In the years following the war the Commonwealth Reconstruction Scheme enabled many servicemen and women to study art, some at the Art School of the National Gallery of Victoria. It was soon realized that many of these students would never become professional painters and vocational training in commercial art-related areas was provided at the Royal Melbourne Institute of Technology [R.M.I.T.] one day per week. Particular attention was paid to printing processes; Australian printing facilities had been modernized during the war but there were few trained staff to operate them.

8.2 *Above left*
NOEL COUNIHAN
A worker resting 1948
lithograph
34.4 × 25.1
edition 100
Australian National Gallery,
Canberra

8.3 The cover of the final issue of *The Australian Artist*
vol. 2, pt. 2, 1949.
The cover illustration depicts an appropriately conspiratorial image,
a lithograph by Will Dyson

Greenhalgh, the ex-Bell student who had sought McClintock's removal from the Victorian Artists' Society, appointed Harold Freedman (born 1915) to head this commercial art department.[34] Freedman had studied at R.M.I.T. from 1929 to 1935 and was greatly influenced by Napier Waller (1894–1972), a mural artist and printmaker. He produced linocuts under Waller's supervision in 1932 and also began to experiment in lithography, drawing on zinc plates during life drawing classes. At the end of his student years he earned his living by designing and preparing the lithographic plates for travel and entertainment posters. During the war he served as an official war artist, and after his release from service he continued making posters and began teaching at the College.

Although Freedman claimed no political (or artistic) affiliations, his work has always been public-orientated, whether in book design, mural work or posters. Heroic posters dedicated to the men and women who worked in essential services in Australia during the war were produced for the Victorian Railways in 1947.

The emerging interest of Freedman's students in printmaking, especially his lithography group, is demonstrated by the inclusion of two lithographs by Kenneth Jack (born 1924) in the 1949 issue of the college magazine *Jargon*.[35] Technical assistance in the printing of lithographs by students had until 1949 been provided by the staff of the Melbourne School of Printing and Graphic Arts, an autonomous school which had been housed at R.M.I.T. since 1899. With the increasing importance attached to the training of printing technicians after the war it moved to its own premises in 1949. After the loss of the convenient assistance from the School of Printing, Freedman turned to friends he had made as a poster artist. To help print Jack's lithographs, he approached Lionel Harrington (born 1906), foreman printer of one of Melbourne's oldest lithographic firms, Troedel & Cooper.

Freedman deplored the demise of the 'painter-printmaker' in Australia and the alienation of fine and commercial art. To encourage artists to experiment in printmaking processes he allowed them to use the presses in the commercial art department on Saturday mornings. In October 1951 he called a meeting of practising artists with a view to forming a printmaking group and to formalize their use of the printmaking facilities at the College.

> In his address to the assembled artists Harold Freedman stated that graphic arts were, at that time, practised by only a small number of artists, notably Murray Griffin and Noel Counihan in Victoria and a few New South Wales artists. He considered that not only artists would benefit immensely by learning this type of art, but ... commercial ... art would also benefit by the injection of the artists' talents and their creative ideas.[36]

The response was enthusiastic and in early 1952 evening classes commenced one night per week. The equipment in the print room comprised two etching presses, three letterpresses and a hand litho press. Overall responsibility was taken by Freedman; Ben Crosskell, Geoffrey Barwell and Kenneth Jack taught etching and relief printing; Freedman's friend Lionel Harrington looked after the lithography area.

Harrington had been apprenticed to a commercial lithographer in 1919 and was able to offer the students the accumulated knowledge of 30 years of practical experience in lithographic production and printing from both stones and plates. He also supplied material assistance in the form of zinc plates and his employer, Troedel & Cooper, reground the plates free of charge. Other firms supplied paper and ink.

Working with artists was a pleasant change for Harrington, although he recalls that they did not always care for the niceties of established lithographic practice; they put down their images with vigour and were impatient for results. Initially most wished to work directly on the stone, which 'they held in a kind of reverence', but after they had to 'regrind a few of their own stones they realized the advantages of zinc plates.'[37] The classes lasted until 1957, by which time most emerging artists in Melbourne had participated in the programme and over four hundred prints had been produced.[38]

Some of the most powerful paintings, prints and drawings of these artists are not united by their subject matter but rather their mood, which might best be described as post-war anxiety. The 1950s were years of material growth, but were fraught with an underlying fear.

Like most Western countries Australia was consumed by the politics of the Cold War and the Menzies Liberal Government traded on the fear inspired by the supposed threat of communism. The 'Yellow Hordes' from the recently formed People's Republic of China and the 'Red Peril' of the U.S.S.R. were portrayed as evil, aggressive and expansive powers that had to be contained at all costs. Communist sympathizers were removed from positions of responsibility and allegations of spying were rife. Added to this was the fear of annihilation as more countries produced nuclear bombs.

The generation of artists who came to prominence in the early 1950s were subjected to this conditioning. Although some registered their misgivings concerning contemporary society, it was almost always expressed in an essentially personal language quite unlike that of the politically aligned programmes of the social realists.

Many of the most vital works of this time were conceived as lithographs; the spontaneity of drawing on the stone or plate suited the production of these intensely personal images. In keeping with their nature the majority of the lithographs were small and several were never exhibited. The generally claustrophobic space found in these prints is accentuated by their dense black ink, which reflects their prevailing mood. When colour was used it was subdued.

During the war years Arthur Boyd[39] (born 1920) began a series of allegorical paintings, many based on Biblical themes. Often set in the semi-industrial suburbs of Melbourne, they are scenes of catastrophic destruction but have an obsessive personal

8.4 ARTHUR BOYD
Hound of fear 1953
lithograph
25.4 × 20.0
Australian National Gallery,
Canberra

8.5 ARTHUR BOYD
Untitled 1953
lithograph
20.8 × 25.4
Australian National Gallery,
Canberra

8.6 KEN WHISSON
Evil city 1953
lithograph
17.8 × 20.0
Australian National Gallery,
Canberra

component which distinguishes them from the work of social realist artists like Counihan.

Boyd had produced a few scrappy prints in the late 1930s and in common with other Melbourne artists was again drawn to printmaking by the facilities at R.M.I.T. Although only a few prints resulted, they rekindled an interest in the process that emerged more strongly in his work in England in the 1960s. The lithograph *Hound of fear*, 1953 (8.4) is an allegory of blackness, fear personified in the dog which bays beneath a moonless sky. A second untitled lithograph (8.5) shows a 'priapic ram-demon with contorted, looped horns, . . . the main Boyd symbol of "bestial sex"'[40] in a theme adapted from Europa and the Bull. The woman, her arm flung out imploringly, lies trapped by a fallen tree and the beast.

Evil city (8.6), a lithograph by Ken Whisson (born 1927), is similar in feeling to Boyd's painting *Melbourne burning*, 1947. A tram and cars have collided in one of Melbourne's main streets, anguished figures walk away from the accident staring blankly while the face of death surveys the scene. It is a swift private image which was never editioned.

The first testing of a hydrogen bomb by the United States in 1952 deepened many artists' distrust of science. Interest in religion increased and in 1951 the Blake Prize for Religious Art was established. Len French (born 1928) was awarded the prize in 1963, but a decade earlier he had already found the subjects for his art in classsical mythology, Christianity, and romantic poetry.

Most of French's lithographs from the early 1950s are steeped in anxiety. *Hector's ship* is buffeted by unrelenting waves that seem to warn of impending doom. The betrayed Christ grimaces in pain in *The Fifth day* and *The Albatrosses* evoke the misfortunes that will fall on any sailor who harms them.

French experimented constantly with the lithographic process, an attitude that he would later bring to his position of lecturer at the Melbourne School of Graphic Arts.

8.7 *Opposite* LEONARD
FRENCH
Head 1952
colour lithograph
45.6 × 36.2
Australian National Gallery,
Canberra

8.8 HARRY ROSENGRAVE
The Mussel gatherers 1955
lithograph
23.1 × 34.2
edition 12
Australian National Gallery,
Canberra

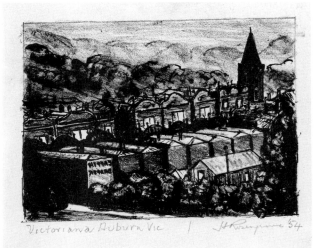

8.9 HARRY ROSENGRAVE
Victoriana, Auburn 1954
lithograph
13.5 × 18.1
Australian National Gallery,
Canberra

8.10 *Right* HARRY
ROSENGRAVE
Near the brickworks 1954
lithograph
21.6 × 16.6
edition 20
Australian National Gallery,
Canberra

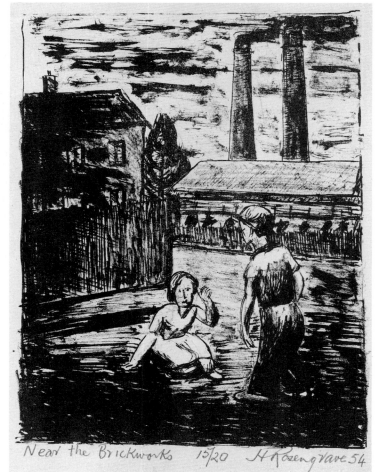

One of his most powerful images from the early 1950s is the colour lithograph *Head* (8.7). The face is contorted in pain and the clenched fists are pushed against the bared teeth, silencing outcry. French's vision of the world at this time is a troubled one.

By contrast, one-time postman Harry Rosengrave (1899–1985) set his work in the southern suburbs of Melbourne which he knew intimately. A long-time student of George Bell, Rosengrave was not interested in political art. His prints – etchings, woodcuts, linocuts and lithographs all produced at R.M.I.T. – are 'innocent' observations of ordinary people and their experiences.

In the scumbled, oily black lithograph *The Mussel gatherers*, 1955 (8.8), two workers bend over their gatherings, anxiously sorting the results of their toil. The beach, hidden by the sea wall, gives glimpses of the pleasures of another more leisured day. A sailing boat skims across the bay and a child's balloon escapes into the sky.

The lithographic process suits the grimy grainy view of *Victoriana, Auburn*, 1954 (8.9), a workers' suburb established in the 19th century. The rows of two-storeyed terrace houses and shops are claustrophobically locked together, while the steeple of the church on the corner is silhouetted against the smoke-filled sky. One can imagine that the site of *Near the brickworks* (8.10) is close by; the factory belching smoke dominates the houses of the neighbourhood. Two children playing in the dirty street are, as yet, unaware of the social and economic forces that shape them.

A feeling of constraint is found in Rosengrave's colour lithograph of an urban park, *The Mafeking tree*, 1954 (col. pl. 34). The gracious old trees flanking the path can be read as symbols for conservative society, while the young Mafeking tree, fiercely growing like a child, is contained by an iron fence.[41]

The fears of adults are often found in the portrayals of children in the prints of the 1950s, particularly in the work of Charles Blackman. Born in Sydney in 1928, Blackman worked as a newspaper artist before moving to Melbourne in 1945. Perhaps his early working experience is recalled in *Newspaper man*, 1953 (8.12), although the

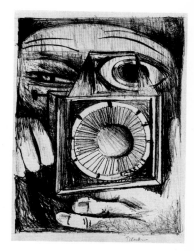

8.12 CHARLES BLACKMAN
Newspaper man 1953
lithograph
33.8 × 25.3
Australian National Gallery,
Canberra

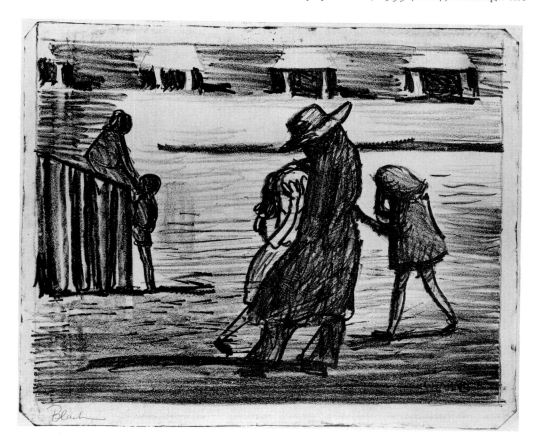

8.11 CHARLES BLACKMAN
Going to school 1953
lithograph
25.0 × 31.4
Australian National Gallery,
Canberra

8.13 CHARLES BLACKMAN
Running girl 1953
lithograph
26.0 × 20.4
Australian National Gallery,
Canberra

8.14 *Above right*
CHARLES BLACKMAN
Boy on scooter 1953
lithograph
34.9 × 23.4
Australian National Gallery,
Canberra

all-knowing eye of the camera (that cannot lie) may also reflect the sinister hounding-down of communist sympathizers by the government and press at the time.

Blackman's deliberately crude drawing was criticized in the early 1950s but his love of the technique and his command of lithography is recognized today. He fills his zinc plates with tones which vary from the gentlest strokes of the crayon to the most violent blacks from the brush. Like Boyd, Blackman already had some reputation as a painter by the time he worked at R.M.I.T. and he never became a member of the college's regular printmaking group.

In his lithograph *Going to school*, 1953 (8.11), Blackman expresses a child's anxiety on beginning school, marking the entry into life outside the home circle. The world of children is shown to be far from innocent. A schoolgirl runs in blind terror through the shadows (8.13) – the source of her fear is unknown and not articulated – and the promise of freedom, the sunlit break in the wall, is blocked by bars. Perhaps the source of fear is the young *Boy on scooter* (8.14) or one of his playmates. He smiles demonically as he lurks in waiting for some unsuspecting victim, crouching over his scooter, his accomplice in evil.

The theme of the loss of innocence is also found in the colour lithograph *The little boy and the stars*, 1957 (col. pl. 35), by Bill Gleeson (born 1927). But rather than rejoicing, the boy is already trying to remember the past. It could be that Gleeson is recalling his own childhood spent on a farm near the western country town of Mildura; or possibly the boy is trying to remember a time when the twinkling of stars was still magic, when it was not known how to split the atom and unleash its destructive forces.

By the time Bill Gleeson produced this lithograph printmaking in Melbourne was beginning to become popular. Exhibitions of works printed at R.M.I.T. had been held annually from 1954 to 1956 and artists, critics and public had become better informed and more articulate on the subject. Artists such as Fred Williams (1927–1982) and Robert Grieve (born 1924), who returned from study overseas in 1957 and 1955

respectively, added their enthusiasm for printmaking to the movement. In 1956 the German immigrants Udo Sellbach and Karin Schepers (both born 1927), who had settled in Adelaide, exhibited prints in Melbourne.

Print exhibitions also began to come from overseas. Recent German Graphic Art toured all state galleries in 1956 and the exhibition Modern British Lithographs organized by the Senefelder Club likewise in 1957–58. Australian lithographs of the period were first presented overseas in 1958, when prints by Karin Schepers, Udo Sellbach, Kenneth Jack and Bill Gleeson were included in the Fifth International Biennial of Contemporary Color Lithography at the Cincinnati Art Gallery.

That Australian artists were beginning to exhibit their work in the United States rather than the traditional centres of Europe is not surprising. In 1951 Australia had cemented its military ties with the United States with the signing of the ANZUS treaty and by the end of the decade American culture dominated Australia to the extent that it was dubbed by some 'the 51st State'.[42] As America strove to demonstrate that it was not only the dominant military power in the world but also the cultural centre, exhibitions like the Cincinnati Biennial were encouraged.[43] The 1958 exhibition included 450 lithographs from 38 countries, demonstrating the unity of the 'free world'.

When the classes at R.M.I.T. were abandoned in 1957 the foundation had been laid for substantial printmaking activity in Melbourne. Other institutions around Australia had introduced printmaking into their art courses and R.M.I.T. introduced a full-time diploma course in 1960. Several lithographic publishers were formed by commercial galleries; South Yarra workshop instigated a short-lived project to distribute commissioned lithographs through the World Record Club, and Janet Dawson (born *10.34* 1935) who had been a lithographic printer at Atelier Patris in Paris supervised the productions of Gallery A Workshop in Melbourne.

Against these commercial initiatives, in the early 1970s the necessity to establish artist-run print workshops was recognized. Artists George Baldessin (1939–1978), John Robinson (born 1935) and Les Kossatz (born 1943) formed Druckma Press in 1974 to print editions for themselves and for other artists. Three years later the Victorian Printmakers Group was established and in 1981 re-formed as the Victorian *10.36* Print Workshop. The workshop moved to its present extensive premises in Fitzroy, Melbourne, in 1985. At this publicly funded access workshop, free from the pressures of commerce, some of the most individual and significant lithographic work in Australia is now being produced.

It was appropriate that Noel Counihan, who had been so influential in promoting lithography since the late 1940s, should have been involved in almost all these organizations. He worked with the South Yarra Workshop in 1968, Druckma Press in *10.35* 1981, and was a foundation member of the Victorian Printmakers Group and a member of the Board of the Victorian Print Workshop until his death in 1986.

9 Lithography In New Zealand:

A coming of age

Anne Kirker

Lithography is without question the most difficult of all print media. Yet it offers a degree of subtlety and a range of textures unequalled by any other medium.

<div align="right">ANDREW BOGLE in Art New Zealand, 1979</div>

IT is not surprising that little is known in Australia, let alone elsewhere, about contemporary printmaking in New Zealand, a country geographically 'on the periphery' and with only just over three million people. Even less is known about the development of lithography there. Because of the complexity of the process, lithography has been little practised by artists until the emergence in the last few years of specialist workshops with master printers and technical assistants. Now New Zealand is experiencing in terms peculiar to itself the lithography boom witnessed by the United States and Europe during the 1960s and 1970s.

The origins of lithography in New Zealand can be traced to the work of the two scientific expeditions made by the French explorer Dumont D'Urville to this remote region in the early 19th century. His artists, Louis Auguste de Sainson (first voyage, 1826–29) and Louis Le Breton (second voyage, 1837–39) produced numerous highly detailed drawings showing '. . . the character of places, the types of men living in them, their costumes, arms, dwellings, . . .'[1] which in turn were translated into hand-coloured prints by highly skilled lithographers and tinters at establishments such as Langlumé and Lemercier in Paris. By the mid 1830s lithography had virtually replaced engraving as the pre-eminent reproductive medium. This is evident, for example, in the romanticized images of the Maori after Augustus Earle and G. F. Angas; Angas himself occasionally drew directly onto the lithographic stone, albeit clumsily, as seen in *Ko Nga Waka te Karaka . . . the Christian chief . . . and . . . his attendant boy*, which was among the 60 plates in *The New Zealanders illustrated*, published in London in 1847.[2]

The first lithographs actually produced in the colony were a view of *Lambton Harbour* of 1841 by William Mein Smith and a chart of Port Nicholson, from the same year. Both were published by the now barely remembered firm of Jones and Bluett in Wellington. Mein Smith was Surveyor-General to the recently established New Zealand Company[3] and his panorama was considered 'a mere sketch' indicating the growth of the settlement to friends in England. By the 1860s and 1870s, with better equipment to hand, commercial lithography was a widely practised means of reportage throughout both islands. Limestone discovered in Westland (South Island) during this period inspired hopes of competing with the Bavarian product, but the deposit proved unsuitable and the venture failed. Lithographers continued to rely, as they largely do today, upon the costly importation of materials.

Lithography was initially employed to satisfy the local need for maps, plans and topographical descriptions, and then from the late 1880s for trenchant political cartoons in a number of newspapers. These often took the form of full-page images in black and white. Peter McIntyre, a cartoonist and lithographer originally from Scotland, drew Dunedin characters for the *Otago Daily Times* and in 1887 produced what may well have been the first New Zealand colour lithograph, made after a painting by A. H. O'Keeffe. It was mundane in comparison to the glorious theatrical

posters he went on to produce for the Caxton Printing Company in Dunedin. *Ferry, the human frog* and *McEwen, the great Scottish hypnotist* are just two of a number of crowd-enticing chromolithographs designed by McIntyre and now in the collection of the Otago Early Settlers' Association. At the time of their appearance, chromolithography was a lucrative business for companies in several centres. It served admirably not only for posters but also for greeting cards, booklets and programmes and, not least, view books characterized by luxurious illustrations. *The New Zealand illustrated*, 1889, comprising 16 plates after paintings by such established artists as C. D. Barraud and John Gully, was produced by the well-known firm of A. D. Willis in Wanganui. 'Chromos' supplemented regular papers such as the *Auckland Weekly News*, often depicting dramatic episodes from the New Zealand Land Wars, genre scenes and flower pieces. Although often crude in colour and of dubious aesthetic merit, these prints did indicate the presence of an audience appreciative of graphic art and opened the way for the development of creative printmaking.

Information is still scarce as to the development of lithography as a fine art in New Zealand. We know that Leonard Booth, a Christchurch artist remembered for his lively Art Nouveau designs for the covers of Canterbury Society of Arts exhibition catalogues, briefly tried his hand at it in 1909. A more concerted effort stems from 1915–26 when English-trained art teachers, mostly brought out under the La Trobe scheme, introduced lithography and other graphic techniques into the technical schools.[4] For several decades it was perceived as a craft, most often linked with designers and typographers. When painters experimented with lithography it never assumed a primary place in their oeuvre and more often than not duplicated existing drawings. This was the case with H. Linley Richardson, who emigrated to New Zealand in 1908, armed with experience from Harry Blackburn's school for 'drawing for the press' and Goldsmith's College of Art. Around 1916 he printed a characteristically sentimental study of his children from stone, followed by the four-colour lithograph *A wet night* (c. 1918), in which he made a greater effort to escape from workaday illustration. The print focused on urban life in Wellington, dramatically silhouetting black figures against the red and yellow light from a shop. Such instances were reminders that public taste for lithographs as information and decoration died hard.

In Auckland, the Quoin Club was founded in 1916, with a membership in its heyday of some 40 professional men who turned to the graphic arts as a hobby. During the 13 years of the club's existence, two comprehensive portfolios comprising etchings and woodcuts as well as lithographs were published, three exhibitions were held and a club book was lithographed for private circulation. Among the most active participants were T.V. Gulliver and Percy Bagnall, who used colour lithography for their 1919 folio of six New Zealand birds.[5] Conceived in broad decorative terms, the *Morepork, Pied Fantail, Pukeko* and their companions were a welcome relief from the conservative black-and-white etchings and woodcuts which held sway at the time. Printed in two editions, the six prints were issued in ten sets pulled from a hand press and 100 sets of six printed offset.

Gulliver, a civil engineer by training, assumed the role of honorary curator of prints at the Auckland City Art Gallery from 1927 and in August 1930 he organized the Loan Collection of Prints representative of Graphic Art in New Zealand. It was the first survey exhibition of autographic printmaking to be mounted in New Zealand. Lithographs were in the minority, but interest in the planographic art was whetted by the appearance of a collection of some 70 images from the Senefelder Club in London, which toured the main centres in 1935–36.[6] This presented the opportunity to become acquainted first hand with the work of Edmund Blampied, Frank Brangwyn, Ethel Gabain, A. S. Hartrick, Charles Shannon and their colleagues who featured regularly in *The Studio* and *The Print Collector's Quarterly*. Works of such artists form the backbone of public collections in New Zealand, reflecting the taste at the time for the works of painter-etchers, lithographers and wood-engravers of English origin.[7]

Throughout the 1940s, Frederick Ellis and Stewart Maclennan in Wellington made both colour and monochrome lithographs from stone, using a small hand press. Both men had trained as designers in England and their graphic images were predictably illustrative. Ellis's *Brick works*, which was reproduced in the 1946 *Year book of the arts in New Zealand*,[8] went some way towards exploiting the lithograph's potential for tonal range but its interest ultimately stems from the fact that it documents a well-known landmark. After World War II, Frederick Ellis set up an evening class specializing in traditional graphic processes at Wellington Technical College (1947–48). Here he coached Don Ramage, the only one of his students to develop an ongoing interest in lithography and who was later to teach at the college.

Both Ellis and Maclennan were familiar with the activities of the London-based Society of Painter-Printers, who saw colour lithography as an ideal means of popularizing art as well as widely distributing original work. When in 1951 a selection of images by John Minton, Julian Trevelyan, Michael Ayrton and others was sent out for exhibition at the John Leech Gallery in Auckland, one local painter conveyed his thoughts in print. John Holmwood pragmatically observed that original paintings by established artists were out of reach for the average art enthusiast and that ' . . . if he were to enjoy and possess works of art in the undiluted form, the only thing to do was to decide on a sympathetic medium . . .'[9]

When in the 1950s lithography began to be seen as capable of serving painters and

9.1 COLIN MCCAHON
Puketu, Manukau 1957
four offset lithographs
each sheet: 21.5 × 26.3
edition 100
Australian National Gallery,
Canberra

sculptors as well as printmakers, this was manifested in New Zealand by a number of small offset lithographs published by Peter Webb while he was director of the Ikon Gallery in Auckland. Colin McCahon's set of 1957, based on the island of Puketutu in the Manukau harbour, is typical (9.1). The artist later wrote:

> All the prints were drawn directly onto the plates. These were paper plates. The man who printed them was just setting up a commercial copying service but as this was a new idea in Auckland the business was not too brisk ... Quite a few other artists were also involved in the venture. Amongst them were Louise Henderson, Gabrielle Hope, Michael Nicholson and Alison Pickmere.[10]

The 'paper plates' referred to by McCahon were plastic coated and yielded an edition of 100 impressions. The venture was primarily a money-spinner and little consideration was given to technical exploration or how to counteract the 'thinness' of ink deposited by offset printing. Quality paper was not considered necessary either. McCahon's *Puketutu* series is prized today chiefly because of his status as New Zealand's foremost contemporary painter.

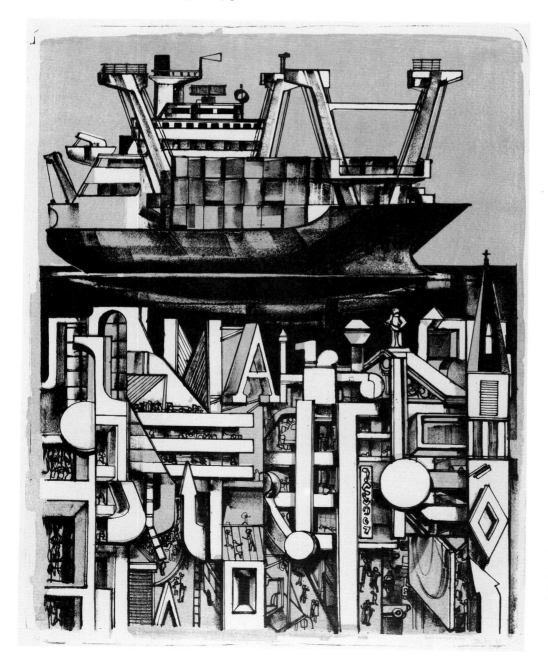

9.2 ROY COWAN
Ship on the roof 1973
colour lithograph
65.6 × 50.6
edition 5/12
Collection of the artist

More in tune with the potential of lithography, not only to translate a linear sketch in chalk but to relay different tonal areas in colour, were the images pulled in 1953 by Michael Nicholson at Camberwell School of Art in London. When he emigrated to New Zealand approximately two years later, Nicholson set up facilities for lithography at Auckland's Elam School of Art. Again the process was viewed mainly as a skill for designers and illustrators in tune with the philosophy of the Arts and Crafts movement at the turn of the century.

In Wellington, Roy Cowan and Juliet Peter similarly followed this pattern, continuing to do so up to the late 1970s. With Stewart Maclennan, they were among the few printmakers to have hand presses in their own homes in 1956. Like Nicholson, both had witnessed the resurgence of interest in autographic lithography at art schools in London in the 1950s. Juliet Peter had studied at the Central School of Arts and Crafts and Hammersmith School of Building and Crafts; Roy Cowan studied at the Slade with Lynton Lamb. From the start they made colour prints, Juliet Peter preferring to print from zinc plates on a converted mangle, Cowan from stone in the traditional manner. Operating in isolation, they took as their guide to the chemistry of the process the third edition of David Cumming's *Handbook of lithography*, a treatise rarely seen nowadays. Although for a time the two were employed by the Department of Education as illustrators for school publications,[11] by 1957 they had established themselves and were managing to eke out a living as full-time printmakers and potters. Juliet Peter's large five-colour lithograph *The World of the night kiln-firers*, 1973, and Roy Cowan's *Ship on the roof* (9.2) of the same year reveal a stylistic debt to John Minton and Prunella Clough of the late 1940s and 1950s, but the subjects refer to a community far removed from Europe.

Don Ramage's involvement in metal-plate lithography began after discussions with his two colleagues in Wellington and 'grew largely from a liking for the problem-solving and intensive planning involved in publicity and theatre design . . .'.[12] English

9.3 DON RAMAGE
Night flowers 1957
colour lithograph
27.4 × 35.6
edition 4/20
Collection of the artist

9.4 STANLEY PALMER
Creek, punga and cloud –
Karamatura 1970
bamboo engraving and
lithograph
57.0 × 42.4
edition 46/60
National Art Gallery,
Wellington

surrealism, via Paul Nash, informed his earliest colour lithographs, such as *Night flowers*, 1957 (9.3), but by the late 1960s Ramage was producing highly complex designs akin to those he conceived for textiles. As a teacher of graphic design at the Wellington Polytechnic in the 1960s and 1970s he passed on his skills in lithography to Australian-born Kate Coolahan. Now one of the country's foremost artist-printmakers, she combined the process with relief printing for her *Tramper rising*, 1966.

Since 1970, Stanley Palmer has displayed similar ingenuity with his bamboo engravings of New Zealand bush, such as *Creek, punga and cloud: Karamatura* (9.4). Combining a vigorous scratched line, using the drypoint technique on the smooth

inside surface of a bamboo sheath,[13] with tonal areas imposed by lithography from a zinc plate, Palmer creates uniquely individual prints. They celebrate the improvisation that has spelt freedom for the New Zealand artist from a former adherence to British standards in taste and a frustrating lack of traditional materials. As he wrote in 1975:

> ...supplies for printmakers are changing as industry discards old processes. Ask a printing ink manufacturer for lithographic varnish in different grades and you will draw a blank. They have never heard of 'press black' and leather lithographic rollers are unobtainable. Still, we struggle on, adapting materials from the large printing industry. These can always be supplemented with hand-prepared materials which in the end are often more sympathetic.[14]

At this time Palmer established, at his home in the Mt Eden suburb of Auckland, the country's first private print workshop with the capacity to make lithographs, etchings, and screenprints. It was an informal affair with editions supervised by artists skilled in particular processes. One large studio space accommodated the hand-operated lithographic press, the etching press and tables for screenprinting. It was a far cry from the sophistication of the Tamarind Lithography Workshop in the United States or Editions Alecto in England. Comparable collaboration between a professional printer and artist working together on editions produced by autographic techniques took until the late 1970s to emerge.[15]

In his article on contemporary printmakers for the quarterly *Art New Zealand* in 1979, Andrew Bogle observed that:

> Many printmakers in this country have never made a lithograph. Part of the problem is the unavailability of workshops and experienced printers. . . . Since the establishment of a well-equipped lithographic workshop at the Elam School of Fine Arts in Auckland in 1974 a number of students have become acquainted with the medium. Two graduate students, Cathryn Shine and Grahame [sic] Cornwall have recently set up a workshop to enable artists who have never made lithographs to make images on stones or plates . . . In the last six months more than twenty artists have made prints under this scheme.[16]

Lithography had begun to come of age in New Zealand.

Commencing their enterprise in 1979, Cornwall and Shine established the Autographic Printmaking Workshop using facilities at the Elam School which included a Charles Brand flatbed proofing press, stones, aluminium plates and a photographic darkroom. In the six months of its existence, the Workshop printed a suite of 35 prints in an edition of ten, which retailed at NZ $1,000. Most of the works were tentative and uncomplicated in technique and were printed in monochrome from stone. The majority of artists invited to participate in the venture were Auckland painters and sculptors; among them were George Baloghy, Patrick Hanly, Terry Stringer and Denys Watkins.

Graeme Cornwall continued to promote lithography through his Atelier Studio (1979–86) at Karaka Street in central Auckland. By this time he had accumulated commercial printing stones from various sources and restored 'an old direct contact transfer press' of the 1860s. He was 'inundated with requests by artists to collaborate with them to make prints'.[17] A good deal of experimentation arose from Cornwall's own research into ink and those of his former tutor, Alberto Garcia-Alvarez, into metal plate lithography.[18] Their touchstone was *The Tamarind book of lithography*. Between 1980 and 1983 Cornwall spent time abroad as a postgraduate scholar, mostly in Britain, investigating lithography workshops. On his return he concentrated on colour printing, generally preferring to use not more than four colours, printing from stones at the Atelier and running editions of his own, such as *Paper tiger*, 1985 (9.5) and those of other artists, including Delyn Williams (col. pl. 37). This operation no longer continues as Cornwall is currently in Australia, teaching drawing and photography at the Sydney College of Advanced Education.

9.5 Graeme Cornwall
Paper tiger 1985
colour lithograph
49.0 × 64.0
edition 18/20
Bowen Galleries, Wellington

A similar dedicated commitment to the practice of lithography has subsequently emerged elsewhere in New Zealand. The Belgian couple Frans Baetens and Magda van Gils arrived in 1983, bringing the materials to establish a lithography workshop in Auckland. The central feature is a hand press large enough to accommodate stones measuring 75 by 55 cm. Three years later, Muka Studio claimed that it was 'probably the best set-up lithography studio in Australasia.'[19] Although Baetens occasionally draws on stone himself, he and his partner regard themselves primarily as master printers, operating very much along traditional lines, with experimentation kept to a minimum. At first they worked at a break-neck pace, producing about 170 images a year. Editions of between 10 and 25 prints were made for artists as diverse in their approach as Richard McWhannell, Toss Woollaston, Christina Conrad, Allen Maddox and Tony Fomison. The prices of individual lithographs ranged from NZ$150 to NZ$400.[20]

Tony Fomison has been the most regular worker at Muka; the tremulous style of his draughtsmanship, coupled with the use of the hand-made flax fibre paper from which the studio took its name, suited the reductive, primeval quality of his imagery. A print such as *Proud Maui*, 1985 (9.6, 9.7), one of a series of 20 images by this artist, demonstrates the readiness of his European-trained lithographers to reflect their Pacific context. They are currently pulling an edition for a hitherto unknown Samoan artist, Fatu Feu'u, as well as expanding their operation to include colour printing from the stone.

About the same time, in July 1986, lithographic services to artists were offered by

9.7 TONY FOMISON
Proud Maui 1985
lithography
23.7 × 27.3
edition 2/14
National Art Gallery,
Wellington

Gingko Print Workshop in Christchurch and the Print Studio at Wellington City Art Gallery. At Gingko, Jule Einhorn specializes in editioning images by painters and those not accustomed to making planographic prints, while at the Print Studio Jill McIntosh provides more of an access facility for printmakers. Einhorn was one of ten students accepted at Tamarind in 1984 for short-term training as a professional printer. McIntosh investigated workshops in the United States and Britain before setting up the Wellington studio; her first experience of working with metal plates was with the Yorkshire Printmakers in Leeds. As students at the Canterbury School of Art in Christchurch, both Einhorn and McIntosh learned the rudiments of stone lithography along with etching and relief printing. McIntosh's teacher from 1977 to 1980 was Barry Cleavin, best known for his intaglio work.

Gathering together the necessary equipment to continue producing lithographs outside the art school system called for perseverance and ingenuity. Jill McIntosh commandeered the small flatbed press which had fallen into disuse at Wellington Polytechnic and managed to borrow 18 small stones from the National Museum. She explained:

> After designing a levigator from a small litho stone connected to a rotating handle, we sent to Yorkshire Printmakers in Britain for a nap roller. Cornellisens in London supplied us with crayons, tusche and ink although later supplies have been bought from Graphic Chemical Co., Chicago.[21]

Printing from zinc and aluminium plates as well as lithographic stones is possible at both the Print Studio and Gingko. Photographic methods are rarely employed as yet.

Operating independently from their Christchurch studio, Marian Maquire and Stephen Gleeson produced editions of 20 impressions from stone during 1985–86 for the well-known painters Ralph Hotere and Philippa Blair. These are perhaps the most accomplished black-and-white lithographs yet produced in New Zealand. Hotere's *Les Saintes Maries de la Mer*, 1986 (9.8), magnificently conveys its religious message through a velvety black of a smudged chalk image scored across by a tangled web of lines; Blair's *Two hearts*, 1985 (9.9), has all the vigour of her abstract expressionist canvases. Following the example of Einhorn, Maquire sought to improve her lithographic skill by participating in the Tamarind professional printer training programme in late 1986.

A Spanish artist who has lived in New Zealand for 12 years, Alberto Garcia-Alvarez works in geometric abstraction and prefers the effect of broad washes of colour in liquid tusche to that of a linear scheme. He is senior lecturer in printmaking at the Elam School of Fine Arts and is responsible for the now well-equipped lithography workshop there. What immediately sets Garcia-Alvarez apart from his contemporaries in New Zealand is the comparatively large scale of his lithographs, some of which

9.6 *Opposite* TONY
FOMISON
Title page 1985
lithograph
edition 2/12
National Art Gallery,
Wellington

are approximately one metre square, and the way he folds the paper, as in origami, which he then prints on both sides. Images such as *Monte Alban*, 1983–84, are generally not editioned, lithography being used to achieve a particular effect that cannot be obtained in any other way. As Andrew Bogle comments:

> Admittedly they bear similarities to watercolours in that the colours are laid in transparent washes with splashes, flecks and puddles that speak of a watery medium. But the texture of the broad washes, so delicate and wrinkled like some fantastic skin, is unique to lithography.[22]

In his country of adoption, Garcia-Alvarez, as designer, painter and printmaker, represents a welcome shift of emphasis. Instead of displaying a traditional reliance

9.8 RALPH HOTERE
Les Saintes-Maries-de-la-Mer 1986
lithograph
51.5 × 42.0
edition 2/20
printed by Marion Maquire and Steven Gleeson, Christchurch
National Art Gallery, Wellington

9.9 PHILIPPA BLAIR
Two hearts 1985
lithograph
48.0 × 75.0
edition 7/20
printed by Marion Maquire
and Steven Gleeson,
Christchurch
National Art Gallery,
Wellington

upon stone lithography and the ordinary use of crayon following a preconceived drawing, he employs aluminium plates and relishes experimentation. His European background followed by 13 years in California from 1960 are in marked contrast to the former British influence on New Zealand artists, whether, as in the 1920s, they were émigrés trained to teach the graphic arts along lines of academic pictorialism or New Zealanders taking their cue from the Senefelder Club or the Society of Painter-Printers. In the 1980s, no single tradition shapes the nature of lithography and other print media in New Zealand. Municipal galleries regularly purchase contemporary international works and from time to time exhibitions of such material, drawn from a wide variety of overseas sources, tour nationally.

It is no longer unusual for local painters, such as Gretchen Albrecht, to pull editions outside New Zealand. In 1982 she spent several weeks in Australia at the Beehive Press in Adelaide run by master printer Robert Jones, producing a handsome set of three colour lithographs from stone which echoed her 'hemisphere' series of canvases (col. pl. 36). In a sense, what is now happening runs parallel to the earliest activities in lithography when the infant colony in New Zealand was a scientific curiosity and artists' on-site recordings were translated by master printers in London and elsewhere. Over a century later, artists and printers work in unison, not for reportage and propaganda but for the sole purpose of realizing an autonomous creative idea.

10 Lithographic Collaboration:
The hand, the head, the heart

Pat Gilmour

So far as the artist is concerned . . . he simply has to draw . . . The complexities of making prints from the drawn stone can be left to the printer.

JULIET WILSON BAREAU on Goya[1]

ROM the very beginning, lithography was seen as a way of multiplying an artist's drawings. Whereas the engraver had to learn a métier—cutting into a block of wood or a sheet of metal—lithography (the argument went) only required the artist to do what came naturally: draw.[2] This emphasis made the process a powerful force in the movement towards 'originality', as well as intimately connecting it to the cult of the romantic genius, whose slightest spontaneous sketch was preferred to a work with craft finish. When transfer papers improved during the second half of the 19th century, it even became possible for a lithographic artist to live in a different country from his printer, and this renewed the idea that to make a lithograph was essentially the same as drawing on a piece of paper.[3]

It was the curator Jean Adhémar who pointed out that because of the very nature of the process, artist-lithographers entered into a closer relationship with their printers than users of other techniques.[4] While drawing a lithograph was presented as so natural and so easy, its chemical processing and printing appeared wayward, fickle, mysterious and much less visible in its effects than a wholly mechanical method. This divorce between conceptual and physical aspects of the experience drew attention away from the fact that a lithograph is not really a drawing at all, but a way of making marks on a matrix of stone or metal with the intention of converting them into lithographic ink on paper. The separation of mind from hand, exacerbated by specialization and the division of labour, concealed the extent to which printing was capable of contributing to the aesthetic of the final result. Consequently, the printer's inventive, creative or interpretative contribution tended to be downgraded, a situation in which the cult of romantic genius again had its part to play. For while in this romantic scenario the artist was cast as creator, the printer was relegated to the position of a craftsman or artisan who looked after the allegedly 'mechanical' tasks with his hands rather than his brain.

Raymond Williams has investigated the way in which the very word 'artisan', together with the denigration of 'the mechanical', developed in Britain as part of the class system, peaking with the division of labour during the Victorian era. It was in the late 18th century, he says

> with special reference to the exclusion of engravers from the new Royal Academy, [that] a now general distinction between artist and artisan—the latter being specialized to 'skilled manual worker' without 'intellectual' or 'imaginative' or 'creative' purposes—was strengthened and popularized. This development of *artisan* and the mid-19th century definition of *scientist*, allowed the specialization of artist and the distinction not now of the *liberal* but of the fine arts.[5]

The word 'mechanical', already current in the 17th century to describe non-agricultural productive work, was increasingly deployed in a socially prejudicial way for routine, unthinking activity. When as a result of the industrial revolution this meaning was joined to the idea of 'machine made' in contradistinction to 'handmade',

the frame of reference was established within which we evaluate a work of printed art and assess those who collaborate in its making.

The writings of the first lithographic printers reveal the considerable problems they encountered as they tried to establish the parameters of the process. In the advertisement and preface to the 1819 English edition of the inventor's treatise, R. Ackermann and Frédéric von Schlichtegroll respectively alluded to 'difficulties and embarrassments' and 'cases [that] happened, not long ago, which surprised the practical artist in the most unpleasant manner and puzzled him like enchantment.'[6] Senefelder provided more detail: first, of course, he had had to design his own press, yet after constructing a 'new and more perfect' model, he was disappointed only to obtain 'a blotched and dirty impression'. Only two or three proofs out of every 20 were tolerable, while a 300-pound weight, intended to increase printing pressure, broke the stones after every two or three copies and fell on him from a height of ten feet. The printers for whom Senefelder devised a simpler and less dangerous method failed to reward his solicitude. 'Oh! the uncertainty of human expectations!' he expostulated, 'not one of all the six printers could make himself master of the simple process of rubbing the surface of the stone'; the net result was a mere 33 perfect sheets out of three reams of the best paper. Even when such mechanical problems had been largely overcome, the chemical processing remained a nightmare. In his section on 'repairing colour', Senefelder admitted that 'it not very unfrequently happens that lines too faintly drawn do not resist the aqua fortis and are entirely obliterated or that, by the unskilful management of the printer, fine lines are rubbed away.'[7] Small wonder then, that by page 179 he deems it

> ... one of the most essential imperfections of Lithography, that the beauty and quantity of the impressions, in a great measure, depend on the skill and assiduity of the printer an awkward printer, even with the best press, will produce nothing but spoiled impressions. Till the voluntary action of the human hand is no longer necessary, and till the impression can be produced wholly by good machinery, I shall not believe that the art of lithography has approached its highest perfection.

Although the early history of lithography is riddled with such printing vagaries, once he had solved some of the basic problems Senefelder's own presence seems to have ensured reasonably smooth production. Following the business deal with Johann André of Offenbach and his innumerable brothers, the inventor stayed in England from late 1800 to mid 1801, waiting with Philipp André for a patent for his process, during which time several artist-lithographers enjoyed his personal attention. Conrad Gessner's spirited pen lithograph of cavalry charging (10.1) seems to have lost very little in the printing and the German edition of Senefelder's treatise makes it clear that he also taught Gessner the crayon manner, which the early printers agreed was much more difficult.[8] Certainly when Senefelder's patentees withdrew discouraged, artists in England lost their lead in artists' 'polyautography'.

5

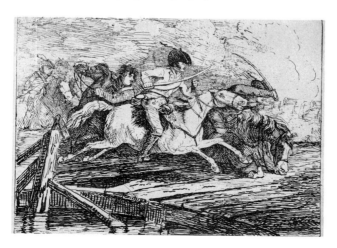

10.1 CONRAD GESSNER
Cavalry charging 1801
from *Specimens of polyautography*, 1803
lithograph printed by Senefelder
23.0 × 31.6
Felix Man Collection
Australian National Gallery, Canberra

10.2 WILHELM REUTER
Man's head without a beard,
in profile c. 1805
chalk lithograph
printed by the artist
10.7 × 7.7
Australian National Gallery,
Canberra

11

Wilhelm Reuter, a German pioneer, experienced many difficulties working in isolation in Berlin. *The Rape of Proserpina*, although it was a pen lithograph, printed patchily and scummed up in a way which Die Brücke artists might have found quite delightful a century later, but which was certainly unacceptable in 1803. On a journey to Paris, Reuter received guidance from the printer François Johannot, an André cousin. He then acquired some better stones and improved the quality of his output, even mastering a year or so after his return to Berlin some coarse chalk lithographs such as *Man's profile* (10.2).[9]

In late 1812 or early 1813, D. J. Redman became the first Englishman to set up his own press. He had worked for Senefelder's London patentees and, when they finally quit in 1807, had helped operate their abandoned equipment for maps and commercial work undertaken at the Quarter-Master-General's office in Whitehall. Attracted to the west country town of Bath, Redman opened a lithographic workshop there and with his help Thomas Barker made the first single-artist portfolios. Although Barker's pen lithographs of *Rustic figures* seem a little laboured compared with their preparatory drawings (10.6), they strikingly anticipate realism in their honest depiction of poverty. The 32 racy plates of *Landscape scenery* are not only the first landscape lithographs, but are among the most vigorous lithographic landscape drawings ever to appear (10.3). Redman, while never more than an adequate printer, facilitated Barker's work and generated the first English-language lithographic treatise by Henry Bankes. Although slight, this carries as frontispiece another of Barker's landscapes.[10] Quite exceptionally, 32 of the stones Barker used for his two portfolios have survived. Comparing states of the prints with the stones that produced them, Michael Twyman has noted that although they were pen lithographs, parts of the drawings had to be replaced during printing and they 'prove beyond doubt that Redman, and presumably other early lithographic printers as well, must occasionally have had their problems even when printing comparatively short runs.'[11]

The French were well behind both Germany and England in exploiting the new process, due partly to an unsettled political situation and partly to the fact that Frédéric was the least technically inclined of the André brothers. The teething problems can be detected in over 40 lithographs by Pierre-Nolasque Bergeret, whose work passes from starved pen drawing to weak and 'visually empty' crayon.[12] The standard improved only when Bergeret's work was printed by Engelmann or the Comte de Lasteyrie, two competent French printers who had studied in Munich before setting up their outstanding presses in Paris. When they were joined by the establishments of Delpech, Villain, Langlumé and Charles Motte, the wealth of printing talent attracted France's finest painters and ushered in a golden age of lithography.

Carle Vernet's assured depiction of the Delpech establishment portrays both the likely customers for an 'album lithographique' and the stone delivery service the printer provided for potential lithographic artists (10.4). Drawn *c.* 1818, the print demonstrates a dramatic improvement in crayon technique. Géricault's later lithographs take on the character not merely of inspired drawing, like his early masterpiece, *Mameluke defending a wounded trumpeter*, but qualities that could only have been produced lithographically. The tiny *Horse being shod*, although printed by Villain in 1823, was without doubt influenced by the technically inventive Engelmann, with whom Géricault also worked. Géricault used Engelmann's confusingly named *lavis lithographique* [lithographic wash][13] as a way of building up greys, by dabbing ink on a stone already painted with gum to reserve as unprinted paper the dapple on the horse and the two men catching light against the shadowy doorway (10.5).

Goya's experience confirms that the game of even the greatest artists could be lifted by the quality of the printer. He had worked with the map-maker José María Cardano at the first lithographic establishment to be set up in Spain, but his pen and ink and wash transfers had printed weakly and unevenly due to his lack of experience combined with Cardano's 'lack of flair'.[14] In voluntary exile in Bordeaux some seven

16

10.3 *Opposite top left*
THOMAS BARKER
Mountain landscape in the rain
from *Thirty-two lithographic impressions from pen drawings of landscape scenery* 1814
lithograph printed by
D. J. Redman
30.0 × 22.6
edition 50
Felix Man Collection
Australian National Gallery,
Canberra

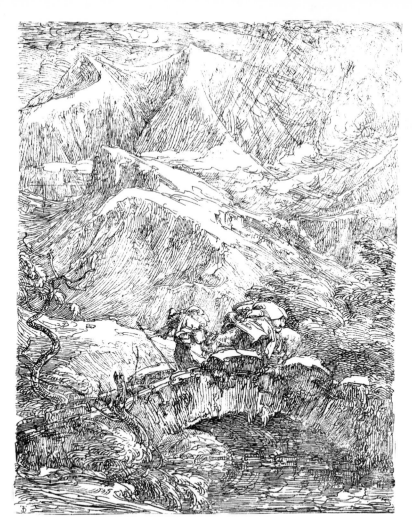

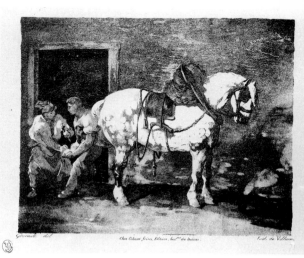

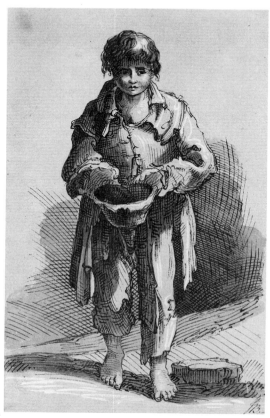

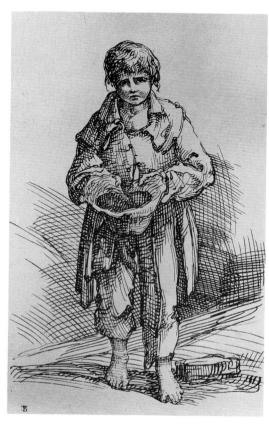

10.4 *Top*
CARLE VERNET
Delpech's print shop 1818
lithograph printed by
Delpech
17.0 × 24.4
first state, before letters
Felix Man Collection
Australian National Gallery,
Canberra

10.5 *Above*
THÉODORE GÉRICAULT
Shoeing the horse
from *Suite de sept pièces*
[*Suite of seven pieces*] 1823
lithograph printed by Villain
13.8 × 17.0
Australian National Gallery,
Canberra

10.6 THOMAS BARKER
Far left Beggar boy with a
bowl *c.* 1813
pen, ink and wash on paper
19.7 × 12.4
Left
Beggar boy with a bowl
from *Rustic figures* 1813
lithograph printed by D. J.
Redman
22.0 × 14.0
Felix Man Collection
Australian National Gallery,
Canberra

years later Goya found the much more skilful French printer Gaulon, and left a wonderful portrait of him.[15] Drawing directly on the stone, Goya would place it on an easel as if it were a canvas and handle his unsharpened crayons like brushes:

> He remained standing, walking backwards and forwards every other minute to judge his effects. Usually he covered the whole stone with a uniform grey tone and then removed with the scraper those parts which were to appear light: here a head, a figure; there a horse, a bull. Next the crayon was again employed to strengthen the shadows, the accents, or to indicate the figures and give them movement ...[16]

17 In 1825 and in this painterly fashion, Goya completed four masterly *Bulls of Bordeaux*, which Gaulon printed to perfection.

> *... parts become thick and heavy which were intended to be bright and clear. These disasters, which are generally attributed by the disappointed artist to the printer, ought, in most instances, to be laid at his own door ...*
>
> HULLMANDEL, *The Art of drawing on stone*, 1824[17]

2.38 Godefroy Engelmann and Charles Hullmandel, who both produced treatises in the early 1820s, dominated printing in France and England for two decades. Their two textbooks, with a third by the Frenchman Raucourt which Hullmandel translated, established some lithographic rules. Gradually the idea gained ground that an artist needed some understanding of printing if he was to draw in a way that would turn out well. Raucourt was particularly sensitive on the subject, pointing out that the marks on the matrix would change in the printing so that it was important '... to foresee these changes, and to avail one's-self of them so as to obtain better impressions.'[18] He reiterated that the difficult art of lithography needed an intelligent printer:

> A lithographic printer is a real artist and all the impressions he produces bear the stamp of his degree of talent; when he has wetted his stone, and has got his roller in his hands, he may be compared to the artist who is giving the last finishing touch to an Indian ink, or a Seppia drawing, like the painter, the printer must study the effect of his drawings, and distribute his ink accordingly.[19]

Hullmandel and Engelmann both made a number of suggestions as to the way an artist should draw. Hullmandel recommended a protective strip to keep the grease of the artist's hand off the drawing surface, similar to one that Jasper Johns improvised 150 years later (10.7). Engelmann, however, dreamed up an intimidating contraption which made lithographic drawing look about as carefree as leaping hurdles in a ball

10.7 Jasper Johns drawing on a lithographic plate at Gemini G.E.L. in Los Angeles

10.8 A desk for artists
drawing on stone
plate 1 from *Manuel du
dessinateur lithographe*
[*Manual of the lithographic
draughtsman*] by G.
Engelmann, Paris 1830–31
16.8 × 18.8
Felix Man Collection
Australian National Gallery,
Canberra

10.9 *Below left*
Of some causes of failure
plate XI from *The Art of
drawing on stone*
by Charles Hullmandel,
London 1824
lithograph drawn and
printed by Hullmandel
21.0 × 15.2
Australian National Gallery,
Canberra

10.10 Examples of accidents
which can happen to a
drawing on stone
plate III from *Manuel du
dessinateur lithographe* by
G. Engelmann, Paris 1830–31
19.4 × 12.4
Felix Man Collection
Australian National Gallery,
Canberra

and chain. A huge handboard all but obliterated the tiny stone on its sunken turntable, while a tight little preparatory sketch, reflected in a mirror, showed the artist how to reverse an image (10.8). As a dreadful warning, both printers illustrated the white spots resulting if an artist sneezed on the stone, as well as the sooty rash which would appear if greasy dandruff floated onto the drawing surface (10.9). Engelmann included some diluted tusche drawings to demonstrate their instability (10.10).

The challenge, as time passed, lay in developing lithography as a tonal medium so as to supersede the laborious early method of building up chalk. It says much for the virtue of perseverance that the initial demand of both printers for painstaking craftsmanship resulted in some of the great masterpieces of lithography. Engelmann's skill influenced Baron Taylor to choose lithography for the cumulative volumes of romantic and picturesque monuments in France that he began publishing in 1820. Eugène Isabey's masterpiece of a church in the Auvergne district (10.11), while displaying adventurous passages of drawing in the detail, is essentially the result of patiently rubbed crayon, darkened here and lightened there to create a symphonic tone-poem of subtle greys.

Auguste Raffet also had a genius for taking pains. At first emulating Charlet by making crayon drawings of the ordinary soldier in the guise of a classic hero, Raffet eventually developed a spatial conception of battle. He treated the Napoleonic campaigns theatrically, creating surface patterns in which men flood through gulleys like waves (10.12). Drawn with a delicately pointed crayon, his lithographs were printed by Auguste Bry, who systematically pulled pale silvery impressions. Raffet's cataloguer reveals that the artist preferred the more tonal and sensuous handling of 'L'Equipe Bertauts' (the Bertauts Team);[20] out of the goodness of his heart, however, Raffet remained faithful to Bry, although his reported preference reveals a growing awareness of the aesthetic effect that may be contributed by the printer's style.

During the 1830s and 1840s many artists and printers made an assault on lithographic wash techniques. The printer Charles Motte, for example, helped artists develop a kind of lithographic mezzotint by laying in a solid area, as seen in some of Charlet's figure studies (10.13), and then regaining whites by scratching. An experiment by Motte's son-in-law Achille Devéria was widely celebrated, but the real achievement was not printing from a drawing in liquid tusche, per se, but stabilizing the nuances of diluted washes throughout an edition. When Hullmandel eventually produced such a method, which he called lithotint and patented in November 1840, he

10.11 Eugène Isabey
Church of St John, Thiers
1831
for *Voyages pittoresques (Auvergne)* [*Picturesque travels (Auvergne)*]
lithograph printed by
G. Engelmann
34.4 × 28.4
Australian National Gallery,
Canberra

10.12 AUGUSTE RAFFET
Departure of the 3rd column
from *Expédition et siège de
Rome* [*Expedition and siege
of Rome*] 1859
lithograph printed by Bry
22.6 × 34.4
first state
Australian National Gallery,
Canberra

had to defend a claim to priority both in court and in the *Art-Union*.[21] In making his case, he complained that although Senefelder had described a wash method, it was defective; four or five impressions would be tolerable, 'after that each runs blacker and blacker until they are at last unfit to be seen.' Similarly, he alleged that the Parisian claims really depended on imitation washes using such roundabout tricks as rubbing the wash with flannel or eroding it with steel brushes. Before he died, Motte told Hullmandel that although he had been elated by his achievement with Devéria he must have struck lucky, as *that stone alone* ever gave a series of saleable impressions!'

Hullmandel quoted in his support a newspaper article of January 1842 by the experienced Belgian printer, Jobard, who said that previous Parisian attempts

> could never be printed, for either the light and middle tints resisted the action of the acid, and printed as one black mass, or they did not resist the acid, and showed as one great white patch; there was no medium, and it is precisely that medium which M. Hullmandel has discovered.[22]

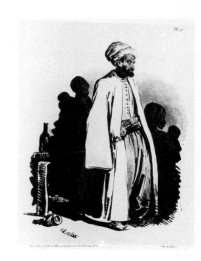

10.13 NICOLAS-TOUSSAINT
CHARLET
Turk standing 1828
lithograph printed by Villain
23.2 × 17.7
Australian National Gallery,
Canberra

Jobard's article went on to reflect the changing tastes which would find their counterpart in Hullmandel's new technique:

> We all know that there reigns in the works of great masters a certain looseness – a certain negligence even – which is always preferred to the mathematical precision of the engraver. We like to catch by surprise, as it were, the aberrations of the hand of these great composers; the high finish, the polish, the geometrical exactness, have none of that charm possessed by the *chic artistique*. The former produce that cold admiration which is doled out to a work of patience, the latter excites you like a flash of the improvisation of genius.

Whatever pocket of current opinion Jobard represented, popular taste had not yet turned against the cool perfection of such reproductive works as Aubry-Lecomte's 1824 rendering of *Danaé* after Girodet, reputed to have sold 600 copies in two days. By contrast, the freely rendered *Faust* illustrations by Delacroix (10.14), published in 1828 and a fine demonstration of spontaneous drawing methods achieved with the help of the printer Motte, were attacked for 'violence and exaggeration'; when in the 1840s the artist produced similar illustrations for *Hamlet*, he believed the public still preferred 'a finished reproduction to a striving for expressiveness.'[23] Theoretically, Hullmandel's

1.2, 1.3

10.14 EUGÈNE DELACROIX
Faust and Mephistopheles
galloping during the witches'
Sabbath 1828
lithograph printed by
C. Motte
21.0 × 29.0
Felix Man Collection
Australian National Gallery,
Canberra

lithotint ought to have permitted major artists to make more painterly lithographs but in fact it proved attractive mainly to minor English watercolourists. According to Lemercier's nephew and successor writing in the late 1890s, Hullmandel had tried to sell the rights to his process in France, first for 100,000, then for 50,000, finally settling for 25,000 francs from the Rigaux brothers, who called the deal off when they were unable to obtain a passable proof.[24] For although his wash could be diluted, it created a mosaic effect bound by hard edges which formed from the outside as it dried.

> *... frequently an antagonism exists between the artist and the printer which would not obtain if each one knew a little more of the other's methods and difficulties.*
>
> W. D. RICHMOND, *Colour and colour printing*, c. 1885[25]

Both Hullmandel and Engelmann made a significant impact on colour lithography and while the strategies they developed were visually quite different, their techniques were known by the similar names of chromolithography and chromalithography.[26] In view of the opprobrium that later attached to this word when it was appropriated for 'commercial' colour printing, it is interesting that Engelmann worked after paintings by using three or four colours with normal methods of lithographic drawing (col. pl. 38), while Hullmandel and Thomas Shotter Boys employed translucent inks to copy the artist's own watercolours. Yet while Engelmann's prints are now set aside as reproductions, Boys's are acclaimed as original colour lithographs. The subtlety of this distinction bears out Peter Marzio's quizzical observation about the passionate determination of modern-day American art historians to distinguish 'color lithographs' from 'commercial chromolithographs' as 'original works of art'.[27]

Bamber Gascoigne has identified two prior examples of Hullmandel's colour printing. The first was in 1835 for George Hoskins's *Travels in Ethiopia*, in which Gascoigne deduces that a change from hand-applied to printed colour followed a

mistake in the colouring of some native bearers' skull caps.[28] Hullmandel's second colour exercise is described by Gascoigne as 'a fiasco', for instead of persevering in rendering lithographically the tiny impressionistic illustrations for Frank Howard's *Colour as a means of art*, the printer gave up the ghost and resorted to body colour applied by hand over some rather unconvincing printed tints.[29]

This inexplicable ineptitude in 1838 makes particularly remarkable Hullmandel's achievement the following year, when, after a steep learning curve, he produced the lucid plates for Boys's *Picturesque architecture in Paris, Ghent, Antwerp, Rouen &c.* *col. pl. 1* Boys's lyrical clarity was enhanced by the fineness of Hullmandel's processing and his biographer, James Roundell, has commented on the considerable difference between prints he made with Delpech having a 'blonde' and slightly sandy quality, and later prints made by Hullmandel where the graining of the stones complements the artist's suave rendering.

Slight discord broke out between the printer and the artist as to who deserved credit for *Picturesque architecture*. Despite a dedication to Hullmandel 'in acknowledgement of his many great improvements and highly important discoveries', Boys virtually retracted this compliment in a subsequent letter to *The Probe*,[30] after being stung by Hullmandel's claim to part of the achievement. Boys insisted that he was *entirely* the originator and inventor of the work and that 'within myself the idea originated, of producing a work by lithography printed in colour, using the primitive colours for the first tints and producing a variety of tints by their successive super or juxtapositions.' The artist asserted that he had modulated his skies by painting his chalk and ink work with weak acid, a procedure which sounds like spitbite in etching. While admitting that once the artist's labour was over 'it is to [the printer's] care and keeping we must confide ourselves', Boys seems, despite his dedication, to have been oblivious of the skill and research that Hullmandel must have put into mixing and registering the appropriate inks, not to mention his prior experimentation with tint lithography.[31]

It was the rather more simple form of flat colour pioneered by Owen Jones that was taken up by commercial lithographers. Profit-oriented methods were bound to lead to alienation between artists and printers; when W.D. Richmond produced his *Grammar of lithography* for trade printers in 1878, the editor commented that the exigencies of trade competition and the division of labour had engendered too much specialization even among printers. While artists knew little of printing, printers were equally ignorant of drawing, leading to 'much heart burning and recrimination.' The writer noted

> The printer perhaps thinks the draughtsman should draw so firmly that there should be little fear of over-etching, while the artist thinks the printer ought to be able to print anything, just as it is put upon the stone.[32]

By this time, the hapless commercial colour draughtsman had learned to master the dotted manner of hand stippling, which could produce tonal effects in colour without employing washes and was unavoidable when polished stones were dictated by mechanized presses. It is an intriguing fact that the chromolithographic printer's juxtapositioning of points of colour and the analysis of its additive effect precede the fine art development known as Pointillism, and that Seurat, the master of this style, is known to have been interested in vernacular printing.

Seurat and his mother collected the work of the poster-maker Chéret, to which some of Seurat's later work has been iconographically compared.[33] Moreover, a folio in Seurat's studio at the time of his death included 'primitive colored broadsides of the mid-century.'[34] Chéret, an unusual amalgam of draughtsman and printer, is frequently instanced as 'an Impressionist before his time.' From the late 1860s, he started to make a reputation for his lively, if slightly repetitive, posters in which sprightly girls sell everything from cough cures to bicycles. Despite their unmistakably 'commercial' intent, Chéret's posters, since he drew them himself, have escaped being categorized as chromolithographs and have passed into the annals of original colour printing.

Working in England in the mid-century, Chéret found as patron the perfumier, Rimmel, who set him up in a workshop in Paris. Here, significantly, the artist installed English power presses. The rather superficial accounts that have so far been written of his activity tell of Chéret's devotion to such respectable fine art influences as Turner, Watteau, Fragonard, and his beloved Tiepolo. No one, however, has assessed the extent to which his sojourn in England must have exposed him to Victorian commercial colour printing, despite the fact that several delightful almanacs, drawn for Rimmel between 1869 and 1881 and still treasured at the firm's London headquarters, display the typical dotting of contemporary English printing.

In tracing influences on Seurat, erudite articles have considered the scientific theorists Chevreul, Ogden Rood, Charles Henry, David Sutter and even Ruskin.[35] Other writers have compared his style to the photomechanical colour screen,[36] the dotting in Japanese prints,[37] and even a method of colour relief printing that the French called 'chromotypographie', which flared briefly but gloriously in the 1880s and was never seen again.[38] Every possibility, in fact, has been advanced except that Seurat may have taken a lead from the humble chromolithographic stippler. If Meyer Shapiro is right and Seurat had democratic leanings which carried him away from the romantic conception of the artist to 'a sympathetic vision of the mechanical in the constructed environment',[39] then the despised Victorian printing industry may well have played its part in one of the more novel developments of modern painting.

On the other hand, it was to combat the perceived limitations of colour printing and eradicate the look of 'the mechanical' that Chéret adapted two long established lithographic techniques – the 'rainbow roll', in which several colours are blended and applied in one passage of the inking roller,[40] and Senefelder's 'sprinkled manner', in which a halftone dot is simulated randomly by drawing a knife across a brush filled with lithographic drawing medium (col. pl. 43).[41]

The Pointillists worried less about avoiding 'the mechanical' in their graphic art. While Seurat made no prints, his comrade-in-arms Paul Signac produced his first colour lithograph as early as 1888 with the help of the printer Eugène Verneau, embellishing a Théâtre Libre programme as a tribute to the colour theorist Charles Henry. Not only was his chromatic circle hand stippled, but the print was partly formed by the mechanical dots and textures of the professional chromolithographer (col. pl. 39). In the few colour lithographs he made a decade later, one of which appeared in the magazine *Pan*, Signac's associate Henry Edmond Cross greatly increased his dot size to allow a more fluid and rapid execution (col. pl. 41). It is fascinating to compare his study of nannies walking their charges in the park with *Evening* by E.J. Steven. This chromolithograph was used to advertise lithographic ink on the frontispiece to the trade journal *The British Lithographer* in 1892–3 (col. pl. 40); but while Chéret has been classified as an original printmaker, Steven has yet to be recognized as a minor master of Pointillism!

> *There must exist between the artist and his printer an affinity, what Odilon Redon, an expert on the subject, characterized in a picturesque phrase: 'It is a marriage.' The role of the printer, without ever encroaching upon that of the artist must be to support and help him, overcoming the hitches, making the right suggestion at the right time . . .*
>
> ANDRÉ MELLERIO, La Lithographie originale en couleurs, 1898[42]
>
> *My God! How I've suffered at print workshops . . .'*
>
> ODILON REDON, A soi-même, 1913[43]

The incursion of photomechanical techniques before the turn of the century reduced the need for copyists in trade lithography and opened the way for fine artists to use the lithographic process for expressive purposes again, a development in which 'origin-

ality' became an even more vital element. There had been many printers in the mid century – Aubert, Trinocq and Destouches, for example – who helped to bring into being the bluntly drawn, technically unpretentious, yet quite unequalled lithographs by the caricaturists Daumier and Gavarni. By then printing techniques for such robust drawings were a matter of course. The 20th-century artist Jean Charlot has argued that lithographs from offset presses can be seen as today's equivalent, for as

> ... tired printers' devils snapped the jaws and pulled the levers of the press that inked the five thousand copies of the weekly *Charivari*, their thoughts through the long twelve-hour day were not on esthetic pursuits. Yet it is their hack labor that made Daumier's oeuvre possible. Had it been submitted to the restraint of limited editions for collectors only, had it been cut off from contact with his fall guy and constant admirer, the French bourgeois at large, Daumier's opus would have withered ...[44]

In fact, more complicated drawing and printing techniques, not to mention the ever more limited edition and the 'belle épreuve', attended French lithography as the painter-lithographer re-emerged in the third quarter of the 19th century. By then Lemercier's vast establishment, which had been in the forefront of lithographic research, dominated artists' prints, although significant differences can be detected in the firm's attitude to artists once the revival of artistic lithography moved into top gear. In 1862, for example, Lemercier had refused to print Fantin-Latour's first lithograph, saying it was 'detestable, insane, and savage',[45] but when Lemercier's nephew wrote his treatise over 30 years later, he suggested a very different approach to artists. The firm from which Alfred Lemercier had by then retired was highly stratified. Crayon lithography was still considered at the top of the hierarchy, with colour, tint, engraved and commercial lithography in descending order of importance. Lemercier not only recommended that a printer should learn to draw so as to understand what an artist was driving at, but revealed that the trial proofer who collaborated with artists

> ... was always chosen from among the most capable and best educated workers, since the constant dealings he was obliged to have with artists – people who while they are almost always easy to get along with can be quite touchy – meant that he had a duty not only to be polite, but willing and eager to do whatever was necessary or demanded of him.[46]

10.16 Plate 2 from
Traité de lithographie artistique
[*Treatise of artistic lithography*]
by E. Duchâtel, Paris 1893
spatter with a gum reserve
printed by Duchâtel at the
Société des Imprimeries
Lemercier, Paris
18.5 × 11.5
Australian National Gallery,
Canberra

10.15 EUGÈNE CARRIÈRE
Marguerite Carrière 1901
lithograph printed by
Duchâtel
43.0 × 34.4
edition 3/50
Felix Man Collection
Australian National Gallery,
Canberra

319

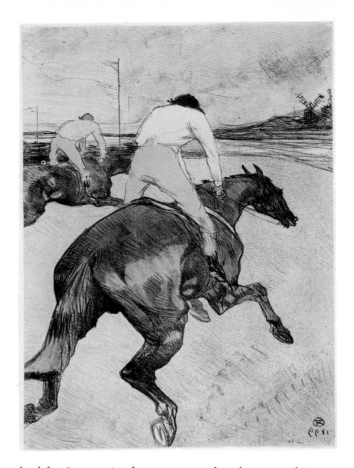

Duchâtel had worked for Lemercier for 22 years when he wrote his treatise for artists in 1893.[47] Although Léonce Bénédite stressed in its introduction that lithography was not a branch of engraving 'but a pure and simple manifestation of the art of drawing', Duchâtel's book presented several 'trucs' and 'ficelles' (knacks and tricks of the trade) that few artists would then have used for drawing on paper (10.16). He advised how halftones could be made by a 'crachis', suggested that wash could be diluted with extenders from distilled water to turpentine, described the application of powdered crayon to a warm stone, how 'faux décalques' could guide the draughtsman in registering colour, how smooth transfer paper could be placed over sandpaper to give the drawing a random rather than a mechanical 'tooth', and how gouache might reserve blanks on a tusche-washed transfer paper; all these devices were taken up by the artists of the decade.

5.32 When André Mellerio published his short book on original colour lithography in 1898, he included brief paragraphs about several contemporary printers.[48] Duchâtel was described as the 'pride and support' of Lemercier 'both expert and enamoured of his art' and was praised for the remarkable printing of Carrière's lithographic 'washes'. These, in fact, were still not the result of diluted tusche, but three monochrome layers printed from rubbing crayon, scraped back to regain highlights (10.15). Reserving his longest but somewhat ambivalent notice for Auguste Clot, who had also been an *essayeur* and *chromiste* with Lemercier before beginning his own business, Mellerio briefly mentioned 'Bellefond' and gave a paragraph to Stern. According to Mellerio, Stern had 'proved himself many times and in good artistic company.' He had probably become Ancourt's chief printer after the death of Père Cotelle – the old craftsman depicted at his press by Toulouse-Lautrec on one of the portfolio covers of *L'Estampe originale*. When Ancourt, who had done much adventurous work in the early 1890s, amalgamated with Bourgerie and then disappeared,[49] Stern seems to have attached himself to Toulouse-Lautrec as his personal printer, an association attested by a whole string of dedicated proofs.

Toulouse-Lautrec is perhaps the most brilliant example of an artist for whom lithography really was essentially coloured drawing. His association with Stern seems to have had its darker side, however, for although *Le Jockey* (10.17) shows that he had by no means lost his touch, it was in 1899 that his alcoholism took him into a mental hospital and a step nearer his premature death. A series of letters from the housekeeper who kept an eye on him reveals that Stern was one of an unsavoury trio who encouraged the artist's dependence on the bottle.[50]

In his book about colour lithography André Mellerio quoted Odilon Redon's belief in the necessity for 'a marriage' between artists and printers. The ideal workshop, Mellerio said, was not 'a big printing factory' but a more modest and friendly place, 'not hidden in too eccentric a quarter.' Here, in close collaboration, artists and printers would proceed by suggestion and agreement. While Mellerio insisted the printer had to be knowledgeable, he also required him to be gentle and retiring, not 'imposing himself on the artist' or complicating the printing procedure in order to boost his own ego. Above all, Mellerio did not want the printer to take any initiative or push forward 'dogmatic knowledge acquired from simple chromolithography' but to encourage the artist to conceive a colour lithograph with 'the range of possibilities which belong to it alone.'

In an attempt to communicate the perception that black was 'the agent of the spirit', Redon worked with many, possibly too many, printers: Lemercier, Becquet, Ancourt, Monrocq, Clot and Blanchard among them. Despite the fact that all of them had had considerable appropriate experience, not one of them seems to have given Redon complete satisfaction, for in 1913, several years after he had made his last lithograph, he was still anguished by negative memories:

My God! How I've suffered in print workshops. What inner fury I've felt when confronted with the confusion and incomprehension that printers have inevitably shown towards my efforts. I admit these were rather unorthodox, were, in fact, quite outside the normally accepted practices associated with work on stone: but I was groping about, experimenting ... All of my prints, from first to last, have been nothing other than a careful, inquisitive, restless and passionate analysis of the expressive power of lithographic crayon, aided by paper and stone. I am amazed

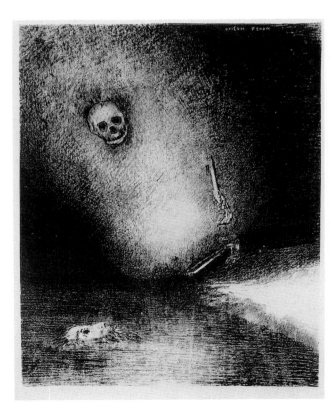

10.18 ODILON REDON
'The Sinister command of the spectre is fulfilled. The dream has ended in death'
from *Le Juré* [*The Juror*] 1887
lithograph printed by Becquet
23.8 × 18.7
edition 120
Australian National Gallery, Canberra

that artists have not expanded further this rich and supple art which responds to the most subtle impulses of one's sensibility.[51]

This heartfelt lament can be partly accounted for by Redon's dislike for the lack of privacy he experienced when working with printers, who, he conceded, were precious when intuitive, but deplorable when they felt nothing. 'One can make a temporary ill-assorted union, where it is necessary to get on together, to come to an agreement,' he allowed grudgingly, 'but two cannot make a work of art. One has to give way.'[52] Whether or not his helpers irritated him, Redon seems to have been admirably served by them as he explored the resources of lithography (10.18). Claude Roger-Marx displayed a fine appreciation of the 'tragic violence' of Redon's blacks and of whites which 'flash like ether or preserve the passivity of stone or the sadness of snow under a dull sky', but also suggested a possible reason for the artist's unhappiness.[53] Apparently Redon scored his stones so deeply that when the printers reclaimed them several millimetres had to be polished away; such rule-breaking would have been commonplace for lithographers like Ancourt and Clot. More probably, Redon was essentially a loner who could not conceive of art as collaboration and coupled this inability with a 19th-century conception of marriage. Here too, one partner was expected to dominate and the other to be a self-effacing help-mate, rarely voicing anything that could be construed as an opinion. If lithographic collaboration was to be characterized as a marriage, the 19th-century printer was undoubtedly the wife.

Paris was by now a mecca for artists. Amidst the wealth of printing talent that proliferated as lithography entered its second century, Auguste Clot was probably the most outstanding printer, closely followed by Belfond, who was equally accomplished with washes. Like Clot, Belfond was a Lemercier employee who left to set up his own business but, starting out earlier than Clot, encountered financial difficulties and eventually went bankrupt. Belfond is particularly remembered for his work in colour with the American expatriate artist, James McNeill Whistler. Whistler had tried colour lithography in 1890 with the English firm of Way and Son, but as he drew on the wrong side of two sheets of transfer paper, his print was a failure.[54] He experimented further with colour between 1890 and 1893 in Paris, developing an idiosyncratic approach. As was already the custom, the artist gave Belfond a dedicated proof of one of their colour prints and was then furious because the lithographer, obviously short of money, sold it. In a letter postmarked 12 November 1893, Whistler told his English printer, Thomas Way, that the only man in Paris who printed 'with intelligence and feeling' was not to be trusted. *Lady and child* (col. pl. 42) is consequently one of the few proofs Whistler and Belfond accomplished together before the artist's career in colour lithography came to an abrupt end.

Whistler, who had been re-introduced to lithography by Way in July 1878, was able to live in France and yet turn out regular lithographs with the help of his English printers. His image would be sent across the Channel as a drawing on transfer paper and speed back by return as lithographic ink on printing paper. Way was committed to the idea of the lithograph as drawing and many of Whistler's works are the product of crayon wielded with exquisite and fastidious elision (10.19).

The artist's most celebrated lithographs, however, are his lithotints, which consist less of conventional drawing than of techniques peculiar to lithography. Although Whistler had wanted to make more lithotints while he was in France, he was unable to do so, since no printer he trusted was at hand.[55] His first lithotints, *Limehouse*, *Nocturne*, and *Early morning*, were made when he lived in England and were executed on stones prepared with a half-tint by the printer, to which Whistler added or subtracted tone. But as printers had found throughout the century, such stones often clogged and *Early morning* quickly became another nocturne, requiring Whistler and his printer to labour many hours until by scraping and re-etching they had restored the desired silvery quality. Although capricious, the results were certainly worth the effort and *The Toilet* (10.20), drawn on the same stone as *Early morning* to save expense for

22

Piccadilly Magazine, was etched again and again, yet retained the delicate inflections of the artist's brush even in the machine printing.[56] After a hiatus of 18 years, Whistler returned to lithotint with *The Thames*, which he worked on stone in 1896 in the room at the Savoy Hotel, London, where his wife lay dying. After her death, the artist rarely touched lithography again. Overcome by grief, not to mention a bill from the Ways that had been accruing since 1888, he severed his long and close connection with his English printers. The long-suffering Ways, who had waited seven years to collect their debts, were deeply upset by Whistler's treatment of them, and Way junior, although always deferential to the artist's talent, recorded his distress in articles and books.[57] Although it is Way's name that has come down to posterity, it was the printer F.H. Bray who probably did Whistler's later printing. A.S. Hartrick, in his engaging history of lithography, writes that Bray was 'probably the ablest lithographic printer there has ever been in England.'[58]

1.10

> He was extraordinarily slow and deliberate about his work, but he could do anything with a stone. He was something of a character too. A small man, neatly dressed in black, ordinarily he looked what he was, the most respectable type of working printer, with just a touch of the local preacher, as might well be. But, master printer though he was, in truly English fashion the state he really fancied for himself was a judge of form in horse-racing![59]

Bray produced admirable prints from the stones entrusted to him, but in Hartrick's opinion Way had made more of a mystery of lithography 'than he need or should have done', keeping Whistler in the dark about much that would have helped him. As already noted, the Ways refused to send the artist their recipe for wash when he wanted to pursue the technique in Paris, and Way junior also wrote a long apologia in his 1912 memoir as to why, at a point when Whistler wanted to set up his own press, he and his

10.19 *Below left* JAMES McNEILL WHISTLER *The beautiful jardinière* 1894 lithograph printed by F. H. Bray at Thomas Way and Son, reprinted by F. Goulding 22.2 × 15.8 Australian National Gallery, Canberra

10.20 JAMES McNEILL WHISTLER *The Toilet* 1878 lithotint printed by F.H. Bray at Thomas Way and Son 25.7 × 16.5 12 proofs and published *Piccadilly* edition Australian National Gallery, Canberra

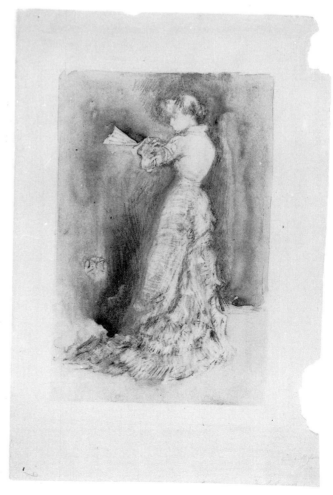

father decided that the artist ought to keep drawing while the Way firm kept printing. 'We neither of us', he explained, 'wanted him to stop his painting to attend to the mechanical side of printing.'[60]

Way expressed the belief that the printer 'will get from the stone exactly what the artist has put there, neither more nor less.'[61] How he was able to sustain such a position in view of his experiences with Whistler's lithotints is not altogether clear, but as one of the myths attaching to autolithography, such a notion had to be sustained.

> *In this country a few artists had tried to keep alive the spirit of lithography which had been abused by the commercial printer.*
>
> HENRY TRIVICK, Chairman of the Senefelder Group, 1961[62]

> *In common with all great craftsmen, he is forever ready to place his great knowledge at the disposal of whoever seeks it.*
>
> *Double Crown Club Register* entry on Thomas E. Griffits, commercial printer[63]

In 1893 Way had addressed the Art Workers' Guild and as a result the American Joseph Pennell, William Rothenstein and several other artists made drawings on stone or transfer paper: '... the rest', says Hartrick, 'was hidden in mystery by the printers, who produced the proofs rather in the manner of a rabbit out of a top hat.'[64] When in 1895 the British Royal Academicians were invited to participate in the Centenary of Lithography in Paris, they turned not to Way, but to Frederick Goulding and his brother Charles.[65] The direction lithography took thereafter was towards greater involvement of the artist in the printing; as a move in that direction, Hartrick helped set up the British Senefelder Club in 1910, with a workshop and press for members. For Hartrick, the problem in England resided in the unyielding regimen of the professional lithographer versus the experimental explorations of the creative artist. Few artists, he wrote, knew anything of the craft of lithography:

> These were secrets concealed in the lithographic shops ... lithographic firms had no place for artists' experiments which too often spelt failures. For business men things had to be fool-proof; therefore the real litho-draughtsmen never did anything that had not been done a thousand times before, and the first rebuff an artist met with, if he did gain admittance and desired to experiment, was the invariable answer 'that is not done', with the further implication that it was 'impossible'.[66]

In Hartrick's view, 'the most potent factor in the dissemination of all that had been till then kept secret' was F.E. Jackson's tuition at the Central School of Arts and Crafts in London. At this school, Jackson, and later Hartrick himself, taught both English and foreign students, including two Americans who were to have considerable impact on lithography in their own country. One was the artist-printer Bolton Brown, who made his own beautiful lithographs as well as printing for others; the second was Margaret Lowengrund, who in the 1950s became a passionate advocate for lithography and started a New York gallery with a workshop attached to it, from which sprang the Pratt Center for the Graphic Arts.[67]

Brown was an extraordinary individual. Residing in England during the 1914–18 war, he determined to learn everything there was to know about lithography. Aware that 'you cannot draw a life-sized gnat on burlap'[68] he became a connoisseur of stone grinding, varying the grit to produce at least 40 distinct textures from the finest grain to one coarse enough to introduce 'air and penetrability.' He made well over a hundred etching experiments using different chemicals. On his return to America where he undertook printing for other artists, he produced 'a much better crayon than the world ever saw', rejoicing in all possible varieties 'from hard as horn to soft as butter, from smooth as soap to sticky as tar, from a consistency like asphaltum to a consistency like soda cracker...'[69] While still in London he had meticulously crafted his own roller and canvassed the need for the artist-printer to understand the subtleties of the instrument:

In use, the timing of the rhythm of its application, the dampness it has from the damp of the stone, the load of ink it has from the inking slab, the significance of the sound it makes, the down-pressure from the arms, the sidewise thrust, the pinch of the fingers on the handles and what the pinch does, the 'drag' on the surface; all this is non-existent to you unless you have the roller in your own hands . . .[70]

Brown did some beautiful printing for the artist George Bellows, the two of them

'making a gorgeous team.' Yet in his own work, Brown's passionate commitment was based on a highly idiosyncratic and restrictive attitude which insisted that only crayon on stone – which he called 'crayonstone' – was really lithography. Despite this self-imposed limitation, Brown could, by varying the nature of the stone, of the acid or of his crayon, produce an extraordinary range of marks, each one speaking in a distinctly different voice. His print *By the creek* of 1922 (10.21) has only to be compared with Thomas Barker's mountain landscape to see how subtly printing had progressed during lithography's first century.

Brown's bête noir was Joseph Pennell. Operating in countries where there was little collaborative tradition, Pennell made a speciality of alienating trade printers and advocating that artists should do their own printing, without following his own advice. Brown frequently made mincemeat of his ideas, for whereas Brown's mind had a sharp if narrow focus and rapier-like precision, Pennell expressed his enthusiasm for lithography like a blunderbuss, rarely allowing his inadequate grasp of technicality to be modified by fact. Years after Pennell's death Brown was still fulminating against him.[71] Because he knew so thoroughly how the technical and 'mechanical' procedures affected the aesthetic of the print, Brown believed he should sign those he printed, feeling 'that the man who pulls a fine impression should get the credit.' When one of his artist clients objected, Brown remonstrated with him, pointing out: 'Your drawing was taken in hand by me and so treated, chemically and physically, that it is now—and I made it so—a printing surface . . . [yet] . . . you want it to appear with only your own name upon it, as though you had done the whole thing.'[72]

This was a very different attitude from George Miller, who between the wars was one of very few professionals catering to American artists. Writing in the 1970s, Miller's son and successor, Burr, made it clear that he still believed in his father's rather self-effacing credo. The printer saved the artist from wasting energy in trying to print, but was

> . . . just an extension of the fine line that runs from his mind to his fingertips. We advise assist and help him deliver his creation much like a doctor delivering a baby. However we do not create, and because we do not, George C. Miller & Son has *never* signed an edition of prints, nor do we even have a chop mark . . .[73]

While George Miller was completely unpretentious, he loved to tell of work he had salvaged from 'fancier but less ept printers.'[74] Coming from a family with eleven other commercial printers, Miller set up his workshop for artists in New York in 1917. Jean Adhémar once wrote, as if he were describing the relationship between Kodak and a photographer, that '. . . the artist draws his picture on a stone slab with a grease pencil . . . and Miller does the rest!'[75] This accurately pictures the relationship between Miller and the American Regionalist painter, Grant Wood, who lived in Iowa and made prints by post. In 1934, Miller sent Wood six stones at a publisher's request. By 1940, Wood had completed nineteen crayon lithographs, of which *March*, although restricted in its means, is nevertheless quite perfect (10.22).

As they then sold for $5 apiece it is not surprising that such prints were monochrome, in large editions, and entailed a minimum of experimentation – the extensive but not immediately productive benchtime for which the printer needs to charge, but the public is less prepared to pay. These factors earned Miller a reputation as a restrictive printer and he is reputed to have compelled novices to leave an inch margin on the stone and draw with very sharp no. 4 Korn's crayon, making marks in just one direction.[76] However, when Miller felt artists knew what they were doing he was less likely to impose limits: Robert Riggs's fight scene (10.23), made by scraping light out of a dense tissue of crayon and wash, is superbly successful and proves that Miller made a more varied contribution to American lithography than is normally credited to him.

Although a commercial pressman called Jimmy Peters proofed for the members of the Senefelder Club,[77] there were no printers specializing exclusively in artists'

10.23 ROBERT RIGGS
On the ropes *c.* 1932–35
lithograph printed by
George Miller
37.8 × 50.0
edition 50
Australian National Gallery,
Canberra

lithography in England. The artist-lithographer either worked alone, obtained technical help in an art school, or, emulating Joseph Pennell, tried to tame a commercial printer. Two printers were particularly sympathetic to the fine artist's penetration into trade lithography—Thomas Griffits, of Vincent Brooks Day and Son and later of the Baynard Press, and Harold Curwen of the London company which bore his name.

Griffits once quipped that he usually printed the black plate first 'just to unnerve the

10.24 BARNETT FREEDMAN
The Darts champion 1956
inspired by *The Guinness
Book of Records*
lithograph printed by the
Curwen Press
48.0 × 73.6
Australian National Gallery,
Canberra

artists—otherwise they get above themselves', although in fact he was a 'confident and bravura personality' happy to share with artists the many chromolithographic skills he had learnt.[78] Far from feeling a need for artists to illuminate him, Griffits complained that he had never been able to convince any of them 'to treat lithography as a painting medium, instead of a black drawing with colours added ...'[79] His teaching nevertheless had important repercussions and Barnett Freedman was one of a number of artists who became advocates for the autographic production of posters, book illustrations, pattern papers and even small advertisements. The 'jumper' Griffits made for Freedman, a kind of knife which could be skittered across the lithographic drawing to remove crayon, produced a hallmark in the innumerable illustrations and dustcovers for which Freedman became famous in the 1930s.

Curwen so loved having artists about the place that he convinced his workers that they would be good for business; union restrictions did not intrude until after the second world war. Just as Curwen proved beautiful books could be made by machine, so Freedman wanted to unite 19th-century autolithographic tradition to modern methods of mass production and erode class distinctions between fine and applied art, bringing an unhierarchical care to everything he did. Freedman was so dedicated to lithography that he was sometimes asked to assist other artists with projects like the lithographs for Lyons Teashops or to celebrate feats in the *Guinness Book of Records* (10.24). In 1974, Rowley Atterbury, assessing the contribution such men had made to the printing industry, said that one could still meet the compositor or pressman who had been berated by Barnett Freedman, yet if asked whether he would relish the opportunity to produce such work again was 'apt to get a nostalgic look about the eyeballs.'[80]

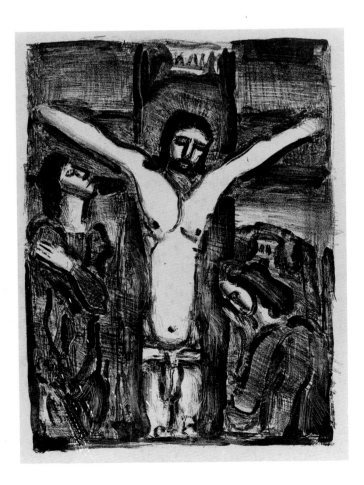

10.25 GEORGES ROUAULT
Christ on the cross II 1925
lithograph printed by
Duchâtel
30.4 × 22.6
trial proof
Felix Man Collection
Australian National Gallery,
Canberra

10.26 L. JIRLOW
The Mourlot workshop
c. 1956
colour lithograph printed by
Mourlot
46.2 × 61.0
Australian National Gallery,
Canberra

It is better to be a first class artisan than a painter.

PICASSO TO HENRI DESCHAMPS, Chromiste at Mourlot, Paris[81]

At the turn of the century in France, lithography had entered one of those cyclical periods when it found less favour. Among many possible reasons may be listed the incursion of photomechanics, the satiation of the market by the production of the 1890s, the complication and cost of colour printing, and the greater suitability of intaglio and relief processes for the dominant styles in painting. This bleak period for lithography extended until after the first world war when monochrome lithography made a comeback. Duchâtel, who probably lost his job when Lemercier went out of business, surfaced again as the printer of some albums by Frapier, featuring major artists such as Matisse, Bonnard and Rouault (10.25).

It was the house of Mourlot, however, which resuscitated colour lithography. The firm had been in existence for many years but was chiefly engaged on the high class commercial printing of perfume and wine labels or luxury religious images, called by the trade 'good-goddery'. Jules Mourlot had died in 1921, leaving his business to several sons. One of them, Fernand Mourlot, who had trained as an artist at the Ecole des Arts Décoratifs, sought out art-related work and began producing posters. With the proliferation of art exhibitions, the French national museums needed to advertise and even some major London galleries discovered Mourlot was one of the best printers for such a purpose. Having begun with reproductive posters, Mourlot moved on to posters made by the painters themselves. Although drawn about two decades after Mourlot's postermaking began, Jirlow's faux-naïf view of the workshop gives some idea of its activity (10.26). The firm also worked on Tériade's luxury magazine *Verve*, and this too helped introduce the most famous artists of the day to the printer.

It was after the austerities of the second world war that colour lithography blazed into the ascendant again as Braque, Picasso, Chagall and Miró—the 'monstres sacrés' of the Ecole de Paris—found their way to the atelier in the rue de Chabrol. Almost every important artist of the era made lithographs with Mourlot, although it was Picasso who ensured the printer's lasting fame.

Just as in the 19th century Lemercier had employed skilful individuals whose names became bywords in the annals of printing, so some of Mourlot's printers achieved

comparable fame by helping artists unfamiliar with printmaking to turn out enormous numbers of lithographs. There were three main categories of printer working with artists: the *chromistes* who, despite the incursions of photography, were still drawing uncannily skilful manual reproductions; the *essayeurs* who processed the stone, pulled the first proofs and arrived at the *bon-à-tirer*; and the *pressiers*, who ran the editions. Artists working in colour tended to favour one of two outstanding craftsmen: Henri Deschamps, who had been a student of the formidable master chromiste Popineau, or Charles Sorlier. After training at the Ecole Estienne, Sorlier had started his working life drawing the less important details of religious images in 'le plus pur style pompier Saint-Sulpicien'.[82]

By this time the problem of who dominated whom had been largely resolved. Alfred Lemercier's advice had been taken to heart and the artist's word was law, his most outrageous requests merely constituting a challenge. Since most of the technical problems had been overcome, the printer was free to act as a facilitator, a super-craftsman who did not question, but simply carried out whatever 'the master' wanted. At the same time, the artist would, if he (or, more rarely, she) had any sense, respect the prodigious abilities of the craftsmen. This genuine regard is summed up by an anecdote that Mourlot tells of the chromiste Henri Deschamps, who showed his Sunday paintings to Picasso. Picasso told him:

> You are the greatest chromiste in the world, be content with that. It is better to be a first class artisan than a painter.[83]

Nevertheless, a romantic notion of the artist still permeated the collaborative activity, although he was not expected to take advantage of it. It was regarded as a true sign of his quality, for example, if he did not insist on the formal address of 'Monsieur', or 'Maître'. For Matisse such formality was *de rigueur*; a certain coolness can always be detected in accounts of the printer's contact with him and several stories record his inability to distinguish his work from theirs.[84] On the other hand, Chagall, said to be gentleness personified, was a man for whom Sorlier had a regard bordering on adoration. The artist is reputed to have quipped: '*Maître? ... centimètre!*' And Picasso, immensely popular with all the workmen, established from the very beginning that he was not to be called 'Monsieur'. Fernand Mourlot's son Jacques, who now runs the business, remembers:

> Picasso was captivating. He was mesmeric. He was always joking, tricking and laughing. He was very sweet, very nice, and very close.[85]

Fernand Mourlot, now in his nineties, never tires of telling how, in November 1945, he was summoned to Picasso's studio and shortly afterwards welcomed Picasso to his workshop. Picasso told him that he had tried lithography before, but had not been greatly impressed. Braque, however, who had already worked with Mourlot, had encouraged him to try again. Père Tutin, Mourlot's most competent trial proofer, stood by as Picasso produced a rather grubby little collage of cut-out shapes of transfer paper covered with lithographic ink. To Mourlot's surprise and Picasso's 'visible stupefaction', Tutin, working with his extraordinarily precise and economical movements, pulled an exquisite proof.[86]

In 1983 Mourlot wrote that the collaboration which exists between the artist and the 'technicians' of lithography was very important 'since a feeling of empathy and mutual understanding must exist at every stage between the artist and the *pressier*.'[87] That being so, Picasso's relationship with Gaston Tutin was indeed remarkable for, illiterate in aesthetic matters, Tutin was a stickler of the old school who thought the artist's work was 'garbage'. Mourlot said of him:

> Not only did he have a horror of what Picasso drew, he was literally disgusted by his manner of working, contrary to all principles; the painter, who was amused by this reprobation, laid more traps, indulging in the most incredible exercises on the stone. The other protested, refused to work, then executed the lithograph, grumbling . . .[88]

10.27 PABLO PICASSO
Hairdressing 1923
lithograph printed by
Charlot Frères
27.0 × 17.0
edition 42/50
Felix Man Collection
Australian National Gallery,
Canberra

Picasso, who entered into every relationship as a combat, was curious to see whether there was any limit to Tutin's resourcefulness, and Tutin never let him down. Picasso was amused by the old man's aversion to his work which was so extreme that Sorlier watched Tutin tear up a proof Picasso had given him of the legendary (and now priceless) *Dove* of 1949, which the artist had drawn on zinc at home one Sunday morning in wash diluted with petrol. Tutin thought the artist stingy only to give him bits of paper and when Picasso got the message and gave him bottles of liquor instead, Tutin was considerably mollified.[89] Whatever Tutin thought of him, the artist had unbounded admiration and respect for the craftsman's work and never wanted anyone else to pull his proofs. As Mourlot explains:

> His skill was prodigious. Picasso would begin with the merest film of lithographic medium on his zinc plate . . . it would be just a breath, nothing at all, and old Father Tutin would bring it out marvellously. And when Picasso saw the proofs, he was himself amazed.[90]

Brigitte Baer, Picasso's most recent cataloguer, regards intaglio printmaking as Picasso's real passion and lithography but a 'passing fancy.'[91] Nevertheless, in the first flush of his temporary infatuation, Picasso virtually reinvented the process, progressing with lithography much as he had done with etching and engraving. In the beginning, he used it like drawing (10.27); later he pushed it as far as he could; finally, having gained a breathtaking fluency, he systematically broke every rule, often to express a mischievous sense of humour. While they could respond to his strategies, the workmen were permanently amazed:

> Working without cease, inventing the most extravagant processes, surmounting the difficulties with brio under the dumbfounded stare of the workmen who had never seen such technical cheek in the service of such bold invention, Picasso looked, listened, did the opposite of what he learnt, and it worked.[92]

10.28 PABLO PICASSO
Flowers in a glass
from *Dans l'atelier de Picasso*
[*In Picasso's studio*]
by Jaime Sabartès Paris 1957
lithograph printed by Mourlot
24.6 × 15.6
edition 48/50
Australian National Gallery,
Canberra

Although normally given to rising at noon, while he was working at the Mourlot workshop Picasso would arrive early and stay late. The particular fascination the shop offered was that of entering and leaving the image on the stone or plate at will. Although the chemistry of correction had been mastered during the 19th century, revision could be hazardous; however, Picasso liked to review the states mapping the way his mind had realized its dream, so he continually risked losing his work. Hélène Parmelin, introducing Mourlot's catalogue of Picasso's lithographs, wrote:

> Normally when it [a stone] has been retouched twice, the original preparation becomes somewhat spoilt. And he would scrape and add ink and crayon and change everything! After this sort of treatment the design generally becomes indecipherable and is destroyed. But with him! Each time it would turn out very well. Why? That's a mystery.[93]

Picasso drew with perpetual invention, setting down a flower in a glass with gouache

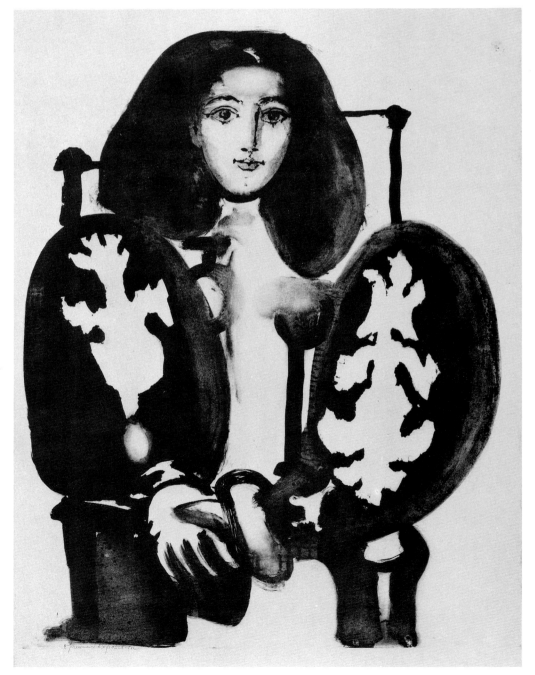

10.29 PABLO PICASSO
Woman in an armchair no. 1
(from the red) 1948
lithograph printed by Mourlot
69.6 × 51.2
printer's exhibition proof
(edition 50)
Australian National Gallery,
Canberra

10.30 PABLO PICASSO
Paloma and Claude 1950
cover for *Picasso lithographe*,
vol. II
lithograph printed by Mourlot
32.0 × 52.0
edition 2000
Australian National Gallery,
Canberra

over a scumbled wash of tusche on transfer paper (10.28); he also made several legendary sequences. He would mutate an image through innumerable states, ending up, as one printer put it, where he should have started. *David and Bathsheba*, the most aesthetically satisfying of many series, was first expressed as a black line on a light ground and abandoned two years later as a white line on a black one. The *Armchair woman*, featuring his mistress Françoise Gilot in a Polish jacket he had bought her (10.29), began as a colour print. Abandoning his first intention after it had been mis-printed, Picasso transformed each of the five colour plates into a monochrome series.

1.12, 1.13, 1.14

By the late 1940s Picasso had moved permanently to the south of France where Mourlot would visit him, collecting his plates and then sending proofs by post. Without the day-to-day stimulus of the printers, the work became more perfunctory, although from time to time a spark re-ignited. After abandoning lithography for a year, for example, the artist drew the portrait of his children *Paloma and Claude* (10.30), by wetting a dried-up bottle of tusche and applying it to the plate with his fingers. His sense of humour was unabated. A publisher asked Mourlot to negotiate for some colour in illustrations Picasso had made for a book about bullfighting. Picasso took a black proof, applied a spot or two of each of the 24 colours in a box of crayons, and handed it back to Mourlot with a chuckle. The printer arduously made and registered 25 separate plates and with the grin now on his own face, returned Picasso's colour illustration for *A los toros [To the bulls]* (col. pl. 46), impeccably realized.

In his memoirs, Mourlot draws an attractive picture of his relationship with the great artists of the era. Braque, a grand figure of a man, would arrive on his prehistoric bicycle. Between 1953 and 1954 he made *Leaves, colour light* (col. pl. 44), one of the great colour lithographs of the century. Exploding colour like fireworks, Miró would adorn poems such as that by Jacques Prévert paying tribute to Mourlot's sensitivity (col. pl. 47). One of the most prolific artists to frequent the workshop was Chagall, who blended Jewish legend and Russian folklore at the same time as taking ecstatic

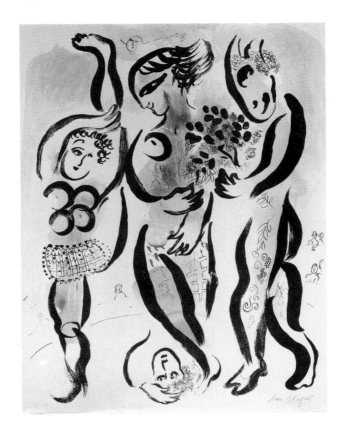

liberties with the human anatomy (10.31). His procedures rate special notice, for he required constant assistance to facilitate his enormous output of colour prints and worked closely with the *chromiste* Charles Sorlier. Sorlier not only formed a working relationship with 'Le Patron' (the Boss), but a personal one too. Eventually their collaboration focused the question of 'originality' and where the hand of the artist stopped and that of the printer began. In 1961 the Print Council of America, which then took such matters seriously, sent a questionnaire to Mourlot, asking among other things:

> Are the prints contained in your book *The Lithographs of Chagall* and referred to therein as original color lithographs in fact original color lithographs...?[94]

Two months later Mourlot's lengthy answer came back and Joshua B. Cahn, the Council's attorney, had to admit the reply was 'complete and frank' but revealed 'that the said color lithographs are not original lithographs as that term is used by the Print Council.'

Mourlot had spelt out in detail that when Chagall made a colour print he would draw the black 'skeleton' and paint a trial proof with gouache or watercolour. Sorlier would trace the outline of each colour onto zinc plates so Chagall could paint his washes. The *chromiste* would then be involved in retouching these washes and to save Chagall standing indefinitely by the machines, or commuting regularly from St Paul to Paris, the printer might subsequently add a few extra colours if requested. As Mourlot explained:

> Since CHAGALL's colored lithos are often printed on large-size outdated presses, it is very difficult to make retouches on these machines. A 'chromer', stretched out on the press, implements CHAGALL's comments, which are usually confined to acid burning, which is done before the artist's eyes.
>
> Marc CHAGALL, who spends entire days at the shop, keeps careful watch over his work...

The problem arose not so much because of any detectable visual quality, but because the market, informed by the notion of originality, needed to distinguish the touch of a mere collaborator from the touch of the romantic genius. The matter, essentially economic, lay with those controlling the market rather than with the printer. A lithograph after Chagall bearing the legend 'Sorlier graveur' brought a tenth as much as one made by Chagall and the issue was compounded by the fact that there were also in existence Chagall reproductions drawn entirely by Sorlier. Up to the mid-1950s, Sorlier explained, before there was a Chagall market, the *chromiste* had not signed such images:

> It was only when the buyers became more numerous that certain unscrupulous dealers advertised my interpretive engravings as if they were the original works of the painter . . .[95]

More honest disclosures were subsequently made as to the various hands involved, but a good deal of special pleading followed. Mourlot wrote of the accident that had forced Chagall to wear a corset, thus preventing gymnastics on the retouching press.[96] Historical precedent invoked artists from Dürer to Toulouse-Lautrec; how could one so small have reached far enough to retouch, or even draw, his own posters, it was asked. Before long, ignominy was converted to nobility and Chagall was roundly praised for his recognition of his collaborator: 'He had to be great enough to share the honor of signing,' wrote Jean Adhémar.[97] But as Sorlier cogently observed, printmaking had always been a collaborative activity involving many hands:

> Famous artists have always had assistants who were also their disciples. Chagall is no exception to this rule and moreover does not hide it. Between this and the insinuation that the Master's original plates were largely executed by me, there is a gulf which only the simple-minded would not hesitate to cross.[98]

Sorlier also tried to explain Mourlot's special quality. Mourlot, he wrote, 'was conscious in his work of being the equal of the great masters, not their servant. That is why everybody loves and respects him.' Mourlot preferred the '*Maître? . . . centimètre!*' approach. Trained as an artist, skilled as a craftsman, inspired as an entrepreneur, distinguished as the scholar behind many books about the most famous 20th-century lithographic artists, he insisted: 'I am an artisan, not more. But that is already very good!'[99]

It was Ceri's poetic nature to think of images and ideas – that is what dominated him. How they were achieved in terms of lithography was almost a secondary challenge . . . He was in his own element when the responsibility of what happened had passed from him to whoever printed the work for him.

STANLEY JONES, Curwen Studio, London, of the artist Ceri Richards[100]

Picasso's work with Mourlot was inspirational, but at the same time a hard act to follow, especially in countries where hardly any tradition of collaborative printing existed. Despite the willingness of some of England's essentially commercial printers, the aesthetic possibilities they offered to painters were not dissimilar to those offered to novices by Miller in New York. When union activity increased after the second world war, secrecy in the printing trade could well have caused lithography to die out. Although experimentation was theoretically feasible in art schools, artists printing for themselves were rarely technically capable of realizing all their aesthetic hopes.

Stanley Jones, one of the longest established artists' printers in England, remembers how in the early 1950s the Welsh artist Ceri Richards, alleged to be teaching him lithography at the Slade School in London, would struggle unsuccessfully even to obtain impressions of his own drawings. Jones recalls:

> We watched as he would bring into school freshly drawn plates to print on the offset machine. The sequence of events was fairly predictable. After several pulls had been

achieved, the image would take on a distinctly blighted look as the chemistry he had employed began to deteriorate.[101]

Fortunately Jones, in whom Richards ignited great enthusiasm despite his technical shortcomings, resolved to go to Paris to learn to be a printer. He was lucky to find a niche in the atelier of Gérard Patris in Montparnasse, a printer not hidebound by protectionist attitudes but young enough to share his knowledge. In 1954 Paris was in the grip of Tachism, the European equivalent of Abstract Expressionism, and Jones served his apprenticeship working for a group of well-known international artists including Paul Jenkins, Riopelle, F. K. Dahmen, Severini, Bazaine, Corneille, Matta, and Soulages. These artists drew on hand-ground stones which the printers pulled on physically taxing traditional manual presses. The French artisan printer's practice, which Jones now absorbed, required him to go to any lengths to achieve a successful collaboration. One of the devices Jones used to assist the impasto painters, Riopelle and Dahmen, to feel at home with an unfamiliar process was tusche so solid it resembled oil paint and could be applied to the stone with a palette knife. For Soulages, already attuned to the erosion of metal by etching, Jones processed the lithographic stone with acid of such strength that the artist's tusche drawing appeared in palpable relief.

In 1958 the owner of a British gallery who was tired of lithographs with marginal fingerprints, 'crooked on their paper and punched through with ugly registration slots', decided to search for printers to 'professionalize the artists' output'.[102] Jones

10.32 JOHN PIPER
Llangloffan, Pembroke:
Baptist chapel
from *A Retrospect
of Churches* 1964
lithograph and
photolithograph
printed by Stanley Jones
52.0 × 69.8
Australian National Gallery,
Canberra

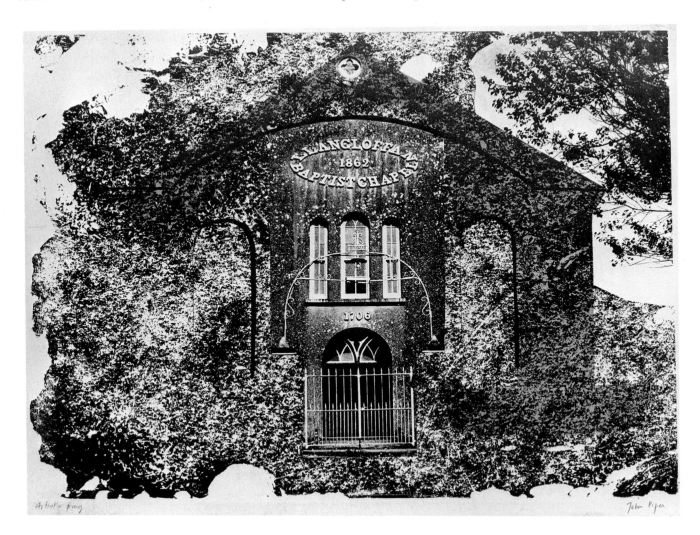

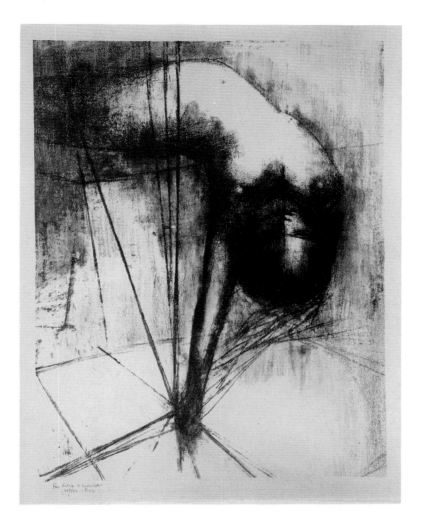

10.33 REG BUTLER
Figure in space
from *Europäische Graphik 1*,
1963
lithograph printed by
Stanley Jones
60.0 × 45.8
dedicated trial proof
(edition 65)
Felix Man Collection
Australian National Gallery,
Canberra

was consequently lured back to England to run a pilot workshop in the artists' colony of St Ives. Thus in 1959, under the aegis of the Curwen Press, he set up the first collaborative studio in Britain and was installed as master printer; Henry Moore and his former teacher, Ceri Richards, were among Jones's earliest customers.

Lithography was well suited to the aformal spontaneity of contemporary painting and the blossoming of colour after the austerity of war. Trevor Bell, one of the St Ives painters, accepted an element of chance in superimposing his veils of ink, drawing more stones than he needed and trying various permutations instead of rigidly registering them (col. pl. 45). He ended his experiments with a healthy respect for Stanley Jones, who, he said later, 'could even print your breath.'[103]

John Piper, distilling half a century of architectural observation for *A Retrospect of churches*, was another early user of the service Jones provided. Inspired by the catalogue of Picasso's lithographs which had just appeared, he played with a whole range of unconventional technical approaches, cutting up transfer paper, splashing tusche and gouache freely, using benzine to create globular washes, deliberately mis-registering successive impressions of the same image, and marbling lithographic ink, with which he succeeded in making 'a filthy mess.' 'You have to be very ingenious to appear spontaneous', he later observed. In all these strategies Jones showed the mettle of the true collaborator: if Piper said: 'Stanley, what if . . . ?', the printer would always respond: 'Let's try it and see . . .'[104]

One of the most daring images in Piper's otherwise autographic portfolio challenged established notions of 'originality'. It incorporated one of the artist's own photographs

10.34 JANET DAWSON
Big noise 1960
lithograph proofed by
the artist and
editioned by Ben Berns
90.5 × 63.4
edition 30
Australian National Gallery,
Canberra

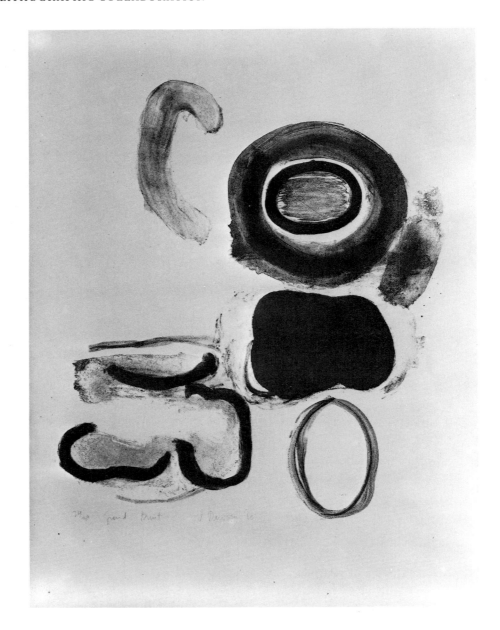

because Piper felt the camera's matter-of-factness would be exactly right for the Welsh Non-Conformist church he was trying to portray. Nevertheless, the phototechnician at the parent company made quite a fuss when Piper asked for a tree to be cut out and collaged into the top right corner (10.32). This early fine art photolithograph printed on an offset press gives English priority to such experimentation in a collaborative situation. In 1963 Jones broke new graphic ground again, pioneering aluminium plates bearing polymer coatings sensitive to ultraviolet light. Such plates are now widely used and mean that lithography is no longer exclusively determined by greasy substances, but embraces light-opaque drawings on transparent surfaces photochemically transferred to plate.

In the early days of the Studio, Jones quickly earned a reputation for his unlimited patience, although it was sorely tested by *Figure in space* (10.33). With more enthusiasm than science, the sculptor Reg Butler had fabricated his own transfer paper, but had used gelatine so thick and so impervious to moisture that instead of

338

transferring the image by one simple passage through the press, the printer spent two days *ironing* it onto the stone. Butler had little idea how his print, transferred, then printed in three different shades of black, had come into being, nor of the printer's code which demanded a successful outcome, no matter how wildly impractical the proposition.[105]

When Ceri Richards came to the Studio a second time in 1965 to make a series based on the poetry of the Welshman Dylan Thomas, the themes he had abandoned when Jones was in his class were now accomplished with his former student's help. For one of two dramatic monochrome lithographs, the stone was selectively ground to accept crayon at the centre and dense wash around the perimeter. Each impression took almost half an hour to ink, a sophistication unimaginable in the previous decade.

1.19

In 1958 after his return from Paris Jones had joined Richards as a teacher at the Slade, and Janet Dawson, a young Australian on a travelling scholarship from the National Gallery School in Melbourne, learnt lithography in their classes. 'Flattened' by European culture, she found Jones a wonderful teacher while Richards's tactic of looking at work obliquely from a number of angles helped her, through lithography, to clear her head. Later, like Jones, she worked at the Atelier Patris in Paris and, at a time when it was rare to find a woman in such a position, she became a trial proofer there. One of a number of celebrated artists for whom she worked was the Japanese painter, Kumi Sugai, who invited her to stay in Paris as his personal printer. In 1960, however, she decided to return to Australia, where, breaking entirely with tradition, she presented lithographs in lieu of the painting normally required by her school as evidence of industry. *Grand bruit [Big noise]* (10.34) was one of the prints editioned for her by the Patris workshop before she left Europe, and nothing quite like it had been seen in Australia before.

The geographic location of Australia has, in times past, required its citizens to be inventive, self sufficient, to make do. On such a vast land mass, with its relatively tiny population,[106] the establishment of the marketing and exhibiting system needed to

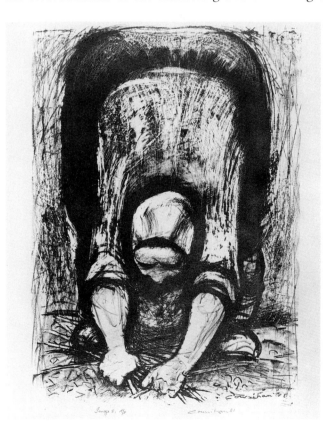

10.35 NOEL COUNIHAN
Woman picking up vine prunings
from *Images of Opoul* 1981
lithograph printed by
John Robinson of
Druckma Press, Melbourne
51.4 × 34.7
edition 40
Australian National Gallery,
Canberra

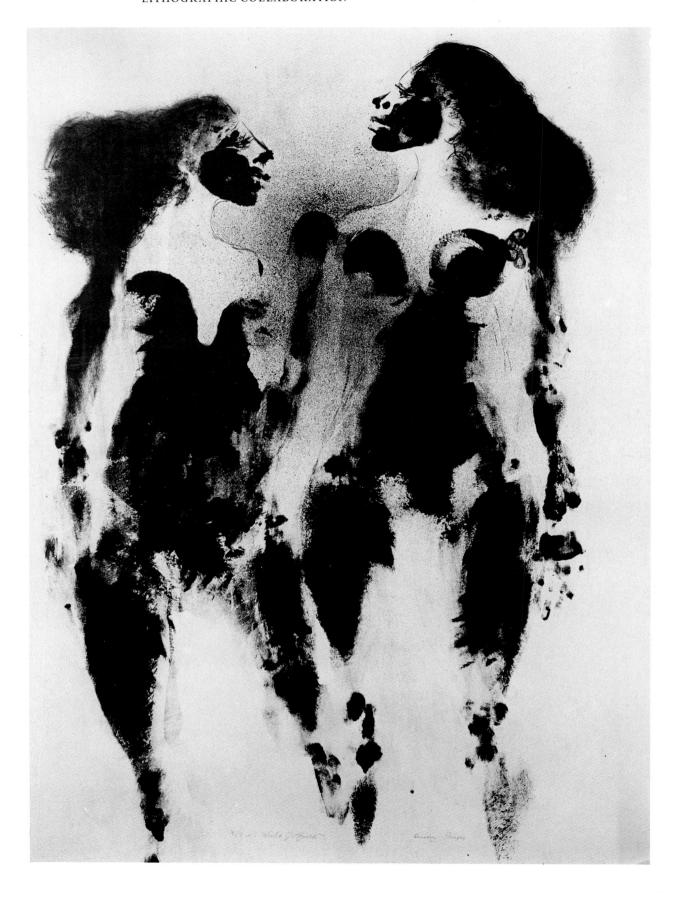

sustain collaborative workshops could hardly emerge overnight. As in England, art school facilities and help from commercial printers were the most usual forms of assistance, although, as part of the growing tendency for artists to help other artists, Janet Dawson established a workshop attached to Gallery A, one of Melbourne's leading commercial galleries, soon after her return from Europe. As larger stones were hard to locate, she had to teach herself plate lithography, but she produced a portfolio for a number of important Australian painters before returning full time to her own work. Lithography in Australia remained, however, a far from dominant technique: when in 1972, twelve years after she had drawn them, her two French prints were shown in the first group exhibition of Australian printmakers in London,[107] only seven of the 22 artists contributed lithographs and two of those were primarily etchers.

Two years after that exhibition, three Melbourne artists set up the Druckma Press. The workshop did not survive in its original form, although in 1981 John Robinson, one of its founders, collaborated with Noel Counihan on the superb suite *Images from Opoul*, a portfolio recording the harsh life of Catalan workers in a French village. The wonderfully solid *Woman picking up vine prunings* (10.35) was drawn on a stone which Robinson carried to Counihan's home in the best 19th-century tradition; the artist, consolidating his earlier experience of lithography, greatly enjoyed the collaboration.

Counihan had earlier been involved with the artist Noela Hjorth in setting up an access workshop in the former meat market in North Melbourne. The only paid employee, Charles Johnstone, was a retired commercial lithographer who provided technical assistance. The workshop was able to regrain metal plates and some of these, previously used commercially for maps or posters, offered unprecedented scale. With Johnstone's help, Noela Hjorth, who like Janet Dawson had learnt lithography in London, pulled a striking group of lithographs drawn by the imprint of her own body (10.36). The fascination of the images, apart from their ambitious size, was that although emanating from a single source, they suggested a whole range of historical depictions in art, from hieratic Greek charioteers to stylized Cambodian dancers.[108]

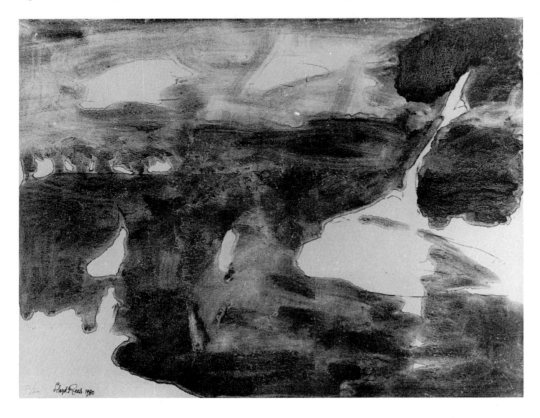

10.36 *Opposite* NOELA HJORTH
Sensory images 1979
lithograph printed by
the artist with the help
of Charles Johnstone
155.0 × 105.0
artist's proof
Australian National Gallery,
Canberra

8.1, 8.2

10.37 LLOYD REES
Quiet day on the harbour
1980
lithograph printed by
Fred Genis
50.6 × 66.1
edition 60
Australian National Gallery,
Canberra

341

Although the Victorian Printmakers' Group existed for only a few years it paved the way for the present access workshop which is one of the best equipped in Australia outside those in art schools. Financially assisted by the Victorian Ministry for the Arts and professionally run by the artist-printer John Loane, the workshop has developed into a space where artists can either work by themselves or enjoy the services of collaborative printers.

col. pl. 36 By the late 1970s some private lithographic presses had also been established. In 1978 Robert Jones, trained in England and Italy, set up his Beehive Press in Adelaide. The following year the Dutchman Fred Genis arrived from Europe and installed a press just north of Sydney. Genis ranks among the most experienced printers in the world, for he worked at several of the most important American shops with such artists as Willem de Kooning, James Rosenquist, Robert Rauschenberg and Jasper Johns. Lloyd Rees, a grand old man of Australian painting, was introduced to lithography by Genis in 1979 at the age of 84; his loosely brushed wash of Sydney's glorious harbour (10.37) was one of a number of prints he made based on the coast of New South Wales. Of a later set from Tasmania, Rees said he felt the colouring was 'so much [the printer's] own creation' that Genis should have signed them.[109] Typically, Genis refused, for the conception of the printer instilled into him by working for Tatyana Grosman in America was that a collaborator should be 'like water', intuitively but invisibly shaping his contribution in response to the artist's intention.[110]

Perhaps the most intriguing of Australian collaborations took place in Canberra in 1983–84. Under the aegis of the Department of Aboriginal Affairs, several aborigines were invited to work at Canberra School of Art. Theo Tremblay, the American artist

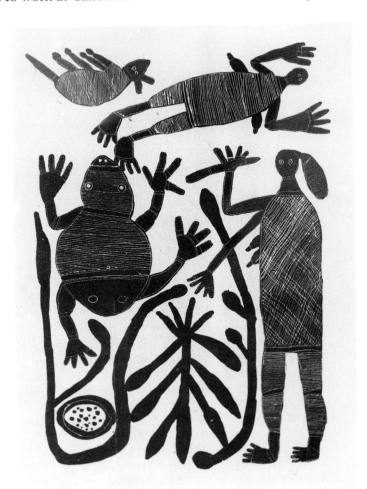

10.38 ENGLAND BANGALA
of the Gunardba language
group from Gotjanjinjirra
lithograph printed by
Theo Tremblay
46.0 × 30.6
edition 20
Australian National Gallery,
Canberra

who runs the School's lithographic workshop, produced editions for a number of indigenous Australians bridging one of the greatest cultural divisions in a richly multicultural society. England Bangala, an Aborigine from Gotjanjinjirra in Central Arnhem Land, had never seen a city before, never mind a lithograph. Since he spoke only the language of the Gunardba group to which he belongs, the collaboration took place through an interpreter. Yet had he gone to the most celebrated press in America, the treatment could hardly have been more sensitively tailored to his needs. Not only did Tremblay adapt the materials of lithography to resemble those Bangala customarily used, but Gaynor Cardew, another artist at the school, made him an appropriate paper of native Australian bullrushes on which the small edition was printed (10.38).

Half a dozen master-printers, scattered around the United States, with a cluster of artists revolving round each, could cause a resurgence and a blossoming-forth in the art of the lithograph ...

JUNE WAYNE, case to the Ford Foundation, 1959[111]

Despite the largeness of its population which, in the long term, made possible extraordinarily extensive collaborative activity, American experience before 1960 resembled that elsewhere in the English-speaking world. There was secrecy in the trade, occasional help for individuals from commercial lithographers, and pockets of expertise in the art schools which led to access workshops. The only difference was the existence of a couple of full-time professional artists' printers.

One of the most heroic early contributions to the evolving situation was made by the black artist Robert Blackburn, who opened a lithographic workshop in 1949. Only dogged persistence permitted Blackburn to acquire his skills over the years. In the late 1930s he had asked George Miller for technical information, but Miller told him that lessons would cost him $100 a week, which was then a king's ransom. In 1940, on a scholarship to the Art Students League, Blackburn studied under the artist-lithographer Will Barnet. Since professional printers pulled the lithographs in the art schools, assisting at the press was the only way artists were able to glean some basic technical information, for although lithography was then despised by the avant garde, secrecy was the policy of the craft unions. As Blackburn explained (interview, 1982):

> We now find that these things are so basic and simple a child can almost do them, but it was part of the craft secrecy that abounded at that time to keep the competition out.[112]

In 1953, Blackburn went to Paris on a Whitney Fellowship and worked at the Desjobert workshop. Although his journey was made at about the same time as that of Stanley Jones, Blackburn, travelling as an artist rather than as a printer, was less fortunate; once more he came away technically frustrated for the printers would not even let him see them grind the stones. Nevertheless, when in the late 1950s the Russian expatriate Tatyana Grosman established Universal Limited Art Editions, her remarkable publishing house in West Islip, it was to Blackburn that she turned for a printer. He had to work on a $15 second-hand press and two badly grained lithographic stones she had found in her garden path. Her first publication was the portfolio *Stones* (10.39), undertaken jointly by the poet Frank O'Hara and the artist Larry Rivers. The basic crayonwork itself would have been child's play to print had she not insisted on the perimeter of the stone also being impressed, which made the job hazardous. From this unlikely beginning, she went on to persuade some of the most outstanding artists of the era to try their hand at lithography; these artists quickly outstripped the printing skills available in America. Although Mrs Grosman had an essentially romantic attitude to the artist and an old-fashioned view of the parameters of lithography, her indomitable will and her refusal to compromise made her output justly celebrated. One of her initial beliefs, however, was that 'the technical aspect of printing is not really important',[113] so it is hardly surprising that none of the earlier printers to serve her

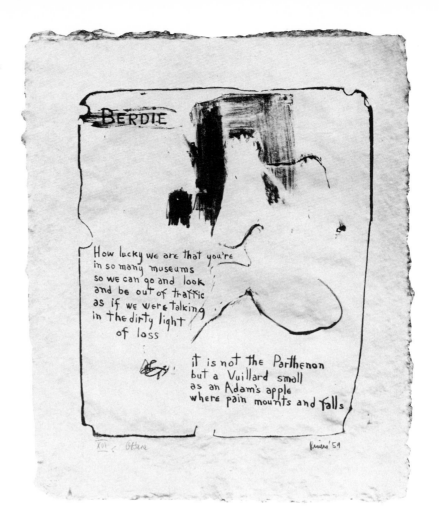

10.39 LARRY RIVERS with
FRANK O'HARA
Page v 'Berdie'
from *Stones* 1957–59
lithograph printed by
Robert Blackburn
48.0 × 60.0
Private collection

survived very long. Blackburn, who had an unfortunate experience when he broke one of Rauschenberg's stones, eventually decided he was losing touch with his own work and returned to his workshop.[114]

So while on the east coast Miller catered to a bygone aesthetic and Blackburn, dedicated but thwarted, first offered an open workshop and then tried to keep pace with some of the greatest talents of the age, the west coast had the only other printer running a collaborative press. Lynton Kistler had set up shop between the wars, producing in colour offset Jean Charlot's remarkable *Picture book* which, the artist acknowledged, was 'as much your achievement as it is mine.' Charlot returned to Los Angeles after the war when Kistler opened a studio in the dining room of his house to which he systematically enticed Californian artists. The printer was keen to teach artists lithographic technique

> ... as an artist who understands the medium ... can produce a better lithograph than one who simply draws on the plate and lets the printer do the rest.[115]

Among those who worked with Kistler in the late 1940s and early 1950s were Clinton Adams and June Wayne, who were to revolutionize American lithography. Kistler has spoken of June Wayne's intellectual approach and the demanding attitude which made her explore every aspect of lithography.[116] In 1953, however, the printer developed a painful allergy to the chemicals used in stone printing and although he retained a press and occasionally printed for old friends, his energies were transferred to his commercial offset operation. So June Wayne went to France to seek out another printer.

She selected Marcel Durassier because she particularly admired a work he had printed for Mario Avati. In France she extended her technical vocabulary by the inventive use of tusche washes on zinc, an exploration that culminated in her book based on John Donne's love poetry, which she completed in 1958. Even so, she told Gustave von Groschwitz, it was 'a long way to go to make a lithograph.' The situation in France, while different from that in America, was not in her view any more healthy for lithography. Printers working for houses like Mourlot were mostly anonymous and in many of the workshops a covert form of reproduction went on. The printers both drew and printed lithographs after artists' gouaches, while most of the money and all of the credit went to the 'name' who signed. Durassier frequently referred to himself as 'slave' or 'counterfeiter'; this later made June Wayne determined to establish more ethical standards in America.

Although Durassier was highly skilled and June Wayne had a clear idea of what she wanted to do, their collaboration was not all plain sailing:

> It was a constant battle. Marcel Durassier would shout: 'C'est anti-lithographic! On ne fait pas ça, Madame Americaine!' . . . I would sit hunched stubbornly over my stone, and he would print angrily, banging his tympan and slamming down the pressure bar. But as the image pulled off the stone, as I predicted it would, he printed more quietly and at the end of the run, there would be a tug at my sleeve and a sheepish 'June, je m'excuse.' Then we were all right until my next 'departure.' In time he accepted that an American could make a lithograph, even an American who was a woman . . .[117]

After her return to America in 1959, June Wayne put her own work on the back burner in order 'to do something for the art that I love'. Having suggested to the Ford Foundation that instead of giving individual grants to artists it should benefit them all by restoring the art of the lithograph, W. McNeil Lowry, vice-president of the Ford Foundation Program in the Humanities and the Arts, asked her to indicate how such a thing could be done. Impressed by her dynamism, her aesthetic sense, her honesty, and most of all the coherence of her plan, he offered Foundation money to carry it out, only if she agreed to do it herself.[118]

The Tamarind Lithography Workshop opened in 1960 and nine eventful years later, June Wayne was able to report to her Board of Directors[119] that the organization had offered almost 100 artists a unique in-depth experience of working with trained lithographic printers, had invited over 50 additional artists on a shorter visit to Tamarind as guests, had trained 29 curatorial grantees, had conducted extensive research into materials, but, perhaps most important of all, had created a body of competent lithographic printers who, through time, would change the ecology of lithography in the United States. By 1985, when the Tamarind Institute which succeeded the Workshop had run for a further 15 years as part of the University of New Mexico, its director Clinton Adams listed 132 printers who had been trained at Tamarind, cited 200 lithographic workshops now available to artists in North America, and mounted Tamarind's 25th anniversary exhibition Fifty Artists, Fifty Printers to make evident 'the richness of the collaborative resources that are available to American artists in lithography today.'[120]

One aspect of the transformation that Tamarind wrought can be traced in the work of Leon Golub. Golub had studied lithography at the Art Institute of Chicago, where it was kept alive by two artist-teachers: Francis Chapin, who had been a student of Bolton Brown, and Max Kahn. Golub's subjective images, informed by primitivism and featuring violence, heroism and stress, represented the changed aesthetic of the postwar generation which existing technical expertise could not always accommodate. It is fascinating to compare *Birth II* (10.40), printed by Golub himself and essentially a monotype, with editions pulled for him in the 1960s by professional printers. His *Fallen fighter* (10.41) of 1965, on which he collaborated with Ken Tyler, sacrifices none

10.40 LEON GOLUB
Birth II 1949–50
lithograph
printed by the artist
59.0 × 44.4
Australian National Gallery,
Canberra

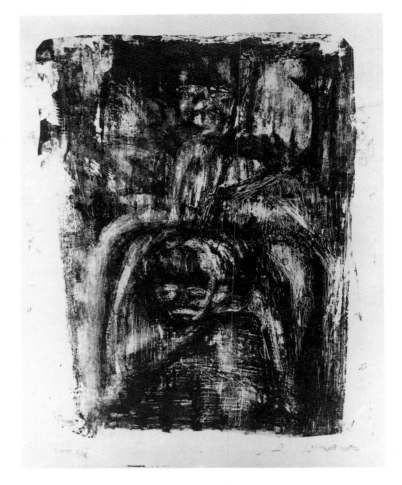

10.41 LEON GOLUB
Fallen fighter 1965
lithograph printed by
Ken Tyler at Tamarind
Lithography Workshop
56.6 × 76.8
edition 12/20
Australian National Gallery,
Canberra

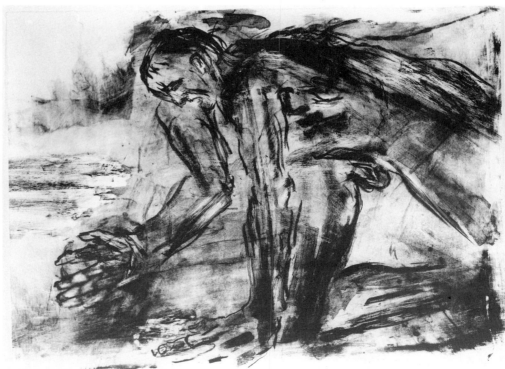

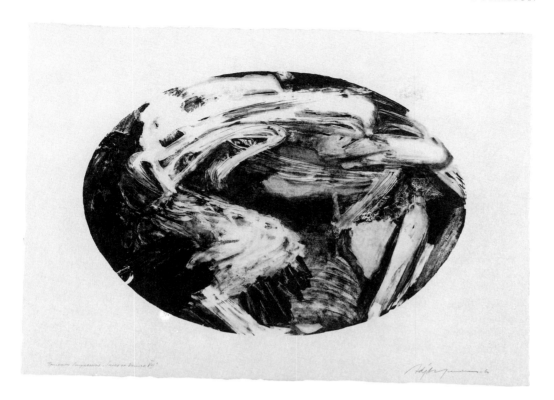

10.42 ADJA YUNKERS
Skies of Venice VIII
from *Skies of Venice* 1960
lithograph printed by
Garo Antreasian at Tamarind
Lithography Workshop
56.2 × 79.6
Tamarind impression
(edition 10)
Australian National Gallery,
Canberra

of its expressive power, yet it no longer emulates a painting or drawing but is a lithograph made to sustain an edition.

Another expressionist artist, George McNeil, spoke in a recent interview of the difference between an artist's own printing, which curators often perversely preferred, and the professional printing of the workshops, where more clarity of intention was required from the beginning. When he took up lithography in the late 1960s, it was not from an interest in multiples because he 'couldn't sell a single drawing, let alone duplicates'. His fascination lay in changing his drawing on the stone, even though after hours of hard labour the results would be devastating and 'each successive proof would be worse than its predecessor.' When he later made lithographs at Tamarind Institute the experience convinced him that

> ... to fight the medium is like trying to make watercolor look like oil. I think each of the various mediums has its own character or ethic, and it seems to me that in lithography you should know what can and cannot be accomplished in the technical process of printing.[121]

McNeil felt the unsympathetic attitude to prints expressed by Kline's generation had proceeded from complete ignorance as to the potential of lithography. When in 1971 he saw what Garo Antreasian and Bohuslav Horak had produced for Adja Yunkers during Tamarind's first year (10.42), it was a revelation that anyone could work so freely 'and yet achieve such an open, rich, and sensuous image.'[122]

June Wayne had intended to staff the Tamarind Lithography Workshop with her European printer so he could pass on his skills, but Durassier made impossible demands. At about the same time, she became aware of Garo Antreasian, who, working in isolation in Indianapolis, had made prints with 17 or 18 colours as expert as any she had seen in France. As June wrote to Clinton Adams, Antreasian was 'as nuts about lithography as we are' and after working with him for a week and realizing how advanced his skills were, she knew that the workshop could start as an all-American venture. And so began the experiment that Barry Walker was to describe in 1983 as 'the single most important factor in the current vitality of lithography in America.'[123]

... there was a complex and extensive relationship between artist and artisan from the beginning of lithography. In almost every case it was the artisan who extended the medium through technological innovations that made new artistic approaches desirable and accomplishable.

<div align="right">DONALD SAFF, Art Journal, 1980[124]</div>

A lithograph is ideally a collaboration between an artist and a printer (who is an artist at printing).

<div align="right">FREDERICK S. WIGHT, UCLA Art Gallery, 1962[125]</div>

One of Tamarind's most remarkable achievements was reinventing lithographic wash in an American setting and banishing secrecy about it for ever with the publication of the *Tamarind book of lithography* by Garo Antreasian and Clinton Adams. When in 1980, W. McNeil Lowry summarized the benefits that Tamarind had brought to America, he commented that the book would by itself have justified the whole of the Ford Foundation's investment.[126]

Another of the Workshop's lasting contributions was presenting the job of the printer as a real vocation; one of the book's chapters gave considerable insight into the role model of the ideal printer as conceived in the 1960s.[127] Many characteristics of the Tamarind printer profile descended directly from Mellerio: the printer was not to be intrusive, but to support and help the artist, overcoming the hitches, making the right suggestion at the right time. For although collaboration was defined as 'the ability to be civilized', some collaborators were expected to be more civilized than others. Extraordinary patience and selflessness were demanded of the printer, who was to realize that 'the artists' judgements [and] not his own are the ones that count', while the artist was never to be inhibited 'by any feeling for the convenience of the printer.' Yet alongside this demand for unobtrusive deference, the model placed a premium on inventive experimentation and showed considerable awareness of the extent to which printers would manifest their own style, adopting the individual printer's chop as a means of identifying the person responsible for helping the artist to realize the print. The workshop also inspired considerable love for lithography in those who passed through the programme.

In her catalogue for a touring exhibition of the Workshop's production, Virginia Allen described the collaborative relationship as

> ... poetry itself, evolving out of mutual need and respect. The artist must learn to communicate his aesthetic needs, even if he knows nothing about the technical language of lithography. The printer must be able to translate an artist's individual requirements into ink densities, etch strengths and rolling patterns, being careful never to cross the fine line that separates technical advice from aesthetic interference.[128]

As one who had been both artist and printer, Garo Antreasian, who returned to teaching in Indianapolis after his spell as Tamarind's first master-printer, knew that the line was almost impossible to draw. He has since written with considerable knowledge of the psychological factors, not to mention the group dynamics, affecting collaborative activity and recognizing that it entails creative input from both participants, for even when the artist appears to make the judgements

> It is the printer's vision, knowledge, and technical skill that brings the work to the state where the artist can make such crucial decisions. In so doing, the printer has tremendous creative leeway: the matrix may be processed precisely or coarsely, impressions may be printed fat or lean and onto papers that have an almost infinite range of appearance and printability ...

The artist's decisions are thus governed by what the printer allows to unfold before his eyes, although once the work is completed

> ... the printer, following prevailing custom, steps back into the shadow of virtual anonymity and the artist steps forward to bask in the light of achievement. Lip

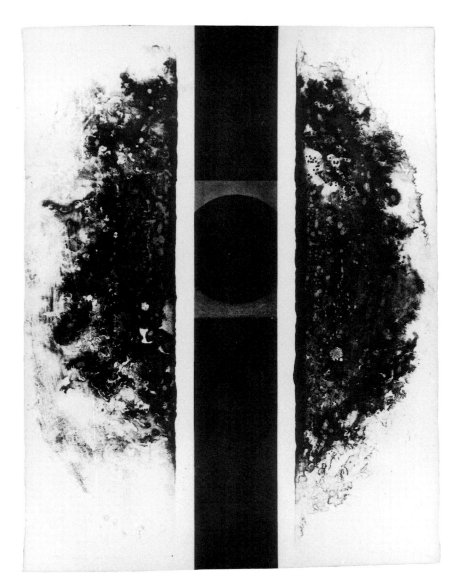

10.43 CLINTON ADAMS
Requiem, November 1963
lithograph printed by
Irwin Hollander at Tamarind
Lithography Workshop
76.2 × 56.5
Gift of Clinton Adams
in memory of John F. Kennedy
Australian National Gallery,
Canberra

service to the contrary, equal status for this curious pavane of shared achievement simply does not exist . . .[129]

The three founding members of the Workshop quickly became connoisseurs of printers' abilities, testing their progress with demanding images. Adams's *Requiem* (10.43), for example, made at the time of President Kennedy's death, was printed by Irwin Hollander who was among the first Tamarind graduates to open his own workshop. Hollander had been impressed by a particular kind of European printing brought to Tamarind by Bohuslav Horak, a Czech who had worked in Paris and could produce rich blacks and particularly subtle greys. Under his tutelage, Hollander came to believe that if 'love for the printing act itself' did not exist, then washes would go black. This necessity to 'roll with love' was also part of Durassier's ethic, which made a particular impression on Ken Tyler when the Frenchman visited Los Angeles for a month. Hollander loved being able to offer artists the possibility of opening and closing stones without getting 'duck soup'. When he teamed up with the Dutchman Fred Genis, appropriately calling their New York workshop 'Hollanders', the two men were particularly associated with the Abstract Expressionists. De Kooning, for example, made two dozen prints there, drawing direct on stone as well as cutting up

349

10.44 ROBERT MOTHERWELL
Automatism A 1965–66
lithograph printed by
Irwin Hollander
71.0 × 54.0
edition 92/100
Australian National Gallery,
Canberra

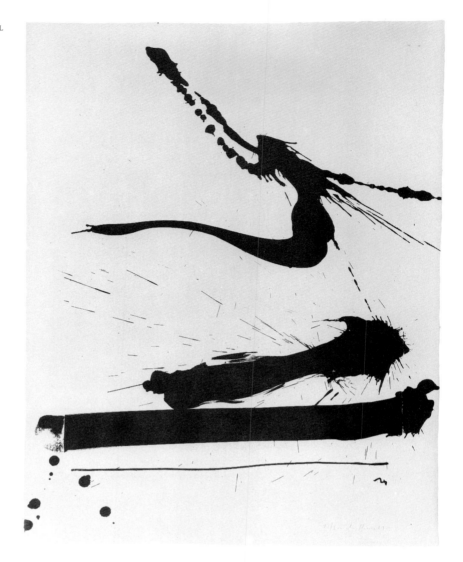

and collaging images on transfer paper.[130] Hollander was aware of the print 'as an original with a different surface (which is the collaboration)' multiplied perfectly, and thus touching fifty people rather than one.

'Meaning the economics of it?' asked an interviewer. 'No, meaning the power of it', Hollander replied.[131]

When his graphic catalogue raisonné was produced in 1980, Robert Motherwell suggested that his nine printer-collaborators (six of whom had been Tamarind-trained) should be offered an opportunity to have their say.[132] Despite some splendid lithographs made with these printers, the collaborative aspects of printmaking present particular problems for Motherwell's aesthetic, which often depends on an ideograph set down 'like a Japanese killer with the brush'[133] in an attempt to record 'the real Motherwell', fully alive at a given moment. Even simple monochrome statements (10.44), which Hollander loved to give the artist back in 'a fast serve', were not entirely unproblematic. Colourful collage prints involving many matrices and photomechanical elements only to be resolved through the hands of others made the artist feel like a foreign poet, the translation of whose work 'betrays the original text because the translator necessarily has a totally different sensibility.'[134] So although he has described printmaking as 'a way of transcending the self', Motherwell felt the need not so much

for a collaborator, as for an *alter ego* to serve him.

Although as the 'Don Juan of printmaking'[135] he seduced Motherwell into making many complex collage prints as well, Ken Tyler, who followed Hollander at Tamarind and went on to found two of the most visible American workshops, showed an intuitive understanding of this aspect of Motherwell's sensibility when he processed *The Stoneness of the stone*. He brought out every nuance of Motherwell's two exquisite and dramatic gestures and returned them to the moment when the artist made them, by imposing them on a paper exactly recapturing the limestone surface on which they were first drawn.

1.23

Tyler has broken most radically with the concept of the retiring and unintrusive printer. His first shop in Los Angeles opened in the mid 1960s when interest in a rapprochement between art and technology was at its peak. He had cut his teeth at Tamarind on the work of Josef Albers, an artist who believed the 'machine-made' to be as capable of arousing emotion as the handmade. This apparent embrace of an 'industrial aesthetic', which was belied by the work, challenged romantic curatorial expectations of 'originality', particularly when Albers authorized Tyler to draw all future plates for him, using the proportions indicated on a graph-paper drawing. The artist's deceptively simple *White line squares* helped Tyler establish Gemini G.E.L. in 1966 as a publishing house rather than as a custom workshop. The portfolio was so

col. pl. 4

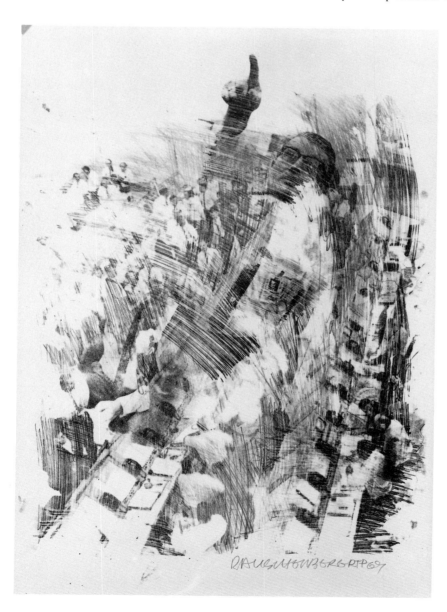

10.45 ROBERT RAUSCHENBERG
Sky rite 1970
from the *Stoned moon* series
1969–70
lithograph printed by Ron
Adams at Gemini G.E.L.
85.0 × 59.0
right to print proof (edition 56)
Australian National Gallery,
Canberra

taxing that to print it required a special hydraulic press, protracted colour mixing, months of research to develop appropriate paper and inks which did not bleed, endless ingenuity to abut the squares within squares without overlap, and finally the formidable skill to print uninflected colour flats with rollers narrower than the areas to be inked. Tyler, who on occasion had to mix 35 blues to find the one Albers wanted, said he adored the activity.

Tyler also worked with the arch-collaborator, Robert Rauschenberg. Claiming a 'non-ego approach to life', Rauschenberg conspires in an impromptu way not only with people, but with materials, a 'strong believer that two people having good ideas can produce more than two people with good ideas can produce separately.'[136] In 1969–70, during a period of frenetic activity, the artist and the Gemini printers worked round the clock to create 33 prints celebrating the American moon landing. The suite, which the artist called *Stoned moon*, included a lithograph said at the time to be the largest hand-pulled lithograph ever made. *Sky rite* (10.45), a modest monochrome example from the series, can be interpreted as a paradigm for the artist-star's achievement through the help of collaborators, for it celebrates the ground staff without whom no one can make it to the moon; Rauschenberg made a special print for each of the eleven people who worked with him on the project.

In 1973 Tyler left Gemini G.E.L. and moved to the east coast where he founded Tyler Graphics, now in Mt Kisco, north of New York. Here he has continued to astound with the fertility of his invention and affront those who insist that the printer should be selfless and retiring. It is fair to say that without him Rauschenberg's *Booster*, Frank Stella's *Circuits* and *Swan engravings* and David Hockney's *Paper*

10.46 DAVID HOCKNEY
Potted daffodils 1980
lithograph printed by
Ken Tyler
right to print proof
(edition 98)
112.0 × 76.0
Australian National Gallery,
Canberra

10.47 DAVID HOCKNEY
An image of Ken 1985
lithograph printed by Ken Tyler
70.0 × 49.8
right to print proof (edition 20)
Australian National Gallery,
Canberra

pools would not exist. Adams, pointing this out, has remarked that no other printer has so changed the character of the contemporary print.[137] The ability to respond to this degree of obvious intervention, however, requires an artist whose ego is not fragile; in a recent interview, Adams asked the artist Steve Sorman, who worked with Tyler in 1984–85, how he had reacted to the printer's 'creative collaboration.' Replying that it had seemed 'a very active kind of conversation', Sorman said:

> People continue to get real nervous about that sort of thing. I find that curious because in other media it's not that way. Writers have editors, film-makers work with directors and producers ... But somehow there's a certain kind of threat to ego that prevents artists from being a little more generous ... Ken ... is an extremely creative, energetic person. He creates an environment in the shop that does everything to facilitate a dialogue, a multifaceted dialogue: the artist to the printer, the printers to each other, the printers to the artist. It's really quite fascinating.[138]

A large part of Tyler's gift lies in making artists on 'Candid Camera' feel at home; a vase of flowers in a room setting, for example, puts David Hockney at his ease (10.46). In an attempt to increase lithographic immediacy, Tyler also developed materials for use on transparent sheets for photochemical transfer to screenless plates, thus introducing the separation of colours as a natural part of the drawing process. This possibility captured Hockney's imagination at the moment he was exploring the limitations of one-point perspective as a way of perceiving the world (10.47). At the same time it offered him a tool for some extremely rich and complex colour prints so that in just over two years he was able to draw 350 plates for 17 editions. Hockney, who believes he has done some of his best work with Tyler, said of him:

10.48 JAMES ROSENQUIST
Dog descending a staircase
1980–82
colour lithograph and
aquatint
printed at Universal Limited
Art Editions
101.4 × 160.4
edition 13/33
Australian National Gallery,
Canberra

> I think collaborators are quite rare, actually. They are. Because a collaborator is offering you something and then you offer him something back. That's how it must work, isn't it? And with somebody like Ken, what he's offering you, is something you couldn't do on your own, something you don't even know about.[139]

Many of the prints Tyler now publishes run the gamut of technique, the artist choosing whatever is appropriate for the kind of mark envisaged. The printers are consequently not so much specialists in lithography or any other process, as professional collaborators. This has made some prints so complex that Tyler has had to become his own historian. The new catalogue raisonné of his shop's output, building on the ethical standards introduced at Tamarind, spells out in quite unprecedented detail the exact involvement of each printer in the platemaking, the nature of every technique, and even the character of the presses.[140]

Although Tamarind graduates have dominated lithographic printing in the United States, some remarkable American printers were trained elsewhere. Among them is Bill Goldston, who after Tanya Grosman's death took over the running of Universal Limited Art Editions. Goldston was introduced to lithography by his teacher Zigmunds Priede at the University of Minnesota and Priede, who worked at U.L.A.E. in his vacations, invited Goldston to join him in the late 1960s. From the moment he discovered lithography, Goldston fell in love with it: 'I thought [the stone] offered a certain element of drawing and I loved the fact that you could paint on it . . .'[141] He has also found that prints, unlike painting, offer the possibility of pursuing a stroke

> . . . by printing it again and again and again—to see what its real possibilities are in various technical situations . . . And prints then become something other than just multiple copies of a nice image. The printing *act* becomes very creative and very interesting.[142]

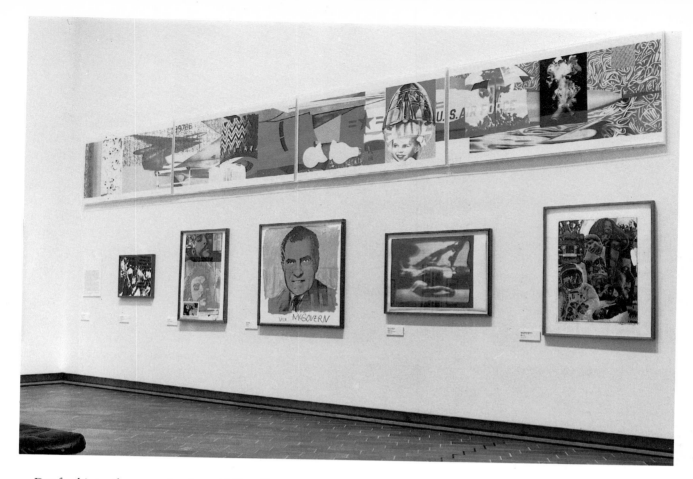

10.49 Installation shot of the four-panel lithograph Fiii of 1974 by James Rosenquist printed by Maurice Sanchez 91.5 × 732.5 overall colour trial proof 2 (edition 75) Australian National Gallery, Canberra

Drafted into the army in the middle of his studies, Goldston passed overnight from art school stone lithography to an Army print shop where millions of impressions poured each month from four offset presses. Since Tanya Grosman, like most other American publishers, had for years been teaching that offset lithography was not art, it produced all kinds of tensions when Goldston, by then her employee, suggested using it at West Islip. Partly through Jasper Johns's involvement in the superb offset lithograph *Decoy*, and partly through the 'incredible trust' that Tanya Grosman came to place in Goldston, U.L.A.E. was transformed from a workshop using extremely basic strategies, to one able to cope with the highly sophisticated complexities of mixed media prints like Rosenquist's *Dog descending a staircase* (10.48). While Rosenquist did much of his best work at U.L.A.E. he also worked with several other printers, among them yet another Tamarind graduate, Maurice Sanchez. Sanchez spent three years on the enormous mural project *F-111* (10.49), and enjoyed the close relationship with one creative individual, describing the necessary rapport as similar to that required by dancing partners. The enormous print is typical of the scale and ambition that collaborative printmaking has engendered, but also points to one of the problems of such activity, which is necessarily confined to those artists whose market value can sustain the expense.

Jasper Johns, who has worked with printers all over the world, believes that when they are trained as artists it is beneficial to collaboration because it makes them more sympathetic. Certainly this is true of most of today's printers in the United States, although it is also the case that throughout the history of lithography, the greatest printers—Hullmandel, Clot and Mourlot, for example – knew how to draw. Johns is often fascinated by, and trades on, the way that both artist and printer work in relation to what each thinks the other can do, so that the image is modified accordingly.[143] Nothing could demonstrate this point more clearly than comparing the warm and rather painterly small-scale prints featuring numerals that the artist crafted early in

Tanya Grosman's enterprise with the large and complex *Color numeral series* made when Tyler was at Gemini (10.50). These prints demanded outstanding technical skill to give back every nuance of the layered washes and a 'rainbow roll' on such a scale that an automatic inking device had to be invented.

The rainbow roll had found its way to the west coast of America when Man Ray worked with Lynton Kistler in 1948.[144] It later became one of Tamarind's hallmarks. June Wayne, who loves and hates it simultaneously, remarks that 'it passed like Asian flu from artist to artist.' She uses it sparingly herself when it is appropriate to convey vast distances, as in her work on solar winds (col. pl. 48). *Desert wind*, a subtle combination of sweet and astringent colours inevitably subverted by reproduction, required extraordinary skill on the part of her printer, since he had to control the delicately graduated merge and calculate ink absorption into the dark paper while retaining the exquisite sensuousness of the surface. Such an achievement is only

See also cover

10.50 JASPER JOHNS
Figure 1
from *Color numeral series* 1969
colour lithograph printed by
Dan Freeman at Gemini G.E.L.
72.0 × 55.0
right to print proof
(edition 40)
Australian National Gallery,
Canberra
© Gemini G.E.L.

possible with the assistance of a printer like Edward Hamilton, who daily practises his craft.

June Wayne is fortunate in being among the select few who enjoy the ideal long-range collaboration of a personal printer working on a regular basis, so that 'the artist finds it unnecessary to complete sentences because the printer already understands.' Although Hamilton finds it ironic that artists, curators, publishers or donors may all be named in exhibition catalogues which give no recognition to printers 'who actually put their lives into a print', he is not disturbed by anonymity because he thinks art should be less about ego and more about love. In his work, he practises Tai-chi-chuan, a series of repeated movements which come closer and closer to an ideal, so that rolling ink, which to some might appear boring or even beneath them, becomes a striving for perfection, rather like the movement of a dancer at the bar. In fact the art of lithography for Hamilton is

10.51 RICHARD DIEBENKORN
Serge 1984
lithograph printed by
Serge Lozingot at Gemini G.E.L.
89.2 × 69.0
edition 12/26
Australian National Gallery,
Canberra

... the experience of the printing, the collaboration, the physical labour, the process, and the dance of repetition, which leads towards perfection.[145]

Hamilton has occasionally worked in some of the west coast workshops, particularly Cirrus, run by another Tamarind graduate, Jean Milant. The shop is named after the highest cloud in the atmosphere and Milant's printing style is said to be appropriately 'light and airy'. As an imaginative publisher, however, Milant now spends less time at the press. His philosophy of collaboration entails 'inventing methods and materials as the need arises'[146] and this engages him in all kinds of entrepreneurial activity; one of his publications, for example, required him to round up American rag merchants for all the white tablecloths they could find when Vija Celmins needed a particular handmade linen paper.

Not every printer wants his own workshop. Since Tyler's move east, Serge Lozingot has been chief printer at Gemini, and feels if he branched out on his own he would be 'at a desk, calling people, having meetings and neglecting the thing I love to do most: printing.'[147] Adams says Lozingot is one of the finest printers in America and 'can do more psychologically to make the artist feel good about his work than anyone else.' He is also renowned for his fidelity in processing washes, so much so, that Diebenkorn named one of his lithographs *Serge* after him (10.51). Other printers often express admiration for this ability, for the aesthetic of a print can be substantially affected by the manner in which the ink is imposed. Some printers like a lush fullness, others prefer

10.52 JEAN DUBUFFET
Impermanence 1959
from *Phénomènes* [*Phenomena*]
lithograph printed by
Serge Lozingot
50.2 × 38.1
edition 10/30
Australian National Gallery,
Canberra

it to be light and lean. Lozingot's ink, says Sanchez, who is one of his admirers, 'kisses the paper.'[148]

Lozingot had an extremely unusual apprenticeship in the fine arts, working as personal printer to the French artist, Jean Dubuffet. Dubuffet embarked at the beginning of the 1950s on the extraordinary project *Phénomènes [Phenomena]* (10.52), a series of albums in which he entered 'wholly into the discipline of lithography', creating a lexicon of textures by obtaining random impressions from the world at large. Using only a roller, he inked such unlikely surfaces as threads, crumbs, soil, or the bare back of a friend, and took impressions on transfer paper for onward transmission to plates. His initial experiments with various assistants produced nothing of value 'except ironic looks on the printer's face'. This convinced Dubuffet that he needed to recruit printers who would be

> ... favorably disposed to my views, therefore prepared to lend themselves to work emanating from a spirit rather different from that ordinarily found among lithographers.[149]

Lozingot, trained as a commercial printer by the French orphanage in which he was raised, was the only one who passed Dubuffet's stringent scrutiny. When their extraordinary contribution to lithography was recognized through yet another Tamarind initiative,[150] it resulted in one more fine European printer being lured to America for good.

In 1974 the last barrier went down, and, entering a previously all male preserve, Judith Solodkin became Tamarind's first 'mistress-printress'. She too now runs her own workshop in New York. During her apprenticeship in Albuquerque, she expressed her lively sense of humour by wearing a frilly apron rather than heavy duty overalls. Loving the actual activity of printing no less than any man, she has particularly enjoyed collaborating with the experienced graphic artist, Robert Kushner, because

> I don't have to explain how to go from A to B. He already knows and has gone on to C. Then I am flying off to D and E. So the print medium becomes extremely fluid ... He says 'Can you do this?' and I say: 'Yes!' and then I have to figure out a way to do it.[151]

Spaghetti as a resist and Fresca soda to extend the lithographic drawing medium are among the ways her sense of humour has manifested itself in Kushner's equally extroverted work.

col. pl. 30

When *Print Collector's Newsletter* published its register of printers in 1983, it revealed that there were now 163 workshops in the United States, 95 of which offered lithography.[152] In less than a quarter of a century, America had been transformed from a country with one or two artists' printers to one offering greater opportunities for collaboration than the world has ever seen, and a group of printers able to offer not only their heads and hands, but also their hearts.

It is one of life's ironies that even as the separation between the inspiration and the realization of a lithograph was being institutionalized, it became clear that concept and technique may be separated, but never divorced. For although the printer's contribution was in the past suppressed to preserve the ego of the romantic artist and the notion of 'originality', as Robert Hughes has rightly observed there is really 'no clear division between *cose mentale* and *cose manuale*.'[153] History confirms that lithographic printers have always been more than a pair of hands carrying out another person's ideas and, in some cases, have contributed as creatively as the artist to the work. As the myth of the lonely artist as hero has been eroded, a better appreciation of both sides of the lithographic partnership has developed and grown. Tamarind created a passion for lithography: no longer the service of a subservient geisha, nor yet the arranged marriage of Victorian wedlock, collaboration appears at last in its true colours, an association of equals united by love.

Notes

INTRODUCTION: C. LEAHY/FELIX MAN

1 John Pope-Hennessy in the foreword to *Homage to Senefelder*, London, Victoria and Albert Museum 1971–72.
2 Correspondence from Felix Man to the Australian National Gallery, 1 October 1973.
3 Tom Hopkinson, 'Felix Man', *British Journal of Photography*, 4 February 1977, p. 105.
4 Felix H. Man, *150 years of artists' lithographs*, London 1953.
5 Felix H. Man, 'Lithography in England, 1801–1810' in *Prints*, ed. Carl Zigrosser, New York 1962.
6 Felix H. Man, *Artists' lithographs: A world history from Senefelder to the present day*, London 1970.
7 Felix H. Man, *The complete graphic work of Graham Sutherland, 1922–1969*, London 1971.
8 Man correspondence, see note 2.
9 Ibid.
10 Ibid.
11 Ibid.
12 Ibid.
13 Felix H. Man, *Artists' lithographs*, p. 22.

1. C. ADAMS/NATURE OF LITHOGRAPHY

1 Robert Motherwell quoted in Stephanie Terenzio, *The Prints of Robert Motherwell*, New York 1984, p. 89.
2 Alois Senefelder, *A complete course of lithography*, London 1819; rpr. 1977. Although a contemporary note in *Gentleman's Magazine* cites Senefelder as the translator of the English edn. of his treatise, the British Library catalogue entry says: 'trans. from the German by A.S. [i.e. Antonin Schlichtegroll]'. Frédérick von Schlichtegroll wrote the preface to the treatise. [The editor is indebted to Michael Twyman for this information.]
3 See Michael Twyman, *Lithography 1800–1850*, London 1970, p. 11, n. 3. Twyman's book is the best source of information in English about the early history of lithography; it includes a comprehensive bibliography.
4 The name of Jean-Auguste Dominique Ingres would find its place in this list were it not for the controversy that surrounds the *Four portraits* (1815). Felix H. Man, in *150 years of artists' lithographs*, London, Melbourne and Toronto 1953, pp. xx–xxiii, and *Artists' lithographs: A world history from Senefelder to the present day*, New York 1970, pp. 35–36, argues that these portraits were drawn on stone by Ingres; Hans Naef, 'Ingres as Lithographer', *Burlington Magazine* Sep. 1966, pp. 476–79, summarizes research which concludes they were not.
5 Twyman, *Lithography 1800–1850*, p. 56.
6 W. McAllister Johnson, *The Restoration Salons 1817–1824*, Kingston, Ontario: Agnes Etherington Art Centre, 1977, p. 8.
7 For a brief biography, see *Aloys Senefelder, 1771–1834*, Philadelphia: Paley Library, Temple University 1972. Carl Wagner's *Alois Senefelder: Sein Leben und Wirken*, Leipzig 1914; 2nd edn. 1943, is the only full biography. Senefelder and his contemporaries appear to have used the spellings Alois and Aloys (Aloisius) indiscriminately.
8 Senefelder, *Complete course*, p. 256.
9 Charles Hullmandel, *The Art of drawing on stone*, London 1824; 2nd edn. 1833; 3rd edn. 1835, pp. v, vii.
10 Ibid., p. ii.
11 Twyman, *Lithography 1800–1850*, p. 187.
12 See Gustave von Groschwitz, 'The prints of Thomas Shotter Boys', in Carl Zigrosser, ed., *Prints*, New York, Chicago and San Francisco 1962. Although Boys's lithographs were the first original works by an artist to be printed in colour, exploration of reproductive colour printing had begun much earlier. Senefelder began to print in colour as early as 1808 and in 1817 printed *Bulgarian Fair*, a twelve-stone lithograph. In 1837 Godefroy

Engelmann applied to patent a system of three-colour printing and later (c. 1838) published the *Album chromolithographique*. Despite earlier work by Senefelder (and others), chromolithography is often considered to have begun with the Engelmann patent.
13 For a discussion of Hullmandel's patent and the yet unsolved mysteries that surround his lithotint process, see Twyman, *Lithography 1800–1850*, pp. 145–53.
14 See Gavin Bridson and Geoffrey Wakeman, *Printmaking & Picture Printing, a bibliographical guide to artistic & industrial techniques in Britain 1750–1900*, Oxford and Williamsburg 1984. Louise Sperling and Richard S. Field, *Offset lithography*, Middletown, Conn.: Davison Art Center, Wesleyan University 1973, briefly outlines the developments in lithographic technology.
15 Existing general histories of lithography, Man, *150 years*; Man, *Artists' lithographs*; and Wilhelm Weber, *A History of lithography*, New York, Toronto and London 1966, deal less than adequately with the mid-19th century. Both Man and Weber give disproportionate emphasis to the early history of the medium; neither provides more than cursory information about 20th century lithography. Weber is at his best when discussing the work of German artists, but there are curious omissions; for example, he omits Rodolphe Bresdin and mentions Henri Fantin-Latour, Odilon Redon and Felicien Rops only in passing; he illustrates works by none of them. The literature of lithography remains in need of a comprehensive and well balanced general history.
16 Richard T. Godfrey, *Printmaking in Britain, a general history from its beginnings to the present day*, New York 1978, p. 106.
17 For a discussion of the lithographs made by American artists in the 19th century—among them Thomas Cole, William Morris Hunt and Thomas Moran—see Janet Flint, 'The American painter-lithographer', in *Art and commerce: American prints of the nineteenth century*, Charlottesville, Va. and Boston Museum of Fine Arts 1978.
18 See Peter C. Marzio, *Chromolithography, 1840–1900: The democratic art*, Boston 1979, and Harry T. Peters, *America on stone: The other printmakers to the American people*, New York 1931.
19 Odilon Redon, *To myself*, New York 1986; trans. of *A soi-même*, Paris 1922, 1979, p. 107.
20 Although the principles of lithographic printing are simple, it is in practice so complex and sensitive a task that from the beginning most artists have made their lithographs in collaboration with professional printers. This and the preceding paragraph are restated from a more detailed discussion of these developments in Clinton Adams, *American lithographers, 1900–1960: The artists and their printers*, Albuquerque, N. M. 1983, pp. 6–7.
21 The concept of 'truth to materials' was forcefully stated by Henry Moore (see 'The sculptor's aims' in Herbert Read, ed., *Unit One*, London 1934). Stanley William Hayter's concern for the 'graphic' nature of the print rests upon this concept.
22 For technical information about transfer lithography see Garo Antreasian and Clinton Adams, *The Tamarind book of lithography: Art & techniques*, New York 1971, pp. 227–53.
23 Redon, *To myself*, p. 108. Many of Redon's lithographs, though begun as transfer drawings, were extensively reworked after transfer to the stone.
24 Walter Sickert, 'Transfer lithography', *Saturday Review*, 26 Dec. 1896. Following publication of Sickert's letter, Pennell brought suit against him. In April 1897 the court decided as a matter of law that transfer lithography was indeed lithography and the jury awarded Pennell £50 in damages. For an account of the Pennell-Sickert trial from the Pennell point of view, see Joseph and Elizabeth Robins Pennell, *Life of Whistler*, London and Philadelphia 1908, vol. ii, pp. 186–92.
25 See page 40.
26 For information about Bolton Brown see Clinton Adams, 'Bolton Brown: artist-lithographer', in David Tatham, ed., *Prints and printmakers of New York State, 1825–1940*, Syracuse, N.Y. 1986.

Although in the century that followed publication of Senefelder's and Hullmandel's pioneering works a very large number of technical manuals appeared, most were written for commercial lithographers. Brown's *Lithography for artists*, Chicago 1930, was the first American technical manual to be directed specifically to artists; others used by artist-lithographers were W.D. Richmond, *The Grammar of lithography*, London 1878; 2nd edn. 1800; 12th edn. *c.* 1901; and David Cumming, *Handbook of lithography*, London 1905; 2nd edn. 1919, 3rd edn. 1932; rpr. 1946.

27 Joseph Pennell, 'The Truth about lithography', *Studio* 1889, p. 38.

28 Joseph Pennell, *Lithography*, New York 1912, p. 6.

29 Bolton Brown, 'Pennellism and the Pennells', *Tamarind Papers* 7, 1984, p. 54.

30 A primary reference for the study of colour lithography in the late 19th century is Phillip Dennis Cate and Sinclair H. Hitchings, *The Color revolution: Color lithography in France*, 1890–1900, Santa Barbara, Calif., and Salt Lake City, Utah 1978. It includes an excellent bibliography and an English translation of André Mellerio, *La Lithographie originale en couleurs*.

31 M. Thiebault-Sisson, *Le Temps*, 5 Nov. 1897, quoted by Mellerio in Cate and Hitchings, p. 98, n. 3.

32 Henri Lefort, quoted by Mellerio, ibid.

33 Mellerio, ibid., pp. 80–81.

34 Ibid., pp. 93–94. Mellerio provided short notes on several of the principal colour printers of the 1890s. A comprehensive study of the work of these printers would be a welcome addition to the literature.

35 Ibid., p. 94.

36 Senefelder began relief printing from stone before his discovery of chemical printing. The fact that he used the generic term 'stone printing' (*Steindruck*) to describe both methods caused confusion as to the date of his invention; the centennial exhibitions thus ranged through several years: Paris 1895; New York 1896; Philadelphia 1896; and London 1898.

37 Called *dessin à la pointe* by F. Mairet, who described the process in *Notice sur la lithographie*, 1818, stone engraving was seldom used by artists, perhaps because they perceived it to be a process that imitated the character of etching. See also Clinton Adams and John Sommers, 'Dessin à la pointe: lithographic stone engraving', *Tamarind Technical Papers* 1, 1974, pp. 1–4.

38 Given the extent of the literature, it has not been possible in this essay to consider more than a fraction of it. References are limited to books, articles, and exhibition catalogues which focus upon lithographs made by artists, and written in or translated into English.

39 As examples of books and catalogues in which such integration is achieved (in varying degree), three might well serve as models for others: Edward Lucie-Smith, *Fantin-Latour*, Oxford 1977; Frederick B. Deknatel, *Edvard Munch*, New York 1950; and James Thrall Soby, *Georges Rouault, paintings and prints*, New York 1945. Soby's essay on Rouault's paintings is supplemented by an excellent short study of the prints written by Carl O. Schniewind.

40 Quoted by William Lieberman in Andrew C. Ritchie, ed., *German art of the twentieth century*, New York 1957, p. 192.

41 Examples are provided in works cited above (see note 39). Lucie-Smith's juxtaposition of Fantin-Latour's great lithograph *The Bouquet of roses* with paintings of similar subjects demonstrates that the rich and vibrant texture of the lithograph reveals more of the artist's presence than does the polished surface of the paintings. The processes of lithography, as employed by Fantin in *Roses*—drawn first with chalk on transfer paper, then further developed (after transfer) by drawing on and scratching into the stone—are indispensable to the character of his print. Similarly, in the Deknatel catalogue, Munch's *The Shriek*, a lithograph starkly drawn in black and white, makes a statement different from but in every sense as forceful as his painting of the same title. Together, the two works tell us more of Munch's response to 'the shriek of nature' than does either image alone.

42 In America, the identification of colour lithography with popular chromolithography (as discussed by Marzio and Peters; see note 18) caused artists to reject its use for original prints. Although the centenary exhibition of lithography in New York in 1896 included 244 lithographs, none was in colour. The catalogue stated an intent to present 'at some time in the future . . . an exhibit of artistic color-printing and general commercial work, accompanied by the implements of the art and trade'. Grolier Club, *Catalogue of an exhibition illustrative of a centenary of artistic lithography*, New York 1896, p. 26.

43 Joseph and E. R. Pennell wrote in *Fortnightly Review*, Dec. 1898, p. 983, that 'lithography has been killed by the Trades' Union.' If not killed, it had certainly been maimed. Even in the 20th century,

artists' printers – particularly those who employ offset presses – have been pressed by printers' unions to work within their rules.

44 Campbell Dodgson and Joseph Pennell, *The Senefelder Club*, London 1922, p. 15.

45 George C. Miller first opened his New York workshop in 1917 but soon thereafter entered military service; he resumed work in 1919. Also in 1919, Bolton Brown opened a workshop in New York. See Adams, *American lithographers*, pp. 17–34.

46 Quoted by Weber, *History of lithography*, p. 113, from an article written by Kirchner (under the pseudonym Louis de Marsalle), 'On Kirchner's graphic works', in *Genius*, 1921.

47 In a provocative article, 'Bad printing', John Loring argued that there are many instances in the 20th century of 'bad printing making good art' and, conversely, of printing which achieves an inappropriate technical perfection 'even when not indicated by or in keeping with artistic content'. *Print Collector's Newsletter*, Mar.-Apr. 1975, pp. 1–3, 21.

48 French printers, particularly Edmond Desjobert, were more open to the use of experimental techniques during the 1920s and 1930s than were their American contemporaries. Among American artists, the greatest technical range is found in the work of Adolf Dehn, who made more than 600 lithographs in collaboration with printers in Austria, Germany, France and the United States; see Clinton Adams, 'Adolf Dehn: The lithographs' in Thomas O' Sullivan, ed., *The Prints of Adolf Dehn, a catalogue raisonné*, St Paul, Minn.: forthcoming.

49 Arthur B. Davies made some colour lithographs, reminiscent of Whistler, in collaboration with George C. Miller in the 1920s. The Federal Arts Project workshop in New York, under the direction of Gustave von Groschwitz, actively encouraged work in colour in the mid-1930s. See Adams, *American lithographers*, pp. 123–26.

50 Adequate study has not been given to the history of autographic offset lithography, that is, offset lithography printed from hand-drawn plates and not reproductive in intent. Within the little that has been written, the pioneering efforts of the 1930s are too often overlooked; for example, the statement in Sperling and Field, *Offset lithography*: 'Only during the past few years has it [offset lithography] been employed for "fine" or "original" prints.'

51 For a description, see Peter Morse, *Jean Charlot's prints: A catalogue raisonné*, Honolulu 1976, pp. 84–90; also Adams, *American lithographers*, pp. 100–04.

52 See Janet Flint, *Art for all*, Washington, Smithsonian Institution 1980; also Adams, *American lithographers*, pp. 147–49.

53 See Pat Gilmour, *Artists at Curwen*, London, Tate Gallery, 1977; also Gilmour, 'Unsung Heroes: Barnett Freedman', *Tamarind Papers* 8, 1985, pp. 15–24.

54 Carl Zigrosser, *A World of art and museums*, Philadelphia 1975, pp. 56–57. Throughout a long career, first at the E. Weyhe Gallery in New York then as curator of prints at the Philadelphia Museum of Art, Zigrosser was America's most effective spokesman for the contemporary print.

55 There are exceptions to this generalization; some significant modernist prints were made in America during the 1940s. Even so, Will Barnet accurately reflected the prevailing attitude among avant-garde artists of the 1950s when he said that in the postwar years 'the graphic medium was considered the lowest possible way of expressing yourself' (interview, Adams with Barnet, 22 Sept. 1979).

56 Picasso made his early lithographs (Mourlot I–XXVII) in a conventional chalk or pen manner; he did not use the medium between 1930 and 1945.

57 According to Brigitte Baer in *Picasso the printmaker*, *Les deux femmes nues* (Mourlot 16) was carried through more than 21 states, *Le Taureau* (Mourlot 17) through 14, *David et Bethsabée* (Mourlot 109) through 12. The technical difficulty of printing from stones so radically modified attests to the great skill and patience of the printers; witness Fernand Mourlot's comment with respect to the sixth state of *David et Bethsabée*:

> After lying in a corner of the studio for almost one year the zinc is re-worked by Picasso. Fine work with scraper. Once again the plate is abandoned. The zinc is extremely hard and has to be deeply scraped so that the printer can ink the plate without obliterating the fine lines. The zinc has suffered serious damage (Picasso's right hand has also suffered somewhat). A transfer to stone is made from this last state without polishing out the zinc, that old work companion. There are therefore in the artist's studio, the zinc and the stone, both well known to visitors, but for 6 months neither of them was touched. (Fernand Mourlot, *Picasso lithographs*, Monte Carlo 1970, cat. no. 109, p.81.)

58 Although the influence of Picasso's lithographs was profoundly affirmative, this cannot be said of all work done in the Parisian

workshops. When after World War II it became evident that modernist lithographs could be sold at high prices, the workshops responded by publishing a flood of editions drawn either partially or entirely by 'colourists'. These editions often bore the names, and sometimes the signatures, of leading modernist artists.

59 Antreasian, in conversation, 7 Mar. 1987. Tyler has likewise acknowledged the central importance of Picasso's work; see Gilmour, *Ken Tyler—Master printer*, p. 15.

60 By 1958 such influential American lithographers as Lawrence Barrett, Theodore Cuno, Lynton R. Kistler and Margaret Lowengrund had either died or abandoned hand-printing. Simultaneously, intaglio printmaking, stimulated by Stanley William Hayter's Atelier 17 and the postwar establishment of a number of university workshops—foremost among them, that of Mauricio Lasansky at the University of Iowa—had gained ascendancy.

61 For Tamarind, see Adams, *American lithographers*, pp. 193–203; Elizabeth Jones-Popescu, 'American lithography and Tamarind Lithography Workshop/Tamarind Institute', unpublished Ph.D dissertation, University of New Mexico, 1980; *Tamarind: Homage to lithography*, New York, Museum of Modern Art, 1969; and Lucinda H. Gedeon, *Tamarind: From Los Angeles to Albuquerque*, Los Angeles, Grunwald Center for the Graphic Arts, 1984.

62 For U.L.A.E., see E. Maurice Bloch, *Words and images*, Los Angeles, Grunwald Center for the Graphic Arts, 1978; Tony Towle, *Contemporary American prints from Universal Limited Art Editions/The Rapp collection*, Toronto 1979; and Esther Sparks, *Universal Limited Art Editions: A history and catalogue raisonné*, Chicago, Art Institute of Chicago: forthcoming.

63 Pat Gilmour, *Ken Tyler—Master printer*, p. 28.

64 Tyler has said: 'People like to think that Ken Tyler invents things; he just robs history' (Tyler, quoted by Elizabeth Jones-Popescu, *American lithography*, p. 231).

65 For description of technical developments at Gemini G.E.L., see Riva Castleman, *Technics and creativity, Gemini G.E.L.*, New York, Museum of Modern Art 1971; Ruth E. Fine, *Gemini G.E.L.; Art and collaboration*, New York 1985; and Gilmour, *Ken Tyler—Master printer*.

66 Developed in the 19th century, the blended-inking method merges two or more inks on the inking roller to create an area of continuously shifting colour. Jean Charlot and Man Ray used it in the 1940s (see Adams, *American lithographers*, pp. 176–77), but not until large-diameter rollers were developed in the 1960s was it possible to ink blended tones over a substantial area. Antreasian's *Quantum suite*, 1966, a tour de force in the use of blended inking, predates Johns's better known *Color numeral series*, 1969, by three years.

67 See Pat Gilmour, *Artists at Curwen*, pp. 95–107.

68 See Pat Gilmour, 'Curiosity, trepidation, exasperation … salvation!! Ceri Richards, his Australian printer, and Stanley Jones', *Tamarind Papers* 10, 1987, pp. 28–37.

69 Gilmour, *Artists at Curwen*, p. 102.

70 Lawrence Alloway dates the beginning of Pop Art from Eduardo Paolozzi's exhibition, Parallel of Life and Art, at London's Institute of Contemporary Arts in 1953. See Alloway, 'The Development of British Pop', in Lucy R. Lippard, *Pop art*, London and New York 1966, pp. 27–67.

71 Ibid., p. 66.

72 Kenneth Tyler, quoted by Gilmour, *Ken Tyler*, p. 36.

73 Gilmour, ibid.

74 Image-transposition is the reversal of light and dark values. See Garo Antreasian and Clinton Adams, *The Tamarind book of lithography*, pp. 404–08, also John Sommers, 'Polymer transposition,' *Tamarind Technical Papers* 1, 1974, pp. 13–20.

75 There is no necessary connection between the kind of plate that is used and the press upon which it is printed; many diazo plates are printed by hand. Even so, there is in practice a linkage between the use of light-sensitive materials and the offset press; very few offset lithographs are now printed from hand-drawn plates (as was Charlot's *Picture book*); most are printed from diazo plates. Offset lithography is not a different manner of lithography; it is simply a different mechanical method for movement of ink from the plate (or stone) to a sheet of paper. There are many technical differences between direct and offset printing, but the principal advantage offset offers to the artist is avoidance of left-right image-reversal when printing.

76 Both positive- and negative-working plates are used. Positive-working plates reproduce the values of the drawing as it appears on the Mylar transparency; negative-working plates provide a light-to-dark transposition.

77 Diazo lithography was also used to creative ends by Eugene Feldman, who used 'photography as freely as a painter uses a brush', while avoiding 'preconceptions about what can be done in lithography' (Alan Fern, *Eugene Feldman prints*, Washington, D.C., Corcoran Gallery of Art, 1967). The artists associated with A.R.T. (Art, Research, Technology, Inc.) in Amherst, Massachusetts, have used these processes in diverse images involving both hand-drawn and photographic plates; see *Offset prints*, South Hadley, Mass.: Mount Holyoke College Art Museum 1977.

78 See Mel Hunter, *The new lithography*, New York, Cincinnati, Toronto, London and Melbourne 1984.

79 An example is provided by the exhibition catalogue, *The Tyler offset workshop*, Philadelphia, Tyler School of Art, 1981, which includes prints ranging from lithographs 'hand separated on Mylar by the artist' (James McGarrell), to prints employing 'halftone from original art work' (Chuck Close). Although the catalogue in each case provides full information about the processes employed, the distinction between original and reproductive work is blurred by their side-by-side presentation. The Close print, clearly identified as a 'facsimile reproduction of an original drawing', is nonetheless signed and numbered and bears the artist's chop.
The problem is greater when the diazo and offset processes are used to publish prints without full disclosure of their origins. Through the use of Mylar transparencies laid over photographs, 'hand-drawn reproductions' are made by colourists; when such prints are hand-numbered and signed, as in the case of numerous lithographs attributed to Salvador Dali, the confusion is complete.

80 Frank Stella, quoted by Gilmour, *Ken Tyler*, p. 128.

81 Ken Tyler, quoted by Gilmour, ibid.

82 Barry Walker, *Public and private: American prints today*, Brooklyn, Brooklyn Museum, 1986 p. 10.

83 Ibid., p. 19.

84 See note 1.

2. M. TWYMAN/HULLMANDEL

1 A short note on Hullmandel, which included a small reproduction of the portrait shown here, is found in one of a series of articles by P. B. Watt, 'The rise and progress of lithography in Britain' in the *British lithographer*, vol. 1 no.2, Dec.-Jan. 1891–92, p.23. The first serious attempt to piece together Hullmandel's contribution to the development of lithography was published in the catalogues of the Abbey Collection of topographical books, and particularly in the notes to *Twenty-four views of Italy*; J. R. Abbey, *Travel in aquatint and lithography 1770–1860* (2 vols.) London 1956–57, no. 167. Hullmandel's published writings and his work as a lithographic printer and draughtsman are discussed in some detail in several chapters of my book *Lithography 1800–1850*, London 1970. An exhibition which concentrated on the lithographic achievements of Hullmandel and Harding was held in Smith College Museum of Art in 1982: see C. Swenson, ed., *Charles Hullmandel and James Duffield Harding: A study of the English art of drawing on stone*, Northampton, Mass.: Smith College Museum of Art 1982.

2 Particularly in chapters 9, 10, 13, and 14.

3 See, for example, the wrappers to the series of drawing books he printed in the 1820s with a changing title: *Ackermann's lithographic drawing book*, *The lithographic drawing book*, and *Hullmandel's lithographic drawing book*.

4 Hullmandel invoice, May 1830, Archives Office of Tasmania, CS01/910/19174.

5 D. Fowler, 'Autobiography or recollections of an artist', in F. K. Smith, *Daniel Fowler of Amherst Island 1810–1894*, Kingston, Ontario: Agnes Etherington Art Centre 1979, p. 102.

6 T. F. Dibdin, *A bibliographical antiquarian and picturesque tour in France and Germany* (3 vols.), London 1821, vol. iii, p. 319.

7 Obituary notices appeared in the *Expositor*, no.8, 21 Dec. 1850, p.114; *Art-Journal*, ns vol.3, 1851, p.30; *Annual Register*, vol.92, 1851, p.280; and *Gentleman's Magazine*, ns vol.35, Feb. 1851, pp.209–10. The obituary notices that appeared in the *Annual Register* and *Gentleman's Magazine* were based on the one in the *Art-Journal*. The indexes to obituary notices in *The Times* do not list Hullmandel.

8 For a full and interesting account of Nicolas-Joseph Hüllmandel, see the entry on him by Rita Benton in *The New Grove dictionary of music and musicians*, London 1980, vol. viii, pp.773–75.

9 The estate is referred to in the obituary notices to Charles Hullmandel in the *Art-Journal*, ns vol.3, 1851, p. 30, and the *Expositor*, no.8, 21 Dec. 1850, p. 114. The former gives no location for the estate, the latter refers to it as at La Roche Guillon.

10 *Art-Journal*, ns vol. 3, 1851, p. 30.

11 The name 'Jos. N. Hullmande' [sic] appears beside the entry for 51 Great Marlborough Street in the Rate Books for the Parish of St James, Westminster, for 1816 (Westminster City Archives).

12 *New Grove*, p. 774.

13 *New Grove*, p. 774. (Adelaide Charlotte) Evelina Hullmandel died in 1839. I have taken the spelling of Evelina found on the title-page of the composition reproduced in illustration 2.12 rather than that used in *New Grove*.

14 *Expositor*, p. 114.

15 C. Hullmandel, *On some important improvements in lithographic printing*, London 1827, p. 5.

16 Charles Hullmandel signed his name and had it printed without an umlaut and with a single terminal l, but the Rate Books for the Parish of St James, Westminster, some of the directories, and other contemporary sources spell the name with a double l at the end.

17 p. 114.

18 C. Hullmandel, *The Art of drawing on stone*, London 1824, p. xiii.

19 *Expositor*, p. 114.

20 *Expositor*, p. 114.

21 For Ackermann's early involvement with lithography, see M. Twyman, *Rudolph Ackermann and lithography*, Reading, Department of Typography & Graphic Communication, University of Reading 1983.

22 On p. 85 Hullmandel is shown under the listing for Great Marlborough Street as '51 C Hullmandel', and on p. 263, in the general alphabetical listing, as 'Hullmandel, C. Esq. 54, Gt. Marlborough-st'. The number 54 is an error, and was corrected in the 1817 issue of the directory.

23 The *Post Office London directory* for 1824, where the name is spelled 'Hullmandell'.

24 Rate Books (specifically those for the Poor Rates) for the Parish of St James, Westminster (Westminster City Archives). Nicolas-Joseph Hullmandel (mostly referred to as Joseph) paid rates on 51 Great Marlborough Street from 1816 to 1820, but the entry for 1818 has the words '& son' added in another hand, and in the entry for 1820 the first name 'Joseph' has been erased and 'Charles' added in the remarks column. The Rate Books show that Charles Hullmandel continued to pay rates on the property until he died.

25 For a discussion of the architectural features of Great Marlborough Street, see F. H. W. Sheppard, ed., *Survey of London*, vol. xxxi, *The Parish of St. James Westminster. Part two, North of Piccadilly*, London 1963, pp. 251–52.

26 *Survey of London*, vol. xxxi, p. 252.

27 *Royal Blue Book; fashionable directory*, 1840, p. 107.

28 *Survey of London*, vol. xxxi, p. 261.

29 See H. B. Jones, *The Life and letters of Faraday* (2 vols.), London 1870, vol. i, p. 419.

30 See particularly C. J. Feret, *Fulham old and new* (2 vols.), London 1900, vol. ii, pp. 69, 206–07. I am grateful to Mrs C. M. Bayliss, Local History Librarian at Hammersmith & Fulham Public Libraries, for her generous help in pointing me to references to Hullmandel's connections with Fulham.

31 Thomas Crofton Croker's articles began to appear in *Fraser's Magazine* in 1845 (Jan., Feb., Mar., Apr., and Dec. issues). Fairholt made sketches for a continuation of the series in about 12 parts, but they were never used. An album containing these drawings is preserved in the Guildhall Library (A.1.3. no. 24), along with some of the wood-engravings made from them. After Crofton Croker's death his text was revised by his son T. F. Dillon Croker and published with the title *A Walk from London to Fulham*, London 1860. There is irony in the fact that of the few visual records that appear to have survived of Hullmandel's life style, some were made on behalf of one of his firm's arch rivals (see p. 84). I am grateful to Mr Ralph Hyde, Keeper of Prints and Maps at the Guildhall Library, for drawing my attention to these Fairholt drawings.

32 Reproduced by Feret, *Fulham* p. 69. Hammersmith & Fulham Public Libraries have the photograph that Feret used, but the whereabouts of the original are not known. In Feret's time the original belonged to a 'John Rooth, Esq.'

33 A full-page wood-engraving by Landells on the cover of the issue of the journal containing Hullmandel's obituary (no. 8, 21 Dec. 1850).

34 Class VII, Period 5. It is signed 'G. B. Black Lith. 1851' and lettered 'Proof/London: Published by Walton & Co. 51, Great Marlborough Street & P. & D. Colnaghi & Co. Pall Mall East.' Beneath the portrait is a specimen of Hullmandel's writing which reads: 'Ys very truly C. Hullmandel'. It seems likely that this lithograph and the wood-engraving that appeared in the *Expositor*

35 Jones, *Faraday*, vol. i, p. 419. Manuel Garcia was a Spanish tenor; his elder daughter, Maria-Felicia Malibran (1808–36), was a celebrated mezzo-soprano who made her London debut in 1825.

36 'The Inventor of lithotint', *Art-Union*, vol. 5, 1843, pp. 290–91.

37 See F. K. Smith, *Daniel Fowler of Amherst Island 1810–1894*, Kingston, Ontario: Agnes Etherington Art Centre 1979.

38 See Smith, *Daniel Fowler*, pp. 81–179.

39 Ibid., p. 102.

40 Ibid., p. 99.

41 Public Record Office, Prob II 2132, f. 342v.

42 J. L. Roget, *A History of the 'Old Water-Colour' Society* (2 vols.), London 1891, vol. ii, pp. 246–47.

43 Hullmandel & Walton exhibited examples of lithotint, along with some other lithographs, in the Fine Arts Court (Class 30, item 71) and issued an eight-page publication for the occasion: *A Few explanatory remarks, addressed to artists & amateurs, on the means by which the plates exhibited by Hullmandel & Walton are executed*, London: Exhibition, Hyde Park, 1851. The firm was awarded a Prize Medal, which is now in the possession of the Yale Center for British Art.

44 Registered in the District of St James, Westminster, Sub-district of Golden Square, London, 20 Nov. 1850 (St Catherine's House, London).

45 Public Record Office, Prob II 2132, f. 342. The will was drawn up on 22 June 1849 and probate was granted on 14 Jan. 1851.

46 The other was probably Thomas Walter, who was referred to in Hullmandel's second will as a beneficiary of his earlier will. He was to have received 'one third of the interest & property of the Lithographic Establishment now existing at No. 51 Gt. Marlbro St'. It seems likely that Thomas Walter was a senior manager of the establishment at the time the first will was drawn up.

47 The burial registers at Highgate Cemetery (Burials May 1839 to Jan. 1862) record that the grave is no. 3856 in square 22. They also record that Hullmandel was buried seven feet deep in consecrated ground, and that his partner, J. F. Walton, paid the sum of £4:9s. for the burial on 20 November. The grave is in the West Cemetery but, exceptionally, is not marked on the detailed set of plans which are supposed to record every burial.

48 I learnt about the location of Hullmandel's grave almost by chance through Mr Eric Smith. He came across it in 1962 while pursuing an interest in Joseph Powell, some of whose lithographs had been printed by Hullmandel. On looking through his notes, he discovered that he had made a record to the effect that on 4 Aug. 1962, with the help of a member of staff of the cemetery, he had helped to clear away the undergrowth that enveloped the headstone. The notes he took on that day also include the reference number and location of the grave and a line by line transcription of the inscription on its headstone.

49 In the *Poll book, for electing two representatives in Parliament for the City and Liberty of Westminster, June 18, to July 4, 1818*, London 1818, Hullmandel's occupation is recorded as 'Painter'.

50 The guard book was in the shop of the late E. Seligmann of Cecil Court, London, who clearly knew its historical significance and seemed reluctant to part with it. I mention it in the hope that a reader may know its whereabouts.

51 C. Hullmandel, [A Collection of proof impressions and experiments made by C. Hullmandel in his attempts to improve the art of lithography], c. 1818–41 (St Bride Printing Library, 15582), ff. 32–33. Both drawings were made in Jersey and are dated Aug. 1818.

52 Hullmandel [Proof impressions and experiments], f. 1.

53 J. R. Abbey, *Travel in aquatint and lithography 1770–1860* (2 vols.), London 1956–57, no. 167; Twyman, *Lithography*, pp. 184–88. The Abbey copy is hand-coloured, whereas other copies I have seen in the Victoria & Albert Museum, British Museum, St Bride Printing Library, and Reading University Library are not.

54 *Literary Gazette and Journal of belles lettres*, 15 May 1819, p. 316.

55 Abbey's notes on the publication discuss some of the variant plates, but not all of them. Plate 15 in the Abbey sequence exists in two states, one dated June 1818, the other 10 July 1818.

56 A copy of F. Moser's circular announcing the dissolution of the partnership (dated 1 Oct. 1818) is in the Department of Prints and Drawings of the Victoria & Albert Museum (ES. 102 i). For brief notes on Moser & Harris and Francis Moser, see M. Twyman, *A Directory of London lithographic printers*, London 1976, pp. 4, 41–42, and Twyman, *Lithography*, pp. 184–86.

57 *Transactions of the Society of Arts*, vol. 37, 1820, p. 53.

58 Ibid., p. 54.

59 Ibid., p. 56.

60 Department of Prints and Drawings (English Lithographs C.260*).
61 Twyman, *Lithography*, p.187.
62 *Expositor*, p.114; *Art-Journal*, p.30.
63 No.27, 3 Jul. 1819. col.415.
64 No.17, 26 Feb. 1820.
65 p.114.
66 See Twyman, *Directory*, p.11.
67 Twyman, *Lithography*, p.188; C. T. C. Lewis, *The Story of picture printing in England during the nineteenth century*, London 1928, p.126.
68 Twyman, *Lithography*, p.187.
69 British lithography in the period between the establishment of peace on the continent in 1814 and the setting up of Hullmandel's press has not yet been adequately studied. Some information can be gleaned from the entries for Ackermann, Bankes, Marcuard, Moser, Moser & Harris, Quarter-Master-General's Office, and Redman in Twyman, *Directory*; in the introducton and notes to M. Twyman, ed., *Henry Bankes's treatise on lithography*, London 1976, pp. ix–xxiii, xxvi–xl; and in Twyman, *Rudolph Ackermann and lithography*.
70 Twyman, *Directory*, p.4.
71 Twyman, *Lithography*, pp.20–21; R. A. Winkler, *Die Frühzeit der deutschen Lithographie*, Munich 1975, no.959.
72 Twyman, *Lithography*, pp.21–22, 24–25; W. Wegner, '"Les Oeuvres Lithographiques" und ihre Entstehungsgeschichte', *Oberbayerisches Archiv*, vol.87, Munich 1965, pp.139–92; Winkler, *Lithographie*, nos.964–67.
73 For Hullmandel's work as a lithographic draughtsman see Swenson, ed., *Charles Hullmandel and James Duffield Harding: A study of the English art of drawing on stone*, Northampton, Mass.: Smith College Museum of Art 1982; Twyman, *Lithography*, pp.183–89, 198–99. Hullmandel's last major exercise in lithographic drawing from his own sketches was his *Picturesque views of ancient castellated mansions in Scotland, c.1830* (Swenson, no.30); he drew all but one of the plates for this publication, but only some of them were put on stone by him.
74 Twyman, *Lithography*, pp.192–99, pls.92–96, 98–101, 105, 107–12.
75 For reproductions of some of these workshops, see M. Twyman, 'The lithographic hand press 1796–1850', *Journal of the Printing Historical Society*, no.3, 1967, pls. 1, 4 (of Peter Wagner in Karlsruhe c. 1820, and R. –J. Lemercier in Paris c.1835 and in the second half of the 1840s). Illustrations of workshops of a slightly later date are to be found in P. C. Marzio, *Chromolithography 1840–1900: The democratic art*, London 1980, pp.35, 80, 150 (of Wagner and McGuigan in Philadelphia, c.1856, and F. F. Oakley, Boston, 1857–60), and M. Twyman, 'The tinted lithograph', *Journal of the Printing Historical Society*, no.1, 1965, p.55 (of Day & Son in London in 1856).
76 The Rate Books (Poor Rates) for the Parish of St James, Westminster (Westminster City Archives), reveal that Nicolas-Joseph Hullmandel began to pay rates on 51 Great Marlborough Street in the year ending April 1816 and continued to do so up to and including 1820. See also note 24.
77 The earliest reference to the new address in connection with Hullmandel that I have come across occurs on a set of specimens he issued with a circular letter dated Apr. 1829 (Royal Institution, M2; Society of Antiquaries, 118A, Tracts 14, no.3; St Bride Printing Library, 17645).
78 Charles Joseph Hullmandel's name first appears in the Rate Books (Poor Rates) for the year ending April 1820. The entry for 51 Great Marlborough Street records Joseph Hullmandell [sic] as the ratepayer, though 'Joseph' has been erased and 'Charles' added in the remarks column.
79 From 1830 to the mid 1840s the Rate Books show Hullmandel (later with Walton) paying rates on both 49 and 51 Great Marlborough Street. The first reference to 49 appears in the Poor Rate Book for 1829 where, in the remarks column, there is a note in relation to 51 Great Marlborough Street which suggests that Hullmandel was also associated in some way with no.49. In this and the following year the rate books refer, erroneously, to George Hullmandel.
80 C. Mayhew, '. . . plans of all the ground, houses and other buildings, within the Parish of Saint James, Westminster . . . revised and corrected to the year 1836' (Westminster City Archives, D1835a).
81 See below, p.57.
82 Great Marlborough Street was renumbered in 1882 (see London County Council, *Names of streets and places in the administrative County of London*, 4th edn., London 1955, p.336), with the result that 51 became 56 and 49 became 54. Little is known about the

original 51, but it would have been a substantial town house. From 1891 to 1904 it was occupied by the Architectural Association (*Survey of London*, vol. xxxi, 1963, p.266). The original 49 is better documented. It was not demolished until 1953 and warrants a full-page entry plus illustrations in the *Survey of London* (vol.xxxi, pp.264–65, vol.xxxii, pl. 142(a)). The original building dated from the early 18th century. Its frontage was five windows wide and it had four floors. The ground and first floors were divided into four, giving two major rooms on each floor measuring about 20 by 18 feet. The outstanding internal feature was a fine staircase, which has been recorded by means of a drawing and a photograph in the *Survey of London* account of the building.
83 The wood-engravings were published in the *Lady's Newspaper*, 4 Jan. 1851, by which time the premises were occupied by the Servants' Provident and Benevolent Society. It is not clear when 49 was sub-divided, but it seems likely that the Society had only just moved to its new site in Jan. 1851. Immediately before this it operated from 8 Cork Street, and by 1855 it had moved to 46 Bedford Row. These illustrations were located for me by the Greater London Record Office and History Library, and I am particularly grateful to Miss Margaret Webster for tracking them down and helping to authenticate them. In nearly every respect, including the fenestration and the view of the entrance hall with its staircase, the wood-engravings accord with what we know of 49 Great Marlborough Street from Mayhew's plan of 1836 and the *Survey of London* drawings.
84 Rate Books (Westminster City Archives). Joseph Fowell Walton's name is first shown in the Poor Rate books in connection with this property in 1844, when it was added in pencil.
85 The first year in which the premises behind 49 and 50 were mentioned in the Rate Books was 1848.
86 If we assume that Hullmandel retained the whole of the four floors of 51 for his own domestic use, which he may well have done, this figure is reduced to about 14,400 square feet.
87 The inadequacy of the natural lighting in the rooms at the back of 51 Great Marlborough Street was remarked on in 1904 by the Secretary of the Architectural Association, which occupied the premises for a period from 1891 (when the number was 56). He was referring to the Office and Library of the Association, which were located in a back room '. . . which was lighted only by a prism light and a small semi-circular window, by which the sun's rays only occasionally entered and pierced the gloom. Gas lighting had to be resorted to continuously' (E. Dixon, *The Architectural Association Library*, London 1979, p.26).
88 See Ackermann's *The Microcosm of London* (3 vols.), London 1809, vol.iii, p.241. This publication also includes a view of the common room of the workhouse by Rowlandson and Pugin.
89 Twyman, *Directory*, pp.17–19. In the light of recent findings, the reference to 49 Great Marlborough Street on p.18 should be changed to read 51 and 49 Great Marlborough Street.
90 Dibdin, *Bibliographical tour*, vol.iii, pp.318–19.
91 G. Engelmann, *Traité théorique et pratique de lithographie*, Mulhouse, 1835–40, p.140.
92 C. Hullmandel, *A Reply to some statements, in an article entitled 'The History of Lithography,' published in the Foreign Review, no.vii. for July, 1829*, London 1829, p.4.
93 See [T. Crofton Croker], 'History of lithography', *Foreign Review and Continental Miscellany*, vol.4, no.7, 1829, p.52; Engelmann, *Traité*, p.45; Hullmandel, *Reply*, pp.3–4. Crofton Croker claimed that Engelmann entered into similar arrangements with printers in Lyons and Marseilles, and that Hullmandel was supplied with printers from Engelmann's establishments at Paris and Mulhouse.
94 In addition to those referred to in note 93, see also C. Hullmandel, *On some important improvements in lithographic printing*, London 1827, p.1; and a letter from John Coindet (of the firm of Engelmann, Graf, Coindet & Co.) and Hullmandel's reply to it in the *Literary Gazette*, no.661, 19 Sept. 1829, p.623, and no.663, 3 Oct. 1829, p.655. Engelmann's own reference to the arrangement (*Traité*, p.45) suggests that he harboured no ill feelings.
95 The lecture took place on 3 Mar. 1826 and is reported in the *Quarterly Journal of Science and the Arts*, vol.21, 1826, pp.133–34. Hullmandel brought along specimens of lithography and stones in various states of preparation, and even etched and printed from the stones during the evening. Faraday described the nature of the materials and explained the general theory of the process. Faraday's notes for his lecture survive in the Royal Institution (F4 C, f.213). For Faraday's lectures, see A.E. Jeffreys, *Michael Faraday: A list of his lectures and published writings*, London 1960.
96 Jones, *Faraday*, vol.1, pp.419, 420.
97 Gregson Correspondence, Liverpool Record Office, 920 GRE 2/5.

98 Smith, *Daniel Fowler*, p. 102.

99 Roget, '*Old Water-colour*' Society, vol. ii, pp. 246–47.

100 John Johnson Collection, Bodleian Library.

101 Referred to in Hullmandel's will of 1849. Public Record Office, Prob II 2132, f. 342.

102 Prob II 2132, f. 342. The firm of Hullmandel & Walton continued for more than a decade after Hullmandel's death, and is recorded in the *Post Office London directory* up to and including 1861. It may be worth noting that the portrait of Hullmandel reproduced here, which is dated 1851, carries the imprint 'London: Published by Walton & Co. 51, Great Marlborough Street & P. & D. Colnaghi & Co. Pall Mall East.' This is the only instance I know where Walton dropped Hullmandel's name from the style of the firm.

103 Dibdin, *Bibliographical tour*, vol. iii, pp. 318–19.

104 E. Panofsky, *Albrecht Dürer*, 3rd edn. (2 vols.), London 1948, vol. i, pp. 46–47.

105 Hullmandel [Proof impressions and experiments], St Bride Printing Library, 15582. The description given in the text is taken from a pencil note on its endpapers. The album was acquired from Maggs Bros on 18 Jan. 1912, but its earlier provenance is not known. The items appear to have been assembled by Hullmandel himself and most of them have to do with his own improvements in lithography. It seems likely that they were assembled around 1841 when Hullmandel's claims to the lithotint process were being disputed. The earliest item in the album dates from 1818 and the latest date referred to is 1841.

106 Smith, *Daniel Fowler*, p. 102.

107 See Twyman, 'Lithographic hand press', pl. 4

108 For the storage of stones in the first half of the 19th century, see M. Twyman, 'Lithographic stone and the printing trade in the nineteenth century', *Journal of the Printing Historical Society*, no. 8, 1972, pp. 32–34.

109 Vol. v, 1824, pl. XCV. See Twyman, 'Lithographic hand press', p. 21, figs. 20–22.

110 *Expositor*, p. 114.

111 The model was made by Vic Green, Woodley Models, for the Ackermann Bicentenary Exhibition, Oct. 1983. It is reproduced here by courtesy of Arthur Ackermann, who placed it on loan with the Department of Typography & Graphic Communication, University of Reading.

112 The plates are printed on sheets measuring 47.0×76.2 cm ($18\frac{1}{2} \times 30$ in.) and 50.8×66.0 cm (20×26 in.) and have image areas of 42.2×66.7 cm ($16\frac{5}{8} \times 26\frac{1}{4}$ in.) and 45.7×57.2 cm ($18 \times 22\frac{1}{2}$ in.).

113 British Library, Tab. 597.a.2(45). The chart has an image size of 56.5×70.5 cm ($22\frac{1}{4} \times 27\frac{3}{4}$ in.). It is undated, but the information on it does not go beyond 1821.

114 [Croker], 'History of lithography', p. 52.

115 Hullmandel invoice, May 1830 (Archives Office of Tasmania, CS01/910/19174). The inside measurement of a bed of a Colombier-size press advertised by Brisset in Paris some 15 years later measured 91×65 cm ($35\frac{7}{8} \times 25\frac{5}{8}$ in.). See Twyman, 'Lithographic hand press', fig. 56.

116 Several Hullmandel (Hullmandel & Walton) invoices have been traced, including three in the Linnean Society Library, and others in the John Johnson collection of the Bodleian Library, and the Archives Office of Tasmania. These show that Hullmandel used the same basic heading—which must have been transferred from a master design—over a long period (from at least 1830 to 1848). The master was altered successively to accommodate changes in the number of the premises and the style of the firm.

117 See Twyman, 'Lithographic stone', pp. 24–30.

118 Gregson Correspondence, Liverpool Record Office, 920 GRE 2/5, 4 Dec. [1820].

119 See Twyman, 'Lithographic stone', pp. 24–26.

120 p. 91, and pl. 7 (figs 8, 9).

121 His invoices in the Linnean Society Library and the John Johnson Collection (see note 116) included the following statement: 'All Drawings made upon Stones belonging to this Establishment remain thereon at a Rent-charge of from 4d. to 18d. per Month each, according to their size until a written Order to rub them off be received.'

122 Gregson Correspondence, Liverpool Record Office, 920 GRE 2/5, 4 Dec. [1820].

123 Gregson Correspondence, 4 Dec. [1820].

124 Gregson Correspondence, 13 Nov. 1820.

125 Gregson Correspondence, 4 Dec. [1820].

126 British Library, Department of Manuscripts, 39783, f. 116. The estimate was signed illegibly on behalf of Hullmandel by someone with the first name Thomas. This may have been Thomas Walter (see note 46).

127 Undated invoice made out to the Linnean Society (receipt dated 11 Sep. 1848) in the Linnean Society Library.

128 See Twyman, *Lithography*, p. 192, pl. 92. The change in responsibility for Hullmandel's works in the mid 1820s can be seen by comparing the advertisements on the rear wrappers of the series of drawing books that Hullmandel printed (*Ackermann's lithographic drawing book for the year MDCCCXXIV* and *The lithographic drawing book for the year MDCCCXXVI*, published by J. Dickinson).

129 Gregson Correspondence, 13 Nov. 1820.

130 Smith, *Daniel Fowler*, p. 101.

131 The anonymous writer of a two-part article on lithography in the *Library of the Fine Arts* (vol. 1, 1831, Feb., pp. 44–58, Apr., pp. 201–16) referred specifically to 'an artist in Mr. Hullmandel's establishment (whose name is not made public).' ('A view of the present State of Lithography in England', p. 215.) The writer claimed that his 'pen-and-ink drawings, and engravings on stone' surpassed those of all others in minuteness and delicacy.

132 In the early 1820s Hullmandel's major letterer seems to have been Joseph Netherclift, who later set up as a lithographic printer on his own (see Twyman, *Directory*, p. 42). Netherclift was responsible for the lettering on the wrappers and title-page of *Roman costumes* (1820–21) and on the wrappers of A. Orlowski, *Costume of Persia* (1820–21). In *Roman costumes* Netherclift is mentioned in imprints which give his address at the time ('J. Netherclift script. 5 Everett St Russell Square' on the wrappers; 'Written on Stone by J. Netherclift, 42 Rathbn. Place.' on the title-page). But in the case of both publications it is likely that he worked at Hullmandel's since both have their lettering placed within a pictorial image drawn by Hullmandel. In addition, the monograms RB and IM appear on items involving lettering that Hullmandel printed. The first is found on the wrappers of R. Newenham, *Picturesque views of the antiquities of Ireland* (2 vols.), London 1830, and on two items of sheet music of the 1820s (J. Blewitt, 'Love a gypsey', and A. Lee, arr., 'Buy a broom!') and may perhaps be identified with B. R. Baker, who drew a map for J. Henderson, *A History of the Brazil*, London 1821, and three plates for Seyer's *History of Brazil*, London 1821. This may be the artist referred to in the *Library of the Fine Arts*, vol. 1, no. 3, Apr. 1831, p. 215, as Baker of Sydenham, who is said to have produced the much praised specimen of ink lithography which served as an advertisement for the lithographic printer Robert Martin in the early 1830s (see Twyman, *Directory*, pp. 40–41). The second monogram is to be found on the title-page and boards of Hullmandel's *The Art of drawing on stone*, London 1824, on the title-page of E. H. Locker, *Views in Spain*, London 1824, and on the wrappers of H. Walter, *Studies of various animals* (London, nd) and Lady Elton, *Four panoramic views of the city of Edinburgh*, 1823. The identity of this letterer is revealed in Richard Lane's *Studies of figures by Gainsborough*, London 1825, where the dedication is signed with the monogram, whereas the title-page is lettered 'J. Magenis Scr:'.

133 For an account of the practice in the early 1850s, see the description of Day & Haghe's establishment written by George A. Sala in 'Stone pictures', *Household words*, 1852, p. 180.

134 Hullmandel printed the twelve lithographs of Géricault's *Various subjects drawn from life and on stone*, London 1821, which was published by Rodwell & Martin. His series of pen and ink lithographs done on stone paper may, or may not, have been printed by Hullmandel. Unfortunately nothing is recorded of the artist's involvement with Hullmandel (see S. Lodge, 'Géricault in England', *Burlington Magazine*, vol. 107, Dec. 1965, pp. 616–26). For Géricault's lithographs, see particularly, F. Bergot, ed., *Géricault: Tout l'oeuvre gravé et pièces en rapport*, Rouen: Musée des Beaux-Arts 1981; L. Delteil, *Le Peintre-graveur illustré*, xviii, Paris 1924; L. E. A. Eitner, *Géricault: His life and work*, London 1983; K. H. Spencer, *The Graphic art of Géricault*, Yale 1969.

135 See Twyman, *Lithography*, pp. 115–28, and M. Twyman, 'The art of drawing on stone', *Penrose Annual*, no. 64, 1971, pp. 104–15.

136 C. Hullmandel, *The Art of drawing on stone*, London 1824, p. 52.

137 Yale Center for British Art, Fol A D20. The note is headed 'Remarks on Mr. G. Cumberland's forty drawings on stone' and ends 'Culver Street, Bristol, August 1821'.

138 Yale Center for British Art, S 497.

139 See note 123.

140 Hullmandel claimed that he had 'used it ever since 1822 with the greatest success', *Reply*, 1829, p. 7.

141 See Twyman, *Lithography*, pp. 132–33.

142 Vol. 92, part 2, Nov. 1822, p. 398; in the previous issue it is said that Hullmandel had taken 3,000 copies from a chalk lithograph (Oct. 1822, p. 359). Faraday's notes for his lecture at the Royal Institution on 3 Mar. 1826 suggest that the mean for the number of impressions to be taken from a chalk drawing on stone was 1,100

(Royal Institution, F4C, f.213). Hullmandel demonstrated aspects of lithography at this lecture (see the *Quarterly Journal of Science and the Arts*, vol.21, 1826, pp.133–34) and it must be assumed that he provided Faraday with this information or at the very least agreed with it.

143 Hullmandel, *Improvements*, pp.2–3.

144 See Twyman, *Lithography*, pp.135–36, pls.58–60.

145 See Twyman, *Lithography*, pp.124–26.

146 W. S. Williams, 'On lithography', *Transactions of the Society of Arts*, vol.56, 1847–48, pp.244–45.

147 Hullmandel [Proof impressions and experiments], f.13. See Twyman, *Lithography*, p.139, pl.63.

148 f.22, Twyman, *Lithography*, pl.64

149 f.19.

150 Abbey, *Travel*, no.29; Twyman, *Lithography*, pp.156, 203–06, pls.115, 116; Twyman, 'Tinted lithograph', pp.46–48, pl.5. Harding's debt to Hullmandel in relation to stumping is acknowledged in a letter Harding wrote to the *Probe* (no.19, April 1840, pp.13–14) in support of Hullmandel's claims with regard to the colour printing of Boys's *Picturesque architecture in Paris, Ghent, Antwerp, Rouen, &c.*, 1839, see note 208, illustrations 2.36, 2.37, col. pl.1.

151 For general discussions of tinted lithography, see Twyman, 'Tinted lithograph'; Twyman, *Lithography*, pp.21–22, 128, 155–60, 201–25, 250.

152 pp.81–82.

153 ff.8–12. Faraday's notes for the lecture on lithography he gave at the Royal Institution on 21 Apr. 1831 include the single-line note 'Recent brush style—specimens—rapidity', which is highlighted with an extremely large asterisk (Royal Institution, F4, I1, f.9).

154 f.24; Twyman, 'Tinted lithograph', pl.5; Twyman, *Lithography*, pls.76, 77.

155 Twyman, *Lithography*, pp.140–45.

156 Guildhall Library, Department of Prints and Maps. The proofs are mounted in a volume, signed TSB, along with prints of the black workings on their own and the prints as published. Some prints appear in variant forms.

157 Abbey, *Scenery of Great Britain and Ireland in aquatint and lithography*, London 1952, no.239; J. Roundell, *Thomas Shotter Boys*, London 1974, pp.49–52, pls.63–71; Twyman, *Lithography*, pp.212–13.

158 pp.75–76, pl. V (figs 3, 4).

159 British patent no.8683, 5 Nov. 1840. See Twyman, *Lithography*, pp.145–53.

160 For an account of the hearing, see the *Art-Union*, vol.5, 1842, pp.105–06. The journal also published a lively correspondence between the two parties; vol.5, pp.291–92 and vol.6, p.19 (from Hullmandel); vol.5, pp.312–13 (from Hancock).

161 I should add to what I wrote about lithotint in *Lithography*, pp.145–53, that Faraday delivered a lecture on the topic at the Royal Institution on 10 Jun. 1842 entitled 'Principles and Practice of Hullmandel's Litho-Tint', the brief notes for which survive (Royal Institution, F4 G12).

162 *A few explanatory remarks, addressed to artists & amateurs, on the means by which the plates exhibited by Hullmandel & Walton are executed*, London: Exhibition, Hyde Park 1851, p.7.

163 See Twyman, *Lithography*, p.151.

164 f.24v. Twyman, *Lithography*, pl.71.

165 Twyman, *Lithography*, pp.216–17, pls.124–29.

166 See Twyman, *Lithography*, pp.217–19.

167 In an undated letter to an unknown enquirer, J. D. Harding wrote from 4 Gordon Square that he was sorry to have to say '...that Mr. Hullmandel is not yet prepared to admit the Public use of his patent. Although I believe it will not be long for it.' (Temple University Library).

168 For lithotint in France and Lemercier's version of it, see Twyman, *Lithography*, pp.152–55.

169 His brief will, drawn up in 1849, included a reference to '...various patents taken out at different periods particularly one for a process of Lithotint' (Public Record Office, Prob II 2132, f.342).

170 *Art-Journal*, p.30. Other obituary notices made similar references to Hullmandel's pioneering work in colour lithography, and so too did W. S. Williams in 'On lithography', *Transactions of the Society of Arts*, vol.56, 1847–48, p.240.

171 B. Gascoigne, 'The earliest English chromolithographs', *Journal of the Printing Historical Society*, no.17, 1982/83, pp.62–71.

172 Gascoigne, 'Earliest English chromolithographs', p.66.

173 Abbey, *Travel*, no.33; G. von Groschwitz, 'The Prints of Thomas Shotter Boys', in C. Zigrosser, ed., *Prints*, London 1962, pp.194, 207, pls.7–8; Roundell, *Boys*, pp.45–48, pls.55–60. See also note 208.

174 French patent no.8848, 31 Jul. 1837, 'Pour des procédés d'impression lithographique en couleurs' (Brevet d'addition et de perfectionnement, 27 Mar. 1838).

175 The published catalogue of the St Bride Printing Library, London 1919, lists the following item: 'Hullmandel & Walton. Specimen of printing in colours. Fol. London [*c.* 1850]'. Unfortunately it cannot be traced.

176 For Ackermann in general see J. Ford, *Ackermann, 1783–1983: The business of art*, London 1983; for his early connections with lithography, see M. Twyman, *Rudolph Ackermann and lithography*, Reading, Department of Typography & Graphic Communication, University of Reading, 1983.

177 See pp.50–51.

178 The first edition was jointly published by Hullmandel and Ackermann, the second and third editions by Longman. Variants of the first edition were noted by James Tregaskis & Son in a catalogue issued from 66 Great Russell Street in 1929 (items 355, 356). The third edition is substantially shorter than the others and Hullmandel revealed in the introduction (p. iv) that he had '... omitted the remarks on one or two modes of drawing that have been found by experience to be either useless in themselves or imperfect in their effects; also the illustrations of them, and other superfluous plates.' The dabbing style and transferring of engravings were not described or illustrated in this edition, and all the plates were redrawn for it.

179 See *Le Lithographe*, vol. 3, Paris 1842, p.224.

180 A. Raucourt, *A Manual of lithography*, London 1820, pp. xi–xii.

181 Raucourt, *Manual*, p. xiv.

182 Hullmandel invoice, May 1830 (Archives Office of Tasmania, CS01/910/19174).

183 C. Hullmandel, *The Art of drawing on stone*, 3rd edn., London 1835, p. iv.

184 Hullmandel, *Drawing on stone*, p. ii.

185 Hullmandel, *Drawing on stone*, p. ix.

186 Hullmandel, *Drawing on stone*, p. xvi.

187 Hullmandel, *Drawing on stone*, p. ii.

188 Hullmandel, *Drawing on stone*, p. v.

189 Hullmandel, *Drawing on stone*, p. vii.

190 Hullmandel, *Drawing on stone*, note pp. x–xi. Hullmandel had already criticized the imposition of this duty in an editorial footnote in Raucourt's treatise (*Manual*, p. 130). For a short discussion of the imposition of this duty, see Twyman, 'Lithographic stone', p. 10.

191 Hullmandel, *Drawing on stone*, p. xii.

192 See Jones, *Faraday*, vol. 1, pp. 419–20.

193 The precise dates for the changes in publisher and titles are not clear. The publication continued to be called *Ackermann's lithographic drawing book* into 1824; by 1826 it was being published by Dickinson with the title *The lithographic drawing book*; in 1827 it was published by Dickinson as *Hullmandel's lithographic drawing book*. In the mid 1820s Dickinson took over responsibility from Ackermann for publishing many of the collections of lithographs that Hullmandel printed. It should be added that Hullmandel was not the first British lithographic printer to have his own series of drawing books; *Rowney & Forster's lithographic drawing book* began to appear in 1820, and *N. Chater & Co's lithographic drawing book* around 1823.

194 Hullmandel, *Improvements*, p. 1.

195 Hullmandel, *Improvements*, p. 1.

196 For Hullmandel's early printing for Baron Taylor's *Voyages pittoresques*, see Twyman, *Lithography*, pp.234–35.

197 See p. 72 and illustration 2.27.

198 [T. Crofton Croker], 'History of lithography', *Foreign Review*, vol. 4, no. 7, 1829, p. 52.

199 C. Hullmandel, *A Reply to some statements, in an article entitled 'The History of Lithography,' published in the Foreign Review, no. vii. for July, 1829*, London 1829.

200 Hullmandel, *Reply*, pp. 3–4.

201 Hullmandel, *Reply*, pp. 4–8.

202 1829, p. 623.

203 1829, p. 655.

204 In *Lithography 1800–1850* I followed the catalogues of the St Bride Printing Library (17645) in referring to this item as *On some further improvements in lithographic printing*, London 1829. I now realize that this might cause confusion as the item has no title, but is merely a set of eight specimens, together with a circular letter signed by Hullmandel and dated April 1829.

205 Library of the Royal Institution (M2); Library of the Society of Antiquaries (118A, Tracts 14, no. 3).

206 The Council Minute Books of the Society of Antiquaries, 8 Mar. 1826, record a report on examples of lithography by 'Ingelmann' [sic].

207 *Probe*, no. 11, 15 Aug. 1839, pp. 172–74; no. 15, 2 Dec. 1839, p. 239, no. 16, 1 Jan. 1840, pp. 258–62; no. 17, 1 Feb. 1840, p. 278; no. 19, Apr. 1840, pp. 13–14.

208 The relative importance of the roles played by Hullmandel and Boys in *Picturesque architecture* is discussed by J. Roundell, *Boys*, pp. 46–48. On 5 Dec. 1839 Hullmandel wrote to the *Probe* (no. 16, 1 Jan. 1840, p. 262) to claim that he, rather than Boys, was the inventor of the innovations seen in *Picturesque architecture*. Boys replied on 10 Jan. 1840 (no. 17, 1 Feb. 1840, p. 278) insisting that he was the 'orginator' and 'inventor' of the work and that ' . . . within myself the idea originated, of producing a work by lithography printed in colour, using the primitive colours for the first tints, and producing variety of tints by their successive super or juxta-positions.' The correspondence between the two men in the *Probe* continued with a reply from Hullmandel, supported by letters from Harding and Joseph Nash (no. 19, Apr. 1840, pp. 13–14). All three letters centred on the rendering of the tones on stone and particularly on the use of the stump style. This was not the main issue, and, uncharacteristically, Hullmandel failed to emphasize the significance of the role of his establishment in controlling the tones and colours of the inks in the printing. My interpretation of the evidence is different from James Roundell's: I believe that credit should go equally to the two parties. In support of Hullmandel's position it should be said that he had already printed colour plates from separate stones for G. A. Hoskins's *Travels in Ethiopia*, 1835, and that the techniques of 'painting with the brush' and 'rubbing down' half-tints referred to by Boys in his letter of 10 Jan. 1840 had been fully explored by Hullmandel experimentally in the early 1830s.

209 Vol. 4, 1842, p. 106.

210 Vol. 5, 1843, pp. 291–92.

211 Vol. 5, 1843, pp. 312–13.

212 It is by no means easy to estimate Hullmandel's output of such prints. I have suggested (*Lithography*, p. 187) that he was responsible for plates in over 150 topographical publications. This figure was arrived at after analysing the Abbey catalogues, and it should be said that Hullmandel would not have printed every plate in all the 150 or so publications included in my total. Since the Abbey collection was acquired by the Yale Center for British Art, the collection has more than trebled in size. Some of the additional items may be duplicates or variants of publications already in the Abbey collection, and it is probable that many of the others are provincial publications or relatively unimportant ones and are therefore less likely to have been printed by Hullmandel. Nevertheless, my earlier figure must now be revised upwards, though by how much is at present largely a matter of guesswork. It should be added that the number of publications Hullmandel contributed to as a printer (as calculated from the Abbey catalogues) was at its greatest in the 1820s and declined slightly, but progressively, in the 1830s and 1840s.

213 Hullmandel, *Reply*, p. 8.

214 Beneath Hullmandel's imprint on the front wrappers of the series of drawing books he printed for Ackermann and then Dickinson in the period 1822–26 (see page 83 and note 193), Hullmandel advertised that at his establishment 'Chalk Drawings, Plans, Circulars, and Ink Drawings of every description, are executed with the greatest care and prompt attention.'

215 Outside a few special areas, such as topography, natural history, and children's books, it is not easy to locate Hullmandel's book illustrations. The evidence for my statement about Hullmandel's work as a printer of book illustrations stems mainly, therefore, from casual browsing along bookshelves.

216 British Library, Tab. 597.a.2(45). It is a large print with its image measuring 56.5 × 70.5 cm (22¼ × 27¾ in).

217 See note 132.

218 Over the last few years I have been working on a collection of lithographed music brought together by Hermann Baron. One of the most remarkable things to emerge from this study is the different pattern of use made of lithography by music publishers in different parts of Europe. Whereas in Germany and Italy lithography was widely used for music printing as soon as the process became established in these countries, in Britain (and to a lesser extent in France) it seems to have been deliberately shunned. I know of no more than a handful of British printers or publishers who made use of lithography for music printing before about 1840, and most of these seem to have used it only rarely. C. Humphries and W. C. Smith, *Music publishing in the British Isles*, 2nd edn., Oxford 1970, p. 188, list just one Hullmandel item, though it is not clear from their description whether the actual music was printed by him.

219 See Delteil, xviii, no. 79, and Bergot, *Géricault*, no. 24.

220 Hullmandel, *Drawing on stone*, p. 79.

221 The copy I have seen is in the John Johnson Collection, Bodleian Library.

222 Hullmandel, *Drawing on stone*, p. 80.

223 See note 116.

224 The Minutes of the Managers' Meeting of the Royal Institution record payments to Hullmandel for cards on nine occasions between 1838 and 1846.

225 John Johnson collection, Bodleian Library.

226 See Jones, *Faraday*, vol. i, p. 419.

227 For a discussion of Ryde's book in the context of lithographic book production of the 19th century, see M. Twyman, *Improper books: Lithographic book production in the age of the hand press*, London, Farrand Press: forthcoming.

228 *Expositor*, p. 114. I have not traced the patent for marble earthenwares; the other patent referred to here is British patent no. 6496, 28 Oct. 1833, for an 'Improvement in the art of block printing, as applied to calico and some other fabrics.' Hullmandel took out a further patent, no. 7605, 26 Mar. 1838, for 'A new mode of preparing certain surfaces for being corroded with acids in order to produce patterns and designs for the purpose of certain kinds of printing and transparencies.'

229 *Builder*, vol. 8, 12 Jan. 1850, p. 22. I am grateful to Howard Leathlean for discovering this interesting sidelight on Hullmandel's activities. The notice in the *Builder* reads: 'Hullmandel's razor strop.—Mr. Hullmandel, whose name is known to most of our readers in connection with lithography, has been applying himself to the manufacture of a new razor strop, and has produced one which seems able, like education, to sharpen and polish the dullest little blade. While engaged in putting things "on the stone," he has devised something to put on the leather, and his friends may now take a rub from him as they would from no other man, for it is positively a blessing, especially to tough beards. Since "men for their sins have shaving, sure, entailed upon their chins", those who provide them with the means of getting through it with something like comfort deserve reward; and this, if all his strops are as good as the one sent to us, Mr. Hullmandel has certainly effected.'

3. J. McKEAN FISHER/MANET

1 Among noteworthy examples are: Phillip Dennis Cate's numerous contributions including his essay 'Original color lithography' in *The Color revolution*, New Brunswick 1978; Douglas Druick and Michel Hoog, *Fantin-Latour*, Ottawa 1983; Douglas Druick and Peter Zegers, *La Pierre parle: Lithography in France 1848–1900*, Ottawa 1981; Druick and Zegers, 'Degas and the printed image, 1856–1914', in *Edgar Degas: The painter as printmaker*, Boston 1984. This last essay broke new ground in considering Degas's artistic exploitation of printmaking processes including new technologies from commercial industry. The length of the essay, its complexity and reference to non-exhibited material were unusual for the standard museum catalogue raisonné format. The organizers should be commended for its inclusion since it brought a new understanding of Degas's artistic process to the study of his print production. With specific regard to Manet's printmaking, Michel Melot raised many of the important questions that now occupy us in his essay in *Edouard Manet: L'Oeuvre gravé, Chef-d'oeuvres du Département des Estampes de la Bibliothèque Nationale, Paris*, Ingelheim am Rhein 1977, pp. 17–20.

2 Frances Carey and Antony Griffiths, *From Manet to Toulouse-Lautrec: French lithographs 1860–1900*, London 1978; Michel Melot, *L'Estampe impressioniste*, Paris 1974; Michel Melot, et al., *Prints, History of an art*, New York 1981.

3 Jay Fisher, *The Prints of Edouard Manet*, Washington 1985.

4 Although the process had earlier precedents (Pat Gilmour, review of Fisher, *Tamarind Papers*, Fall 1986, p. 73) it was refined and codified by Firmin Gillot in 1850. Simply stated, the gillotage process begins by obtaining a greasy imprint from an engraving or lithograph or the drawing of an artist on *papier autographique* (transfer paper) and then transferring it in the conventional way to a zinc plate. The transfer ink acts as an acid resist and the plate is immersed in acid and unprotected areas of metal are eaten away. The relief plate so obtained was printed on the same press as movable type, thereby allowing the easy combination of text and illustration in a process that allowed a large edition. An excellent reference tool describing a wide variety of print technologies used in Europe in the 19th century is J. M. Herman Hammann, *Des Arts graphiques destinés à multiplier par l'impression . . .*, Geneva and Paris 1857.

5 Senefelder described transfer lithography both in the German edition of 1818 and the French and English editions of 1819 of his treatise, see Bib. section 2A for full citations.

6 Antony Griffiths, *The Burlington Magazine*, Jan. 1986, pp. 46–47; Barbara Shapiro, *Print Quarterly*, June 1986, pp. 144–47; Antony Griffiths, *Print Quarterly*, June 1986, pp. 147–49; Pat Gilmour, *Tamarind Papers*, Fall 1986, pp. 71–76; Pat Gilmour, *Print Quarterly*, Dec. 1986.

7 Marcel Guérin, *L'Oeuvre gravé de Manet*, Paris 1944.

8 Druick & Zegers, *Degas*, pp. xxiii–xxiv.

9 Griffiths, *Print Quarterly*, p. 149.

10 Gilmour, *Print Quarterly*, p. 360; Michel Melot, *Graphic art of the Pre-Impressionists*, New York 1980, p. 262.

11 Joseph and Elizabeth Robins Pennell, *Lithography and lithographers*, London 1915, p. 188; Gilmour, *Print Quarterly*, p. 361.

12 Etienne Moreau-Nélaton, *Manet graveur et lithographe*, Paris 1906 (M-N 90).

13 'Toujours est-il que, dans se dernières années, Manet ne toucha plus à la pierre. Il existe deux croquis faits par lui avec un pinceau trempé d'encre autographique et reportés ensuite sur pierre.' Etienne Moreau-Nélaton in Guérin, p. 20.

14 Moreau-Nélaton, quoted in Guérin, p. 20.

15 Druick and Zegers, *Degas*, p. xxxiii.

16 Senefelder, 1819, pp. 161, 256–59, English translation 1968.

17 Druick and Zegers, *Degas*, p. xxiv.

18 Fisher, pp. 63–64, 114–16, 118–19.

19 I am grateful to Arsène Bonafous-Murat for suggesting this source.

20 This published advertisement can be found in a Lefman folder in the uncatalogued S.N.R. material in the Cabinet des Estampes at the Bibliothèque Nationale, Paris.
The text in French is as follows:

> Nous avons l'honneur de vous informer que notre établissement de gravure, par notre procédé dit photo-typographique, et de relief simple, est en pleine activité.
>
> Les conditions spéciales d'installation nous permettent d'offrir à nos clients les deux avantages si précieux dans ce genre d'industrie, c'est-à-dire la *rapidité* et le *bon marché*.
>
> Notre procédé photo-typographique qui constitue notre brevet a été apprécié par les grands éditeurs de Paris et par les principales industries se servant de gravures.
>
> Quoi de plus précieux en effet que de pouvoir obtenir, avec un simple dessin ou une ancienne estampe, un cliché en relief sur zinc, que nous livrons tout monté et prêt à mettre sous la presse?
>
> Comme ce résultat est obtenu par la photographie, les réductions ou les agrandissements sont des plus exacts; on s'en rendra compte en jetant les yeux sur notre album-spécimen, dans lequel nous avons réuni une variété de types de notre fabrication.
>
> Nous sommes, du reste, à la disposition de toutes les personnes qui voudraient tenter, à titre d'essai, toute espèce de gravure, soit industrielle, soit artistique.
>
> Quant à la mise en relief simple de dessins au moyen de report, nous obtenons, grâce aux moyens mécaniques de notre installation, une gravure excessivement soignée, et cela à un prix de revient excessivement réduit.

21 Motteroz, *Essai sur les gravures chimiques en relief*, Paris 1871.

22 Motteroz, p. 57.

23 Motteroz, pp. 43–44.

24 I am grateful to Juliet Wilson Bareau for alerting me to this fact though her research of Dépôt Légal documents is still in progress.

25 Juliet Wilson (now Wilson Bareau), *Manet: Dessins, aquarelles, eaux-fortes, lithographies, correspondance*, Paris 1978, cat. 105.

26 Fisher, pp. 106–07, 118.

27 Juliet Wilson (now Wilson Bareau), *Edouard Manet: L'Oeuvre gravé. Chef-d'oeuvres du Département des Estampes de la Bibliothèque Nationale, Paris*, Ingelheim am Rhein 1977.

28 Druick and Zegers, *Degas*, pp. xliii–xlvi.

29 Deposited in 1877.

30 This identification was first made in Bareau, cat. 89, see note 25.

31 Shapiro, pp. 145–46.

32 Jacob Kainen, letter to Pat Gilmour, 30 June 1986.

33 I am particularly grateful to Juliet Bareau for having shared this observation with me in personal conversation, since she has not yet published it.

34 Alfred Lemercier, *La Lithographie française de 1796 à 1896*, Paris 1896–98, pp. 263–67.

35 Motteroz, p. 64 translated in Gilmour, *Tamarind*, p. 76.
Motteroz in French:

> ... après avoir impressionné la surface sous une gravure ou un cliché photographique, ils mouillent l'épreuve du côté du papier et mettent le côté gélatiné sur la pierre; au moyen d'une pression, la gélatine non-impressionnée se colle à la pierre et fournit l'empreinte destinée à recevoir l'encre lithographique. En opérant ainsi sur plaque, il doit être facile d'obtenir par le gillotage toute espèce de dessin au trait; on aurait, de cette façon, une variante des procédés de M. Lefman. Cet artiste, qui le premier a appliqué la paniconographie à la photogravure, obtient ses épreuves de report avec du papier gélatiné et bichromé qu'il encre à l'aide d'un rouleau lithographique, après l'exposition à la lumière, et qu'il décalque ensuite, comme une épreuve ordinaire, sur la plaque de zinc. Ces procédés extrêmement simples sont brevetés, et c'est grace à eux que M. Lefman a pu faire de la photogravure une véritable industrie.

Gilmour reprints a fuller explanation of photo-relief processes, an article by Hornig on paniconography in her *Tamarind Papers* article, pp. 74–75.

36 I am grateful to Roy Perkinson, Paper Conservator, Museum of Fine Arts, Boston, for his suggestions concerning the drawing surface.

37 Juliet Wilson Bareau, 'Hidden face of Manet: An investigation of the artist's working processes', *The Burlington Magazine* 1986, pp. 71–73.

38 Cate, *The Color revolution*, p. 5.

39 Ken Tyler's reactions to *The Raven* were directed to Pat Gilmour, who generously sent this author a transcript of their conversation, which took place in September 1986.

40 For example, Gabriel Weisberg, *The Etching renaissance in France: 1850–1880*, Salt Lake City 1971, and Janine Bailly-Herzberg, *L'Eau-forte de peintre au dix-neuvième siècle: La Société des Aquafortistes 1862–1867* (2 vols.), Paris 1972.

41 Cate, *Color revolution*.

4. P. D. CATE/ALBUMS

1 For a discussion on group albums see Phillip Dennis Cate and Sinclair Hamilton Hitchings, *The Color revolution: Color lithography in France 1898–1900*, Salt Lake City 1978.

2 Donna M. Stein and Donald H. Karshan, *L'Estampe originale: A catalogue raisonné*, New York 1970.

3 For bibliographic reference on artists referred to in this essay see Janine Bailly-Herzberg, *L'Estampe en France, 1830–1950*, Paris 1985.

4 André Mellerio, *Odilon Redon*, Paris 1913.

5 Gustave Flaubert, *La Tentation de Saint-Antoine*, Paris 1951, p. 244.

> Et en face, de l'autre côté du Nil, voilà que le Sphinx apparaît. Il allonge ses pattes, secoue les bandelettes de son front, et se couche sur le ventre.
>
> Sautant, volant, crachant du feu par ses narines, et de sa queue de dragon se frappant les ailes, *la Chimère aux yeux verts, tournoie, aboie.*
>
> Les anneaux de sa chevelure, rejetés d'un côté s'entremêlent aux poils de ses reins, et de l'autre ils pendent jusque sur le sable et remuent au balancement de tout son corps.

6 Paul Jeanne, *Les Théâtres d'ombres à Montmartre de 1887 à 1923*, Paris 1937, p. 61.

7 Phillip Dennis Cate and Patricia Eckert Boyer, *The Circle of Toulouse-Lautrec*, New Brunswick 1985, pp. 11–15.

8 *Chat Noir-Guide*, Paris 1887, p. 62.

9 Henri Rivière, *La Tentation de Saint-Antoine*, Paris 1888.

10 The Volpini albums of Gauguin and Bernard were in fact only to be seen upon demand; they were not exhibited until the Boussod et Valadon show of 1891. Carolyn Boyle-Turner, *The Prints of the Pont-Aven school*, Washington DC 1986, p. 26 and note 30. See also Marcel Guérin, *L'Oeuvre gravé de Gauguin*, Paris 1927.

11 Ces quelques planches sont le résultat modeste de mes premières recherches. Elles inaugurent une SUITE DE PAYSAGES dans lesquels je cherche à exprimer les émotions fugitives que donnent les divers aspects de la nature. Idéaliser le plus possible, sans pourtant dénaturer les formes réelles, tel est mon but.

12 Faut-il ranger parmi les artistes ceux qui, servilement rivés aux grossières doctrines du matérialisme, ne voient rien au delà des réalités sensibles? C'est à ceux-là que semble faire allusion David, le divin poète: 'L'homme comblé d'honneur n'a pas compris: il est devenu semblable à l'animal sans raison'.
Mais, grace à Dieu, il en est d'autres dont les visées sont plus hautes; qui savent que les choses que l'oeil voit ne sont que l'emblême et le miroir de l'Invisible, et que, suivant la belle pensée de Dante, *l'ordre qui les relie toutes entre elles fait l'univers à l'image de Dieu.*

13 Charles Chasse, *The Nabis and their period*, Paris 1960; English trans. New York 1969, p. 57.

14 Ibid., p. 7. The Nabis included among others Pierre Bonnard, Edouard Vuillard, Félix Vallotton, Henri Ibels and Ker-Xavier Roussel.

15 Pierre Cailler, *Catalogue raisonné de l'oeuvre gravé et lithographié de Maurice Denis*, Geneva 1968.

16 See Cate and Hitchings, op. cit., pp. 17–18.

17 Gustave Geffroy, 'Le plaisir à Paris: les restaurants et les cafés concerts des Champs Elysées', *Le Figaro illustré*, July 1893, pp. 137–40.

18 Ce que l'on chante au café-concert n'est pas si indifférent que beaucoup d'étoiles le supposent. Un répertoire intelligemment choisi donne quelques privilèges. Le triomphe fabuleux d'Yvette Guilbert se fait de deux parts; son propre talent si en dehors, sa voix mordante, son entente du costume, son air gaiement funèbre qui est la dernière forme de notre rire, mais l'autre part est son répertoire. Elle a chanté autrement et elle a chanté autre chose. Elle s'est faite la muse des pince-sans-rire, la traductrice d'une humour très singulière, splénétique et immorale ingénuement.

19 Wolfgang Wittrock, *Toulouse-Lautrec: The complete prints*, London 1985.

20 Herbert D. Schimmel and Phillip Dennis Cate, eds., *The Henri de Toulouse-Lautrec/W. H. B. Sands correspondence*, New York 1983.

21 For another interpretation of *Elles* see Michel Melot, 'Questions au Japonisme', *Japonisme in art*, Tokyo 1980, pp. 239–60.

22 Jehan Rictus, 'L'Hiver', *Les Soliloques du pauvre*, Paris 1913, p. 9.

> Merd'! V'la l'Hiver et ses dur'tes,
> V'là l'moment de n'pus s'mett'a poils:
> V'là qu' ceuss' qui tienn'nt la queue d'la poêle
> Dans l'Midi vont s'carapater!

23 Marilyn McCully, *Els quatre gats: Art in Barcelona around 1900*, Princeton 1978, p. 132.

24 Phillip Dennis Cate and Susan Gill, *Théophile Alexandre Steinlen*, Salt Lake City 1982.

25 Bordant au midi le champ de courses de Saint-Ouen, le long de terrains vagues au gazon lépreux, à l'horizon desquels se profilent les tristes silhouettes d'usines aux immenses cheminées, soufflant sans répit une fumée épaisse et noire, s'étend une route poussiéreuse qui sert de garage aux voitures de toutes sortes (...) C'est sur cette route que se tient ce que, par ce besoin d'anglicanisme qui caractérise tout ce qui, de près ou de loin, touche aux courses, on a denommé le *Petit Betting*. Tout *Petit Betting*, en effet; sorte de carreau, de cour des miracles du jeu.

26 Eugenia W. Herbert, *The Artist and social reform*, New Haven 1961, p. 188.

27 Maxime Vallotton and Charles Goerg, *Félix Vallotton, Catalogue raisonné of the printed graphic work*, Geneva 1972.

28 Una E. Johnson, *Ambroise Vollard, éditeur*, New York 1977.

29 Claude Roger-Marx, *L'Oeuvre gravé de Vuillard*, Monte Carlo 1948.

30 Francis Bouvet, *Bonnard: The complete graphic work*, New York 1981.

31 Gabriel Weisberg et al., *Japonisme: The Japanese influence on French art, 1854–1910*, Cleveland 1975, pp. 53–67. Colta Feller Ives, *The great wave: The influence of Japanese woodcuts on French prints*, New York 1974.

32 Armond Field, *Henri Rivière*, Salt Lake City 1983.

5. P. GILMOUR/AUGUSTE CLOT

1 Claude Roger-Marx (1888–1977) wrote innumerable periodical articles and catalogues raisonnés for several important artists who worked with Clot—including Bonnard, Vuillard, and Renoir (see the name Roger-Marx, Bib. section 8). His general history of prints, *French original engravings from Manet to the present time*, London, Paris, and New York 1939, also gives considerable detail about Clot's contribution, especially pp. 45, 50, 74. Roger-Marx, junior, is to be distinguished from his father, Roger Marx (1859–1913), who was also a graphic arts enthusiast sympathetic to Clot.

2 Written in CA581 to André Clot seeking information about Vuillard prints for the catalogue raisonné of 1948.

3 Five letters survive from Claude Roger-Marx—CA246, 332–34, 581; the letter to Madame Clot, c.1951, says: 'Voilà bien longtemps que j'aurais le grand désir de venir vous voir et de vous montrer les ouvrages que j'ai publiés, où j'ai pu, à diverses

reprises, rappeler le rôle important joué par votre mari dans le renouveau de la gravure moderne et combien les artistes ont bénéficié de son goût et de son expérience technique.'

4 André Mellerio, *La Lithographie originale en couleurs*, Paris 1898, p. 26.

5 Mellerio's article 'Les dessins de Rodin interprétés lithographiquement en couleurs par A. Clot' appeared in *Rodin et son oeuvre*, fascicule VI, 'numéro exceptionnel', *La Plume*, 1900, pp. 81–82.

6 Two groups of letters have survived. One is a set of some 570 communications found in Clot's workshop after his son's death in 1962, ranging from scribbles on visiting cards to letters several pages long from artists, writers, and dealers. Only about 100 letters have been dated by the sender; the majority are neither dated nor addressed. While most dated letters are concentrated into the second half of the 1890s, a few fall into every year from the earliest, sent by Jacques-Émile Blanche on 2.4.1896 to that from Henry de Groux dated 2.4.1915. A second group of 216 letters, kept by relatives of André Clot, presents a greater concentration of letters from between the wars.

7 Alfred Lemercier, 'L'Imprimeur lithographe' in *La Lithographie française de 1796 à 1896 et les arts qui s'y rattachent: Manuel pratique s'adressent aux artistes et aux imprimeurs*, Paris 1896–98, pp. 445–47.

8 Rose-Joseph Lemercier (1803–1887) founded his firm in 1828; his nephew Alfred, who began work there in 1848, succeeded him. In 1891 Alfred sold his interests and the firm became a Société Anonyme with five investors and moved from the rue de Seine to the rue Vercingétorix. In 1901 it was sold again, this time to Johnstone Foreign Patents Co., a British concern. (Conversation with Jeff Rosen, Chicago, author of *Lemercier et Compagnie: Photolithography and the industrialization of production in France [1837–1859]*.)

9 *Le Lithographe*, Journal des artistes et des imprimeurs, vol. ii, 1839, p. 55. Other workmen were said to average 3.50–4 fr. per day for printing 'écritures' (writing) and 6–7 fr. per day for 'dessins' (drawings).

10 The *Inventaire du Fonds Français après 1800* (15 vols), Paris 1930–85; vol. v, pp. 49–50, names Clot as the lithographer of *Polichinelle*. When considered an original print by Manet, *Polichinelle* was hailed as the harbinger of colour lithography. F. Carey and A. Griffiths in *From Manet to Toulouse-Lautrec: French lithographs 1860–1900*, London, British Museum 1978, p. 40 and Jay McKean Fisher in *The Prints of Édouard Manet*, Washington DC, International Exhibitions Foundation 1985–86, pp. 103–04, have unveiled *Polichinelle* as a chromolithograph after Manet's watercolour, so approval may cool.

11 This information is given in a note to cat. no. 82 in E. Moreau-Nélaton, *Manet, graveur et lithographe*, Paris 1906, n.p. Clot claimed that none of the four Manet stones, cat. nos 82–85, had been printed before the artist's death. It is most unlikely that a printer of Clot's experience could have been mistaken about whether stones had been printed before or not. Any 'states' are therefore likely to have stemmed from the printer rather than the artist.

12 Mellerio, in *La Lithographie originale en couleurs*, p. 25, defines an 'essayeur' as the expert 'to whom it falls to do the research and experiments which lead to the printing.'

13 Belfond's identity is a problem; at least three different spellings of the name can be found, two of them on the introductory sheet to Dulac's portfolio *Suite des paysages*. This may indicate a cavalier 19th-century attitude to orthography, or the existence of two or more printers similarly named. In the journal *La Lithographie*, vol. i, no. 6, Nov. 1897, Belfond recalled retouching experiments he conducted whilst with Lemercier; he is also reported by G. Hédiard in *Fantin-Latour, catalogue de l'oeuvre lithographié du maître*, Paris 1906, p. 18 to have introduced Fantin-Latour to transfer paper there. Mellerio (see note 12), who mis-spells other names, refers to 'Bellefond' as a 'specialist in black and white'— possibly with the outstanding lavis plates of c. 1890 by Alexander Lunois in mind. However, Belfond is also associated with Whistler's colour lithographs and it was partly the printer's bankruptcy in 1893–94 that prevented their completion. In the late 1890s, the name Belfond can be found in association with other printers—F. Dupont, Eugène Marx, and Maison Engelmann. At the latter house, Belfond shared with Clot the realization of many colour illustrations by Lunois in Merimée's *Carmen*. Joseph Pennell, *The Life of James McNeill Whistler* (2 vols.), London 1909, vol. ii, p. 135, gives Belfond's 1892 address as rue Gaillon. In the *Annuaire-Almanach du Commerce Didot-Bottin*, Paris 1888–91, 'Bellefond relieur' is shown at 25 rue du Cherche-Midi and 1 rue d'Assas—streets which abut; an early Clot visiting card

preserved in the Musée Rodin, Paris, gives Clot's address as 23, 25 rue du Cherche-Midi.

14 *Album des peintres-lithographes de Manet à Matisse* and *Maîtres et petit-maîtres d'aujourd'hui.*

15 Redon's *Le Buddha* (M132) was in part IX of André Marty's *L'Estampe originale*. A letter from Madame Redon (CA 336/7) confirms Clot's involvement, asking him to put Redon's drawing on stone: 'It's very urgent. We have no more than 10 days to do it, including the printing.'

16 The full text of Clot's reference, dated 27 August 1888, is:

Nous certifions que Monsieur Clot (Auguste) a fait son apprentissage d'imprimeur lithographe dans nos ateliers—qu'il y a occupé pendant plusieurs années une place d'essayeur. Il connaît parfaitement son métier et les études lithographiques en noir et en couleur qu'il a faites lui permettent assurément de rendre le veritable service à la maison qui l'occupera. Sa conduite est très reguliere je n'ai pendant dix-huit années qu'il a été occupé dans nos ateliers aucun reproche à lui addresser.

17 A. Marty in *L'Imprimerie et les procédés de gravure aux vingtième siècle*, Paris 1906, p. 23, says that 'M. Clot surveilla jadis l'exécution du catalogue Spitzer'; similarly Roger-Marx in *Le Populaire* (untraced press cutting) says '. . . il exécutera nottament les planches du remarquable catalogue de la vente Spitzer.'

18 Aymer Vallance so described the collection in the *Art-Journal* 1893, pp. 185–89. The sale began on 17 April that year.

19 *La Collection Spitzer: Antiquité, Moyen-Age, Renaissance* (6 vols.), Paris 1890–92. The volumes arrived at the Victorian State Library, Melbourne, between August 1890 and June 1893 (vol. 5 later than vol. 6), suggesting despatch from France some two or three months earlier.

20 H. Bouchot, 'La Chromolithographie' in *La Lithographie*, Paris 1895, p. 247: 'montrent l'art chromique à son faîte.'

21 Ambroise Vollard, *Recollections of a picture dealer*, trans. V. M. Macdonald, Boston 1936, rpr. 1978, p. 29.

22 Camille Pissarro, *Letters to his son Lucien*, 1944, rev. 1972, rpr. Santa Barbara and Salt Lake City 1981. The letters summarized here appear on pp. 288, 300, 370–77 of the 1981 rpr.

23 Janine Bailly-Herzberg, *Dictionnaire de l'estampe en France 1830–1950*, Paris 1985, p. 361.

24 Letters to Clot survive from the following artists who showed in Vollard's first group print exhibition: J. E. Blanche, P. Bonnard, M. Denis, H. Fantin-Latour, A. Guillaumin, Hermann-Paul, A. Lunois, E. Munch, O. Redon and E. Vuillard. For details see the schedule of letters and works printed by Clot in the Appendix, pp.382–91.

25 The proofs and editions in the Drouot sale of 1919 [D.1919:] and in Clot's estate handled by Paul Prouté after Mme Clot's death [Pr. 1954] are also entered on the schedule in the Appendix. Used in conjunction with catalogues to an artist's prints these entries throw considerable light on Clot's activity and occasionally reveal areas of doubt. For example, the printer Blanchard is credited by Hédiard with printing a number of Fantin's prints for Vollard, notably six zincographs of 1898 (H. 138–142, 146). Blanchard is also credited in Redon's catalogue raisonné by Mellerio, Paris 1913, with 18 of the 24 plates of *La Tentation de Saint Antoine 3e*, published both as a portfolio in 1896 and in the 1930s as a book. Mellerio credits Clot with plates I, III, VIII, XV, XVIII, and XXI (M. 134, 136, 141, 151, 154) all of which turn up in the printer's sale and estate. However, Clot also sold proofs of plates XVI, XVIII, XX, XXII and XXIV; the last was dedicated to him and 29 copies of pl. XVIII turned up in his estate. Similar observations apply to Redon's late lithographic portraits; of the six credited to Blanchard by Mellerio and said to be in editions of 12–25 (M. 190–194) all turn up in Clot's keeping in anything from 27 to 31 copies! Perversely, three portraits of 1904-8 are credited to Clot (M. 195–197), and although he sold two trial proofs in 1919 no copies were found in his estate. The simplest explanation may be that Clot stored not only his own editions, but those printed for Vollard by other printers. If so, there are nevertheless numerous other images credited to Blanchard that Clot does not appear to have had in his keeping.

26 Fantin illustrated two books by Adolphe Jullien—*Richard Wagner, sa vie et ses oeuvres*, Paris 1886 (H61–74) and *Hector Berlioz, sa vie et ses oeuvres*, Paris 1888 (H76-89). Added to 426 untitled plates which must emanate from these books, Prouté lists 101 copies of the last Berlioz plate, *Apothéose* (H89).

27 CA406–420. Of the dated letters, one falls in each of the years 1897, 1905, 1906, 1928, two in 1903 and 1912, and five in 1911. The rest are undated.

28 'Je me tourmentais en effet vous savez très bien que je ne voulais pas donner une seule épreuve. Je crois que vous êtes satisfait du

travail fait pour moi, puisque je n'ai jamais donné autant pour des tirages. Je suis en ce moment à la vente Degas' (CA289 from G. Pellet,? La Festé Alois—Dimanche soir, n.d. [but Degas sales took place in 1918 and 1919].)

29 See introduction 'La Maison Gustave Pellet—Maurice Exsteens', in Kornfeld and Klipstein sale catalogue no. 106, Berne: 24 May 1962, p. 7.

30 Gertrude Stein, 'Paris 1903–1907' in *The Autobiography of Alice B. Toklas* (Stockholm, London 1947), pp. 39–40.

31 André Suarès, 'Ambroise Vollard', *La Nouvelle Revue Française*, 1 Feb. 1940, pp. 184–93.

32 CA24b. from Bénédite on headed notepaper of Musée National du Luxembourg, n.d.

33 Berthe Morisot and the history of *Le Tiroir de laque* is told in Janine Bailly-Herzberg, 'The Prints of Berthe Morisot', *Gazette des Beaux Arts*, May-June 1979, pp. 215–27.

34 A printed letter of 19 October 1905 from the Société des Amis des Arts d'Angers asks Clot to send them one of the coloured lithographs after Rodin 'exposée au Salon de cette année sous le no. 1965.'

35 André Mellerio, *La Lithographie originale en couleurs*, Paris 1898. All Mellerio quotations come from this unless otherwise stated.

36 CA140 (18.10.[18]97) from Eugène Grasset, 65 Bd. Arago requests: 'Prière de tirer le *vert* du fauteuil *plus foncé et plus chaud.*'

37 Edouard André, *Alexandre Lunois: Peintre, graveur et lithographe*, Paris 1914. The prints are not illustrated, nor are they dated except when exhibited.

38 CA220b. n.d. 'La pierre du *Lawn tennis* . . . est *terminée* . . . J'ai reçu une lettre attendrie de Vollard!!!! Il paraît qu'il a vu la pierre.'

39 In CA208 (8.9.1907) from Lofthus, Norway, Lunois, who has been spitting blood, tells Clot he has been wrapped up like a parcel and sent to a sanatorium, '. . une question de vie ou mort'. Cared for by his medically trained wife he survived until 1916, but was still only 53 when he died.

40 Raymond Escholier, 'Peintre-graveurs contemporains: Alexandre Lunois', *Gazette des Beaux Arts*, March 1912, pp. 215–24 (p.218). 'En 1888, ce procédé, qui prête à l'estampe une saveur de libre peinture, était, en raison des difficultés du tirage, entièrement délaissé. Lunois allait le remettre en honneur et le faire vraiment sien.'

41 G. Engelmann, 'Section XII. Lavis lithographique' in *Manuel du dessinateur lithographe*, Mulhouse and Paris 1830–31, pp. 74–85.

42 E. Duchâtel, *Traité de lithographie artistique*, Paris 1893, p. 22.

43 CA139 from Roger-Maurice Grillon says: '. . il y a un voile dans toute la partie inférieure, on dirait un coup de chiffon qui aurait brûlé par le contact avec un acide.'

44 Phillip Dennis Cate illustrates and discusses Anquetin's prints in *The Circle of Toulouse-Lautrec*, Rutgers, State University of New Jersey: Jane Voorhees Zimmerli Art Museum 1986, p. 77, col.pl.27. The spread in *Courrier français* was not lithographed, but a line block signed 'Ch. Decaux sc.' The two undated letters to Clot offer a few clues—the artist's intention to show his 'tartines' at the Champ-de-Mars, a reference to a drawing exhibition, and an address to which he moved in 1893. However, none of these securely dates the lithographs or confirms Clot's independent activity as early as 1894.

45 E. W. Kornfeld and P. A. Wick, *Catalogue raisonné de l'oeuvre gravé et lithographié de Paul Signac*, Berne 1974, cat. nos 8–13.

46 CA540 (16.4.[18]98) a letter of condolence: '. . . très peinés du malheur qui vient de vous accabler.'

47 CA357 from Signac asks for a price for three lithographs 20 × 26 cm in five colours, and editions of 1237 (137 on Japan) for the German journal. Three other letters report Kessler's go-ahead, the intention of Signac and Cross to call on the printer, and the intention to return to Paris and pick up proofs of the prints for *Pan*, Vollard and Pellet. Signac's diary for 29.12.1897 (see *Gazette des Beaux Arts*, 1952, pp. 300, 304) securely dates the commission.

48 The catalogue of the prints (see note 45) details several examples of such proofs.

49 Antony Griffiths, 'The Prints of Toulouse-Lautrec' in W. Wittrock, *Toulouse-Lautrec: The complete prints* (2 vols.), London 1985, p. 41.

50 Dr Guy Georges, who still owns one of Auguste Clot's Brisset presses, gives the sheet sizes for Jésus and Colombier as 56 × 76 cm and 65 × 92 cm respectively. This does not entirely coincide with other published measurements, such as those given by Maindron in *Les Affiches illustrées*, Paris 1896.

51 CA380, Steinlen to Clot, n.d.: 'Vous devez sans doute, vous souvenir des petites pierres que vous avez vues . . . qui sont destinées à un album musical—comme j'ai un peu peur de la façon dont Dupré—grand sabreur—se tirera de ces choses plutôt

délicates j'ai engagé l'Editeur "Maison Enoch" à vous demander de vous charger de ce travail.'

52 Lebeau's cheque for 346 francs was sent with CA386 (20.5.1905).

53 Johannes Sievers and Emil Waldmann, *Max Slevogt: Das druckgraphische Werk 1890–1914*, Heidelberg and Berne 1962, p. 47 cat. nos 496–815:

Die Vorzugsausgabe des Werkes ist von A. Clot in Paris gedruckt worden, da sich bei dem in Berlin gemachten Probedrucken herausstellte, dass sie in dieser in Deutschland seit Menzels "Versuchen mit Pinsel und Schabeisen" fast unbekannt gewordenen Technik der Tuschpinsel-Lithographie befriedigende Resultate nicht zu erzielen vermochten.

54 Clot's business was always located in the rue du Cherche-Midi, although he worked from four different numbers. The earliest letter bearing an address is from Maxime Dethomas, dated 3 January [1897], sent to no. 23. A printed visiting card 'Auguste Clot Lithographe, 23, 25, rue du Cherche-Midi' is kept in the Clot folder at the Musée Rodin; its printed numbers are crossed out and 21 inserted by hand. A book by the Comtesse Molitor, in galley-proofs by September 1903, carries the legend: 'A Clot Editeur, 21 rue du Cherche Midi'. The letter sent to no. 23 in August 1904 by the dealer, Charles Hessèle, must have been wrongly addressed; indeed, a second letter from him later that year is addressed to no. 21. Several surviving letters sent to no. 21 are dated 1911, but there is also one from L. Grandel, 7 rue de Laborde, Paris, 8ᵉ—CA135b (23.?8.1911)—which discusses new premises and whether Clot would prefer a yearly rent instead of a lease. This may concern his last address at 102 rue du Cherche-Midi to which the letters from between the wars were directed.

55 CA463/4 (12.3.1936): 'Le commerce frequent avec M. votre père laisse un souvenir plein de gratitude et d'agrément.'

56 There are two publications with the name *L'Estampe moderne*— one published by Loys Delteil from November 1895–March 1896 for which Clot was the lithographer. The other was directed by Masson and Piazza and printed by Champenois from May 1897-April 1899. See Bailly-Herzberg, *Dictionnaire*, pp. 354–55 for complete listing of contents of both portfolios.

57 Blanche's print for fascicule V of *L'Estampe moderne* was called *Le Cheval blanc*. CA33 (16.6.[18]96): 'Je n'ai pas trouvé les petits chevaux dans le carton que vous m'avez envoyé hier.' CA35, n.d.: 'Voici une pierre que j'ai faite pour le Monsieur que vous m'avez présenté, Deltheil (sic) je crois.'

58 Fantin had been sent lithographic stones by Cadart in 1862 and had drawn a lively version of *Les Brodeuses* which Lemercier refused to edition. See Hédiard, p.16.

59 It has been persistently reported that Clot worked with the printer Ancourt. The only, extremely thin, evidence we have found that could possibly support this is the presence in Clot's 1919 sale of Lautrec's eight-colour lithograph *Marcelle Lender en buste* 17/100 from the luxury French edition of *Pan*, 1895; the printing is credited in the journal to Ancourt. However, the apparent gap in Clot's career, and the large number of accounts claiming his association with Ancourt, may point to a reference we have missed; they are as follows: P. D. Cate and S. Hitchings, *The Color revolution: Color lithography in France 1890–1900*, Santa Barbara and Salt Lake City 1978, p. 38; D. Druick and P. Zegers, *La Pierre parle: Lithography in France 1848–1900*, Ottawa, National Gallery of Canada 1983, cat. no. 520; Janine Bailly-Herzberg, 'Quelques imprimeurs-lithographes . . .' in *Dictionnaire*, p. 367 (see note 23); Antony Griffiths in 'The Prints of Toulouse-Lautrec' in Wittrock, p. 46 (see note 49). As well as printing for Marty's *L'Estampe originale* in 1893–95 and the earlier black-and-white prints of the Nabis, Ancourt is known as a printer of posters. The firm is shown in *Didot-Bottin* from 1888–1891 in the rue du Faubourg St.-Denis, 83. In the *Repertoire des papetiers et imprimeurs de Paris et de la Province* for 1895, the reference says 'voir Bourgerie'. By 1897, the intervening reference to 'Bourgerie et Ancourt' gives way to 'Bourgerie et Cie' at Ancourt's former address.

60 Letter of 7.1.1923 from Pierre Bonnard to Claude Roger-Marx quoted in *Bonnard lithographe*, Monte Carlo 1952, p. 11. 'J'ai travaillé avec Clot qui facilitait beaucoup l'exécution par sa souplesse.'

61 Misia Godebska was married to Thadée Natanson of the *Revue blanche* and knew all the Nabis artists. The Godebskis came originally from Poland.

62 Bonnard's letter is not dated, but Leon Wyczółkowski (1852–1936) became Professor at the Academy of Fine Arts in 1895. See exhibition catalogue *Grafika z Krakówskiej Akademii Sztuk Pieknych [Graphic art studies at the Academy of Fine Arts, Kraków]*, June-Sept. 1986, n.p. In fact Kraków is now a leading city for graphic art in Poland, and a major biennial, which draws

entries from all over the world, is held there.

63 See exhibition cat., *Vuillard lithographe*, Galerie Huguette Berès, Paris 1955.

64 Jacques Guignard, *Le Livre*, Editions du Chêne 1942.

65 Maurice Denis, *Journal 1884–1904*, Paris 1947, p. 86. 'ELLE EST PLUS BELLE que toutes les images, que toutes les représentations, que tous les efforts subjectifs.'

66 CA76b. Denis Clot, n.d. 'en mauve soutenu à votre fantaisie'.

67 CA72b. Denis to Clot, n.d. 'Si vous arrivez à mieux faire voir la ligne de la tête, la ligne du bras, le coeur, ce sera parfait.'

68 CA75b. (4.8.1899) Denis to Clot, 'Je vous prie de tirer si c'est possible *telque*, c.a.d., avec les teintes de mon lavis.'

69 See *Ker-Xavier Roussel 1867–1944 Gemälde, Handzeichnungen, Druckgraphik*, Bremen, Ausstellung Kunsthalle 1965, compiler Christian von Heusinger.

70 *Têtes et pensées*, published in 1901 consisted of 22 portraits of well known men such as Catulle Mendès, Octave Mirbeau and André Gide. A later set based on famous women does not seem to have been published, see *Inventaire*, vol. i, pp. 355–57.

71 CA443/4 (4.1.1909) written for Alexandre Lunois, president of the Association Française des Artistes Lithographes, invites Clot to participate in an evening school teaching the techniques of lithography. There is no evidence as to Clot's reply, except that a later correspondent, Yvonne Préveraud de Sonneville, responsible for *Rêveries romantiques*, describes herself as Clot's pupil.

72 CA132/3 (12.2.1908) Frazier-Soye to Clot.

73 CA250 (12.6.1910) and CA251a, n.d. '. . . en vous priant d'avoir par amitié pour moi l'humanité, la bonté de lui donner un bon conseil . . . vous qui connaissez si bien la vie laborieuse de Paris. Ce pauvre enfant est bien en retard, mai il est plein de bonne volonté . . .'

74 Stanley Jones, now master printer at the Curwen Press, London, tried the Clot workshop as a possible place in Paris where one might learn to be a printer, but André Clot was already running down his operation and employed no staff.

75 CA78–79 of 10.5.1907, 13.5.1907 and 8.6.1907.

76 Introduction to *Têtes et pensées*, see note 70.

77 A *faux décalque* is literally a false tracing. It usually entails transferring to the colour stones an outline from the keystone. A substance is used which will not print, but merely serves as a guide for subsequent work.

78 Veber's letter says 'Voulez vous me l'envoyer à nouveau avec sa petite voiture.' Clot, who by 1912 does not even seem to have had a telephone (Bernheim Jeune CA376 mentions that he cannot find a number) is hardly likely to have had motorized transport by 1903. The 'petite voiture' was probably some kind of handcart, or possibly a horsedrawn vehicle. Bd. Péreire is on the north-west outskirts of Paris and rue du Cherche-Midi, south of the Seine and lying to the west of the Jardins du Luxembourg, runs north to Bd. St-Germain and south towards Bd. Montparnasse.

79 CA421–424, dated 1897 to 1907. Although the catalogue of his prints quotes a letter in which Veber claims that 'Dorénavant les épreuves seront tirées par moi' and entry no. 83 claims that *L'Arracheuse de dents* was pulled by the artist, the surviving letters make it quite clear that Clot both proofed and editioned this print. See Pierre Veber and Louis Lacroix, *L'Oeuvre lithographié de Jean Veber*, Paris 1931, pp. 19, 52.

80 Mlle. Colthurst asks in CA49 for 5 sheets of transfer paper 'à grain' and in CA50 for 'the most solid of the kind that you prepare.' Denis writes in CA74 that he 'prefers "Clot paper"'; Steinlen too asks Clot to prepare paper especially for him. Artists frequently mistake the side on which they ought to draw and ask for it to be marked so they can distinguish it.

81 Mystery has shrouded the prints pulled for Whistler in Paris. He used the services of Lemercier, but most frequently sent his transfer images across the Channel to Thomas Way and Son in England. Clot set up shop just too late to be of great service to the artist, and by 1895 Whistler's wife was mortally ill, necessitating his return to England. After her death, he virtually gave up lithography.

82 A stern injunction to this effect is contained in a letter from André Marty on behalf of Roger Marx at the *Gazette des Beaux Arts* (n.d. but Roger Marx was Editor from 1902 to 1913). The letter asks for it to be confirmed that the 13 Lautrec stones are in good shape and for an assurance to be given that no extra proofs will be pulled. *Portraits d'acteurs et d'actrices: Treize lithographies* was drawn by Lautrec *c.* 1898. A portfolio originally conceived by W. H. Sands, exact publication details are still obscure (see Wittrock, cat. nos 249–261). Copies of these prints were found in Clot's estate, suggesting that he pulled an edition.

83 Figures given by Antony Griffiths in Wittrock, p. 40.

84 Information given by John Boulton Smith, *Frederick Delius and Edvard Munch*, London 1983, p. 48. Boulton Smith says of Tulla

Larsen and Munch '. . . she was as determined to marry the artist as he was to remain single.'

85 CA454a. (23.2.1900) from Ollendorff orders an edition of 800 each of 15 portraits at 12 francs per 100 impressions. CA17a. from the artist says Fasquelle has offered 13c. per print inclusive of paper.

86 Prices have little meaning except in relation to the average wage paid. According to Quid Encyclopaedia, 1987, the range of wages in French francs for a day's work of 10 hours was:

	1880	1900	1919
agricultural worker	2.20	3.00	12.00
roadworker	5.50	5.50	20.00
carpenter	8.00	9.00	22.00

In 1894, shop girls earned 150–200 francs per month for a 12-hour day with 2 hours off for meals. Between 1803 and 1914, the US$ was worth 5 francs and the £ sterling 25 francs.

87 The receipts from Clot are dated 20.8.1897 and 1.3.1898.

88 This short note from Munch is extremely hard to read and also includes a reference to 'verres de champagne'. This identifies the print as a portrait of Gunnar Heiberg with a framing line of green and green champagne glasses in the background.

89 There is no hard evidence to prove that Toulouse-Lautrec worked in Clot's shop, but Wittrock believes it reasonable to assume that *Elles* was printed there. The basis for this belief is that Clot worked regularly for Pellet and that none of the *Elles* proofs turn up in the possession of Stern, which was almost always the case when he did the printing. There is also implicit confirmation in the wording of Claude Roger-Marx's introduction to Bonnard's print catalogue: '. . .l'essor que connut entre 1890 et 1900 la gravure polychrome, et beaucoup grâce à l'expérience technique de l'atelier d'Auguste Clot. Avec *Elles* de Toulouse-Lautrec, avec les *Paysages et intérieurs* de Vuillard, la suite intitulée *Quelques aspects de la vie de Paris*, publiée en 189? chez Vollard, constitue la plus précieuse et la plus précise musique de chambre que l'on ait orchestrée à l'aide de quatre à six pierres de couleurs.'

90 The attempt of the German artist Paul Herrmann to differentiate himself from the Frenchman Hermann-Paul must be accounted a dismal failure. H. Singer, *Das graphische Werk des Maler-Radierers Paul Herrmann*, Munich 1914, p. 14, gives Paul Herrmann's birth date as 5.2.1864, a date invariably also given to Herman-Paul; sometimes the names are conflated as well.

91 If Clot did indeed 'book in' Munch, it does not seem to have been the norm for his longstanding customers. The incidence of letters breaking or making appointments at the drop of a hat is enormous. While the polite correspondents ask to be assured that their change of plan is convenient, one nevertheless wonders how Clot ever regulated his customers, or got anything done at all.

92 Memoir of Erich Büttner in Jens Thiis, *Edvard Munch*, Berlin 1934, p. 92.

93 Related in Singer, p. 7 (see note 90).

94 These pseudo-mezzotint plates, once thought to have been printed at Lemercier, should probably be credited to Salmon Porcaboeuf (subsequently called Atelier Leblanc). A letter sent to the atelier by Munch in July 1897 asking for the plates to be sent to him, has been discovered with the note 'Expedié contre remboursement le 1ᵉʳ Août, 1897' [Sent on receipt of payment, 1.8.1897]. (Letter kindly provided by G. Woll, Curator, Munch Museum, Oslo.)

95 Héran's *Centaure* print is entitled *Nymphe effrayée*. However, the iconography of a pair in the water seems more in keeping with one of his other mixed media prints, *Sirène* or *Undine*, also printed by Clot.

96 A. Lemercier, 'Les Reports de gravures' in *La Lithographie française* pp. 139–143 (see note 7). There is no documentary evidence that Munch combined techniques while still in Paris but he was certainly introduced to transfer paper by the printer. In a note written c. 1922 he enthuses about a particularly good transfer paper made especially for him by 'the excellent printer Clot'. The draft was written in response to a criticism of his use of transfer paper by Paul Gauguin's son, Pola. [Information from Gerd Woll, Munch Museum, Oslo.]

97 The print Jeanniot describes in **letter 9** sounds remarkably like *Jeune femme assise dans un jardin* illustrated in J. Baas and R. S. Field, *The Artistic revival of the woodcut in France 1850–1900*, Ann Arbor Univ. of Michigan Museum of Art 1984, cat. 63, p. 107.

98 Three interior scenes by Vuillard with pink wallpaper have a tiny repeat unit which looks as if it has been partially printed by relief block on transfer paper and then set down on the stone (Roger-Marx nos 36–38).

99 A brilliant reconstruction of Munch's plans for his graphic art was published by Bente Torjusen, 'The Mirror', in *Edvard Munch: Symbols and images*, Washington DC: National Gallery of Art 1978, pp. 185–212. The author has also generously shared

100 information about Munch's letters with the writer of this essay.

101 The original of this letter, probably an unsent draft, is in the Munch Museum, Oslo, and is thought to have been written in the middle of 1897.

102 Munch's undated letter from Norway to Meier-Graefe in Paris is speculatively dated to late 1897 because he mentions the sale of a painting of Jaeger. The German text of the relevant paragraph is: 'Wenn Du farbigen Holzschnitte haben wirst muss die Sachen hier gedruckt werden—als ich lasse die Farbe mit lithografische Steine drucken.'

103 The drawing in coloured crayon *Double portrait of two young women* is now part of the Sarah G. and Lionel C. Epstein collection. On the basis of annoyed letters from Meier-Graefe, who has been awaiting the work for his portfolio for nearly two years and whose last letter is dated 15.10.1899, the drawing must date to the end of 1899 or later.

104 A. Mellerio, 'Exposition de la deuxième année de L'*Album d'estampes orginales*; galerie Vollard, 6 rue Laffitte' in L'*Estampe et l'affiche*, vol. ii, January 1898, pp. 10–11.

105 Vollard's visit to Whistler in search of a print for his album is recounted in *Recollections*, p. 194 (see note 21). It can be dated to March 1895 because the artist was full of the Eden court case. Whistler must have given Vollard two drawings on transfer paper—*Afternoon tea* (Levy 114/Way 147) which Vollard used for his album, and another print, not described in Way, known both as *Mother and daughter* and *La Mère malade* (Levy 77). The latter was no. 203 in Clot's sale, and was illustrated but wrongly titled. Mellerio illustrated Whistler's album print for Vollard with his review (see note 103). There were 160 copies of *Mother and daughter* (called *La Grandmère*) and 45 copies of the other lithograph in Clot's estate in 1954.

105 See note 103.

106 Mellerio, p. 3: '. . . Manet, révolutionnaire dans l'estampe comme ailleurs, fit son *Polichinelle*, d'un coloris vif et gai, sans être brutal ni chargé, présageant un nouveau mode.'

107 In CA338 (14.12.[18]96) Mme Redon writes: 'Eh la Béatrice! Vous semblez l'oublier? Voilà six semaines que vous l'avez.' In CA339 (13.4.1897) Redon himself writes: 'Je crois qu'il sera bien que je sois présent aux essais du pastel réproduit de M. Vollard. Il y aura sans doute quelque couleurs à changer ou à modifier'. Quite apart from the clear indication that a pastel belonging to Vollard is being reproduced, the delay of almost six months would alone suggest that Clot must have drawn this print. It would not have taken this time just to proof something Redon had left on stone, and a colour print of this complexity, had the artist drawn it himself, would have needed each stage to be proofed separately, building the next colours on proofs of the last.

108 After he was introduced to transfer paper by Belfond, it was Fantin-Latour's habitual practice to transfer an image and then to continue to work it on the stone. From the time he worked with Clot as an independent printer, the artist frequently drew directly on stone, although during the same period, if he worked with other printers, he would revert to transfer paper again.

109 CA360a. (4.1.[18]97) makes it clear that Sisley has given Clot a pastel. However in CA350b. n.d. he also writes: 'Je vous expédie en colis postal le contour en question. Cela peut-il marcher comme cela? [I'm sending you the outline in question. Can it go ahead like this?]

110 Douglas W. Druick, 'Cézanne, Vollard, and lithography: The Ottawa maquette for the "Large bathers" colour lithograph', in *Bulletin 19/1972*, Ottawa, National Gallery, Canada 1972, pp. 1–33 (p. 33).

111 Conversation of the author with Stanley Jones who visited André Clot in the mid 1950s.

112 Agreement reproduced in *Nouvelles de l'estampe* xxv, January-February 1976, p. 17. It was signed on 10 February 1899 and in the Musée Rodin there are receipts for the collection or return of drawings dated 28.2.1899 and 13.9.1899.

113 CA583, 584 from André Mellerio ask for an appointment and later for a list of all the Rodin drawings on which Clot has worked.

114 See note 5.

115 The phrase in French is: '. . une gravure de reproduction, employant la polychrome lithographie, et conservant sa faculté d'interprétation.'

116 F. Fague, 'Ses collaborateurs', *Revue des Beaux Arts et des Lettres*, 1.1.1899, p. 13.

117 Rodin quoted in A. Vollard, *Auguste Renoir*, Paris 1920, p. 209.

118 CA537b. card of 12.3.1905 from G. Astruc: 'J'ai écrit un mot rue de l'Université , mais je sais que c'est vous qui avez la vraie influence!!'

119 A long letter from Chas. Ephrussi, Director of the *Gazette des Beaux Arts*, n.d. but c. 1904, discusses a plan to issue an album of 12 of Rodin's drawings in an ordinary edition of 100 copies costing 200 francs and a special of 5 on Japan for 1,000 francs.

Clot agrees to make a prospectus at his own expense of 500 copies. As his contribution, Rodin supplied 11 pages of names and addresses of possible subscribers. All documents are at Musée Rodin. Charles Éphrussi was mourned in the *Gazette des Beaux Arts*, Nov. 1905, pp. 353–60.

120 A statement in English from Ch. Geard has been translated into French for Clot's benefit—CA61 (8.2.[19]06)—and explains that 'Lord Boleskine . . . a man of means' is travelling in India. His solicitor promises his account will be settled on his return 'but does not know when this will be.'

121 E. de Crauzat, 'Une Découverte en lithographie', *L'Art décoratif*, xxiii, Jan.–June 1910, pp. 166–67.

122 David Cumming, *Handbook of lithography*, London 1905, 1919, rev. 1932; rpr. 1946, pp. 328–30. In Chap XXVI Cumming states: 'These machines, usually referred to as pantographs, have been almost displaced by photo-lithography.'

123 See note 102. The print exactly follows the drawing. As revealed by letters held in the Munch Museum, Oslo, Meier-Graefe asked Munch's permission to use the drawing in a print to be published by a German curator, on condition that it was printed by Clot. Later Munch was sent copies to sign. The print does not appear in Schiefler.

124 CA411b. (25.7.1903) asks Clot to return the pastel of the little girls with the balloon so Vollard can show it to someone. CA406a. (16.7.1911) asks Clot to send 'the edition of the child with the biscuit'. CA406b. (13.9.1911) asks for six of the large lithographs by Renoir of 'the two girls with flowers' and four of 'the girls with the balloon.' CA412/3 and 414/5 are printed in full, see **letters 3** and **15**. Several letters of 1920, after Renoir's death (concerning M. Rauch, Albert André) show that Clot was reproducing Renoir watercolours.

125 The word 'autographie' has been applied to lithography since the earliest attempts to transfer writing. The term is also applied generally to images made from transfer paper. See also essay no. 3 in this book by Jay McKean Fisher on Manet, pp. 91–109.

126 Claude Roger-Marx in the introduction to *Les Lithographies de Renoir*, Monte Carlo 1951.

127 R. Passeron, *Impressionist prints*, London 1974, p. 126.

128 See C. and B. Bouret, *La Lithographie en France des origines à nos jours*, Paris: Fondation Nationale des Arts Graphiques et Plastiques, n.d. (*c*.1984); cat. nos 134 and 135 record dedications on *Buste de femme, Germaine Raynal*, 1914 and on *La grande liseuse*, 1923 (dates given thus), saying 'à Clot cordialement, Henri Matisse.' Wanda de Guébriant, who has access to Matisse's archive and correspondence, says there is no mention of Clot in the letters, but that Clot printed the artist's lithographs until 1924.

129 The original works as they appear in Prouté's list are included in the schedule, Appendix pp.387–88. One of Matisse's woodblocks was also part of the estate. The similarity between Matisse's drawings and the lithographs exactly following them is also commented on in note 22 of John Hallmark Neff's essay on the artist's early prints from: *Matisse Prints from the Museum of Modern Art*, Fort Worth Art Museum and New York, Museum of Modern Art 1986, pp. 17–24.

130 The drawings and the prints they inspired have only been compared from reproductions, but it is difficult to see any difference whatever. Mme Matisse helped the artist cut the blocks, see *Matisse, l'oeuvre gravé*, Paris, Bibliothèque Nationale 1970, p.25.

131 Degas, quoted by Vollard in *Recollections*, p. 201 (see note 21).

132 The Toulouse-Lautrec prints in Clot's estate (see schedule, Appendix p.391) were probably all Pellet reprints, described in Wittrock, cat. nos 55, 56, 57 as 'second edition before 1910.' Mystery has always surrounded both first and subsequent printings of *Portraits d'acteurs et d'actrices: Treize lithographies*, Wittrock cat. nos 249–261.

133 Clot's estate describes the Degas prints in terms of 'grande', 'moyenne', and 'petite' plates. There were 3, 7, and 8 copies respectively.

134 Degas to de Valernes in *Degas letters*, M. Guérin ed., Oxford 1967, pp. 174–75. 'I am hoping to do a suite of lithographs, a first series on nude women at their toilet . . .' The letter is dated 6.12.1891 in the English edition and 6.7.1891 in the French edition of the letters.

135 Mary Cassatt to Samuel P. Avery in *Cassatt and her circle*, N. M. Mathews ed., New York 1984, p. 246: 'I will try to get you some proofs of Degas, but I cannot promise that I will be successful he is not an easy man to deal with, he has been talking for some time of doing a series of lithographs but I am afraid it will end in talk.' The letter is dated 2.3. [1893].

136. The prints of women washing have been definitively catalogued by S. W. Reed and B. S. Shapiro in *Edgar Degas: The painter as printmaker*, Boston 1984. The information pertinent to Clot based on inspection of all known copies is as follows:

no. 61, st. i–vi: *Nude woman standing, drying herself* (Delteil 65). States iv and vi are known to have been in the possession both of Clot and Pellet. Radical change takes place from st. iv.
no. 63, st. i–ii: *After the bath I* (Delteil 61). Three impressions of st. ii are on Japon pelure. The image was not proceeded with.
no. 64, st. i–v: *After the bath II* (Delteil 60). A very dark photo-transfer is aggressively scratched back and the format enlarged in st. v. At this point it is transferred to a new stone to make —
no. 65, st. i–ii: *After the bath III* (Delteil 63). Both states are known to have been in Clot's possession.
no. 66, st. i–v: *After the bath (large version)* (Delteil 64). An impression of st. iii is pulled on Japon pelure; radical changes probably involving textural transfers are made to the image, followed by the entire composition being transferred to a new and larger stone. A small edition pulled of st. v and one copy inscribed by Clot, 'Litho inédite de Degas, tirée par moi, A. Clot.'

137 A drawing in greasy ink on celluloid, formerly owned by Michel Manzi, was sold in 1919 as 'Dessin à l'encre grasse sur celluloid ayant servi pour tirer héliographiquement une contre-épreuve à la presse sur papier humide par M. Degas.' One of the states of *After the bath I* is inscribed 'Experiment at Manzi's', in French.

138 Proofs on Japon pelure can be documented for work printed by Clot for La Gandara, Lunois and Fantin-Latour.

139 M. Melot, *L'Estampe impressioniste*, Paris 1974, p. 88 cat. nos 201–02.

140 Clot's lithographic examples for Marty (see note 17) include the printing and/or drawing a 'lithographie d'interprétation' by Fischer after Delacroix, a crayon lithograph by Léon Detroy, a lavis lithograph *Maternité* by Clot after Carrière, a croquis autographie by Fantin-Latour, and a colour lithograph on seven stones by Clot after Sisley.

141 See **letter 15** from Vollard.

142 Edmond and Jules de Goncourt, *Gavarni*, Paris 1924. There are 20 lithographs reproduced by Clot, who probably made the cover image and the monogram as well.

143 There were 82 copies of 'Cavaliers de Degas' by Clot in the printer's estate. In 1905 and 1910 he also received letters from W. Thornley (known to have reproduced Degas images) about unspecified projects on which they were clearly both engaged.

144 Two of the letters from Rouault can be dated to 1924.

145 The print has been called *L'Attelage*, *La Chevauchée*, and *Le Cavalier*. Under the last title a copy was sold by the printer in 1919, dated 1910 and dedicated to him. There were 3 copies of *L'Attelage* in the printer's estate.

146 Quoted in 'Rouault the lithographer', François Chapon and Isabelle Rouault, *Rouault: Oeuvre gravé* (2 vols.), Monte Carlo 1978, vol. ii, p. 246.

147 See Chapon, vol. ii, p. 77, n. 56.

148 'Rouault and Vollard' in Chapon, vol. ii, p. 61.

149 Chapon, vol. ii, p. 80, n. 193.

150 Clot's grandson says his grandfather never had an etching press and printed only lithographs, woodblocks and collotypes. This does not accord with Una E. Johnson, *Ambroise Vollard éditeur*, 1st edn. 1944, rev. New York: Museum of Modern Art 1977. She credits Clot with the printing of several etchings for the Vollard albums. See, for example, cat. nos 7, 67, 81, 144. We have followed these attributions in the schedule, but it may be considered significant that no copies surface either in Clot's sale or estate.

151 Chapon, vol. ii, p. 73.

152 Chapon, vol. ii, p. 319. The colour collotype trials for *St Suaire* and *Parade*, proofed in 1925, were abandoned and the artist asked for all copies to be destroyed. However, 29 copies of *Clowns, couleurs* and 61 of *Christ couleurs* were sold with the printer's estate and there were also 116 prints listed as *Miserere*.

153 Chapon, vol. ii, p. 249.

154 In CA179a. (9.12.[18]96) Jeanniot asks for gum and acid at home: 'Je voudrais avoir de la préparation à ce moment. Si vous pouvez, passez en faire ici. J'ai de la gomme liquide mais je ne connais pas votre proportion d'acide.' In CA231, Lunois writes: 'A ce soir envoyez-moi un peu de préparation. Il se pourrait que je ne finisse mes pierres que demain matin, je les préparais moi-même.' In CA468 Denis writes to André Clot: 'Voulez vous me préparer un petit pot de votre mélange . . .'

155 In a letter to Thomas Way, postmarked 16 October 1893 [FGA letter file 102] Whistler writes: 'I want you to send me the exact formula for the liquid your Father gave me to use for the *wash* on stone.' Way replies on 17 October: 'You ask us for a very difficult receipt! No less than the distillation of my father's experience . . . The exact chemical prescription . . . would be valueless without the experience . . .' (Text of the letters kindly supplied by Nicholas Smale.)

156 De Groux, returning to Clot's studio after an absence of several years, writes in CA69a. (2.4.1915): 'J'ai grandement besoin, autant que de votre collaboration précieuse en ce métier diabolique Je m'adresse donc à vous qui êtes le roi du métier ...' Roger Marx, writing on Rodin's drypoints in *Gazette des Beaux Arts*, March 1902, p. 208, explains that Clot has made the watercolour reproductions and is 'un imprimeur d'une science consommée.'

6. A. GRIFFITHS/GERMANY

1 Another aspect of this is the possibility of transferring an etching or a woodcut to a lithographic stone; it is impossible to do this the other way round.

2 An economic historian would perhaps see the centre of the subject as lying in the promotional activities of various publishers. Much evidence to support this approach will emerge in this essay.

3 D. Druick and P. Zegers, *La Pierre parle: Lithography in France 1848–1900*, Ottawa, National Gallery of Canada 1983, p. 94. The Paris exhibition was titled Exposition Internationale du Centenaire de la Lithographie and included loans from Munich of many of the important incunabula. The largest of the German exhibitions was held in the Kunstgewerbemuseum in Düsseldorf.

4 There are inevitably numerous mentions of lithography in the course of contemporary accounts of recent printmaking, but I have found nothing which discusses the state of lithography itself.

5 The other well-known Berlin printers who specialized in printing for artists, Otto Felsing, Carl Sabo and Fritz Voigt, seem to have confined themselves to intaglio, though Voigt certainly expanded into printing woodcuts. See his visiting card made by Schmidt-Rottluff in the mid-1920s in R. Schapire, *Karl Schmidt-Rottluffs graphisches Werk bis 1923 [Karl Schmidt-Rottluff's graphic work to 1923]*, Berlin 1924, p. 92 no. 51.

6 M. Lehrs, 'Die Kunst des Steindrucks' ['The Art of lithography'], *Pan* II, Nov. 1896, pp. 233–35. H. W. Singer, 'Modern German lithography', *The Studio* XV, 1899, pp. 260–72; XVI, 1899, pp. 164–75; XVII, 1899, pp. 232–44.

7 Helga Hollmann and others, ed. *Das frühe Plakat in Europa und den USA, ein Bestandkatalog, III Deutschland [The early poster in Europe and the USA, A catalogue of the collection, III Germany]*, Berlin 1980, whence the following information is drawn.

8 Druick and Zegers, *La Pierre parle*, p. 101 (see note 3), devote a section of their catalogue to the 'Estampe murale', and refer to the colour lithographs for schools published by the Fitzroy Society in London. A monograph has been devoted to this subject by Inge Schlünder, *Die deutschen Künstler—Steinzeichnungen und die Kunstpädagogische Reformbewegung in der Wilhelminischen Ära [The German artist—Lithographs and the art-pedagogical reform movement in the Wilhelmine era]*, Bern and Frankfurt 1973. I have not been able to consult it.

9 R. Voigtländers Verlag, Leipzig, *Die farbige Künstlerlithographie und ihre Bedeutung für die künstlerische Kultur [The artistic colour lithograph and its significance for artistic culture]*. 1912 edn.

10 Sozialdemokratische Partei (Bildungsausschuss), Berlin, *Künstlerischer Wandschmuck, eine Anregung und ein Verzeichnis [Social Democratic Party (Education Committee), Berlin, Artistic wall decoration, an introduction and catalogue]*. 1909 edn. A copy of this and the preceding item can be found in the library of the Victoria and Albert Museum.

11 'Algraphy, a substitute for lithography', *The Studio* XI, 1897, p. 243. Singer rejected such claims in *The Studio* XVII, 1899, p. 244.

12 Fritz von Ostini, *Thoma*, Bielefeld & Leipzig 1908, pp. 52–54; Richard Graul in R. Graul and F. Dörnhoffer, eds., *Die verfielfältigende Kunst der Gegenwart, vol. iv, Die Lithographie [Reproductive art of the present, vol. iv, Lithography]*, Vienna, Gesellschaft für vervielfältigende Kunst, 1903, p. 39.

13 The process of 'bat' printing had been developed in the 18th century for transfer printing on to ceramics.

14 Von Ostini, see note 12, p. 54.

15 H. W. Singer, *The Studio* XVII 1899, p. 244.

16 Four prints are known, Klipstein 54, 56, 58 and 72. Max Lehrs, 'Käthe Kollwitz', *Die graphischen Künste [The graphic arts]* XXVI, 1903, pp. 59, 66–67.

17 Peter Paret, *The Berlin Secession*, Cambridge, Mass.: London 1980, p. 69.

18 Slevogt had been first associated with Bruno Cassirer in a set of etchings published in 1905. However his first set of lithographs—scenes from the Iliad—was published by A. Langen in Munich. According to Sievers-Waldmann some of these suffered from being printed from transfers on to new stones rather than from the original stones. J. Sievers and E. Waldmann, *Max Slevogt, das druckgraphische Werk: Radierungen, Lithographien, Holzschnitte; erster Teil*

1890–1914 [Max Slevogt, the graphic work: Etchings, lithographs and woodcuts, part I, 1890–1914], Heidelberg 1962, p. 14. Slevogt therefore had a new edition printed in 1915 from the original stones; this was published by Bruno Cassirer.

19 *Kunst und Verleger*, Berlin 1922, p. 12, being a Festschrift on the 50th birthday of Bruno Cassirer. Bruno was also the publisher of Carl Kappstein, *Der künstlerische Steindruck [The artistic lithograph]*, Berlin 1910, which is of importance in that it is addressed directly to the artist rather than to the specialist printer. The introduction concludes on p. 8: '... if the advice given here makes the artist more independent from the often narrow outlook of the printer and shows him new ways of artistic expression, then the goal of this publication will have been reached.'

20 This advertisement is to be found in the catalogue of the 18th exhibition of the Berlin Secession in 1909. Facilities for printing woodcuts were added later.

21 *Katalog der auf der Pan-Presse gedruckten Bücher und Mappenwerke [Catalogue of the books and portfolios printed by Pan Press]*, Berlin 1912.

22 The letters from Barlach to Cassirer have been published by Friedrich Dross, *Ernst Barlach, die Briefe [Ernst Barlach, Letters]*, Munich 1968–69.

23 Kokoschka's early lithographs present considerable problems: the dating is often uncertain and many seem more likely to be photolithographs than transfer lithographs. The work illustrated here was published in *Der Bildermann* in 1916.

24 Other examples can be found in two of the more significant portfolios of lithographs published before the war: *Sema 15 Originalsteinzeichnungen [Sema 15 original lithographs]*, Delphin-Verlag, Munich 1912; and *Freie Sezession Berlin, Siebzehn Steinzeichnungen [Free Secession Berlin, 17 lithographs]*, Berlin c. 1914. After the war, the terminology seems to have changed: *25 Originallithographien der Münchener Neuen Sezession [25 Original lithographs of the New Secession of Munich]*, Munich 1919.

25 In 1908 Kirchner made 32 etchings and 28 lithographs to 13 woodcuts; with Heckel the relative figures are 32, 27, and 15; with Schmidt-Rottluff 8, 21 and none.

26 Arne Eggum, *Die Brücke –Edvard Munch*, Oslo: Munch Museum 1978, p. 19.

27 Francis Carey and Antony Griffiths, *The Print in Germany 1880–1933*, London: British Museum 1984, pp. 37–38. The interview was conducted by Roman Norbert Ketterer and an extract published in the British Museum catalogue through the courtesy of Herr Ketterer.

28 L. de Marsalle, pseudonym for Kirchner, in 'Uber Kirchners Graphik', *Genius* II, 1921, pp. 250–63, reprinted in *Ernst Ludwig Kirchner*, Frankfurt, Städel 1980, pp. 25–27.

29 Gerhard Wietek, *Georg Tappert, ein Wegbereiter der deutschen Moderne [Georg Tappert, a pioneer of German Modernism]*, Munich 1980, is the best monograph on Tappert. But his prints remain uncatalogued and often misdescribed; the lithograph illustrated here, despite being numbered from an edition of five, used to be called a monotype.

30 Gustav Schiefler, *Die Graphik E. L. Kirchners* II 1931, pp. 33–34. The best account of Kirchner as a printmaker is by Jacob Kainen in *German Expressionist prints from the collection of Ruth and Jacob Kainen*, Washington: National Gallery of Art 1985, pp. 31–49.

31 These techniques of colour printing are described in the interview with Heckel, see note 27.

32 The only member of Die Brücke to number his prints was Pechstein. The others kept no records and rarely seem to have printed more than a handful of impressions.

33 Dube 310 (Städel Kunstinstitut, Frankfurt).

34 There is a precedent in Munch's procedure for his lithograph *The sick girl* of 1896; see the account of Paul Herrmann quoted by Elizabeth Prelinger in *Edvard Munch, master printmaker*, New York, London and Toronto 1983, p. 76. But Nolde's changes of colour go far beyond anything to be found in Munch.

35 This conclusion is derived from an examination of the remarkable collection of Nolde's prints in the Sprengel collection in Hanover. It contains examples of Schiefler 21, 23, and 27 in this mixed technique. See *Kunstmuseum Hannover mit Sammlung Sprengel, Emil Nolde, Gemälde, Aquarelle und Druckgraphik, Verzeichnis der Bestände [Hanover Art Gallery with the Sprengel Collection, Emil Nolde, Paintings, watercolours and prints, catalogue of the holdings]*, Hanover 1980. The subject of Nolde's lithographs deserves much closer investigation.

36 See Florian Karsch, *Otto Mueller, Leben und Werk [Otto Mueller: Life and work]*, Berlin 1963.

37 A different procedure is recorded in the case of Walter Grammaté.

He was making two lithographs on the stone in Barcelona; in
order to print them in Berlin, he took off a 'Fettabdruck'
(impression in transfer ink) which he could easily carry back to
Germany to transfer back on to a stone again. See Ferdinand
Eckhardt, *Das graphische Werk von Walter Grammaté*, Vienna
1932, cat. 94.

38 Hans Kollwitz, ed., *Käthe Kollwitz, Tagebüchblätter und Briefe
[Käthe Kollwitz, Diaries and letters]*, Berlin 1948, p. 42.

39 Alexander Dückers, *George Grosz: Das druckgraphische Werk
[George Grosz: The printed work]*, Frankfurt 1979, p. 7. The
original drawing from which our illustration was
photolithographed is now in the Scottish National Gallery of
Modern Art in Edinburgh, and may have been drawn in 1920.

40 Florian Karsch, ed., *Otto Dix: Das graphische Werk*, Preface by
Hans Kinkel, Hanover 1971, p. 14

41 Hans M. Wingler, *Graphic work from the Bauhaus*, London 1969
and Heinz Peters, *Die Bauhaus Mappen [The Bauhaus portfolios]*,
Cologne 1957.

42 The title-pages bear the date of 1921, which was the year that
Gropius wrote to solicit contributions to help raise funds for the
Bauhaus (see the letter to Jawlensky published in the catalogue of
Kornfeld, auction 129, Bern 1968, lot 57). But the fourth portfolio
was only published in 1924 and the second never appeared.

43 See Jim Jordan's essay 'Klee's prints and oil transfer works: some
further reflections', in *The graphic legacy of Paul Klee*, Bard
College, Annandale-on-Hudson 1983, pp. 87–113; the original
drawing for *Akrobaten* is illustrated on p. 83 of that catalogue.

44 W. Kandinsky, *Punkt und Linie zu Fläche [Point and line to
plane]*, Munich 1926, p. 105 (my translation).

45 Heinz Spielmann, *Willi Baumeister: Das graphische Werk*,
Hamburg 1972, p. 114; Karin von Maur, *Oskar Schlemmer*,
Staatsgalerie Stuttgart in the Württembergischen Kunstverein 1977,
rpr. Munich 1982, pp. 181–94, especially p. 181.

46 In this respect Schwitters's *Die Kathedrale* is a surprising
precursor of Dubuffet's lithographs of the 1950s. On Schwitters
see Werner Schmalenbach, *Kurt Schwitters: Leben und Werk
[Kurt Schwitters: Life and work]*, Cologne 1967.

47 Merz was a term that Schwitters coined for his own form of
artistic expression. In his first collage, he had used a scrap of paper
with 'commerz' on it, but with only half the word visible.
Eventually 'merz' was applied to any readymade element, either
two- or three-dimensional, that he could incorporate in his art.

7. R. FINE/POSTWAR AMERICA

1 Robert Rauschenberg wrote in *Work notes*, 1962: 'I began
lithography reluctantly, thinking that the second half of the 20th
century was no time to start writing on rocks.' Quoted by Tony
Towle in *Contemporary American prints from Universal Limited
Art Editions: The Rapp collection*, exhibition catalogue, Art
Gallery of Ontario, Toronto 1979, p. 11.

2 On Universal Limited Art Editions see note 1; also E. Maurice
Bloch, *Words and images: Universal Limited Art Editions*,
exhibition catalogue, University of California, Los Angeles 1978;
Wolfgang Wittrock, *25 Jahre Universal Limited Art Editions
1957–1982*, exhibition catalogue, Wolfgang Wittrock
Kunsthandel, Düsseldorf 1982. On Tamarind see Virginia Allen,
Tamarind: Homage to lithography, exhibition catalogue,
Museum of Modern Art, New York 1959; E. Maurice Bloch,
Tamarind: A renaissance of lithography, exhibition catalogue,
International Exhibitions Foundation, Washington DC 1979; and
Marjorie Devon, *Tamarind: Twenty-five years*, Albuquerque,
University of New Mexio 1985. On Gemini see Riva Castleman,
Technics and creativity: Gemini G.E.L., exhibition catalogue,
Museum of Modern Art, New York 1971; and Ruth E. Fine,
Gemini G.E.L.: Art and collaboration, exhibition catalogue,
National Gallery of Art and Abbeville Press, Washington DC and
New York 1984. This volume includes an essay by Bruce Davis,
'Print workshops at mid-century' that provides an overview on the
subject. On Tyler at Gemini G.E.L. and Tyler Graphics Ltd. see
Pat Gilmour, *Ken Tyler—Master printer and the American print
renaissance*, New York, Hudson Hills Press in Association with
the Australian National Gallery 1986. On Graphicstudio, see Gene
Baro, *Graphicstudio U.S.F.: An experiment in art and education*,
exhibition catalogue, the Brooklyn Museum, Brooklyn 1978.
Graphicstudio was closed down in 1977 and reactivated in the
early 1980s. A publishing workshop was founded at the Nova
Scotia College of Art and Design, Nova Scotia, in 1969 with Jack
Lemon as the first director and Robert Rogers as the first master
printer. The shop operated until 1976, and although in Canada,
worked with many artists from the United States. See Eric
Cameron, 'The Lithography workshop', *NSCAD: The Nova

Scotia College of Art and Design, exhibition catalogue, The New
England Foundation for the Arts 1982. The catalogue was
published by The Press of the Nova Scotia College of Art and
Design. Several other university based workshops are mentioned
in note 24.

3 See *WPA/FAP Graphics*, exhibition catalogue, Smithsonian
Institution Traveling Exhibition Service, Washington 1976. The
WPA workshops were phased out in the early 1940s as the war
effort became a national priority.

4 On screenprinting see Richard S. Field, *Silkscreen: History of a
medium*, exhibition catalogue, Philadelphia Museum of Art,
Philadelphia 1971; and Reba and Dave Williams, 'The early
history of the screenprint', *Print Quarterly* III, Dec. 1986,
pp. 287–321. On lithography, Jacob Kainen explained the printers'
reluctance to reveal trade secrets as essential to their protecting
their jobs. Conversation with the author, 5 May 1987.

5 Jacob Kainen, 'The graphic arts division of the WPA Federal Art
Project', *The New Deal art projects: An anthology of memoirs*,
Francis V. O'Connor, ed., Washington, Smithsonian Institution
Press 1972, p. 175. Kainen's prints to 1976 are recorded in Janet
Flint, *Jacob Kainen: Prints, a retrospective*, exhibition catalogue,
Washington National Collection of Fine Arts 1976.

6 On Atelier 17, see Joann Moser, *Atelier 17*, exhibition catalogue,
Elvehjem Art Center, University of Wisconsin, Madison 1977.

7 See Elizabeth Jones, 'Robert Blackburn: An investment in an
idea', *Tamarind Papers* 6, Winter 1982–83, pp. 10–14; and Nina
Parris, *Through a master printer: Robert Blackburn and the
printmaking workshop*, exhibition catalogue, Columbia Museum
of Art, Columbia 1985. The workshop was later named the
Creative Graphics Workshop and today is called Printmaking
Workshop. It has been described by printmaker Lois Johnson as
'an oasis in New York for people who love prints'. Conversation
with the author, 15 May 1987.

8 See Lauris Mason and Joan Ludman, *The Lithographs of George
Bellows: A catalogue raisonné*, Millwood, New York 1977; Fuller
Griffith, *The Lithographs of Childe Hassam*, Washington DC,
Smithsonian Institution 1962; and Louis A. Wuerth, *Catalogue of
the lithographs of Joseph Pennell*, Boston 1931. In the early 1920s
Pennell set up a lithography shop at the Art Students League, New
York, possibly the first art school litho shop in the country.

9 The best source for information on these and other printers is
Clinton Adams, *American lithographers 1900–1960: The artists
and their printers*, Albuquerque 1983. Also useful on the period
under discussion are Gene Baro, *30 years of American
printmaking, including the 20th National Print Exhibition*,
exhibition catalogue, The Brooklyn Museum, Brooklyn 1976; Una
E. Johnson, *American prints and printmakers*, Garden City 1980;
Judith Goldman, *American prints: Process and proofs*, exhibition
catalogue, Whitney Museum of American Art, New York 1981;
James Watrous, *A Century of American printmaking 1880–1980*,
Madison 1984; and Riva Castleman, *American impressions: Prints
since Pollock*, New York 1986.

10 Lithographs today are increasingly drawn on to specially prepared
metal plates as well as on the traditional limestone.

11 See Clinton Adams, 'Lynton R. Kistler and the development of
lithography in America', *Tamarind Technical Papers* 8, Winter
1977–78, p. 101ff; and Hanlyn Davies and Hiroshi Murata, *Art
and technology: Offset prints*, exhibition catalogue, Ralph Wilson
Gallery, Lehigh University, Bethlehem 1983, p. 6.

12 *Fine prints of the year* was published by Halton & Truscott Smith
Limited, London, from 1924 (covering prints from the year ending
October 1923) through 1938; beginning with Volume 2 there was
also a New York publisher, Minton, Balch & Company, and
starting with Volume 6 there was a section on American prints.

13 See Kainen, 'The Graphic Arts Division', p. 166.

14 See Rosalind Bengelsdorf Browne, 'The American abstract artists
and the WPA project', in O'Connor, *New Deal art project*, p. 230.
Of the 39 artists in the exhibition, only thirty made prints for this
portfolio.

15 Jones, 'Blackburn', pp. 10–11. Parris in *Blackburn*, n.p., notes
Blackburn's frustration at Jacques Desjobert's similar approach.

16 On Spruance, see Ruth E. Fine and Robert F. Looney, *The Prints
of Benton Murdoch Spruance: A catalogue raisonné*, Philadelphia,
University of Pennsylvania Press in cooperation with the Free
Library of Philadelphia 1986.

17 See Garo Antreasian's comments in Adams, *American
lithographers 1900–1960*, p. 166. Also see two surveys titled
'Instruction in lithography, A survey of art schools and
universities', *Tamarind Technical Papers* 6, Jan. 1977, pp. 71–74;
and *Tamarind Papers* 3, Spring 1980 , pp. 53–58.

18 Deli Sacilotto is the author of *Photographic printmaking
techniques*, New York 1982; with Donald Saff he is co-author of

Printmaking: History and process, New York 1978.

19 Quoted in Clinton Adams, 'Rubbed stones, middle tones, and hot etches: Lawrence Barrett of Colorado', *Tamarind Papers* 2, Spring 1979, pp. 37–38; and in Nicholas J. Capasso, *Reginald Neal: A retrospective of his prints*, exhibition catalogue, New Brunswick, The Jane Voorhees Zimmerli Art Museum, Rutgers, State University of New Jersey 1986, p. 4.

20 Capasso, *Reginald Neal*, p. 24. Neal also taught lithography at Milliken University, the State University of New York at New Paltz, Southern Illinois University, and Douglass College, Rutgers University where he founded the MFA Graduate Program in 1959.

21 On Margaret Lowengrund see Adams, *American lithographers 1900–1960*, p. 182–85, 188–89.

22 Peterdi retired in 1986, Lasansky in 1985, and Pozzatti in 1984. One wonders what changes will take place in their printmaking departments as a result.

23 I would like to thank Larry Day and Jerome Kaplan for information about these art school lithography workshops in Philadelphia during the 1940s. On California, see Clinton Adams, *American lithographers 1900–1960*, pp. 173–75.

24 On Jack Damer, see *Jack Damer: Prints and multiples, 1965–83*, exhibition catalogue, Elvehjem Museum of Art, University of Wisconsin, Madison 1983. On Wayne Kimball see Janet Kutner, *Wayne Kimball* exhibition catalogue, Tyler Museum of Art, Tyler, Texas 1977.

25 Among other publishing workshops at colleges and universities are those at the Visual Arts Research Institute, Arizona State University, Tempe; the Hartford Art School, University of Hartford, Hartford; Indiana University, Bloomington; Mount Holyoke College, South Hadley, Massachussets; Rutgers University, New Brunswick, New Jersey; and Smith College, Northampton, Massachussets. I would like to thank Nancy Campbell who set up and directs the Mount Holyoke Printmaking Workshop for supplying some of this information.

26 In conversation with the author, both Jack Damer (2 May 1987, by telephone) and Wayne Kimball (2 Apr. 1987) put forth this point of view.

27 Gustave von Groschwitz, *The First international biennial of contemporary color lithography*, 1950, n.p.

28 The American Color Print Society was founded in 1939.

29 See Richard S. Field et al., *American prints 1900–1950*, exhibition catalogue, Yale University Art Gallery, New Haven 1983.

30 I would like to thank Joshua P. Smith and Kristin Spangenberg for supplying me with catalogues or xerox copies of catalogues for all of the biennial exhibitions held in Cincinnati from 1950–1962. The titles of the lithography shows are The First International Biennial of Contemporary Color Lithography to The Fifth International Biennial of Color Lithography; titles of the last two shows are The 1960 International Biennial of Prints and International Prints, 1962. The catalogues are the source for all information on these exhibitions. See also Clinton Adams, 'Color lithography in the 1950s: The Cincinnati biennials, a conversation with Gustave von Groschwitz', *Tamarind Technical Papers* 7, Summer 1977, pp. 96–98.

31 Garo Z. Antreasian with Clinton Adams, *The Tamarind book of lithography: Art and techniques*, Los Angeles, Tamarind Lithography Workshop Inc., and New York 1971. In sixteen chapters and two appendices the authors cover everything from drawing a lithograph to proofing and printing. They attend in detail to material and special processes and include a chapter on organizing a lithography workshop.

32 This prediction, of course, dates from several years before what is now considered the period of the print renaissance: this is usually dated from 1960, and certainly not earlier than Tatyana Grosman's founding of Universal Limited Art Editions in 1957.

33 A selection of prints from Flory's Japanese workshop is part of the Rosenwald Collection, National Gallery of Art, Washington DC.

34 Single media shows were the tradition, having been held by many of the printmaking societies throughout the United States, and by such institutions as the Philadelphia Print Club.

35 *American Prints Today—1959*, New York 1959, nos 13 and 43. This exhibition was seen in sixteen cities. It was on view from varying dates in September to October 1959 at the Baltimore Museum of Art, Museum of Fine Arts, Boston, Cincinnati Art Museum, Los Angeles County Museum of Art, Whitney Museum of American Art, Philadelphia Museum of Art, Achenbach Foundation for Graphic Arts, and the National Gallery of Art; and from varying dates in November to December or January, 1960 at the Art Institute of Chicago, Detroit Institute of Arts, Wadsworth Athenaeum, Currier Gallery of Art, Brooks Memorial Art Gallery, Walker Art Center, Norfolk Museum, and City Art Museum of Saint Louis. American Prints Today—1962 was

similarly organized with three sets of showings rather than two. To the institutions listed above were added the Albany Institute of History and Art, Cleveland Museum of Art, Colorado Springs Fine Arts Center, Flint Institute of Arts, The John and Mabel Ringling Museum of Art, Columbia Museum of Art, Dallas Museum of Fine Arts, Museum of Fine Arts, Houston, and the J. B. Speed Art Museum. The Norfolk Museum did not participate in this second exhibition.

36 See Sam Francis and George Page, *Sam Francis: The litho shop, 1970–1979*, exhibition catalogue, Brooke Alexander Gallery, New York 1979.

37 Most speciality print galleries were apt to show the cabinet picture—small, black and white, etc., and there were few painting dealers who viewed printmaking as important. This latter situation still prevails—few painting dealers seem interested in prints, but the variety of approaches that print galleries now champion has been dramatically altered and increased. Fascinating, too, is that even today almost all articles about artists' work, if focusing on paintings or sculpture, essentially ignore their work in printmaking. Occasional issues of broadly based major art journals feature prints, mainly *Art News*, which ran a column including announcements of new print editions called 'The Print Collector' during the 1940s and 1950s. Now, almost all information of note about contemporary American prints is to be found in publishers' release announcements and brochures and in the speciality publication, *The Print Collector's Newsletter*, published since 1970.

38 Unpublished interview: Irwin Hollander in conversation with Pat Gilmour, Brooklyn, New York, 28 Sept. 1984. I would like to thank Pat Gilmour for sharing this and other unpublished interviews with me.

39 Unpublished interview: Irwin Hollander with Pat Gilmour, see note 38; and Clinton Adams, interviewer, 'Life and work: Thoughts of an artist-printer, a conversation with Irwin Hollander', *Tamarind Papers* 8, double issue, 1985, p. 36.

40 On Los Angeles printmaking see Ebria Feinblatt and Bruce Davis, *Los Angeles prints, 1883–1980*, exhibition catalogue, Los Angeles County Museum of Art, Los Angeles 1980; and Ruth E. Fine, 'L.A. Prints', in *A Bibliophile's Los Angeles*, John Bidwell, ed., Los Angeles, International Association of Bibliophiles 1985.

41 For a list of lithography workshops in the United States and Canada see Susan von Glahn, 'Lithography workshops: A survey', *Tamarind Papers* 4, summer 1981, pp. 48–52. A more recent list including shops for all media is in *The Print Collector's Newsletter*, Jan.-Feb. 1983, pp. 201–06. This issue also features a discussion among a group of printers, 'Printing today: Eight views', pp. 189–200.

42 'Donald Saff: A conversation', in Baro, *Graphicstudio U.S.F.*, p. 16.

43 See Alexandra Schwartz and Paul Cummings, *David Smith prints*, exhibition catalogue, Pace Prints, New York 1987. Smith completed a seventh lithograph two years later, printed by Reginald Neal at the University of Mississippi.

44 This episode is recounted in Schwartz and Cummings, *David Smith prints*, no. 30. I thank Alexandra Schwartz for showing me the various impressions of this work at Pace Prints.

45 Unpublished interview: Irwin Hollander with Pat Gilmour, see note 38.

46 For catalogues of their graphic work: on Motherwell, see Stephanie Terenzio and Dorothy C. Belknap, *The Prints of Robert Motherwell, A catalogue raisonné, 1943–1984*, New York, Hudson Hills Press in association with the American Federation of Arts, 2nd edn., 1984; on Frankenthaler see Thomas Krens, *Helen Frankenthaler prints: 1961–1979*, New York, Harper & Row, Publishers, in association with the Williams College Artist-in-Residence Program 1980.

47 See note 38.

48 See note 38.

49 Quoted in Fine, *Gemini G.E.L.*, p. 41.

50 For Johns's prints see Richard S. Field, *Jasper Johns prints, 1960–1970*, exhibition catalogue, Philadelphia Museum of Art, Philadelphia 1970; Richard S. Field, *Jasper Johns prints, 1970–1977*, exhibition catalogue, Wesleyan University Center for the Arts, Middletown 1978; Judith Goldman, *Jasper Johns: Prints, 1977–1981*, exhibition catalogue, Boston, Thomas Segal Gallery, 1981; and Riva Castleman, *Jasper Johns, A print retrospective*, exhibition catalogue, Museum of Modern Art, New York 1986.

51 This point has been made by Richard S. Field in his introductory essay to Richard S. Field and Ruth E. Fine, *The graphic muse: Prints by contemporary American women*, exhibition catalogue, Mount Holyoke College Art Museum and Hudson Hills Press, South Hadley and New York 1987.

52 See Richard H. Axsom, *The Prints of Frank Stella, A catalogue raisonné*, New York, Hudson Hills Press in Association with The University of Michigan Museum of Art, Ann Arbor 1983.

53 These prints are included in the exhibition Recent Graphics from American Print Workshops organized and circulated by the Mitchell Museum, Mount Vernon, Illinois 1986, with catalogue by Charles T. Butler and Marilyn Laufer.

54 On Crown Point Press, see Nancy Tousley, 'In conversation with Kathan Brown', *The Print Collector's Newsletter* Nov.–Dec. 1977, pp. 129–34; and Abner Jones, *Kathan Brown, publisher: A selection of prints from Crown Point Press 1977–1985*, exhibition catalogue, Trisolini Gallery, Ohio University, Athens 1985.

55 Unpublished interview: Jim Dine in conversation with Pat Gilmour, New York, 18 Sept. 1984.

56 On woodcuts, see Riva Castleman, *Prints from blocks: Gauguin to now*, exhibition catalogue, Museum of Modern Art, New York 1983. For a selection of recent prints in all media, see Clifford S. Ackley et al., *70s into 80s: Printmaking now*, exhibition catalogue, Museum of Fine Arts, Boston 1986.

57 See Pat Gilmour, *Paperworks*, exhibition catalogue, Australian National Gallery, Canberra 1982.

58 On this subject, see Joan Lyons, ed., *Artists' books: A critical anthology and sourcebook*, Layton and Rochester, Gibbs M. Smith Inc., Peregrine Smith Books and Visual Studies Workshop Press 1985.

59 See Louise Sperling and Richard S. Field, *Offset lithography*, exhibition catalogue, Davison Art Center, Wesleyan University, Middletown 1973, p. 15; and Ruth E. Fine, 'Eugene Feldman (1921–1975): An appreciation', *Exposure* vol. 21, no. 3, pp. 10–13.

60 See Davies and Murata, *Art and technology*.

61 I know of no study of offset workshops at the present time. It is clear they are growing in number, both privately and within the University system. For information on these workshops I thank Kevin Osborn and Don Cushman.

62 Notable are Robert Rauschenberg's paper pulp pieces, *Pages and fuses*. Produced in Ambert, France in 1973–74, they undoubtedly helped spark the paperworks craze in the United States that has followed. Shoichi Ida has recently completed a group of etchings and a woodcut with Crown Point Press, San Francisco.

8. R. BUTLER/AUSTRALIA

1 The Contemporary Art Society of Australia, Anti-Fascist Exhibition, Atheneum Gallery, 8–18 Dec., 1942.

2 In 1828 the population of New South Wales was only 43, 522. Until 1825 approximately fifty relief and intaglio prints had been engraved in the colony. Naturally there were many Australian views engraved overseas especially in England and France but also in Russia, Holland and Italy.

3 See Roger Butler, 'Australia's first lithographs', *Australian Connoisseur*, no. 3, 1982, pp. 94–99, 130–31.

4 For general information on early prints including lithographs in these colonies see, respectively, Clifford Craig, *The Engravers of Van Diemen's Land*, Launceston: Tasmanian Historical Research Association, 1961 (but see also note 9); Barbara Chapman, *The colonial eye*, Perth: Art Gallery of Western Australia, 1979; Alison Carroll, *Graven images in the promised land*, Adelaide: Art Gallery of South Australia 1981; F. Woodhouse, *Victorian pioneers of litho-drawing and engraving*, 1889, M. S. La Trobe Library, State Library of Victoria, reprinted with an introduction and annotations by R. Butler: forthcoming.

5 See Heather Curnow, *William Strutt*, Sydney, Art Gallery of New South Wales 1980.

6 Cyrus Mason, *The practical lithographer, dedicated to painters and artists*, London 1852; Joseph Aresti, *Lithozôgraphia; or, the new art of obtaining aqua-tinto effects upon painted or washed drawings on stone*, London 2nd edn. 1857.

7 *Flowers and their kindred thoughts*, London 1848; *Fruits from the garden and field*, London, 1850; and Mary Ann Bacon, *Winged thoughts*, designed and printed by Owen Jones, lithographed by E. L. Bateman, London 1851.

8 For a general introduction to von Guérard as a printmaker see Roger Butler, 'Ballarat from the Fire Brigade Tower looking east', *La Trobe Library Journal* (Melbourne), vol. 9, no. 36, December 1985.

9 See *Mary Morton Allport: A commemorative exhibition*, Hobart, State Library and Museum, State Library of Tasmania.

10 For instance J. C. Cox, *Monograph of Australian land shells*, Sydney 1868; G. Krefft, *Snakes of Australia* , Sydney 1869.

11 Elizabeth Parsons (née Warren) had studied in England under James Duffield Harding.

12 For instance see John Skinner Prout, *Sydney illustrated*, Sydney 1842. The lithographs were printed by Thomas Bluett who had trained with Day & Haghe, London. Prout, nephew of Samuel Prout, is also credited with the first lithograph printed in colour in Australia. *Hobart Town Courier*, 17 April 1854. See also T. Brown and H. Kolenberg, *Skinner Prout in Australia 1841–48*, Hobart, Tasmanian Museum and Art Gallery 1986.

13 At this time in Australia 'chromolithographs' were understood to be reproductions of oil paintings, printed from numerous stones, often with a final oil varnish and applied texture. The first published 'chromolithographs' were by Nicholas Chevalier (1828–1902); see *N. Chevalier's album of chromo lithographs*, Melbourne 1865 [published in parts from 1864].

14 'Photo-lithography. Report of the board appointed . . . together with evidence taken before the board. Presented to both Houses of Parliament.' *Victorian Parliamentary Papers no. 11, 1860–61*, Melbourne 1861.

15 See John Fletcher, *John Degotardi*, Sydney, Book Collectors' Society of Australia 1984. A copy of C. Hullmandel, *The Art of drawing on stone*, London 1824, was included with a shipment of lithographic equipment to Tasmania in June 1830—see Craig, *Old Tasmanian prints*, Launceston 1964, pp. 324–26; *The Chromolithograph* was advertised in Australia in *The Australasian* (Melbourne), 4 January 1868, p. 2, col. 2; *The American art printer* organized the collection of American works for the Centennial International Exhibition, Melbourne 1888; *The British Lithographer* contained articles on Australian printing practice.

16 F. Woodhouse, op. cit. This was the first lecture given to this society.

17 See *Sun* (Melbourne), 21 April 1893, p. 6. Mary Eagle kindly drew my attention to this reference.

18 This exhibition of posters formed part of the Society of Artists' Annual Exhibition, Sydney 1897.

19 Blamire Young was probably introduced to the Beggarstaff Brothers by their mutual friend Phil May.

20 For instance in England, Thea Proctor (1879–1966), Arthur Streeton (1867–1943), Christine Asquith Baker (1868–1960), Charles Conder (1868–1909); in France, Ethel Carrick (1872–1952); in America John Richard Flanagan (1894–1964). For the response to lithographs by members of the Senefelder Club when exhibited in Melbourne and Proctor's attempt to interest local artists in lithographs in 1920 see Roger Butler and Jan Minchen, *Thea Proctor: The prints*, Sydney 1981.

21 Many artists produced lithographs during this period but because they never held any group exhibitions this aspect of Australian print history has been overlooked.

22 For general references to printmaking from this period see James Mollison, 'Printmaking in Australia', *Art and Australia*, vol. 1, no. 4, February 1964, pp. 231–38; Lilian Wood (comp.), 'Melbourne printmaking in the 1950s', *Imprint*, no. 1, 1980, [pp.] 1–2. J.Burke and S. Davis, 'Tate Adams and Melbourne printmaking', *Imprint*, no. 2, 1979 [pp.] 1–3. See also C. Dixon and T. Smith, *Aspects of Australian figurative painting 1942–1962. Dreams, fears and desires*, Sydney, Power Institute of Fine Arts, University of Sydney 1984.

23 See 'Pictures in schools—By modern artists', *Home*, Sydney, September 1937, pp. 30–31, which states they were on view at Anthony Horden's Fine Art Gallery, Sydney, at that time. The Australian representative for these prints was Notanda Gallery, Sydney. A copy of the English prospectus with Australian prices is in the author's possession.

24 See 'British artists record the war in contemporary prints', *Australian National Journal*, Sydney, 1 December 1940, pp. 50–51.

25 The Contemporary Art Society of Australia Anti-Fascist Exhibition, Athenaeum Gallery, 8–18 December 1942. The catalogue states that there were 'Lithographs and Etchings by Käthe Kollwitz' (nos. 54–56). Noel Counihan remembered being five or six lithographs but no etchings. See Robert Smith, *Noel Counihan prints*, Sydney 1981, p. 26.

26 See Richard Haese, *Rebels and precursors*, Ringwood, Victoria 1981.

27 *The Australian Artist* was published in six quarterly issues from 1948 to June 1949.

28 *The Australian Artist*, vol. 1, no. 3, Autumn 1948, p. 6.

29 Ibid., vol. 1, no. 2, 1948, p. 11.

30 Ibid., vol. 1, no. 3, 1948, p. 9.

31 Information derived from discussions with the artist's family, February 1987.

32 See Robert Smith, op. cit.

33 MS 7593, 557/1, 2 July 1949, La Trobe Library, State Library of Victoria. McClintock is listed as being a communist member of

The Arts Council of Australia, formerly the Council for the Encouragement of Music and the Arts. See 'Communist party of Victoria, report of the Royal Commission on the origins, aims, objects and funds of, and other related matters', *Victorian Parliamentary Papers*, Melbourne 1950/1, vol. 2 no. 12, pp. 58, 60.

34 Interview with the author, Melbourne, 6 February 1987.

35 *Jargon*, vol. 14, 1949. Jack contributed two lithographs, *A bit of Carlton* (p. 16), and *Yarra Falls* (p. 32). Freedman drew the green tint stones.

36 H. Rosengrave, *Prints in Melbourne*, unpublished MS, Australian National Gallery files.

37 Interview with the author, Melbourne, 5 February 1987.

38 Harry Rosengrave collected impressions of most prints produced at RMIT in this period. His collection was acquired by the Australian National Gallery in 1986.

39 See Franz Philipp, *Arthur Boyd*, London 1967. For prints from 1962 see Imre von Maltzahn, *Arthur Boyd: Etchings and lithographs*, London 1971.

40 Philipp, op. cit., p. 38.

41 The word Mafeking is usually associated with unrestricted rejoicing. It is derived from the breaking of the siege of Mafeking in 1902.

42 The possibility of the domination of American culture had been articulated as early as 1942. See Margaret Preston, 'The orientation of art in the post-war Pacific', *Society of Artists Book 1942* (Sydney), pp. 7–9.

43 From 1952 parts of these exhibitions had been toured; the entire American section of the third biennial travelled to France, Yugoslavia and Holland under the auspices of the United States Information Agency. For aspects of American cultural imperialism during these years see Max Kozloff, 'American painting during the Cold War', *Artforum*, vol. 11, no. 9, May 1973, pp. 43–54; Eva Cockcroft, 'Abstract Expressionism weapon of the Cold War', *Artforum*, vol. 12, no. 10, June 1974, pp. 39–41.

9. A. KIRKER/NEW ZEALAND

1 Quoted in E. M. and D. G. Ellis, *Early prints of New Zealand 1642–1875*, Christchurch 1978, p. 44.

2 There are two historical accounts of the development of printmaking in New Zealand: an introduction by Gordon H. Brown to the catalogue of *The Print Council of New Zealand Exhibition*, 2, 1969, and the unpublished Dip F.A. (Hons.) thesis by Anne Kirker, *A History of printmaking in New Zealand*, University of Auckland 1969.

3 The New Zealand Company played a significant part in the European settlement of New Zealand by a British government Charter of Incorporation, February 1841.

4 William S. La Trobe was appointed Superintendent of Technical Education in 1919; by enlisting outside expertise he hoped to improve the quality of art instruction available in New Zealand.

5 For a detailed account of T. V. Gulliver and his involvement with the Quoin Club, refer to Anne Kirker, 'An early champion of black and white', *Quarterly 58*, Auckland City Art Gallery 1974.

6 In the wake of this show in 1936 the Elam School of Fine Arts in Auckland issued lithographs, drawn with crayon on stone, by Peter Crowley, G. Mahon, Clifford Murray and others.

7 At the National Art Gallery, Wellington, most of the relevant intaglio and relief prints were donated between 1952 and 1969 by Sir John Ilott who initially purchased them for his own collection, most often from P. D. Colnaghi and Craddock and Barnard, London. A large number of colour lithographs (by John Piper, Graham Sutherland, Eduardo Paolozzi and others) were donated in 1951 by Rex Nan Kivell.

8 H. Wadman, ed., *Second year book of the arts in New Zealand*, Wellington 1946, p. 103.

9 John Holmwood, 'Outstanding reproductions through painter-printer co-operation', *Home and Building*, August 1951, p. 26.

10 Colin McCahon, quoted in 'Paintings, drawings and prints by Colin McCahon', *Quarterly 44*, Auckland City Art Gallery, 1969, p. 15.

11 The *School Journal* was one component of these publications and featured the designs of a number of New Zealand artists.

12 Peter Cape, *Prints and printmakers in New Zealand*, Auckland and London 1974, p. 180.

13 Palmer discovered by experimentation that if the smooth inside surface of a bamboo sheath (or husk) was scratched (after it had been pressed flat and mounted on a cardboard or hardboard plate), the cellular, absorbent area beneath would hold ink after the surface had been wiped off, and an image could be printed with a simple press.

14 Stanley Palmer, 'Notes for printmakers', *The Print Council of New Zealand Newsletter*, July 1975.

15 Evidence of such procedures had been witnessed in New Zealand from the 1960s onwards in exhibitions such as *Paul Wunderlich Lithographs 1949–1967*, Auckland City Art Gallery, Nov.–Dec. 1967 and *Graphic Works* by Edward Ruscha, Auckland City Art Gallery, Aug.–Oct. 1978. More recently, *Print U.S.A.* (with lithographs from Tamarind) was mounted in Christchurch, Robert McDougall Art Gallery, March–April 1984.

16 Andrew Bogle, 'Some contemporary New Zealand printmakers and their processes of work', *Art New Zealand 14*, 1979, p. 43.

17 Letter to the writer from Graeme Cornwall which gives a detailed description of his activities with lithography, 2 December 1986.

18 For his M.F.A. thesis (School of Fine Arts, University of Auckland, 1977–78), Graeme Cornwall investigated 'Ink, the rheology of lithographic ink'. His text analysed commercial lithographic inks and the methods available to the direct contact press operator. In 1980 he was a research assistant to Alberto Garcia-Alvarez who with Dr Gregory of the School of Engineering, University of Auckland, was examining the properties of different types of aluminium and other metals produced and sold locally with the aim of readily making available metal plates as an alternative to stones. Photosensitized aluminium plates, as used in offset lithography, could be easily obtained but heavier, uncoated plates had to be ordered from overseas at considerable cost and effort to the individual printmaker. Garcia-Alvarez developed a method of producing in New Zealand grained metal plates, suitable for hand lithography, cheaply and by a comparatively simple process.

19 Garth Cartwright, 'New stone age', *NZ Listener*, 6 Dec. 1986, p. 56.

20 NZ$150 (£52, US$87), NZ$400 (£140, US$230).

21 Letter to the writer from Jill McIntosh, 17 Dec. 1986.

22 Andrew Bogle, 'Alberto Garcia-Alvarez: Illusionism and abstraction', *Art New Zealand 35*, 1985, pp. 33–34.

10. P. GILMOUR/COLLABORATION

1 Juliet Wilson Bareau, *Goya's prints: The Tomás Harris Collection in the British Museum*, London 1981, p. 86.

2 Between Senefelder's treatise in English which advertised that it was 'accompanied by illustrative specimens of drawings', and Corot's transfer lithographs of 1872 described as 'dessins originales' (original drawings), there is no decade in which lithographs are not frequently described as drawings.

3 The whole question of lithography as drawing was discussed particularly vehemently in the 1890s. In Léonce Bénédite's article 'La Lithographie originale', *Revue de l'art ancien et moderne*, December 1899, pp. 440–60, Bracquemond and the printer Duchâtel are quoted to establish that the artist who can draw, can make a lithograph without special training.

4 Jean Adhémar in 'Les Imprimeurs lithographes au XIXe siècle', *Nouvelles de l'estampe*, Nov.-Dec. 1975, pp. 8–9: 'L'imprimeur lithographe est peut-être plus un collaborateur de l'artiste du peintre, que l'imprimeur en taille-douce.'

5 Raymond Williams, *Keywords*, London 1976 discusses 'art' on p. 33 and 'mechanical' on p. 167.

6 Alois Senefelder, *A complete course of lithography containing clear and explicit instructions . . .*, London 1819, rpr. 1977. Advertisement p. iv; preface by Frederic von Schlichtegroll pp. xviii–xix.

7 The Senefelder quotations are taken from the 1977 rpr., pp.18, 132, 179.

8 Felix Man translates the passage on Gessner: '. . it was he who made for us a number of pleasing drawings in the crayon manner, which I also had invented in Munich.' Quoted in 'Lithography in England 1801–1910' in C. Zigrosser, ed. *Prints*, New York 1962, p. 101.

9 This lithograph is not in Dussler, but Man dates it to 1805.

10 See *Henry Bankes's treatise on lithography: Reprinted from the 1813 and 1816 editions with an introduction and notes by Michael Twyman*, London, Printing Historical Society 1976.

11 M. Twyman, 'Thomas Barker's lithographic stones', *Journal of the Printing Historical Society*, 12, 1977–78, p. 19.

12 See Dominique H. Vasseur, *The Lithographs of Pierre-Nolasque Bergeret*, Dayton Ohio, Dayton Art Institute 1982, p. 6. 'The Beheading of John the Baptist . . . demonstrates again the disappointing results of the chalk manner, its light printing and visually "empty" quality.'

13 G. Engelmann, *Manuel du dessinateur lithographe*, 3rd edn., Paris and Mulhouse 1830–31, section XI. Engelmann claims to have discovered this method, which Hullmandel called the 'dabbing manner', in 1819. It was first published in 1822, but even nine

years later in the 3rd edn. of his manual, he was still putting it forward as a way of avoiding the vagaries of a tusche wash.

14 Bareau, p. 86 (see note 1).

15 There is a superb reproduction of the portrait in *The Tamarind book of lithography*, Los Angeles and New York 1971, fig. 3.4, p. 81. For more information on Gaulon, see E. Bouvy, 'L'Imprimeur Gaulon et les origines de la lithographie à Bordeaux', *Revue philomathique*, Jan.–Feb. 1917, pp. 241–44.

16 Bareau, p. 91. This is an eyewitness account from Antonio Brugada, a young Spanish artist who visited Goya when he was drawing the lithographs.

17 C. Hullmandel, *The Art of drawing on stone*, London 1824, introduction, p. 1.

18 [Raucourt de Charleville] trans. C. Hullmandel, *A Manual of lithography, or, Memoir on the lithographical experiments made in Paris*, London 1820, p. 70.

19 Raucourt, pp. 93–94.

20 Béraldi, *Les Graveurs du XIX siècle*, see Raffet, p. 78, note 1. For other information see 'Raffet and the role of the military print' in *All the banners wave: Art and war in the romantic era 1792–1815*, Providence, Rhode Island, Brown University 1982, pp. 27–32.

21 *Art-Union*, Nov. 1843, pp. 290–92.

22 Hullmandel quoted Jobard's article 'Lithotinte Hullmandel' which appeared in *Fanal* on 11 Jan. 1842. Jobard, Director of the Department of Industry in the Royal Museum, Brussels, was said to have been a lithographic printer for 17 years. *Art-Union*, Nov. 1843, p. 292.

23 Delacroix quoted by Michael Marqusee in the introduction to *William Shakespeare, Hamlet with sixteen lithographs by Eugène Delacroix*, New York, London and Ontario 1976.

24 A. Lemercier, *La Lithographie française 1796–1896*, Paris 1896–98, p. 80.

25 W. D. Richmond, *Colour and colour printing as applied to lithography*, London *c*.1885, preface, p. iv.

26 Engelmann perfected his technique in 1836 and was granted a patent on 31 July 1837. He brought out his *Album chromo-lithographique ou recueil d'essais couleurs*, Paris and Leipzig ?1838; Hullmandel appended a descriptive notice to Boys's work concerning 'chromalithography', making it clear that 'every touch was the work of the artist and every impression the product of the press.'

27 Peter C. Marzio, *Chromolithography 1840–1900: The democratic art: Pictures for a 19th century America*, Boston 1979, p. 11.

28 Bamber Gascoigne, 'The earliest chromolithographs', *Journal of the Printing Historical Society*, 1982–83, pp. 62–71.

29 Frank Howard, *Colour as a means of art, being an adaptation of the experience of professors to the practice of amateurs*, London 1838.

30 The letters from Boys and Hullmandel appeared in *The Probe*, 5 Dec. 1839, p. 262; Feb 1849, p. 278. Boys's letter is quoted in full in James Roundell, *Thomas Shotter Boys*, London 1974, pp. 46–47.

31 M. Twyman, 'The tinted lithograph', *Journal of the Printing Historical Society*, 1965, pp. 39–56.

32 Editor's introduction, p. xii in W. D. Richmond, *The Grammar of lithography: A practical guide for the artist and printer*, London 1878.

33 Robert L. Herbert, 'Seurat and Jules Chéret', *Art Bulletin*, June 1958, pp. 156–58.

34 Robert L. Herbert, *Seurat's drawings*, New York 1962, note 6, p. 166. The drawings found in the folio were preserved but the popular broadsides and clippings were 'inadvertently discarded'. They dated from 1870 to early 1880s.

35 William Innes Homer, *Seurat and the science of painting*, Cambridge, Mass. 1969, rpr. 1978.

36 This theory must be incorrect because the colour screen was not developed until well after Seurat's death.

37 Henri Dorra, 'Seurat's dot and the Japanese stippling technique', *Art Quarterly*, summer 1970, pp. 108–13.

38 Norma Broude, 'New light on Seurat's "dot"', its relation to photomechanical color printing in France in the 1880s' in *Seurat in perspective*, New Jersey 1978.

39 Meyer Schapiro, 'New light on Seurat', *Artnews* 1958, pp. 22–24, 44–45, 52.

40 *Le Lithographe* vol II, 1839, p. 176, for example, features a rainbow roll in pink, blue and yellow on an Egyptienne typeface.

41 Senefelder's treatise, English edn. rpr. 1977, p. 268.

42 André Mellerio, *La Lithographie originale en couleurs*, Paris 1898, p. 25.

43 Quoted in André Mellerio, *Odilon Redon*, Paris 1913, p. 71.

44 Jean Charlot, *An Artist on art: Collected essays of Jean Charlot*, 2 vols, Honolulu 1971, vol. I, p. 159.

45 G. Hédiard, *Fantin-Latour, catalogue de l'œuvre lithographié du maître*, Paris 1906, p. 16 (Geneva rpr., p. 50). 'Quand elles revinrent chez Lemercier, ce fut un cri: c'était détestable, insensé, sauvage, on n'avait jamais vu chose pareille, on n'oserait pas mettre cela sous la presse!'

46 A. Lemercier, *La Lithographie française 1796–1896*, Paris 1896–98, p. 147. 'L'essayeur est toujours choisi parmi les ouvriers les plus capables et les mieux élevés, car les rapports constants qu'il est obligé d'avoir avec les artistes, presque toujours gens aimables mais susceptibles, lui font un devoir d'être poli, empressé et disposé à faire ce qu'on peut et doit lui demander.'

47 E. Duchâtel, *Traité de lithographie artistique*, Paris 1893.

48 Mellerio, p. 26.

49 See essay no. 5 on Auguste Clot, note 59, p. 372.

50 Lucien Goldschmidt and Herbert Schimmel, *Unpublished correspondence of Henri de Toulouse-Lautrec: 273 letters by or about Lautrec written to his family and friends*, London and New York 1969. The letter from Berthe Sarrazin to the chambermaid at Albi on 20 Jan. 1899 told her that the artist had been found 'at Père François with Gabrielle and Stern. I don't dare tell you how drunk.' Big Gabrielle was a prostitute; the other companion was Calmèse, the alcoholic owner of a livery stable. Thus Mellerio's comment that Stern 'had proved himself many times and in good company' is open to an alternative reading.

51 See note 43.

52 See note 43.

53 Claude Roger-Marx, *French original engraving from Manet to the present time*, London, Paris and New York 1939, pp. 31, 32. '... he frequently furrowed the granite (sic) so deep that several millimetres had to be pumiced. These irregular methods were a source of annoyance to the professionals.'

54 T. R. Way, *Memories of James McNeill Whistler the artist*, London 1912, p. 90.

55 In an exchange of letters of October 1893, Whistler asked Way for 'the exact formula of the liquid your father gave me to use for the wash on stone.' Way replied that the etching prescription for it was 'my father's secret.' On 31 October Whistler replied: 'I would not dream of proposing that your father and you should give away the secrets of the house . . .'

56 Way, *Memories*, pp. 18–20.

57 See the introduction, pp. 5–6 of Thos. R. Way, *Mr Whistler's lithographs*, 2nd edn. London 1905, and chapter VII of *Memories*.

58 Both F. E. Jackson and Hartrick name Bray as the printer of Whistler's lithographs, but in the 1880s there was also a French printer at Way's called Champagne who had trained with Lemercier; as well as printing lithographs, he helped the artist with his Venice etchings. See *Memories*, p. 57.

59 A. S. Hartrick, *Lithography as a fine art*, London 1932, p. 36.

60 See *Memories*, pp. 102–03.

61 Thomas R. Way, 'Whistler's lithographs', *Print Collector's Quarterly*, October 1913, pp. 277–309.

62 Henry Trivick, Chairman of the Senefelder Group, in the introduction to *The Senefelder Group 1910–1960*, London, Arts Council of Great Britain 1961, p. 7.

63 *Double Crown Club: Register of past and present members*, privately printed, 100th meeting, May 1949.

64 Hartrick, *Lithography as . . .*, p. 37.

65 Way, *Memories*, p. 112. For Way's activity after the severance with Whistler, see Nicholas Smale, *Tamarind Papers*, Spring 1987, pp. 17–27. See also 'Goulding as a printer of lithographs', chapter VI, in Martin Hardie, *Frederick Goulding: Master printer of copper plates*, Stirling 1910, p. 105. In 1906, Goulding gave 76 lithographic proofs that he and his brother had printed to the Victoria and Albert Museum, London.

66 Hartrick, *Lithography as . . .*, p. 38.

67 For Margaret Lowengrund's work, see Clinton Adams, 'Margaret Lowengrund and The Contemporaries', *Tamarind Papers*, Spring 1984, pp. 17–23.

68 Bolton Brown, 'My ten years in lithography', *Tamarind Papers*, Winter 1981–82, p. 11, with notes by Clinton Adams.

69 Bolton Brown, *Lithography*, New York 1923, p. 12.

70 Bolton Brown, 'Pennellism and the Pennells', *Tamarind Papers*, Fall 1984, pp. 49–71.

71 See note 70.

72 Bolton Brown, 'My ten years in lithography' part II, *Tamarind Papers*, Summer 1982, pp. 36–54.

73 Michael Knigin, Murray Zimiles, *The contemporary lithographic workshop around the world*, London 1974, p. 125.

74 Prentiss Taylor of George Miller, in Janet A. Flint, *George Miller and American lithography*, Washington D.C. National Collection of Fine Art, 1976.

75 Jean Adhémar, *Twentieth century graphics*, London 1971, p. 175.

76 Maltby Sykes, 'Recollections of a lithographile', *Tamarind Papers*, Summer 1983, p. 41.

77 Thomas E. Griffits, *Colour printing*, London 1948, p. 11: '...he was made the honorary printer member of the club and well deserved the distinction being the cleverest transferrer and printer I have ever known and a man who loved his job.'

78 Rowley Atterbury, *The Contributors: being the paper of a talk delivered to the Wynkyn de Worde Society*, Westerham, 16 May 1974, p. 25.

79 Griffits, *Colour printing*, p. 12.

80 Atterbury, *The Contributors...*, p. 9.

81 Fernand Mourlot, *Gravés dans ma mémoire*, Paris 1979, p. 86. 'C'est très bien, tu es le premier chromiste du monde, reste donc dans cette position, il vaux mieux être un excellent artisan qu'un peintre.'

82 Charles Sorlier, *Mémoires d'un homme de couleurs*, Paris 1985, p. 108. The style was in the worst kind of academic bad taste.

83 See note 81.

84 In *Mémoires*, pp. 145–46, Sorlier comments that the address 'Sir' or 'Master' was always *de rigueur* for Matisse and in close proximity relates how Matisse mistook one of his lithographic interpretations for the original and then pretended he had known which was which all along. Picasso, on the other hand, 'n'hésitait pas à se mêler aux ouvriers de chez Mourlot comme s'il était un de leurs. [Did not hesitate to mix with the workmen at Mourlot as if he were one of them]' (p. 158).

85 Jacques Mourlot in taped conversation with the author, 2 Dec. 1985.

86 The story of Picasso's initiation at Mourlot is related in Pierre Cabanne, 'Mourlot', *Connaissance des arts*, April 1955, pp. 62–66; Fernand Mourlot in *Souvenirs et portraits d'artistes*, Paris, 1973, p. 107; and in *Gravés dans ma mémoire*, Paris 1979, pp. 13–14.

87 Fernand Mourlot, 'The Artist and the printer' in *Lithography: 200 years of art, history and technique*, New York 1983, p. 186.

88 Cabanne, p. 66.

89 Sorlier, p. 85.

90 Fernand Mourlot in taped conversation with the author, 29 Nov. 1985.

91 Brigitte Baer, *Picasso as printmaker: Graphics from the Marina Picasso collection*, Dallas Museum of Art 1983, pp. 122–23.

92 Cabanne, p. 64.

93 Hélène Parmelin, intro. 'Picasso's iron wall', in *Picasso Lithographs*, trans. Jean Didry, Boston 1970.

94 A memorandum from Theodore J. H. Gusten to the Board of Directors of the Print Council of America was circulated before the annual meeting of 1962. It contained a letter and questionnaire sent to Fernand Mourlot on 16 Dec. 1961, a translation of Mourlot's reply of 13 Feb. 1962, and Joshua B. Cahn's comment of 5 Mar. 1962. Documents not yet catalogued, Print Council of America boxes, Archives of American Art, Washington, DC.

95 Charles Sorlier, *Chagall lithographs 1974–1979*, New York 1980, p. 14.

96 Mourlot, *Gravés dans...*, p. 139.

97 Preface by J. Adhémar to *Nice and the Côte d'Azur*, quoted by C. Sorlier, see note 95.

98 Sorlier, *Chagall lithographs*, p. 9.

99 Mourlot, *Gravés dans...*, p. 231. 'Je suis un artisan, pas plus. Et, c'est déjà très bien.'

100 Stanley Jones in taped conversation with the author, 18 Dec. 1985.

101 See note 100.

102 Robert Erskine, 'St. George's Gallery' in *A Decade of printmaking*, ed. Charles Spencer, London and New York 1973, p. 20.

103 Letter to author from Trevor Bell, 2 Jan. 1977.

104 John Piper in taped conversation with the author, 11 Dec. 1975, also see Pat Gilmour, *Artists at Curwen*, London, Tate Gallery 1977, p. 101.

105 See Gilmour, *Artists at Curwen*, pp. 99–100.

106 As an extremely rough rule of thumb, the population of Great Britain is four times that of Australia, while the population of the United States is four times that of Great Britain.

107 *Australian prints*, London, Victoria and Albert Museum 1972. Janet Dawson's prints listed as cat. nos 26, 27.

108 Vicki Pauli and Judith Rodriguez, *Noela Hjorth*, Clarendon, S. Australia 1984. The artist's lithographs are illustrated pp. 32–43.

109 Artist's statement of 28 June 1984 in brochure: *Lloyd Rees: Sandy Bay set*, Roseville, New South Wales 1984. 'Admittedly Fred worked from my drawings, but the colour work is so much his own creation that I feel his signature should be alongside mine on each colour print. This he won't agree to, so the little bird—his "chook"—impressed on a lower corner of each print is the only symbol of his artistry.'

110 Sonia Dean, *The Artist and the printer: Lithographs 1966–1981: A collection of printers' proofs*, Melbourne, National Gallery of Victoria 1982, p. 5. 'Genis says the printer must be "like water", able to accommodate an idea, to develop an intuitive understanding of the artist's needs and aims; a fluidity which enables a perfect harmony between them.'

111 June Wayne's case to the Ford Foundation quoted in C. Adams, *American lithographers 1900–1960: The artists and their printers*, Albuquerque 1983, p. 198.

112 Elizabeth Jones, 'Robert Blackburn: An investment in an idea', *Tamarind Papers*, Winter 1982–83, p. 12. See also Nina Parris, *Through a master printer: Robert Blackburn and the Printmaking Workshop*, S. Carolina, Columbia Museum 1985.

113 Tatyana Grosman, quoted by Calvin Tomkins, in *New Yorker*, 7 June 1976.

114 See Jones, note 112.

115 Kistler, quoted by Peter Morse, 'Lynton Kistler: "The happy printer"', *Artnews*, March 1978, p. 91.

116 See Ebria Feinblatt in *Los Angeles prints 1883–1980*, Los Angeles County Museum, 1980–81, p. 20.

117 June Wayne in taped conversation with the author, September 1984.

118 The best account of the history of Tamarind is in Lucinda H. Gedon, *Tamarind: From Los Angeles to Albuquerque*, Grunwald Center for the Graphic Arts, University of California, Los Angeles 1985. This also lists all the artists and printers who worked there.

119 *About Tamarind*, report for the annual meeting of the Board of Directors, Tamarind Lithography Workshop, 19 April 1969, prepared by June Wayne.

120 *Fifty artists fifty printers: Los Angeles 1960–1970 — Albuquerque 1970–1985*, Albuquerque 1985, introd. C. Adams, p. 3.

121 George McNeil in conversation with Clinton Adams, 'The Artist as lithographer: A conversation', *Tamarind Papers*, Fall 1984, p. 45.

122 See note 121, p. 42. 'I knew that tusche existed, but when I came to Tamarind in 1971 and saw a large lithograph by Adja Yunkers, I hardly could believe that anyone could work so freely in this medium and yet achieve such an open, rich and sensuous image.'

123 Barry Walker, *The American artist as printmaker: 23rd National Print Exhibition*, Brooklyn, The Brooklyn Museum 1983–84, p. 14.

124 Donald Saff, 'Editor's statement: Printmaking, the collaborative art', *Art Journal* Spring 1980, p. 167. 'She [Karen Beall, writing in the same issue] shows there was a complex and extensive relationship between artist and artisan from the beginning of lithography. In almost every case it was the artisan who extended the medium through technological innovations that made new artistic approaches desirable and accomplishable.'

125 Frederick S. Wight, 'Tamarind and the art of the lithograph', intro. exhibition catalogue, University of California, Los Angeles, 1962–63, p. 7.

126 Gedeon, p. 22, quoting W. McNeil Lowry's statement from Elizabeth Jones-Popescu, Ph.D. dissertation, *American lithography and the Tamarind Lithography Workshop/Tamarind Institute, 1900–1980*, University of New Mexico 1980. Lowry added that 'the comprehensiveness and integrity of the whole program made it a classic example of the impact of philanthropic funds.'

127 'The Artist and the printer', chapter 3, *The Tamarind book of lithography*, Los Angeles and New York 1971, pp. 75–85.

128 Virginia Allen, *Tamarind: Homage to lithography*, touring exhibition under the auspices of the Museum of Modern Art, New York, New Zealand, Govett-Brewster Art Gallery, 1973, p. 6.

129 Garo Antreasian, review of Gilmour, *Ken Tyler, master printer and the American print renaissance*, in *Tamarind Papers*, Spring 1986, n.p.

130 Most of the printers' proofs of De Kooning's lithographs, including some rare colour trials, are in Australia. Genis sold his proofs to the National Gallery of Victoria (see note 110), while the Australian National Gallery bought those belonging to the printer Irwin Hollander.

131 Irwin Hollander interviewed by Stephanie Terenzio, *The Prints of Robert Motherwell*, 2nd edn. New York 1984, p. 32.

132 Irwin Hollander, Emiliano Sorini, Donn Steward, Kenneth Tyler, Robert Bigelow, Maurice Sanchez, had all been to Tamarind. Ben Berns, Bill Goldston and Catherine Mousley were trained elsewhere.

133 See note 131, p. 26.

134 Robert Motherwell in taped conversation with the author, Nov. 1985.

135 Motherwell referred to Tyler in these terms at the dedication of the Walker Art Center extension in Minneapolis, 21 Sept. 1984. An archive of the printer's production was opened on this occasion.

136 Robert Rauschenberg interviewed by Joseph E. Young, 'Pages and fuses: an extended view of Robert Rauschenberg', *Print Collector's Newsletter*, May-June 1974, pp. 25–30.

137 Clinton Adams, review of Gilmour, *Ken Tyler, master printer* ... in *Print Collector's Newsletter,* July–Aug. 1986, p. 108. Significantly only the first of the works Adams cites is a lithograph. The Stellas were extraordinary mixed media prints worked from the relief and intaglio surfaces of wood and metal and printed on specially formed multicoloured papers, while *Paper pools* was a series of studies of Tyler's swimming pool, painted with paper pulp.

138 Clinton Adams in conversation with Steve Sorman, *Tamarind Papers*, Spring 1987, pp. 7–8.

139 David Hockney in taped conversation with the author, 22 June 1985.

140 *Tyler Graphics catalogue raisonné 1974–1985*, New York 1987, intro. by Pat Gilmour 'Kenneth Tyler, a collaborator in context'; companion volume of essays on the printer by E. Armstrong et al, *Tyler Graphics: The extended image*, New York 1987.

141 Bill Goldston in taped conversation with the author, 16 Mar. 1983.

142 Goldston quoted by Terenzio, see note 131, p. 78.

143 Jasper Johns, in conversation with the author, New York, June 1985.

144 Man Ray and Lynton Kistler made a four-colour merge in *Le Roman noir*.

145 Letter from Edward Hamilton to the author, 6 Dec. 1985.

146 Jean Milant's statement about Cirrus in Michael Knigin and Murray Zimiles, *The contemporary lithographic workshop around the world*, New York 1974, p. 63.

147 Serge Lozingot in taped conversation with the author, 27 Sept. 1983.

148 Maurice Sanchez in taped conversation with the author, 15 Mar. 1983.

149 Dubuffet's statement of 1962, translated by Marthe La Vallée Williams in *The lithographs of Jean Dubuffet*, Philadelphia Museum of Art 1964–65.

150 To their amazement, a prize was awarded out of the blue both to Dubuffet and to Lozingot, in the case of the printer, equal to two-and-a-half months' salary. 'These Americans' said Dubuffet. Related by Lozingot, see note 147.

151 Judith Solodkin in taped conversation with the author, 24 Sept. 1984; see also Pat Gilmour, 'Thorough translators & thorough poets: Robert Kushner and his printers', *Print Collector's Newsletter*, Nov.–Dec. 1985, pp. 159–64.

152 Lisa Peters, 'Print workshops USA — A listing', *Print Collector's Newsletter*, Jan.–Feb. 1983, pp. 201–06.

153 Robert Hughes, *Frank Stella: The Swan engravings*, Fort Worth Art Museum, 1984, p. 6. 'His collaboration with Stella represents the conjunction of two highly specialized gifts: one for conception, the other for execution. If Stella's sardonic blague is to affect an indifference to technique, so Tyler's is to come on as a technician pure and simple: a two-man routine. But in printing, as in other collaborative work — the mutuality of architect and engineer, for instance — there is no clear division of labor between *cose mentale* and *cose manuale*.' It may not be realized how well qualified Hughes is to write this: he made a lithograph at Tamarind in 1964.

Schedule of letters and provisional list of works printed by Auguste Clot

This list of works printed by Auguste Clot has been based on the correspondence sent to him, supplemented by other records, plus information in standard reference works. Each entry summarizes evidence of Clot's involvement, listing established or 'descriptive' titles. An artist's work in the catalogue of the 1919 sale of Auguste Clot's collection is not watertight evidence that Clot printed it, but trial, annotated or dedicated proofs are regarded as increasing that likelihood, especially if supported by an appearance of the same print in Clot's estate, handled by Prouté in Paris in 1954, or in the exhibition of family holdings mounted at the Galerie Peintres du Monde, Paris, 1965, three years after the death of Auguste's son, André. Records of these events are entered within square brackets beneath the main list, since changed titles and sparse illustration make it impossible to be completely sure whether some of these prints duplicate those in the main list or not. This provisional list makes no claim to be complete, in fact letters providing evidence of work by minor artists for whom no biographical details can be found, have been omitted. Then, while some letters of little consequence have been preserved for almost 100 years, there is often no correspondence at all from artists known to have collaborated with the printer.

KEY TO THE SCHEDULE

The members of the International Print Department at the Australian National Gallery have worked from a set of photocopies sometimes bearing two or more communications per sheet from the total of almost 800 surviving documents. Each sheet has been given a Clot archive (CA) number; a few letters, set in bold type in the list below, have been completely transcribed and translated. Communications from an artist, or from another party dealing exclusively with that artist, are dealt with under the artist's name. The letters remain the property of Auguste Clot's grandson – Dr Guy Georges of Clot, Bramsen et Georges, Paris – who generously gave the Australian National Gallery permission to use the correspondence.

col. lith: colour lithograph
 TP: trial proof

ann.: annotated proof
ded.: dedicated proof
 st.: state
BAT: bon-à-tirer
 pf: portfolio
 UJ: Una Johnson, *Ambroise Vollard éditeur*, Museum of Modern Art, New York 1977.
AVI: Vollard's first album *L'Album des peintres-graveurs*, 1896.
AVII: Second album *L'Album d'estampes originales de la Galerie Vollard*, 1897.
 IFF: *Inventaire du Fonds Français après 1800* (15 vols.) Paris, Bibliothèque Nationale 1930–1985.
B-H: Janine Bailly-Herzberg, *Dictionnaire de l'estampe en France 1830–1950*, Paris 1985.
[D.1919]: signifies inclusion in the Hôtel Drouot sale of Auguste Clot's Collection: *Catalogue des lithographies de . . . composant la collection de M.A.C.*, Hotel Drouot, salle no. 7, Paris, 13 Juin 1919, assisté de M. Loys Delteil.
[P.1965]: included in exhibition catalogue, *Les Lithographies originales des peintres de l'Atelier Clot*, Galerie Peintres du Monde, Paris 1965.
[Pr.1954]: part of Auguste Clot's estate, handled by Paul Prouté, rue de Seine, Paris. Titles appear exactly as noted by Prouté followed by the number of copies. Where prints in the estate can be related to the main list, the number of copies is bracketed after the date. The prefix (c.) indicates colour, (b.) monochrome impressions; *uw*: indicates unique works – paintings, pastels, drawings, touched proofs, etc.

A catalogue raisonné or monograph on an artist is cited by CR/ or Mono/ followed by the author's name; the full reference will be found in the Bibliography, section 8.

* in front of a title indicates that an impression of the print is in the collection of the Australian National Gallery.

+ following an artist's dates indicates that there are no letters from or about that artist and the entry has been formulated on the basis of other evidence.

A **CA number** in bold type signifies that the letter has been transcribed and translated between pages 176 and 182.

? indicates that a date or attribution is in some doubt.

A **ADLER** Jules, France. (1865–1952)
 4 Faubourg du Temple, 11e
CA1–2, 450–453: Nine letters ask for transfer paper, seek colour advice and request Clot to hurry and finish proofs for an unnamed lith for Weill/Devambez.

AMAN-JEAN Edmond, France. (1858–1936)
 9 rue Poulletier, Ile St Louis
CA3–4: Three undated letters seek advice on colour, offer to do retouching, and make an appointment to sign work.
UJ1 ***Portrait de Mlle. Moréno de la Comédie Française**, *AVII*, col. lith, 1897
UJ2 **Tête de femme (left profile)**, col. lith, 1897
[D.1919: 1. **Profil**, col. lith; 2. **Buste de femme penchée**, col. lith; 3. **Réflexion**, col. lith.]

ANQUETIN Louis, France. (1861–1932)
 10 rue Clauzel, 9e
CA5–6: Two letters about retouching 'this famous litho' and an appointment.
IFF **Un Canter**, col lith, ?1898 (1)
B-H **Les Courses**, col lith, ?1898 (9)
[D.1919: 4. **La Course**, TP, col. lith; 5. **La Course**, TP, two col. lith; 6. **Le Jockey**, col. lith, 2 copies, one in col., one ded.] [Pr.1954: **Les Courses** (9); **Jockey** (1)]

ARONSON Naoum, Russia, France. (1872– active 1938)
CA7–8: Two letters dated 1910 and 1911 from Fernand Roches, director of *L'Art décoratif* discuss Aronson's transfer drawings and ask Clot to visit the artist at 93 rue Vaugirard.
Beethoven in *L'Art décoratif*, lith, 1910
Tolstoy in *L'Art décoratif*, lith, 1910

AURIOL George, France. (1863–1938) +
CR/Marie Lerov-Crevecoeur (1–c) in Armond Fields, Bib. 8.
UJ3/L-C11 **Jeune femme assise ('Je hais le mouvement qui déplace les lignes')** *AVI*, col. lith, 1896
UJ4/L-C13 **Selim, enfant de Damas**, col. lith, 1897

B **BATAILLE** Henry, France. (1872–1922)
 19 rue Marguerite, 17e; 'Chartrettes'; 12 ave Bois de Boulogne.
CA11–22, 454–460: 31 communications from, or related to, the artist. 14 letters discuss *Têtes et pensées* – among them CA18/19 (**letter 1**) expressing the artist's displeasure. CA454a (23.2.1900) from Ollendorff offers 12 frs per 100 for 850 impressions of 15 portraits. Of three telegrams dated September, 1910 from Bataille's address, one signed 'Bady' may relate to a portrait of the actress. Six notes guarantee seats at performances of Bataille's plays. Sirven writes in December 1902 and August 1910 concerning posters (?for Bataille's own plays) the printing of which Clot is to supervise. CA17a. discusses an edition of 2400 prints with 30 additional larger proofs. CA455 plans a col. lith, CA456 a self portrait in an edition of 1500 drawn directly on stone. CA458 (23.7.1908) affirms that Bataille intends to produce another album 'this winter'.
IFF **Berthe Bady emmitouflée dans un boa**, sanguine lith, ? date
 Têtes et pensées (22 portraits) pf, (Librairie Ollendorff) 1901
 Visages de femmes [?pf unpublished by Fasquelle] ?1908

BERTHON-CHINCHOLLE Marcel, France. (exhib. 1903–1904)
 7 rue du Commandant Rivière, 8e
CA25–28: Two letters request 15 'très belles épreuves' on Japon and a larger edition on ordinary paper, discuss a 'tête reposée', promise to pay a bill and mention another edition.

BESNARD Albert, France. (1849–1934) +
CR/Delteil (D) Bib. 8.
UJ7/D66 **La Robe de soie** (1887), *AVI*, intaglio, 1896 (st. 3)

BESSON Jules-Gustave, France. (1868–active 1925)
CA156 (14.12.1904) from the publisher C. Hessèle asks Clot to pull '**la petite fillette assise**'.

BLANCHE Jacques-Émile, France. (1861–1942)
19 rue du Dr Blanche, Auteil, 16e
CA30–36, 461–465: B–H: '30 large plates printed by Clot'; IFF . . . 'his large prints were printed by Clot between 1895 et 1900 . . .' Of 16 letters, CA31 (2.4.1896) asks Clot to give a proof to Hardy Alan for exhibition at the Champ-de-Mars; four mention Barrès and/or the print for *Le Centaure* of which he wants 12 copies. CA33 (16.6.1896) discusses a problem with the print of Barrès, which the artist wants in an edition of 50, as well as some missing 'little horses'. CA35 mentions 'a stone for . . . Deltheil' (sic). CA416 (3.7.1897)(letter 2) explains Vollard's delay in using Blanche's print. CA34b. is about a new plate for Vollard. CA461 (30.11.1898) and 456a. express dissatisfaction with what he has done for Vollard and offer to re-do it. Two other letters refer to stones or proofs. CA462 mentions a '**tête de jeune fille**' for *Studio*; CA465b. reports that he has given *L'Art décoratif* permission to use the *Centaure* print. CA463/4 (12.3.1936) expresses condolences to André after hearing of Auguste Clot's death.
IFF **Lecomte de Lisle**, lavis lith, 1895
L'Enfant au panier, **Jeune fille** and **Petite fille** for *L'Epreuve*, liths, 1895
IFF **Pouponne 2e pl.**, bistre lith, 1895
IFF **Pouponne 3e pl.**, lith, 1895
***Petite fille** (or **Pouponne Zelinska**), *Le Centaure I*, col. lith, 1896
Maurice Barrès, lith, 1896
Le Cheval blanc, *L'Estampe moderne*, lith, 1896
Five o'clock, *Etudes de femmes*, lith, 1896
IFF **Pouponne 4e pl.**, lavis lith, 1896
UJ8 **Jeunes filles lisant**, *AVI*, col. lith, 1896
Les Deux pouponnes, lith, 1896
Madeleine et Yvonne Lemoinne, lavis lith, 1896/7
UJ9 **Jeunes filles dans un jardin**, col. lith, 1897
Portrait de Bequier, lith, 1897
Lucie Esnault, lith, 1897
Henri de Régnier, lavis lith, 1897
Pouponne 5e pl., bistre lith, 1897
[D.1919: 7. **Les Deux fillettes sur un banc de jardin**, col. lith; 8. **La Fillette assise** and **Fillette à mi-corps**, both ded. and dated 1896; 9. **Buste de jeune femme**.] [Pr.1954: 2 sujets (21)]

BONNARD Pierre, France. (1867–1947)
65 rue de Douai, 9e; 6 rue Ballu, 9e; 56 rue Molitor, 16e
CA37–39, 196: 20 letters from or about the artist. One note asks for proofs to be sent to the address of the Théâtre des Pantins. Three letters of 1912/13 from Bernheim Jeune and two from Bonnard relate to a small lithograph published in 2,500 copies in a 1913 catalogue (B81). CA196 rearranges the prelims of *Daphnis and Chloe* (B75). CA39Ca. introduces Leon Wyczółkowsci of Kraków. CA39Bb discusses the grey keystone for a **Boulevard**. One note requesting proofs is from Bonnard's address after first world war. CR/Roger Marx (R-M) and CR/Bouvet (B) Bib. 8.
B35–6 ?**Les Cartes** and **Le Nouveau né** for *L'Epreuve*, liths, 1895
UJ10/B58–70 *Quelques aspects de la vie de Paris*, cover and pf of 12 col. liths incl.* **Place, le soir**, 1895–1899 (46)
UJ11/B40 **La Blanchisseuse**, *AVI*, col. lith, 1896
UJ12/B38 **Poster** for *AVI*, col. lith, 1896 (6)
UJ13/B42 **Le Canotage**, *AVII*, col. lith, 1897 (5)
UJ14/B41 **Cover** for *AVII*, col. lith, 1897 (27)
UJ15/B43 ***Enfant à la lampe**, col. lith, 1898 (9)
B46–51 ?**Répertoire des pantins**, lith song covers, 1898
B72 ***Les Boulevards**, for *Insel*, col. lith, 1900 (16)
UJ166/B73 ***Parallèlement**, by Verlaine with 109 liths, (Vollard) 1900
UJ168/B75 ***Daphnis and Chloe** by Longus with 151 liths, (Vollard) 1902 (434+71)
B52, 53 ***Cover and Frontis**. for *La lithographie originale en couleurs* by Mellerio, 1898 (15)
B56 **Le Verger**, in *Germinal*, col. lith, 1899 (5)
B80–82 **Nu, Femme, Baigneur**, liths for Bernheim Jeune, 1912–1914
B85 **Bulletin de la vie artistique**, lith poster, 1919 (1)
B88 **Place Clichy**, col. lith, 1923 (15)
B111 *La Vie de Sainte Monique* by Vollard with 29 liths, (Vollard) 1920–1930 (469)
Printed by André Clot:
B128 *Le Crépuscule des nymphes* by Pierre Loüys, with 24 transfer liths, 1946

[D.1919:10 *Quelques aspects* . . . (B58–70) 12 col. liths incl. one BAT, 3 ded. (illus. B59). 11. **Une Rue de Paris** (B?), TP, ann; 12. **La Marchand de quatre saisons** (B65) col. lith with croquis; 13. **Une Rue à la tombée de la nuit**, col. lith (?B64 or 68); 14. **Une Rue de Paris**, (B?) TP, col. lith; 15. **Une Fenêtre à Paris** (B61) TP, col. lith; 16. **Les Cartes**, lith (B35); 17. **Le Nouveau-né** (?B36) col. lith; 18. **Le Lever** (?B80) TP 'en ton violacé'; 19. **Baigneurs et baigneuses** (B81, 82?) TP; 20. **A travers champs** (Vuillard?), TP, col. lith; 21. **Le Verger** (B56) col. lith; 22. **L'Enfant au panier** (?B40) col. lith, ded.; 23. **La Loge**, cover (in fact frontisp.) of *La Lithographie originale en couleurs* by A. Mellerio (B53), TP, col. lith; 24. **Femme assise dans un intérieur**, frontisp. and **Femme nue debout, accoudée** (?); 25. **Portrait de Cézanne par Vuillard**.]
[P.1965: **Couverture**, *Quelques aspects* . . . TP, col. lith. (RM56); **Place le soir** TP, col. lith, (RM62)] [Pr.1954: **Place Clichy** (15); **Couverture** 2me album Vollard (27); **Affiches Peintres-graveurs** (6); **Canotage** (5); **Sous la lampe** (9); **Le Verger** (5); **Affiche Vie artistique** (1); **Titre Aspects de Paris** (5); **Planches séparées des Aspects de Paris** (41); **Boulevards** (13) 'mauvaises' (2) 'noir' (1); **Frontis and Couv. Mellerio** (6 + 8); **Vie S. Monique** (469); **Daphnis** (434) gd papier (71); uw: **Petit frontis**.]

BRANGWYN Frank, Great Britain. (1867–1956) +
Scène champêtre mythologique, *Germinal*, col. lith, 1899
[D.1919: 26. **Le Joueur de flûte**, 2 liths, one in col; 27. **Sur la terrasse**]
[Pr.1954: 2 sujets (2); uw: **Composition**]

BRESDIN Rodolphe, France. (1822–1885) +
Clot may have printed for Bresdin at Lemercier, but the proofs sold in 1919 probably came from the posthumous edition of 1899 authorized by Bresdin's daughter, who inherited the stones. CR/Dirk van Gelder (VG), Bib. 8.
[D.1919: 28. ***Le Bon Samaritain** (1861) (VG100); 29. **Le Torrent**, 1884 (VG 153 Le Gave)]

BROWN Jean Louis, France. (?–1930)
96 ave des Ternes, 17e
CA41a (15.8.1909) asks for 'my 30 proofs'; CA41c. makes an appointment for the writer and Lunois and promises tracings and a pastel. CA233 from Lunois explains that JLB wants to do a little stone in colour.

BROWN John Lewis, France. (1829–1890)
In CA24b, Léonce Bénédite, probably preparing the exhibition of Brown's work at the Musée du Luxembourg in 1903, asks Clot for stones, trial proofs, notes and the address of the compiler of Brown's catalogue raisonné – Germaine Hédiard (GH) Bib. 8. Dedicated proofs suggest Clot worked with Brown at Lemercier; he may have reprinted Brown's stones for his heirs.
GH16 **Cavalier au cheval gris**, col. lith, 1884
GH8 **Cavalier et amazone dans la campagne**, col. lith, 1885
GH15 **Programme, soirée du 23 Mai (Cirque Molier)**, col. lith, 1885
GH17 **L'Eventail des Courses de la Marche**, col. lith, 1889
GH18 **Cavalier au cheval blanc**, col. lith, 1890
[D.1919: 30. **Programme, soirée du 23 Mai** (GH15) TP, col. lith, ded; 31. **Cavalier au cheval gris** (GH16) col. lith, ded; 32. **Eventail des Courses de la Marche** (GH17) col. lith, ded; 33. **Cavalier au cheval blanc** (GH18) col. lith, ded.]

BUHOT Félix, France. (1847–1898) +
CR/Bourcard (B), Bib. 8.
[D.1919: 34. **Le Petit chasseur** (B181)] [Pr.1954: **Le Chasseur** (2)]

C **CARABIN** François-Rupert, France. (1862–1932) +
UJ20 **La Statuette**, *AVI*, embossing, 1896

CARO-DELAVILLE Henry, France, (1876–1928) +
[D.1919: 35. **La jeune mère**, col. lith]

CARRIÈRE Eugène, France. (1849–1906)
CA466a. from Delteil asks Clot to give a proof of *Verlaine* to his porter. CR/Delteil (D), Bib. 8.
UJ21/D36 **Le Sommeil** (Jean-René Carrière), *AVII*, lith, 1897
D38 **Maternité** (grande planche), *Germinal*, lith, 1899
Maternité, lavis interpretation by Clot for André Marty in *L'Imprimerie et les procédés de la gravure au vingtième siècle* (Paris) 1906

CASSATT Mary, United States, France. (1844–1904) +
IFF entry for Clot says he printed for Cassatt who made only two lithographs. Clot also made counterproofs for Vollard of 13 of Cassatt's pastels of mothers and children, possibly intending to print

lithographs from them. CR/Breeskin (B) Bib. 8.
B23 **Au théâtre, woman in loge**, lith, c.1881
B198 **Sarah portant son bonnet et son manteau**, lith, c.1904
Counterproofs of thirteen pastels (1889–1903), c.1904
(B.279, 313, 327, 365, 374, 376, 382, 427, 429, 439, 446, 449, 459)

CÉZANNE Paul, France. (1839–1906)
Several letters from Vollard mention Cézanne: CA412/413 (4.8.1912)
(letter 15) chides Clot for not completing **le repas sur l'herbe** after 'the
little painting by Cézanne' which the printer has had for a year. In
CA407a. (9.8.1911) Vollard says he 'is coming for the litho of Cézanne',
although it is not clear whether Cézanne is author or subject – several
other artists made lithographic portraits of him. In CA562–570 Duret
discusses reproductions by Clot of Cézanne paintings for Bernheim
Jeune.
UJ22 **Les Baigneurs (small plate)**, AVII, direct lith, col. stones by Clot,
1897 (22)
UJ23 ***Les Baigneurs (large plate)**, transfer lith, 2 variants with col.
stones by Clot, 1897 (23 + 23)
UJ24 **Portrait of Cézanne**, transfer lith, 1897 (23)
Déjeuner sur l'herbe, col. lith reproduction of painting, c.1912 (20)
[D.1919: 36. **Les Baigneurs, grande pl.** TP col. lith, (illus); 37. **Les
Baigneurs, moyenne pl.**, col. lith.] [P.1965: **Les Baigneurs, grande pl.** TP,
black pl.] [Pr.1954: **Son portrait** (72); **Petits baigneurs** (22); **Grands
baigneurs** (c.23) (b.23)]

COTTET Charles, France (1863–1924) +
UJ26 **Un Enterrement en Bretagne**, AVII, col. lith, 1897
[D.1919: 38. **Enterrement en Bretagne**, 2 lith TPs, ded, one in col.]
[Pr.1954: **Feux de la St Jean** (4); **Les Veuves** (6)]

COURBOIN François, France. (1865–1925) +
B–H **Mademoiselle Mariette**, *L'Estampe moderne*, lith, 1895/6

CROSS Henri-Edmond, France (1856–1910)
Mentioned in CA355b. from Signac. Mono/Isabelle Crompin (IC)
Bib. 8.
UJ27/IC:337 **La Promenade (Les Cypresses)**, AVII, col. lith, 1897 (3)
IC:338 ***Les Champs Elysées** in *Pan IV (i)*, col. lith, 1898 (14)
[D.1919: 39. **Au bois** 2 TPs, one ann. col. lith (illus. IC:338); 40. **Scène
antique**, col. lith, ded.] [Pr.1954: **Les Nourrices** (14) **Les Cyprès** (3)]

D DE FEURE Georges, France. (1868–1943)
35 rue Boissy d'Anglas, 8ᵉ
CA129a. (8.5.1898) the artist asks Clot to collect stones as he always
works on transfer paper.
UJ43 **Dans le rêve (Allégorie)**, AVII, col. lith, 1897
[D.1919: 41. **4 pieces – Les Laitières flamandes; Allégories; L'Huître**.]

DEGAS Edgar, France. (1834–1917)
CA68 (27.9.1899) from Meier-Graefe agrees a price of 500 fr. rather
than 400 fr. for the reproduction by Clot of a pastel after Degas for
Germinal. CA414/415 (28.3.1911)(letter 3) from Vollard, discusses the
artist's framing preferences etc. Adhémar and Cachin (A&C) Bib. 8. and
B–H list several reproductions by Clot after Degas; the most recent
CR/Reed and Shapiro (R&S) Bib. 8. cites several original liths by Degas
in Clot's estate, the matrices for which are usually conjecturally dated
1891/2. One impression, now in the Bibliothèque Nationale, was
inscribed by Clot, at Atherton Curtis's request, to say that he printed it.
?A&C **Quinze liths. d'après Degas** published by Boussod, 1910
?A&C/UJ176 **Quatre-vingt-dix reproductions**, Vollard (1914); Bernheim
Jeune (1918)
UJ177 **Table, hors texte** in *La Maison Tellier* by de Maupassant
4 collotype plates by Clot, reproducing Degas monotypes (Vollard)
1934
UJ178 **Table, hors texte, in-text illus.** in *Mimes des Courtisanes*
4 collotype plates by Clot, reproducing Degas monotypes (Vollard)
1935
B–H **Les Jockeys** after a pastel by Degas, ? date (83)
Danseuse à mi-corps, by Clot after pastel for *Germinal*, 1899
A&C **The Ballet**, after a 'pre-1909' pastel by Degas, ? date
R&S61 **Nude woman standing, drying herself**, lith (st.4–6), 1891/2 (7)
R&S65 **After the Bath III**, lith (st.1 and 2 in printer's estate), 1891/2 (8)
R&S66 **After the Bath (Large version)**, (st.5 inscr. by AC 'tirée par moi'),
1891/2 (3)
[D.1919: 42. **Danseuse à mi-corps**. st.1, before letters] [P1965: **Femme
nue debout à sa toilette** (D65. st.4)] [Pr.1954: **Gde Sortie de bain** (3);
Moyenne " (7); **Petite "** (8) **Cavaliers de Degas** (83)]

DE GROUX Henry, Belgium, France. (1867–1930)

?Martatte, Seine et Marne
CA69a. (15.9.1897) promises to finish the 'stone for a colour print
already begun' and to start transfer lith; CA69b. (2.4.1915) announces
intention to take up 'this diabolic craft' seriously again. The dating
suggests Clot may have worked on the lithographs inspired by Wagner
(1896) and later plates occasioned by first world war.
[D.1919: 43. **Napoleon I.** (2 different pls.) 44. **Retraite de Russie**,
45. **Siegfried et les filles du Rhin**, 46. **Scène populaire en Belgique**.]
[Pr.1954: *uw*: **Napoléon**, 2 dessins]

DELACROIX Eugène, France. (1798–1863)
CA70 (13.11.1913) from J. F. Schnerb of the *Gazette des Beaux Arts* asks
for simple proofs, not 'belles épreuves', of stones by Delacroix
(**Femmes d'Alger** and **Les Muletiers de Tétuan**), purchased by the
journal after the artist's death for 135 fr and reprinted.
[Pr.1954: **Femmes d'Alger** (42); **Muletiers de Tetouan** (70)]

DENIS Maurice, France. (1870–1943)
59 rue de Mareil; Le Pouldu; Perros Guirec
CA72–79, 467–476: 30 letters from or about the artist. Three from the
Gazette des Beaux Arts in May/June 1907 become increasingly agitated
about **Nativité**, late for their *May* issue. CA75b. (4.8.1899) specifies
colours, probably for the *Germinal* print. CA72b. asks Clot to heighten
parts marked on a proof by bringing out 'the line of the head, the line
of the arm, the breast'. CA74 (22.7.1897) (letter 4) specifies printing
changes to Vollard prints. CA75a. mentions Vollard's album, 75a.
requests colour modification, 76b. allows Clot to choose a colour for
another Vollard print. CA77b. mentions a publication planned by
Rouart (?CI25). Half the letters, dating 1931–1936 relate to the artist's
later collaboration with André Clot. CR/Cailler (c) Bib. 8 names Clot in
several entries; the printer may also have assisted Denis with other
prints, not listed here, such as birth and Holy Communion
announcements for children of both the artist and his friends.
UJ29/c87 **?Jeune fille à sa toilette** (UJ **à la fontaine**), col. lith, 1895
C93 **?Baigneuse au bord d'un lac**, col. lith, 1896
UJ30/C94 **La Visitation à la villa Montrouge**, AVI, col. lith, 1896
UJ31/C100 ***Le Reflet dans la fontaine**, (*ded. 'à Clot'), AVII, col. lith,
1897 (5)
C102 **?Programme for an audition**, col. lith
C103 ***Maternité au cyprès**, *Pan III (iii)*, col. lith, 1897
C105 **Fragment d'une décoration d'église**, col. lith, 1899
UJ32/C107–119 **Amour**, 12 col. liths with cover, published by Vollard,
1899 (61) incl. ***Elle était plus belle que les rêves**
C120 **Maternité devant la mer**, col. lith, 1900 (10)
C121 **Nymphe couronnée de paquerettes**, in *Germinal*, col. lith, 1899
C124 **Frontis. des concerts du petit frère et de la petite soeur**, col. lith,
1903 (2)
C125 **?La Descente de Croix** (st.1), col. lith, 1904
C132 ****Nativité**, in *Gazette des Beaux Arts*, col. lith, 1907
C152 ***Enfant couronnant sa mère**, col. lith, 1929–31
C154 **Sainte Geneviève de Paris**, tint lith, 1931 (29)
Printed by André Clot:
c.162–228 **Poèmes** by Francis Thompson with 13 col. liths and 56 in-
text (1939) 1942 ***incl. plate page 75 (C170)
[D.1919: 47. **La Nativité** 2 TPs, different cols (C132); 48. **Fragment d'une
décoration d'église**, sanguine proof (C105); 49. **Amour**, 15 col. liths –
12 pl., 2 st. of frontis. several ann., one BAT. (C107–119); 50. **La jeune
mère** (illus. C103); 51. The same print chine volant; 52. **La Baigneuse**,
ann. (C93 or 100); 53. Same print, ded. (possibly ANG's copy?); 54. **Les
Enfants musiciens**, TP (C124); 55. **Billet de naissance, Billet de première
communion**, one ded. col. liths. (one of a dozen listed in Cailler).]
[Pr.1954: **Titres 'Amours'** (7); **Planches séparées de 'Amours'** (54); **La
Fontaine** (5); **Femme de marin** (10); **Ste. Geneviève** (29); **Enfants
musiciens** (2); **Gdes pl. diverses** (27); **Pet. pl. diverses** (102); *uw*:
Frontis. 'Amours'; Le Chevalier; 5 croquis; épreuves rehaussées]

DETHOMAS Maxime, France. (1867–1929)
50 ave des Ternes, 17ᵉ
CA80–84; 5 letters. CA80a. and b. request transparent transfer paper
and ask for an unsatisfactory drawing to be cleaned off the stone. CA84
talks of adding crayon and 'crachis' to a transferred drawing. CA84
asks for a large stone with margins. CA81/82 (3.1.[1897]) (letter 5)
concerns a lost portrait by Blanche and payment for the printing of a
poster.
***Croquis** in *Le Centaure I*, sanguine lith, 1896
13ᵉ **exposition Impressionistes & Symbolistes**, col. lith poster, 1896

DILLON Henri-Patrice, France. (1851–1909) +
B–H **Le Monologue**, *L'Estampe moderne*, 1896

E ELIOT Maurice, France. (1864– active 1937)

21 Bd. de Clichy; ?Epinay par Brunoy
CA99–107: 14 letters. CA99a. and 99b. (23.2.1897) talk of saving a 'Tête' (?UJ38) while CA100a. mentions a pastel that the owner wants back. Three letters from January–June 1898 mention Eliot's ill health and arrangements for printing. 101b. expresses horror about colour and proposes solutions. CA103 suggests other colour amendments. CA104 (letter 6) asks Clot to prevent a print looking like 'a chromo' and says the artist wants it to appear 'as though it has been done <u>by me.</u>' CA105 (12.6.1898) requests 25 proofs.
UJ38 Tête de fillette, AVII, col. lith, 1897
[Pr.1954: Pastel]

F FANTIN-LATOUR Henri, France. (1836–1904)
8 rue de Beaux Arts, 6e; Buré par Le Mesle.
CA109–128, 477–484: 28 letters from or about the artist. In CA117a. (25.6.1896) Fantin sends Clot a signature for **Baigneuse** (H130) and in CA120a. tells him to send the print to Alboize who is 'complaining loudly'. CA117b. tells the printer that Meunier has paid him for *Les Bucoliques* or *Poésies d'André Chénier*. CA119 (1.5.1899) asks for a stone for the Musée du Luxembourg catalogue lith. Five letters from E. A. Seeman, Berlin, May/June 1901 discuss **Ariane** for the German edition *Gazette des Beaux Arts* in 3000 ordinary plus 25 de luxe copies. The artist's wife consults Clot about the condition or cancellation of lith stones, some of which are sent to Nantes Museum. In CA115c. she discusses copies of **Frontis.** Verité (GH56) being offered to dealers although out of print. She also requests copies of four lithographs for Léonce Bénédite's 1906 book on the artist and LB himself insists on strictly limited editions. CA112/113 (21.3.1906) (letter 7) from Charles Meunier, Chénier publisher, takes up the question of ownership of the BATs, a matter which CA124 (30.6.1907) suggests is still unresolved. Letters from the Secretary and President of the Société des Amis des Arts de Pau in 1901 tackle a similar matter telling Clot – 'you are only the printer' and in CA477 (22.4.1901) ask for a cancelled proof and assurance no more will be pulled. Letters of May and June 1903 ask for Berlioz proofs. In CA126 (27.10.1903) the organizers of the Berlioz Centenary write about 400 copies of **Romeo et Juliette. Confidences à la nuit** (GH176) for their commemorative album. CR/Germaine Hédiard (GH), Bib. 8.
GJ123 **Les Brodeuses**, *L'Épreuve*, lith, 1895
GH124 **Venus et l'amour**, 2e pl., *L'Estampe moderne*, lith, 1895
GH125 **Baigneuses** in *Le Centaure I* (de luxe), lith, 1896
GH129 **Naiade** or **Ondine**, *L'Estampe moderne*, lith, 1896
GH130 **Baigneuse debout**, 2e pl., in *Les Peintres-Lithographes*, lith, 1896
UJ39/GH131 **Venus et l'amour** (grande planche), AVI, 1896
GH133* **Études de femme assise, vue de dos**, in Geoffroy's *La Vie artistique*, 1897
GH136 **La Lecture**, lith, in *Les Lith. nouvelles de F–L* (1897), 1899
GH137 **La Romanesca**, lith for song sheet (1897), 1898
GH143 **Les Brodeuses**, 3e pl. lith, 1898
GH149 **Baigneuses**, 2e moyenne, for Lorilleux inks, lith, (not used), 1899/1900
GH150 **Pleureuse, Étude de femme, assise de profil à droite**, in Musée du Luxembourg catalogue, lith, 1899
GH151 **Maléfice** for the Société des Amis des Arts de Pau, lith, 1899
GH152 **Baigneuse debout**, 3e pl. in 'La lithographie originale', in *Revue de l'art*, lith, 1899
GH153 **A Johannes Brahms**, Gr. pl., lith, 1900
GH155 **Étude de femme debout, vue de face**, used in *Sensations d'art*, 1900
GH156 **Vérité**, petit pl., lith, 1900
GH154 ***Ariane**, in *Gazette des Beaux Arts*, lith, 1901
GH157 **Le Paradis et la Péri**, 3e pl., in *Zeitschrift für bildende Kunst*, lith, 1901
GH159 **Rêverie**, in *Maîtres artistes*, lith, 1903
UJ42/GH160 **A Rossini**, for Ambroise Vollard, 1903 (18)
GH161–172 ***Illustrations** in *Les Bucoliques (Poésies d'André Chénier)*, 12 liths, 1903
GH174 **Titre pour la Revue musicale**, lith, 1903
GH175 **Centenaire H. Berlioz**, lith, 1903
GH176 **Roméo et Juliette. Confidences à la nuit**, 2e pl., lith, 1903
GH177 **Duo des Troyens**, 7e pl. in *La Revue de l'Art, ancien et moderne*, 1903
GH178–199, plus 8 uncatalogued **Feuilles d'études**, posthumous transfer.
[D.1919: 56. Suite de six pièces (GH138–142 and 146/UJ41) (?printed by Blanchard); 57. Maléfice (GH151); 58. A Johannes Brahms (GH153)]
[P.1965: Baigneuses, TP] [Pr.1954: Apothéose (H89) (101); Source, Danses, Siegfried, Kundry (?Blanchard) from 88 to 118 copies of each; 'Berlioz et Wagner' (H61–74 and H76–89) (426); Chenier petites pl. diverses; Nymphes ?(118); Hommage à Rossini (18); uw: Baigneuses]

FORAIN Jean-Louis, France. (1852–1931)

In CA408a. (25.10.1905) Vollard writes that it is urgent for him to have the sketches by Forain put on stone. CR/Guérin (G) Bib. 8.
UJ46/G61 **Femme assise, la tête dans la main droite**, AVII, 2-col. lith, 1897
UJ47/G60 **En Grèce**, lith, 1898
UJ55 ***Portraits of Ambroise Vollard**, lith? date
[D.1919: 59. En Grèce (G60)] [P.1965: Portraits d'Ambroise Vollard
UJ55 *Portraits of Ambroise Vollard, lith, ? date
(52); Cabinet inachevé (9); Vollard (39); Etude pour Vollard (48); Plaidoirie (46); Scène d'audience (52); A la Bourse (31); Homme au parapluie (53); En Grèce (9); Portrait de Renoir 4 pl. (38); Petit nu remarque (10); Nu de profil à droite bras levé (29); Nu assis, la main sur les reins (b.25/c.32); Nu tortillé (b.32/c.36); Femme qui se peigne (b.31/c.3); Le Peintre et le modèle (31); Repos du modèle (25); Forain et son fils (4); uw: Repos du modèle, A la Bourse.]

G GANDARA Antonio de la, France. (1862–1917)
22 rue Monsieur-le-Prince, 6e
CA150b. asks Clot to pick up a stone.
[D.1919: 69. Paul Verlaine, 70. Repos, 71. Profils de femmes (2)]

GAUGUIN Paul, France. (1848–1903) +
No letters, and no evidence this suite was printed by Clot.
UJ59 **Dix zincographies** (1889) reprint on white paper, 1894

GAVARNI Paul, France. (1804–66)
CA151–153: three letters of 1924 from Eugène Fasquelle discuss the production of the de Goncourts' book *Gavarni* the reproductions for which have been made by Clot from a drawing belonging to Geoffroy and from lithographs, some of which Clot owned.

GRASSET Eugène, Switzerland, France. (1841–1917)
65 Bd. Arago, 13e
CA140a. (18.10.1897) and CA140b. discuss a work in progress and ask for 'the green armchair' to be darker and warmer.
UJ60 **Morphinomane**, AVII, col. lith, 1897

GRILLON Roger-Maurice, France. (1881–1938)
162 Bd. Voltaire, 11e
CA138–139: three letters ask for advice and a sheet of transfer paper, request Clot to put a wash on stone, and bewail an area in a print which looks like 'a piece of chiffon burnt by acid.'

GUIGUET François, France. (1860–1937)
92 rue les Charmettes, Lyon; 21 rue de Navarin, 9e
CA141–142: two letters tell Clot a stone is ready for collection and that Rodriguez is impatient to see the edition. In CA141 (5.6.1905) the secretary of the Berlioz Festival orders 350 copies of a scene from the *Symphonie Fantastique*.
La Leçon in *Gazette des Beaux Arts*, lith, 1904
'Scène from Symphonie Fantastique', lith, 1905
[Pr.1954: uw: Etude de femme]

GUILLAUMIN Armand, France. (1841–1927)
Crozant, Creuse
One letter CA136/137 (4.7.1898) (letter 8) discusses the anaemic colouring of the landscape with haystacks. CA135a. – a card from Ch. Guillaumin of 'Petit paradis', Cannes, PO stamp 1930, possibly son Armand known as 'Chabral' – asks Clot about 'mes charettes et mon bébé' (my carts and my baby). Letter from Duret for Bernheim-Jeune discusses Guillaumin reproduction. Mono/Christopher Gray dates five lithographs 1896, Bib. 8.
UJ61 **Les Rochers**, AVI, col. lith, 1896
UJ62 **Tête d'enfant**, AVII, col. lith, 1897
UJ63 **L'enfant mangeant sa soupe**, for AV, (UJ c.1920, IFF c.1902), ? date
B–H **Jeune fille en buste**, col. lith, ? date
B–H ***Paysage aux meules**, col. lith, 1898 (9)
[D.1919: 60. L'Enfant couché, col. lith; 61. L'Enfant à la soupe, TP, col. lith; 62. Le Garconnet, TP, col. lith; 63. Les deux meules, col. lith, ded; 64. Les Roches rouges, col. lith] [Pr.1954: Les Meules (9); Enfants 4 subjs (20); uw: Esquisse au pastel, Tête d'enfant]

H HÉRAN Henri (pseud. for Paul Herrmann), Germany, France. (1864–?) +
CR/H.W. Singer (s) Bib. 8.
S18 **Sirène**, col. lith with woodcut, 1896
S20 ***Nymphe effrayée**, in *Le Centaure II*, col. lith and woodcut, 1896
S22 **?L'Ame de la forêt**, col lith and woodcut, 1896
S19 **?Spielendes Meerweib** in *Pan III (iv)*, col. lith and woodcut, 1898 (possibly also s7,8,12,23,24)

HERMANN PAUL, France. (?1864–1940)
Salto bartha, Guethary, Basses Pyrénées
CA160a. and 160b. – ask Clot to pick up a stone, prepare three more for colour and promise to continue work on his return from the Pyrénées (where he often stayed second half 1890s).
UJ64 **Les petites machines à écrire**, AVI. col. lith, 1896
[D.1919: 65. **Images pour les demoiselles**, 10 liths and cover (no. 21), ded. 1896]

HUGO Georges, France. (1868–1925)
La Mancherie, St Martins, Guernsey
CA163–165, 484–485: Eight letters. They concern invitations for a soirée, a visit to Clot's studio by Hugo's friend Frederick Lauth, a supply of Japanese paper and finishing 'the boats in progress.' CA484a. asks Clot to clean and renew a lith press; CA484b/485 (29.6.1896) asks for editions of 10 of each of six colourful boat liths.
Six bateaux. col. liths, 1896/97

J JEANÈS Sigismond, France. (1863–?)
atel: 23 rue Poussin; 14 rue de la Curé, 16ᵉ
CA185–187, 438/9: Of four letters, two dated 1910 ask for modifications of lettering on invitations and for Clot to do the impossible and deliver 100 by 5 June.

JEANNIOT Pierre-Georges, France. (1848–1934)
4 rue Picot, 16ᵉ; Diénay, Côte d'Or
CA166–184: 25 letters. Six date from the second half of 1896; they discuss beginning a lith; Vollard's character; delivery of 1 small and 10 large stones; a visit from Pellet and an impending series; its urgency; and lithographic chemicals which Jeanniot is using himself at the studio. CA178a. says Jeanniot has had no time for Vollard's project. Four letters of 1897 discuss Pellet publications – arranging the trials for **Les Conscrits**; the completion of **Le Pays**, another unidentified colour print and the BAT for **Le Soldat blessé**. Jeanniot requests fine proofs for the Princesse de Polignac and Degas who have lent him back his own paintings to work from. Undated letters discuss modifications to **Les Pays** and an unnamed print depicting a policeman and carriage with colours which 'lack energy'. Three letters of 1898 record Jeanniot's attempt to sell back to Clot – for 150 frs then 100 frs – a press he purchased from Clot for 250 frs, resolved in 1898 when Léandre takes an interest in it. CA166 (letter 9) discusses ink for transferring images from wood to stone and suggests lithographic colour will be added to a woodblock print; CA175/176 (letter 10) complains bitterly of an imperfection spotted after editioning.
?**Jeune femme assise dans un jardin**, transferred woodcut with lith col., 1896
Le Soldat blessé, lith, 1897
Le Conseil de revision, col. lith, 1897
Les Conscrits, col. lith, 1897
Les Pays, 1897
Le Lever, col. lith, exhib. 1897
[D.1919: 66. **Conseil de revision**, 2 copies, one in col., one ded; 67. **La Payse**, (sic) **Le Soldat blessé**, ded; 68. **Le Modèle**, col. lith.]

JOHN Augustus, England (1878–1961)
CA63b.–65, 394, 436 from Aleister Crowley concerning commissioning, delivery and payment
Portrait of Aleister Crowley, lith by Clot after a drawing, 1911/12

K KAVLI A., Norway. (1878–?)
CA188a. (1.11.1903) sends small sketch of drawing left on stone with Clot and asks for 15 proofs at 1 fr. each; a second letter 10 days later asks for a reply.

KLOSSOWSKI Erich, Germany. (1875–?)
16 rue Boissonade, 14ᵉ
CA188b. asks for 15 sheets of transfer paper for col. liths; CA189a. mentions Meier-Graefe and proofs and corrections for Leipzig.

L LAPRADE Pierre, France. (1875–1932) +
[D.1919: 72. **Le Baiser de Pierrot**, with remarque, 2 tones; 73. **L'Image** ded.] [Pr.1954: **2 sujets** (8)]

LAURENT Ernest, France. (1859–1929)
17 rue Rousselet, 7ᵉ
CA200a. asks for his stone to retouch.

Portrait, after his painting of 'Mme. N', in *Gazette des Beaux Arts*, lith, 1901

LÉANDRE Charles, France. (1862–1934)
Veber writes about a banquet for Léandre for which Clot prints the menu.
B–H **Vieux fumeur**, *L'Estampe moderne*, lith, 1895/96
Touchez l'amour in *Le Centaure I*, lith, 1896

LEBASQUE Henri, France. (1865–1937)
CA199b. (23.6.1903) sends transfer paper drawing and mentions retouching stone. In CA201–203 (14.7.1903) Schnerb of the *Gazette des Beaux Arts*, unable to wait for the artist's comments, gives printing instructions.
La Promenade au jardin in *Gazette des Beaux Arts*, lith, 1903

LEGRAND Louis, France. (1863–1951) +
Legrand was essentially an etcher although two lithographs appear in the Drouot sale and the printer's estate.
[D.1919: 74. **Les Deux fillettes**, TP, col. lith; 75. **Buste de fillette**, TP, lith.] [Pr.1954: **Danseuses, 2 sujets** (15)]

LEGROS Alphonse, France, England. (1837–1911)
CA157 (2.8.1904) from Hessèle sends BAT and asks for 70 proofs.
CR/Soulier (S) Bib. 8.
S630 ?**Paysage: Brume du matin**, lith, 1904
[D.1919: 76. **Paysage**.]

LEHEUTRE Gustave, France. (1861–1932) +
C/R Delteil (D) Bib. 8.
UJ67/D41 ?**Le Duo (Jeunes filles au piano)**, AVI, col. drypoint, 1896
UJ68/D134 **Femme au repos (Le Repos)**, col. lith, 1896
UJ69/D136 **La Danseuse**, AVII, col. lith, 1897
[D.1919: 77. **Repos** col. lith; 78. **Danseuse accotée à un battant** (D136)]
[Pr.1954: **Danseuse** (7)]

LE SIDANER Henri-Eugène, France. (1862–1939)
CA204–206: four letters – make an appointment, send a lithographic drawing, request proofs and say he is authorized to have an edition of 50 prints for himself. In CA204a. (19.7.1909), A. Marguillier of the *Gazette des Beaux Arts*, asks for a proof; another correspondent from the journal asks Clot for photographs of Le Sidaner.
La Maison au clair de lune, in *Gazette des Beaux Arts*, lith, 1909
?**Le Perron** et **La Balustrade**, in *Gazette des Beaux Arts*, liths, 1911

LÉVY-DHURMER Lucien, France. (1865–1953)
3 bis rue La Bruyère, 9ᵉ
CA234, 286, 287: Three letters. The artist thanks Clot for advice, tells him of an agreement with Arnould, asks the printer to pull 50 impressions and advises him when 'this important edition' is finished, to bring proofs himself so the artist can consult him about 2 more lithographs.
[D.1919: 79. **Femme nue**, sanguine lith, ded.]

LEWISOHN Raphael, France. (1863–1923)
65 rue Lepic, Pavillon B., Montmartre
CA198b. (29.4.1897) advises Clot he has finished a sketch on lithographic paper and will come to work on stone.
UJ71 **La Danse en Bretagne**, AVII, col. lith, 1897

LIEBERMANN Max, Germany (1847–1935)
In CA198b. W. Bondy of Bd. Raspail, agent for Bruno Cassirer, asks to have 4 proofs on any paper as soon as possible. CR/Schiefler (S) Bib. 8.
[D.1919: 80. **Max. Liebermann, de face** (?S133); 81. **Liebermann, de trois quarts à gauche** (?S134); 82. **La Manifestation** (S138); 83. **Le Marché**, (illus.) (S136); 84. **Le Marché** (different composition) (S137); 85. **Sur la plage** (?S141); 86. **Les deux cavaliers sur la plage** (?S112); 87. **Le Chasseur**.]

LUCE Maximilien, France. (1858–1941) +
CR/Tabarant (T) Bib. 8.
La Mée, col. lith, 1897
Environs de Gisors, col. lith, 1897
Environs de Vernon, col. lith, 1897
Le Port de St Tropez, col. lith, 1897
La Mer à Camaret, col. lith, 1897
Percement de la rue Réamur, col. lith, 1897
*****Usines de Charleroi** for *Pan IV (i)*, col. lith,, 1898 (6)
[D.1919: 88. **Les Récifs** col. lith, ded.; 89. **Paysages des bords de la mer**, col. lith, ded. (illus); 90. **Le Verger**, col lith; 91. **Au bord de l'eau**, col. lith; 92. **Le Village**, col. lith; 93. **Cheminées d'usines**, col. lith.]
[Pr.1954: **Pl. en couleurs** (20); **Charleroi** (6)]

LUNOIS Alexandre, France. (1863–1916)
1 rue de Poissy, 5ᵉ
CA207–233, 341, 486–494: 58 letters from or about the artist, only four dated. CA207b. (24.8.1900) and 341 (1.4.1901) from Lahune and Rodrigues deal with the book *Carmen*, the former regarding corrections to pages 1–32. In CA218b. the artist is anxious to start a new book and see 'what he and Clot can do together'. In CA208 (8.9.1907) Lunois writes from a sanatorium in Lofthus, Norway, that he has been coughing up blood. Four letters from Lunois reveal that Rodrigues has chosen the tone of grey for a book's first plate, requires page proofs showing recto and verso with text, and suggest a way of solving a technical problem. In CA212a. (14.6.1912) the artist reports that Floury is enchanted with the latest proofs, but in a hurry. CA221a. asks Clot to collect 2 transfer drawings in a box because he has used gouache; In CA487c. Lunois discusses lavis and his belief in lithography. CA222b. discusses a tint stone for a sanguine print. Several letters discuss the need to complete a job for the Hotel de Ville before money runs out. The artist's letter to an un-named third party concerns a reduction in the charge of 500 fr. for printing the latest lithograph. Several letters discuss paper – the shortage of Perigot and Masure for ?*Carmen*; the need for the proofing paper to approximate the final edition. In CA207a. Charles Waltner thanks Clot for his help with a Lunois exhibition. In CA231 the artist vehemently complains about slow progress with a lithograph and asks for chemicals to process it himself. Among specific works cited are: **Danseuse espagnole, St Paul and the lion** and **St Pélagie with the raven** for ?*La Legende dorée*; **Lawn tennis** about which Vollard has written 'a tender letter'; the stone for 'The Women with rackets'; lost stones used for *La Legende dorée*; **Le Menuet** and **Les Raquettes**; **Colin-maillard**, a '**Procession**' and a drawing of Puvis. In CA217 Lunois mentions a new plate for Dufaux (?Duffau) and requests 30 each of **La Raquette** and **L'Embarquement** and 35 of **Le Menuet**. In CA219 Lunois says he is varying the techniques of the second and third plates of **Courses de taureaux** for the sake of variety. Several letters from Mme S. Lunois may date from her husband's serious illness c.1907–09. In CA214a. she tells Clot her husband feels incapable of 'serious' work but would like to do two lithographs. Several letters concern collectors – to whom she sells both her own proofs and those belonging to Clot; one letter suggests exchanging four small prints – **La Marocaine, Feste de nuit, Des Fiancés**, and another unnamed – for the rare **Buveuse d'absinthe**, worth 200 fr. In CA209 she asks for promised editions as a lawyer is making inventory. Another letter advises that a collector has taken **Le Rameur** and portrait of **Piazza**, but already has bullfight scenes from Pellet, although is willing to buy states if Clot will accept 50 fr. each. In CA492/493 Bénédite asks to borrow a print in connection with an article. Mono/André (A:p. no.) gives little information about printers and dates only exhibited prints. Bib. 8.
IFF **Menu pour les noces d'argent de Monsieur L. 1885 et pour le baptême de son petit-fils**, col. lith, 1885
A:214 **Les Lavandières descendant l'escalier d'un quai**, after Daumier, lith, 1888
A:227 **La Buveuse d'absinthe**, col. lith, 1894
IFF/A:201 ?**Portrait de Mme L———**, col. lith, c.1893
A:223 **Danseuses espagnoles avant la danse**, col. lith, 1894
A:216 **Intérieur hollandais**, col. lith, 1895
A:228 **Le Volant (Partie de volant or La Raquette)**, col. lith, 1895
A:227 **Le Menuet chez Mme Ménard-Dorian**, col. lith, 1896
B–H **La Toilette**, *L'Estampe moderne*, col. lith, 1895
IFF **Société de Gymnastique et de tir Alsacienne-Lorraine de Paris**, diploma, c.1896
A:228 **L'Embarquement**, col. lith, 1896
A:202 ?**Danse Espagnole**, col. lith, 1896
A:228 ?**Junon**, col. lith, ? date
La Legende dorée, by Voraigne, with 75 liths, Paris: Boudet 1896
A:229 **Le Rameur**, 1895
Portrait of Piazza, 1896
UJ72/A:221 **Femme espagnole remettant son soulier**, *AVI*, col. lith, 1896
A:221 *La Corrida*, (**Courses de taureaux**), pf 8 col. liths, 1897 (62)
UJ76/A:228 *****Le Colin-maillard**, col. lith, 1897 (14)
UJ74/A:203 *****Le Lawn tennis**, 1898
?**Le Ballet**, col. lith, 1897
UJ73/A:228 **Le Départ pour la chasse**, *AVII*, col. lith, 1897
La Procession (de la Fête Dieu), col. lith, 1898 (13)
A:222 **Calle Passion**, col. lith, 1898
*****Fêtes de nuit sur les bords de Guadalquivir**, 1898 (19)
A:225 ?**La Marocaine**, ? date
*****Les Fiancés**, in *Revue de l'Art ancien et moderne*, lith, 1899
Laboureur du Kef, in *Gazette des Beaux Arts*, lith, 1899
Carmen, by Mérimée with 170 col. liths, (64 printed by Clot), 1901
A:216 **En attendant l'office – Eglise de San Salvador** in *Revue de l'Art ancien et moderne*, lith, 1901
*****Au coin du feu** in *Revue de l'Art ancien et moderne*, lith, 1901

A:222* **Guitarrera** in *Revue de l'Art ancien et moderne*, lith, 1901
A:223 ?**Le Café de 'L'Imparcial'** (Toilette des danseuses), col. lith, 1902
A:224 ?**Les Coulisses de 'L'Imparcial'**, col. lith, 1903
A:243 **Intérieur hollandais**, col. lith, 1903
[D.1919: 94. **Mme L***, rare; 95. **La Procession**, col. lith; 96. **Le Menuet chez Mme Ménard-Dorian**, col. lith, ded.; 97. **Jeu de volant**, col. lith, ded.; 98. **Le Ballet**, 2 proofs, one col. lith, one TP in black; 99. **En scène**, tint lith, ded.; 100. **Au cirque**, proof with remarque and col. crayoning 2/30; 101. *La Corrida*, 7 of 8 pieces, col. TPs; 102. **La Dance, scène d'Espagne**, 2 TPs, one col. one black; 103. **La Danse**, variant TP; 104. **La Danseuse aux castagnettes**, col. lith with remarque; 105. **Calle Passion**, col. lith; (illus.); 106. **Espagnoles à leur toilette**, 2 proofs, one black TP, one col.; 107. **L'Espagnole remettant sa chaussure**, col. lith, 1908; 108. **Dans les coulisses**, verdâtre lith; 109. **Intérieur Hollandais, Sur le bateau**, 2 pls.; 110. **Intérieur Suédois**; 111. **La Femme au paon**, bistre lith; 112. **Illustrations**, 19 TPs. 113. **Les Lavandières**, dpr. H. Daumier] [Pr.1954: Gde Flamenca (22); Tauromachie (62); Pl. couleurs gdes (5); Pl. noir gdes (11); Pl. couleurs moyennes (14); Procession (13); Fête sur le Guadalquivir (19); La Toilette (11); Colin-maillard (14); Pl. noir diverses (21); Petites pl; uw: Aquarelle odalisque; epr. rehaussées]

MAILLOL Aristide, France (1861–1944) +
[D.1919: 114. **Femme nue, étendue**] [Pr.1954: **Nu** (13)]

MANET Edouard, France. (1832–1883) +
CR/Moreau-Nélaton (M–N) Bib. 8.
IFF/M–N87 **Polichinelle**, chromolith, col. stones by Clot, 1874
M–N82 *****La Barricade**, lith, 1884
M–N83 **Berthe Morisot**, lith, 1884
M–N84 **Berthe Morisot, esquisse**, lith, 1884
M–N85 **Les Courses**, lith, 1884

MANZANA PISSARRO Georges, France. (1871–1961)
20 rue Choron 9ᵉ; 31/39 Bd. St Jacques, 14ᵉ
CA257–264, 495: 12 letters. In December 1909, Hessèle tells Clot he has sent Manzana to see him. A letter of late 1909/early 1910 asks for proofs for shows of 'The Orientalistes' and the Société Moderne at Durand Ruel. In January 1910 the artist requests proofs of all his lithos for a dealer who cannot go to Devambez to see them; he tells Clot that the State has bought a print for 100 fr. In March 1910 Manzana reports that Pellet has a publisher for *1001 nights*; the artist has also sold 4 proofs for 400 fr. which will enable him to give Clot some money; also a collector has promised to buy all future lithos which will allow them to 'really work'. Letters at the beginning and end of 1912 from E. Rodrigues ask about progress on the book; in November 1912 the artist, just settled in a new studio, says that he wants to continue with it. A letter from the artist of January 1913 complains of ugly proofs and asks what he and Clot are to do.
Nu à la biche, 1910
Trois baigneuses, 1910–13
Femmes orientales
Récolte d'oranges
Les Sultanes au bain
Cakountala, 1910–13
Rarahu se lavant, 1910–13
Le Mariage à Loti
Proofs of *Les Mille et une nuits*, 1912–13
[D.1919: 115. **Scènes d'Orient**, 6 pls, col. liths] [Pr.1954: 'planches impr. en or' (12)]

MARTIN Henri, France. (1860–1943) +
B–H ?**Le Vice**, 1897
B–H ?**Le Silence**, 1897
B–H/UJ78 **Tête de femme**, *AVII*, col. lith, 1897

MATISSE Henri, France. (1869–1954)
CA496 returns proofs and asks if observations about the mise-en-page have been carried out together with Mr Carré's comments. CR/Duthuit (D) Bib. 8.
D317 **Le grand bois**, woodcut, 1906
D318 **Petit bois clair**, woodcut, 1906
D319 **Petit bois noir**, woodcut, 1906
D320 **Le Luxe**, woodcut, 1906
D390 **Tête de femme, les yeux clos** (pl. 1), lith, 1906
D391 **Nu mi-allongé les bras dissimulant les yeux** (pl. 2), lith, 1906
D392 **Nu mi-allongé, bras repliés vers les yeux** (pl. 2 ter), lith, 1906
D393 **L'Idole** (pl. 2 bis), lith, 1906
D394 **Nu accroupi les yeux baissés** (pl. 4), lith, 1906
D395 **Nu accroupi, profil à la chevelure noire** (pl. 3), lith, 1906
D396 **Figure pensive au fauteuil pliant** (pl. 4 bis), lith, 1906

D397 Tête renversée (pl. 5), lith, 1906
D398 Nu assis, main tenant le menton (pl. 5 bis), lith, 1906
D399 Tête aux yeux clos, (pl. 12), lith, 1906
D400 Torse aux bras croisés (pl. 6), lith, 1906
D401 Nu de trois-quarts, la tête penchée (pl. 7), lith, 1906
D402 Figure de dos au collier noir (pl. 8), lith, 1906
D403 Grand nu (pl. 10 or 29), lith, 1906–? 1913
D404 Nu au pied droit sur un tabouret (pl. 9), lith, 1906
D405 Nu de face, vue plongeante (pl. 11), lith, 1906
D407 Torse de face (pl. 16), lith, 1913
D408 La Lecture, nu de profil (pl. 14), lith, 1913
D409 Nu de trois-quarts, une partie de la tête coupée (pl. 15), lith, 1913
D410 Nu au rocking chair (pl. 17), lith, 1913
D411 Les Yeux noirs (pl. 18), lith, 1913
D412 Nu assis, vu de dos (pl. 19), lith, 1913
D413 Visage à la frange (pl. 20), lith, 1913
D414 Visage légèrement penché vers la gauche (pl. 21), lith, 1913
D415 Jeune femme accoudée (pl. 21 bis), lith, 1916/17
D417 Nu couché aux cheveux courts (pl 39 bis), lith, 1922
D418 La Nuit (pl 32), lith, 1922
D419 Le Jour (pl 33), lith, 1922
D420 Nu assis dans un fauteuil, une jambe repliée (pl 30), lith, 1922
D421 Nu assis, chevelure foncée (pl 37), lith, 1922
D422 Nu assis, chevelure claire (pl 31), lith, 1922
D423 La Robe d'organdi (pl 38), lith, 1922
D424 La Robe jaune au ruban noir (pl 34), lith, 1922
D425 Jeune fille à la chaise-longue dans un sous-bois (pl 36), lith, 1922
D426 Nu sur chaise de repos sur fond moucharabieh (pl 35), lith, 1922
D427 La Sieste (pl 39), lith, 1922
D428 Jeune fille au col d'organdi (pl 45), lith, 1923
D429 Jeune fille en robe fleuri au col d'organdi (pl 46), lith, 1923
D430 La Capeline de paille d'Italie (pl 41), lith, 1923
D431 Petite liseuse (pl 40), lith, 1923
D432 Odalisque au magnolia (pl 42), lith, 1923
D433 Odalisque à la culotte rayée, lith, 1923
D434 Odalisque au collier (pl 44), lith, 1923
D435 Nu couché au paravent Louis XIV (pl 47a), lith, 1923
D436 Petite aurore (pl 48), lith, 1923
D437 Grande liseuse (pl 49), lith, 1923
D438 Jeune fille assise au bouquet de fleurs (pl 51), lith, 1923
D439 Jeune fille accoudée au paravent fleuri (pl 50), lith, 1923
D440 Autoportrait (pl 132), lith, 1923
[D.1919: 116. Repos, ded., st. (illus. D317); 117. Nus de femmes, series of 5 on japon; 118. Buste de femme; 119. Femme assise.] [Pr.1954: Grandes pl. (28); Moyennes pl. (36); Petites pl. (42); *uw*: Femme assise dans un jardin; Femme couchée; Femme lisant; Femme assise près d'un guéridon; Nus à la plume (2); Dessins de nus (11); Bois gravé, nu]

MATTHÈS Ernst, German. (1879–1918)
5 rue Cavallotti, 18ᵉ, and addresses in Germany
CA267–270, 514: Seven letters between June and Dec. 1908 discuss an almanach for Insel Verlag, the printing (and therefore the payment of which) has been delayed by the artist's visit to Germany.
Scènes Parisiennes, col. liths, (Insel Verlag) 1909

MAURIN Charles. (1856–1914) +
UJ81 Étude de femme nue, *AVI*, col. etching, 1896
UJ82 Eve, *AVII*, col. etching, 1897

MISTI (Ferdinand MIFLIEZ), France. (1865–1923)
CA243b. (16.7.1907) asks for 60 cm stone.

Ctesse de MOLITOR Malvina Cécile (pseud. 'QUILL' active 1879–1903)
40 rue de Monceau, 8ᵉ; Chateau de Burthecourt, par Vic sur Seille; Villeneuve, Lac de Genève
CA272–280, 515a.b.: Ten letters of 1903, discuss the manuscript, agreement, estimate of 4000 fr. for 500 copies, payment and corrections for her book, which Clot edited.
Vieux échos d'une éternelle chanson (L'Astrée), 29 liths, 1903

MOREAU Luc-Albert, France. (1882–1948)
CA285, 497–509: Eleven letters from or about Luc-Albert Moreau.
CA285b. (3.10.1928) to André Clot hopes he is 'rested after the exertions of May, June, July and August' and sends greetings to Auguste. The other letters are all addressed to André and date from 1931–1946. Letters from Dunoyer de Segonzac concern a homage in *Les Nouvelles littéraires* in 1958. Only works up to Auguste Clot's death are shown.
Tableau de l'amour vénal by Francis Carco, 12 liths, 1924
L'Excentrique musical, lith, 1924
Le Jongleur, lith, 1924

Eight, nine, ten, le noir, lith, 1924
Eight, nine, ten, le blanc, lith, 1924
La Course de flambeau, lith, 1925
Little Tich – la réception à la cour, lith, 1925
Little Tich – le petit chapeau, lith, 1925
Les Paradis artificiels, lith, 1925
L'Homme à l'éventail, lith, 1925
L'Aventure by Conrad and Ford Madox Ford, 1 lith, 1926
Le Cagibi, lith, 1926
La Tentation de Saint-Antoine, lith, 1926
Nahandove, lith, 1926
Méfiez-vous des blancs, lith, 1926
Il est doux de se coucher, lith, 1926
Saint-Antoine à la chouette, lith, 1926
Tableaux de Paris by Émile-Paul (1 lith, Le Cinéma), 1927
Bagatelle, lith, 1927
*Danseur nègre, lith, 1927
Boxeur à genoux, lith, 1927
Grock au concertina, lith, 1927
Le Bibliophile, lith, 1927
Jeanne d'Arc, lith, 1927
Boxeur knock-out, lith, 1927
Fin de combat, lith, 1927
Images cachées by Francis Carco, 13 liths, 1928
Portrait de Francis Carco, lith, 1928
Boxeur se couvrant la figure, lith, 1928
Les Fées, lith, 1928
Physiologie de la boxe, by Des Courières, 60 liths, 1929 incl. *la Defaite
[Pr.1954: Grandes pl. (11); Petites pl. (135)]

MUNCH Edvard, Norway. (1863–1944)
CA249A (29.5.1897) (see illus. 5.24) an agreement in Mme? Clot's hand, signed by Munch, promises to buy 23 stones for 598 fr. (26 fr. each) within 3 months, or to pay 25 fr. per month in rental from September. Another note asks Clot not to destroy 'the green frame' of a portrait (of Gunnar Heiberg) because it now pleases him. Two letters; one CA249Bb. (22.8.1897) asks for a receipt for 25 frs; the second also asks how much Clot would charge for 100 or 200 proofs of one or two stones the artist may wish to edition.
CR Schiefler (s) Bib.8.
S95 Metabolism, lith, 1896
S73 Death in the sickroom, lith, 1896
S72 By the deathbed, lith, 1896
S65,66 *Attraction I and II, 2 liths, 1896
S57,58 Jealousy (small and large versions), 2 liths, 1896
S104 The Urn, lith, 1896
S67,68 Separation I and II, 2 liths, 1896
S70 The Flower of love, lith, 1896
S71 *Lovers in the waves, lith, 1896
S61/UJ64 Anxiety (or Le Soir), *AVI*, lith, 1896
S62 Anxiety, woodcut, 1896
S69 Ashes, lith, 1896
S55 In the clinic, lith, 1896
S56 In the woman's clinic, lith, 1896
S82 Melancholy, col. woodcut, 1896
S80a Man's head in woman's hair (The Mirror), col. woodcut, 1896
S62 The sick child, col. lith, 1896
S81 Moonlight, col. woodcut, 1896
Portrait of Mallarmé, lith, 1896
S77 Portrait of Strindberg, lith, 1895
S75 Portrait of Gunnar Heiberg, lith, 1896
S76 Portrait of Hans Jaeger, lith, 1896
S78 Portrait of Sigbjorn Obstfelder, lith, 1896
Two women at the shore (Moonbeam) (intended for *Germinal*, 1899), 1913
[D.1919: 120. Deux portraits en buste sur la même planche (2 TPs, one in col.)] [P.1965: Les deux soeurs, TP, col. lith] [Pr.1964: Têtes de jeunes filles (10); *uw*: Deux têtes]

N **NICOLET** Gabriel, France. (1856–1921)
52 rue de Courcelles, 8ᵉ
CA288–292, 510–511: Ten letters, 1903–1908. Three from Nicolet's wife concern his ill health. In CA290/1 Nicolet, enthuses about the 'whole new vision to be exploited in this original and interesting means of expression.' In 1908 Nicolet works with Clot again and asks for his judgement on a second litho.

O **OGÉ** Eugène, France. (active to 1901)
CA294 discusses trials not yet ready and an illness impeding his work.
La Cigarette, *L'Estampe moderne*, lith, 1895–96

P **PETITJEAN** Hippolyte, France. (1854–1929) +
*Portrait of Maeterlinck in *Pan III (iv)*, lith, 1898
*Weisliche Akstudien in *Pan IV (i)*, col. lith, 1898
[Pr.1954: *uw*: **Pastorale**, pastel]

POINT Armand, Algeria, France. (1861–1932) +
*Pour Henri Régnier for *Le Centaure* II, sanguine lith, 1896

PITCAIRN KNOWLES James. (1864– active 1914) +
UJ97 **Le Bain**, *AVI*, col. woodcut ? printed lith, 1896

PISSARRO Lucien, France. (1863–1944) +
UJ96 **Les Lavandières**, *AVII*, col. woodcut, 1897

POPESCO Stefan, Rumania, France. (1872–1948)
242 Bd. Raspail, 14ᵉ
CA307a. (14.12.1909) asks for a price for 500, 1000 and 2000 of a poster in five colours measuring 0.75 × 1.10 m.; an undated card requests Clot to send 10 posters before his wife departs for Rumania. CA307b. (1.2.1912) asks for 50 copies of 'l'Arbre'

PRÉVERAUD DE SONNEVILLE Yvonne, France. (?-active 1920s)
CA306 (3.2.1928) from Editions Stendhal asks Clot to cancel stones; the artist, addressing him as 'Cher Monsieur et ami' asks what Clot thinks of his pupil.
Rêveries romantiques, (Stendhal) 1928

PUVIS DE CHAVANNES Pierre, France. (1824–1898) +
Pauvre pêcheur, *AVII*, mauve lith, 1897 (4)
[D.1919: 121. **Le pauvre pêcheur**, TP (ill); 122. Another copy] [Pr.1954: **Pauvre pêcheur** (4)]

PUY Jean, France. (1876–1960)
CA409 (3.7.1928) from Vollard mentions Puy's col. proofs – 'the scene of the woodshed'. CA512a. and 512b. talk of correcting proofs for Vollard's books and of 'seeing something finally emerge'.
UJ194/B–H *Le Père Ubu à la guerre*, 1 lith, 1923
UJ210 *Le Pot de fleurs de la Mère Ubu*, 10 liths, 1923–1925
UJ199 **Scène orientale**, lith, ?
?*Candide*
[Pr.1954: **Divers** (13) *uw*: 25 dessins]

R **RAFFAELLI** Jean François, France. (1850–1924) +
CR/Delteil, Bib. 8.
D134/UJ **Le Terrassier de la plaine Saint-Denis**, *AVI*, col. lith, 1896
[D.1919: 123. **Les Cheminées**, col. lith, ded.] [Pr.1954: **Couleurs** (12); **Noir** (24)]

RANSON Paul-Élie, France. (1864–1909) +
*Tristesse in *Centaure* II, col. lith, 1896

RASSENFOSSE Armand, Belgium. (1862–1934)
CA518/9 (4.7.1919) – appreciative letter to Clot asking for advice.

REDON Odilon, France. (1840–1916)
32 avenue de Wagram, 8ᵉ
CA336–339, 513–14: Seven letters – one concerns **Buddha** for *L'Estampe originale* with only ten days for completion; a letter of December 1895 mentions *The Haunted house* and **Béatrice**, in connection with which Redon writes on 13 April 1897 that he should be present at the proofing of the 'reproduced pastel of Mr. Vollard.' CA514 (23.11.1907) concerns stones coming from Blanchard. CR/Mellerio (M) Bib. 8.
M71 *Christ, lith, 1887 (6)
M148 **Voici la bonne déesse**, pl. XVI, 1896 (32)
M150 *Il tombe dans l'abîme, pl. XVII, 1896 (29)
M158 **Vieux chevalier**, *AVI*, lith, 1895 (3)
M132 **Le Buddha**, *L'estampe originale*, 1895
M133 **Centaure visant les nues**, lith, 1895
M134–140 **Frontis, plates III** (136), **VIII** (141), **XV** (148), **XVIII** (151)
XXI (154) in *La Tentation de St Antoine*, 3ᵉ, (Vollard) 1896 and 1938
M160–166 *La Maison hantée*, 6 liths and frontis., 1896
M167 **La Sulamite**, col. lith, 1867
M168 *Béatrice, *AVII*, col. lith, 1897 (1)
M186–8 **Un Coup de dès jamais n'abolira le hazard**, 3 liths (1 lost) not published, c.1898 (29) (25) (26)
M195 **Mlle Juliette Dodu**, lith, 1904
M196 **Roger Marx**, lith, 1904
M197 **Llobet**, lith, 1908
[D.1919: 124. **Jeune fille** (M70), ded; 125. **Christ** (M71), TP, rare (illus); 126. 3 pl. from *St Antoine* (M84,96,151); 126 bis. **L'Art céleste** (M131) TP, before letters; 126 ter. **Same print**, ded.; 127. **Le Buddha** (M132) TP,

ded. 128. *Tentation de St Antoine, VIII* (M141), TP, before letters; 128 bis. *Tentation de St Antoine pls. III, VIII, XVI, XX, XXI*, 5 pls. 2 ded. (M136, 141, 149, 153, 154); 129. *Tentation de St Antoine pl. XV* (148) 2 TPs one ded.; 130. *Tentation de St Antoine, XVIII* (M151) TP before letters. 131. *Tentation de St Antoine pl. XXI* (M151) [P.1965: **Profil de femme**, TPs before letters; 132. *Tentation de St Antoine pl. XXIV* (M157) TP, ded.; 133. **Vieux Chevalier** (M158) ded.; 134. *La Maison hantée* (M160–166); 135. **Béatrice** (M168) TP, col. lith; 136. Same print, 3 colours, BAT; 137. Same print, 3 cols; 138. **Homme sur Pégase** (M171) rare; 139. *Apocalypse de St Jean, pl. III* (M176) rare proof, st.1, undescribed; 140. Trial proofs, unpublished (M186–187); 141. **Éd Vuillard** (M190), **Pierre Bonnard** (M191), **P. Sérusier** (M192), **Maurice Denis** (M193) 4 pls. 142. **Mlle Juliette Dodu** (M195), sanguine TP, 143. **Roger Marx** (M196) TP sanguine lith.] [P.1965: **Profil de femme**, 1898 from *Un Coup de dès* (M186), and **Quel est le but de tout cela . . .** from *Tentation de St Antoine* (M151)] [Pr.1954: **Portrait de Vines** (30); **M. Denis** (31); **Sérusier** (27); **Bonnard** (27); **Vuillard** (27); **Femme à la toque** (29); **Tête d'enfant** (25); **Femme de profil** (26); **Il tombe dans l'abîme** (29); **Voici la bonne déesse** (32); **Christ** (6); **Diverses** (33); **Vieux Chevalier** (3); **Béatrice** (1)]

RENOIR Pierre Auguste, France. (1841–1919)
CA340 of November 1920 (signature illeg.) discusses a watercolour belonging to Albert André which has been in Clot's keeping. Vollard letters mentions several Renoir prints and appears to withdraw copies stored for him by Clot. A letter of July 1903 asks for the pastel of **Little girls with a ball**. In 1911, however, he asks for the edition of **L'Enfant au biscuit**, and in August 1912 for 30 proofs on Japan of the portrait of **Wagner**.
CRs/Delteil, Roger-Marx, Stella ((D), (R–M) (S)) Bib. 8.
IFF/S26 **Jeune fille en buste (Mlle. Diéterle)** in *Germinal*, 1899
S28 **Baigneuse, debout, en pied**, col. lith, 1896
S30 **Le Chapeau épinglé**, 1ᵉ, 2ᵉ, 2 liths, one in col., 1897/98
S32 **Enfants jouant à la balle**, col. lith, ? date
S31 **L'Enfant au biscuit (Jean Renoir)**, col. lith, 1899
S34 **Paul Cézanne**, lith, 1902
S33 **Richard Wagner**, lith, 1900
S35 *Odalisque, lith, 1904
S36 **Le Chapeau épinglé** and **La Baigneuse**, liths, c.1905
*Suite of 12 plates (1904?) with collotype table by Clot, 1919
S56 **Jeanne Baudot**, lith, 1903–04
UJ116 **Rodin**, lith, c.1910
UJ117 **Maternité, grande pl.**, lith, c.1912
[D.1919: 144. **Baigneuse** TP, col. lith (illus. S28); 145. **Jeux d'Enfants** TP, col. lith; 146. **Chapeau épinglé**, 1ᵉ 1897, TP; 147. Same subject, 2ᵉ col. lith; 147. Same subject, different impression; 149. **L'Enfant au biscuit**; 150. Same subject, col. lith.
[P.1965: **Enfants jouant à la balle** (D13) TP] [L'une des 6 planches constituant cet album resté inachevé, TP, col. lith] [Pr.1954: **Chapeau épinglé** (b.35) [b.27 [1897]) (2-col.11) (c.7); **Enfants jouant à la balle** (b.22) (c.10); **Grande maternité** (2); **Rodin** (25); **Enfant au biscuit** (b.106) (2-col.125) (c.11); **Baigneuse** (c.5) (b.1); **Autographies: mère et 2 enfants** (21), **Petit garcon** (19), **Laveuses 1** (21), **Laveuses 2** (22), **Baigneuses** (31); **Maternité** (31); **Cézanne** (6); **Wagner** (164); '**Petites planches**' (20 + 135 + 16 + 82); *uw*: **Trois têtes de femmes**, tête d'enfant, tête d'enfant et croquis, ?figure, calque]

RENOUARD Paul, France. (1845–1924)
'La Birotière'
CA343 tells Clot he has many ideas to discuss with him.

RIPPL RÓNAI Jozsef, Hungary. (1861–1927) +
UJ119 **Été au village (Fête populaire en Bretagne)**, *AVI* lith, 1896

ROCHEGROSSE Georges. (1859–1938)
61 Bd. Berthier, 17ᵉ
CA354 three letters, one dated 12.4.1897 ask for Clot's counsel for the lithograph for Vollard; another letter talks of needing Clot's 'enlightenment'. The third letter talks of 7 plates now finished. UJ records no Vollard lithograph by this artist.
[Pr.1954: *uw*: **Allegorie**, pastel]

RODIN Auguste, France. (1840–1917)
CA57–65, 235, 310–330, 394, 440, 446–449, 521–537: extensive correspondence exists between Clot, Rodin, and others involved in the publication of lithographs drawn by Clot after Rodin's watercolours. They range in date from 1897 for Mirbeau's *Jardin des supplices* and an album print for Vollard and *Les Cathédrales de France* made between 1909 and 1912. Charles Morice liaised with Clot on the latter, while letters from Aleister Crowley, the notorious black magician, deal with Rodin facsimiles by Clot for several slim volumes of his verse, pulled in editions of 500. In CA537AB, G. Astruc asks Clot to put in a good word

to Rodin for his niece, Louise Mayer.
UJ120/D6 **Nu de Femme**, *AVII*, sanguine lith, 1897
Le Jardin des Supplices by O. Mirbeau,
 with col. lith frontis., (Charpentier & Fasquelle) 1899
 with 20 col. liths by Clot *incl. 4 pls., (Vollard) 1902
Deux femmes debout in *Germinal*, 1899
Rosa mundi by H. D. Carr (Aleister Crowley) 1 col. lith by Clot, 1905
Rosa coeli by H. D. Carr (Aleister Crowley) 1 col. lith by Clot, 1907
Rosa inferni by H. D. Carr (Aleister Crowley) 1 col. lith by Clot, 1907
*Rodin in rime: with seven lithographs by Clot from the watercolours of
Auguste Rodin with a chaplet of verses by Aleister Crowley*, col. liths,
1907
Les Cathédrales de France by Rodin, introd. Ch. Morice, with
100 col liths by Clot after Rodin drawings, 1914
[D.1919: 151. **Deux figures** (D13) line image (illus. from *Jardin des
supplices*) rare; 152. **Figures nues**, 5 two-col. facsimiles by Aug. Clot.]

ROUAULT Georges, France. (1871–1958)
CA349–353 seven letters from the artist range from his reaction that a
quotation of 175 fr. for 25 proofs is 'a bit stiff', to complex
arrangements involving the photoengravers Macquart, Vollard and 100
reproductions, some from *Miserere* planned for an unnamed album.
CR/Chapon and Rouault, (C&R) Bib. 8.
C&R305 **L'Attelage** (also called **Le Cavalier** and **La Chevauchée**), col.
lith, 1910
Saint Suaire and **Parade**, col. collotype, 1925
C&R **Portraits of Verlaine, von Hindenburg, Saint Jean-Baptiste**, 3 liths,
1926–1933
C&R ***Automne**, lith, 1927–1933
Fleurs du mal, central motif from **Automne**
[D.1919: 153. **Le Cavalier**, col. lith, ded. dated 1910] [P.1965. L'Attelage,
TP, col. lith] [Pr.1954: Attelage (3), Clowns, couleurs (29), Christ,
couleurs (61), Miserere (116), Hindenbourg (11), St Jean (11), Verlaine
(9), Automne (7), Pl. pour 'Ubu' japon (35), essais (82); Petit nu (5);
uw: Têtes, 2 croquis.]

ROUSSEL Ker-Xavier, France. (1867–1944)
CA409 (3.7.1928) from Vollard asks 'And Roussel? Are his stones ready
to be worked?' CA539–40 from Roussel to Clot discuss a visit to Paris.
CR/Bremen Kunsthalle 1965, Bib. 8.
UJ133 **Paysage avec maison** for *AVII*, col. lith, 1897
UJ134 ***L'Album de paysage**, 12 col. liths and cover, 1899/1900
Leda et le cygne for *Album of nudes*, 1931/32
Le Centaure and **La Bacchante** by M. de Guérin, 1932/33
50 liths including:
Le Panthère dans la caverne, 1931–32
Nymphe dans une caverne, 1931–32
and six **Variations**, 1934–35
printed by André Clot:
Virgile les Bucoliques trans. by Xavier de Magállon, with 31 liths, 1943
[D.1919: 154. **La Source**, col. lith (illus); 155. **Les Baigneuses**, col. lith;
156. **Les Champs**, col. lith; 157. **Promenade au bord de l'eau**, col. lith]
[Pr.1954: Pl. de la série (48); Source (78 + ?16); uw: Esquisse peinte;
Pastorales 4 pastels; Paysage sous bois, pastel; Petit nu, pastel; dessin
sur calque; Petit paysage au crayon; Naissance de Brigitte; 3 dessins
non terminés; peinture sur toile.]

S **SCHNERB** Jaques Félix, France. (1879–1915)
CA365–369: four letters dating from 1903 to 1907 deal with work for
the *Gazette des Beaux Arts* and Schnerb's own brush drawings on
transfer paper which he asks to be proofed on the same paper as the
Rodin prospectus.

SCHUFFENECKER Émile, France. (1851–1934)
CA558 (20.1.1899) apologizes that a legal process has impeded progress
with his lithograph.

SHANNON Charles Haslewood, England. (1863–1937) +
CR/Ricketts (R) Bib. 8.
UJ137/R45 **La Lutte enfantine**, *AVII*, lith, 1897

SIGNAC Paul, France. (1863–1935)
16 rue La Fontaine, Auteuil 16ᵉ
CA355–357, 540–543: seven letters – CA540 (16.4.1898) expresses
condolences to Clot. Signac asks how much three 5-col. liths for 'a rich
and prestigious journal' will cost in an edition of 1237. In other letters
he mentions that he and Cross will come to see Clot, complains of
delay, and thanks Clot for preparing proofs for Vollard, Pellet and *Pan*
which he is coming to Paris to collect. One letter makes it clear that a

Vollard and a Pellet lith post-date the lith for *Pan*. CR/Kornfeld and
Wick (KW) Bib. 8.
KW8 **En Hollande – La Balise**, col. lith, ?1894
KW9 **La Bouée – Port St Tropez**, col. lith, ?1894
KW10 **Les Andelys**, col. lith, ?1895
KW11 **A Flessingue**, col. lith, ?1895
KW12 **Les Bateaux à Flessingue**, col. lith, ?1895
KW13 **Les Bateaux**, col. lith, ?1895
KW19/UJ188 ***Saint Tropez: Le port**, col. lith for Vollard, ?1897/98
KW20 ***Le Soir** in *Pan IV (i)*, col. lith, 1898
[D.1919: 158. **Les Blanchisseuses** (KW10) 2 TPs, col. lith, ann.;
159. **Marine: plein soleil**, 2 col. liths, one ann. one ded.; 160. Same print,
col. lith with remarque; 161. **Plein soleil** (KW9) 2 col. liths, one
crayoned and ann., one ded.; 162. **Brume**, col. lith, ded.; 163. **Les
Barques à voiles** TP, col. lith; 164. **Récréation au bord de la mer**, col.
lith, ded.] [P.1965: **La Balise, le Port d'Anvers** TP, col. lith;] [Pr.1954:
Planches couleurs (26); Pet. pl. du Pan (8); 4 essais; uw: **Port de
Hollande, dessin**; 2 dessins sur calque]

SIMON Lucien, France. (1861–1945) +
UJ139 **Vieille Bretonne conduisant des enfants**, *AVII*, col. lith, 1897

SISLEY Alfred, France. (1839–1899)
CA360, CA544: Three letters advise Clot the artist has sent 'the outline
in question' and on 4.1.1897 and 24.2.[1897] request the return of his
pastel as he has heard nothing. Six letters of 1899–1900 from Sisley's
daughter Jeanne discuss a reproduction after the artist's death; in
CA358/9 (11.1.1900) she expresses delight that Bénédite has lent Clot
one of her father's pictures for the printer to work from, rather than
from her imperfect pastel copy. There are also letters from Duret for
Bernheim Jeune discussing painting reproductions for Clot.
Les Bords de rivière (Les Oies), *AVI*, col. lith by Clot after pastel, 1897
L'Été de Saint-Martin, col. lith by Clot after Sisley painting (?), 1900
'Landscape', interpreted by Clot for André Marty in *L'Imprimerie et les
procédés de la gravure au vingtième siècle*, (Paris) 1906
[D.1919: 165. **Les Oies**, 2 TPs, col. lith, ann.; 166. **L'Été de Saint-Martin
par J.S.** (sic) one col. lith, one TP] [Pr.1954: Les Oies (2)]

SLEVOGT Max, Germany. (1869–1932)
CA42–48 six letters and one telegram from Bruno Cassirer in Berlin
from 1910–1913 concerning the supply of transfer paper and the arrival
and dispatch of stones carrying work by Slevogt who is drawing several
subjects on one stone. The telegram – CA549 (17.7.1913) discusses a
visit by Clot to Germany and stresses Slevogt's importance.
CR/Johannes Sievers and Emil Waldman (SW) Bib. 8.
SW420 **Die Zauberflöte**, lith, 1910
SW496–815 *Benvenuto Cellini*, with 303 liths, 1914

STERN Mme Ernesta (Maria STAR)
CA361–2: three communications record the collaboration between
Marty and Clot for a book on Egypt by the society hostess, pen name
Maria Star, for the *Gazette des Beaux Arts*.
Terre de Symboles with 13 col. liths by Clot after watercolours by M. R.
Mainella, 1904

STEINLEN Théophile Alexandre, France. (1859–1923)
59, 69 and 73 rue Caulaincourt, 18ᵉ
CA370–390, 550A–552: 34 letters from or about the artist. CA376 and
CA551 request some paper supplied by Clot that the artist particularly
likes and sends 50 frs, owed for some time. CA379 (18.5.1896) mentions
a stone for Vollard but none appears to have been issued by this
publisher. In CA373a. and **378** both of (2.1.1897), (letter 11) Steinlen
asks Clot to send to Marty for a pf on women a '**femme sauvage**' – one
of 5 heads he has drawn in Clot's workshop recently. Arising out of
this, sixteen small stones to make a suite for the music publishers,
Maison Enoch, are also discussed. 5000 copies of **Ouvriers sortant de
l'usine** are requested for a special number of *Studio* in 1903. The prints
of **Gorki** for Carl Lebeau of Heidelberg in 1905 are detailed in eight
letters from the publisher. CA55A (27.9.1903) and 550B (13.3.1908)
make it clear that Steinlen is financially pressed and has bills to settle.
CR/de Crauzat (C) Bib. 8.
C165 **Filles et souteneur**, lith, 1895
C166 **Dispute de filles**, lith, 1895
C171 ***Rue Caulaincourt, L'Estampe moderne**, lith, 1896
C173 **Intérieur de tramway**, lith, 1896
C174 **Femme triste**, lith, 1896
C175 **Blanchisseuses**, lith, 1896
C176 **Misère**, lith, 1896
C177 **Modèle**, lith, 1896
C178 **La Veuve**, lith, 1896
C180 **Type populaire 'femme sauvage'**, one of 5 heads put on stone by
Clot, printed by Lemercier for Marty's *Études de femmes*, lith, 1896 (9)

C183–198 *Chansons des femmes*, 15 liths and cover, 1897 ?(121)
C218 **Les Chanteurs des rues** from *Chansons de Montmartre*
C254 **Ouvriers sortant de l'usine**, special issue of *Studio*, lith, 1903 (15)
C263 **Steinlen de face, tête inclinée**, lith, 1905
C264 **Maxime Gorki étendu**, lith, 1905
C265 **Maxime Gorki à mi-corps de face**, lith, 1905
C266 **Maxime Gorki de face**, lith, 1905 (12)
C267 **Maxime Gorki de face, vu jusqu'aux épaules**, lith, 1905
C521 **Après l'atelier**, (Trottin) for *L'Art décoratif*, lith, 1910
C519 ?*La Chanson des Gueux*, by Jean Richepin, 24 liths, 1910
[D.1919: 167. **Filles et souteneur** (C165); 168. **Dispute de filles** (C166); 169. **La Rue Caulaincourt** (C171); 170. **Intérieur de tramway** (C173); 171. **Misère** (C176); 172. *Chansons de femmes*, 15 pls. (C184–199); 173. **Les Chanteurs des rues** (C218), rare st. 1; 174. **Maxime Gorki étendu** (C264) and **Maxime Gorki de face** (C267) 2 pls; 175. **Portrait d'homme à binocles sous cinq aspects différents**; 176. **Types populaires**, 2 pls. not described; 177. **Le Baiser; 177. bis. Titres de romances** 12 pls. incl. cancellation proof.] [P.1965: **Maxime Gorki de face** (C266) TP, st. 2, printed in black] [Pr.1954: **Gd. Gorki** (12); **Affiche Verneau** (1), Pl. diverses (12); 3 portrits (sic) de Gorki (47); Titres de musique (121); Grosses têtes de femmes (9); Sortie de mine (15). *uw:* Portrait de Gorki; Les Amants]

T

TOOROP Jan Théodore, Dutch. (1858–1928) +
UJ **La Dame aux cygnes**, for *AVI*, brown lith, 1896

TOULOUSE-LAUTREC Henri de, France. (1864–1901)
CA580 from André Marty for Roger Marx at the *Gazette des Beaux Arts* discusses 13 Lautrec stones. CR/Wittrock (w) Bib. 8.
UJ143 **Partie de campagne** (or **La Charette anglaise**), *AVII*, col. lith, 1897
W155–165 *Elles*, cover, frontis, 10 col. liths, 1896
W167 ?**Promenoir** in *Germinal*, 1899
W249–261 *Portraits d'acteurs et d'actrices* (1899) 13 liths, (?Pellet) 1906 (41)
W55 **Adolphe où le jeune homme triste**, (1894) lith, (6)
W56 *Eros vanné*, (1894) lith, (Pellet) bef. 1910 (11)
W57 **Les vieux messieurs**, (1894) lith, (8)
[D.1919: 178. *Lender en buste*, col. lith 17/100; 179. **Adolphe où le jeune homme triste**, st. 1; 179 bis. **Eros vanné**, st. 1 in verdâtre; 180. **Les vieux messieurs**, st.] [P.1965: **Jeanne Granier** from *Portraits d'acteurs . . .* (D154) TP in black] [Pr.1954: Acteurs et actrices (41); Adolphe (3); Adolphe avant la lettre (3); Vieux messieurs (2); Vieux messieurs avant la lettre (3); Vieux messieurs avec 1 seul pers. (3); Eros vanné (1); Eros vanné avant la lettre (8) Eros amour seul (2)]

V

VALADON Suzanne, France. (1867–1938) +
UJ144 **Les Baigneuses** (**Femmes s'essuyant**), *AVI*, etching in brown, 1896
? 2 pls. for *Le Rêvue et l'idée*

VALLOTTON Félix-Edouard, Switzerland. (1865–1925) +
UJ145 **Le premier Janvier**, *AVI*, woodcut, 1897
UJ146 **Le Gagnant**, woodcut, 1898

VAN RYSSELBERGHE Théodore, France. (1862–1926)
Ambleteuse par Marquise; 32 rue de l'Industrie, Brussels
CA403–404, 553: Three letters. CA403 (10.10.1889) (letter 13) relates that flat tints have caused the artist's transfer paper to swell and he relies on Clot's great talent to put this right; CA404 (30.10.1899) requests Clot to make the necessary retouches according to the maquette supplied.
UJ **Le Café concert**, *AVI*, etching, 1896
Femme sur la jetée, in *Germinal*, col. lith, 1899

VEBER Jean, France. (1864–1928)
CA421–433, 554–6: 24 letters, those dated ranging from June 1897 to Dec. 1904. CA423 and 424 (letters 14a and b) concern a print to be exhibited at an April salon (possibly **La Barbière**) and ask Clot to proof and print colours without the artist's supervision, so as to be ready. CA555 (16.6.1903) asks for a cancellation proof of **La Barbière**. Another print of 1901 is also made chiefly by post. CA413A (5.11.1900) reveals that Veber has drawn too much for Enoch on a stone and needs to cut out a figure. Titles mentioned include a portrait of Mme Hazern, **L'Arracheuse de dents**, **Les trois bons amis** (for which Clot is asked to make up for a number of unsatisfactory proofs without charge) and 'Maisons'. Several prints are referred to descriptively i.e. 'Place publique', 'L'Oie poursuivant le petit bonhomme' and 'L'Oie poursuivant part le petit bonhomme'. CR/Veber and Lacroix (VL) Bib. 8.
VL13 **La Bergère** for *Album des chansons*, lith, 1898
VL20 **Les Musiciens du Lac d'Annecy**, col. lith, 1900
VL42 **Les Maisons sont des visages**, col. lith, 1899

VL45 **Le Nain et l'oie**, col. lith, 1901
VL46 **L'Oie et le nain**, col. lith, 1901
VL47 **Le Diable dans la marmite**, col. lith, 1904
VL80 **La Barbière**, col. lith, 1903
VL82 **Les trois bons amis**, col. lith, 1903
VL83 **L'Arracheuse des dents**, col. lith, 1904
[D.1919: 181. **La Barbière**, col. lith with remarques, ded. (illus); 182. **Le Diable dans la marmite**, lith with remarques, ded.; 182 bis. **Musiciens des rues**, lith, ded.; 183. **Le Viol**, col. lith with remarques, ded.; 183 bis. **La Bergère effrayée**, three col. lith, ded.] [Pr.1954: **La Barbière** (c.11) (b.2); **La Dentiste** (10); **Les trois amis** (13); **Divers** (59)]

VERTÈS Hungary. (1895–1961) +
IFF credits Clot with the printing of this artist's lithographs.
B–H *Dancing*, 12 col. liths, 1924
Maison lith, 1925
La Journée de madame, 10 liths, ? date
Rue Pigalle, lith, 1928

VUILLARD Édouard, France. (1868–1940)
6 place Vintimille, 9e
CA405, 557: Four letters. CA405 expresses irritation over a last minute but unspecified change to a lithograph which the artist would have opposed had it been more serious. CA557a.–c. of 1934/5, probably to André, concern *Cuisine*. CA581 to André from C. Roger-Marx asks for information about Vuillard for his catalogue raisonné and the author says that he mentions Auguste Clot 'sans cesse.' The Drouot sale catalogue seems to have mixed Bonnard with Vuillard – see D.1919 entry for Bonnard.
CR1 Roger-Marx (CRM) Bib. 8.
CRM28/UJ151 **Le Jardin des Tuileries**, *AVI*, col. lith, 1896
CRM29/UJ152 *Jeux d'enfants*, *AVII*, col. lith, 1897
CRM31–43/UJ155 **Paysages et intérieurs**, 12 prints and cover, col. liths, 1899
CRM47/UJ156 **Cover for unpublished Vollard album of 1898**, col. lith, 1899
CRM/UJ157 **Naissance d'Annette** (**La jeune mère**), col. lith, 1899
CRM45 **Jardin devant l'atelier** in *Germinal*, col. lith,
CRM46 **La Petite fille au volant**
CRM48 *Une Galerie au gymnase* for *Insel*, 1900
CRM **Portrait de Cézanne**, lith, 1914
CRM52 **Lucien Fabre**, 1924 (4)
CRM53 **Tristan Bernard**, 1924 (6)
CRM60 **Paul Léataud**, 1934 (5)
Printed by Andre Clot:
Cuisine by H. J. Laroche, 6 liths, (Arts et Métiers Graphiques) 1935 (62)
[D.1919: 184. **Frontis. of album** TP, col. lith; 185. **Les Régates**, TP, col. lith; (Bonnard?) 186. **L'Avenue**, col. lith (CRM33); 186 bis. The same print, BAT; 187. **La Rue**, TP col. lith; 188. **Au Luxembourg**, col. lith, BAT; 189. **Le Jardin**, col. lith; 190. **Galerie d'un théâtre** TP, col. lith; 190 bis. The same print; 191. **Terrasse de café**, TP, col. lith; 192. **Conversation**, col. lith; 192 bis. The same print, BAT; 193. **Les Fillettes en promenade**, BAT, col. lith, ann. (CRM40); 194. **Le Dimanche sur la pelouse**, col. lith, BAT; 195. **La Table**, col. lith, ded. (CRM12, 35?); 196. **Le Jeu de dames**, TP col. lith, (CRM32); 196 bis. The same print, TP, col. lith; 197. **L'Enfant aux jouets**, col. lith (CRM29); 198. **Intérieur**, col. lith, ded. (CRM35); 198 bis. The same print, col. lith; 199. **Coins d'intérieurs bourgeois**, 3 pieces, TPs, col. liths (CRM36–38); 200. **A la cuisine**, col. lith (CRM42); 201. **Nature morte, devant la cheminée**, col. lith (CRM39); 202. The same print, TP col. lith] [P.1965: **Cover, Paysage et interieur**, (CRM) TP, col. lith; **Intérieur aux teintures roses I** (CRM36) TP col. lith] [Pr.1954: Couverture Album Vol. (9); Galerie du gymnase (c.2) (b.1); Cézanne (11); T. Bernard (6); Fabre (4); Léautaud (5); Titre Album Vuillard (c.5) (b.1); Feuilles séparées de L'Album Vuillard (c.41) (b.1); Jeux d'enfants (3); Jardin des Tuileries (3); Naissance d'Annette (c.6) (b.1); Jardin devant l'atelier (2); Planches pour Cuisine (62)]

W

WHISTLER James McNeill, America, England. (1834–1903)
CA91–92, 434–436: No letters from the artist but in 1904, Théodore Duret corresponds with Clot about two reproductions for his book on Whistler – an oil portrait of himself, in colour, and the lithograph **Nocturne**. The Drouot sale wrongly identifies as **The Sisters**, a print which is illus. and is **Mère malade** (L77). CR/Way (w) or Levy (L) Bib. 8.
UJ160/W147/L114 **La Conversation** (**Afternoon tea**), *AVII*, lith, 1897
L77 **Mère malade** (or **Mother and daughter**), lith, ? date
Portrait of Duret, col. lith after painting and **Nocturne** lith, reproduced in Duret's *Histoire de J. McNeill Whistler et son oeuvre*, 1904
[D.1919: 203. **The Sisters** on papier ancien (W71) (illus); 204. **Afternoon tea** (W147)]
[Pr.1954: Afternoon tea (45); La grand mère (160)]

Bibliography

All bibliographies exhibit the bias of the compilers in one way or another and this is no exception. Our bias has been towards English language texts, including those dealing with Australasia, as well as the subject-matter of the essays in this volume. Where topics are not covered in the essays, as in posters or illustrated books, we have provided a general survey and have not included entries for individual lithographers.

As a general rule, we have listed only works which are substantially lithographic in content. Therefore, where artists have made only a few lithographs, references to their work have been excluded. In the case of a major artist such as Goya, whose lithographs were infrequent but important, only the most recent catalogue has been included. Similarly, where recent titles supersede past scholarship, as with the catalogue raisonné of Degas's prints by Susan Welsh Reed and Barbara Stern Shapiro, this latest work has alone been included as the reader will find references to earlier material in the book's bibliography.

Due to limitations of space, material from periodicals has been cited sparingly and included only where extant literature is incomplete or slight. Some of the important periodicals that would repay further study are listed below:

1 TRADE JOURNALS

American Lithographer and printer (1886–1890)
British Lithographer (1891–1895)
The Chromolithograph (1867–1869)
The Lithographer and Printer (1883–1886)
Le Lithographe (1838–1848)
The Lithographers' Journal (New York) (1915–1964)
La Lithographie (1897–1900)
National Lithographer (1893–1963)
Penrose Annual (1895–)
Prang's Chromo: A Journal of Popular Art (1868–1870)
Printing Magazine (1913–1973)
Printing Times and Lithographer (1873–1901).

2 JOURNALS WITH ARTICLES ABOUT LITHOGRAPHY

Artist's Proof (1961–1971)
Grafik (1948–)
Die graphischen Künste (1879–1933); (1936–)
Impression (1957–1958)
Imprint (1966–)
Lithopinion (1965–1975)
Neue Grafik (1958–1965)
Nouvelles de l'estampe (1963–)
Print Collector (Italy) (1972–1975)

Print Collector = Il conoscitore di stampe (1975–)
Print Collector's Newsletter (1970–)
Print Collector's Quarterly (1911–1950)
Print Letter (1976–1982)
Printnews (1979–)
Print Quarterly (1984–)
Print Review (1973–)
Printing Historical Society Journal (1965–)
The Tamarind Papers (1974–).

3 JOURNALS WITH ORIGINAL LITHOGRAPHS

L'Artiste (1831–1904)
L'Assiette au beurre (1901–1912)
La Caricature (1830–1835)
Le Centaure (1896)
Le Charivari (1832–1915)
Derrière le miroir (1946–1982)
The Dial (1880–1929)
L'Estampe et l'affiche (1897–1899)
Gazette des Beaux-Arts (1859–)
Kunstkroniek (Holland) (1840–1893; 1909–1910)
The Neolith (1907–1908)
Pan (1895–1900)
Paris (1852–1853)
La Plume (1889–1914)
La Revue Blanche (1891–1903)
Signature (1935–1940, 1946–1954)
The Studio (1893–)
Ver Sacrum (1898–1903)
Verve (1937–1960).

All texts have been listed alphabetically under author or editor, except where authorship has not been credited. In this circumstance the entry is by title.

For exhibition catalogues the *first* exhibiting institution is cited followed by the relevant date. For monographs only the place and date of publication are listed. In section 8, which is devoted to artist-lithographers, the books are listed alphabetically by author, but the artist's surname has been printed in capitals to help the reader.

This bibliography has been divided into eight categories which are not mutually exclusive. Nevertheless, each text only appears once and is listed in the subject area of predominant concern.

The bibliography was compiled by the staff of the Department of International Prints with help from Library Staff, in particular Joan Bruce, and from Roger Butler for Australian sources.

CHRISTINE DIXON, JANE KINSMAN
Editors

1 *Reference*

1A. BIBLIOGRAPHIES

BIGMORE, E. C., and WYMAN, C. W. H.
A Bibliography of printing
London 1880

BRIDSON, Gavin, and WAKEMAN, Geoffrey
Printmaking & picture printing: A bibliographical guide to artistic & industrial techniques in Britain 1750–1900
Kidlington Oxon and Williamsburg Va 1984

COURBOIN, François, and ROUX, Marcel
La Gravure française: Essai de bibliographie, 3 vols
Paris 1927–28

KAMPMANN, C.
Die Literatur der Lithographie von 1798–1898
Vienna 1899

LEVIS, Howard C.
A descriptive bibliography of the most important books in the English language relating to the art & history of engraving & the collecting of prints
London 1912

LUDMAN, Joan, and MASON, Lauris
Fine print references: A selected bibliography of print-related literature
Millwood NY, London, Nendeln Liechtenstein 1982

MASON, Lauris, and LUDMAN, Joan
Print reference sources: A selected bibliography 18th–20th centuries
Millwood NY 1975; 2nd edn. 1979

MIESSNER, M. C.
'Bibliographie élémentaire sur la lithographie'
Nouvelles de l'estampe, Nov.–Dec. 1975, p. 28

RIGGS, Timothy A.
The Print Council index of oeuvre-catalogues of prints by European and American artists
Millwood NY, London, Schaan Liechtenstein 1983

1B. BIOGRAPHICAL DICTIONARIES

BAILLY-HERZBERG, Janine
Dictionnaire de l'estampe en France 1830–1950
Paris 1985

BÉNÉZIT, E., ed.
Dictionnaire critique et documentaire des peintres, sculpteurs, dessinateurs et graveurs
Paris 1911–23, 3 vols; 2nd edn. 1948–55, 8 vols; 3rd edn. 1976, 10 vols

BÉRALDI, Henri
Les Graveurs du XIXe siècle: Guide de l'amateur d'estampes modernes, 12 vols
Paris 1885–1892
i Abbema-Belhatte; ii Bellangé-Bovinet; iii Braquemond; iv Brascassat-Chéret; v Cherrier-Dien; vi Doré-Gavard; vii Gavarni-Guérard; viii Guérin-Lacoste; ix Laemlein-Mécou; x Meissonier-Piguet; xi Pillement-Saint Evre; xii Saint Marcel-Zwinger

Bryan's dictionary of painters and engravers
London 1816, 2 vols.; 2nd edn. vol. 1 1849; suppl. 1876; 3rd edn. 1884–89, 2 vols.; 4th edn. 1903–04, 5 vols.; 5th edn. 1964, 5 vols.

MEYER, Julius, and others
Allgemeines Künstler-Lexikon unter Mitwirkung der namhaftesten Fachgelehrten des In- und Auslandes, 3 vols
Leipzig 1872–85

SERVOLINI, Luigi
Dizionario illustrato degli incisori italiani moderni e contemporanei
Milan 1955

THIEME, Ulrich, and BECKER, Felix, eds.
Allgemeines Lexikon der bildenden Künstler von der Antike bis zur Gegenwart, 37 vols
Leipzig 1907–49; 2nd edn. 1983 and continuing

VOLLMER, Hans
Allgemeines Lexikon der bildenden Künstler: Des XX Jahrhunderts, 6 vols
Leipzig 1953–62

2 *Technical Treatises*

2A. BEFORE 1850

[BANKES, H.]
Lithography; Or, the art of taking impressions from drawings and writing on stone, for the purpose of being multiplied by printing
Bath 1813; 2nd edn. 1816

BRY, A.
L'Imprimeur lithographe
Paris 1835

DESPORTES, J.
Manuel pratique du lithographe
Paris 1834; 2nd edn. 1840

ENGELMANN, Godefroy
Manuel du dessinateur lithographe ou description des meilleurs moyens à employer pour faire des dessins sur pierre dans tous les genres connus
Paris 1822; 2nd edn. 1824; 3rd edn. 1830–31; German trans. 1833

[ENGELMANN, Godefroy]
Rapport de la lithographie, et particulièrement sur un recueil de dessins lithographies par M. Engelmann
Paris 1816

ENGELMANN, Godefroy
Recueil d'essais lithographiques
Paris 1817

ENGELMANN, G[odefroy]
Traité théorique et pratique de lithographie
Mulhouse 1835–40; German trans. 1840; 2nd edn. 1843

HULLMANDEL, Charles
The Art of drawing on stone
London 1824; 2nd edn. 1833; 3rd edn. 1835

HULLMANDEL, Charles
On some improvements in lithographic printing
London 1827

LANDSEER, J.
Lectures on the art of engraving, delivered at the Royal Institution of Great Britain
London 1807

M[AIRET, F.]
Notice sur la lithographie, ou l'art d'imprimer sur pierre
Dijon 1818

P[EIGNOT], G.
Essai historique sur la lithographie, renfermant, 1. L'histoire de cette découverte; 2. Une notice bibliographique des ouvrages qui ont paru sur la lithographie; et 3. Une notice chronologique des différens genres de gravures qui ont plus ou moins de rapport avec la lithographie
Paris 1819

[RAPP, H.]
Das Geheimnis des Steindrucks in seinem ganzen Umfange practisch und ohne Rückhalt nach eigenen Erfahrungen beschrieben von einem Liebhaber. Als Einladung zum Nachdenken und Mitwürken an Alle, denen die Vervollkommnung dieses neuen Kunstzweigs angelegen seyn kann
Tübingen 1810

RAUCOURT (DE CHARLEVILLE), A.
Mémoire sur les expériences lithographiques faites à l'École Royale des Ponts et Chaussées de France; Ou manuel théorique et pratique du dessinateur et de l'imprimeur lithographes
Toulon 1819

RAUCOURT (DE CHARLEVILLE), A., transl. C. HULLMANDEL
A Manual of lithography or Memoir on the lithographical experiments made in Paris at the Royal School of the Roads and Bridges
London 1820; 2nd edn. 1821; 3rd edn. 1832

RIDOLFI, C., and TARTINI, F.
Memoria sulla litografia
Florence 1819

SENEFELDER, Aloys
Vollständiges Lehrbuch der Steindruckerey enthaltend eine richtige und deutliche Anweisung zu den verschiedenen Manipulations-Arten derselben in allen ihren Zweigen und Manieren, belegt mit den nöthigen Musterblättern, nebst einer vorangehenden ausführlichen Geschichte dieser Kunst von ihrem Entstehen bis auf die gegenwartige Zeit, 2 vols
Munich and Vienna 1818; 2nd edn. 1821; 3rd edn. 1827

SENEFELDER, Aloys
A complete course of lithography: Containing clear and explicit instructions in all the different branches and manners of that art: accompanied by illustrative specimens of drawings. To which is prefixed a history of lithography, from its origin to the present time ... Translated from the original German, by A.S.
London 1819

SENEFELDER, Aloys
L'Art de la lithographie, ou instruction pratique contenant la description claire et succincte des différens procédés à suivre pour dessiner, graver et imprimer sur pierre; précédée d'une histoire de la lithographie et de ses divers progrès
Paris 1819

TWYMAN, Michael
Henry Bankes's treatise on lithography: Reprinted from the 1813 and 1816 editions with an introduction and notes by Michael Twyman
London, 1976; facsimiles of both edns.

2B. AFTER 1850

ANTREASIAN, Garo Z., and ADAMS, Clinton
The Tamarind book of lithography: Art and techniques
New York 1971

ARNOLD, Grant
Creative lithography and how to do it
New York 1941

BARRETT, Lawrence
Techniques of stone preparation
Colorado Springs 1940

BROWN, Bolton
Lithography
New York 1923

BROWN, Bolton
Lithography for artists
Chicago [1930]

BRUNNER, Felix
A Handbook of graphic reproduction processes = Handbuch der Druckgraphik = Manuel de la gravure
New York 1962

CLIFFE, Henry
Lithography
New York 1965

CRAUZAT, E. de
Handbook of lithography
London 1905; 2nd edn. 1919; rev. 1932

CUMMING, David
Handbook of lithography: A practical treatise
London 1904; 2nd edn. 1919; 3rd edn. 1932; rev. 1946

DEGOTARDI, John
The Art of printing
Sydney 1861

DEHN, Adolph, and BARRETT, Lawrence
How to draw and print lithographs
New York 1950

DUCHÂTEL, E.
Traité de lithographie artistique
Paris [1893]

DUCHÂTEL, E.
Manuel de lithographie artistique pour l'artiste et l'imprimeur
Paris [1908]

Every man his own printer, or, lithography made easy, being an essay upon lithography in all its branches, showing more particularly the advantages of the 'patent autographic pen'
London 1854; 2nd edn. 1859

FRITZ, Georg
Handbuch der Lithographie, nach dem gegenwärtigen Stände dieser Technik
Halle 1901

HARTSUCH, Paul J.
Chemistry of lithography
New York 1952

HENDERSON, George K.
American textbook of lithography
Indianapolis 1906

JONES, Stanley
Lithography for artists
London 1967

KISTLER, Lynton R.
How to make a lithograph
Los Angeles 1950

LEMERCIER, Alfred
La Lithographie française de 1796 à 1896: Et les arts qui s'y rattachent s'adressant aux artistes et aux imprimeurs
Paris [1896–98]

LIST, Albert Peter
Die Technik der Lithographie für Künstler
Ravensburg 1913

MAROU, P., and BROQUELET, A.
Traité complet de l'art lithographique, au point de vue artistique et pratique
Paris 1907

MASON, Cyrus
The practical lithographer, dedicated to painters and artists
London 1852

RICHMOND, W. D.
The Grammar of lithography: A practical guide for the artist & printer in commercial & artistic lithography & chromo-lithography, zincography, photo-lithography, & lithographic machine printing
London 1878; 2nd edn. 1880; 12th edn. c. 1901; German trans. 1880

SACILOTTO, Deli, and SAFT, Donald
Printmaking: History and process
New York 1978

SEWARD, C. A.
Metal plate lithography for artists and draftsmen
New York 1931

STRAKER, C.
Instructions in the art of lithography
London 1867

TRIVICK, Henry
Autolithography
London 1960

VICARY, Richard
The Thames & Hudson manual of lithography
London 1976

WEAVER, Peter
The Technique of lithography
New York 1965

WEDDIGE, Emil
Lithography
Scranton Penn. 1966

WENGENROTH, Stow
Making a lithograph
London 1936

3 *Histories*

3A. GENERAL

ABBEY, J. R.
Travel in aquatint and lithography 1770–1860, 2 vols
London 1956

ADAMS, Clinton, and others
'Into the crystal ball: The future of lithography, a panel discussion' with Riva Castleman, Leonard Lehrer, Harry Nadler, Carter Ratcliff, Theodore F. Wolf, and Clinton Adams, Moderator
Tamarind Papers, vol. 8 nos 1–2 1985, pp. 50–60

Bild von Stein: Die Entwicklung der Lithographie von Senefelder bis heute
Munich, Staatliche Graphische Sammlung 1961

Catalogue of an exhibition illustrative of a centenary of artistic lithography, 1796–1896, at the Grolier Club …
New York, Grolier Club 1896

Catalogue of the loan collection of lithographs 1898–99
London, Victoria & Albert Museum 1898

CATE, Phillip Dennis
Circa 1800: The beginnings of modern printmaking 1775–1835
New Brunswick NJ, Rutgers University Art Gallery 1981

Centenaire de la lithographie: Catalogue officiel de l'exposition
Paris, Palais des Beaux-Arts 1895

CURTIS, Atherton
Some masters of lithography
New York 1897

Exposition générale de la lithographie
Paris, École des Beaux-Arts 1891

FRIEDLÄNDER, M[ax] J.
Die Lithographie
Berlin 1922

GILMOUR, Pat
The mechanised image: An historical perspective on 20th century prints
London, Arts Council of Great Britain 1978

GILMOUR, Pat, ed.
Lasting impressions: Lithography as art
Canberra, Australian National Gallery 1988

GROSCHWITZ, Gustave von
One hundred and fifty years of lithography
Cincinnati, Cincinnati Art Museum 1948

HALBMEIER, C.
The History of lithography
New York 1926

HARTRICK, A. S.
Lithography as a fine art
London 1932

LEPRIEUR, Paul
'Le Centenaire de la lithographie'
Gazette des Beaux-Arts, part 1, Jan. 1896, pp. 45–57; part 2, Feb. 1896, pp. 147–162

Lithography in the 19th century: Selections from the National Gallery of Art, Rosenwald Collection
Trenton NJ, New Jersey State Museum 1972

MAN, Felix H.
Artists' lithographs: A world history from Senefelder to the present day
London and New York 1970

MAN, Felix H.
Homage to Senefelder: Artists' lithographs from the Felix H. Man Collection
London, Victoria and Albert Museum 1971

MAN, Felix H.
150 years of artists' lithographs 1803–1953
London 1953

MARTHOLD, Jules D.
Histoire de la lithographie
Paris 1898; 2nd edn. 1910

PENNELL, Joseph
'Lithography'
Print Collector's Quarterly, Dec. 1912, pp. 459–482

PENNELL, Joseph
'The Truth about lithography'
The Studio, 1899, pp. 38–44

PENNELL, Joseph, and PENNELL, Elizabeth Robins
Lithography and lithographers: Some chapters in the history of the art
London 1898; 2nd edn. 1915

PORZIO, Domenico, ed.
La Litografia: Duecento anni di storia, arte e tecnica
Milan 1982; 2nd edn. 1983; French trans. 1983; English trans. 1983

PRASSE, Leona, and FRANCIS, Henry
Catalogue of an exhibition of the art of lithography commemorating the sesquicentennial of its invention 1798–1948
Cleveland, Cleveland Museum of Art 1948

ROGER-MARX, Claude
La Gravure originale au XIXe siècle
Paris 1939; English trans. 1962

ROSSITER, Henry, and HOYT, Anna
An Exhibition of lithographs, 527 examples by 312 artists from 1799 to 1937
Boston, Museum of Fine Arts 1937

SPIELMAN, M. H.
'The Revival of lithography: Its rise and first decline'
Magazine of Art, Dec. 1896, pp. 75–79

SPIELMAN, M. H.
'Original lithography: The revival on the Continent'
Magazine of Art, Jan. 1897, pp. 144–152

TWYMAN, Michael
'The Art of drawing on stone'
Penrose Annual, vol. 64, pp. 97–124

TWYMAN, Michael
Lithography 1800–1850: The techniques of drawing on stone in England and France and their application in works of topography
London, New York, Toronto 1970

TWYMAN, Michael
'The lithographic hand press 1796–1850'
Journal of the Printing Historical Society vol. 3, 1967, pp. 3–50

TWYMAN, Michael
'Lithographic stone and the printing trade in the nineteenth century'
Journal of the Printing Historical Society vol. 8, 1972, pp. 1–41

TWYMAN, Michael
'The tinted lithograph'
Journal of the Printing Historical Society vol. 1, 1965, pp. 39–56

VERNON, Kay
'Felix Man Collection: Australian National Gallery'
Art and Australia, Summer 1986, pp. 224–29

WAGNER, Carl
Die Geschichte der Lithographie
Leipzig 1914

WEBER, Wilhelm
Saxa loquuntur, Steine reden, Geschichte der Lithographie
Heidelberg and Berlin 1961; English trans. 1966; French trans. 1967

WEDMORE, Frederick
'The Revival of lithography'
Art Journal, part 1, 1896: pp. 11–14; part 2, 1896, pp. 41–44

3B. NATIONAL HISTORIES

AUSTRALIA AND NEW ZEALAND

Australian prints
London, Victoria & Albert Museum 1972

BUTLER, Roger
'Australia's first lithographs' [Augustus Earle]
Australian Connoisseur and Collector vol. 3, 1982, pp. 94–99, 130

CAPE, Peter
Prints and printmakers in New Zealand
Auckland 1974

CARROLL, Alison
Graven images in the promised land: A history of printmaking in South Australia 1836–1981
Adelaide, Art Gallery of South Australia 1981

CHAPMAN, Barbara
The colonial eye
Perth, Art Gallery of Western Australia 1979

CRAIG, C.
The Engravers of Van Diemen's Land
Launceston 1961

CRAIG, C.
More old Tasmanian prints
Launceston 1983

CRAIG, C.
Old Tasmanian prints
Launceston 1964

ELLIS, E. M. and D. G.
Early prints of New Zealand
Christchurch 1978

FLOWER, Cedric
Prints and printmakers of Australia 1788–1850
Melbourne 1975

HARGREAVES, R. P.
'The first New Zealand lithographs',
Art New Zealand, Winter 1982, pp. 50–51

KEMPF, Franz
Contemporary Australian printmakers
Melbourne 1976

FRANCE

ADHÉMAR, Jean
L'Estampe française: La lithographie en France au XIXe siècle
Paris 1944

All the banners wave: Art and war in the Romantic era 1792–1852
Providence RI, Brown University Department of Art 1982

'L'Arrivée de la lithographie en France (1802): Un document inédit'
Nouvelles de l'estampe, Nov.–Dec. 1975, pp. 12–13

BÉNÉDITE, Léonce
'Les "peintre-lithographes"'
Revue de l'art ancien et moderne, Dec. 1903, pp. 491–505

BÉNÉDITE, Léonce
'Peintres-graveurs et peintres-lithographes'
Gazette des Beaux-Arts, part 1: March 1909, pp. 240–45; part 2: Dec. 1909, pp. 483–491

BERIAC, Jean-Pierre, and others
La Litografia en Burdeos en la epoca de Goya = La Lithographie à Bordeaux au temps de Goya
Zaragoza and Bordeaux 1983

BERSIER, Jean E.
La Lithographie originale en France: L'époque du Romanticisme
Paris 1943

BERSIER, Jean E.
Petite histoire de la lithographie originale en France
Paris [1971]

BERSIER, J. E., and LANG, Léon
La Lithographie en France: De la fin du Romanticisme à 1914
Mulhouse 1952

BOUCHOT, Henri
La Lithographie
Paris 1895

BOURET, Claude and Blandine
La Lithographie en France des origines à nos jours
Paris, Fondation Nationale des Arts graphiques [1984]

CAREY, Frances, and GRIFFITHS, Antony
From Manet to Toulouse-Lautrec: French lithographs 1860–1900
London, British Museum 1978

DRUICK, Douglas, and ZEGERS, Peter
La Pierre parle: Lithography in France 1848–1900
Ottawa, National Gallery of Canada 1981

FARWELL, Beatrice
French popular lithographic imagery 1815–1870, 2 vols
Chicago and London 1981–82

FARWELL, Beatrice, ed.
The Cult of images (Le Culte des images): Baudelaire and the 19th-century media explosion
Santa Barbara Calif., UCSB Art Museum, University of California 1977

GRAFF, Walter
Die Einführung der Lithographie in Frankreich: Eine kunstgeschichtliche Untersuchung
Heidelberg 1906

JOHNSON, W. McALLISTER
French lithography: The Restoration Salons 1817–1824
Kingston Ontario, Agnes Etherington Art Centre 1977

LANG, Léon
'Les premiers essais de G. Engelmann: Catalogue des incunables de la lithographie française, 1814–1815'
Nouvelles de l'estampe, July–Aug. 1972, pp. 11–19

LANG, Léon, and BERSIER, Jean E.
La Lithographie en France, 3 vols
Mulhouse 1946–1952

LARAN, Jean, and others
Inventaire du fonds français après 1800, 15 vols
Paris 1930–1985

MELLERIO, André
La Lithographie originale en couleurs
Paris 1898; English trans. in CATE and HITCHINGS 1978, pp. 77–99
(see part 4)

MELOT, Michel
L'Estampe impressioniste
Paris 1974

MELOT, Michel
Grands graveurs
Paris 1978; English edn. *Graphic art of the pre-Impressionists*, New York 1981

PALMER, Tony
L'Estampe moderne
Canberra, Australian National Gallery 1983

PASSERON, Roger
La Gravure impressioniste: Origines et rayonnement
Paris 1974; English trans. *Impressionist prints: Lithographs, etchings, drypoints, aquatints, woodcuts*, London 1974

RIGGS, Timothy Allen
L'Estampe originale: A late nineteenth century publication of original prints
New Haven Conn., Yale University M.A. thesis 1966

ROGER-MARX, Claude
La Gravure originale en France de Manet à nos jours
Paris 1938; English trans. 1939

RUTTEN, R., and DRESCHER, H., eds.
Die politische Lithographie im Kampf und die Pariser Kommune 1871
Stuttgart 1976

STEIN, Donna M., and KARSHAN, Donald H.
L'Estampe originale: A catalogue raisonné
New York 1970

STEVENS, MaryAnne
Post-Impressionist graphics: Original prints by French artists 1880–1903
London, Arts Council of Great Britain 1980

WALLER, Brett, and SEIBERLING, Grace
The Artists of 'La Revue Blanche'
Rochester NY, Memorial Art Gallery 1984

WECHSLER, Judith
A human comedy: Physiognomy and caricature in 19th century Paris
London 1982

GERMANY

BOCK, Elfried
Die deutsche Graphik
Munich 1922

BOCK, Elfried
Geschichte der graphischen Kunst von ihren Anfängen bis zum Gegenwart
Berlin 1930

CAREY, Frances, and GRIFFITHS, Antony
The Print in Germany 1880–1933: The age of Expressionism
London, British Museum 1984

DE LA MOTTE, Manfred
Dokumente zum deutschen Informel
Bonn 1976

DÜCKERS, A.
Erste Konzentration
Munich 1982

DÜSSLER, L.
Die Incunabeln der deutschen Lithographie (1796–1821)
Berlin 1925; 2nd edn. 1955

FERCHL, Franz Maria
'Übersicht der einzig bestehenden, vollständigen Incunabeln-Sammlung der Lithographie und der übrigen Senefelder'schen Erfindungen als Metallographie, Papyrographie, Papierstereotypen und Volgemälde-Druck (ohne Presse)'
Oberbayerisches Archiv für vaterländische Geschichte
Munich 1856, pp. 115–203

FERCHL, Franz Maria
Geschichte der Errichtung der ersten lithographischen Kunstanstalt bei der Feiertagsschule für Künstler und Techniker in München
Munich 1862

German graphics of the sixties
Austin, University Art Museum, University of Texas 1974

GRAUL, Richard, and DORNHOFFER, Friedrich, eds.
Die vervielfältigende Kunst der Gegenwart, vol. IV *Die Lithographie*
Vienna 1903

KAINEN, Jacob and Ruth, and others
German expressionist prints from the collection of Ruth and Jacob Kainen
Washington, National Gallery of Art 1985

KAPPSTEIN, Carl
Der künstlerische Steindruck
Berlin 1910

KOSCHATZKY, W.
Die Kunst vom Stein. Kunstlerlithographie von ihren Anfängen bis zur Gegenwart
Vienna, Graphische Sammlung Albertina 1985

LANG, Léon
'Le catalogue par A. Winkler des premières lithographies allemandes'
Nouvelles de l'estampe, Nov.–Dec. 1975, pp. 10–12

MENZ, Henner
Die Frühzeit der Lithographie in Deutschland
Dresden 1955

NAGLER, G. K.
Alois Senefelder und der geistliche Rath Simon Schmid als Rivalen in der Geschichte des mechanischen Steindrucks, nicht der Lithographie in höherer Bedeutung
Munich 1862

PETERS, Heinz
'Die Bauhaus Mappen' = The Bauhaus portfolios
Cologne 1957

POPPE, I. H. M.
Die Lithographie in ihrem ganzen Umfang
Stuttgart 1833

REED, Orrel P. Jnr.
The Robert Gore Rifkind Collection: Prints, drawings, illustrated books, periodicals, posters: German expressionist art
Los Angeles 1977

ROH, Juliane
Deutsche Kunst seit 1960: Druckgraphik
Munich 1974

ROTHE, Wolfgang
Druckgraphik des deutschen Informel 1951–1963
Nürnberg 1975

SCHLUNDER, Inge
Die deutschen Künstler-Steinzeichnungen und die kunstpädagogische Reformbewegung in der Wilhelminischen Ära
Bern and Frankfurt 1973

WAGNER, Carl
Die Geschichte der Lithographie
Leipzig 1914

WEISHAUPT, Heinrich
Das Gesamtgebiet des Steindrucks
Weimar 1865

WINKLER, R. Arnim
Die Frühzeit der deutschen Lithographie: Katalog der Bilddrücke von 1796–1821
Munich 1975

MEXICO

GORMAN, Edmundo, and FERNANDEZ, Justino
Documentos para la historia de la litografia en Mexico
[Mexico] 1955

MASUOKA, S. N.
'Original copies'
Américas, 1985, pp. 20–23, 64

MATHES, W. Michael
Mexico on stone: Lithography in Mexico, 1826–1900
San Francisco 1984

MAYOR, A. Hyatt
Popular prints of the Americas
New York 1973

TOUSSAINT, Manuel
La Litografia en Mexico en el siglo XIX
[Mexico] 1934

RUSSIA AND THE SOVIET UNION

GOLLERBAKH, E.
Istoriia Graviury i Litografii v Rossii
Petrograd 1923; American edn. Ann Arbor Mich. 1948

150 Jahre Russische Graphik, 1813–1963: Katalog einer Berliner Privatsammlung
Dresden, Staatliche Kunstsammlung 1964

KOROSTIN, A. F.
Russian lithography in the nineteenth century
Moscow 1953

LEMAN, I. I.
Graviura i Litografiia
St Petersburg 1913

MAKOVSKII, S.
Sovremennaia grafika Sbornik
Petrograd 1917

OSTROVSKII, G.
'L'vovskaya litografiya [L'vov lithography]'
Tvorchestvo, June 1978, pp. 14–16

SCHMIDT, Werner
Russische Graphik des XIX und XX Jahrhunderts
Leipzig 1967

VOINOV, V.
Russkaia litografiia za 25 let
Petrograd 1923

ZELENINA, K. A.
Starye Russkie Graviury i Litografii
Moscow 1925

UNITED KINGDOM

ABBEY, J. R.
Life in England in aquatint and lithography 1770–1860
London 1953

ABBEY, J. R.
Scenery of Great Britain and Ireland in aquatint and lithography 1770–1860
London 1952

CARRINGTON, Noel
'Art in the teashops'
Penrose Annual, 1953, pp. 50–54

DODGSON, Campbell, and PENNELL, Joseph
The Senefelder Club
London 1922

GILMOUR, Pat
Artists at Curwen
London 1977

GODFREY, Richard T.
Printmaking in Britain: A general history from its beginnings to the present day
Oxford 1978

HARTRICK, A. S.
'Lithography and the Senefelder Club'
Apollo, April 1925, pp. 203–210

JACKSON, F. Ernest
'Modern lithography'
Print Collector's Quarterly, April 1924, pp. 205–226

LEWIS, C. T. Courtney
The Story of picture printing in England during the nineteenth century
London [1928]

MAN, Felix H.
'Lithography in England (1801–1810)'
in ZIGROSSER, 1962, pp. 97–130 [see United States below]

PENNELL, Joseph
'The Senefelder Club and the revival of artistic lithography'
Studio, Feb. 1914, pp. 3–17

SPIELMAN, M. H.
'Original Lithography: The present revival in England'
Magazine of Art, April 1897, pp. 289–296

SWENSON, Christine
'Landscapes into limestone'
Artnews, Sept. 1982, pp. 66–69

TRIVICK, H.
The Senefelder Group 1910–1960
London, Arts Council of Great Britain 1961

TWYMAN, Michael
'A Note on some lithographic stones relating to Henry Alken's "Ideas and Notions"'
Journal of the Printing Historical Society vol. 14, 1979–1980, pp. 82–88

TWYMAN, Michael
Printing 1770–1970: An illustrated history of its development and uses in England
London 1970

TWYMAN, Michael
'Thomas Barker's lithographic stones'
Journal of the Printing Historical Society vol. 12, 1977–78, pp. 1–32

WATTS, Philip Butler
'The Rise and progress of lithography in Britain'
British Lithographer, vol. I 1892: part 1, no. 2, pp. 21–23; part 2, no. 3, pp. 13–17; part 3, no. 4, pp. 22–25; part 4, no. 5, pp. 29–31

WILTON, Andrew, and others
The Print in England 1790–1930
Cambridge, Fitzwilliam Museum 1985

UNITED STATES

ADAMS, Clinton
American lithographers 1900–1960: The artists and their printers
Albuquerque 1983

American prints today – 1959
New York, Print Council of America 1959–60

American prints today – 1962
New York, Print Council of America 1962–63

Art & Commerce: American prints of the 19th century
Charlottesville, Va. 1978

BARO, Gene
30 years of American printmaking, including the 20th National Print Exhibition
Brooklyn NY, Brooklyn Museum 1976

CAREY, Francis, and GRIFFITHS, Antony
American prints 1879–1979
London, British Museum 1980

CAREY, John Thomas
The American lithograph from its inception to 1865 with biographical considerations of twenty lithographers and a checklist of their works
Athens Ohio, Ohio State University dissertation 1954

CASTLEMAN, Riva
American impressions: Prints since Pollock
New York 1986

CASTLEMAN, Riva
American prints 1913–1963
Brussels, Bibliothèque Royale Albert 1er 1976

CHARLOT, Jean
American printmaking 1913–1947
New York, American Institute of Graphic Arts, Brooklyn Museum 1947

COMSTOCK, Helen
American lithographs of the 19th century
New York [1950]

CONNINGHAM, Frederic A., and SIMKIN, Colin
Currier and Ives prints, an illustrated checklist
New York 1970

CRAVEN, Thomas
A Treasury of American prints
New York 1939

FEINBLATT, Ebria, and DAVIS, Bruce
Los Angeles prints 1883–1980
Los Angeles, Los Angeles County Museum of Art 1980–81

FIELD, Richard S., and others
American prints 1900–1950
New Haven Conn., Yale University Art Gallery 1983

FIELD, Richard S., and FINE, Ruth E.
The graphic muse: Prints by contemporary American women
South Hadley and New York, Mount Holyoke College Art Museum 1987

FLINT, Janet A.
'The American Painter Lithographer'
in *Art & Commerce: American prints of the 19th century* pp. 127–142 (see part 3B, United States)

FLINT, Janet A.
Art for all: American print publishing between the wars
Washington DC, National Museum of American Art 1980

FLINT, Janet A.
The Print in the United States from the 18th century to the present
Washington DC, National Museum of American Art 1981

FLINT, Janet A.
Prints for the people: Selections from the New Deal graphics projects
Washington DC, National Museum of American Art 1979

JOHNSON, Una E.
American prints and printmakers
New York 1980

NORTON, Bettina A.
'William Sharp: Accomplished Lithographer'
in *Art & Commerce: American prints of the 19th century* pp. 51–75 (see part 3B, United States)

PETERS, H. T.
America on stone
New York 1931

SCHURRE, Jacques
Currier and Ives prints: A checklist of unrecorded prints produced by Currier and Ives, N. Currier and C. Currier
New York 1970

TATHAM, David, ed.
Prints and printmakers of New York State 1825–1940
Syracuse NY 1986

WALKER, Barry
The American artist as printmaker, 23rd National Print Exhibition
Brooklyn NY, Brooklyn Museum 1983–84

WALKER, Barry
Public and private: American prints today, 24th National Print Exhibition
Brooklyn NY, Brooklyn Museum 1986–87

WATROUS, James
A Century of American printmaking 1880–1980
Madison Wisc. 1984

ZIGROSSER, Carl
The Artist in America: Twenty-four close-ups of contemporary printmakers
New York 1942

ZIGROSSER, Carl
Between the wars: Prints by American artists 1914–41
New York 1942

ZIGROSSER, Carl, ed.
Prints: Thirteen illustrated essays on the art of the print, selected for the Print Council of America
New York and London 1962

4 Chromolithography and Colour Lithography

ADAMS, Clinton
'Color lithography in the 1950s: The Cincinnati Biennials, a conversation with Gustave von Groschwitz'
Tamarind Papers, Summer 1977, pp. 86–88, 96

AUDSLEY, George A.
The Art of chromolithography
London 1883

BURCH, R. M.
Colour printing and colour printers
London 1910; 2nd edn. 1910; rev. 1983

CATE, Phillip Dennis, and HITCHINGS, Sinclair
The Color revolution: Color lithography in France 1890–1900
Santa Barbara Calif. and Salt Lake City Utah, Rutgers University Art Gallery 1978

Color in prints: Catalogue of an exhibition of European and American color prints from 1500 to the present
New Haven Conn., Yale University Art Gallery 1962

DRUICK, Douglas W.
'The Color revolution: Color lithography in France 1890–1900' by CATE, Phillip Dennis, and HITCHINGS, Sinclair Hamilton, reviewed in *Print Collector's Newsletter*, Mar.–Apr. 1979, p. 25

FRIEDMAN, Joan M.
Color printing in England 1486–1870
New Haven Conn., Yale Center for British Art 1978

GASCOIGNE, Bamber
'The earliest English chromolithographs'
Journal of the Printing Historical Society, 1982–83, pp. 63–71

GRIFFITS, Thomas E.
Colour printing: A practical demonstration of colour printing by letterpress photo-offset lithography and drawn lithography with illustrations demonstrating alternative methods of production, and including a comprehensive colour chart, 2 vols
London 1948

GRIFFITS, Thomas E.
The Technique of colour printing by lithography
London [1944]

GROSCHWITZ, Gustave von
The Albert P. Strietmann collection of color lithographs
Cincinnati, Cincinnati Art Museum 1954

GROSCHWITZ, Gustave von
'American color lithography 1952–54'
Studio, July 1954, pp. 1–9

GROSCHWITZ, Gustave von
'The Significance of 19th century color lithography'
Gazette des Beaux-Arts, vol. 44, 1954, pp. 243–266

GROSCHWITZ, Gustave von, ed.
International Biennial of contemporary color lithography
Cincinnati, Cincinnati Art Museum, 1950–58

HARDIE, Martin
English coloured books
London [1906]

HITCHINGS, Sinclair H.
'"Fine art lithography" in Boston: Craftsmanship in color, 1840–1900'
in *Art & Commerce* pp. 103–126 (see Part 3B, United States)

KAJANDER, Kathy D.
Colour lithography in England during the nineteenth century
Reading, University of Reading dissertation 1981

McLEAN, Ruari
Victorian book design and colour printing
London 1963; 2nd edn. 1972

MARZIO, Peter C.
The democratic art: Pictures for a 19th-century America, chromolithography 1840–1900
Boston Mass. 1979

MARZIO, Peter C.
'The democratic art of chromolithography in America: An overview' in *Art and Commerce* pp. 76–102 (see Part 3B, United States)

MELLERIO, André
La Lithographie originale en couleurs
Paris 1898; English trans. in CATE and HITCHINGS 1978, pp. 77–99 (see part 4)

MORSE, Peter
'Jean Charlot's colour lithographic technique'
Print Review vol. 7, 1977, pp. 28–40

MUNNINGS, Sir Alfred
An artist's life
London 1950

NOBLE, F.
The Principles and practices of colour printing stated and explained
London 1881

RICHMOND, W. D.
Colour and colour printing as applied to lithography, containing an introduction to the study of colour, an account of the general and special qualities of pigments employed, their manufacture into printing inks, and the principles involved in their application
London [c. 1885]

SHARP, R.
The Development of chromolithography in the nineteenth century: A brief history of lithography & its association with colour in Germany, France & England over a hundred years
Manchester 1962

TOOLEY, R. V.
English books with coloured plates 1790 to 1860: A bibliographic account of the most important books illustrated by English artists in colour aquatint and colour lithography
London 1935; 2nd edn. 1954; rev. 1979

WADDLETON, N.
A Chronology of books with coloured illustrations or decorations, mainly in relief or planar colour printed: Mainly of the nineteenth century
London; 3rd edn. 1981

WAKEMAN, Geoffrey
XIX century colour illustration
Loughborough 1976

WAKEMAN, Geoffrey
Victorian colour printing
[Loughborough] 1981

WAKEMAN, Geoffrey, and BRIDSON, Gavin D. R.
A Guide to nineteenth century colour printers
Loughborough 1975

WATT, P. B.
A few hints on colour & printing in colours
London 1872

5 Offset Lithography & Photolithography

ADAMS, Clinton
'Collotype processes and their applications in lithography'
Tamarind Papers, Spring 1980, pp. 34–35

ADELINE, Jules
Les Arts de reproduction vulgarisées
Paris [1894]

BURTON, W. K.
Practical guide to photographic & photo-mechanical printing
London 1887; 2nd edn. 1892

DAVIES, Hanlyn, and MURATA, Hiroshi
Art and technology: Offset prints
Bethlehem Pa., Ralph Wilson Gallery, Lehigh University 1983

Exhibition illustrating the technical methods of the reproductive arts from the XV century to the present time, with special reference to the photomechanical processes
Boston, Museum of Fine Arts 1892

FRITZ, G.
Photo-lithography
English trans. London 1895

HAMMANN, J.-M.-Hermann
Des arts graphiques destinés à multiplier par l'impression
Geneva and Paris 1851

HUNTER, Mel
The new lithography: A complete guide for artists and printers in the use of modern translucent materials for the creation of hand-drawn original fine-art lithographic prints
New York 1984

KAINEN, Jacob
Photography in printmaking
Washington DC, National Collection of Fine Arts 1968

LAWSON, L. E.
Offset lithography
London 1963

MEISEL, Susan Pear
The complete guide to photo-realist printmaking
New York, Louis K. Meisel Gallery 1978

MILLER, Alexander
The Handbook of transfer lithography
Liverpool 1840

MOTTEROZ
Essai sur les gravures chimiques en relief
Paris 1871

NEWTON, Charles
Photography in printmaking
London, Victoria and Albert Museum 1979

SACILOTTO, Deli
Photographic printmaking techniques
New York 1982

SCHNAUSS, Julius
Der Lichtdruck und die Photolithographie
Düsseldorf 1879; 3rd edn. 1886; English edn. *Collotype & photo-lithography practically elaborated . . .* [London?] 1889

SPERLING, Louise, and FIELD, Richard S.
Offset lithography
[Middletown Conn.], Davison Art Center, Wesleyan University 1973

WATSON, Wendy
Offset prints: Editions from Artists-Research-Technology
South Hadley Mass., Mount Holyoke College Art Museum 1977

WILKINSON, W. T.
Photo-etching on zinc and copper, in line & half-tone, & photo-lithography: A practical manual, with an appendix
London and Otley 1886; 2nd edn. c. 1887; 3rd edn. (American) rev. and enl. by Edward L. Wilson 1888; 4th edn. 1890; 5th edn. 1894

WILKINSON, W. T.
Photo-mechanical processes: A practical guide to photo-zincography, photo-lithography & collotype
London 1892; 2nd edn. 1897

6 Books, Posters and Ephemera

6A. ILLUSTRATED BOOKS AND PERIODICALS

ANTHONIOZ, Michel
Hommage à Tériade
Paris, Centre National d'Art Contemporain 1973; English edn. London 1975

The Artist and the book 1860–1960 in Western Europe and the United States
Boston, Museum of Fine Arts 1961; 2nd edn. 1972

BLAND, David
A History of book illustration: The illuminated manuscript and the printed book
London 1958; 2nd edn. 1969

CARON, Antoine
Le Livre et l'artiste: Tendances du livre illustré français 1967–1976
Paris, Bibliothèque Nationale 1977

COMPTON, Susan P.
The World backwards: Russian Futurist books 1912–1916
London, British Library 1978

FAWCETT, Trevor, and PHILLPOT, Clive, eds.
The art press: Two centuries of art magazines
London 1976

GARVEY, Eleanor M., and WICK, Peter A.
The Arts of the French book 1900–1965: Illustrated books of the School of Paris
Dallas, Dallas Public Library 1967

HARTHAN, John
The History of the illustrated book: The Western tradition
London 1981

HOGBEN, Carol, and WATSON, Rowan, eds.
From Manet to Hockney: Modern artists' illustrated books
London, Victoria and Albert Museum 1985

HUGHES, Jean
50 ans d'édition de D.-H. Kahnweiler
Paris, Galerie Louise Leiris 1959

LANG, Lothar
Expressionistische Buchillustration in Deutschland 1901–1927
Leipzig 1976; English trans. 1976

LYONS, Joan, ed.
Artists' books: A critical anthology and sourcebook
Rochester NY 1985

MAHE, Raymond
Bibliographie des livres de luxe de 1900 à 1928, 4 vols
Paris 1931–1943

RAUCH, Nicholas
Les peintres et le livre
Geneva 1957

RAY, Gordon N.
The Art of the French illustrated book 1700 to 1914, 2 vols
New York, Pierpont Morgan Library 1982

RAY, Gordon N.
The Illustrator and the book in England from 1790 to 1914
New York 1976

SKIRA, Albert
Anthologie du livre illustré par les peintres et sculpteurs de l'École de Paris
Geneva 1946

[SKIRA, Albert]
Vingt ans d'activité
Geneva and Paris 1948

STRACHAN, W. J.
The Artist and the book in France: The 20th century livre d'artiste
London 1969

SÖDERBERG, Rolf
French book illustration 1880–1905
Stockholm 1977

TAYLOR, John Russell
The Art Nouveau book in Britain
Edinburgh 1966; 2nd edn. 1979

TWYMAN, Michael
Improper books: Lithographic book production in the age of the hand press, forthcoming

WALLER, Bret, and SIEBERLING, Grace
Artists of La Revue Blanche: Bonnard, Toulouse-Lautrec, Vallotton, Vuillard
Rochester NY, Memorial Art Gallery, University of Rochester 1984

WEITENKAMPF, Frank
The illustrated book
Cambridge Mass. 1938

WHEELER, Monroe
Modern painters and sculptors as illustrators
New York, Museum of Modern Art 1936

6B. EPHEMERA AND CARDS

Art for commerce: Illustrations and designs in stock at E.S. & A. Robinson, Printers, Bristol in the 1880's
London 1973

CARLINE, Richard
Pictures in the post: The story of the picture postcard and its place in the history of popular art
London 1959; rev. 1971

COOK, David
Picture postcards in Australia 1898–1920
Lilydale Vic. 1986

Le Fait divers
Paris, Musée Nationale des Arts et Traditions populaires 1982

FERN, Alan M., and RUBINSTEIN, Daryl R.
The Avant-garde in theatre and art: French playbills of the 1890s
[Washington DC], Smithsonian Institution 1972

GARNER, Gretchen
An art history of ephemera
Chicago 1982

GUYONNET, Georges
La Carte postale illustrée
Nancy 1947

HANSEN, Traude
Die Postkarten der Wiener Werkstätte: Verzeichnis der Künstler und Katlog ihrer Arbeiten
Munich and Paris, Österreichischen Museum für angewandte Kunst 1982

HORNUNG, Clarence P., and JOHNSON, Fridolf
200 years of American graphic art: A retrospective survey of the printing arts and advertising since the colonial period
New York 1976

LEWIS, John
Printed ephemera: The changing use of type and letterforms in English and American printing
New York, London 1962

LORING, John
'Postcards of the Wiener Werkstätte'
Print Collector's Newsletter, Sept.–Oct. 1978, pp. 105–108

STAFF, Frank
The picture postcard and its origins
London, New York, Washington DC 1966

TWYMAN, Michael
The first fifty years of lithographed music, forthcoming

6C. POSTERS AND ADVERTISING

ABDY, Jane
The French poster: Chéret to Cappiello
London and New York 1969

ADES, Dawn, and others
The 20th century poster: Design of the avant-garde
Minneapolis, Walker Art Center 1984

ADHÉMAR, Jean
Cent ans d'affiches dans le monde
Paris, Bibliothèque Nationale 1972

L'Affichomanie: Collectionneurs d'affiches – Affiches de collection 1880–1900
Paris, Musée de l'Affiche 1980

ALEXANDRE, Arsène, and others
The modern poster
New York 1895

ARWAS, Victor
Belle Epoque: Posters and graphics
London 1978

BARNICOAT, John
A concise history of posters
London and New York 1972; rev. 1985

BOUDET, G., ed.
Les Affiches etrangères illustrées
Paris 1896–97

BROIDO, Lucy
The Posters of Jules Chéret: An illustrated catalogue raisonné
New York, London, Toronto 1980

CABAN, Geoffrey
A fine line: A history of Australian commercial art
Sydney 1983

CONSTANTINE, Mildred, and FERN, Alan M.
Word and image: Posters from the collection of the Museum of Modern Art
New York, Museum of Modern Art 1968

DOOIJES, Dick, and BRATTINGA, Pieter
A History of the Dutch poster 1890–1960
Amsterdam 1968

FREEMAN, Larry
Victorian posters
Watkins Glen NY 1969

HAMPEL, J., and GRULICH, R.
Politische Plakate der Gegenwart
Munich 1971

HARDIE, Martin, and SABIN, Arthur K., eds.
War posters issued by belligerent and neutral nations 1914–1919
London 1920

HAWORTH-BOOTH, Mark
E. McKnight Kauffer: A designer and his public
London 1979

HILLIER, Bevis
100 years of posters
London 1972

HILLIER, Bevis
Posters
London and New York 1969; French trans. 1970

HOFSTAETTER, Hans H.
Jugendstil Druckkunst
Baden-Baden 1968

HUTCHISON, Harold F.
London Transport posters
London 1963

HUTCHISON, Harold F.
The Poster: An illustrated history from 1860
London and Toronto 1968

Images of an era: The American poster 1945–75
Washington DC, National Collection of Fine Arts, Smithsonian Institution 1975

International Poster Biennale 1–8
Warsaw 1966–1986

JONES, Sydney R.
Posters and their designers
London 1924

KAHN, Gustave
L'Esthétique de la rue
Paris 1901

KAUFFER, E. McKnight, ed.
The Art of the poster: Its origins, evolution and purpose
London 1924; New York 1928

KEAY, Carolyn
American posters of the turn of the century
London and New York 1975

KOSSATZ, Horst-Herbert
Ornamental posters of the Vienna Secession
London 1974

LAVER, James, HUTCHINSON, Harold F., GRIFFITS, Thomas E.
Art for all: London Transport posters 1908–1949
London 1949

LYAKHOV, V.
Soviet advertising posters 1917–1932
Moscow 1972

LYAKHOV, V.
Soviet advertisement poster[s] and advertisement graphic[s] 1933–1973
Moscow 1977

MAINDRON, Ernst
Les Affiches illustrées
Paris 1886

MAINDRON, Ernst
Les Affiches illustrées 1886–1895
Paris 1896

MALHOTRA, Ruth, and others
Das frühe Plakat in Europa und den USA, 3 vols
Berlin 1973; 2nd edn. 1977; 3rd edn. 1980

MARX, Roger
Les Maîtres de l'affiche, 5 vols
Paris 1896–1900

MASCHA, Ottokar
Österreichische Plakatkunst
Vienna [c. 1914]

MAUCLAIR, Camille
Jules Chéret
Paris 1930

MENEGAZZI, Luigi
Il Manifesto italiano 1882–1925
Milan [c. 1974]

METZL, Ervine
The Poster: Its history and its art
New York 1963

MOURLET, Fernand
Les Affiches originales des maîtres de l'Ecole de Paris [Monte Carlo]
1959; English trans. *The original posters of Braque, Chagall, Dufy, Léger, Matisse, Miró, Picasso*, Monte Carlo, London, New York 1959

MULLER-BROCKMANN, Josef and Shizuko
Geschichte des Plakates = L'Histoire des affiches = History of the poster
Zurich 1971

OOSTENS-WITTAMER, Yolande
La Belle Epoque: Belgian posters, watercolours and drawings from the collection of L. Wittamer-DeCamps
New York, International Exhibitions Foundation 1970

PHILIPPE, Robert
Political graphics: Art as a weapon
Milan 1980; English trans. 1982

PIWOCKI, Ksawery
Polish graphic arts and posters
Warsaw 1966

RADEMACHER, Hellmut
Das deutsche Plakat: Von den Anfängen bis zur Gegenwart
Dresden 1965; Italian trans. 1965

RICKARDS, Maurice
Internationale Plakate: 1871–1971
Munich, Haus der Kunst 1971–72

ROGERS, W. S.
A Book of the poster
London 1901

RUBEN, Paul
Die Reklame: Ihre Kunst und Wissenschaft, 2 vols
Berlin 1913–14

SALANON, René, and SAMSON, Claude
Cent ans d'affiches: 'La belle époque'
Paris, Musée des Arts Décoratifs 1964

SCHARDT, Hermann, ed.
Paris 1900: Französische Plakatkunst
Stuttgart 1968; English trans. *Paris 1900: Posters of an era*, London and New York 1970

SCHINDLER, Herbert
Monografie des Plakats: Entwicklung, Stil, Design
Munich 1972

Seht her, Genossen! Plakate aus der Sowjetunion
Dortmund 1978

SHELDON, Cyril
A History of poster advertising
London 1937

TOVELL, Rosemarie, and SCHUTT, Karl
Posters from three wars = Affiches de trois guerres
Ottawa, National Gallery of Canada 1969

WEILL, Alain
L'Affiche dans le monde
Paris 1984; English trans. *The Poster: A worldwide survey and history*
New York and London 1985

WEMBER, Paul
Die Jugend der Plakate 1887–1917
Krefeld 1961

7 Lithographic Printers, Workshops and Publishers

ADAMS, Clinton
Fifty artists: Fifty printers
Albuquerque, University of New Mexico 1985

ADAMS, Clinton
'Grant Arnold, lithographer, New York and Woodstock 1928 to 1940'
Tamarind Papers, Spring 1980, pp. 38–43

ADAMS, Clinton
'Lynton R. Kistler and the development of lithography in Los Angeles'
Tamarind Papers, Winter 1977–78, pp. 100–109

ADAMS, Clinton
'Rubbed stones, middle tones and hot etches: Lawrence Barrett of Colorado'
Tamarind Papers, Spring 1979, pp. 36–41

ADHÉMAR, Jean
'Les Imprimeurs lithographes au XIXe siècle'
Nouvelles de l'estampe, Nov.–Dec. 1975, pp. 8–9

ADHÉMAR, Jean
Lithographies de l'Atelier Mourlot Paris
London, Redfern Gallery 1965

ADHÉMAR, Jean
Prints from the Mourlot press
Washington DC, National Collection of Fine Arts 1964–65

ADRIAN, Dennis
Master prints from Landfall Press
Chicago, David and Alfred Smart Gallery, University of Chicago 1980

ALEXANDER, Brooke
'Interview with Sam Francis and George Page, master printer' in *The Litho Shop 1970–79*, New York, Brooke Alexander 1979

ALLEN, Virginia
Tamarind: Homage to lithography
New York, Museum of Modern Art 1969

ANTREASIAN, Garo Z.
'Some thoughts about printmaking and print collaboration'
Art Journal, Spring 1980, pp. 180–188

Archives de la maison Gustave Pellet – Maurice Exteens
Berne, Klipstein and Kornfeld 1962

ARMSTRONG, Elizabeth
Prints from Tyler Graphics
Minneapolis, Walker Art Center 1984

ARMSTRONG, Elizabeth
Tyler Graphics: The extended image
New York 1987

BARO, Gene
Graphicstudio U.S.F.: An experiment in art and education
Brooklyn NY, Brooklyn Museum 1978

BEAL, Graham
Artist and printer: Six American print studios
Minneapolis, Walker Art Center 1981

BEALL, Karen F.
'The Interdependence of printer and printmaker in early 19th-century lithography'
Art Journal, Spring 1980, pp. 195–201

BLANCHARD, Gérard
Les Lithographies originales des peintres de l'atelier Clot
Paris, Galerie Peintres du Monde 1965

BLOCH, Maurice E.
Made in California: An exhibition of five workshops
Los Angeles, Dickson Art Center, UCLA 1971

BLOCH, Maurice E.
Tamarind: A renaissance in lithography
Washington DC, International Exhibitions Foundation 1971

BLOCH, Maurice E.
Words and images – Universal Limited Art Editions
Los Angeles, Frederick S. Wight Art Gallery, University of California 1978

BOUVY, Eugène
'L'Imprimeur Gaulon et les origines de la lithographie à Bordeaux'
Revue philomathique de Bordeaux et du Sud-Ouest, Jan.–Feb. 1917,
pp. 241–255

BROWN, Bolton, with notes by ADAMS, Clinton
'My ten years in lithography'
Tamarind Papers, part 1, Winter 1981–82, pp. 8–25; part 2, Summer
1982, pp. 36–54

BUTLER, Charles T., and LAUFER, Marilyn
Recent graphics from American printshops
Mount Vernon Ill. 1986

CABANNE, Pierre
'Mourlot'
Connaissance des Arts, Apr. 1975, pp. 62–67

CASTLEMAN, Riva
'Tatyana Grosman 1904–82'
Print Collector's Newsletter, Sept.–Oct. 1982, p. 117

CASTLEMAN, Riva
Technics and creativity: Gemini G.E.L.
New York, Museum of Modern Art 1971

CATE, Phillip Dennis
The Rutgers Archives for printmaking studios
New Brunswick NJ, Jane Voorhees Zimmerli Art Museum, Rutgers
University 1983

CHAPON, François
'Ambroise Vollard éditeur'
Gazette des Beaux-Arts, part 1, July–Aug. 1979, pp. 33–47; part 2, Jan.
1980, pp. 25–38

COLLINGS, J.
Thomas Ham, pioneer, engineer and publisher
Melbourne 1961

CRAUZAT, E. de
'Une Découverte en lithographie'
L'Art Décoratif, Jan.–June 1910, pp. 164–168

CUNO, J.
'The Business and politics of caricature: Charles Philipon and La
Maison Aubert'
Gazette des Beaux-Arts, Oct. 1985, pp. 95–112

CUTLER, Carol
'The House of Mourlot'
Art in America, May 1966, p. 100

DAVIS, Bruce
'Print workshops at mid-century'
in FINE, *Gemini G.E.L.*, pp. 9–14 (see part 7)

DEAN, Sonia
*The Artist and the printer: Lithographs 1966–1981, a collection of
printer's proofs*
[Melbourne], National Gallery of Victoria 1982

DEVON, Marjorie, and others
Tamarind 25 years, 1960–1985
Albuquerque, University of New Mexico Art Museum 1985

DEVON, Marjorie
'The Scottish printmaking workshops'
Tamarind Papers, vol. 8 nos. 1–2 1985, pp. 31–43

'Ediciones Poligrafa' Barcelona
London, Redfern Gallery 1979

EICHENBERG, Fritz
'Workshops'
in *The Art of the print: Masterpieces, history, techniques*
New York 1976

FERGUSON, Gerald
'A professional lithography workshop'
Arts Canada, April 1970, pp. 60–61

FIELD, Richard S.
'Gemini G.E.L.' by Ruth E. Fine reviewed in
Print Quarterly, June 1985, pp. 144–46

FINE, Ruth E.
Eugene Feldman 1921–75
Philadelphia Pa, Tyler School of Art, Temple University 1976

FINE, Ruth E.
Gemini G.E.L.: Art and collaboration
New York and Washington DC, National Gallery of Art 1984

FISCHER, E., and OHRT, K.
[*I. Chr. Sorensen: A lithographic workshop*]
Aalborg, Nordjyllands Kunstmuseum 1981

FLETCHER, J.
John Degotardi
Sydney 1984

FREUND, Andreas
'Mourlot, master printer of lithographs'
Artnews, Mar. 1973, pp. 30–32

FLINT, Janet
George Miller and American lithography
Washington DC, National Collection Fine Art, Smithsonian Institution
1976

GARDNER, Paul
'Tamarind: Transforming the great stone place'
Artnews, March 1973, pp. 27–29

GEDEON, Lucinda, ed.
Tamarind: From Los Angeles to Albuquerque
Los Angeles, Grunwald Center, UCLA 1985

GILMOUR, Pat
'Curiosity, trepidation, exasperation, salvation! Ceri Richards, his
Australian printer and Stanley Jones'
Tamarind Papers, Spring 1987, pp. 28–37

GILMOUR, Pat
Ken Tyler – Master printer, and the American print renaissance
New York and Canberra, Australian National Gallery 1986

GILMOUR, Pat
*Lithographs from the Curwen Studio: A retrospective of fifteen years'
printmaking*
London, Camden Arts Centre 1973

GILMOUR, Pat
'Picasso and his printers'
Print Collector's Newsletter, July–Aug. 1987, p. 81–90

GILMOUR, Pat
'Thorough translators and thorough poets: Robert Kushner and his
printers'
Print Collector's Newsletter, Nov.–Dec. 1985, p. 159–164

GLAHN, Susan von
'Instruction in lithography: A survey of art schools and universities'
Tamarind Papers, Spring 1980, pp. 53–58

GLAHN, Susan von
'Lithography workshops: A survey'
Tamarind Papers, Summer 1981, pp. 48–52

GOLDMAN, Judith
Art of the picture press: Tyler Graphics Ltd
New York, Emily Lowe Gallery, Hofstra University 1977

GOLDMAN, Judith
'Gemini prints in the Museum of Modern Art'
Print Collector's Newsletter, May–June 1971, pp. 30–31

GOLDMAN, Judith
'The master printer of Bedford N.Y.'
Artnews, Sept. 1977, pp. 50–54

GOODMAN, Linda
'Print workshops in Italy'
Print News, Winter 1986, pp. 14–18

GOULDING, Frederick
'Lithographs and their printing: An interview by Gleeson White'
Studio, Nov. 1895, pp. 87–101

GRAFTON, Samuel
'Tamarind: Where artist and craftsman meet'
Lithopinion vol. 5, 1967, pp. 18–25

GRIFFITS, Thomas E.
'The Printing of posters'
in LAVER, HUTCHINSON, GRIFFITS (1949), pp. 27–33 (see part 6 C).

GROSCHWITZ, Gustave von, and ADAMS, Clinton
'Life and work: Thoughts of an artist-printer, a conversation with
Irwin Hollander'
Tamarind Papers, vol. 8 nos. 1–2 1985, pp. 34–43

HARDIE, Martin
'Goulding as printer of lithographs'
in *Frederick Goulding: Master printer of copper plates*, pp. 105–111
Stirling 1910

JOACHIM, Harold
Landfall Press
Chicago [1971]

JOHNSON, Una E.
Ambroise Vollard, éditeur: Prints, books, bronzes
New York 1944; rev. 1977

JONES, Elizabeth
'Robert Blackburn: An investment in an idea'
Tamarind Papers, Winter 1982–83, pp. 10–14

JONES-POPESCU, Elizabeth
*American Lithography and Tamarind Lithography Workshop,
Tamarind Institute 1900–1980*
Albuquerque, University of New Mexico Ph.D dissertation 1980

KIRSHNER, Judith R.
Landfall Press, a survey of prints (1970–1977)
Chicago, Museum of Contemporary Art 1977

KLEIN, Henry F.
'Tamarind at the crossroads'
Print News, May–Aug. 1985, pp. 14–16

KNIGIN, Michael, and ZIMILES, Murray
The contemporary lithographic workshop around the world
New York 1974

LANGSNER, Jules
'Is there an American print revival? Tamarind Workshop'
Artnews, January 1962, pp. 34–35, 58–60

LE MEN, Ségolène
'De l'image au livre: L'Éditeur Aubert et l'abécédaire en stampe'
Nouvelles de l'estampe, Dec. 1986, pp. 17–30

LEHRER, Leonard
'Artist and printer: Some matches are made in heaven and others . . .'
Tamarind Papers, vol. 8 nos. 1–2 1985, pp. 44–49

LEJARD, André
'Mourlot: A centre of lithographic art in Paris'
Graphis, 1955, pp. 500–505

LEVINSON, Robert S.
'Renaissance of lithography . . . and it's happening in Los Angeles'
Westways, Nov. 1970, pp. 6–12

LOVEJOY, Margot
'The National Experimental Graphics Workshop of Cuba:
Printmaking in Cuba today'
Print Review vol. 9, 1979, pp. 80–90

Lynton R. Kistler: Printer-lithographer
Northridge Calif., California State University Library 1976

McCLINTON, Katherine Morrison
'L. Prang and Company'
Connoisseur, Feb. 1976, pp. 97–105

MAURICE, Alfred P.
'George C. Miller and Son: Lithographic printers to artists since 1917'
American Art Review, Mar.–April 1976, pp. 133–144

MELLERIO, André
'Les Dessins de Rodin interprétés lithographiquement en couleurs par
A. Clot'
in *Rodin et son oeuvre* facsicule 6, 'numéro exceptionnel', *La Plume*,
1900, pp. 81–82

MELLERIO, André
'Exposition de la deuxième année de *L'Album d'estampes originales*,
Galerie Vollard'
L'Estampe et l'Affiche, Jan. 1898, pp. 10–11

MILLER, George C.
'The Craft of lithography'
American Artist, Sept. 1943, pp. 21–23

MORSE, Peter
'Lynton Kistler "The happy printer"'
Artnews, March 1978, pp. 90–93

MOSER, Joann
Landfall Press 1970–1980
Washington DC, US International Communications Agency 1981

MOURLOT, Fernand
'The Artist and the printer'
in PORZIO, Domenico, ed., *Lithography: 200 years of art, history and
technique*, pp. 183–189 (see part 3A, General)

MOURLOT, Fernand
*Gravés dans ma mémoire: Cinquante ans de lithographie avec Picasso,
Matisse, Chagall, Braque, Miró*
Paris 1979

MOURLOT, Fernand
Souvenirs & portraits d'artistes
Paris 1973

MOURLOT, J.-M.
'L'Impression lithographique'
Art et métiers graphiques vol. 4, 1 Apr. 1928, pp. 209–212

PARRIS, Nina
*Through a master printer: Robert Blackburn and the printmaking
workshop*
Columbia S. Car. 1985

PETERS, Lisa
'Print workshops U.S.A. – A listing'
Print Collector's Newsletter, Jan.–Feb. 1983, pp. 201–206

PHILLIPS, Deborah C.
'Artist and printer: "A coincidence of sympathies"'
Artnews, Mar. 1981, pp. 100–106

'Printing today', a discussion of 30 Oct. 1982 with Pat BRANSTEAD,
Chip ELWELL, Alexander HEINRICI, Jack LEMON, Bud SHARK, Judith
SOLODKIN, Jeff WASSERMAN and moderator Ken TYLER; with a
listing of workshops in the USA
Print Collector's Newsletter, Jan-Feb. 1983, pp. 189–200

RIVERS, Larry
'Tatyana Grosman: "There is power in obsession, and finally it is
catching"'
Artnews, Oct. 1982, pp. 101–102

ROBERTS, Holly
'Printer's chops 1960–1978'
Tamarind Papers, Autumn 1978, pp. 17–21

ROSEN, Jeff
*Lemercier et Compagnie: Photolithography and the industrialization of
production in France (1837–1859)*
Thesis in preparation

ROTHENSTEIN, W., and WAY, Thomas R.
'Some remarks on artistic lithography'
The Studio, 13 Apr. 1894, pp. 16–17

SAFT, Carol
'The Growth of print workshops and collaborative print making since
1956'
Print Review vol. 13, 1981, pp. 55–68

*Schenkung Vollard: Original Graphik und illustrierte Bücher
herausgegeben von Ambroise Vollard 1867–1939*
Winterthur, Kunstmuseum 1949

SCHNELKER, Rebecca
'Printer's chops: 1979–1984'
Tamarind Papers, Spring 1984, p. 36

SCHNELKER, Rebecca, ed.
*Tamarind lithographs: A complete catalogue of lithographs printed at
Tamarind Institute 1970–1979*
Albuquerque 1980

SCHULZE, Franz
'Landfall press: "Making marks" in Chicago'
Artnews vol. 75, Sept. 1976, pp. 60–62

SHERRILL, Robert
'Interview with Kenneth Tyler: Gemini G.E.L.'
Lithopinion vol. 18, Summer 1970, pp. 51–61

SMALE, Nicholas
'Thomas R. Way: His life and work'
Tamarind Papers, Spring 1987, pp. 17–27

SOMMERS, John
'The acid-tint lithograph'
Tamarind Papers, Spring 1984, pp. 17–23

SORLIER, Charles
Mémoires d'un homme de couleurs
Paris 1985

SPARKS, E.
'ULAE: The paradigm of printshops'
Print Voice, University of Alberta 1983

SUARÈS, André
'Ambroise Vollard'
La Nouvelle Revue Française, 1 Feb. 1940, pp. 184–193

SWENSON, Christine
Charles Hullmandel and James Duffield Harding: A study of the English art of drawing on stone 1818–1850
Northampton Mass., Smith College Museum of Art 1982

SYKES, Maltby
'Recollections of a lithographile'
Tamarind Papers, Summer 1983, pp. 40–47

TABAK, May Natalie
'Tamarind Lithography Workshop'
Craft Horizons, part 1, Oct. 1970, pp. 28–34; part 2, Dec. 1970, pp. 50–53; part 3, Feb. 1971, pp. 34–37

TOMKINS, Calvin
'The art world: Tatyana Grosman'
New Yorker, 9 Aug. 1982, pp. 82–86

TOMKINS, Calvin
'Profiles: The moods of a stone, Tatyana Grosman'
New Yorker, 7 June 1976, pp. 42–76

TOWLE, Tony
Contemporary American prints from Universal Limited Art Editions: The Rapp Collection
Toronto 1979

TWYMAN, Michael
'A Directory of London lithographic printers'
Journal of the Printing Historical Society vol. 10, 1974–75, pp. 1–55; issued as monograph London 1976

TWYMAN, Michael
John Soulby, printer, Ulverston
Reading 1966

TWYMAN, Michael
'Lithographic stone and the printing trade in the nineteenth century'
Journal of the Printing Historical Society vol. 8, 1973, pp. 1–41

TWYMAN, Michael
Rudolf Ackermann and lithography
Reading 1983

Tyler Graphics catalogue raisonné: 1974–1985
New York 1987

VOLLARD, Ambroise
Recollections of a picture dealer
Boston 1936; French edn. *Souvenirs d'un marchand de tableaux*

WAY, T. R.
Memories of James McNeill Whistler the artist
London and New York 1912

WHEELER, Marilee and others
Armstrong & Company, artistic lithographers
Boston, Boston Public Library 1982

WIGHT, Frederick S.
Tamarind and the art of the lithograph
Los Angeles, UCLA 1962–63

WOIMANT, Françoise
'La Lithographie et les ateliers d'imprimeurs au XXe siècle'
Nouvelles de l'estampe, Nov.–Dec. 1975, pp. 15–18

WOIMANT, Françoise, and ELGRISHI, Marcelle
'Répertoire des imprimeurs lithographes en France (1975)'
Nouvelles de l'estampe, Nov.–Dec. 1975, pp. 19–28

YOUNG, J. E.
'Los Angeles: Gemini G.E.L.'
Art International, 20 Dec. 1971, pp. 70–72

ZERNER, Henri
'Universal Limited Art Editions'
L'Oeil, Dec. 1964, pp. 37–43, 82

8 *Artists*

ADAMS, Clinton
'Art as testament: A Conversation with Margo HUMPHREY'
Tamarind Papers, Spring 1986, pp. 16–26

ADAMS, Clinton
'A Conversation with James McGARRELL'
Tamarind Papers, Apr. 1976, pp. 49–56, 64

ADAMS, Clinton
'Margaret LOWENGRUND and the Contemporaries'
Tamarind Papers, Spring 1984, pp. 17–23

ADAMS, Clinton
'The Personality of lithography: 'A Conversation with Nathan OLIVEIRA'
Tamarind Papers, Winter 1982–83, pp. 4–9, 17

ADAMS, Clinton
'The Prints of Andrew DASBURG: A complete catalogue'
Tamarind Papers, Winter 1980–81, pp. 18–25

ADHÉMAR, Jean
DERAIN, peintre-graveur: Catalogue de l'exposition
Paris, Bibliothèque Nationale 1955

ADHÉMAR, Jean
TOULOUSE-LAUTREC: Lithographies, pointes sèches, oeuvre complet
Paris 1965; English trans. 1965; German trans. 1965

ADHÉMAR, Jean, and CACHIN, Françoise
DEGAS: The complete etchings, lithographs and monotypes
Paris 1973, English edn. London 1974

ADRIAN, Dennis
'The Prints of Philip PEARLSTEIN'
Print Collector's Newsletter, July–Aug. 1973, pp. 49–52

Allen JONES: Das graphische Werk
Cologne, Galerie der Spiegel 1970

ALPERS, Danièle
MESSAGIER: Les estampes et les sculptures 1945–74
Paris 1975

ANDRÉ, Édouard
Alexandre LUNOIS: Peintre, graveur et lithographe
Paris 1914

ANGOULVENT, P. J.
'L'Oeuvre gravé de COROT'
Byblis, Summer 1926, pp. 39–55

ARMELHAUT, J., and BOCHER, E.
L'Oeuvre de GAVARNI: Lithographies originales et essais d'eau-forte et de procédés nouveaux: Catalogue raisonné
Paris 1873

ARWAS, Victor
BERTHON and GRASSET
London 1978

AXSOM, Richard H., and others
The Prints of Frank STELLA: A catalogue raisonné 1967–1982
New York 1983

BAER, Brigitte
PICASSO the printmaker: Graphics from the Marina Picasso collection
Dallas, Dallas Museum of Art 1983

BAILLY-HERZBERG, Janine
'Les Estampes de Berthe MORISOT'
Gazette des Beaux-Arts, May–June 1979, pp. 215–227

BAILLY-HERZBERG, Janine
MANZANA-PISSARRO
Paris, Galerie Boccara 1973

BAREAU, Juliet Wilson
GOYA's prints: The Tomás Harris Collection in the British Museum
London, British Museum 1981

BARO, Gene
Claes OLDENBURG, drawings and prints
New York and London 1969

BARO, Gene
NEVELSON: The prints
New York 1974

BASILY-CALLIMAKI, Mme de
J. B. ISABEY, sa vie, son temps: Suivi du catalogue de l'oeuvre gravé par et d'après Isabey
Paris 1909

BASKETT, Mary W.
The Art of June WAYNE
New York 1969

BASSHAM, Ben
'The Lithographs of Robert RIGGS'
Tamarind Papers, Summer 1983, pp. 32–39

BELLEROCHE, Albert
'The Lithographs of SARGENT'
Print Collector's Quarterly, 1926, pp. 30–44

BELLOWS, Emma S., and others
George W. BELLOWS: His lithographs
New York and London 1927

BÉNÉDITE, Léonce
Catalogue des lithographies originales de Henri FANTIN-LATOUR
Paris, Musée National du Luxembourg 1899

BÉNÉDITE, Léonce
John LEWIS BROWN: Étude biographique et critique suivie du catalogue de l'oeuvre lithographique et gravé de cet artiste exposé au Musée du Luxembourg
Paris 1903

BERNSTEIN, Roberta
'JASPER JOHNS' "Decoy"'
Print Collector's Newsletter, Sept.–Oct. 1972, pp. 83–84

BERNSTEIN, Roberta
'ROSENQUIST reflected: The Tampa prints'
Print Collector's Newsletter, Mar.–Apr. 1973, pp. 6–8

BLOCH, Georges
Pablo PICASSO: Catalogue de l'oeuvre gravé et lithographié 1904–1969, 2 vols.
Berne 1968

BLOOMFIELD, Lin, ed.
Frank HINDER: Lithographs
Sydney 1978

BLOOMFIELD, Lin, ed.
Vincent BROWN: Life and work
Sydney 1980

BOCK, Elfried
Adolph VON MENZEL: Verzeichnis seines graphischen Werkes
Berlin 1923

BOGLE, Andrew
Graphic works by Edward Ruscha
Auckland City Art
Gallery 1978

BOURET, Blandine, ed.
Pablo PICASSO: L'oeuvre gravé 1899–1972
Paris 1984

BOUVENNE, Agläus
'Théodore CHASSÉRIAU, souvenirs et indiscrétions'
Bulletin des Beaux-Arts vol. 1, 1883–84, pp. 134–139, 145–150, 161–166

BOUVET, Francis
BONNARD: The complete graphic work
Paris and New York 1981

BOYLE-TURNER, Caroline
The Prints of the Pont-Aven School: GAUGUIN and his circle in Brittany
Washington DC, Smithsonian Institution 1986

BREDT, E. W.
'Zu STADLERS Lithographien'
Die graphischen Künste, 1915, pp. 58–64

BREESKIN, Adelyn D.
The graphic work of Mary CASSATT: A catalogue raisonné
New York 1948

BRIDGES, Ann, ed.
Alphonse MUCHA: The complete graphic works
London 1980

BRODY, Jacqueline
'Elizabeth MURRAY, thinking in print: An interview'
Print Collector's Newsletter, July–Aug. 1982, pp. 73–77

BROWN, Bolton
'Pennellism and the PENNELLS' with notes by Clinton Adams
Tamarind Papers, Fall 1984, pp. 49–71

BURNELL, Devin
'Honoré DAUMIER & the composition of humor'
Print Collector's Newsletter, Nov.–Dec. 1973, pp. 102–105

BUTLER, Roger, and MINCHIN, Jan
Thea PROCTOR, the prints
Sydney 1981

CACHIN, Françoise and others
MANET 1832–1883
Paris, Galeries Nationales du Grand Palais 1983

CAILAC, Jean
'The Prints of Camille PISSARRO; A supplement to the catalogue by Loys Delteil'
Print Collector's Quarterly, 1932, pp. 74–86

CAILLER, Pierre
Catalogue raisonné de l'oeuvre gravé et lithographié de Maurice DENIS
Geneva 1968

CALABI, A., and SCHREIBER-FAVRE, A.
'Les Eaux-fortes et les lithographies d'Alexandre CALAME'
Die graphischen Künste vol. 2, 1937, pp. 64–77, 110–117

CAPASSO, Nicholas J.
Reginald NEAL: A retrospective of his prints
New Brunswick, Rutgers State University of New Jersey 1986

CARROLL, Alison
Barbara HANRAHAN printmaker
Adelaide 1986

CASTLEMAN, Riva
Jasper JOHNS: A print retrospective
New York, Museum of Modern Art 1986

CASTLEMAN, Riva, and WITTROCK, Wolfgang, eds.
Henri de TOULOUSE-LAUTREC: Images of the 1890s
New York, Museum of Modern Art 1985

CATE, Phillip Dennis, and GILL, Susan
Théophile-Alexandre STEINLEN
Salt Lake City 1982

CATE, Phillip Dennis, and BOYER, Patricia Eckert
The Circle of TOULOUSE-LAUTREC
New Brunswick NJ, Jane Voorhees Zimmerli Art Museum, Rutgers State University 1986

CHAPON, François, and ROUAULT, Isabelle
Oeuvre gravé: ROUAULT, 2 vols
Monte Carlo 1978

CHARLOT, Jean
'The Lithographs of Alfredo ZALCE'
in *An Artist on art: Collected essays of Jean Charlot*
Honolulu 1972, vol. 1, pp. 183–187

CHARTIER, Emile, and SALOMON, Jacques
L'Oeuvre gravé de Ker-Xavier ROUSSEL
Paris 1968

CHILDS, Bernard
'Tropical noon: High speed presses and the unlimited edition'
Artist's Proof, 1970, pp. 84–86

CIRANNA, Alfonso
Giorgio DE CHIRICO: Catalogo delle opere grafichi [incisioni e litografie] 1921–1969
Milan and Rome 1969

COLE, Sylvan, and TELLER, Susan
Grant WOOD: The lithographs
New York 1984

COMPIN, Isabelle
Henri-Edmond CROSS
Paris 1964

COPLANS, John, ed.
Roy LICHTENSTEIN
New York 1972, London 1973

CORN, Wanda M.
Grant WOOD: The Regionalist Vision
New Haven and London 1983–84

CRAMER, Gérald, and others
Henry MOORE: *Catalogue of graphic work 1931–1979*, 3 vols
Geneva 1973–80

CRAUZAT, E. DE
L'Oeuvre gravé et lithographie de STEINLEN: *Catalogue descriptif et analytique suivi d'un essai de bibliographie et d'iconographie de son oeuvre illustré*
Paris 1913

CROQUEZ, Albert
L'Oeuvre gravé de James ENSOR
Geneva 1947

CURTIS, Atherton
Auguste RAFFET
New York 1903

CURTIS, Atherton
Catalogue de l'oeuvre lithographié de Eugène ISABEY
Paris 1939

CURTIS, Atherton
Catalogue de l'oeuvre lithographié et gravé de R. P. BONINGTON
Paris 1939

DACIER, Emile
'Artistes contemporains: Alexandre LUNOIS'
Revue de l'Art, part 1, 1900, pp. 410–421; part 2, 1901, pp. 36–48

[DAUMIER special issue]
Nouvelles de l'estampe, July–Oct. 1979, pp. 9–40

DAVIES, Hugh M., and CASTLEMAN, Riva
Prints of Barnett NEWMAN
New York 1983

DAYOT, Armand
Carle VERNET, *étude sur l'artiste suivie d'un catalogue de l'oeuvre gravé et lithographié*
Paris 1925

DEKNATEL, Frederick
Edvard MUNCH
New York 1950

DELANEY, Paul
The Lithographs of Charles SHANNON
London 1978

DELANEY, Paul
'WHISTLER, SHANNON and the revival of lithography as art'
Nineteenth Century, Winter 1978, pp. 76–80

DELTEIL, Loys
'Eugène CICERI: Catalogue de son oeuvre lithographique'
L'Artiste, 1891, pp. 216–221

DELTEIL, Loys
Le Peintre-graveur illustré
BARYE vi, BESNARD xxx, CARPEAUX vi, CARRIÈRE viii, COROT v, DAUBIGNY xiii, DAUMIER xx–xxix, DE BRAEKELEER xix, DEGAS ix, DELACROIX iii, DUPRÉ i, ENSOR xix, FRÉLAUT xxxi, GÉRICAULT xviii, GOYA xiv–xv, HUET vii, INGRES iii, LEHEUTRE xii, LEYS xix, MILLET i, PISSARRO xvii, RAFFAELLI xvi, RENOIR xvii, RODIN vi, RUDE vi, SISLEY xxvii, TOULOUSE-LAUTREC x–xi
Paris 1906–26, 31 vols.; rpr. New York, 1969, vol. 32 Appendix and glossary, New York 1970

DEZARROIS, A.
'AMAN-JEAN graveur et lithographe: Conversation'
Revue de L'Art, Jan. 1926, pp. 42–46

DODGSON, Campbell
Catalogue
in GIBSON, Frank, *Charles* CONDER, *his life and work*, London 1914

DODGSON, Campbell
A Catalogue of the etchings, drypoints and lithographs by Professor Alphonse LEGROS (1837–1911) *in the collection of Frank E. Bliss*
London 1923

DODGSON, Campbell
'Catalogue of the lithographs of J. S. SARGENT, R. A.' Supplement to BELLEROCHE, Albert, 'The lithographs of SARGENT', *Print Collector's Quarterly* vol. 13, 1926, pp. 31–45

D'OENCH, Ellen G. and FEINBERG, Jean E.
Jim DINE *prints 1977–1985*
Middletown Conn., Davison Art Center and Ezra and Cecile Zilkha Gallery, Wesleyan University 1986

DOY, Guinevere
'DELACROIX et Faust'
Nouvelles de l'estampe, May–June 1975, pp. 18–23

DRUICK, Douglas W.
'CÉZANNE, Vollard and lithography: The Ottawa maquette for the "Large bathers" colour lithograph'
Bulletin of the National Gallery of Canada vol. 19, 1972, pp. 1–35

DRUICK, Douglas W.
'PUVIS and the printed image (1862–1898)'
Nouvelles de l'estampe, July–Oct. 1977, pp. 27–35

DRUICK, Douglas, and HOOG, Michel
FANTIN-LATOUR
Paris, Galeries Nationales du Grand Palais; English trans. 1983

DRUICK, Douglas and ZEGERS, Peter
'DEGAS and the printed image, 1856–1914'
in REED and SHAPIRO 1984, pp. xv–lxxii (see part 8)

DRUICK, Douglas, and ZEGERS, Peter
'MANET's "Balloon": French diversions, the Fête de l'Empereur 1862'
Print Collector's Newsletter, May–June 1983, pp. 37–46

DUBE, Annemarie and Wolf-Dieter
E. L. KIRCHNER: *Das graphische Werk*, 2 vols
Munich 1967; 2nd edn. 1980

DUBE, Annemarie and Wolf-Dieter
Erich HECKEL: *Das graphische Werk*, 2 vols
New York and Berlin 1964–65

DUBUFFET, Jean, trans. Marthe La Vallée Williams
The Lithographs of Jean DUBUFFET (*with the artist's statement of 1962*)
Philadelphia, Philadelphia Museum of Art 1964–65

DÜCKERS, Alexander
George GROSZ: *Frühe Druckgraphik, Sammelwerke, illustrierte Bücher 1914–1923*
Berlin, Berlin-Dahlem Museum 1971

DÜCKERS, Alexander
Philip PEARLSTEIN: *Zeichnungen und Aquarelle, die Druckgraphik*
Berlin 1972

DUTHUIT-MATISSE, Marguerite, and DUTHUIT, Claude
Henri MATISSE: *Catalogue raisonné de l'oeuvre gravé*, 2 vols
Paris 1983

ENGEL, Charlene S.
'The realist eye: The illustrations and lithographs of George BELLOWS'
Print Review vol. 10, 1979, pp. 70–86

EPSTEIN, Sarah G.
The Prints of Edvard MUNCH: *Mirror of his life*
Oberlin Ohio, Allen Memorial Art Museum 1983

ESCHOLIER, Raymond
'Peintres-Graveurs contemporains: Alexandre LUNOIS'
Gazette des Beaux-Arts, Mar. 1912, pp. 215–224

FATH, Creekmore
The Lithographs of Thomas Hart BENTON
Austin Tex. and London 1969; rev. 1979

FIELD, Richard S.
Jasper JOHNS: *Prints 1960–1970*
Philadelphia and New York, Philadelphia Museum of Art 1970

FIELD, Richard S.
Jasper JOHNS: *Prints 1970–1977*
Middletown Conn. and London, Davison Art Center, Wesleyan University 1978

FIELDS, Armond
George AURIOL *with a catalogue raisonné by Marie Leroy-Crèvecoeur*
Salt Lake City 1985

FIELDS, Armond
Henri RIVIÈRE
Salt Lake City 1983

FINE, Ruth E., and LOONEY, Robert F.
The Prints of Benton Murdoch SPRUANCE: *A catalogue raisonné*
Philadelphia 1986

FISHER, Jay McKean
The Prints of Edouard MANET
Washington DC, International Exhibitions Foundation 1985

FIZELIÈRE, Albert de la
L'Oeuvre originale de VIVANT DENON . . ., 2 vols
Paris 1873

FLINT, Janet
Jacob KAINEN: Prints, a retrospective
Washington DC, National Collection of Fine Arts 1976

FLINT, Janet
The Prints of Louis LOZOWICK: A catalogue raisonné
New York 1982

FOSTER, Edward A.
Edward RUSCHA (Ed-Werd Rew-shay), young artist: A book accompanying the exhibition of prints, drawings and books of Edward Ruscha
Minneapolis, Minneapolis Institute of Arts 1972

FOSTER, Edward A.
Robert RAUSCHENBERG: Prints 1948/1970
Minneapolis, Minneapolis Institute of Arts 1970

FRANTZ, Henri, and UZANNE, Octave
DAUMIER and GAVARNI
Studio special issue
London, Paris, New York 1904

FREEDMAN, Barnett
'Lithography, a painter's excursion'
Signature, vol. 11 January 1936

FREEMAN, Richard B.
The Lithographs of Ralston CRAWFORD
Lexington Ky 1962

GABLER, Karlheinz
Das graphische Werk von Fritz WINTER
Frankfurt 1968

GALFETTI, Mariuccia, and VOGEL, Carl
TAPIES: Das graphische Werk = L'oeuvre gravé, 1947–1972
St Gallen and Barcelona 1974

GALIMARD, Auguste
AUBRY-LECOMTE
Paris 1860

GALLWITZ, K.
Max BECKMANN, die Druckgraphik: Radierungen, Lithographien, Holzschnitte
Karlsruhe 1962

GEIGER, R.
HERMANN-PAUL
Paris 1929

GELDER, Dirk van
Rodolphe BRESDIN: Catalogue raisonné de l'oeuvre gravé, 2 vols
La Haye 1976

GÉRICAULT: Tout l'oeuvre gravé et pièces en rapport
Rouen, Musée des Beaux-Arts 1981

GETTINGS, Frank
Raphael SOYER: Sixty-five years of printmaking
Washington DC, Hirshhorn Museum 1982

GIACOMELLI, Hector
RAFFET, son oeuvre lithographique et ses eaux-fortes, suivi de la bibliographie complète des ouvrages illustrés de vignettes d'après ses dessins
Paris 1862

GILMOUR, Pat
'Howard HODGKIN'
Print Collector's Newsletter, Mar.–Apr. 1981, pp. 2–5

GILMOUR, Pat
'MANET continued'
Print Quarterly, Dec. 1986, pp. 360–362

GILMOUR, Pat
'*The Prints of Edouard MANET*, by Jay McKean Fisher' reviewed in *Tamarind Papers*, Fall 1986, pp. 71–76

GILMOUR, Pat
'Unsung Heroes – Barnett FREEDMAN'
Tamarind Papers vol. 8, nos 1–2, 1985, pp. 15–24

GRAHAM, Lanier
'The Prints of Willem DE KOONING: An illustrated catalogue'
Tamarind Papers, 1988

GRAY, Christopher
Armand GUILLAUMIN
Chester Conn. 1972

GRIBAUDO, Ezio
J. PUY
Geneva, Musée du Petit Palais 1977

GRIFFITH, Fuller
The Lithographs of Childe HASSAM
Washington DC, Smithsonian Institution 1982

GRISEBACH, Lucius, ed., trans. Frank WHITFORD
Prints and drawings by Adolf MENZEL
Cambridge, Fitzwilliam Museum 1984

GROSCHWITZ, Gustave von
'The Prints of Thomas Shotter BOYS'
in ZIGROSSER 1962 (see part 3B, United States)

GUÉRIN, Marcel
Catalogue raisonné de l'oeuvre gravé et lithographié de Aristide MAILLOL, 2 vols
Geneva 1965–1967

GUÉRIN, Marcel
J.-L. FORAIN lithographe: Catalogue raisonné
Paris 1912

GUÉRIN, Marcel
L'Oeuvre gravé de GAUGUIN, 2 vols
Paris 1927

GUSMAN, Pierre
'Achille DEVÉRIA, illustrateur et lithographe romantique (1800–1857)'
Byblis vol. 6, 1927, pp. 34–40

HAMILTON, Richard
Collected works 1953–1982
London and New York 1982

HARRISSE, Henry
L.-L. BOILLY, peintre, dessinateur et lithographe: Sa vie et son oeuvre
Paris 1898

HASLEM, Jane
Mark TOBEY Graphics
Washington DC, Jane Haslem Gallery 1979

HÉDIARD, G.
FANTIN-LATOUR: Catalogue de l'oeuvre lithographié du maître
Paris 1906

HÉDIARD, Germain
'Les Maîtres de la lithographie: JOHN-LEWIS BROWN'
L'Artiste, Dec. 1897, pp. 401–409

HERBERT, Robert L.
'SEURAT and Jules CHÉRET'
Art Bulletin, June 1958, pp. 156–58

HEUSINGER, Christian von
Ker-Xavier ROUSSEL 1867–1944: Gemälde, Handzeichnungen, Druckgraphik
Bremen 1965

HOBBS, Susan, and SPINK, Nesta R.
Lithographs of James McNeill WHISTLER: From the collection of Steven Louis Block [with supplementary technical notes by Nesta Spink]
Washington DC, Smithsonian Institution 1982

'Honoré DAUMIER: A centenary tribute'
Print Review vol. 11 1980, pp. 5–144

Honoré DAUMIER 1808–1879
Los Angeles, The Armand Hammer Collection 1982

HÜLSEN, Dorothy von
Graphik von Georg TAPPERT, 1880–1957
Hamburg, Altonaer Museum 1971

Jim DINE: Complete graphics
Berlin, Hanover, London 1970

Jim DINE: Prints 1970–1977
New York, Hagerstown, San Francisco and London 1977

JOHNSON, Una E., and MILLER, Jo
Adja YUNKERS: Prints 1927–1967
Brooklyn NY, Brooklyn Museum, 1969

JOHNSON, Una E., and MILLER, Jo
Milton AVERY: Prints and drawings 1930–1964
New York, Brooklyn Museum 1966

KARSCH, Florian
Otto DIX: Das graphische Werk
Hanover 1970

KARSCH, Florian, and WESTHEIM, Paul
Otto MUELLER: Das graphische Gesamtwerk
Berlin 1974

KEARNS, Martha
Käthe KOLLWITZ: Woman and artist
New York 1976

KLIPSTEIN, August
Käthe KOLLWITZ, Verzeichnis des graphischen Werkes für die Jahre 1890–1912 unter Verwendung des 1913 erschienenen Oeuvrekataloges von Prof. Dr. Johannes Sievers
Berne 1955; English trans. 1955

KNOWLES DEBS, Barbara
'On the permanence of change: Jasper JOHNS at the Modern'
Print Collector's Newsletter, Sept.–Oct. 1986, pp. 117–123

KNUPP, Christine
Max PECHSTEIN 1881–1955: Graphik
Hamburg, Altonaer Museum 1972

KOLENBERG, Hendrik
Lloyd REES, etchings and lithographs: A catalogue raisonné
Sydney 1986

KORNFELD, Eberhard W.
Verzeichnis des graphischen Werkes von Paul KLEE
Berne 1963; English trans. 1964; French trans. 1964

KORNFELD, E. W., and WICK, P. A.
Catalogue raisonné de l'oeuvre gravé et lithographié de Paul SIGNAC
Berne 1974

KRENS, Thomas, ed.
Helen FRANKENTHALER: Prints 1961–1979
New York, Williams College 1980

Kumi SUGAI
Hanover 1963

KUNZLE, David
'CHAM, the "popular" caricaturist',
Gazette des Beaux-Arts, December 1980, pp. 213–24

[LABBAYE, Christian]
SOULAGES: Eaux-fortes, lithographies 1952–1973
Paris 1974

LA COMBE, Joseph Félix Leblanc de
CHARLET, sa vie, ses lettres, suivi d'une description raisonnée de son oeuvre lithographique
Paris 1856

LAMBERT, S.
MATISSE lithographs
London 1981

LAMBOTTE, Paul
Henri EVENEPOEL
Brussels 1908

LANKHEIT, Klaus
Franz MARC: Katalog der Werke
Cologne 1970

LARSON, Philip
'El LISSITZKY's "Victory over the Sun"'
Print Collector's Newsletter, Mar.–Apr. 1976, pp. 10–11

LARSON, Philip
'The exotic ladies of Henri MATISSE – Late 1920s, early 1930s'
Print Collector's Newsletter, Jul.–Aug. 1983, pp. 77–81

LARSON, Philip
'Wilhelm DE KOONING: The lithographs'
Print Collector's Newsletter, Mar.–Apr. 1974, pp. 6–7

LEGROS, Lucien A.
Catalogue in SOULIER, Gustave, *L'Oeuvre gravé et lithographié d'Alphonse LEGROS*
Paris 1904

LEHRS, Max
'Käthe KOLLWITZ'
Die graphischen Künste, 1903, pp. 55–67

LEIRIS, Michel and MOURLOT, Fernand
Joan MIRÓ lithographe, 4 vols.
Paris 1972; Spanish trans. 1972

LE MEN, Ségolène
'MANET et DORÉ: L'illustration du *Corbeau* de Poe'
Nouvelles de l'estampe, Dec. 1984, pp. 4–21

LEMOISNE, Paul-André
GAVARNI: Peintre et lithographe, 2 vols
Paris 1928

LEVINSON, Orde
John PIPER, the complete graphic works: A catalogue raisonné 1923–1983
London 1987

LEVY, Mervyn
WHISTLER lithographs: An illustrated catalogue raisonné
London 1975

LOCHNAN, Katherine A.
'WHISTLER & the transfer lithograph: A lithograph with a verdict'
Print Collector's Newsletter, Nov.–Dec. 1981, pp. 133–37

LOCHNAN, Katherine A.
'Les Lithographies de DELACROIX pour *Faust* et le théâtre anglais des années 1820'
Nouvelles de l'estampe, July 1986, pp. 6–13

LOYER, Jacqueline
LABOUREUR, oeuvre gravé et lithographié
Paris 1962

LOYER, Jacqueline, and PÉRUSSAUX, Charles
'Catalogue de l'oeuvre lithographique de Robert DELAUNAY'
Nouvelles de l'estampe, May–Jun. 1974, pp. 3–9

LOREAU, Max
Catalogue des travaux de Jean DUBUFFET fascicule xvi: Les Phénomènes
Paris 1964

LUCIE-SMITH, Edward
FANTIN-LATOUR
Oxford 1977

LUST, Herbert C.
GIACOMETTI: The complete graphics and 15 drawings
New York 1970

MALTZAHN, I. von
Arthur BOYD, etchings and lithographs
London 1971

MAN, Felix H.
Graham SUTHERLAND: Das graphische Werk 1922–1970
Munich 1970

MANDY, R.
Brett WHITELEY: Graphics 1961–1982
Perth, Art Gallery of Western Australia 1983

MARGUILLIER, Auguste
'Charles DULAC'
Gazette des Beaux-Arts, April 1899, April pp. 325–32

MASON, Lauris, and LUDMAN, Joan
The Lithographs of George BELLOWS: A catalogue raisonné
Millwood NY 1977

MASON, Rainer Michael, and others
FANTIN-LATOUR lithographies [with rpr. of Hédiard 1906]
Geneva, Musée d'Art et d'Histoire 1980–81

MATISSE, L'Oeuvre gravé
Paris, Bibliothèque Nationale 1970

MAYOR, A. Hyatt
'DAUMIER'
Print Collector's Newsletter, Mar.–Apr. 1970, pp. 1–4

MELLERIO, André
Odilon REDON
Paris 1913

MILES, Rosemary
The complete prints of Eduardo PAOLOZZI: Prints, drawings, collages 1944–77
London, Victoria & Albert Museum 1977

MILLER, Jo
Josef ALBERS: Prints 1915–1970
New York 1973

MOREAU-NÉLATON, E.
MANET, graveur et lithographe
Paris 1906

MORPHET, Richard
Howard HODGKIN prints 1977–1983
London, Tate Gallery 1985

MORSE, Peter
Jean CHARLOT's prints: A catalogue raisonné
Honolulu 1976

MORSE, Peter
John SLOAN's prints: A catalogue raisonné of the etchings, lithographs, and posters
New Haven Conn. 1969

MOURLOT, Fernand
Bernard BUFFET: Oeuvre gravé, lithographies 1952–1966
Paris 1967; English trans. 1968

MOURLOT, Fernand
BRAQUE lithographe
Monte Carlo 1963; English edn. 1963

MOURLOT, Fernand
PICASSO lithographe, 4 vols
Monte Carlo 1949–1964; English edns.

MOURLOT, Fernand
Picasso lithographe
[Monte Carlo] 1970; English trans. 1970

MOURLOT, Fernand, and others
CHAGALL lithographe: 1922–1979, 5 vols
Monte Carlo 1960–1984; English edns

MULLER, Heinrich
Die späte Graphik von Lovis CORINTH
Hamburg 1960

MYERS, Jane
'A Reality parallel to nature: Stuart DAVIS's lithographs, 1929–31'
Tamarind Papers, Fall 1986, pp. 46–51

NAEF, Hans
'INGRES as lithographer'
Burlington Magazine, Sept. 1966, pp. 476–79

NAKOV, André B.
'MALEVICH as printmaker'
Print Collector's Newsletter, Mar.–Apr. 1976, pp. 4–10

Odilon REDON, Gustave MOREAU, Rodolphe BRESDIN
New York, Museum of Modern Art 1962

OLSEN, John
My complete graphics 1957–1979
Melbourne, Australian Galleries 1980

Oskar KOKOSCHKA
Linz, Neue Galerie der Stadt Linz 1951

PACQUEMENT, Alfred, and BEAUMELLE, Agnès A. de la, eds.
Henri MICHAUX
Paris and New York, Musée National d'Art Moderne, Centre Georges Pompidou 1978

PAULI, Vicki and RODRIGUEZ, Judith
Noela HJORTH
Clarendon, South Australia 1984

PENNELL, Joseph
The Life of James McNeill WHISTLER, 2 vols
London 1909

PENNELL, Joseph
'WHISTLER as etcher and lithographer'
Burlington Magazine, Nov. 1903, pp. 160–68

PETERS, Hans Albert
Die schwarze Sonne des Traums: Radierungen, Lithographien und Zeichnungen von Rodolphe BRESDIN
Cologne and Frankfurt 1972

PLANTIN, Yves
Eugène GRASSET
Paris 1980

PRELINGER, Elizabeth
Edvard MUNCH, master printmaker
New York, London, Toronto 1983

PRESCOTT, Kenneth W.
The complete graphic works of Ben SHAHN
New York 1973

QUENEAU, Raymond
Joan MIRÓ lithographe II
Paris 1975; Spanish trans. 1975

RATCLIFF, Carter
'Robert LONGO: The city of sheer image'
Print Collector's Newsletter, July–Aug. 1983, pp. 95–98

RATCLIFF, Carter
'Vija CELMINS: An art of reclamation'
Print Collector's Newsletter, Jan.–Feb. 1984, pp. 193–96

REDON, Odilon, trans. Mira JACOB and Jeanne L. WASSERMAN
To myself: Notes on life, art and artists [from French edn. *A soi-même* 1979], New York 1986

REED, Sue Welsh, and SHAPIRO, Barbara Stern
Edgar DEGAS: The painter as printmaker
Boston, Museum of Fine Arts 1984

RICKETTS, Charles
A Catalogue of Mr SHANNON's lithographs
London 1902

ROETHEL, Hans Konrad
KANDINSKY, das graphische Werk
Schauberg 1970

ROGER-MARX, Claude
'À propos de deux lithographies de M. LE SIDANER'
Gazette des Beaux-Arts, Oct. 1911, pp. 314–16

ROGER-MARX, Claude
BONNARD lithographe
Monte Carlo 1952

ROGER-MARX, Claude
Les Lithographies de RENOIR
Monte Carlo 1951

ROGER-MARX, Claude
'The Lithographs of Luc-Albert MOREAU'
Print Collector's Quarterly Anthology 7, 1977, pp. 4333–4350

ROGER-MARX, Claude
'Odilon REDON'
Burlington Magazine, June 1920, pp. 269–75

ROGER-MARX, Claude
L'Oeuvre gravé de VUILLARD
Monte Carlo 1948

ROUIR, Eugène
'Una litografia inedita di G. ROUAULT = An unpublished lithograph by G. Rouault'
Print collector = Il conoscitore di stampe, Jan.–Feb. 1977, pp. 4–7

ROUNDELL, James
Thomas Shotter BOYS
London 1974

SANDOZ, Marc
Théodore CHASSÉRIAU 1819–1856: Catalogue raisonné des peintures et estampes
Paris 1974

SANDSTRÖM, Sven
'Odilon REDON: A question of symbols'
Print Collector's Newsletter, May–June 1975, pp. 29–34

SANESI, Roberto
The graphic work of Ceri RICHARDS
Milan 1973

SASOWSKY, Norman
Reginald MARSH: Etchings, engravings, lithographs
New York 1956

SCHAPIRE, Rosa
Karl SCHMIDT-ROTTLUFFs graphisches Werk bis 1923
Berlin 1924

SCHAPIRO, Barbara Stern
'PISSARRO as printmaker'
in *Camille Pissarro 1830–1903*, London, Hayward Gallery 1980, pp. 191–234

SCHIEFLER, Gustav
Edvard MUNCH: Das graphische Werk 1906–1926
Berlin 1928

SCHIEFLER, Gustav
Die Graphik E. L. KIRCHNERs, 2 vols
vol. 1 to 1916; vol. 2, 1917–27
Berlin, Charlottenburg 1926 and 1931

SCHIEFLER, Gustav
Das graphische Werk von Max LIEBERMANN
Berlin 1902–14; 2nd edn. 1923

SCHIEFLER, Gustav
Verzeichnis des graphischen Werks Edvard MUNCHs bis 1906
Berlin 1907

SCHIEFLER, Gustav, and MOSEL, Christel
Emil NOLDE: Das graphische Werk, 2 vols
Cologne 1966–67

SCHMALENBACH, Werner
Kurt SCHWITTERS: Leben und Werk
Cologne 1967

SCHMITT, Ursula
Supplément au catalogue des gravures et lithographies de Jean DUBUFFET = Tilfjelse til kataloget Jean Dubuffet Grafik
Silkeborg 1966

SCHULT, Friedrich
Ernst BARLACH, Das graphische Werk
Hamburg 1958

SCHULZ-HOFFMAN, Carlas, and WEISS, Judith
Max BECKMANN retrospective
Saint Louis, Saint Louis Art Museum 1984

SCHWARTZ, Alexandra, and CUMMINGS, Paul
David SMITH prints
New York 1987

SCHWARZ, Heinrich
'INGRES graveur'
Gazette des Beaux-Arts, Dec. 1959, pp. 329–42

SCHWARZ, Heinrich
'Die Lithographien J. A. D. INGRES'
Mitteilungen der Gesellschaft für vervielfältigende Kunst, 1926, pp. 74–79

SCHWARZ, Karl
Das graphische Werk von Lovis CORINTH = The graphic work of Lovis CORINTH
Berlin 1917; 2nd edn. 1922; 3rd edn. 1985

SENNA, Pier Luigi
'L'Opera grafica di DE CHIRICO = DE CHIRICO's graphic works'
Print collector = Il conscitore di stampe 45, 1980, pp. 2–25

SENNA, Pier Luigi
'L'Opera litografica di DAUMIER = DAUMIER's lithographic works'
Print collector = Il conscitore di stampe vol. 47, 1980, pp. 2–25

SIEVERS, Johannes, and WALDMANN, Emil
Max SLEVOGT, das druckgraphische Werk: Radierungen, Lithographien, Holzschnitte: Erster Teil 1890–1914
Heidelberg and Berlin 1962

SINGER, Hans Wolfgang
Das Graphische Werk des Maler-Radierers Paul HERRMANN (Henri HÉRAN)
Munich 1914

SMALE, Nicholas
'WHISTLER and transfer lithography'
Tamarind Papers, Fall 1984, pp. 72–83

SMILANSKY, Noerni
'An interview with Jim DINE'
Print Review 12, 1980, pp. 56–61

SMITH, Richard
'Painting prints, printing paintings'
Print Collector's Newsletter, Jan.–Feb. 1976, pp. 156–57

SMITH, Robert
'WAS INGRES a portrait lithographer? Some reattributions to GÉRICAULT'
Nouvelles de l'estampe, Jul.–Aug. 1973, pp. 8–14

SMITH, Robert
Noel COUNIHAN prints 1931–1981
Sydney 1981

SOBY, James Thrall
Georges ROUAULT: Paintings and prints
New York 1945

SPARROW, Walter Shaw, and BRANGWYN, Frank
Prints & drawings by Frank BRANGWYN with some other phases of his art
London and New York 1919

SPENCER, Kate
The graphic art of GÉRICAULT
New Haven Conn., Yale University Art Gallery 1969

SPIELMANN, Heinz
Willi BAUMEISTER, Das graphische Werk
Hamburg 1926

STELLA, Joseph G.
The graphic work of RENOIR: Catalogue raisonné
Fort Lauderdale, Museum of Fine Arts 1975

SUTTER, Jean
'Maximilien LUCE 1858–1941'
in *The Neo-Impressionists*, London 1970, pp. 153–64

TABARANT, A.
Maximilien LUCE
Paris 1928

TANNENBAUM, Herbert
Hans THOMAS graphische Kunst
Dresden 1920

TAVEL, Hans Christoph von
Franz MARC: Das graphische Werk
Berne, Berner Kunstmuseum 1967

TEIXIDOR, Joan
Joan MIRÓ lithographe I–III: 1930–1969
Paris 1972–76; Spanish edns.; English edns. 1976

TERENZIO, Stephanie
The Prints of Robert MOTHERWELL with a catalogue raisonné 1943–84 by Dorothy C. BELKNAP
New York 1980; rev. 1984

THOMÉ, J.-R.
Catalogue de l'oeuvre lithographié et gravé de Luc-Albert MOREAU
Paris 1938

THORSON, Victoria
'Reassessing RODIN's drypoints, lithographs and book illustrations'
Nouvelles de l'estampe, Jan.–Feb. 1976, pp. 17–18

THORSON, Victoria
RODIN graphics: A catalogue raisonné of drypoints and book illustrations
San Francisco, Fine Arts Museums of San Francisco 1975

TIMM, Werner
The graphic art of Edvard MUNCH
Berlin and London 1969

TORJUSEN, Bente
'The Mirror'
in *Edvard MUNCH: Symbols & images*, Washington DC, National Gallery of Art 1978, pp. 185–227

TOUDOUZE, Georges
Henri RIVIÈRE, peintre et imagier
Paris 1907

TREGENZA, John
George French ANGAS
Adelaide, Art Gallery of South Australia 1980

TROTTER, Massey
Catalogue of the lithographs of George BIDDLE
New York 1950

URBAN, Martin
Emil NOLDE: Graphik
Seebüll, Sammlung Ada und Emil Nolde 1979

VALLIER, Dora
BRAQUE: L'oeuvre gravé, catalogue raisonné
Paris 1982

VALLOTTON, Maxime, and GOERG, Charles
Félix VALLOTTON: Catalogue raisonné de l'oeuvre gravé et lithographié = Catalogue raisonné of the printed graphic work
Geneva 1972

VASSEUR, Dominique H.
The Lithographs of Pierre-Nolasque BERGERET
Dayton Ohio, Dayton Art Institute 1981

VEBER, Pierre, and LACROIX, Louis
L'Oeuvre lithographié de Jean VEBER
Paris 1931

VUILLARD lithographe
Paris, Galerie Huguette Berès 1955

WALKER, Rainsforth A.
The Lithographs of Charles SHANNON with a catalogue of lithographs issued between the years 1904 and 1918
London 1920

WAY, Thomas R.
The Lithographs by WHISTLER illustrated by reproductions in photogravure and lithography, arranged according to the catalogue by Thomas R. Way, with additional subjects not before recorded
New York 1914

WAY, Thomas R.
'WHISTLER's lithographs'
Print Collector's Quarterly, Oct. 1913, pp. 227–309

WEIHRAUCH, Jürgen, ed.
Asger JORN: Werkverzeichnis Druckgrafik
Munich, Galerie van de Loo 1976

WEISBERG, Gabriel P.
'Georges DE FEURE's mysterious women'
Gazette des Beaux-Arts, Oct. 1974, pp. 223–32

WEITENKAMPF, Frank
'George W. BELLOWS, lithographer'
Print Connoisseur, vol. 4, 1924, pp. 224–44

WESTON, Neville
Franz KEMPF, graphic work 1962–1984
Adelaide 1984

WESTON, William
Alexandre LUNOIS 1863–1916
London, William Weston Gallery 1980

WHEELER, Monroe
The Prints of Georges ROUAULT
New York, Museum of Modern Art 1938

WHITFORD, Frank, and others
Käthe KOLLWITZ 1867–1945: The graphic works
Cambridge 1981

WICKENDEN, Robert J.
'Auguste RAFFET (1804–1860)'
Print Collector's Quarterly, vol. 7, 1917, pp. 25–54

WIETEK, Gerhard von
SCHMIDT-ROTTLUFF Graphik
Munich 1971

WILSON, Juliet
Edouard MANET: L'Oeuvre gravé, Chef d'oeuvre du Département des Estampes de la Bibliothèque Nationale, Paris
Ingelheim-am-Rhein 1977

WILSON, Juliet
MANET: Dessins, aquarelles, eaux-fortes, lithographies, correspondance
Paris 1978

WINGLER, Hans, and WELZ, Friedrich
Oskar KOKOSCHKA: Das druckgraphische Werk
Salzburg, Galerie Welz 1975

WITTROCK, Wolfgang
TOULOUSE-LAUTREC: The complete prints, 2 vols
London 1985

WOIMANT, Françoise
Jean DUBUFFET: Livres et estampes, récents enrichissements
Paris, Bibliothèque Nationale 1982

WOLL, Gerd
'The graphic production of Edvard Munch' in *Munch*
Milan, Palazzo Reale 1985, pp. 173–241

WRIGHT, Harold J. L.
The Lithographs of John COPLEY and Ethel GABAIN
Chicago, Roullier Galleries 1924

WUERTH, Louis A.
Catalogue of the lithographs of Joseph PENNELL
Boston 1931

ZABEL, Barbara
'The Lithographs of Louis LOZOWICK: Changing attitudes towards technology between the wars'
Tamarind Papers, Spring 1984, pp. 6–16

ZAO Wou-ki, and CAILLOIS, Roger
ZAO Wou-ki: Les estampes 1937–1974
Paris 1975

Index

All figures are page numbers, bold page numbers for images

A
Ackermann, Rudolphe 44, 52–3, 80, 83, 309
Adams, Clinton 264, 344–5, 347–8, **349**, 358
Adhémar, Jean 308, 335
Adler, Jules 382
Albers, Anni 266
Albers, Josef 35, **212**, 266, 276, 351, 352, 353
Albrecht, Gretchen **244**, 307
Album des estampes originales **160**, 161, **227**
Album des peintres-graveurs **133**, 161
Allport, Mary Morton 284
Aman-Jean, Edmond 160, **160**, 382
American Abstract Artists 260
American Art Printer 284
Ancourt, Edward 131, 144, 154, 157, 320, 321, 322
André, Frédéric 310
André, Johann 309
André, Philipp 309
Angas, G. F. 296
Anning Bell, R. 284
Anquetin, Louis 139, 382
Antreasian, Garo 35, 38, 262, 264, 347, 348
Aresti, Joseph 283
Aronson, Naoum 382
Art Bulletin 109
Art décoratif, L' 151, 165
Artiste, L' 110
Art-Journal 46, 78
Art New Zealand 296, 302
Art-Union 46, 85
Arundel Society 11
Aubry-Lecomte, Hyacinthe **24**, 25, 27, 28, 315
Auriol, George 128, 160, 382
Australia
 presses 283, 295;
 early lithographers 283–4
Australian Artist, The 285, 287, **287**
Autographe au Salon, L' 95
Ayrton, Michael 298

B
Bady, Berthe 150
Baetens, Frans 303
Bagnall, Percy 297
Baldessin, George 295
Bankes, Henry 310
Barker, Thomas 310, **311**
Barlach, Ernst 191, **191**, 203
Barnard, George 46, 57
Barnet, Will **258**, 261, 262, 264, 343
Barry, James **10**, 11
Bartholomew, Valentine **86**

Bataille, Henry 150, 151, 154, 176, 382
Bateman, Edward LaTrobe 283
Bauhaus 205, 208
Baumeister, Willi **206**, 208
Bawden, Edward 285
Baynard Press 327
Baynes, T. M. 64, 67
Beckmann, Max 191, 201–2, **202**
Becquet 111, 321
Beggarstaff Bros. 284
Belfond, Henry 131, 137, 138, 320, 322
Bell, Trever **253**, 337
Bellows, George 259, 325
Belville, Eugène 116
Bergeret, Pierre-Nolasque 310
Bergner, Yosl 285
Bernheim Jeune 144, 171
Bernard, Émile 110, 112–14, **115**, **115**
Bertauts, L'Équipe 314
Berthon-Chincholle, Marcel 382
Besnard, Albert 383
Besson, J.-G. 383
Bildermann, Der 191, **197**, 200, **200**, 201, 203
Black, G. B. 43
Blackburn, Robert 38, 258, **259**, 260, 261, 264, 265, 343, 344
Blackman, Charles 293, **293**, 294, **294**
Blackburn, Harry 297
Blair, Philippa 305, 307
Blanchard 133, 321
Blanche, Jacques-Émile 142, 143, **143**, 176, 177, 383
Bodmer, Karl 99, 100
Bolotowsky, Ilya 260
Bonington, Richard Parkes 25
Bonnard, Pierre 18, 20, 30, 110, 126, 127, **127**, 133, **133**, 144, **144**, 145, 146, **146**, **147**, 148, **148**, **161**, 175, 219, 329, 383
Bontecou, Lee 266
Booth, Leonard 297
Bouchot, Henri 110, 132
Bourgerie et Cie 154, 320
Boyd, Arthur 289, **289**, 294
Boys, Thomas Shotter 28, 75, 76, 78–9, **79**, 85, 209, 316, 317
Brangwyn, Frank 166, 297, 383
Braque, Georges 20, **22**, 252, 329, 330, 333
Bray, F. H. 323, **323**
Bresdin, Rodolphe 14, 383
British Lithographer, The 248, 284, 318
Brown, Bolton 30, 259–60, 262, 324, 325, 326, 345
Brown, Jean Louis 383
Brown, John Lewis 132, 137, 383
Brücke, Die 20, 33, 192, **193**, 195, 198, 200, 203, 310
Bry, Auguste 314, **315**

Buhot, Félix 383
Burlington Magazine 109
Butler, Reg 20, **337**, 338–9
Buzacott, Nutter 285, 287

C
Carabin, F.-R. 383
Cardew, Gaynor 343
Carman, Albert 33
Caro-Delaville, Henry 383
Carrière, Eugène 144, **319**, 320, 383
Cassatt, Mary 110, 120, 165, 169, 383–4
Cassirer, Bruno and Paul 184, 188, 189, 190, 191, 192, 200
Celmins, Vija 275, **275**, 358
Centaure, Le **143**, 154, 156, **157**
Cézanne, Paul 134, 161, **162**, 163, 171, 182, 384
Chagall, Marc 20, **21**, 329, 330, 333, 334, **334**
Chalon, Henry Bernard 25, **26**
Charivari 319
Charlet, Nicolas-Toussaint 13, **14**, 110, 314, **315**
Charlot, Jean 33, **210**, 260, 282, 319, 344
Chassériau, Théodore 11
Chéret, Jules 18, 174, **251**, 284, 317–18
Chromolithograph, The 284
Chromolithography 30, 32, 79, 137–8, 183, 297
Chromotypographie 106
Cincinnati Biennial 263, 264, 265, 266, 267, 295
Cirrus 275
Clot, André 129, 143, 145, 150, 163, 174
Clot, Auguste 129–75
 apprenticeship 130–1;
 & collotype 169, 171;
 & de Crauzat 165–6;
 drawing of **144**;
 letterhead **155**;
 letters to 176–82;
 photo of 129, **164**;
 reference 131, **132**;
 schedule of work 382–91;
 & Spitzer catalogue 131–2;
 & Vollard 133–6;
 works printed by **120**, **126**, **127**, **130**, **133**, **134**, **136**, **139**, **141**, **143**, **145**, **146**, **147**, **148**, **149**, **152**, **153**, **156**, **159**, **160**, **161**, **162**, **166**, **168**, **170**, **173**, **174**, **175**, **215**, **216**, **217**, **219**, **220**, **221**, **222**, **223**, **224**, **225**, **226**, **227**, 249
Clot, Mme Auguste 151, 177, 178, 179, 180, 182
Coen, Eleanor 265
Comte, procédé 99
Contemporaries Gallery 262

Contemporary Lithographs 285
Coolahan, Kate 301
Cooper, Richard 11
Corinth, Lovis **190**, 191
Cornwall, Graeme **245**, 302, **303**
Corot, J.-B. Camille 28, **29**, **29**, 94, **94**, 95, 96
Cottet, Charles 160, 384
Courrier français, Le 139
Counihan, Noel 285, 286, **286**, 287, **287**, 288, 290, 295, 339, 341
Courboin, François 384
Cowan, Roy 299, 300
Crawford, Ralston 264, **265**
Cross, Henri Edmond 20, 140, 141, **249**, 318, 384
Crowley, Aleister 164–5
Currier & Ives 28
Curwen, Harold 33, 38, 327, 328
Curwen Press 38, 328
Curwen Studio 38, 337

D
Dahmen, F. K. 336
Damer, Jack 262
Dasio, Max 185
Daumier, Honoré 14, **16**, 28, 29, 137, 142, 319
Davie, Alan 38
Davis, Stuart 260, 264
Dawson, Janet 295, 338, **339**
Day & Haghe 58, 78
Decamps 110
De Feure, Georges 384
Degas, Edgar 91, 108, 111, 120, 134, 166, 169–70, 171, **171**, 177, 384
De Groux, Henry 165, 175, 384
Dehn, Adolf 262, 264
De Kooning, Willem 267, 270, **271**, 342, 350
Degotardi, John 284
Delacroix, Eugène 25, 110, 315, 316, 384
Delpech, F. 57, 310, **311**
Denis, Maurice 18, **19**, 20, 110, 117, 118, 122, 126, 134, 144, 148, **148**, 149, 150, **150**, 174, 177, **217**, 224, 384
Deschamps, Henri 328, 330
Desjobert, E. 343
Dethomas, Maxime 154, 177, 178, 384
Devéria, Achille 314, 315
Diebenkorn, Richard 266, 279, 357, 358
Dighton, Denis 64, 67
Dillon, H.-P. 384
Dine, Jim 266, 278, 279, **279**
Dix, Otto 205, **230**
Drewes, Werner 33
Druckma Press 295, 339, 341
Druick, D. & Zegers, P. 94, 95, 101, 163
Dubuffet, Jean 358, **358**, 359

Duchâtel, E. 131, 138, **319**, 320, 329
Dulac, Charles 110, 114–16, **116**, **117**, 118, **214**
Durassier, Marcel 35, 345, 347
Duret, Théodore 171
Dyson, Will **287**

E
Earle, Augustus 283, 296
Einhorn, Jule 305
Eliot, Maurice 163, 178, 384
El Lissitzky 208
Ellis, Frederick 298
Engelmann, Godefroy 13, 57, 61, 72, 79, 82, 83, 84, 138, **246**, 310, 312, 313, **313**, 316
Engelmann, Graf, Coindet & Co. 44, 57, 72, 84, 85, 86
England Bangala 342, 343
Éphrussi, Charles 150
Épreuve, L' 143, 144
Ernotte 174
Estampe et l'affiche, L' 160
Estampe moderne, L' 133, 143
Estampe originale, L' 110, 118, 119, 131, 143, 171, 180, 320
Everyman prints 285
Evermon, Robert 268
Expositor 44, 46, 51

F
Fantin-Latour, Henri 11, 18, **18**, 110, 133, 134, 137, 143, 153, **153**, 154, 162, 163, 169, 170, **170**, 175, **175**, 178, 319, 385
Feininger, Lyonel 203, 205
Feldman, Eugène **241**, 280, 282
Fischer, Otto 185
Figaro illustré, Le 119
Fliegende Blätter 186
Flory, Arthur 264
Fomison, Tony 303, **304**, 305, **305**
Forain, Jean-Louis **136**, 385
Fougeadoire 165
Fowler, Daniel 42, 47
Francis, Sam 265, 266, 267, 269, **269**
Frankenthaler, Helen **235**, 257, 269, 270
Frapier 131, 329
Freedman, Barnett 33, 285, **327**, 328
Freedman, Harold 288
Freeman, Daniel B. 268
French, Leonard 290, **291**
Fuseli, Henry **10**, 11

G
Gabain, Ethel 297
Gallatin, Albert 33
Gandara, Antonio de la 385
Garcia-Alvarez, Alberto 302, 305
Gascoigne, Bamber 78, 316
Gauci, Maxime 64, 85, 86
Gauguin, Paul 20, 110, 112, 113, **113**, 114, **114**, 115, 118, 144, 385
Gaulon, C.-C.-M.-N. 312
Gavarni, Paul 14, **17**, 28, 171, 319, 385
Gazette des Beaux Arts 100, 101, 129, 150, **150**, 151, 173
Gemini G. E. L. 35, 37, 257, 265, 267, 273, 274, 276, 277, 351, 352, 357
Genis, Fred 270, 342, 349
Georges, Dr Guy 150, 174

Géricault, Théodore 13, **15**, 25, 26, 27, 46, 68, **68**, 88, 110, 181, 310, 311
Germinal 160, 166, 181
Gessner, Conrad 10, 11, 309, **309**
Gillot and Son 104, 106
Gillotage 91, 95, 96, 97, 99, 101–4, **101**, 105, 107, **107**, 108
Gilmour, Pat 35, 95, 101, 104, 105
Gingko Print Workshop 305
Girodet-Trioson, Anne-Louis 25
Glarner, Fritz 265, 266, **266**
Glaser, Curt 188
Gleeson, Bill **243**, 294, 295
Goldston, Bill 257, 354, 355
Golub, Leon 345, **346**
Goode, Joe 274, **274**
Goulding, Frederick 324
Goya y Lucientes, Francisco 14, **16**, 25, 308, 310, 312
Grandville 110
Graphicstudio 257, 262, 267, 277, 278
Grasset, Eugène 106, **106**, 137, 385
Greiner, Otto 185, 186
Grieve, Robert 194
Griffiths, Antony 91, 94, 140
Griffits, Thomas 324, 327
Grillon, Roger-Maurice 138, 385
Grooms, Red 177
Gros, Antoine-Jean 13, **15**
Grosman, Tatyana 35, 257, 266, 273, 342, 343, 354, 355, 356
Grosz, George 203, 205, **206**
Guérard, Henri 108
Guiguet, François 385
Guillaumin, Armand 151, 160, 171, 179, 222, 385
Guston, Philip 266, 269, 270

H
Hamilton, Edward **256**, 357–8
Harding, James D. 28, 47, 48, 58, 64, 67, 68, 70, 71, 72, 73, **73**, 75, **75**, 76, 77, **77**, 85, 86
Hardy, Dudley 284
Harrington, Lionel 288
Hartigan, Grace 266, **266**
Hartrick, A. S. 297, 323, 324
Hassam, Childe 259
Hauber, Joseph 53
Heath, Charles 11, **11**
Heckel, Erich 20, 33, 192, **193**, 194, 195, 196, **197**, 198, 200, 200, 201
Heizer, Michael **281**, 282
Helfond, Riva 264
Heller, Jules 262
Henderson, Louise 299
Héran, Henri (Paul Herrmann) 154, 155, **223**, 385
Hermann-Paul 110, 118, 120, 121, **121**, 151, 155, 386
Hjorth, Noela 341, **342**
Hoberg, R. 189
Hockney, David 22, 23, 40, 41, **41**, 236, 266, 275, 352, 353, **353**
Hoffmann, Wilhelm 185, 186
Hollander, Irwin 264, 267, 269, 270, 349, 350
Hollerbaum & Schmidt 186
Hope, Gabrielle 299
Horak, Bohuslav 38, 349
Hotere, Ralph 305, **306**
Hugo, Georges 151–2, 386
Hullmandel, Charles 27, 28, 42–90, 312, 314, 315, 316

Art of drawing on stone 26, 42, 44, 62, 63, 68, 69, 73, 76, 80, 81, **81**, 82, **82**, 85, 88, **313**; & colour 28, 316–17; & Cumberland, G. 69; draftsmen 64–7; establishment 45, **45**, 54–68; & Evelina Hullmandel 48, 58, **58**; his houses 46, **47**; & Faraday, M. 46, 57, 58, 68, 72, 85; & Fowler, D. 47, 57, 59, 67; & Gregson, M. 57, 63, 64; & Harding, J. D. 58, 64, 67, 72; & Hancock, C. 77, 85; lithographs drawn by 49, **49**, 50, 51, 52, 54, 59, 66, 84, **84**; lithotint 28, 46–7, 72, 76, 77, 77, 78, 314, **315**; life 42–8; & Paterson, J. S. 70; portrait **43**, 46; presses 44, 51–2, 60, **60**, 61, **61**, 62; & Raucourt, A. 80; & St Bride Library Album 48, 58, 59, 72–80, 74; tinted lithography 53, 72–8; *Twenty-four views of Italy* 49, 50–3, **50**, 54, 64, 69, 80; & Walton 56, 58, 77, 88, 89, **89**; will 58; works printed by **26**, 27, **43**, ?50, 53, 58, 59, 63, 65, 66–8, 70, 71, 73–7, 79, 81, 82, 84, 86, 87, 89, 90, 209, 313

I
Ibels, Henri-Gabriel 111, **118**, 119
Ida, Shoichi 282
Isabey, Eugène 13, **13**, 25, 110, 314, **314**
Isham, Timothy 268

J
Jack, Kenneth 288, 295
Jackson, F. E. 324
Jacquette, Yvonne 276, 277
Jargon 285
Jeanès, Sigismond 386
Jeanniot, Pierre-Georges 150, 151, 153, 179, 180, 386
Jirlow, L. 329, 329
Johannot, François 310
John, Augustus 140, 165, 386
Johns, Jasper 37, **211**, 257, 266, **272**, 273, 282, 312, **312**, 342, 355, **356**
Jones, Owen **10**, 11, 138, 283, 317
Jones & Bluett 296
Jones, Robert **244**, 307, 342
Jones, Stanley 38, 150, 163, 335, 336, 337, 338, 339, 343
Jugend 186

K
Kahn, Max 265, 345
Kainen, Jacob 104, **234**, 258, **258**
Kalckreuth, Count 186
Kandinsky, Wassily 183, 205, 206, 208, **233**
Katz, Alex 275
Kavli, Arne 154, 386
Kelly, Ellsworth 41, 267, 276, **276**

Kimball, Wayne 262, **263**, 268
Kirchner, Ernst Ludwig 20, 32, 33, 33, 183, 192, **192**, 193, **193**, 194, **194**, 195, **197**, 198, 200, 201, **201**, 206, 208, **231**
Kistler, Lynton R. 33, 259, 260, 267, 282, 344, 356
Klee, Paul 205, **205**
Klein, Johann 12, **13**
Klinger, Max 185
Klossowski, Erich 386
Kokoschka, Oskar 191, **191**
Kollwitz, Käthe 188, 201, **201**, 229, 285
Kossatz 295
Kozloff, Joyce 239, 276
Kriegszeit 200
Kruck, Christian 20
Kuniyoshi, Yasuo 260
Kushner, Robert **238**, 276, 359

L
Lamb, Lynton 300
Lane, Richard 67, 73, **74**
Langlumé 296, 310
Laprade, Pierre 386
Lassally, M. W. 184, 200
Lassaw, Ibram 33, 310
Lasteyrie, Comte de 13, 310
Laurent, Ernest 386
Léandre, Charles 386
Lebasque, Henri 169, 386
Le Breton, Louis 296
Lee, Doris 262
Lefort, Henri 30
Lefort, Louis 98, 99
Lefman, Ferdinand 99, 104, **101**, 102, 104, 105
Léger, Fernand 20, 22
Legrand, Louis 120, 144, 386
Legros, Alphonse 386
Leheutre, Gustave 386
Lehrs, Max 183, 184, 186
Lemercier 59, 94, 104, 130, 131, 132, 134, 137, 143, 144, 151, 157, 180, 296, 316, 319, 320, 321, 322, 329
Lemon, Jack 267
Le Sidaner, Henri-Eugène 169, 386
Leunis & Chapman 208
Lewisohn, Raphael 386
Lévy-Dhurmer, Lucien 169, 386
Leyendecker, Christian 284
Lichtenstein, Roy 257, 267, 273, 274, 279
Lichtwark, Alfred 186
Lidner, Richard 267
Liebermann, Max 142, 190, **190**, 386
Limbach, Russell T. 264
Lithographie originale en couleurs, La 161, **161**
Lithographische Kunstproducte 53
Lithography
 algraphy 187;
 autographie 91, 94, 95, 96, 105, 166;
 chalk 10, 25, 30;
 colour 10, 32, 198, 330;
 lavis 72, 82, 138;
 lithotint 31, 316, 322;
 manière noire 31;
 mylar method 29, 40;
 offset 28, 33, 260, 267, 282;
 pen 10, 30;
 'rainbow roll' 37, 318, **284**, 356;

sprinkled manner 318;
Steinzeichnung 187, 189, 192, 200;
stipple 248, 318, 356;
stone engraving 31;
tinted 73, 75, 75;
transfer 27, 29, 30, 31, 91, 94, 94, 95, 96, 97, 144, 158, 179, 198, 200, 201, 205;
zinc 29, 33, 115, 288
Loane, John 342
Lowengrund, Margaret 262, 264, 268, 324
Lozingot, Serge 358–9, 357
Lozowick, Louis 260, 260
Luce, Maximilien 20, 110, 122, 123, 123, 124, 124, 125, 134, 138, 141, 386
Lührig, Georg 185, 186
Lunois, Alexandre 20, 134, 137, 138, 139, 139, 143, 154, 169, 221, 387

M
Maclennan, Stewart 298
McCahon, Colin 298, 298, 299
McClintock, Rem 285, 287, 288
McGarrell 40
McIntosh, Jill 305
McIntyre, Peter 296
McNeil Lowry, W. 345, 348
McNeil, George 345, 347
Maillol, Aristide 144, 387
Man, Felix 9, 11
 Collection 9–23;
 portrait 22, 23
Manet, Édouard 18, 91–109, 92, 93, 97, 100, 102, 103, 105, 111, 130, 131, 137, 161, 387
Mangold, Sylvia Plimack 276
Manzana-Pissarro, Georges 152, 154, 387
Manzù, Giacomo 20
Maquire, Marian 305, 306
Marcuard, Charles 52
Marini, Marino 20
Martin, Henri 387
Marty, André 110, 118, 171, 180
Marx, Roger 175
Mason, Cyrus 283
Matisse, Henri 20, 21, 33, 169, 329, 387–8
Matthès, Ernst 388
Maurin, Charles 388
Meier-Graefe, Julius 154, 159, 160, 166, 181
Meldrum, Max 287
Mellerio, André 30, 41, 129, 131, 137, 138, 139, 140, 141, 161, 162, 163, 174, 177, 318, 320, 321, 348
Melot, Michel 170
Meunier, Charles 153, 178
Michel, Toby 267
Milant, Jean 267, 358
Milcendeau, Charles 150
Miller, George C. 259, 260, 325, 326, 326, 335, 343, 344
Miró, Joan 20, 22, 254–55, 329
Misti (Ferdinand Mifliez) 388
Mitchell, Joan 237, 270
Moholy-Nagy, Lazlo 206, 208
Molitor, Comtesse de 171, 388
Monet, Claude 171
Monrocq 321
Moore, Henry 40, 337
Moreau, Luc-Albert 174, 174, 388

Moreau-Nélaton, E. 94, 95
Morisot, Berthe 131, 137
Morley, Malcolm 40, 40
Morris, George L. K. 33
Moser & Harris 50, 51, 52
Motherwell, Robert 25, 28, 37, 40, 41, 41, 213, 257, 267, 269, 270, 350, 350, 351
Motte, Charles 310, 314, 315
Mourlot, Fernand 33, 252, 329, 330, 332, 333, 334, 335, 345, 355
Mucha, Alphonse 284
Mueller, Otto 33, 195, 199, 200, 200
Muka Studio 303
Munakata, Shiko 264
Munch, Edvard 33, 154, 155, 155, 156, 156, 157, 157, 158, 159, 160, 188, 193, 388
Münchner Blätter für Dichtung . . . 205
Murray, Elizabeth 279

N
Nabis 118, 134, 137, 144, 166
Nash, Paul 33, 285, 301
Neal, Reginald 262
Nevelson, Louise 267
Newlin, Richard 267
Newman, Barnet 266
New Zealand
 early lithographic artists 296–7;
 Loan collection 297;
 Quoin club 297;
 workshops 302, 303
Nicholson, Francis 64
Nicholson, Michael 299, 300
Nicolet, Gabriel 388
Noland, Kenneth 280, 281
Nolde, Emil 20, 33, 198, 199, 229

O
O'Connor, Vic 285
Ogé, E. 143, 388
Oldenburg, Claes 37, 38, 277
Oliveira, Nathan 265
Ollendorff, Paul 176
Osborne, John 284

P
Page, George 265
Palmer, Stanley 301–2, 301
Pan 140, 141, 151, 154, 184, 186, 248, 318
Pan-Presse 189, 190, 191
Parsons, Elizabeth 284
Passeron, Roger 169
Patris Atelier 293, 336, 339
Pearlstein, Philip 275
Pearson, Henry 267
Pechstein, Max 195, 197, 198, 232
Peintres-Lithographes, Les 110
Pellet, Gustave 134, 139, 140, 141, 154, 155, 169
Pennell, Joseph 29, 30, 32, 94, 259, 262, 324, 326, 327
Perlmutter, Jack 265
Peter, Juliet 300
Peters, Jimmy 326
Petitjean, Hippolyte 140, 389
Phillips, John 52
Photolithography 28, 38, 40, 104–5, 203, 205
Picasso, Pablo 11, 20, 20, 21, 32, 33, 34, 35, 38, 253, 329, 330, 331, 331, 332, 332, 333, 333

Piccadilly Magazine 323
Pickmere, Alison 299
Picturesque architecture 76, 78–80, 79, 85, 317
Piloty 53
Point, Armand 389
Piper, John 33, 38, 336, 337, 338
Pissarro, Camille 20, 20, 122, 132, 134
Pissarro, Lucien 132, 389
Pitcairn Knowles, James 157, 389
Plume, La 150, 155, 163
Popesco, Stefan 389
Poitevin, Alphonse 104
Pointillism 140, 317
Polyautographische Zeichnungen 12
Ponce de Leon, Michael 268
Porter, Fairfield 275
Préveraud de Sonneville, Y. 389
Priede, Zigmunds 38, 354
Print Collector's Quarterly 297
Printmaking Workshop 259
Print Quarterly 109
Prout, Samuel 66, 67, 67, 95
Purrmann, Hans 20
Puvis de Chavannes, Pierre 144, 389
Puy, Jean 389

Q
Quoin Club, Auckland 297

R
Raffaelli, Jean François 389
Raffet, Auguste 138, 314, 315
Ramage, Don 298, 300, 300, 301
Ramos, Mel 265
Ranson, Paul-Élie 143, 144, 389
Rassenfosse, Armand 389
Raucourt, Antoine 80, 80, 81, 82, 312
Rauschenberg, Robert 36, 37, 37, 38, 257, 273, 274, 276, 282, 342, 344, 351, 352
Redman, D. J. 310
Redon, Odilon 18, 28, 29, 110, 111, 112, 112, 117, 118, 131, 133, 134, 134, 137, 144, 161, 162, 227, 318, 321, 321, 322, 389
Renoir, Pierre-Auguste 20, 137, 161, 165, 166, 166, 167, 168, 169, 177, 182, 389
Rees, Lloyd 341, 342
Renouard, Paul 389
Repository of Arts 44
Reuter, Wilhelm 11, 13, 13, 310, 310
Revue Blanche, La 154
Revue de l'art ancien 139, 139, 151
Richards, Ceri 38, 39, 335–6, 339
Richardson, H. Linley 297
Richmond, W. D. 260, 317
Riggs, Robert 326, 327
Riopelle 336
Rippl Rónai 389
Rire, Le 125
Rivière, Henri 110, 111, 112, 127, 127, 128, 218
Rivers, Larry 266, 343, 344
Robinson, John 195
Rochegrosse, Georges 389
Rockburne, Dorothea 277
Rodin, Auguste 136, 137, 150, 155, 161, 162, 163, 164, 164, 165, 169, 175, 177, 226, 389–90

Roger-Marx, Claude 129, 131, 145, 166, 169, 174, 322
Rosengrave, Harry 242, 292, 293
Rosenquist, Jim 257, 277, 278, 342, 354, 355
Rothenberg, Susan 279
Rouault, Georges 154, 171, 172, 173, 173, 174, 328, 329, 390
Roussel, Ker-Xavier 126, 144, 148, 149, 149, 174, 390

S
Sacilotto Deli 262
Saff, Donald 257, 267, 348
Sainson, Louis Auguste de 296
Sanchez, Maurice 267, 355, 355, 359
Schanker, Louis 260
Scharf, George 62, 65, 67, 85
Schiefler, Gustave 193, 198
Schepers, Karin 295
Schinkel, Karl Friedrich 12, 12
Schmidt-Rottluff, Karl 192, 193, 195, 195
Schnerb, Jacques Félix 390
Schuffenecker, Émile 390
Schwitters, Kurt 207, 208
Scott, Harriet & Helena 284
Scott, William 38, 39
Sellback, Udo 295
Senefelder, Alois 11, 25, 27, 28, 30, 194, 283, 307, 309, 315
 Complete course of lithography 1, 2, 26, 27, 80;
 Club 32, 38, 297, 307, 324, 326;
 portrait 23
Serra, Richard 279
Sérusier, Paul 118, 144
Sessler, Alfred 262
Seurat, Georges 140, 317, 318
Shannon, Charles 160, 297, 390
Shapiro, Barbara 91, 101, 102
Shark, Bud 262, 277
Shatter, Susan 276
Shine, Cathryn 302
Sickert, Walter 29
Signac, Paul 20, 134, 140, 141, 150, 225, 247, 318, 390
Simplicissimus 203
Simon, Lucien 160, 390
Simon, Timothy 38
Singer, Arnold 262
Singer, Hans W. 184, 186
Sisley, Alfred 20, 161, 162, 163, 171, 390
Slevogt, Max 142, 188, 189, 189, 190, 390
Smith, David 268, 268, 269
Smith, William Mein 296
Society of French Artists 30, 137
Solodkin, Judith 238, 267, 359
Sorlier, Charles 330, 334, 335
Sorman, Steven 240, 280, 353
Soyer, Raphael 260
Specimens of Polyautography 11, 25
Spitzer, Frédéric 131, 132
Spruance, Benton 261, 261, 262, 264
Stafford, George 284
Stasik, Andrew 264
Steg, James Louis 265
Steinberg, Saul 267
Steinhausen, Wilhelm 185
Steinlen, Théophile 20, 122, 123, 141–3, 141, 154, 165, 180, 390

Stella, Frank 41, 257, 273, 276, 277, 282, 352
Stern, Mme Ernesta (Maria Star) 171, 391
Stern, Henry 154, 320–21
Steven, E. J. 248, 318
Strixner 53
Strutt, William 283
Studio, 151, 184, 287
Sugai, Kumi 339
Sukimoto, Chris 268
Sunyer Miró, Joachim 110, 122, 122
Sutherland, Graham 20, 23

T
Tamarind Book of Lithography 264, 302, 348
Tamarind Lithography Workshop 35, 37, 38, 40, 257, 261, 262, 265, 266, 267, 268, 276, 302, 345, 347, 348, 354, 356
Tamarind Institute 257, 262, 345, 347
Tappert, George 195, 196
Tasmania 42, 62, 163, 282, 342
Taylor, Baron Isidore 54, 84, 314
Thiebaud, Wayne 265
Thiebault-Sisson 30
Thoma, Hans 185, 185, 186, 187, 188
Toorop, Jan Théodore 391
Toulouse-Lautrec, Henri de 18,

19, 20, 30, 110, 111, 119, 119, 120, 121, 135, 137, 140, 154, 155, 160, 169, 215, 320, 320, 321, 335, 391
Tremblay, Theo 342, 342
Troedel & Cooper 288
Tullis, Garner 265
Tutin Père 330, 331
Twyman, Michael 27, 42, 310
Tworkov, Jack 269
Tyler Graphics 41, 257, 267, 270, 275, 276, 280, 345, 352
Tyler, Kenneth 35, 41, 108, 257, 267, 275, 345, 349, 351, 352, 352, 354, 356

U
Universal Ltd Art Editions (U.L.A.E.) 35, 37, 38, 257, 265, 266, 273, 274, 343, 354, 354
Uzanne, Octave 154, 180

V
Valadon, Suzanne 391
Vallotton, Félix 110, 124, 125, 125, 391
Van Rysselberghe 166, 181, 391
Veber, Jean 151, 155, 181, 391
Verneau, Eugène 128, 140, 318
Vernet, Carle 13, 310, 311
Vernet, Horace 13, 15, 283
Vertès 174, 391
Verve 329

Victoria and Albert Museum 20
Victorian Print Workshop 295
Vignaux, Henri 105, 105
Villain 310, 315
Vincent, Brooks Day & Son 427
Voigtländer 187
Vollard, Ambroise 110, 126, 132, 133, 134, 136, 137, 138, 139, 140, 143, 148, 149, 150, 151, 153, 160, 160, 161, 162, 163, 164, 166, 169, 171, 171, 172, 173, 173, 176, 177, 179, 182, 182, 189, 220, 227
Von Groschwitz, Gustave 263, 264, 265, 282, 345
Von Guérard, Eugène 283
Von Menzel, Adolphe 14, 17, 31, 142, 184
Von Schlichtegroll 309
Von Wicht, John 264
Voyages pittoresques . . . 54, 84, 314, 314
Vuillard, Edouard 20, 20, 30, 111, 126, 126, 127, 144, 145, 145, 148, 149, 157, 174, 216, 220, 391
Vytlacil, Vaclav 260, 260

W
Wagenbauer, Max 53
Walker, Barry 41, 347
Ward, James 25, 27, 27
Way, Thomas 31, 175, 322, 323, 324

Wayne, June 35, 35, 256, 257, 262, 264, 266, 267, 343, 344, 345, 355, 356, 357, cover
Webb, James L. 268
Weddige, Emil 265
Welliver, Neil 275
West, Benjamin 11, 24, 25
Westall, William 64
Westphalen, Flensburg 198
Whisson, Ken 290, 290
Whistler, James McNeill 18, 19, 29, 31, 31, 144, 153, 160, 161, 163, 171, 175, 250, 322, 323, 323, 324, 391
Wigley, James 285
Williams, Delyn 245, 302
Williams, Fred 294
Willich, Charles Madinger 52
Winters, Terry 279
Wood, Grant 325, 326
Works Progress Administration (W.P.A.) 257, 258, 259, 263
Wyczólkowski, Leon 145

Y
Young, Blamire 284
Yunkers, Adja 35, 265, 266, 347, 347

Z
Zaubitzer, Carl 205
Zigrosser, Carl 33
Zille, Heinrich 203